STIEGLIT

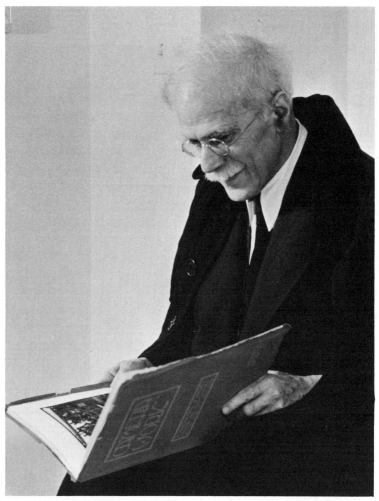

Alfred Stieglitz at An American Place, ca. 1942 Georgia Engelhard

SUE DAVIDSON LOWE

STIEGLITZ

A MEMOIR / BIOGRAPHY

FARRAR STRAUS GIROUX · NEW YORK

Library of Congress Cataloging in Publication Data
Lowe, Sue Davidson.
 Stieglitz: a memoir.
 Bibliography: p. 411
 Includes index.
 1. Stieglitz, Alfred, 1864–1946. 2. Photographers—
United States—Biography. I. Title.
TR140.S7L68 1983 770′.92′4 [B] 82–18341

*To Ellen—who threw me in, kept me afloat,
and brought me ashore—with love and gratitude*

ACKNOWLEDGMENTS

To thank adequately all those who have helped and sustained me through seven years of stubborn effort would take at least another chapter. It is no measure of my gratitude that those to whom I owe the most—the relatives and friends whose generously shared recollections, letters, souvenirs, and photographs have added substance and color to the book—here receive little more than a listing. Some have earned extra credit as well: Georgia Engelhard Cromwell for wading through and checking for accuracy the nearly 1,000-page penultimate MS; Peggy Davidson Murray for tackling an even earlier MS, refreshing my childhood memory, and providing a multitude of kindnesses; Flora Stieglitz Straus (who also suffered through the initial MS) for giving me first use of her treasured collection of family letters predating Alfred's birth and spanning his childhood before donating them to the Stieglitz Archives at Yale; Ann Straus Gertler for permitting me access to further documents; and Dorothy Obermeyer Schubart (another veteran of the first opus) for giving me an abundance of anecdotes and consistent hospitality.

Among friends, Dorothy Norman has been exceptionally generous with time, reminiscence, hospitality, and photographs, as have also—to the full measure of what I asked of them—Marie R. and George K. Boursault, Mary Steichen Calderone, Aline and Bill Dove, Josiane Einstein, Norma and John Marin, Jr., Josephine B. Marks, the late Claire O'Brien, Frank Prosser, and Herbert J. Seligmann. Among those who have become friends through the medium of the book are Donald Gallup (Curator Emeritus of the Collection of American Literature at the Beinecke Library of Yale University and erstwhile custodian of the Stieglitz Archives), to whom I am deeply indebted for multifarious aid during fifteen months of intense research and thereafter, and three others who were kind enough to share some of their independent researches with me: Sarah Greenough Cikovsky, Ann Lee Morgan, and Sarah Whitaker Peters.

Other relatives who have earned my gratitude include family genealogist

Charles Jackson Friedlander, the late Flora Werner Harris, Jane Harris Hubbard, Arthur Kuhn, the late Herbert Small, and Edward Werner, Jr. I regret that, for lack of time and energy, I had to forgo the warm offers of Hannah Small Ludins and Amy Gans Small to share reminiscences.

Without the prior research developed in the books (listed in the Bibliography) of Doris Bry, Bram Dijkstra, Barbara Haskell, MacKinley Helm, William Innes Homer, Laurie Lisle, James R. Mellow, Weston Naef, Beaumont and Nancy Newhall, Dorothy Norman, Sheldon Reich, and Herbert J. Seligmann, my task would have been immeasurably onerous. My thanks to them as well as, in warm memory, to Arthur Dove, John Marin, Edward Steichen, and Paul Strand both for rich conversation long before I contemplated this work and for committing their thoughts and recollections to paper. To the indomitable Georgia O'Keeffe, whose words have always had singular power, my appreciation for having allowed others, if not me, to quote her directly at length.

Marie Rapp Boursault, Georgia Engelhard Cromwell, William C. Dove, Ann Straus Gertler, Peggy Davidson Murray, Flora Stieglitz Straus, and Edward Werner, Jr., have generously permitted me to quote their own and/ or their forbears' unpublished letters now in the Stieglitz Archives at the Beinecke Library. In helping me deal physically with the vast correspondence, the Library staff has been unfailingly supportive. I thank David Schoonover, the current Curator of the American Literature Collection; Anne Whelpley, Librarian; and all those cheerful and willing souls on whom I was dependent for so long: Donna Brown, Gerry de Petto, Gay Gibson, Joan Hofmann, Pat Howell, Steven Jones, and others whose names I may unintentionally have omitted. Mrs. Emmi Tuchman's translations from German of early family letters simplified my work significantly.

I owe special thanks to the following authors for their generosity of spirit *vis-à-vis* my use of their works listed below: William Innes Homer, *Alfred Stieglitz and the American Avant-Garde;* Dorothy Norman, *Alfred Stieglitz: An American Seer;* Dorothy Norman and Herbert J. Seligmann as editors, and John Marin, Jr., as heir, *The Selected Writings of John Marin*; and Herbert J. Seligmann, *Alfred Stieglitz Talking.* Farrar, Straus & Giroux have kindly granted me the right to quote at length from Edmund Wilson's *The American Earthquake.* I am grateful as well to those authors and publishers from whose works I have quoted a few sentences or phrases without specific permission; in each case, I have given full credit in the Notes.

I cannot adequately express the depth of my gratitude to my photo

editor/researcher and daughter, Ellen Lowe, for her judgment, commitment, and arduous work over several years; to the photographers who have generously allowed me to use their eloquent images in the text—Ansel Adams, Georgia Engelhard, Josephine B. Marks, Herbert J. Seligmann, and Flora Stieglitz Straus; to Josiane Einstein for entrusting her late husband's photo to the overseas mails; and to those within and beyond the family who have loaned me copies or original Stieglitz prints from their personal collections. My thanks go as well to Weston Naef at the Metropolitan Museum of Art, to Michael E. Hoffman and Catherine Vedilago at the Paul Strand Foundation, and to Christine Armstrong, Evelyn Brenner, Martha Chahroudi, Conna Clark, and Laura Hammonds at the Philadelphia Museum of Art, for facilitating the search for and reproduction of photographs (identified in the Notes on Illustrations), and to the many other people at other institutions who were so generous with assistance, among them: Miles Barth and Stan Johnson at the Art Institute of Chicago, James A. Conlin, Susan Peters, and Mary Widger at George Eastman House; Esther Brumberg and Steve Miller at the Museum of the City of New York; Peter Galassi at the Museum of Modern Art; and Peter Bunnell at Princeton University. I appreciate also the quick and courteous help of a number of other people, here unnamed, at the Boston Museum of Fine Arts, the Cleveland Museum, the Library of Congress, the New-York Historical Society, and the New York Public Library. For the high-quality reproduction prints that promote legibility and pleasure, I am indebted to Timothy Druckrey, especially for his meticulous "translations" of ferrotypes and moving picture images; to Marjorie Hammer, Jennifer Harper, and William Homer for providing fine copy prints; and to Norman Sanders and his conscientious staff for their artistry in the printing of the center section of Stieglitzes.

I have not forgotten those to whom I owe the ultimate gratitude. Heading the list are the Messrs. Straus and Giroux, for granting me publication. For her unassailable optimism, her warmth, her patience, and for the tactful delicacy of her surgery, I thank my editor, Pat Strachan, as I thank also her assistant, Carol McKeown. My unreserved appreciation goes to Carmen Gomezplata, Dorris Janowitz, Naomi Lipman, and Jackie Schuman, as well as to the unnamed backstage crew who worked so hard to forge this work into an entity.

I could not have survived this long travail without the enthusiasm, patience, humor, sustenance, and straightforward help of some very special friends. Raymond Gerome, Marjorie Harvey, Leueen MacGrath, John

ACKNOWLEDGMENTS

Moffitt, Dorothea Straus, and Howard Teichmann encouraged me from the first page of the first MS nearly ten years ago; Mrs. Straus gave me the nerve to test the publishing waters and made her way through the mammoth next-to-last version as well. The nearby steadying presence and understanding of Augie Capaccio and Jim Mellow did much to preserve my sanity; at various stages I leaned heavily on the friendly expertise of Peter Ryan and Tennyson Schad, and on the help and support of Betsy McManus, Sven Mohr, Dany Nechoushtan, and Darrel Sewell; I thank them all. And, finally, I thank my grandchildren David C., Ted, Megan, and Monica—as well as their parents, Alice and David Lowe, Jr.—for reminding me lovingly that I belong to them, too.

Sue Davidson Lowe
Connecticut, May 1982

CONTENTS

Introduction xvii

PART ONE
Reaching for the Camera
1848–1882

3

PART TWO
The Picture, the Word, and the Public
1883–1913

71

PART THREE
Portraits and Paintings
1914–1929

177

PART FOUR
Equivalents and After
1930–1946

307

Chronology 379
Notes 391
Notes on Illustrations 409
Bibliography 411

Appendices
I *Camera Work*, 1903–1917 *423*
II Exhibitions arranged by Stieglitz, 1902–1946 *429*
III Major Stieglitz collections *439*
IV Miscellaneous *441*
 a. Stieglitz Statement, 1921
 b. Stieglitz Photo Equipment
 c. Photo-Secession Statement and Members
 d. Members of Linked Ring, New Society of American Artists in Paris,
 International Union of Art Photographers
 e. Royal Photographic Society Progress Medal (Citation)

Map of Stieglitz property at Lake George 445
Modified family tree 446

Index 449

ILLUSTRATIONS

Images that represent Stieglitz as the consummate artist he was have been, and will continue to be, published widely. Those included here, most of which have not been reproduced elsewhere, are fragments of what might have been a personal album.

Frontispiece *Alfred Stieglitz at An American Place, ca. 1942* Georgia Engelhard

Alfred Stieglitz at the Farmhouse, Lake George, ca. 1942 Georgia Engelhard / 5

Alfred, Hedwig, and Edward Stieglitz and Rosa Werner, Lake George, 1878 Anonymous / 12

Flora and Alfred Stieglitz, New York City, ca. 1868 Studio / 33

Edward Stieglitz's business, New York City, 1870–79 Studio / 41

Interior of parents' home, 14 East Sixtieth Street, New York City, ca. 1890 Alfred Stieglitz / 46

Edward Stieglitz, two guests, Hedwig Stieglitz, Rosa Werner, and boatman, Fort William Henry Hotel, Lake George, ca. 1878 Anonymous / 54

Alfred Stieglitz, Louis Schubart, and Joseph Obermeyer, Berlin, 1887 Studio / 78

Self-portrait, Mittenwald, 1884 Alfred Stieglitz / 82

Agnes Stieglitz, Barbara Foord, Selma Stieglitz, Flora Stieglitz Stern, and "Maggie" Foord at Oaklawn, Lake George, 1888 Alfred Stieglitz / 91

Edward Stieglitz, the Farmhouse, Lake George, ca. 1888 Alfred Stieglitz / 96

Agnes and Selma Stieglitz and Emmeline (Emmy) Obermeyer, New York City, ca. 1888 Studio / 101

Katherine (Kitty) Stieglitz, ca. 1900 Alfred Stieglitz / 116

Eduard and Clara Steichen, Oaklawn (?), 1903 Eduard J. Steichen / 123

Emmy and Kitty Stieglitz, 1904 Eduard J. Steichen / 135

Edward Stieglitz, Oaklawn, ca. 1907 Alfred Stieglitz / 139

ILLUSTRATIONS

Selma Stieglitz Schubart, ca. 1908 Alfred or Leopold Stieglitz / 144

Elizabeth Stieglitz, Oaklawn, 1914 Alfred Stieglitz / 171

Family, Westchester, 1918 (*see* page 409 for identities) Alfred Stieglitz / 214

Donald Douglas Davidson, ca. 1919 Alfred Stieglitz / 221

Peggy and Sue Davidson, Lake George, 1925 Alfred Stieglitz / 224

Following page 232

1 *Self-portrait, ca. 1894* Alfred Stieglitz
2 *Edward Stieglitz, ca. 1894* Alfred Stieglitz
3 *Hedwig Stieglitz, 1895* Alfred Stieglitz
4 *Family at Oaklawn, 1888* (*see* page 409 for identities) Alfred Stieglitz
5 *Self-portrait, Bavaria (?), 1887* Alfred Stieglitz
6 *Agnes and Selma Stieglitz, Oaklawn, 1888* Alfred Stieglitz
7 *Julius and Leopold Stieglitz, Oaklawn, ca. 1900* Alfred Stieglitz
8 *Oaklawn, ca. 1900* Alfred Stieglitz
9 *Flora and Elizabeth Stieglitz, ca. 1906* Alfred Stieglitz
10 *Kitty and Alfred Stieglitz, Oaklawn, 1908* Alfred Stieglitz
11 *Georgia O'Keeffe, Oaklawn, 1918* Alfred Stieglitz
12 *Georgia Engelhard, ca. 1911* Alfred Stieglitz
13 *Cousins, Oaklawn, ca. 1916* (*see* page 410 for identities) Alfred Stieglitz
14 *Elizabeth Stieglitz, the Farmhouse, 1917* Alfred Stieglitz
15 *Donald Douglas Davidson, the Farmhouse, ca. 1922* Alfred Stieglitz
16 *Hedwig Stieglitz, the Farmhouse, 1922* Alfred Stieglitz
17 *Sue Davidson, Lake George, 1925* Alfred Stieglitz
18 *Peggy Davidson, the Farmhouse, 1924* Alfred Stieglitz
19 *Sue and Peggy Davidson, the Farmhouse, 1925* Alfred Stieglitz
20 *Elizabeth Stieffel Stieglitz (Lizzie), the Farmhouse, ca. 1932* Alfred Stieglitz
21 *Leopold Stieglitz, the Farmhouse, ca. 1934* Alfred Stieglitz
22 *Arthur Dove, ca. 1917* Alfred Stieglitz
23 *John Marin, ca. 1921* Alfred Stieglitz
24 *Dorothy Norman, 1932* Alfred Stieglitz

ILLUSTRATIONS

Elizabeth and Donald Davidson, Georgia O'Keeffe, the Shanty, Lake George, 1920 Alfred Stieglitz / 235

Judith, 1920 Alfred Stieglitz / 238

Paul Strand, ca. 1917 Alfred Stieglitz / 252

Alfred Stieglitz, New York, 1925 Flora Stieglitz Straus / 270

Georgia O'Keeffe, Hotel Shelton, New York, 1925 Flora Stieglitz Straus / 277

Georgia O'Keeffe and Alfred Stieglitz, Lake George Josephine B. Marks / 297

Alfred Stieglitz and John Marin, An American Place, 1931 Herbert J. Seligmann / 308

Alfred Stieglitz, the Farmhouse, ca. 1942 Georgia Engelhard / 337

William Einstein, ca. 1955 (?) Anonymous / 345

Alfred Stieglitz and Georgia O'Keeffe, Lake George, ca. 1938 Josephine B. Marks / 355

Alfred Stieglitz, An American Place, 1940 Ansel Adams / 372

INTRODUCTION

In 1983, a century will have passed since Alfred Stieglitz bought his first camera and processed his first print, starting his rapid climb to international prominence as a photographer; seventy-five years will have elapsed since his first gallery—at 291 Fifth Avenue—stunned the New York art world with the first showing in America of the European avant-garde painters. It was here—in the five years *before* the 1913 Armory Show that many still regard as modern art's American genesis—that Pablo Picasso and Henri Rousseau had their first one-man shows anywhere, and Paul Cézanne, Henri Matisse, Auguste Rodin, and Henri de Toulouse-Lautrec had their debuts on this continent. In those same five years, Stieglitz introduced also three of the five durable antiestablishment American artists who became his mainstay in his next two galleries: John Marin, Marsden Hartley, and Arthur Dove, soon joined by Georgia O'Keeffe and Charles Demuth. Constantin Brancusi and Georges Braque, Elie Nadelman and Marius De Zayas, Abraham Walkowitz and Francis Picabia, Gino Severini, Gaston Lachaise, and George Grosz all soloed for the first time with Stieglitz, vividly counterbalancing the artists of the camera whose works found their first New York audience and critical acclaim under his aegis: among the Americans, his near-contemporaries Alvin Langdon Coburn, Frank Eugene, Gertrude Käsebier, Edward Steichen, and Clarence White, and the youngsters, Paul Strand, Ansel Adams, and Eliot Porter; among the Europeans, the pioneers Julia Margaret Cameron, David Octavius Hill, and Robert Adamson, as well as his friends Heinrich Kuehn and Baron Adolph de Meyer.

Five years before starting his first gallery, Stieglitz founded, published, and edited one of the most beautiful and prestigious art magazines of all time. *Camera Work*, produced in fifty-two issues (forty-nine regular and three special) over a period of nearly fifteen years, printed not only superb illustrations of the works shown at his gallery, 291, but also essays on art and photography by such diverse writers as Henri Bergson, Charles Caffin, Benjamin de Casseres, Hutchins Hapgood, Sadakichi Hartmann, Wassily Kandinsky, Maurice Maeterlinck, George Bernard Shaw (whose photo-

graphs were also reproduced), Gertrude Stein (making her American debut in its pages), and Oscar Wilde.

Among Stieglitz's creations, perhaps the most difficult to penetrate was the person he presented to the public. Part of its opacity came, no doubt, from the fact that he had a mission: to awaken an indifferent world to the new art of photography and to modernism in painting, sculpture, and, to a lesser degree, literature. To do so, he felt, he had first to be an iconoclast, then an interlocutor, and finally and always, a teacher. During the existence of his three galleries—291 between 1905 and 1917, The Intimate Gallery between 1925 and 1929, and An American Place from 1930 to 1946, at each of which he served as full-time unpaid manager and impresario, guide and guarantor to his group of artists—he welcomed probably half a million visitors. With them, he was an indefatigable raconteur, lecturer, and listener, exploring the realms not only of art and literature but also of philosophy, and of public and private morality. He charmed, he cajoled; he played the innocent and the all-knowing; he bullied and praised. Thriving on talk, his message—although not misleading in substance—was often obfuscatory in effect. His intent was systematic, his set of principles clear, but his discourse was spontaneous and formless; what mattered to him always was "the moment," in life as in photography. As a result, his talk was more often epigrammatic than it was either pointed or self-revealing. He invited questions, but not doubts, about his ultimate wisdom—disclaiming meanwhile that he "knew" anything at all.

Each of us offers up multiple personae in our commerce with others. It was Stieglitz's talent—and his limitation, like that of other personages—to create a single public image, oversimplified and overpure. It was not a self-conscious or deceitful image; it evolved naturally, from deep-seated convictions—spiced with experience, informed by genius, vitalized by purpose. But, like most public images, it was as vulnerable to attack as it was seductive to adherents. Inevitably, he was characterized in mutually exclusive and extreme terms: prophet and poseur; sage and windbag; pioneer and opportunist. Praise of him, even during his lifetime, was often as saccharine as criticism of him was vituperative; even then, his dicta were preserved as in formaldehyde by detractors and supporters alike. Amazingly, thirty-six years after his death, the partisans and the foes are still having it out.

He deserves to be known better. Like any other man, he grew up in particular ways, experienced joy and sorrow according to his particular limitations, talents, contradictions, and aspirations; he achieved the hard-

won and the easy triumphs, the painful defeats, and occasionally the grandeur that made him uniquely himself. And, like any other man, he came from a particular family, with which he had a particular set of relationships.

I was part of that family—a grandniece whose parents were unusually close to him. I spent (as did my sister Peggy) a major portion of twenty-one of the twenty-four summers my life overlapped his at the Stieglitz family compound at Lake George, in upstate New York, where he, one brother, and two sisters were at least part-time annual residents. I visited him regularly at two of his three galleries in New York, as well as occasionally at his home, and with him at other family gatherings. In addition, I knew from my earliest days a number of the colleagues and friends who were members of his circle—some visitors at Lake George, and others whose contact was confined to the city.

Some years ago, I began to wonder if I might not possess, or find, a few insights and clues to the complexities in Stieglitz that he himself blue-penciled, especially in relation to the family he insisted publicly meant little to him. I began with a memoir. Then gradually, as I examined the ties I had with some of his friends—as a child, peripherally, with Dove, the Strands, and O'Keeffe; as an adult, directly, with Marin, Seligmann, and William Einstein (the youngest colleague of his later life)—I realized how inextricably woven into his person were the experiences of his career. Memoir expanded into part biography.

Even in biography, my fascination with Stieglitz the man—whom I shall henceforth call Alfred, although during his lifetime he was Uncle Al to me—focused on the enigmatic influences on him of family and place. Of the two, he acknowledged only the latter. Lake George especially was a magnet, a haven, from his ninth year on. From then until the year before his death at eighty-two, he missed only eleven summers at the lake—six during the seven years of his higher education in Germany, one in which he combined work and a honeymoon abroad with his first wife, and four others in Europe on career-related matters. For sixty-one summers, he found it a place in which to think, to exercise, to work, to rest. Almost always, he described it as peaceful. In fact, except for the limited times when he was there without the family, it was anything but peaceful; whenever his close relatives were there, it was a three-ring circus.

From his youth, Alfred had rejected the habits of thought, the style, the attitudes, and the values of his sisters and brothers, molding a life for himself that was consciously different from theirs. In all the years I knew

him, he found their company almost unrelievedly irritating. Yet he joined them at the lake every summer: why? His excuses for not changing the pattern, as both his wives begged him to do (the second, Georgia O'Keeffe, even more than the first), were the physical handicaps with which he felt he was beset, and a persistent lack of funds. His reasons were not intractable: the money could have been found, and his health was far better than he claimed. Inertia probably played a role. A far more potent factor, however, seems to have been his paradoxical attachment to the family he found frustrating, irksome, and even offensive. He seems to have needed them, if only to rekindle his rebellion, to fuel his purpose. And he said repeatedly: "Everything is relative except relatives, and they are absolute."

What made the Stieglitz family especially absolute was an occasionally vocalized conviction that the inherited qualities they shared, the Stieglitz qualities, set them apart from ordinary mortals. Alfred and his sister Agnes, although less arrogant in their belief than their sister Selma and brothers Leopold (my grandfather, Lee) and his twin, Julius, shared a subliminal certainty that Stieglitz achievements, troubles, romances, virtues, illnesses, setbacks, and triumphs were of a magnitude that surpassed others', and that this was both their curse and their glory. The perception was convincing enough to my grandmother Lizzie (who was, after all, only Stieglitz by marriage) that she indoctrinated my sister Peggy and me with a sense of stern obligation. You were loyal (and obedient) to Stieglitzes not because you necessarily liked or admired them, or because you found commonality with them of feeling, attitude, experience, or belief, but because it was a moral imperative. Whatever their foibles or even major failings, you were enjoined to respect them as if they had genuine meaning for you, as if you—by accident of birth partly a Stieglitz—were in their debt. We were fortunate that her half-Stieglitz daughter (and our mother) Elizabeth, found the concept of Stieglitz superiority totally absurd, and that our father, Donald Davidson, who traced with oddly mingled pride and disparagement a somewhat frazzled clan line back to King David I of Scotland, found most of his Stieglitz in-laws absurd on all counts.

Although Alfred, too, had his absurdities in my parents' eyes, he was generally free of their derision. The all-inclusive democratic view, the genuine humility, the simplicity of style that Alfred had developed—through his art, and through the extension of his native empathy to literally thousands of people—were congenial to their own precepts; they celebrated his freedom from the materialistic bondage suffered and enjoyed by the rest of the family. From the point of view of his brothers and sisters, however,

Alfred, although lovable and talented, was rather an odd bird leading a peculiar and hazardously impractical life. Curiously, nonetheless, each relied heavily on his approval.

Alfred was almost wholly unaware of any emotional or psychological kinship with his brothers and sisters—or with his parents, for that matter. When I was a child and adolescent listening to him reminiscing, I had the impression that he regarded himself fundamentally as a foundling brought into a luxurious home, growing to love the inhabitants, to understand their ways, and to accommodate himself to them to the degree required for peaceful coexistence, but conscious always that he was a street Arab with experience of the *real* world. Although he read eagerly each volume of Freud as it appeared, was beguiled by the analyst's emphasis on the potency of dreams, and embraced wholeheartedly his theories of sexuality—and although, with sweeping confidence, he applied to others what he gleaned—Alfred seems never to have gained much understanding of his relationship with his family, especially with his parents. Repeated sessions of what he called ruthless self-examination in his later life seem never to have revealed to him that, as a child, he sought to emulate his father in every way, that his mother understood him, and that he was not the black sheep but the adored favorite of both parents.

Granted, the materials for a closer reading of his mother and father were not available to him. Neither their confidences nor their behavior were particularly enlightening. His mother acted the role assigned to her by marriage, motherhood, and the times in which she lived, allowing herself to be seen as feather-brained, helpless, and governed by emotional inconsistencies. His father's gift for hyperbole, combined with a zest for playing domestic tyrant, formed an able disguise for insecurities and self-doubts. Furthermore, by the time Alfred might have felt that knowing them better could help him to understand himself better, his father had died and his mother was drifting into senility.

So much for psychologizing. The rest is narrative, sieved through a mesh of my own construction. I have had to make many choices. Efforts to corroborate information have often turned up surprising counterevidence, not only of my own memory but of recollections supplied by friends and relatives I interviewed. Often, too, contemporaneous accounts of events described by his friends, colleagues, and relatives—as well as by Alfred himself—have furnished so many variations that the only possible approach to verisimilitude has been to concoct a compound and hope for an essence.

Nevertheless, for the most part, I have relied on what must be called hard evidence. Fifteen months of reading primary sources in the Stieglitz Archives at Yale University's Beinecke Library—to which was added, during my investigations, a treasure trove of recently uncovered family letters, a source capable of providing the detailed and subtle information about his formative years that his own ornamented recollection (so painfully transcribed by friends) largely circumvented—were followed by further research, at Beinecke and elsewhere, in as many secondary sources as I could find. Simultaneously, I pestered for their recollections family members and those friends and colleagues of Alfred's whom I knew personally.

A caution about my researches: they have been meticulous, but they are not exhaustive. As a practical measure, I limited my plunge into primary sources at Beinecke to the documents and several thousand letters exchanged by (1) Alfred and his closest confidants—especially those I knew, (2) Alfred and his family, and (3) the family of an earlier era, dating back to 1841, twenty-three years before his birth. The account which follows, although as forthright, full, and balanced as I am capable of making it, is not definitive. Such completeness will not be possible until all the currently available primary documents have been digested and weighed and until, well into the next century, the more than 11,000 pages of Alfred's and Georgia O'Keeffe's correspondence and his similarly voluminous exchanges with Dorothy Norman are unsealed.

A few words, as well, about my methods. Wherever there is a single written source for anecdote, opinion, or mood, that source is cited, even when not directly quoted. In instances where there are accounts that differ, especially in important matters, the differing sources are cited. In most cases where I make a guess based on information gathered from interviews and/or written material, I employ qualifiers such as "possibly, probably, perhaps," etc., but not in all. Where I do not, the occasion is too slight or too brief to warrant such encumbrances or the waffling effect of their use would drastically inhibit the flow. I have tried to limit my unattributed passages to such occasions. There remain, however, more than a few that the skeptical reader might question for accuracy, where I write, for example, "Alfred felt . . ." Whenever such a construction appears, I give my assurance that it is based on one of the following: (1) Alfred (or the moment's protagonist) described the feeling, event, etc., to me personally, or to a number of correspondents, or to people I interviewed who do not wish to be named; (2) I observed that feeling or event myself; (3) the collective memory of relatives or friends forms a convincing consensus of what actu-

ally took place; (4) two or more published accounts, many of which appeared during Alfred's lifetime and were not challenged by him, concur; (5) a single sentence of mine is the distillation of numerous references spanning a considerable time; (6) a careful scrutiny of the action or series of actions taken by Alfred (or X) renders a conclusion about impetus or mood inescapable.

Whatever effort I have made toward detachment and perspective is at least partially doomed by my own relationship to Alfred. In my favor is the fact that I was never so close to him as to be unable to see him. Of the females in the family whose contact was frequent, I am the only one who did not write him more than perfunctory messages—which he did not save. Those of his notes to me that I have kept are two-line birthday greetings, wishes for my recovery from some childhood ailment, or some inquiry about my enjoyment of (not progress in) school; none speculates or describes or instructs or refers to a shared experience other than our anticipated or recent mutual presence at Lake George. In the mammoth Beinecke collection, I am seldom mentioned as anyone other than one of "the Davidson girls." My sister Peggy, on the other hand, rates identification as "a wonder."

Nevertheless, I saw him almost daily at Lake George when we were both resident—often alone, and often for hours at a time. There, as in New York, he preferred that I drop in when the spirit moved me. Why did the spirit move me? Whatever it was that I sought from him, it was not, as it was with many others, answers to current problems, or reassurances about myself, my philosophy, my life plan. I came neither to listen nor to confide in him. Often I was silent, and so was he, unless other visitors spurred him to talk, or unless he was in a mood to expatiate on a favorite theme, to instruct, or to tease. Sometimes I arrived with the script of an anticipated dialogue already in mind, only to find that it evaporated, forgotten, in his presence. Sometimes our encounters awakened embarrassment in me, or irritation, or even repugnance. But I never left him without feeling stimulated—and most of the time exhilarated, even merry, with a renewed appetite for life. I went to him to be recharged.

It is my hope that I have succeeded in humanizing Uncle Al, whom I loved but did not idolize. He was a cantankerous, inspired, whimsical, candid, insightful, naughty, sweet, dynamic, and outrageous man. I am grateful to have been a part—even a small part—of his life.

PART ONE

REACHING FOR THE CAMERA
1848-1882

1

In my sixth summer—Uncle Al's sixty-fifth—I was invited for the first time to watch him and his friend Louis Kalonyme play a round or two of Tom Thumb Golf, the rage of the 1929 season, following their morning walk to the village, three-quarters of a mile south of the Hill. The village, formerly known as Caldwell, was the small town of Lake George, on the southwest shore of the lower Adirondack lake. Kalonyme was a journalist and art critic, a witty, olive-skinned man with hooded peridot eyes. The Hill —the forty-acre upland remnant of a waterfront estate, Oaklawn, bought in 1886 by Edward Stieglitz—was the summer compound of his children, among whom were my maternal grandfather Lee and his elder brother, Uncle Al. Uncle Al was Alfred Stieglitz—photographer *extraordinaire*, art entrepreneur, one-time publisher and editor, and full-time idiosyncratic moralist.

Kalonyme had introduced Alfred to miniature golf only a few weeks earlier; he had become a quick convert, then an addict, and was already local champion. Coming down the long slope from my grandparents' bungalow, I saw Alfred sitting on his porch at the Farmhouse, the command post of the Hill, from which all the family's comings and goings could be observed. I ran. Despite Alfred's public inveighings against clock watchers he, like all the Stieglitzes, was a stickler for other people's punctuality.

This time he did not appear impatient. Still wearing his breakfast napkin tucked into his shirt collar, he was, characteristically, chewing absently on its corner, his bristling white mustache wavering over sculptured lips. Obviously he had not checked his appearance in the long mirror in his study. Even the hair that sprouted from heavy brows, nostrils, and ears seemed as richly rumpled as his grey-brindle thatch; his steel-rimmed glasses were askew on his autocratic nose. Dark eyes twinkling, he rose to claim his rusted black porkpie from Kalonyme and, quoting the 1920s quip: "Here's your hat and what's your hurry?" thrust it on his head, eliciting my predictable laugh. With arthritic fingers, he buttoned his grey

sweater, straightened his loden cape, and reached for my hand, stooping to receive my kiss. Then, with a sweeping glance at the weathered barns across the driveway oval, he stepped off the porch and turned left into the drive, and left again past the whitewashed shed on its other side—his darkroom. Down the hill, the compound's road was steep and the footing treacherous with pebbles (I held Kalonyme's hand as well) until we reached the state thoroughfare known locally as the Bolton Road. Cautiously crossing the road and turning right to face the oncoming traffic, we walked the parallel path installed by Alfred's father; when the path ended, Alfred led us, Indian-file, along the road's shoulder, barking Kalonyme and me into immobility at the approach of every car.

Often Alfred was the earliest arrival at the miniature golf course, but on this morning he was not; we were ushered nonetheless to the head of the line by Mr. Parrott, the owner. Nobody grumbled. "Mr. Alfred"— unknown here for any of the accomplishments by which he was recognized internationally in the art world—was already a drawing card. A putter was reserved for his exclusive use, as was his own ball, and at the end of play the scorecard bearing his name was posted for all to see. It might take him an hour to complete the round; but his attentive followers were patient.

Among the sun-blistered players in tight, garish pants and souvenir-studded straw hats, Alfred was a startling figure. Pale beneath his dark hat, his cape falling in a triangle as he assumed a putting stance, he looked like a frail curate at a Coney Island picnic. He approached each hole with the confidence of a several-time cup winner in golf tournaments at the Lake George Country Club in the nineties, and with the same deliberation he had accorded billiards as amateur champion of Germany and Austria a decade earlier. He studied the lumps, dents, and tears in the matting and calculated the degree of slope between the wide encircling rim and the cup. His specialty was a suspenseful carom hole-in-one. He paid as little attention to the hushed onlookers as he did to the air.

Whereas in other parts of the country, miniature golf went into a long period of decline, at Lake George it continued to prosper. When the state took over the south end of the lake in the thirties to create a broad public beach, Mr. Parrott relocated his course on a large corner lot abutting its feeder road. Here, well into his seventies—and allowing me sometimes, or my sister Peggy, to try a round against him—Alfred played eighteen holes under a shady canopy of tall pines. He was then escorted tenderly to the gate by Mr. Parrott, who continued to post Alfred's most challenging

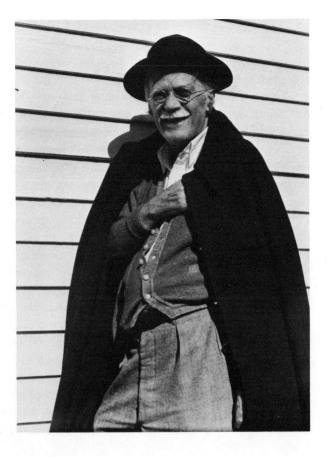

Alfred Stieglitz at
the Farmhouse,
Lake George,
ca. 1942
Georgia Engelhard

scorecard several years after his death, to make his way up the slope to the post office in the next block for a chat with the aging postmaster or to sit on a sidewalk bench and wait for a ride back to the Hill with my grandfather's chauffeur. In most of the later years of his playing, Peggy's and my father, Donald Davidson, accompanied him.

Alfred and I each visited Lake George for the first time at an interval of fifty-three years—he when he was eight, over a hundred years ago, and I when I was nearly three. During that interval, only three major changes had taken place in the village of Caldwell. Electric and telephone wires had sprouted overhead; the handsome trees of Alfred's childhood had been sacrificed to a widening of the main street; and automobiles had displaced both the horse-drawn vehicles and the trolley that had served as links to Saratoga. Although I arrived that first time from New York in a train that was shunted to a dead-end spur at the lake's south end, in subsequent years

I came more often by car, along the same route of Alfred's first stagecoach ride from Saratoga.

That route, a segment of the major connection between New York and Montreal, wandered the twenty-seven miles from Saratoga through a plateau dense with pine and sprigged with sweet fern and sumac. Bisecting the town of Glens Falls, past its hulking paper mills, busy commercial center, and elm-shadowed mansions at the north end, the road thereafter traversed vaguely undulating ground in which each curve was almost imperceptibly higher than the last. At the top of the long rise, a broad bend suddenly revealed Lake George, two hundred feet below and nearly a mile distant, cupped in the blue-green, rolling foothills of the Adirondacks. In the distance, the dark clefts in the receding hills mapped the uneven stretch of the lake thirty-three miles to the north. A moment later and the view was gone; the road sloped rapidly to the village at the water's edge.

Alfred's first visit was on an overnight excursion with his parents in late August of 1872. He had accompanied them on a long-delayed honeymoon that started at Niagara Falls and proceeded to Saratoga where, in the sumptuous Grand Union Hotel, he basked in freedom from his five younger brothers and sisters. At the Spa, his father leavened the obligation to take the waters with regular visits to the track and cigar-fragrant evenings with fellow sportsmen; Alfred and his mother sipped their sulfurous potions, walked, read together, and attended concerts in the park and in the hotel lounge.

For the cultivated visitor to Saratoga in the seventies, a trip to Lake George was *de rigueur*. Since the 1830s it had attracted landscapists of the English and Hudson River Schools; by the sixties it was a favorite, and lucrative, subject for American painters and engravers. Vignettes of the lake adorned the walls of railway carriages, the pages of books on the French and Indian Wars and the Revolution, and James Fenimore Cooper's *Leatherstocking Tales*. Its mysterious, tranquil bays edged with leaning birches, its steep rock walls and mounded islands, its spectacular storms whipping water to foam, exemplified every tenet of Victorian esthetics.

If seeing the lake was obligatory for the casual Saratoga vacationer, it was even more so for Alfred's father, Edward, who had begun recently to paint during recesses from his flourishing wool importing business; six years later he would be tutored weekly in the studio he created in his brownstone off Fifth Avenue. Certainly he was acquainted with the currently fashionable Lake George landscapes of James Edward Buttersworth;

possibly, in the early years of his marriage, he had met the artist, when both were living in Hoboken. In any event, his quickly organized overnight stay at the Fort William Henry Hotel included energetic sightseeing with his wife and son.

From the splendors of the hotel that dominated the south end of the lake, Edward may well have taken wife and son on a tour of the half-mile cluster of modest shops and homes, rooming houses, churches, and bars that constituted unprepossessing Caldwell. To the west, its grid of streets crept toward the first abrupt rise of Prospect Mountain, one of the lowest of the lake area's foothills. To the east, the town hall/police station and the post office flanked a park sloping to the shore and boasting a tall bandstand, flower-hemmed paths, and a number of benches.

In the village, Edward may have hired a carriage for the scenic drive along the lake's west shore to Bolton Landing, the stretch that included his own future estate and was known in later years as Millionaires' Row. Or he may have hustled them aboard the smallest of three excursion side-wheelers for a short ride on the lake; the largest, going to the far end of the lake, provided a full day of entertainment, with a string quartet, dancing, and elegant meals. (In the 1940s, a descendant, bearing a painful-pink neon sign that arched from prow to stern, offered grotesquely amplified be-bop and a wake of hot-dog wrappers, beer bottles, and whiskey pints.) Alternatively, he may have helped them into one of the hotel's manned rowboats to take tea at an island a mile or so up the lake; years later, Tea Island was bought by one of his nephews.

Eventually, Alfred's attachment to Lake George would rival his attachment to New York City, to his camera, and, indeed, to any woman—Georgia O'Keeffe included. His infatuation did not begin, however, until his second visit, in 1873, when he was on a six-week trip alone with his father, designed in part to seek the right location for the family's future summers and in part for Alfred's nine-year-old pleasure and instruction. And his health. The family doctor insisted on his need for mountain air and Saratoga waters. For reasons never spelled out, he was regarded as a delicate child. Every twisted ankle, stomach twinge, eye sting, and cough was met with distress by his mother and near-hysteria by her maiden sister Rosa, who lived with them. His escape from the ladies, as well as from his brothers and sisters—Flora, his junior by a year and a half; the twins, Julius and Leopold, doubly obnoxious six-year-olds; the two little ones, Agnes and Selma, four and two respectively and already embarked on a

lifetime of bickering—put the finishing touches on his delight in having his father to himself. Or almost; they were joined intermittently by one or another of Edward's male friends.

Even as a toddler, Alfred had been Edward's favorite, granted every wish. Aboard the *S. S. Germania* bound for a half-year in Europe a month after his second birthday, the oranges and chocolates Alfred demanded were daily entries in his father's expense book, in which the only other extravagances listed were Edward's "segars," pipe tobacco, wine, and tips. (Apparently Hedwig, Aunt Rosa, and the nursemaid tending baby Flora did not merit "extras.") The morning after their arrival in Hamburg, Edward hired a droshky to take his importuning son immediately to the zoo, and whenever he was off on business for longer than a day, he had to promise to return with oranges. His wife and sister-in-law were ordered to write him news of Alfred daily when he was away, especially as he deemed the windows in their rented Berlin apartment "dangerous." In a letter to Leipzig, Rosa reported that, as instructed, all remained tightly shut. She added that "dear little Alfy watches every sound thinking you are coming." Some indecision about what to call Alfred persisted through his early years; "Ally" predominated, but even "Freddy" was given an occasional try.

Of his two-year-old self in Berlin, Alfred later described one habit as prophetic of his eventual calling. A studio photograph bears witness. In a dress and high-button shoes, and with a mass of curls that his Aunt Ida wrote she intended when he came home to coif in two rows instead of one, Alfred clutches a photograph as some other child might hold a cherished toy. He was not devoted to the cousin whose portrait it was, he said, but the image was intrinsically magical.

Edward's special affection for his eldest carried unique privileges. Whereas decorous distance was required of the other children, Alfred was invited at the age of six to join the company of Edward's male friends in their regular Sunday afternoon sessions at his home. Following a sumptuous meal—at which Hedwig and Rosa were often the only women among as many as thirty horsemen, artists, newsmen, teachers, and those few business friends who eschewed shoptalk—the men adjourned to the parlor for port and pinochle, poker and conversation. Sometimes, with Alfred again in tow, they climbed to the top-floor game room for billiards. At seven, Alfred was entrusted with choosing and fetching wines from Edward's cellar, "one of the finest . . . in the country," he later reported. At eight, he was invited to play cards, and at nine, much to that gentleman's

astonishment, he beat his father at billiards without benefit of a single lesson. Evincing characteristic persistence, Alfred had practiced the moves of "Pa" and his friends by himself. Now, in the course of their 1873 trip, Edward prodded him to demonstrate his skills before an admiring audience at Boston's Tremont House, where they had lunched.

Predisposed to favor the mountains, Edward had nevertheless agreed to give the seashore a try. Before Boston, they had stopped at Newport, Rhode Island. Praised by friends for its settlement of artists, writers, and genteelly wealthy southerners, as well as for its natural beauties and the huge and luxurious hotel that served vacationers, it had not yet been invaded by Belmonts, Vanderbilts, and Astors. The trip from New York had taken nine hours, with two ferried portages for their train, as Alfred, in exquisite calligraphy and indifferent spelling, recorded in his journal. By six next morning, they had set off on foot from the Ocean House to begin their inspection of cottages. They were surely a dignified pair: Edward, by habit formal, and strikingly handsome with a guardsman's mustache, flashing dark eyes, and slender build, and Alfred with romantic curls, a solemnly beautiful face, and a demeanor that had already earned him the nickname "Hamlet" from his aunts. Twice during the day they walked the beach, and twice hired a carriage to take them farther afield. Next morning, their inspection done, they were off for Boston and an even more hasty tour; Boston was irrelevant to their purpose.

Edward's scrutiny next of White Mountain resorts included three: Conway, the site of Mount Cranmore; Crawford Notch, the site of Mount Washington; and Franconia Notch, accessible to both Mount Washington and Profile Mountain. Traveling by stage and wagon, seeing all the obligatory sights, and staying in vast hotels, Alfred noted also that they walked in the woods, cut canes, and fished once or twice, and that he went to bed later than usual. Not included in his diary was an account of one of Edward's familiar rages. Vented freely on the Crawford House manager for offering them inferior accommodations, it propelled them immediately to the next hotel on their itinerary, three days early, and continued with a wire being sent to Hedwig demanding an explanation for the absence of a waiting letter. She, accustomed to his petty tyrannies, had in fact written to three hotels in advance. Now she wired calmly, "Wrote according to directions every day all is well love to Al." Without contrition, Edward responded in martyred tones that he had been the victim for two days of a dreadful headache.

Coincidentally, that headache had arrived almost as soon as he and Al-

fred had left behind the business friend who had accompanied them as far as Conway. It was not so easy, Edward was discovering, to be solely responsible for a nine-year-old's entertainment. Furthermore, he was not really taken with the White Mountains. They were imposing, but, paradoxically, both remote and claustrophobic—fine for a hiker, perhaps, but otherwise limited both in the sports he liked and in social and cultural opportunities. Cutting short by several days their scheduled stays at the next two hotels, Edward and Alfred headed down the Green Mountain valley to Lake George in a series of conveyances that ranged from rustic cart to train to tallyho. They found the Fort William Henry as elegant, hospitable, and lively as it had been the year before.

Within a day of their arrival, Edward wrote to suggest that the rest of the family join them. Hedwig, however, declined, on the grounds that they moved around too much. "I would not like to lessen your pleasure in any way," she wrote, "so I shall stay home and await your return . . . with pleasure, as I think [by then] you [will] feel strong, healthy and good-natured." The good nature, in fact, would return much more quickly than she anticipated. As father and son each made friends among the hotel's residents, their time together to explore the lake's beauties took on added value.

Two happenings during their stay at Lake George in 1873 were recalled frequently by Alfred for the remainder of his life. Mirroring his father's passion for horses—the only Jewish member of New York's Jockey Club, Edward was a zealous equestrian whose thoroughbred mount, Catherine, claimed nearly as much of his long-distance attention as did his children—Alfred had begun devouring horse literature almost as soon as he could read. His knowledge of racing and breeding established his prestige among his peers as firmly as familiarity with baseball statistics would in a later generation. On the first rainy day at the Fort William Henry, he brought out his collection of tiny lead horses—one was stabled in his pocket at all times—to show his new coterie of friends. Improvising a game, as he often did for his brothers and sisters, he set out his horses on the Parcheesi board. Each animal, solemnly named after a favorite, advanced to the roll of the dice and the growing excitement of the "owner." Within minutes, the game had attracted the attention of a group of men that included New York's governor; in the manner of adults, they began immediately to bet on the finish. Later, Alfred said, someone patented his game and introduced it as shipboard entertainment. Never modest about his inventiveness, he claimed credit also for certain officially adopted re-

finements to the game of baseball as it was played in the sand lots of Hoboken, his early home and the home of America's first professional team.

The second event Alfred found significant that summer was one he classified as another omen. A few days after the racing game was born, Edward brought the young sports to the local photo studio to have their steeds' portraits made. Impatient with the time Alfred took to arrange horses precisely on the velvet cloth, the photographer was surprised next to be asked permission to follow him into the darkroom. There, mesmerized and breathless, Alfred watched the metamorphosis of the inert plate into a "living" image.

Something else happened that summer that Alfred did not mention in later life, perhaps because it was at odds with his proclaimed indifference to money: he became an efficient little negotiator and bookkeeper. One of the penalties of being his father's constant companion was availability as errand-boy. Regularly, he was dispatched to get newspapers, stamps, segars, opera glasses, matches, coats; after a strenuous day, he was required to massage his father's feet. In short order, he established a fee for each task, and his abandoned journal became a meticulous daily log of Edward's debts to him. Onerous tasks carried a surcharge: an extra penny if he had to get out of bed to fetch matches, a dime each for getting a blanket, going upstairs on his own, or carrying Edward's book for an hour. The most original ten-cent charge was for returning to their room to change his "bossume" (shirt). This venal practice did not end at the age of nine, but continued sporadically until Alfred received a regular monthly allowance of $250 as a university student in Berlin. As a schoolboy in New York, he charged his father not only the cost of every meal he had to eat in a restaurant but also, if the necessity arose because the cook was absent or the family away, a nominal fee for having been inconvenienced. A young uncle proposed jocularly that, "à la Alfred," he should bill Edward for every Sunday dinner to which he had not been invited.

It was hard for Edward and Alfred to tear themselves away from Lake George, which had all the qualities, sports, and entertainments they sought, but Edward had made dates to meet friends in Saratoga and later at a mountain resort near Catskill Landing. Saratoga was, in any event, mandated for his health. And for Alfred's. Hedwig underlined his instructions from Dr. Jacobi to drink a glass of water from the Columbia Springs every day, and Aunt Rosa expressed her hope that he had gained enough strength to stay "well and hearty" when he went back to school. There was

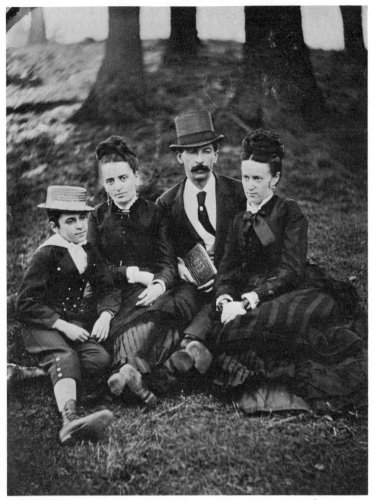

Alfred, Hedwig, and Edward Stieglitz and Rosa Werner, Lake George, 1878 Anonymous

no end to the ladies' cautions concerning Alfred's health—and no end to Edward's concern for his own. Indeed, if the menu of an 1876 luncheon with business associates was in any way typical of his intake, his persistent kidney trouble was well earned. Accompanied by three wines, the meal progressed from oysters through turbot to *filet de boeuf* and pheasant, salad, fruits, and cheeses to an epilogue of coffee and liqueurs.

Health routines out of the way, there was one glory Alfred would have endured torture to earn: the races. His passion for horses, which, to the

end of his days, he would regard as earth's most magnificent beings, nobler and more perfect than any human, was shared with his brother Lee. Divided on almost every other issue, their only wholly safe topics were the equine bloodlines that determined the skeleton and musculature, proportion, speed, temper, and beauty of the thoroughbred, and the relative merits of this or that trainer, jockey, or track. If Alfred's youthful anticipation was heady, the experience was overwhelming. His letters home, always colorful, became rhapsodies of reportage. There was a lot to describe. In eleven days at Saratoga, he had a probable five afternoons at the racecourse with his father. And his father's friend Mr. Simon, whose presence Alfred tolerated when he, like Edward, agreed to pay for errands.

There seems little doubt that Edward had decided while there that Lake George would be the site of his family's future summers. He thought seriously of returning to it after Saratoga, but realized there would be hell to pay with his brother Siegmund and sister Julia if he cancelled his plans to scout the areas near their vacation favorites: Highland Falls, adjacent to West Point, and Buttermilk Falls, near Nyack. On the way, he would take Alfred to a splendid Catskill resort.

If Alfred was reminded occasionally by his parents and Aunt Rosa that he was singularly privileged to have his father to himself that summer, he was never allowed by his brothers and sisters to forget it. Although Flora, who was uniquely attached to him, missed him quite as much as she did her father, the younger girls' envy took the form of ignoring his absence entirely. Agnes wanted to know if her father was coming home "in a year or at 5 o'clock," and Selma chanted "Papa? Papa, letter-box." The twins complained loudly of the unfairness of Alfred's trip, although Leopold laughed when Julius cried that "Ally should come home" directly after his Saratoga "cure." He had only been allowed to go, he raged, because the doctor ordered him to.

The pattern was set. Everything Alfred did or said thereafter to convince his brothers and sisters that he was not Edward's favorite was to no avail; clearly, they believed he was. Each, however, reacted differently. In time Leopold adopted an attitude of amused and fond condescension, confident that he himself represented what Edward *really* wanted in an eldest son. Julius's hostility (of which he seemed wholly unaware) was less well cloaked. He greeted every hardship or failure of Alfred's with a monitory lecture in which he suggested more than once that, had he not recognized his obligation to more serious and important work, he himself

might have indulged a photographic talent equal to Alfred's. Agnes transferred her jealousy to Selma—who, by her early teens, was indeed Papa's spoiled darling.

There was no subtlety to Selma's expressions of jealousy. She told Alfred repeatedly that her unique sensitivity had been irremediably bruised in early life by the disproportionate support he received from both parents, and that her ability to survive was due only to her extraordinary will power, understanding, and generosity of spirit—self-characterizations that were marvelously wide of the mark. The only one of his brothers and sisters who seemed free of resentment toward Alfred was Flora, but she was unable to be his champion for long. After her fifteenth year, they saw each other only on vacations; she married at twenty-two, and at twenty-four died in childbirth. Forty-six years after her death, Julius was still dishing out patronizing advice to Alfred and admonitions to "grow up." And in the nine years that remained to Alfred after Julius died, he heard again and again from Leopold, Agnes, and Selma how, according to the bias of each, either his maturity had been hampered or his way had been smoothed by the special treatment accorded him by their parents.

Alfred's trip with Edward in 1873 may have provoked the first collective cries of "unfair" from his brothers and sisters; there would be more. Nearly fifty years later, when their mother's will revealed that, although she had left the Lake George property to them in more or less equal shares, it was her clear intent that Alfred was to have primary use of the house, their resentment resurfaced. The implication was that their plans were secondary, and would have to be made with Alfred's approval and cooperation. Hedwig recognized, as none of them seemed to, that he and Lake George were inseparable.

2

Had either of the twins, Julius or Leopold, held the position of Edward's favorite son, he would probably have accepted it with self-confident equanimity. Not Alfred. To him the role was as much a responsibility and a source of anxiety as it was a boon, especially in his preadolescent years. Demanding even more of himself than Edward did, he strove to match the manly ideal that his father's exhortations, if not always his example, conjured up.

Excellence in every task undertaken. Rigorous probity. Physical courage. Unfailing generosity to the needy. Self-discipline. Taste. Perseverance. Love of country. Indeed, with the conspicuous omission of devotion to God, Edward's code was that of the upright Victorian gentleman. It was a code that Alfred embraced before he was eight and—no matter how elusive strict observance would seem to him, or how bizarre some of his interpretations would seem to friend, foe, and family—never really deserted.

Early in life, he put in long hours of practice perfecting games and passing tests he devised for himself. He conquered billiards. He raced for hours around the basement, posting friends along the course with pails, sponges, and towels; one kept tally of his laps. Instructed that obedience was the cornerstone of self-discipline, he observed so assiduously the rule to remain mute unless addressed that his aunts and older cousins dubbed him the Silent One.

Perfect honesty was a difficult goal. At thirteen, Alfred agonized over a transgression committed five months before. Finally, unable to bear the burden alone, he wrote his father a full confession: a composition he had tried to pass off as his own was, in fact, one he had read and retold from memory. Pleading for Edward's forgiveness, and swearing that this was the "first & last" lie of his life, he invited the severest punishment should he ever break his word. In this instance, however, he sought clemency, or at least privacy; he was too ashamed to have even his mother know about it.

Obviously he had taken to heart at least half the lesson inscribed three years earlier in the copybook that served as his first autograph album:

> Be the servant of Truth
> Master of Passion.
> To his son Alfred
> E*d* Stieglitz
> New York, May 2*d* 1874

That Alfred escaped being insufferably pompous in his struggle to emulate, and surpass, his father's moral perfection was due in large measure to the moderating touch of his mother, to whom love and forgiveness —not justice—were the highest ideals. Her first entry in his autograph collection was a couplet once copied in a love letter to her husband:

> If you love me as I love you,
> No knife can cut our love in two.
> Mamma

Hedwig, who was scolded by Edward sometimes for being "flighty," was indeed romantic and sentimental, but the love she dispensed generously to husband and children was essentially maternal. She indulged their wishes and dreams, rode out their troubles and moods with sympathy, worried more over their health than over their morals, and was at all times the warm integument within which they could be childish without fear of rejection.

If she was evenhanded in apportioning attention, domestic discipline, and compassion among her six children, however, there was never any doubt that she preferred Alfred to the others. She was twenty when he was born, at the pinnacle of happiness in the second year of marriage to an adoring and dashing thirty-one-year-old husband. With the advice and reassurance of his nearby older brother's gentle wife, she had become quickly acclimated to unfamiliar Hoboken. Her house was comfortable, if not yet luxurious, and, with the help of a live-in maid, easy to keep spotless for fastidious Edward. He rewarded her with outings to theater and opera, with jewels and furs, and with hospitality to her younger sisters and brother that equalled his insistence that she visit regularly with her father and stepmother in Manhattan. Alfred's arrival capped her joy.

How and where Hedwig Werner and Edward Stieglitz met is one of the missing pieces of this narrative. It would be charming to imagine that they met at some *bal masqué* at the elegant German Winter Garden on the

Bowery, for Edward carried in his wallet, together with a love poem and a note from Hedwig written during their engagement, a card enumerating the "Order of Dancing" for an early 1860s ball. The likelihood, however, is that they were introduced at the home of a relative, or of a friend common to both families. In any event, they met, fell in love, received the approval of Hedwig's father and stepmother, and became engaged in August 1862, two months before Hedwig's eighteenth birthday; Edward was twenty-nine.

Edward (born Ephraim) was the youngest of the six surviving children of Loeb (Levi) Stieglitz and Johanna Rosenthal. The eldest was Zerlina; then, in descending order, Siegmund, Marcus, Pauline, Julia, and Edward. The first to emigrate from Saxony were Siegmund and Marcus, in 1848; they were followed in the ensuing year by Edward, and in 1850 by their parents and the girls.

About Loeb's and Johanna's early lives, all that is certain is that he was born in 1787 and she in 1792, and that some years of their married life were spent in Gehaus, a hamlet not far from Eisenach in Thüringen (Saxony). Like those of many later Stieglitz spouses, Johanna's antecedents did not become a part of family lore, and Loeb's were not much more clearly defined. For many years, Edward's grandchildren swallowed his tales of having been forced to run away alone to America by the harshness of his childhood on his parents' farm, where his overly strict orthodox father assigned him backbreaking chores, and, even worse, his mother was incapable of pressing his shirts properly. He told Alfred and his other children, however, that Grandfather Loeb, a member of a family distinguished for accomplishments in medicine and law, was a "scholar-leader" in the Jewish community.

In the late 1920s, a descendant of a Baron von Stieglitz, seeking to establish consanguinity with famous artist Alfred and renowned chemist Julius, spurred their cousin Lillie to undertake a genealogical quest. Her inconclusive findings suggested the remote possibility that orthodox Loeb and the Christian nobleman shared a grandfather Siegfried. The story was greeted by Alfred with guffaws, by the twins and Agnes with amused indifference, and by Selma with glee. The most vocal anti-Semite of the family, she couldn't wait to lard her conversations with cousinly Christian titles.

Pedigrees aside, what is known about Edward and his brothers in Gehaus is that they were not rustics and that they did not run away from home. Paucity of opportunity in revolution-torn Europe in 1848 surely accounted for twenty-six-year-old Siegmund's and twenty-three-year-old

Marcus's decision to try their luck in burgeoning America, in which, in that same year, gold had been discovered in California, and four more states had been brought into the fold. They made the crossing from Le Havre to New York probably aboard the clipper ship *Columbia*, a journey that averaged thirty-nine days, and were plunged immediately into the competitive life of the commercial city, an area bounded by John Street, Broadway, Canal Street, and the East River waterfront in which nearly a half-million people of the working classes, native and immigrant, also lived.

Just how Siegmund and Marcus made their way in their first New York year is unchronicled. Possibly they were welcomed by a friend from the old country, or possibly they struck out on their own. In any case, their reports to the family must have been encouraging, and Edward was sent to join them in 1849; he was sixteen years old. At eighteen, he established a partnership with Siegmund "in the manufacture of Surveying and Rail Road Implements . . . at 2 Cliff St., corner of John St., N.Y. . . . a good selection of DRAWING INSTRUMENTS always on hand . . . All Mathematical Optical Instruments made to order at very moderate prices." Marcus had founded his own hat and cap business.

In their spare time, the brothers probably joined the elbowing crowds window-shopping Broadway's elegant emporia, strolled the Bowery with its fashionable row-houses, or explored the bustling East River wharfs where the masts of ocean-going merchantmen rivaled church steeples for domination of a skyline that was seldom interrupted by a building more than four stories tall. But work governed their lives. And they prospered. Before 1850 was over, they sent for their parents and sisters. Siegmund, who had married the year before, had a son to show off; Marcus had a bride.

Loeb did not arrive empty-handed, but he waited a year before investing his capital in a partnership in which there were five principals: Loeb, his three sons, and his friend Moritz Isidor. Marketing imported woolens and shirts of their own manufacture, the five profited equally until first Marcus and then Edward withdrew to start independent businesses. By the end of 1852, two of Loeb's and Johanna's daughters were married and had borne sons; Zerlina Schmal (later Small) was thirty-one, Pauline Nathanson twenty-five. In another year or so, Julia became Mrs. Alsberg; her first daughter was born in 1856, when she was twenty-seven. Edward, the bachelor, had twenty-five or twenty-six nieces and nephews before his

twenty-seventh birthday in March 1860. Infant Alfred, in 1864, would be greeted by thirty-two first cousins.

Little information survives about the home life of the Stieglitzes during their early years in America. Until first Siegmund and then Marcus married, the three brothers probably had rooms in a boardinghouse. By the time the rest of the family arrived, Edward had moved into Siegmund's home. A confirmed atheist by then, he would not consider living again under his father's doctrinaire thumb, even though, as his sisters married, the half-house his parents had taken offered more space than Siegmund's child-filled premises. He traveled a good deal, for pleasure as well as business, and even when intermittent quarrels with his eleven-year-older brother prompted thoughts of leaving New York altogether, he returned to the corner that was always held for him.

Poor Siegmund seems to have spent a large part of his life in a muddle, saying one thing and meaning another, worrying endlessly over the health and safety of his family—especially over Edward after the 1860 death of their father, when he realized suddenly that Edward was "as dear to [him] as any son"—generous to the point of gladly undergoing hardship to furnish an extravagance for a loved one, and burdened with a conscience that led him to continue a partnership with his father's ineffectual old friend Moritz through two bankruptcies. To Edward's children and grandchildren, he was also a figure of fun, possibly with Edward's compliance. They remembered him mostly for his resemblance to Don Quixote—soulful and emaciated, with a narrow beard flowing wispily over his vest and a constantly plaintive high, thin voice. Uncle Marcus survived their teasing somewhat better, thanks to a sense of humor much needed in a man who, as Alfred's brother Lee assured giggling granddaughters (me and my sister Peggy), was able to reach his overrich meals only by having a semicircular berth for his enormous belly carved out of the dining table.

Apparently, Edward relished his bachelorhood, and had the means to make the most of it. Before he was twenty-five, he broke away from father, brothers, and Moritz Isidor to form a partnership with Hermann Hahlo, a fabrics dealer seeking a new venture. With a $900 loan from his father and $1,500 saved from his share of profits in the previous five years, Edward provided three-quarters of the capital. Even in that first depression year, 1857, Hahlo & Stieglitz, "in the business of importing, vending and selling dry goods, merchandise and commodities," turned a profit, as it did in most of the ensuing twenty-four. By the time Edward donned a Union

Army uniform in 1861, he had converted unused profits and a legacy of a little over $1,000 from his father, who had died in December 1860 after three years as a lonely widower, into bonds worth nearly $20,000. His $2,500 investment in the eight-year construction of Central Park imbued him with a proprietary zeal that could hardly have been greater had he been its sole benefactor.

Good-humored Marcus, meanwhile, had fared less well in his second independent venture. By the time the eighth of their thirteen children had arrived in 1861, he and his wife Sarah had given up the city temporarily and were running a water mill inherited from her mother. In partnership apparently with a vintner abroad, Marcus was also operating his own windmill, working in a nearby vineyard, and smoking hams. Clearly, Loeb's orthodox injunctions were defunct.

Although their lives focused on the city, all the Stieglitzes were nostalgic enough for Gehaus fresh air and greenery to seek country respite, if only for an occasional day. An excursion discovered by the brothers around 1850 became a favorite for their wives and later for their children: the Hudson River round-trip boat ride to West Point, capped with a picnic at the military academy and the spectacle of the cadets' parades and artillery drills. Alfred relished his visits there until he was a teenager. His uncle Siegmund and Aunt Helena became so attached to the area that, in the midsixties, they began renting vacation quarters at nearby Highland Falls ample enough to accommodate their eight children and, until 1874, Edward's and Hedwig's six as well.

Before 1861, Edward's social circle beyond the extensive family seems to have been composed primarily of business-directed, hard-working, young German Jews who, like himself, were in a hurry to slough off old-country ways, including religion. They were not so quick, however, to shed their native language. Their commerce was conducted in German, they joined German-speaking fraternal groups, attended lectures in German, and read the *Staats-Zeitung*. At the same time, they picked up both the international and the American tastes of their new cosmopolitan home: French champagne and Long Island oysters, English tweeds and Georgia cotton, and spectator sports from crew regattas to baseball. For some, baseball became a passion. Edward, living in Siegmund's rented house in suburban Hoboken, to which they had moved probably after their father's death, played host to his friends at the Elysian Fields for games of the New York Knickerbockers.

Their enthusiasm for things American led some of Edward's group to

join the state militia's 6th Regiment—not so much from patriotic motives as for the sport and spectacle it offered. The peacock exhilaration of competitive parades in which the roar of the crowd proclaimed the winner among New York's strutting regiments (in uniforms of their own devising) seem to have been the militia's principal occupation for years. Language was no problem to Edward and his friends: Company F of the 6th Regiment was made up almost entirely of the German-born.

Then, on April 15, 1861, their patriotism was called to account. President Lincoln, realizing immediately after the Confederacy's capture of Fort Sumter that the regular army's 16,000 troops were too few, asked for 75,000 ninety-day volunteers to defend the nation's capital. Fifteen companies from the North's militias responded at once; the "6th Regiment, New York Troops, Governor's Guard, Organized May 9, 1814," set sail from the Battery on April 21. On board was Lt. Edward Stieglitz of Company F, resplendent in a custom-tailored uniform and bearing a fine regimental sword. Displayed in subsequent family homes, that sword would later conjure for me an image of great-grandfather Stieglitz, whose features I knew largely from a plaster bas-relief of his fierce profile, charging across a battlefield on a hard-galloping steed, cutting the air with Excalibur.

The fact was, however, that he had a peaceful war. Alfred placed him with General Meade's army in Pennsylvania, and others in the family insisted he had been under McClellan's command. Edward limited his oral history to describing a meeting with President Lincoln in which he, a young lieutenant, personally alerted his commander-in-chief to the deplorable food being issued the troops.

The 6th Regiment's immediate response to the President's April 15 call generated civic enthusiasm that was described in the *Herald* as "unique in the annals of New York." Its valor thus celebrated, the 6th quickly disappeared from the headlines, which were dominated thenceforth by the popular 7th and 71st Regiments. Until protests from its readers forced the assignment of a correspondent four weeks later, even the *Staats-Zeitung* ignored the 6th. By then Company F was settled in Annapolis, in a temporary camp that Edward described in his first letter home as "dreary . . . no wooden floor[s]" in the tents, cots too close together, food sparse, and an uncovered kitchen where the fire was constantly doused by rain. "On the other hand," he continued, "this life has a certain fascination and I do not mean to complain."

Worried Siegmund immediately dispatched a second package—one

of many—to replace a first that had gone astray. This shipment was of "two boxes, one containing 1 dozen bottles of wine, the other 1 sausage, 1 ham, 1 tongue, 1 bread, nuts, almonds, tobacco, a pipe, pomade, mustard, chocolate, cookies and macaroons, and 1 bottle of caraway liqueur, 1 bottle of rum, some linens [underwear] . . ." and a great deal more. By June 3, Edward was reporting that he now had two compensations for his boring life of "daily duties . . . correspondence with home, bathing and going for walks:" the beautiful landscape surrounding his new post at Fort Morgan, and the dinners he mounted for his fellow and superior officers. Comparing his hospitality jauntily to that of "the most accomplished housewife . . . roses and laurel [on the table] . . . a large turkey of quality . . . a good cup of coffee with a first-class Havana cigar [after] wine [that] was just the right thing to loosen our tongues," all he lacked, he felt, were the table linens he urged Marcus to bring on his next visit.

The fact that Edward was having a gentleman's war did not weigh heavily on his conscience. After all, he and his friends had volunteered not only with the first call from Washington, but for five weeks more than agreed to by the celebrated 7th. His relatively placid life, moreover, reflected not an unwillingness to take up arms but confusion and ineptness in the Union command which, in the early months of the war, had made use of fewer than a third of its volunteer troops—and these it had thrust into engagements untrained. Undoubtedly, too, the generals really didn't know what to do with this bunch of foreigners.

Edward was hardly to be blamed for the ease of his service—for having an orderly to see to his comforts, or for receiving no more onerous commissions than the two (or three, if the Lincoln meeting is included) he carried out with exemplary skill. In the first, with two captains from his regiment, he negotiated successfully for the pay long overdue the line officers; in the second, he and two other officers managed to obtain from the Secretary of War in Washington a firm commitment for the demobilization of the 6th Regiment which, under the terms of enlistment, should have taken place five weeks earlier. For his pains, he was granted a three-day furlough to New York, from which he returned to a celebration in his honor: music, cheers, banners, and a scroll recording the thanks of his company.

It seems contradictory that this American patriot, devoted to the Union cause and a firm supporter of Lincoln, would be satisfied to end his service in July with the hiring of a substitute. The war had just begun to heat up; indeed, the North had just been ingloriously defeated at Manas-

sas. But substitutes were abundant, and Edward, at twenty-eight, undoubtedly agreed with his brothers that others younger than himself should serve. Furthermore, he was worried about having left a flourishing business in the hands of a partner whose questionable judgments might spell its decline, especially in a period of economic uncertainty. And there was another powerful reason.

Except in New York, German volunteers had from the start met with public antagonism. "Good Americans" greeted them with the hated Revolutionary War epithet *Hessians* and before long there were uglier confrontations. In the first week of June, civilians in St. Louis attacked German volunteers assigned to the defense of the city, and similar incidents arose elsewhere. Edward may not have known at first what was happening in other parts of the country—and certainly the 6th never suffered direct conflict with townspeople—but he was kept apprised of the general civilian attitude by Siegmund, who wrote him bitterly in May: "The 'Dutchmen' are only good enough for work and eventually to be killed . . . [I] ask you to take into consideration not only the question of honor, but also . . . the cold attitude of the 'Yankees' before you decide to make a larger sacrifice than the favored native soldiers" of the 7th, who were heading home after only four weeks of duty. "Give some thought to the possibility of returning to us at the first opportunity. There is enough work here for the good citizen." Giving up the fleeting romantic thought of reenlisting, Edward, like most of the German-Americans in Company F, decided to finish his term and be done with it. If he felt any resentments, they were ephemeral; what he passed on to his children was his deep pride in having served the Union cause in uniform.

In New York again in late July, he seems to have lost no time in getting back to business. During his absence, Hahlo had moved their goods to a new location, prompting Siegmund to write, "One must assume that the store is a bargain . . . I hope that you will soon be able to give it the missing touch of glamor." Taking charge again, Edward sent his partner on the road—across the continent this time, as two years later he would send him to Germany and England—while he remained at home to work his considerable charm on customers and banks. Hahlo & Stieglitz began again to prosper.

And Edward became a commuter again, ferrying the Hudson between lower Manhattan's morning silhouette and Hoboken's sunset blaze. A quiet town, Hoboken bore a resemblance to old Baltimore, with a preponderance of modest but substantial brick row houses entered from white

marble steps through tidy little gardens, with trees and parks and even a few high-walled estates. Most of its inhabitants were repatriated Germans who had passed the middle of the economic ladder and were still climbing; some, like John Jakob Astor, were already firmly at the top. An ideal setting for a family with growing children, it was a little quiet for a bachelor. Fortunately, nightlife bloomed across the river.

Edward's army stint had firmed old friendships and engendered new. Attractive as he was—handsome, sophisticated, well dressed, and quick to pick up the tab—he was undoubtedly as much in demand for parties and for escorting the sisters of his chums to dances as he was for stag evenings of pinochle. For a man of pride and imagination, however, who had gained some maturity—he was approaching thirty—the role of social extra soon began to pall. A popular though demanding uncle to twenty-nine nieces and nephews, and surely convinced that he could govern children more efficiently than his brothers and brothers-in-law, Edward began to envision a family of his own. He was ready to meet Hedwig.

3

Although "Granny Stieglitz" (Hedwig) died when I was less than a month old, her visage is as familiar to me as if she had been present during my lifetime, thanks to a small portrait by Alfred that reappeared in the homes of his brothers and sisters. What makes her vivid to me still, however, is less her photograph than the cluster of stories about her that the family savored telling. There seemed no end to the entertainments that could be had at her expense.

A pet target was her language. Repeating their stories about her, her children and grandchildren could be rendered helpless with laughter over the Germanic contortions of her sentences and the elisions that produced sometimes startling non sequiturs. Among their favorites were her plaint, "Must the dog come in with his feet from the rain?" and her effective cut-off of a long-winded theologian's dinner lecture on the significance of rabbinical beards: "Ach, all religions have beards!" Other relatives also embellished the portrait of Mrs. Malaprop. A skit survives in which she is fondly—and cruelly—caricatured, not only for her twisted syntax but also for her lack of reticence in commenting publicly on the problems of an aging bladder. The unfeeling author insisted on performing it in her presence; according to one witness, she had the grace and humor to join in the laughter it provoked.

With all the stories of her difficulty with the English language, it was a surprise for me to discover that, a few months before she and Edward were married, Hedwig had taken up writing him in German at *his* request. At seventeen, she seems to have been more comfortable with English. While, for the next twenty-five years, most of her letters to him were in German, the sprinklings of English phrases were basically grammatical if a little telegraphic. In one 1873 letter (in English) she excused her elisions thus: "You know I am not able to write a decent letter my thoughts run too fast, and I get mixed up as in talking too."

Until the 1870s—the Werners had emigrated from Offenbach around

1855—German was probably the first language in Hedwig's home. It remained the only language of her father and stepmother, but all the children were fluent in English within a short time of beginning school in New York, and Hedwig's cousin Adolph Werner was a tutor in English at the City College of New York as early as 1857. It seems quite probable that Hedwig's explanation for curious-sounding English was valid: her mind outran her tongue. Whatever the limits of her own eloquence, she had an abiding love for the beauty of the English language, and was a passionate enough devotee of Shakespeare to have memorized page after page of dialogue; at theater she would recite Hamlet's lines like an overconscientious prompter—two or three beats ahead of the disconcerted actor.

Aside from the quaintness of her speech, there seems to have been at least one other reason for Hedwig's celebration as family clown; it contributed to the image of Stieglitz superiority. With the possible exception of Alfred, Hedwig's and Edward's children were adamantly certain that their peerless cultural endowments had their origin in Edward and his forebears, not in their mother's family. This condescending assessment of her cultural contribution to their lives was fostered by Edward. And Hedwig acquiesced, for the most part, to bolster her husband's self-esteem.

That Edward had a talent for painting and a voracious appetite for the enjoyment of all the arts is undeniable, but it is significant that this side of him went unmentioned among friends and family until Hedwig was a part of his life; much more had been made of his talents as a gourmet. Furthermore, it was only after their marriage that he decided to better his English in classes given by the Hoboken Academic Society. He may never have developed the passion for literature that Hedwig had, but his later letters in English show how assiduously he practiced to achieve a more elegant style. Frequently he made several drafts before he was satisfied with the product (as Alfred would in later life when addressing adversaries, such as the Internal Revenue Service). Hedwig, meanwhile, continued to write with the self-confidence—and mistakes—that seem to indicate an early and easy familiarity with English.

In any event, it seems clear that Hedwig brought to their marriage a large part of the appreciation of art, literature, and music that enriched their, and later their children's, lives. One may guess that she brought the materials and Edward the energy to use them. The compulsion for excellence that enabled him to be tenacious in his efforts to achieve whatever goal he set himself—with a patience that was observable in little else in his life—was a legacy to his sons that they never lost.

Information about Hedwig's childhood and about her parents is tantalizingly sparse. The remnants of a correspondence between Abraham Werner and Flora Collin before their marriage (four letters he wrote her from Frankfurt to Offenbach between March 1841 and January 1842) are more suggestive than evidential. The first proclaims his innocence of a scandalous charge that he had jilted a young lady. His family, in response to the rumors, "decided to send me to Mayence, Brussels or elsewhere." Thoughtfully, in the postscript, he translates "*entre nous*" for her benefit. It appears both that his education included French and that his family had the means to provide the upper-middle-class cure for gossip: send the culprit off on holiday.

The second letter invites her to a matinee the following day of *The Marriage of Figaro* on the anniversary of Mozart's death and looks forward to seeing her as well in the evening. He praises Flora's "excellent and beautiful work" in embroidery and/or shirtmaking, which she seems to have done for his brother's clothing business.

The third, addressed to "My precious Flora," carries the hope that God "will grant me my greatest wish soon." God, or Flora, cooperated; they were married a year or so later. Their first child, Hedwig, was born in October 1844, followed by Rosa in 1846, Ernest in 1848, and Ida in 1850. They made their home in Offenbach.

Other than a May 9, 1854, school exercise of Hedwig's in Offenbach, when she was nine, there is no further dated information about her young years, but it is known that her mother died soon after Ida's birth, and her father remarried; his second wife was Fredrika Dietz, with whom he had two daughters, Sarah and Jane. It is probable that Hedwig, with sisters and brother, father and stepmother, and their baby daughters, emigrated to New York around 1855. By the time she and Edward Stieglitz met in 1861 or 1862, the Abraham Werners seem to have been firmly established in their new land, with an already active social and cultural life. Abraham's brothers Edward J., Julius, and Siegmund had probably also arrived by then; Edward J. may have arrived earlier. His son, Adolph, a professor of German Language and Literature at City College during Alfred's two years there as a student, would become a favorite cousin of Alfred's in spite of the gap in their ages.

Whatever the circumstances of their meeting, in early August of 1862, seventeen-year-old Hedwig Werner became engaged to marry twenty-nine-year-old Edward Stieglitz. From the start of their engagement to the eve of their marriage, Edward saved, and numbered, the letters he insisted Hed-

wig write him daily. Her first, in German, had an English postscript asking him not to laugh: "I would rather have written English but I know you like German better," but a week later, signalling her tactful acquiescence to his wishes, she claimed she was beginning to "like German almost better now." Whatever the language, she chafed at the daily letter assignment, and tried to find ways to stretch its contents; she found it especially galling that she was required to have an early morning message ready for her brother Ernest to deliver personally to Edward. (Ernest, who charged an average of two cents for the service, appears to have succumbed more than once to temptation, for Hedwig soon wrote *Closed* across the envelope's flap, and finally consigned her letters to the mails.) After a month of struggling for topics to write about, she hit upon the less taxing effort of quoting loving little verses, of greeting-card caliber, to fill the mandatory page.

From the start of their relationship, Heddy seems to have been aware not only of her wifely prerogatives, amongst which was the setting of their social schedule, but also that in some subtle way she, more than eleven years Edward's junior, was more mature emotionally than he. Some of her self-confidence may have been seventeen-year-old insouciance (she scolded him for not thinking about her all the time as she did of him, and admitted without apology to being occasionally "cross," or "naughty") but it also seems that she recognized, and welcomed, a need in him for mothering that would manifest itself repeatedly throughout their life together. In these early letters she called him often "my dear child," and when she felt most adoring, "my golden child."

Edward's letters were far more romantic than hers. He saw her image "always in the foreground" of the scenic beauties he enjoyed on his morning and evening ferry rides between Hoboken and lower Manhattan; he was fearful that his "longing for her" might divert his attention from business matters; and he found it hard to contain his passion, telling her that he had to "stick to cold prose . . . and not let my phantasy grow so far as to write in verse." If he felt no obligation to write her every day—he was, after all, a working man—he went to considerable lengths to spend all but one or two evenings of their engagement with her, on several occasions ferrying back after business to dine at home with Siegmund and his family, crossing again to see Heddy, and returning to Hoboken late at night. His most effusive letter during their engagement was written on the eve of her eighteenth birthday in October, "an age which is the most lovely . . . especially for [a] girl who is also a loving fiancée." Wishing that he could

be "the first person tomorrow to greet you," he prayed that "the recollection of this day and all [our] beautiful and holy hours [might] be a protection against the dangers that life may bring," and that the coat he had bought as a present would "protect you in the days to come from cold and rain and be a symbol to you of the concern I have for Heddy. You do not know yet how far this concern goes—it extends even to your friends . . . even if on a modest scale—my darling, what more do you want?"

He was true to his word. Not only was he hospitable to Heddy's family and friends, but within a few months of their marriage he made a place for her brother in his business, and between Alfred's birth in 1864 and the next child in 1865, he accepted full responsibility for Heddy's sister Rosa, who lived with them thereafter until her death thirty-four years later. In Lake George and in New York, Hedwig's other sister, Ida, her brother Ernest, her father and stepmother, and her stepsisters were always made welcome.

Edward's relationship with his sisters-in-law was erratic but generally warm. With Ida it ran an undulating course from flirtation to injured feelings. Ida to vacationing Edward in 1872: "At Sharon . . . you have so many acquaintances [that] you might pass off as a single gentleman . . . alas for all the broken hearts," and in 1873, referring to the pleasure of a walk with him in Central Park: "In future my dear Eddy . . . I shall endeavor to take more walks with you, and each time you will find out something more about me and then—perhaps an elopement will take place." To which Edward responded (in English), "That glorious walk . . . had such a deep and lasting impression on my mind that it controlled my whole soul and body . . . Your letter came . . . kindling anew the flames . . . which if not conquered in time will perhaps put all Saratoga on fire," and promptly handed his missive to Heddy to add her greeting. Ida to Edward, several years later: "All my letters [have been] as much for you as for my sisters. [Not addressing you alone was not] 'ugliness' [but] extreme sensitiveness . . . thinking you did not care about hearing from me."

Ida enjoyed her flirtation with Edward, but Rosa appears to have been seriously smitten. Soon after coming to live with Heddy and Edward, she took over from her sister the daily reports Edward demanded whenever he was away, almost always adding some coy reference to the natural confluence of their thoughts or the coincidence of headaches suffered on the same day. If she knew herself sometimes to be a cause of friction, as when she wrote during his summer of travels with Alfred in 1873, "[Although I] have always *tried* to contribute to your and Heddy's happiness in mar-

ried life, I have succeeded but poorly, and been I know a great deal the original cause of unpleasant scenes between you and Heddy," she was apparently unable to suppress or rechannel her feelings. Days after this self-effacing message she wrote, "I have since Sunday night dreamt every night that you and d. Ally were back, and a great many *other* things about you d. Ed.—my constant thoughts . . . are always with you both my D[arling]s."

No letters from Edward to Rosa remain, but his references to her elsewhere imply that, although he may have been flattered, he was far from reciprocating her fervid "imaginings." On the other hand, Alfred spoke of having gathered the impression in childhood that his father and his aunt mutually enjoyed a more than conventional liaison.

It was in late November of 1862 that Edward took the first major step in preparing for married life: he signed a seventeen-month lease for a house in Hoboken, Number One Sea View Place. Hedwig assembled the missing pieces of her trousseau, visited the house to see what furnishings would be needed, and helped her stepmother and sisters address the wedding invitations. Finally, on Sunday, December 21, 1862, at Hind's Hotel on Ludlow Street, Edward and Hedwig became Mr. and Mrs. Stieglitz.

It would be nearly ten years before they went to Niagara Falls—with Alfred—for a honeymoon; at the end of 1862, Edward was too busy to go away. His business had increased substantially, not because he profiteered, as others did, from supplying shoddy uniforms to the armed services, but because in the North, where cotton from the South was unobtainable, wool had become king. Probably bride and groom went directly from their wedding dinner to their new home, even though it would not be completely equipped until the day after Christmas. On the twenty-fourth, "Mama" Werner and Rosa tried to arrange delivery of Heddy's trunks of clothing and baskets of linens and chinaware, but, as it was Christmas Eve, the carter they hired agreed only to take the load from 140 West Fourteenth Street to Edward's store at 4 Murray Street; he refused point-blank to go to Hoboken. Edward took charge, cajoled a friend into volunteering himself and his carriage, and over the next two days transported everything to their new home except the furniture from Hedwig's former room.

Within a week or two, Heddy's days were humming with visits from her family: her father, Ida and Ernest, her stepmother with the little girls, and most of all Rosa, who wished Hoboken weren't so far away. She had

so much to tell Heddy—about the parties she was going to, the dances at Liederkranz Hall, the cashier's job she would take in March when she turned sixteen—and so much she wanted to ask that she wrote almost daily to make up for what she had forgotten during visits three or four times a week.

In April, Hedwig learned that she was pregnant and set about at once preparing for the event she would describe thirty-four years later, when Alfred's daughter was born, as "the happiest moment of my life." The months before her confinement went quickly, and she grew increasingly grateful for the good air, the space, and the safety of Hoboken, well away from the frightening July draft riots in New York that had left a thousand or more people dead or injured.

Alfred was born on New Year's Day, 1864. The year of his birth was a momentous one for America: in March, Ulysses S. Grant became commander of the Union forces, coordinating at last the campaigns in scattered parts of the country that would bring federal victory thirteen months later; and in November, Abraham Lincoln was elected to his second term in the White House. Two months before, when Alfred was eight months old, Edward had moved his family to a larger house he had purchased on Garden Street. Although the spring had somewhat taxed Edward's resources—he had had to help Siegmund pay off business debts incurred in 1861—his own business was faring so well that the new house was one of the handsomer three-story brick structures of the area, with an English basement and a garden in front. Alfred would remember it well; the family remained there for seven years. A housemaid joined the ménage to relieve Heddy of most of the cooking, giving her more time to lavish on Alfred.

Mother and son formed a special bond from the beginning. Edward's business days were long, and Hedwig compensated for his occasional travelling by concentrating her attentions on her little boy. During the summer she apparently took him for short stays with her in-laws in the Buttermilk Falls retreat shared alternately by the Smalls and the Siegmund Stieglitzes; at home, she enjoyed showing him off to her sisters. Often Rosa stayed overnight, but at least one of her visits incurred Edward's impatience. As he left the house on August 23, he handed a hurried note to "My dear but naughty Heddy: You will find enclosed in this letter the funds for preparing a good meal for to-night—but don't forget the salt! I was rather cross about the affair of this morning [unexplained], but it is already forgotten and I hope by you too. Many kisses for MY Alfred and best regards (but

no kisses) for Rosa and also for Brush [his horse] if he's rid of his kicking shoe. Yours, Edward. P.S. I did not win the 32nd part of $100,000." In whatever squabble had taken place, Rosa appeared the major villain. Probably she had been cooing over "her" little Alfred; possibly she had made some acid comment about Edward's success at the track on one of the excursions with men friends that he allowed himself from time to time. Horses, in fact, had already become important enough to him to spur his enrollment in riding classes that would progress through Hexamer's in Hoboken in 1869 to a French riding master in Manhattan in 1876. Four years later still his doctor would warn him that not posting would be bad for his kidneys, but eventually, it seems, his style improved; an equestrienne granddaughter would praise his general excellence in spite of "hard hands."

April of 1865 was a wrenching time for the nation: there was cause for exuberant celebration in the long-awaited treaty that ended the war, but within five days of its signing, the President had been assassinated. Edward grieved as if he had lost a dear friend, and for the rest of his life saved the newspaper accounts of the tragedy: the shooting, the night's vigil of April 14, and the devastating reality of Lincoln's death on the fifteenth. The period of mourning was long, for the country and for Edward; his consolation came on July 1, when Heddy gave birth to a daughter, Flora.

Flora's arrival seems to have been accompanied by some fairly radical changes in the Stieglitz home. In addition to the housemaid, a cook was engaged, and a nursemaid. By the end of the year, Rosa had moved in, bringing with her a passionate devotion to the minutiae of child rearing that Hedwig did not share. If Edward's increasing business success made these housekeeping alterations possible, it is likely that his increasing irascibility with the sounds, smells and clutter of infant care made them essential. Eventually even the overhead footsteps of chambermaids doing their work would excite the master's fury; they would be instructed to remove their shoes.

Edward's first year and a half as a father had been one of delight in the novelty of Alfred, a son to display and instruct, and of joy in Heddy, with whom it was as much a pleasure to spend quiet evenings at home as it was to take her to concerts, theater, and opera when Rosa was available to spend the night. Edward seems to have confined his socializing with men friends during this period to daytime activities—luncheons downtown, a day at the races or a football game—or an occasional late afternoon drink or round of billiards before going home for dinner. Sundays, he and

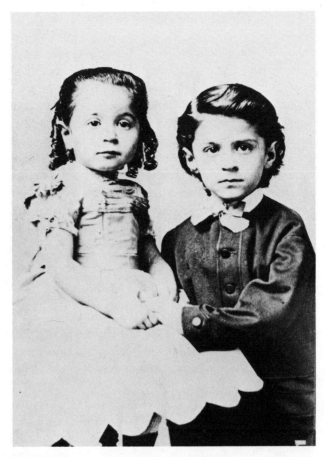

Flora and Alfred Stieglitz, New York City, ca. 1868
Studio

his little family sometimes joined brother Siegmund, sister-in-law Helena, and their brood of eight for a picnic in the Elysian Fields park, or took the Hudson River boat to West Point for the day, stopping on the way back to visit his older sister Lina Small, her husband Julius, and their four children at their place north of Yonkers. Meanwhile, he enjoyed taking charge of the more splendid articles of Heddy's wardrobe, establishing accounts for her at silversmiths, department stores, and jewelers, and adding to the accoutrements of a fine home. The couple's contentment with each other and with their son was complete.

There are intimations that Edward was not as at ease with daughters as he was with sons. The female, beginning with Hedwig, was a puzzling species, with wholly inexplicable motivations, responses, and thought processes. Romanticizing women, as his sons would later on, he was alternately submissive and autocratic, worshipful and disdainful in their presence. Flora, however, who was born when Alfred was not yet two, seems to have

fallen into a middle category; Edward apparently resolved some of his malaise with her by elevating her to the status of almost-son. He would provide her with a lady's education, complete with piano and drawing lessons, French, and elocution, but he would insist also that she sharpen what were regarded at the time as basically masculine attributes: intellectual curiosity, moral righteousness, independence, and a strong interest in politics and history. Flora did not become a tomboy—she had strong domestic leanings and served happily as little mother to her brothers and sisters, including older Alfred, who adored her—but, at least partly to please her father, she honed a business sense that led him to suggest when she was twenty-four that she enter her husband's winery as a partner.

Flora was the last of Edward's children to receive his concentrated instruction. The twins, although boys, would be left to absorb their father's lessons from his example and his rules for the house rather than from any curriculum he devised or têtes-á-têtes he encouraged. Oddly enough, they adopted his precepts more unreservedly than either Flora or Alfred, who were closer to him. The younger girls, Agnes and Selma, would be treated by Edward as more traditional little girls who merited his affection. Not equally, as it turned out; tempestuous Selma was hopelessly overindulged by him.

Soon after Flora's birth Rosa became a permanent member of the household. Thenceforth, each child in turn would learn how to manipulate her far more easily than their astute mother or their implacable father; all would love her for her availability to their whims or their needs. She was the chronicler of their growth, noting the way they expressed themselves, behaved with one another, and reacted to the absence of one parent or both. Far from being the self-effacing spinster, however—at least in her early years as part of the household—Rosa enjoyed the company of gentlemen callers, chaperoned certainly, but free enough to laugh and sing and demonstrate her considerable skill at the piano. Unfortunately, none of them ever measured up to her brother-in-law.

If Hedwig resented her sister's devotion to Edward, she apparently showed it little. In Rosa she had not only a built-in confidante on whose support she could rely in most disputes with Edward, but also an exemplary volunteer nanny, more than willing to give Heddy the free time she wanted to pursue two special pleasures. One was the indulgence of an addiction to novels. Thirty, forty, and even fifty years later, her grandchildren would be dumfounded by her total recall of nuances of character and convolutions of plot. The other was the chance to spend more time

with Alfred. After making orders clear to the servants—in which she was exacting to a surprising degree, considering her otherwise democratic embrace of humankind—and planning for Edward's evening entertainment, she could have her firstborn to herself for as long as she wanted. Clearly Alfred was her "little man."

4

Alfred's major opportunity to have his mother to himself came in his third year, during the six-month family stay in Europe in 1866. In Berlin, where they stayed from late January through April, Hedwig was free of the friends and relatives she saw regularly at home, she had a nursemaid to care for Flora, and Edward was often away on side trips for business. With Rosa beginning to succumb to the headaches and dizzy spells that were later almost chronic, it would have been natural for Heddy to insist that she rest, and to take Alfred with her to explore shops and museums and parks, her favorite daytime activity abroad. Alfred would not have been a hindrance to her. He was a lively child and a good companion, and, although deemed skinny by his oversolicitous parents and aunt, he was apparently sturdy enough even at two and a half to walk quite unusual distances. (At twenty, when he kept a record, he walked more than 550 miles during his summer holidays, a good part of the way with a sprained ankle.) It is quite possible that his walks with his mother gave him a sort of infant familiarity with the city that brought him momentary impressions of *déjà vu* when he returned to Berlin at eighteen. Later still, he told me that he could repicture places seen from his first year on; events entered his memory only after the family's move to New York, when he was seven. There was one exception, of which he spoke often. At the age of two, he fell in love for the first time, with a beautiful dark lady who came frequently to the house. He remembered turning so pale at the mention of her impending visits that there was talk of sending for the doctor.

No strict itinerary of the 1866 Europe trip remains, but it is certain that the family went to Stuttgart and Frankfurt as well as Berlin, traveled for a while in the Strasbourg area, and remained for some time in Lucerne. The letters they received from the States remain a rich source of description of their quotidian lives at home in New York and Hoboken. A large part of young Ernest Werner's reportage, for example, is in response to questions from Hedwig and Rosa, and from Edward, by whom he was

employed. Ernest's descriptions of births, romances, and illnesses in the vast Stieglitz family and among his sisters' friends, of New York's social and cultural scene, and even of household matters, give a glimpse of the tenor of their lives.

The Italian opera season had closed, he wrote, and the German season was about to begin. Cousin Adolph Werner had held another literary gathering; Cousin Julius Werner had given a virtuoso piano performance with one hand. He agreed with his sisters that a particular actor was stiff; he was beginning to like Meyerbeer. Apologizing for an exceptionally short letter, he explained that he had not returned from the Tentonia Masquerade until "6½ in the morning [and] do not feel at present remarkably bright or entertaining"—a tidbit that may tell more about Ernest's life than theirs, but obviously he did not expect them to remonstrate.

There was more about Adolph: "It seems to be quite 'the thing' now to have one's teeth drawn, filled, filed, cleaned and replaced. Adolph was infected by the disease. He took chloroform, had all his teeth extracted and had a new set made. His teeth are masterworks of art . . . as natural as natural can be." And there was news about their sublet house in Hoboken, where their two maids were finding the need to deal with children and to get up at 5 a.m. more demanding than they had been used to; two months after the Stieglitzes' departure, they quit. Hedwig, though strict and fastidious, had never made unreasonable demands.

The four and a half years following the family's return from Europe would be marked by the arrival of four more children. Alfred had been one and a half years old when Flora was born. By the time he was four, he had twin brothers; at five, another sister, Agnes; at seven, a third sister, Selma. Thenceforth he would have only intermittent protracted sessions alone with Hedwig, usually on brief trips with his parents after 1871, when Edward began seeking curative waters at various New York spas. On these occasions, Hedwig and Alfred took walks together again, talked, read, and listened to chamber music in the hotel lobby while Edward cosseted his ailments and enjoyed the company of men.

Conversations between Alfred and his mother probably followed an agenda from which they rarely strayed. His health first, and his behavior and progress in school; his relationship with his father, as a dutiful son who owed respect and obedience—only after Edward's death did Hedwig begin to confide that he was the source of many of her earlier frustrations and problems—and finally the welfare of "the children," as she, and Alfred even before he was ten, referred to his brothers and sisters. Through-

out her life, Hedwig consulted Alfred about what she ought to do about the children's moods, attitudes, and behavior. Most of the time, mother and son agreed in their diagnoses, but their prescriptions were often widely divergent. Hedwig sought methods to influence them, and Alfred argued that any such efforts would be not only fruitless but exhausting, to her. In the realm of principles, however, they were in agreement to the degree that no discussion was necessary; their harmony was complete.

Nevertheless, one of Alfred's favorite half-fictions in later life was that he was as much an enigma to his mother as he was to the rest of the world. It pleased him to think that he was too honest, too unpredictable, and too original a person to be understood by conventional mortals. While there is some reason to trust his later assessment of certain limits to his mother's understanding, it seems that in this regard, as in a variety of others, he exaggerated.

There was one story he told often to prove that she was perplexed by him, as well as to illustrate his own unique subjective idealism. After they had moved to Manhattan in 1871, a street musician, with hand organ and mendicant monkey, appeared every Saturday outside the Stieglitz house on Sixtieth Street, arriving always when the family had just begun dinner. Around his twelfth year, Alfred initiated a routine he would follow for the next five years. As soon as he heard the strains of the "Marseillaise," he collected the coffee and sandwich he had persuaded the cook to prepare and, with a dime saved from his allowance, brought them to the old man, who thanked him solemnly and launched into the "Miserere" from *Il Trovatore*. One frigid snow-heavy night, his mother, worried about his health—he had recently achieved his adult height without compensating in weight and looked, he said, like a scarecrow—suggested that he at least finish his soup while it was hot. Without answering, he left the table. Some forty years later, seated with him on the veranda of the family's rambling house at Lake George, Hedwig asked him suddenly why he had insisted that night, against her wishes, on taking the old Italian his ration. As he put it, her belated question gave him an opportunity to try to bridge the gap of incomprehensibility between them. "But, Mama," he answered, "I *was* the organ-grinder! Don't you see?" and went on to explain that throughout his life, whatever he gave away was always a gift to himself.

In one version of the story, he said that she accepted his explanation in puzzled silence; in another, denoting considerably more understanding than he was willing to concede her, she asked, "How long have you known

that?" By the time I began hearing its several versions, all were as polished as fables, with suitably simplified and ritualized dialogue. All ended, as Alfred's stories usually did, without an identifiable moral; if any was to be drawn, it was the listener's responsibility to find it.

One other facet of this favored tale merits brief comment. Neither Hedwig nor Edward would have insisted that Alfred have his soup hot: the inherited "Stieglitz tongue" made anything hot a torture that touched off a fusillade of German expletives in all the family males. Thanks to Alfred and my grandfather, Leopold, I grew up thinking that at least half the German language was composed of the *Donnerwetters, Gott im Himmels, verdammts,* and *noch einmals* they released over the most trivial misdeeds, as certain a legacy from their father as was the sensitivity of their tongues.

Despite Alfred's claims in later life that he was "always a loner," it is hard to imagine that he greeted the arrival of twin brothers in his fourth year with much enthusiasm. Lee and Julius were strappingly healthy, and commensurately loud; during their infancy, Hedwig's times alone with her firstborn would become shorter and more infrequent. Instead of mourning his displacement, however, Alfred seems quite quickly to have channeled his energies toward a more positive end: he would, like his father, find escape from the world of women and babies. He would learn, at five, to read—a skill that brought him at least two almost immediate rewards: deliverance from Aunt Rosa's fairy tales, and a growing understanding of the captions and texts of Edward's racing periodicals.

There is little information about the family's doings between their return from Europe in 1866 and their move, in June 1871, to Manhattan. All that is known with certainty is that, for several weeks in the summers of 1868 and 1869, Hedwig and Rosa took the children to visit their aunts, uncles, and cousins in Highland Falls and Buttermilk Falls, and in the intervening nine months Alfred started school in Hoboken, providing him with further happy evidence of his seniority to "the children." Best remembered from his first two years of school was his active introduction to baseball, the game that would be his favorite throughout his life. The restrained family picnics in the park that had only occasionally included the chance to see the pros at the Elysian Fields diamond now gave way to the exhilaration of firsthand participation. In his seventies, Alfred's descriptions of the thrills of sand-lot baseball took on some of the color of the radio reporting that kept him glued to the set during the World Series. The feats he described were certainly beyond the reach even of an exceptionally

gifted seven-year-old athlete, which he was not. What made him exceptional at that age was the intensity of his efforts to excel, and the independence that led him to be inventive about game rules.

If all Alfred found memorable about his first seven years in Hoboken was his introduction to baseball, the last six months of his eighth year were another story. In June of 1871, Edward brought his wife, sister-in-law, six children, cook, and two maids across the Hudson to Manhattan, to the five-story house he had had built at 14 East Sixtieth Street. The move was far more exciting to Alfred than his change of schools; in September he and the twins started classes at the Charlier Institute, a prestigious private academy for boys.

Family mythology had it that Edward's ability to build the capacious brownstone on Sixtieth Street arose from the magnitude of overnight profits his business realized after the Chicago Fire. Family mythology was mistaken; the Chicago Fire raged from October 8 to 11, 1871, by which time the Stieglitzes had been living in their new home almost four months. Furthermore, their house had already taken longer to build than the others in the block—all new in that year, and all cut from the same pattern—thanks to Edward's changes in its design. In the other brownstones, the dining room adjoined the first-floor parlor; food prepared in the ground-floor kitchen was dumb-waitered to an upstairs pantry for a maid or butler to serve. In Edward's house, the kitchen and dining room were on the same ground level, and the first-floor room originally designated for dining was used as a second parlor. As further innovations, he had ice water piped to every floor, an expanded steam heating system that required a huge furnace in the basement—in which there was also a laundry and a cooled area for the wine cellar—and throughout the house, cabinetmakers executed his designs for built-in furniture. On the top floor the billiard room, crowning the house, left room for only one live-in servant; the others came daily.

Obviously, the growth of Edward's profits was attributable to conventional means—to his business acumen and the high quality of his merchandise, to imaginative salesmanship, expanded inventory, and general prosperity. By 1871, he was a steady supplier of two of the major department stores in the country: A. T. Stewart in New York and Cooley, Wadsworth & Co. in Chicago, the forerunner of Marshall Field's. Edward didn't need the Chicago Fire to finance his house.

Nevertheless, that catastrophe advanced considerably Edward's ability to invest in the stock market. Within hours of the news, he applied to New

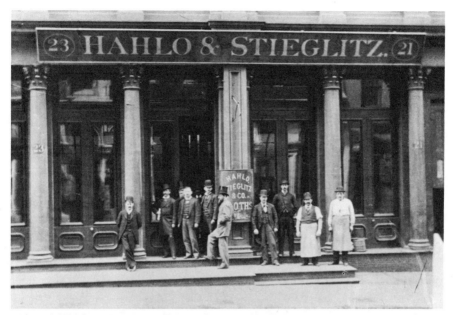

Edward Stieglitz's business, New York City, 1870–79 Studio

York's most prestigious and conservative bank for a loan. His reputation for probity was such, his children related, that collateral was not even suggested. On occasion, in fact, Edward boasted to them that his reputation was so splendid that a letter from England addressed to "The Most Honest Wool Merchant in New York" was delivered to him without hesitation. At other times, paradoxically, he told them that his Chicago Fire loan was granted merely on the strength of his honest face, having nothing whatever to do with a prior reputation. Whatever the truth about the granting of the loan, within a day of the fire, Edward had cornered the market in imported woolens. In the course of the next year, Hahlo & Stieglitz's profits soared, the loan was paid back, and Edward was able to use funds he would earlier have put back into the firm for the private investments that would permit him to retire from business in 1881, at the age of forty-nine.

The location of the new house required some daring on Edward's part; New York's fashionable life still revolved around Madison Square, nearly two miles farther downtown. To the south of that square, on Broadway, a string of elegant shops, from great department stores to expensive couturiers, stretched to Eighth Street, so crowded with matriarchs and young matrons that it was known as Ladies' Mile; the "best" hotels and restau-

rants formed its perimeter; there were theaters and clubs within a few blocks. In 1866, however, the completion of Central Park had spurred the start of improvements in Fifth Avenue above Forty-second Street. The skating and boating lakes, the grassy knolls and winding footpaths drew both the fashionable and hoi polloi to the park. In late afternoon, crowds gathered to watch society parade—in barouches, landaus, and hansoms, in victorias, broughams, and phaetons—along the Grand Drive to and from its new playgrounds: the Belvedere, the Terrace House, the Beach House, the music pavilion, The Mall. Although there were still only a few mansions above Forty-second Street in 1871, Fifth Avenue had been paved with cobblestones all the way to Fifty-ninth; a few blocks farther north, its winter mud and summer dust prevailed.

The area east of Fifth Avenue, where the Stieglitzes were to live, remained largely farmland. Above Fifty-fifth Street, cows, goats, and chickens roamed the fields between Madison Avenue and Park, where, between the north- and south-bound lanes, the open New York Central Railroad tracks sloped, halfway below street level, to Ninety-sixth Street. A short block east and southeast of the street on which Edward chose to build his house were stables and barns; equally close, to the north, were the tumbled outposts of shantytowns.

For a year at least after the Stieglitzes moved into their house, a large part of Sixtieth Street remained undeveloped. In the summer of 1872, Rosa wrote "Heddy, Eddy and Ally" in Saratoga of "a horrible smell around the house from two dead horses [victims of the heat] lying in the lots next to Mr. Wallach's," and as late as October 1880, the land opposite them was still empty. In that month Heddy, remaining with an ailing Rosa at Lake George until the arrival of a beneficial first frost, wrote of their hope that when they returned to the city, Rosa would not be required by the doctor to take a hotel room "downtown," but could "come up to Six-tieth Street without fear of malaria." Rosa added that, considering "the rocky state of the ground opposite . . . there is not *much* miasma rising from there—but more than enough to affect *me*."

All the same, their immediate neighborhood was already the site of what would become New York's most elegant area. In 1870, Mrs. Mary Mason Jones, the eccentric widow of a hotel magnate and the city's lead-ing socialite (regarding whom the phrase *keeping up with the Joneses* came into common usage), decided to develop the block between Fifty-seventh and Fifty-eighth Streets on Fifth Avenue's east side with a row of elegant houses, to be known as Marble Row, for people of her class.

Within months of her lead, developers were selling plans for the adjoining blocks; Edward was an early buyer.

Other radical physical changes in the city were taking place. In December 1870, work was begun on the piers for the Brooklyn Bridge; predictions of its imminent collapse were rampant until the eve of its opening twelve and a half years later. Already there was a prototype elevated railway along Greenwich Street and Ninth Avenue. Within a few years the city would bear such an efficient and popular web of steel that the addition of Pullman cars to the Third Avenue line would seem entirely appropriate.

Not all the excitement of the early seventies lay in the transformation of the city's face. Feminist Victoria Woodhull's reputed advocacy of free love and the ostentatious amours of Erie Railroad magnate Jim Fisk were naturals for yellow journalism, just as Fisk's financial misdoings and the shenanigans of Tammany Hall's Boss Tweed were fodder for the moralizing guns of *The New York Times*'s editor. One of the *Times*'s prize reporters in the Tweed investigations, John Foord, would soon become a friend of Edward Stieglitz and, twenty years later, Alfred's first business associate.

Without question, Edward was one of those to be deeply shocked by the villainy of public figures, whether in government or business. If others since the Civil War had begun to admire not only the efficiency of the robber barons and their political counterparts but also their audacity and cunning in evading strict applications of the law and—so long as it seemed to advance prosperity—even their corruption, Edward did not join them. He abhorred, first of all, dishonesty in business dealings (his own were spotless), and, secondly, the fiscal and political immorality that daily assaulted his American ideals. No doubt he deplored the reputed bedroom excesses of a Woodhull or a Beecher as well, but found them less abominable than violations of public trust, which betrayed *all* citizens. The marketplace and politics began to lose his respect and his interest; he would bring up his children to appreciate the finer things of life, to cultivate individual talents and virtues, to mistrust the popular (which was, by definition, inferior), to value nature, music, painting, and conviviality far above money and status, and to be charitable to those unfortunately deprived of culture as well as material security. *Noblesse oblige.*

The move to Manhattan reflected, to be sure, a change in Edward's financial position. But it reflected also a change in direction. Besides designing a new house, he had designed a new life.

5

Pictures of Alfred during his early years support his description of himself as a solemn youngster: serious, observant, shy—to which his family added "delicate," "poetic," and "moody." But letters and other memorabilia suggest that the brooding expression recorded in youthful photographs and paintings was at least partly a pose. If the pose was dictated primarily by Victorian convention and the need for protracted immobility, it was clearly enhanced by Alfred's flair for the dramatic. What could have been more romantically theatrical than his eventual garb, for example? The broad "painter's" tie of his university days, or the nearly invariable costume of his later years, a long dark cape swirling over a flicker of scarlet waistcoat, a soft, black porkpie hat? And the solemn expression. Almost completely lacking in portraits of him, early or late, studio print or snapshot, are the other personae he embodied: the imp, the flirt, the clown.

The reputation for drollery and banter he enjoyed even in childhood is documented in the comic entries of his classmates, cousins, and friends in the autograph books he began at ten. Before he was eighteen, moreover, Alfred was known not only as an incurable punster but also as a happy participant in locker-room gossip and a spellbinding raconteur of his exploits with "women." The latter tales attested probably more to his imagination than to his experience, however, for he later mentioned that he was nearly twenty when he was first "seduced." All in all, it is hardly reasonable to suppose that his demonstrable eminence as "a young sport" at nineteen in Berlin—with all the ramifications the term implies—was an overnight metamorphosis from "a melancholy youth" in New York.

Nevertheless, it would be a mistake to characterize Alfred's recollection of childhood solemnity as a maudlin reconstruction. He *was* a serious child in most respects and, in adolescence especially, suffered considerable inner torment. His facility in entertaining his peers does not rule out the fact that he harbored a sense of private, and unassuageable, pain; it merely

makes him human. Throughout his life, indeed, seriousness and even lugubriousness would often vanquish levity, and the family's overweening concentration on "symptoms" during his childhood would find expression in psychosomatic disguises for anxiety, in malfunctionings of a limb or an organ, and in nonspecific illnesses that would convince him finally that he was physically handicapped. The major difference between the child and the man was one of disclosure: the former was stoically mum, the latter increasingly discursive, often with the most casual acquaintance. The more the aging man revealed of himself, furthermore, the more puissant his revelations became, especially about the past.

To return to the child. Alfred was seven when the family moved to Manhattan in 1871; the move was associated in his mind with a multiplicity of beginnings. It was the beginning of his enduring, and frustrating, love affair with the city; it was the beginning of his acknowledged status as favorite son of an adored father, who, free now of daily commuting on the unpredictable Hoboken ferry, finally had time for him. And it was the beginning, indeed, of a whole new life for the Stieglitz family.

Heretofore, Edward's and Hedwig's almost compulsive sociability had been largely bisected—Hedwig's devoted primarily to visits with a few women friends and vast numbers of her and Edward's relatives in Hoboken, and Edward's to luncheon gatherings downtown or an occasional evening in the city with friends. Now, at Sixtieth Street, they were able at last to consolidate their hospitality.

Their first visitors were old friends and family members; their home was for years a temporary residence for cousins, nieces and nephews, aunts and uncles. Gradually Edward's business friends from distant cities accepted the offer to use a guest room when it was available. (Alfred would later recall a constantly changing clientele, and would himself develop a taste for filling empty rooms with friends.) And finally the Stieglitz home became a regular rendezvous for an agglomeration of sportsmen, artists, musicians, actors, newspaper reporters and editors, and (through Hedwig's cousin Adolph Werner) academics, all attracted by the promise of unstructured conversation and lavish food. Edward's downtown lunches continued, and so did Hedwig's "female engagements," but their large Sunday gatherings became the highlight of the week, interspersed with occasional smaller evening parties.

By the end of the seventies, it seems, the business friends had largely ceded their places to creative types, finding the atmosphere a little rarefied

Interior of parents' home, 14 East Sixtieth Street, New York City, ca. 1890
Alfred Stieglitz

for their taste; they would be happier to meet Edward downtown. Meanwhile, two young artists, the German painter Fedor Encke and his American-born friend Moses Ezekiel, a sculptor, became Edward's star protégés. Each resided for nearly a year, consecutively, at 14 East Sixtieth Street and with the family at rented quarters at Lake George; each on returning to Europe would receive Edward's financial support; each encouraged Edward to pursue more seriously the drawing and painting he had begun to enjoy. Probably the two together chose Edward's painting instructor, Mr. Erxleben, who came every Saturday through 1879 and 1880 to the studio Edward had built at home.

The heterogeneous stream of visitors to 14 East Sixtieth Street, and the ideas and biases they exchanged, were potent influences on young Alfred. The seeds of his later appetite for group discussion, for the collective search for verities, for the company of creative people, undoubtedly took root in his early New York years. Like his father, he would become a magnet toward whom people of all walks of life were drawn, though on a vastly broader scale than Edward, thanks to the intrinsically public nature of his varied career. Alfred's home, or his gallery, or his favorite restaurant, would be the meeting place of a group of regulars, some with intense opinions to air, some mute acolytes. Like his father, Alfred would become a people collector.

Alfred quickly became the mascot of Edward's coterie. He was shy with them, more even than the prevailing definition of good manners pre-

scribed, but his shyness was less a shield against ridicule than it was a means of preserving his privacy; his reserve announced an unwillingness to be drawn out by adults. Quite possibly some members of the Sunday group regarded him merely as Edward's errand-boy, for he carried out his father's instructions with prompt deference, and obviously took pride in his role as *sommelier*. But underneath his silence and obedience he was, in his own way, participating intensely, watching every expression and gesture, listening to nuances and pauses as raptly as to words. He reported later that he was not overawed by the conversations that agitated the atmosphere around him; rather, he was stimulated to weigh what was said as well as to study the proponent of any given point of view, to speculate on the evasions and inconsistencies of grown-ups. The sessions in the parlor and the billiard room were his school, far more than were his classes at the prestigious Charlier Institute for boys.

From the talk of his father's friends, it is probable that Alfred devised his own curriculum, spurred by one or another of the gentlemen to follow a new adventure in the reading that claimed so much of his time. Apart from the horse-centered books and periodicals he had devoured since he could first read, by the time he was ten he had developed a passion for nonchildish, though romanticized, accounts of American history. As a significant portion of the adults' debates was devoted to challenging and supporting Edward's zealous fidelity to the ideals and founding principles of his adopted country, Alfred sought more information about the Revolution: *The Boys of '76,* became his favorite book. Here he discovered his first military hero, General Nathanael Greene, who won his particular admiration for strategies that were both effective and humanitarian: ordering seemingly cowardly retreats from massive engagements, Greene saved his troops for small surprise assaults that eventually won him large victories. If Alfred would later cite Greene as his sole tactical inspiration for "battles" on behalf of photography and avant-garde art, forgetting that as a student in Berlin he had identified his heroes as Leonidas of Sparta, George Washington, and Napoleon, it was probably because his childhood fascination with the American Revolution introduced martial color to his imagination. He was prone to describing almost all his major efforts as "carrying on the war," "holding the fort," and outmaneuvering his "enemies."

Historical wars notwithstanding, however, it was eventually the wars of the spirit that moved him most deeply. By the time he was thirteen, he later told me, Goethe's *Faust* had already claimed precedence over all

other books; one of the pleasures of every Lake George summer for the rest of his life would be a dip into its pages. Conceivably he was introduced to *Faust* by his teacher-cousin Adolph Werner, who was attracted to young Alfred. Alternatively, it may have been Edward's friend and protégé Hermann Lind who suggested Goethe's masterpiece. A lecturer and soliloquist on the German-speaking lyceum circuit, who usually concentrated on Shakespeare, Lind wrote Edward in 1877 that he was considering adding lectures on *Faust* to his repertoire. Lind was indebted to Edward not only for financial assistance on his wide-ranging tours but also for introductions at Sunday lunches to Edward's more important friends in publishing, among them John Foord, by 1876 an editor of *The New York Times*, Ernst von Hesse-Wartegg, an editor/publisher with a wide following in the German-American community, and Joseph Keppler, founder and editor of *Puck* magazine.

Whoever his literary cicerone, Alfred claimed that *Faust* marked the beginning of his philosophical education. From it he derived both wisdom and inspiration, not only because it was a palliative for the tensions and terrors of an adolescence that required answers, but also because it introduced him to what he would regard thenceforth as the mystery and purity of Woman. Margarete/Gretchen was the ultimate tragic heroine. No subsequent reading or experience would ever disengage him from his idealized concept of Woman—always upper case in Alfred's disquisitions—including her ability to redeem man's soul through her virtue.

Faust entered his life compellingly in his thirteenth year, the "ripe moment," he said, for his "awakening." But long before then, Alfred's senses seem to have been in turmoil and his perceptions to have become more acute. Not only were physical and emotional changes causing him anxiety, but his long-standing heroic image of his father was in conflict with what he now saw as the truth about him. A later generation would call a conflict like Alfred's oedipal. Pre-teen Alfred was aware only that "evidence" of his father's "dishonesty," gathered in long sessions of parent-watching, was piling up, threatening to alter forever the lineaments of his idol.

Disillusionment was painful. For roughly three years he had been observing, and attempting to reject, gaps between Edward's uncompromising principles and his performance. No doubt the progressive shocks Alfred experienced were proportionally larger than they might have been had Edward been less of a moralist, had he not schooled his son so thoroughly in absolute purity of motive and behavior. They were shocks that would

lead Alfred to devise new rules for himself from which he would not consciously deviate for the remainder of his days.

The first discovery was that his father could not be trusted to keep every promise. Although Alfred would say little about it in later life, and seems never to have specified a particular incident, he related several times that it was one of his father's broken promises—when he himself was about ten years old—that led him to vow that he would never make a promise to anyone about anything. So far as I know, he never did.

An even more upsetting disillusionment, with more complex ramifications, arose from his discovery in the late seventies that his father, in the manner befitting a Victorian gentleman of his class, routinely visited the chamber of the chambermaid. Alfred later told several confidants that, before he was thirteen, he was aware of the use of the stairs after midnight, and the objective. His discovery awakened ambivalent feelings, he said: profound offense on behalf of his mother, to whom he attributed innocence foully betrayed; unspeakable terror at the thought that Aunt Rosa might also be in the picture; and a new fascination with his father, compounded of loathing, disbelief, jealousy, and a dazzled wonderment that excited his body as well as his imagination. It would not have made any difference had he known that Edward had probably been denied Hedwig's bed after the birth of their sixth child; to him, his mother was the hapless victim of his father's infidelity.

Again, Alfred's disillusioned response was to devise a new policy for himself. This one would turn out, however, to be neither so well formulated nor so successful as his solution to the problem of broken promises. Philosophically, he would be able to be true to his vow never to betray Woman; in practice, and in the conventional sense, he would never be able to be conventionally faithful to any woman. Like his father, and his brothers, he was both too passionate and too romantic to confine himself to one individual: he was constantly falling in love, constantly on the lookout for his Ideal, who bore usually an astonishing resemblance to his mother. Classically, his phantasies endowed his beloved of the moment—or the year, or years—with attributes she did not possess. Only in his relationship with O'Keeffe would he be forced to transcend the limiting effects of the model he superimposed on other objects of his infatuation. O'Keeffe, with a candor that outmatched even his, would require that he see her, not invent her.

The most profound childhood conflict, and the one which would have the most far-reaching consequences, centered on money. Of the six Stieg-

litz children, Alfred would be the only one to reject entirely the luxurious accoutrements of their early years. Here, again, his rebellion was touched off by the dishonesty he perceived in his father.

All the children lacked a yardstick for comparison, and all, including Alfred, accepted as normal the easy comfort of their lives. An elegantly appointed home, servants, private schooling, music lessons, the best seats at theater and concerts, the best accommodations at hotels, were simply a matter of their parents' insistence on quality. Besides, Hedwig and Edward both denied vigorously that wealth conferred either honor or nobility on its possessor; both were generous to worthy causes as well as to friends; both proclaimed the desirability of leading a life that was modest and good.

Obviously, the parents' approval of modesty contained elements of snobbery. Their loud disparagement of the excesses of the *nouveaux riches* proclaimed their own good taste. Edward was not averse to luxury per se, only to vulgarity. And, after Edward's death in 1909, Hedwig, who worried constantly about household expenses at Lake George, was unable to narrow her hospitality or to give up either the personal maid who interrupted her morning letter to Alfred to give her a manicure or the new gardener who came for the day's instructions while she breakfasted in bed. Even though she had quickly agreed with Edward in 1900 or 1901 that a sharp reduction in their means could be absorbed if they sold the house at 14 East Sixtieth Street and moved into an apartment at the new Majestic Hotel for the winter; even though another financial blow in 1904 forced them into smaller rooms at the New Weston Hotel; and even though, after Edward's death, she would move to quarters that were smaller still at the Hotel Fourteen, a modest but refined apartment hotel built on the very ground once occupied by their house—with all these accommodations, she would be unable until 1920 to reduce either the scale of her hospitality at their Lake George home, Oaklawn, or the size of the staff it required.

Whatever inconsistencies there were in the Stieglitz parents' convictions about the nature and uses of money were insignificant, however, when compared to the burning role that money played in their emotional lives. It was this wholly irrational and incongruous fact about his parents that became the cause of Alfred's greatest unhappiness and insecurity from his tenth year forward.

Money, it turned out, although characterized as unimportant by both parents, was the fuel and the fire of terrifying explosions between them. Alfred, with a room by then on the same floor as theirs, probably heard

every detail of the increasingly frequent and fulminating epilogues to their celebrated evenings of relaxed and liberal conviviality, with Edward shouting accusations and Hedwig sobbing rebuttals. Alfred began to associate their footfalls on the stairs with harbingers of war, their bedroom with a battleground. And he was overwhelmed with confusion.

How could it be that his father could combine in one person extreme openhandedness and extreme (or so it appeared) parsimony? How could he present Hedwig with a gold chatelaine watch at breakfast, and in the evening upbraid her for being extravagant with dish cloths? How could he reconcile the fact that his father was, as his cousin Adolph described him nearly forty years later, both "hospitable and generous and lavish, to relatives, friends, strangers and meanly quarrelsome about household expenditures?" Was this not proof of his detestable dishonesty?

The questions tormented Alfred for years, even after he had formulated the philosophy by which he tried to live. One cornerstone of this philosophy was the elimination from his life of what he understood to be the prime source of his parents' fights: Edward's wildly unreasonable demands for an accounting of every household penny—where it went, and why—in spite of his unwillingness either to budget or curb his own generosity, and in spite of his certain awareness that, in this task, Hedwig was both inefficient and inattentive. Not only was arithmetic as arcane to her as celestial navigation, but she could neither follow nor care about where money went; to her, its only potency arose from its ability to excite Edward's fierce temper, and her own misery at his inquisitions.

Alfred was alone in his childish agony. Cousin Adolph was not yet a confidant, his brothers and sisters were not old enough to confer with, Aunt Rosa would not countenance criticism of their father by any of the children, and his mother needed his protection, not his complaint. All he could do was to resolve never to behave over money the way his father did. In this he would not be wholly successful, especially in his first marriage, when his rage at his wife's insatiable appetite for "frivolities"—paid for usually out of her own funds—got out of hand. Often, indeed, his ability to stifle his fury and remain silent succeeded only in triggering in him massive and protracted bouts of depression.

Nevertheless, it was probably Alfred's childhood anguish about the toxic effects of wrangles over money on human relationships, on love, that played the major role in his adult rejection of all the trappings of his early home life; he adopted a mode that was Spartan compared to that of his

parents, brothers, and sisters. Probably by the time he was thirty (perhaps even earlier) he had formulated the philosophy by which he tried to live for the rest of his days. Whether or not there were deviations and inconsistencies, certain facts about him were, from then on, incontrovertible: he had a thorough distaste not only for ornamentation but for possessions per se (to paraphrase him, anything worth possessing cannot be possessed); he deplored the corruption in values, personal commerce, and humanity that the accumulation of money feeds in both the wealthy and those over whom they exercise power (absolute money corrupts absolutely); and he channeled whatever small personal funds he had toward assuring the artists for whom he felt responsible the means to work productively, without fear of economic drought (I am my brothers' keeper, and/or, my position in life mandates generosity). His aims were constant, and he succeeded in their realization to a remarkable degree. If he had not also pontificated about them, had not been quite so vehement about the uniqueness of his efforts, his devotees would have had fewer strands with which to fashion his halo, and the unorthodoxy of his methods would probably not have aroused the intense irritation and animosity of other—less intimate— Alfred-watchers.

Twelve-year-old Alfred's persistent altruism toward the neighborhood organ-grinder was the first practical step in his new policy; it was also a small-scale demonstration of one of the inconsistencies that would accompany his future magnanimity. Although his sacrifice of a dime a week from his allowance was a real self-denial, and the humanitarian concern was genuine, the coffee and sandwich were inescapably gifts from his parents' larder.

Similarly, in later life, he would have no difficulty in accepting from his family—and from the two women he married—the economic necessities of food and shelter. The allowance he received from his father extended beyond the end of his student days, beyond the life of his single business venture—of which his share was capitalized by Edward—and well into the twenty-five years of his first marriage. From 1898 until Georgia O'Keeffe became the center of his emotional life in 1918, he lived in an apartment financed by his first wife's considerable annuities from her brothers' business, using his own small trust income after Edward's death to help support his various enterprises. From 1918 until 1924, he and O'Keeffe were housed by his brother Lee, first in a studio leased originally by Lee for his daughter Elizabeth, and later on the top floor of his town house. When Lee

sold his house in 1924, he provided Alfred with a small quarterly stipend that continued to the end of Alfred's days, helping meanwhile to pay rent for rooms at the Shelton Hotel until O'Keeffe's success as a painter ensured her ability, in 1936, to take on full responsibility for her own and Alfred's expenses. From then until his death in 1946, Alfred spoke of living in "her" penthouse, "her" apartment.

There was no sense of guilt in Alfred for the help he received from either his family or other major donors to his enterprises; it was simply his due. He was carrying on important work from which he derived no personal income; those who helped him suffered no hardship thereby; he was, in effect, a cultural clergyman leading a responsive congregation.

Among his brothers and sisters, only Julius questioned his refusal to seek payment for his work, especially his resistance to selling his photographic talents. In 1917, Julius urged him to accept an offer from the War Department to direct research in speed photography, and a year later, when Georgia and Alfred had begun living together, he made a stronger pitch: "I hope that the inspiration and presence of Miss O. will give you not only the artistic life . . . but also the strength and courage to take up the burden which life lays on any man assuming responsibilities." With gross misunderstanding of Alfred's entire canon, he proposed helping him find work with one of the great movie firms, and added what he hoped would be the most persuasive argument: "The man who can face the world financially is free to carve his own way otherwise, be it what it may." Not surprisingly, his exhortation so infuriated Alfred that it was nearly a year before they were reconciled, and then only after Julius had capitulated. Bewildered though he continued to be by Alfred's motivations, he did not thereafter challenge them, preferring to do what he could to renew the affectionate bonds of childhood. A belated birthday check in 1919, designed to help Alfred meet photographic expenses, initiated an annual contribution that Julius thought only fair, considering Alfred's instant willingness in their youth to provide him and his twin brother with cash whenever they asked for it.

Sometimes, no doubt, Alfred's generosity was doubly assailed. The twins, being absolutely identical, had been able from their earliest years to extract favors and avoid punishment by accusing each other of masquerading. Even when they were in their late sixties, they had identical sprouting mustaches and goatees, identical white tonsures, identical hands, shapes, and weights. The only ways to distinguish between them was familiarity

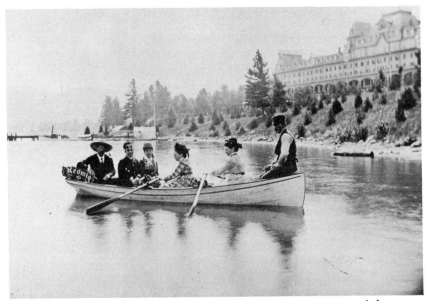

Edward Stieglitz, two guests, Hedwig Stieglitz, Rosa Werner, and boatman, Fort William Henry Hotel, Lake George, ca. 1878 Anonymous

with the minuscule differences in the timbre of their voices and the expression of their eyes, and in their merciful agreement finally that, when they appeared together, Lee's tie would be a cravat and Julius's a bow.

Alfred's benefactions to Julius and Leopold in childhood did not end with the dispersal of precious nickels and dimes. Even though he felt himself older by a generation than they (or perhaps *because* he did), he spent patient hours during the long summers at rented cottages in Lake George between 1875 and 1880 instructing them in games of his own invention as well as in ten pins and archery. Under his tutelage, the girls, too, learned to play chess and a variety of card games; all the "children" were passengers in his rowboat and benefited from his careful supervision of their swimming.

Excepting the occasions when a picnic outing required the "men" of the family to hike together to a chosen site (the ladies, children, and food followed by carriage), Alfred, at eleven, began to insist on taking his walks alone. Several times that summer he visited in the village the photographer to whose studio Edward had taken him on their first Lake George trip in 1873. Later he said that he more or less drifted there, feeling none of the compulsion he remembered in carrying around a photograph at the age of two, but he found his visits thoroughly enjoyable. The photographer, recognizing his seriousness and attentiveness, was hos-

pitable even after Alfred dared suggest that "improving" prints with tinted-in color made them look artificial (as an adult he would call them obscene), and allowed him to observe both sittings and darkroom procedures whenever business was not too heavy.

There was one further responsibility that Alfred took on as a youngster with "the children": he became the official mediator in disputes between the twins and between Agnes and Selma. Lee's and Julius's battles were brought to him for resolution only on the rare occasions when their grappling and punching failed, but Ag and Sel were constant combatants whose noisy fracases threatened to unleash Edward's temper. Alfred's intervention became necessary to preserve the peace of the entire household. From the ages of four and two respectively, Agnes and Selma began to display the corroding jealousy that dominated their relationship over the next seventy-nine years. Albeit Agnes was fundamentally sweeter in nature than Selma, and more given to silent suffering, she was not inept at needling. And Selma was a tantrum-thrower of imposing dimensions. Nonvolatile Flora, meanwhile, presumably departed the battlefield at the first opportunity.

Alfred was a singularly effective mollifier, especially when Hedwig called upon him for help. He was not, however, always the perfect Solomon. During the years I knew him, he was likely, when bored or irritated, to provoke the very dramas he would then be called upon to cool. Sometimes at the Lake George dining table (virtually the only place where brothers and sisters sat down together for more than a few minutes), when he was in a dark mood or frustrated after a day of mishaps in photographing or printing, he would spur Agnes and Selma to quarrels that could be resolved only in their, and sometimes his, departure from the arena—to two or three separate rooms behind two or three slammed doors. More often, the exercise would restore him to playful good humor, propelling him into feats of charming absurdity that soon had everyone aching with laughter. Not infrequently, his propitiating method was to turn the guns on some absent figure commonly regarded as foolish or tasteless, and to orchestrate a gossip session from which all except my grandmother Lizzie derived pleasure and renewed self-esteem.

Whatever responsibility Alfred took as a boy for the amusement, instruction, or distraction of "the children" did not, however, include intellectual matters. He regarded himself as an indifferent student and refused to learn either the rules of grammar or the steps in geometric theorems. Starting piano lessons at nine, he wondered idly at thirteen if he might not

become a concert artist, but reality intervened. Technique-building exercises and metronomes were awful. What he loved was to linger over melody, to pound chords and race arpeggios, to pedal his way to an orchestral swell. He would never be a pianist.

He was aware that eventually he would have to settle on a profession or a business, but he had no inkling of what it might be. And he was in no hurry.

6

During Alfred's early teens there were only a few changes in the routines at home: the younger girls were now also attending school, all the children were taking lessons on a variety of musical instruments, and the artists Encke and Ezekiel were intermittent residents. By June 1879, Alfred was fifteen, had been graduated from Townsend Harris High School, and was enrolled as a freshman at the College of the City of New York.

Apparently he had come to terms with his disappointment in his father, whom he was to view henceforth with a blend of bemused skepticism, continuing respect, and not a little awe. It seemed possible, indeed, that he could love Edward without either worship or fundamental distrust, a realization that coincided with his elevation, beginning when he was fifteen, of a series of older women to the pedestal once occupied by his father. It was not that the pain of his thirteen-year-old's *Walpurgisnacht* was ever entirely resolved, but some of it he managed to bury; some was probably unknotted in conversations with his mother, whose love for Edward was always manifest, and the remainder was simply dispersed with the passage of time. He was helped further by the broadening of his experiences away from home: new friends, new interests, and new independence in moving between home and school, between home and doctors' or dentists' appointments. Strangers crowding streets and omnibuses now came under the scrutiny he had previously focused on family and friends, bringing him the fascinating discovery that they, too, were people, heterogeneous and discrete, leading intense and unknowable lives.

There were horses to watch, too, not just the well-fed and groomed thoroughbreds his father preferred, but the scrawny, the battered, the old. And there was the excitement of a city never fixed, never permanent: buildings that last year had been points of reference were now replaced by bigger and newer ones; roads were suddenly paved; street-lamps, once lone guardians, were now becoming lost in a tangle of overhead wires carrying telegraph stutters and the faint, metallic voices of Mr. Bell's new sub-

scribers. There were trains lumbering up and down the chasm in the center of Park Avenue, and elevated lines with vertiginous loops strung out to the farthest corners of Manhattan.

Alfred's new and more independent awareness of the world around him did not mean that he was free of all familial supervision. When he left his vacationing family at Lake George in September 1879 to enter City College, he lived for a month with his Werner grandparents, holding himself to a relatively circumscribed pattern of study, meals with the family, and more study—a conscientiousness that did not last beyond his early discovery that he could maintain high grades with almost no effort. During that first month, however, the only interruptions to his schedule were piano lessons and visits to doctors—to Dr. Jacobi because he was still considered underweight, and to Dr. Gruening for treatments for a mysterious eye condition.

Alfred's and his family's references to his eye trouble abound, from his eighth year to his last, but with no more specifics than accrue to their mention of the "terrible illness" he suffered in his childhood. Possibly there was a connection between the two—if, for instance, the illness was measles. Beyond the certainty that Alfred's eye ailment never interfered seriously with either his vision or his photography, the discernible facts are these: he had an astigmatic condition that was corrected by eyeglasses; he suffered eye strain from long, concentrated sessions in the darkroom; and, in his late seventies, he underwent two minor surgical procedures in an ophthalmologist's office. What is surprising is that his brother Lee, who became his physician and was renowned as a diagnostician, seems never to have treated Alfred for allergies although an overview of his ailments shows a consistent annual pattern. His eye trouble, sinusitis, skin rashes, stomach upsets, and even the shortness of breath he associated later with angina, were all at their worst between mid-August and the first heavy frost—the season when the Hill's crop of blossoming ragweed was at its most abundant.

Ailments aside, what Alfred reported to "Pa, Ma, Aunty and the Children" about the little he did with free time on Saturdays and Sundays precipitated a concerned query from Hedwig about his bashful avoidance of social gatherings. Presumably, the gatherings he avoided were adult-oriented; at college, he seems to have been gregarious. Probably his first year was devoted to general studies, during which it was hoped that he would discover a field he might enter as a profession. Nothing, however, seemed to awaken a special interest.

Edward consulted Cousin Adolph, who was on the CCNY faculty. Both men realized that Alfred's innate energies would need a suitable outlet; both agreed that his interest would not be held by mediocre teaching or insufficient challenge. Edward, convinced that hard work was a basic ingredient of man's happiness, was determined that Alfred both find his proper niche and achieve measurable success. Was there a specialty that would satisfy equally the demands of practicality and imagination? There was. All one had to do was watch the galvanic physical changes in the city to realize that engineering was the career of the future. Showing surprising flexibility, Edward did not insist, but he thought Alfred would do well to become an engineer. Professor Werner agreed, and Alfred decided to give it a try.

By the start of his second year at CCNY, however, it was clear that two ingredients of Edward's prescription were not being fulfilled: the teaching *was* mediocre, and Alfred was not sufficiently challenged. While he was only coasting along, his grades grew higher and higher. More consultations with Adolph ensued. This time the solution would mean a radical change for the entire family.

Edward was known throughout his life for the alacrity of his decisions. It had taken him less than twenty-four hours to decide to borrow heavily after the Chicago Fire, and he seems to have been equally resolute in all business matters. At home, even in trivial issues, he acted with similar dispatch. A grandchild recalls a dinner when Edward, announcing "Nobody wants soup!," ordered the removal of a full tureen because—whether through inattention or timidity—the first plate he filled had passed through thirteen pairs of hands and come to rest again in front of him. No questions; a simple decision.

His decision in 1881 to sell his business and retire was made almost as rapidly. He would take the whole family to Europe, where the children would have a rigorous and thorough education, where the adults would find treatment at suitable watering places for their various ailments—the aftereffects of Rosa's possible malaria, Hedwig's increasing headaches and dizzy spells, Edward's kidney troubles—and where all could visit the centers of culture.

Edward was himself ready for a sweeping change. For several years now business had been a bore: profits were almost automatically high; his partner, though honest, was dull; his employees' judgment was reliable. He was content to absent himself from the office for longer and longer periods. The one-month vacation he allowed himself in 1872 had stretched, by

1880, to four; his travels in the United States had less to do with business than with helping his artist friends find commissions. Finally, he had reached the point in his own painting where he wanted the freedom to apply himself to it seriously. He was forty-eight years old, and time was growing short for him to develop fully his ambition for a new and richer life.

It took him less than six months to complete his plans for the ensuing five years. First, he sold the major part of his interest in the business, netting nearly a half-million dollars. This he invested promptly in the stock market, except for a small percentage in savings and an emergency cash reserve—meticulously accounted for—in a trunk at home.

The educational arrangements took a little longer to complete. While Edward, Hedwig, and Rosa travelled, the three boys would attend the Realgymnasium in Karlsruhe, the twins to continue from the level they had achieved, and Alfred to backstep briefly to improve his German and ready himself for European university standards. The two younger girls would be placed in Frau Wappenhans's seminary for young ladies in Weimar, and Flora, who had completed high school, would attend a music conservatory to continue her piano studies. The family as a whole would gather henceforth only for vacations that would be divided among rustic hamlets, sophisticated spas, and cities rich in culture; in the next five years, they would become familiar with Vienna and Paris, Rome and Venice, Florence and Zurich.

Preparations for the long absence from New York were under way before the beginning of May. Already the dressmaker had begun cutting, fitting, and stitching new dresses and coats for the girls, altering Hedwig's and Rosa's latest purchases, and rounding out the family's supply of underlinens. Edward harassed his tailor and his haberdasher to complete the suits, shirts, and ties he and his sons would need for the summer (fall and winter clothing would be bought in Europe). New shoes were ordered, and older boots dispatched for repairs to the shoemaker, who was charged also with cleaning, steaming, and blocking Edward's hats and the boys' caps.

The closing of the house itself demanded Herculean energies of Hedwig and Rosa, the regular staff, and the "dailies" enlisted for the task. Books were removed, dusted, and returned to shelves to be shrouded in sheets; carpets were beaten and rugs washed to be rolled individually in camphor and tar paper; floors were scrubbed and rewaxed, furniture slipcovered, drapes taken down for storage in trunks. Wines that would not benefit from indeterminate aging were dispersed among family and friends,

as were children's garments that would be too rapidly outgrown to take along. Wardrobes and bureau drawers were relined; table and bed linens were washed, pressed, and interleaved with tissue to prevent discoloration along creases; camphor flakes were spread liberally on the pool table and inside the piano, then covered with newspaper, to protect their felts from marauding moths. Plants were entrusted to friends for care. A like ordeal was still undergone by Stieglitzes during my childhood whenever home was left for a period longer than a month.

Edward's major responsibilities took him away from the chaotic woman-dominated house to his bankers, to arrange letters of credit and assign them powers to clip and deposit coupons, and to his broker, to leave instructions about the handling of his investments. The children, when not commandeered for fittings with Miss Mary, busied themselves with long farewell visits with their friends. Alfred wrote those who were distant in tones suggesting that he despaired of ever making another friend. Of all his leave-takings, he would relate later, the most difficult was saying goodbye to the organ-grinder whose faithful regularity had warmed the sometime loneliness of his young teens. Edward found it equally difficult to leave his horse.

On June 18, 1881, Edward's and Hedwig's servants were embraced and counselled to be conscientious in the new jobs that had been found for them; the army of cousins, uncles, aunts, nieces, and nephews had been visited or entertained, offered hospitality abroad should they wish to come, and promised frequent letters and periodic photographs of the growing children, as well as pictures illustrating palaces, museums, cathedrals, and inspiring landscapes on their itinerary, and programs portraying stars of opera, theater, and concert hall in Paris, Berlin, Vienna. The ladies promised also to send clippings describing the latest fashions. One can imagine the procession to Hoboken, where the Stieglitzes would board the steamer: the first carriages bearing the principals—Edward, Hedwig, Rosa, the six children, and the personal maid—and the members of Rosa's and Hedwig's immediate family. Following in their wake came a string of well-wishing friends bearing baskets of fruit, flowers, and champagne. At the end, the luggage-wagon: new Saratoga trunks, footlockers, crates, valises, portmanteaus, hat boxes, compartmented shoechests, duffel bags heavy with parasols, umbrellas, and walking sticks. At last they were aboard. Father Abraham, with his "heart nearly broken," as Hedwig would write Alfred thirty-two years later, "watched us go from the shore, where no one saw him!"

Hedwig was to refer later to their sailing as "a turning-point in our lives." She was right; the ten-day crossing to Bremen was to bear consequences none of them dreamed of at the time. On the second or third evening, Hedwig noticed two woebegone youngsters, boys of Alfred's age, watching the Stieglitzes' contentment with a yearning that betrayed homesickness. In sympathy—and in the hope of finding some diversion for her eldest—she commissioned Alfred to invite them to join the family circle. Their lives would be intertwined for the next twenty-five years.

Young Joseph Obermeyer and Louis Schubart were on their way to Europe to join parents who had departed before their schools let out. Although they were excited at their first trip "alone," their bravado had melted as soon as land was out of sight. Hedwig's motherly wing was accepted and within a few days Alfred, Lou, and Joe were inseparable.

They were a somewhat incongruous threesome. Joe and Lou were scions of highly conventional, upper-middle-class Jewish families with little interest in lives that were not similar to their own. Artists, newspapermen, and writers, like actresses, might be beguiling and even fun, but one hardly made friends of them. Joe, whose attitudes would change little, unconsciously epitomized them in a letter to Alfred in 1908. Rating the social ambience of the grand races of Europe he had attended, he concluded that "in England, unless you are a member of the Club, the best you can do is Tattersall's enclosure, which is very much like our own crowd on a small scale, although it is true that between races you can mix with the better class in the paddock. In France, you are in the same enclosure with all the ornamental people. Just like in Berlin, only with the difference that the ornamentals are so much more so . . ." Lou was equally pretentious. Like many of their compeers, they aspired to the look and manner of the British gentry—cool, unapologetically snobbish, elegant (even foppish), adequately but not overwhelmingly "cultured," and unshakably complacent.

To Obermeyer and Schubart eyes, the Stieglitzes must have seemed almost bizarre. They possessed the ease and general attributes to which Joe and Lou were accustomed, but clearly they were less conventional, inclined to take risks socially to enrich their experience, hospitable to challenge, markedly egalitarian, and intellectually curious. Joe and Lou, who were quite satisfied with the mere trappings of self-confidence, were doubtless beguiled by signs of Alfred's still nascent but genuine self-esteem; they appointed him their leader. The fact that he was light-years ahead of them in intelligence may have been one ingredient in their admiration, but even more persuasive were his inexhaustible supply of stories

about his "love-adventures," his awful schoolboy puns, and a passion for horses that surpassed even their own. By the time the ship docked in Bremen, the three had resolved that, wherever they were, whatever each was doing, they would remain friends.

Within eighteen months, as it happened, they were roommates in Berlin; within nine years, they were business partners in New York; within twelve, they were in-laws, with Alfred's sister Selma married to Lou Schubart, and Alfred married to Joe's younger sister Emmeline. Meanwhile, there were other ends to be met, beginning with Alfred's educational plans in Karlsruhe. During his year there, the three youths cemented their friendship with frequent and unconstrained letters.

In early September, after two months of travel and a month of rest, in Baden-Baden, the Stieglitz boys were ensconced in the homes that would be theirs while they attended the Karlsruhe Realgymnasium. The twins were with the family Träutlein, through whom, some five years later, they would be introduced to chamber music sessions with the Stieffel sisters; eventually, Julius and Anny, and Lee and Elizabeth would marry. Alfred moved into the home of Professor Doktor Karl L. Bauer, a master at the Realgymnasium who, Alfred wrote Cousin Adolph, had a reputation throughout Germany as an able mathematician. Edward, Hedwig, Rosa, and Flora, with the younger girls, whose school would open later, took off for Lichtenthal to join their friends Fedor Encke and Ernst von Hesse-Wartegg. Edward wrote immediately to Alfred:

> My dear good boy . . .
> I leave it to you to measure the extent and quality of my feelings [on saying goodbye] since it was a certainty, that you should leave your parental roof. As it should be. [We must keep] constantly before our mind the aim for which we started. Whatever is useful and necessary to secure for you a thorough education must be uppermost, the rest has to be secondary— . . . Morals I need not preach to you—! I know you are a good & firm boy & the warnings necessary I gave you some time ago.—Permit [me] only . . . to repeat— *Shy bad company!* & let me add yet be careful of your health & try to develope [sic] the body as well as the mind . . .
>
> <div align="right">Your affectionate Pa . . .
Edward Stieglitz</div>

Hedwig's letter the following day admonished him to dress warmly in bad weather, told him to instruct the twins to *"take more pains in writing —Papa made a remark,"* and reminded him to rent a piano.

Two major themes would dominate Flora's and Alfred's letters during the year: the piano and his autograph collection. Perhaps it was Flora's anguish over the piano, which she studied intensely, that persuaded Alfred to give up lessons the following year. Free of a hovering taskmaster, he could open his bound volumes of sheet music where he chose, plunge with voluptuous sentimentality into piano adaptations of tragic arias from the major operas of Wagner, Strauss, and Verdi or a "Potpourri pour Piano" that included themes from Gounod's *Faust,* and even enjoy the latest music hall serenades of the kind my pianist grandmother referred to as *Schmierkäse.*

Until then, it was clearly Alfred's autograph collection that took precedence over music during his early years in Germany. In 1881–82 he pressed Flora repeatedly to get Liszt's autograph from her piano teacher, and enjoined all three sisters and Aunt Rosa not only to report the comings and goings of royal and noble persons at one or another spa but also to wheedle their signatures on ever-ready tablets. His parents, their friends, and their friends' friends were pressed into soliciting on his behalf, while he himself addressed luminaries among the University's visiting lecturers; some of his requests for advice or information related to his studies were flattering ruses designed simply to produce signatures.

Two elaborate albums in his collection, in questionnaire form, are especially revealing about Alfred. In the first, from his thirteenth year, he recorded that his favorite color was "cardinalian black"; his favorite season, "whenever there is no school"; his favorite nonreligious book, a "pocket-book filled with money"; the place where he would like most to live, Lake George; the most admirable traits in men and women, "Honesty and truth"; his own distinguishing characteristics, inquisitiveness and changeableness; the sweetest words, "Father and mother"; and the saddest, "too late." On the day after his twentieth birthday, the only notable changes were that he would now like to live "in Venusberg," and that his favorite painters had changed from an unidentified "H.L." and "Fedor Encke" to "Rubens, Van Dyke, Angelo [sic] etc." with "Raphael" crossed out. He still regarded himself as "changeable."

In his third week at the Karlsruhe Realgymnasium, Alfred received a letter from Edward describing, tersely, his impressions of the "new" Berlin, incredibly rebuilt since his last visit in 1866, with imposing "public institutions & Government buildings" that reminded him keenly of New York. Expatiating on the warm receptions he received in the homes of friends, he remarked, apropos, that he was grateful Alfred found pleasure

"in neatness and tasty [sic] arrangement [in his rooms]—it is the exterior [sign] of the inner mind—."

Edward was not the only member of the family to draw comparisons between the major European cities and New York. In the spring, Hedwig found Paris "a striking contrast to New York . . . all life on the streets . . . people walking, [sidewalk] cafés, beautiful stores [and] florists . . . everything is terribly dear, just like New York . . . [All seems] gaiety, but people work here immensely [hard], much more than in Germany, where every body takes their ease." Twelve-year-old Selma was more impressed with "the Notterdam I suppose you know that is a church [and] the Louvre . . . an *awful* big building and built beautiful."

The fact is that the whole family was homesick for New York during most of the first year abroad. Nobody was particularly happy with Germany, which all found surprisingly inefficient, even slipshod; Lee was infuriated by the laxity of his schoolmasters in enforcing discipline. Joe Obermeyer answered an apparently critical and unhappy letter from Alfred with sympathy for having to live in Germany without liking it, and Alfred wrote "Sellie" in May, when a birthday telegram from her brothers failed to reach her, that, though angry, they should remind themselves that they were in *Germany*. America continued to loom large in their daily consciousness; they subscribed to and swapped American newspapers, and they celebrated the arrival of news from home with a flurry of postcards.

If Alfred's eventual change of attitude toward Germany was slow in coming, it was unshakable. Through two world wars, to the chagrin of most of his friends and almost all his relatives, he would maintain a staunch sympathy for the Germans that he was not reticent to express. He condemned the "mistakes" of Kaiser Wilhelm and the "excesses" of Hitler, but he adhered stubbornly to his conviction that the German people were hard-working, idealistic, spiritually innocent, nonmaterialistic, and socially responsive to the needs of the downtrodden. Their aggressive behavior in the twentieth century could be attributed, he insisted, to their having allowed themselves to be seduced by American vices cloaked in American prosperity—materialism, efficiency and greed—and to having lost in the process the generous morality and simplicity he had so admired in them between his seventeenth and twenty-sixth years.

It is unfortunate that so few clues remain about Alfred's conversion from Germany-antagonist to Germany-lover. In later life he tended to forget the former, and already in his first acolyte year abroad, there were hints that his disapproval was undergoing change. To begin with, he was at a

stage in his life when he was unusually receptive to new experiences, new ideas. Within a month of beginning studies at the Realgymnasium, he was writing his cousin Adolph with enthusiasm about teaching methods that were significantly different from those he had met in New York. Books were not only secondary to classroom instruction but banned by some teachers, who preferred to explain everything until every pupil had a demonstrable understanding of the subject.

The youngest of eight among classmates aged seventeen to twenty-one, he had thirty-six one-hour classes a week, including Saturdays, a heavier schedule, but with far less homework than he was accustomed to. The teaching method differed radically from anything he had known at CCNY. Issued a set of materials which was unlike that given the others, each boy had to work out his own problems; copying was impossible. It was Alfred's first introduction to independent study. Clearly the boy who a year before had been content to skim through boring courses with the aid of "cribs" was intrigued by being allowed to—by having to—stand on his own. Unlike Lee, he was delighted with being treated like an adult in school. Discipline as he had known it in America was almost nonexistent, yet all the boys in his class studied diligently and few earned even a reprimand for misconduct.

His new appetite for learning brought him a plum. Although Alfred was the youngest, Bauer soon chose him to act as his laboratory assistant; given responsibility to teach, he learned more than he had in class. Alfred's childhood persistence in teaching himself skills in sports and games was turned now toward his studies. In Dr. Bauer's home, moreover, he enjoyed his first taste of a tranquil household.

That a father could be calm was a revelation. Edward's short fuse had always made a minefield of the Stieglitz household, through which everyone learned to walk with extreme caution whenever he was at home. Misdemeanors were many and dealt with severely. Anyone, family member or guest, who showed up at table inappropriately dressed, who squeaked a knife across a plate, or who chewed audibly was dismissed summarily without dinner. One terrified in-law recalls to this day swallowing an almond whole to avoid a tirade. I never knew Edward, but I had sufficient experience of the volatility of my grandfather Lee, the son said to resemble him most, to reconstruct the apprehension Alfred and the others, including Lee, must have felt living with him.

Lee, whose dignity was awesome, whose voice was normally quiet and controlled, even gentle, who was moved to instantaneous tears by his

own recital of the docile suffering of a child patient, and who could be as delightfully playful with a grandchild as he could be magnetizing to a beautiful woman on whom he concentrated his charm, was capable also of monumental rages over not only the stupidity of one of us falling ill, but also over some natural or mechanical mishap that disrupted the "harmony" he demanded as his due. A clogged sink, a telephone out of order, a slammed door, the least whiff of cooking, all were irritants to which he reacted violently. Only at a distance and in retrospect was it possible to realize that his tantrums were childish, extravagant, and even ridiculous; at close range they were absolutely petrifying. From all accounts, Edward was the same and more: he was known even to accost strangers on the street to reprimand them for ill-mannered words or gestures. Living with either of them demanded often the wariness of a spy in enemy territory, especially when a "mood" was in the air.

Professor Bauer seems to have been a father of an entirely different stripe: exacting in school but jovial and patient at home, openly devoted to his wife and little girl, he was also sensitive to the feelings of his two young and homesick boarders. They were included in outings and entertainments, listened to without condescension for their fledgling philosophizing, and welcomed for their youthful exuberance. In Bauer's home, Alfred became "jolly"; he laughed and sang without constraint. No doubt the gentle congeniality of the Bauer family was another factor in Alfred's gradual acceptance of, and growing enthusiasm for, Germany.

Another was his awareness of the scenic beauties and picturesque culture of his surroundings. From Easter holidays with the family in Lichtenthal, Alfred took off with one of his parents' friends, an artist named Hermann Hâsemann, for a short trip through part of the Black Forest. From Gutach he wrote Adolph a long description of the valley in flower, the quaintly costumed women and good-looking men; the "peasants" were not dense, as he had expected, but friendly and alert, good company. Two years later he would return, with a camera.

By the end of the school year, Alfred had achieved family recognition that he was no longer a child but a young man, ready to face studies at the Polytechnikum in Berlin in September on his own. Although Edward's first choice for Alfred had been the engineering school of the University of Zurich, a single preliminary visit had changed his mind: to his horror, he had found the University not only Calvinist but coeducational, with "loose-living, cigar-smoking Russian women." Berlin's all-male Polytechnikum could only be better.

To satisfy Edward, certain conditions would have to be met by Alfred in Berlin. He would be required to accept, at least temporarily, the supervision of Erdmann Encke (Fedor's older brother, who lived in Berlin); he would be required, as before, to write frequent reports to his parents, especially about his health; he would be held responsible for living within his allowance; and he would be obliged to spend at least part of his vacations with the family. He was otherwise free.

There was no alternative for Hedwig and Edward. Bauer had certainly informed them that Alfred was "a good boy," doing well in school, constant in his habits, sensible with his friends, faithful to his piano, and happy. Except for occasional nudges to instruct the twins to write more often, his parents had not had to remind him of his year's responsibility for overseeing his brothers. He had, on his own, established a routine of visits with them on Sundays when he was free—in poor weather a meal, a concert or horse-talk, in good weather a hike, skating, or horseback-riding.

At the end of May 1882, the family assembled—Hedwig, Edward, Rosa, the girls and their governess, Miss Winter, coming from Paris, the twins and Alfred from Karlsruhe—at Badenweiler, in the section of the Black Forest that abuts France and Switzerland, from which they went together to Schlangenbad. The older generation was quickly immersed in the daytime routines of the spa, diets, massages, the baths, and infusions of the saline springs noted since Roman days; in the evenings, they often took the children to nearby Wiesbaden to attend theater and symphony concerts. Alfred's daytime passion was to explore, on his own, the steep vineyards, lush valleys, and lovely forests, the tiny villages and hamlets of the Taunus range.

A September week in Vienna, another in Lucerne, and the family was back in Germany, parents and Rosa established in Stuttgart and the twins dispatched to Karlsruhe. Alfred accompanied the girls and their governess/companion to Weimar for a few days' visit. And then it was Berlin.

THE PICTURE, THE WORD, AND THE PUBLIC

1883 - 1913

7

With all the letters that survive from Alfred's later life, there is a scant handful from his student years in Berlin. The result is that there is little evidence to check against his later recollections, his tendencies to bend the story to his wishes or the needs of his listener—or to the romanticizing of his image. If there was a pervasive undercurrent to his narrative, it was the one that characterized all his reminiscences: that he was a loner, then and always, working in isolation and basically against the mainstream.

To listen, as I did, to one version of his first semesters in Berlin was to picture a shy lad who, until he discovered the camera in 1883, spent long hours in his room, at the piano, poring over his racing magazines, reading French, German, and Russian novels far into the night. He was awed and silent in his classes, and given to solitary walks through the city. Always the observer, he resented the ubiquitous and haughty military presence—of every three Berliners, one seemed to be in uniform—and bristled at the indifference of men toward wives who, no matter how frail, were apparently always laden with packages, tangled in dog leashes, and struggling to maintain the prescribed three to four paces behind their husbands. This Alfred was nostalgic for country simplicity and the spirit of recent summer festivals. Berlin was cold and grey, its sunlight harsh; daylight hours were shorter than any he had experienced before. When he asked timidly for more heat in his room, he was treated to a lecture that simultaneously deplored the inability of Americans to survive outside a hothouse environment and warned against the dangers of open windows; a draft, as a Bostonian chronicler of the period noted, is regarded by a Berliner "as a messenger of death." Alfred had heard this message throughout childhood. It was so vigorously reinforced during his student days that, in his seventies, the merest whisper of air across the back of his neck could induce panic. One of the multitude of reasons he gave for excusing himself from visits to our grandparents' cottage on the Lake George hill was their

rejection of his claim that, yes, he *could* feel a draft from a window open three rooms away through two closed doors.

The waif image was no doubt an accurate reflection of an intermittent state of mind, and probably became most acute when he was concerned about his health. Hedwig and Rosa continued to send him warnings to look after himself well, Rosa going so far as to suggest that he be extra careful because her brother Ernest had had diphtheria—in New York—and "it's very contagious."

There is little doubt that he felt lonely and somewhat timid during the early weeks of his Berlin life. Arriving in mid-September, he stayed with Fedor Encke's brother Erdmann, a fashionable sculptor and studio photographer whose clientele included a peremptory royal family. With little time for Alfred, Erdmann directed him to museums to study what Alfred called dead art, and to neighborhoods where he might find lodgings that were both congenial and inexpensive. Fortunately, as the search seems to have been difficult, the Polytechnikum was not due to open until the second week in October. At the end of September, Lee was still wondering why it was so hard to find suitable rooms, and whether his brother's "$3,000 a year from Pa" arrived weekly, monthly, or annually. The sum is at odds with Alfred's retrospective claims that his allowance during the years abroad was either $1,200 or $1,300, but whatever the Berlin figure, it is doubtful that his basic lodging, food, and school fees exceeded $700 a year. Discounts were offered students on books, the "Roman Baths," lodgings, entry to race tracks and other sports events, as well as—within an hour of their start—on tickets to concert, theater, and opera performances that cost the general public a miniscule fifteen or eighteen cents. Alfred was certainly not culturally deprived.

The trepidation and loneliness Alfred probably experienced in his first Berlin weeks were dispatched when the opening of school occasioned two discoveries: that European university life was entirely free of supervision, and that, among the 5,000 or more students at the University and the 2,000 more at the technical college, there were several hundred Americans whose informal congeniality announced their nationality immediately. Homesickness vanished; Alfred embraced Berlin, liberty, and Life wholeheartedly.

The first month or two at the Polytechnikum proved bewildering scholastically. Registered in courses leading to a degree in Mechanical Engineering, Alfred was conscientious in attending lectures, but he soon found that he had no aptitude for drafting, little dexterity and even less

mechanical inventiveness, and that, among his mandatory courses, only chemistry held his interest. More experienced students soon urged him to sample courses at the University rather than waste time and energy on those that bored him. By the end of the fall, he was running or taking the trolley from the Polytechnikum at the western end of the lovely Tiergarten to the University at the eastern limit of Unter den Linden, nearly a mile distant, commuting between required courses and the lectures of world-renowned professors in a number of disciplines. Among the latter were the protean Hermann von Helmholtz, in physics; the pioneering physiologist Emil DuBois-Reymond, in anthropology; the founder of cellular pathology, Rudolf Virchow, who lectured on anthropology and archaeology and was also, as leader of the Liberal Party, a fierce opponent of Bismarck in the Reichstag; and the innovative chemist, August von Hofmann, father of the vapor-density method of weighing molecules but also—and perhaps more importantly to Alfred—an early researcher in coal-tar products and aniline dyes. Helmholtz's discourse soon proved too abstruse, even though he explained gently to an Alfred wholly at sea that he was dealing only with the most "elementary" concepts. Quitting his lectures, Alfred admitted to learning not to waste the time of "XYZ" people on ABC questions.

He continued to slog through the mechanical engineering courses, but before his first semester had ended he wrote Cousin Adolph that his classes in Analysis and Technology were unbearably boring. Feeling under enormous pressure, he began to think he might have to give up engineering, a possibility he was not quite ready to face. In all other respects, he was delighted with the pattern of his life. When the day's classes were over, the only problem he and his fellow students had to resolve was which of many entertainments to choose. Did they have time to run to the Gendarmenmarkt Schauspielhaus to get tickets for the new Ibsen, grab a bite on the way in, and still make the 7:00 curtain? Should they stop at the Kaffeehaus at the corner of Friedrichstrasse for some black bread, cheese, and a beer on the way to *Carmen* at the Staatsoper? They were probably too late to get a table at the Philharmonie, to order a Silvaner or a Schokolade before the opening passages of the Mozart. If they ate the intermission supper, they wouldn't have the money to join the others later at the Rathskeller on the other side of Cölln. Maybe they'd better go straight to the Café Bauer, where Alfred could teach them his queen's unorthodox moves in chess or, on his way to becoming amateur champion of Germany, practice for his next billiard match. At the end of the month, with their allowances dwindling, they might take their bread, sausage, and beer (Al-

fred would have wine) to Alfred's room for another of the sessions of his reading aloud. In one night he had read them Zola's *Madeleine Férat*; Daudet's *Sappho* took somewhat longer; and Mark Twain, the only American author he enjoyed, was always fun. Even if the Germans couldn't understand everything, they found his hilarity contagious.

But the dullness of his curriculum continued to plague him. Dejected at being unable to cobble up any enthusiasm for his studies, unwilling to be a failure, afraid of disappointing his father, he was appalled at the thought that he might have to give up his exhilarating independence. Fortunately, relief was in store.

On a January afternoon in 1883, heading back to his room after another intensely uninteresting lecture, his eye was caught by a shop window display on the Klosterstrasse: it featured a large black cube with a lens. On impulse, he darted into the shop. For the equivalent of $7.50, he emerged with the camera, a candle light with a "ruby" shade, some developing trays, photographic plates, chemicals, and a manual of instructions. In his room, subduing a growing excitement, he carefully set up his drawing board on a table, pinned on it a selection of photographs taken of him by Erdmann Encke, and, of this composition, took his own first photograph. This was only one of the "first" photographs he described later. Others were views outside his window, still-lifes, etc. It seems, however, that his first picture was indeed an interior shot; he waited to take his camera outside until he had both a tripod and more confidence.

For a darkroom, he opened his door across the corner of the room to form a triangle, and strung a blanket over the gaps. Within this space he set a little chair, placed the ruby light and one developing tray on its seat, and beneath it another tray, a pitcher, and a slop pail. In a Chaplinesque frenzy for an hour, he washed his first negative more than twenty times before being satisfied that it was properly clean. He could barely wait to take it to the window's thin January light in the morning to examine it; it was perfect.

That this was the beginning of his life as a photographer is well established. At first he had little understanding of photographic processes, relying on what he could pick up from his instruction booklets, the occasional advice of the supplier of his paper, and his own dogged experimentation with the materials at hand. He photographed the wall across from his window "a thousand times": at different times of day, under clouded and sunlit skies, with as many exposures as it was possible to make, at varying angles. Then he altered by a drop at a time the chemicals he used, their

ratio, the length of immersion, the washing. Every variable it was possible to explore, he pursued. It is doubtful he ever asked the help or advice of Erdmann Encke, having surely no interest in becoming an apprentice, and probably little pleasure in the stiffness of studio portraiture. He was not even aware, until by chance a fellow student in one of his classes told him, that a course in photochemistry was available at the Polytechnikum. Within days he was attending his first class with Professor Hermann Wilhelm Vogel.

It was a stroke of extraordinary luck (or fate, he would sometimes declare). Although his lectures were to be no more enthralling than others in Alfred's daily life, Vogel's important earlier work in increasing the range of sensitivity in photographic plates, his formidable patience, and above all his respect for his "crazy American" student's incorrigible persistence and originality, were of inestimable value to Alfred's progress. He was permitted to skip most of the lectures and concentrate on laboratory work. By the end of the term, he sensed that he might decide to give up engineering, but he would postpone until summer facing Edward with the plan growing in his mind. Meanwhile, he would finish the academic year, dutifully if with minimal effort, he would concentrate on understanding his new machine and its capabilities as best he could, and he would sharpen his ability to "see."

When summer came, Alfred was able to spend the weeks he allowed himself away from Berlin in Gutach with the family and Hâsemann. This year, when Hâsemann, sometimes accompanied by Edward, set off for the day with sketch pad, easel, paints, and canvases, Alfred was weighted down with his new paraphernalia, thirty or more pounds of camera, tripod, and plates. Following hushed trails under virgin pine and spruce through sun-bright beeches at the forest's perimeter, they emerged at the top of a high field overlooking the valley. Here, again, they found gaily costumed peasants tending their cows, their neat stands of grain, and the gristmills turned by distant headwater streams of the Danube. Hâsemann and Edward worked in the convention of the period, their sketches romantic, often sentimental, anecdotal. Alfred's photographs shared the imagery, and often the mood, but they were different in one important respect that would become a hallmark of his work: outlines would always be sharp, the focus would always be critical. Here he continued the habit begun in Berlin: if he found a landscape or a tableau that appealed to him, but not the light or the contrast that would best express its inherent beauty, he returned again and again, until conditions seemed right. Alone, or with

Hâsemann or Edward, he knew absolutely that it was the camera that brought him the greatest joy. Still, he was seeking the right way to confront Edward.

Relations with the rest of the family were curious. With Hedwig, Aunt Rosa, and the girls, as with his father, they remained virtually unchanged: he was their unchallenged favorite. But between him and the twins there was a new distance, that which stands between prep school homogeneity (and snobbery) and the new enlightenment of Alfred's urban university life. The twins, at sixteen, were unshakably self-assured, even smug. Lee's "concern for the poor laborers' hard lives" was expressed in his diary in tones that underlined the superior nature of his egalitarian views; Julius was even more fastidious. Alfred, on his own, in daily contact with working people at every level, "seeing" intensely, and conscious always of the constraints of their existence, the dreariness of lives that would never include sufficient food, far less opportunities for a pastime, had a deepening empathy for the worker, whatever the nature of his work. It was as true here in the country, observing the peasants, as it was in the city. If Alfred romanticized, it was in terms of admiration for the workingmen's quiet persistence, in the simple satisfactions he felt they derived from craftsmanship, the pride taken in a job well done. His attitude would last him a lifetime.

In later years, Alfred would explain his attitudes, his philosophy of life, as expressions of an inner nature, by implication generous, molded by a difficult life (sometimes referred to in Alfredian hyperbole as a life of poverty). He was at pains to discount any influences that were theoretical, intellectual, organized, or even the result of the informal bull sessions that are the indispensable fertilizer of growth at a university. Whatever his disclaimer, however, the isolated, innocent mind he described would have been an impossibility. He did *not* live in isolation. Furthermore, during the years of his residence, Berlin was a ferment of new and potent ideas.

In a city where the poverty of the workers stood in stark contrast to the wealth of the upper and trading classes, social justice was a dominant theme. Albeit Bismarck's chancellorship had introduced legislation holding factories responsible for working conditions, and after 1883 would add measures that provided a form of social security, his premises were dictatorial, coercive; outspoken critics and "agitators" were imprisoned or deported. Marx's treatises on capital (which, although feared by the entrenched, had not yet engendered a successful revolution), Darwin's laws of heredity and environment, Tolstoy's denunciations of the ruling classes

and idealization of asceticism, Dostoevsky's plunges into psychological motivations, Zola's documentarian novels, were all part of the fervid material of university discourse, from the lecture podium as well as in student quarters and *Weinstuben*.

If Alfred did not study philosophy, he nevertheless dipped into the works of thinkers, including Kant, Hegel, and Schopenhauer, whose ideas were exciting his companions; Emerson, said later by some to have been a primary influence on his thought, was only an interpreter of sources already familiar to Alfred.

What ground remained for conversation with his brothers? Horses.

His relations with the girls seemed unchanged: he was closest to Flora, and amused by Ag and Sel. Sharing confidences more easily with Flora than with his brothers, and encouraged by her to continue in photography, he found the nerve to approach Edward with the suggestion that the camera might be a viable replacement for the draftsman's drawing board. His father proved far less difficult than he had anticipated. Edward was genuinely pleased that at last Alfred was moved by a compelling interest to deepen his education, to work toward a goal. Being Edward, he no doubt began to think of the practical possibilities: a professorship in photochemistry perhaps; an invention that could be profitable; a new process that might be marketed. In any case, he could hardly refuse approval on the grounds that a business career would not be immediately forthcoming; he had spent too many years inveighing against the narrowness of the business mentality, upholding the need for art, culture, education.

The 1883 summer only half over, Alfred went back to Berlin, eager to finish some darkroom work before the resumption of classes. It was probably in this fall that his steamer-met pals, Joe Obermeyer and Lou Schubart, arrived in Berlin to attend the university. Pooling their resources, they found rooms that Alfred, at least, could not have afforded on his own. Studying separately, the three spent Saturdays together—at the races, rowing (or skating, in winter) on the Wannsee, and walking the brushed and labelled paths of Berlin's suburban forest, the Grünewald. Once at least, Joe and Lou were timekeepers for Alfred's run up the Kreuzberg, the mountain at the city's edge. On rare occasions they visited the Altes Musee in the old city to look at its not very distinguished old masters; except for the Correggios and the single Titian, Alfred thought they looked like tired leather. The treasures of the Royal Library were far more seductive—not the manuscript of Luther's translation of the Bible, or even the Codex of Charlemagne, but the second-floor reading room's American newspapers

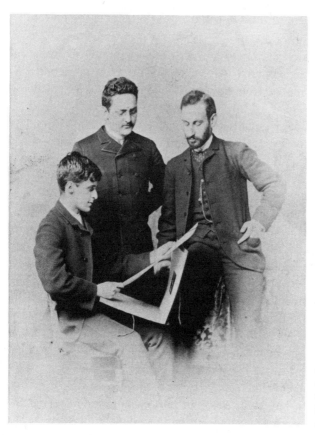

Alfred Stieglitz, Louis Schubart, and Joseph Obermeyer, Berlin, 1887 Studio

and magazines and, best of all, its clusters of female students barred from the masculine fortresses of the university and the Polytechnikum.

Sexual tension had been building in Alfred ever since his discovery, during the family's holiday in Vienna the previous Easter, of Rubens's portrait nude of Helena Fourment, enfolded in furs. He had returned several times, alone. In Berlin, in Wagner's *Tannhäuser*, Venus would appear to him suddenly unclothed; Carmen's gown evaporated; Tristan's and Isolde's embracing bodies were bare. He sought the cure and lost his virginity.

The experience of achieving "manhood," his final emancipation from childhood, was one he would describe glowingly to hesitant youths until the end of his days; fifty-five years later, one college lad wrote to thank him for the liberating effects of "your confession that life began for you when first you were seduced." The operative verb was probably apt. At nineteen, Alfred was broodingly handsome, with black curly hair, dark

eyes that could melt and flash with equal virtuosity, and an abundant mustache that added a swashbuckler touch.

Nieces and grandnieces in later years were treated, usually at thirteen, the age Alfred deemed appropriate to their "enlightenment," to a bowdlerized account of this momentous rite of passage. Perhaps to spare them the embarrassment of learning that sex was an experience common enough to be their own one day—or, conversely, to pique their interest—all he would say was that his first instructress had been a noble whore. At my own hot-faced reaction, he immediately prescribed that I read Zola's *Nana*, fetched it from his library and sent me on my way with the admonition that I not let my grandmother know I had it. With splendid unoriginality, I hid the book under my pillow and pursued its revelations by flashlight.

Of course I was found out. With supreme tight-lipped control, my grandmother spared me the castigation her strict Lutheran and Alt-Katholische forebears would have demanded, but immediately confiscated poor *Nana*. Next morning she set off down the hill to the Farmhouse, clutching the odious volume, while I waited trembling at the window for some explosion to rend the atmosphere. Nothing was said to me. But for at least a week Alfred was "too busy" to see me, and I was questioned sternly about my destination every time I left the house. When the probationary period was over, Alfred and I sat on his porch, in full view; the books I brought back up the hill were unimpeachable.

But he would not be defeated in his task of educating me. I was soon dispatched to read in his library certain assignments in Havelock Ellis, various passages in Rabelais, and a number of Zola's novels—including the end of tragic Nana's story—while he stood guard in his study with the shades high, or sat innocently on his porch, ready to intercept my grandmother. Some years later, when I described the subterfuges to my mother, she laughed until the tears came. At thirteen she had hidden the Freud Alfred was introducing to her—from which he occasionally read aloud certain underlined passages—under the radiator in her tower room at Oaklawn; she had not been found out.

Whatever the consequences to "pupils" of succeeding generations, Alfred's youthful introduction to sex was profoundly satisfying to him: Goethe's Margarethe, Zola's Madeleine Férat, Carmen, Isolde, Venus, and the dignified heroine of Scheffel's *Ekkehard* formed a dizzying composite he sought to find echoed in more ordinary mortals. The search, however romantic, apparently bore other fruit: he sent the mother of a child he felt he had fathered a stipend for the rest of her life, and thereafter to the

child. One can only call disingenuous his insistence to some later listeners that his love life in Berlin was all innocence and poetry. His 1889 sun-striped portrait of "Paula"—demurely bonneted, writing at his table—shows dimly in the background another photograph of her uncovered and gently disheveled head denting a rumpled pillow.

Entertainments and romances aside, as well as the piano playing that continued to act as a catharsis, the most exciting aspect of Alfred's life in Berlin belonged to photography. It would come to be the core. Receiving permission again in the fall of 1883 to skip most of Dr. Vogel's lectures, he threw himself into work in the laboratory, carrying out his assignments with unparalleled zeal. His attempts to wash chemically the glass for plates until all impurities were removed found him still struggling long after his classmates had advanced to other work; he was relieved of this obsession only when Dr. Vogel assured him that total "purity" was impossible. Given the task of bringing out the contrasting values of a plaster figure and a black velvet drape, he again persevered beyond all expectations; Vogel's observation that exactitude was impossible plunged Alfred into ever more complex, self-imposed trials. A pronouncement that a successful photograph could never be made without natural light drove him to the school's basement to make a twenty-four-hour exposure of an old dynamo lit dimly by a single distant bulb; he emerged triumphant with a perfect negative. Every time a limitation of the camera was described, he labored to disprove it, defending the instrument's capabilities as if it were an extension of himself. The passion of his persistence held echoes of the little boy racing against himself, and indeed, much to the amusement of Dr. Vogel and his classmates, he experimented also in the speed of the photographic process, producing finally a completed print in less than forty minutes after making the exposure. (He reenacted the exercise five years later at the Berlin Jubilee Exhibition.) He defended this bizarre experiment by advancing the novel idea that speed might be important one day for newspapers.

Alfred's good fortune in finding Dr. Vogel was not restricted to the learned professor's technical and scientific knowledge. Vogel was himself an amateur photographer from whom Alfred learned the subtleties of focusing, the placement of lamps to augment natural light indoors without losing contrast and depth, the opposing effects of draperies or reflective surfaces on the quality, distribution, and intensity of light. If he skipped Vogel's lectures on the aesthetics of photography, instinctively rebelling against conventional rules of content and arrangement, Alfred nonetheless

gained the realization that Vogel regarded photography as at least an embryonic art.

In his second Berlin year, Alfred's passion to work became so intense that, when the school moved to a new building, he harried the administration into allowing him to take responsibility for the laboratory in exchange for being allowed to keep it open beyond regular hours—all night if he chose. The well-equipped laboratory, with space to conduct precisely controlled simultaneous experiments, a wide choice of materials, and water that could be varied in temperature, was a luxury he would never be able to duplicate in his later life. His darkroom shed at Lake George had no heat, and its water was piped directly from a stream-fed well, aggravating the pain in his arthritic hands. The facilities in Berlin contributed to the acceleration of his learning. He continued to vary the uses of his camera, with different exposures and different timings. When dry plates appeared on the market that year, he immediately bought a more modern camera that could utilize them. When he found he could get platinum paper from England, a paper which, although he pronounced it "difficult," appeared to be both quicker to process and more permanent, he sent for it despite its greater cost; he used it until it was no longer available. His insistence on quality in his materials, if not luxury in his surroundings, would prove expensive for the rest of his days; it was probably at this time in Berlin that he began to live almost as modestly as he later boasted he did.

More sophisticated work required a more extensive knowledge of chemistry than the Polytechnikum could provide, so Alfred returned to von Hofmann for more advanced study at the university, and enrolled in a class at the Charlottenburg Institute under Professor Karl Liebermann, a noted chemist who had recently discovered a synthetic capable of expanding significantly the range of commercial dyes.

Although Alfred's knowledge of chemistry has been underplayed, most often by himself, there is evidence that he had an early and impressive command of photochemistry. In January 1889, having just turned twenty-five, he received the offer of a full partnership with an experienced New York printer on the understanding that he would continue to seek "a process that will do [photographic] color work as well as black and white." His interest in polychromatic possibilities was further demonstrated between 1907 and 1914 with his use of Lumière color plates in family portraits; he dropped further experimentation in color only because he found its printing more limiting than black and white. In 1908, he was invited by L. H. Baekeland, the inventor of Bakelite, to contribute "a

Self-portrait, Mittenwald, 1884 Alfred Stieglitz

paper on some technical subject" concerning photography for the seventh International Congress of Applied Chemistry.

If he had time in 1883–84 (which seems doubtful), Alfred may have enrolled in courses at the University unrelated to physics or chemistry. All that is known is that he retained enough interest in anthropology to write his former professor, DuBois-Reymond, for guidance in continuing his studies. The writers the latter suggested for "supplying your first wants" were Darwin, Vogt, Huxley, and Peschel.

In essence, nevertheless, Alfred was his own university; here the loner characterization becomes apt. He worked, he said, like one possessed, asking nobody's direction except in the study of chemistry and physics. His reading for pleasure moved rapidly through Zola and Daudet and on through the Russians: Turgenev to Pushkin to Gogol to Lermontov. And above all, his photography advanced.

When summer came, he was commissioned by Edward to supplant studio photographers and take pictures of "the children" for the folks at home. Edward paid for materials, if not for labor. This year, they met in Mittenwald, the enchanting town in the Bavarian Alps that Goethe described as "a living picture book." Edward organized at least one trip with the family to Innsbruck; from there, Alfred took his camera along the eastern Engadine valley that cradled the river Inn. In this summer too, he expanded his acquaintance with Vienna, made a pilgrimage to Beethoven's

home in Grinzing and filled his evenings with theater and the music of Bruckner, Brahms, Johann Strauss, Mozart, and Beethoven.

His crop of photographs from the summer was rich. When he returned to Berlin, some of his prints so excited Professor Vogel that he asked Alfred's permission to show them to a group of painter friends. Proclaiming that his talent was demeaned by the use of the camera, they wanted to know why Alfred didn't paint, for any one of them would have been happy to produce a painting as lovely as his photographs. Alfred's inner response was that he would never wish to produce a photograph that in any way resembled their paintings.

The question acted as catalyst to a new realization: that the camera, though mechanical, was as much a tool of the photographer as were the paints and brushes of the painter. The creative process was different because instantaneous at the moment of exposure, but it was the photographer who *saw*, who chose, who thereafter intensified or reduced elements in developing and printing that gave the ultimate picture its unique character. Photography *was* an art, he decided. To be an effective champion of this conviction, he realized, he would need to acquire a broad reputation. He began assembling prints he might enter in competitions for exhibits that were beginning to draw attention abroad, especially in England. He would not feel ready for another two years.

If the harvest of the 1880s holidays produced images that were still somewhat romantically chosen, with an emphasis on the affinities between nature and man, the dignity and patience of the poor, the rewards of craftsmanship, they were nevertheless direct, uncontrived, and sharply defined. The trimming down, the concentration, the move away from the pictorial, the anecdotal, would come later.

By May 1885, Alfred was convinced that, although the university still had something to offer, he had extracted from the Polytechnikum all that would be of use to him. He joined the family for part of their stay in Mittenwald and persuaded his father that, in order to best advance his career in photography, he should remain in Berlin after the family returned to America. Edward had already made up his mind that the following spring would be the right time to take Hedwig, Rosa, and the girls home. Flora was nearly twenty and should be finding a husband soon; Agnes and Sel, at sixteen and fourteen, needed to be reacquainted with a homeland that was becoming dim in their minds; all of them needed to reestablish roots. The twins, who would finish in the spring at the Karlsruhe Real-

gymnasium, had already decided on the professions they would follow and the universities at which they would complete their doctorates; Leopold was to study medicine at Heidelberg, Julius would specialize in chemistry at Jena (he stayed there only one year, and completed his studies at Berlin University). There was never any question about their ultimate success since they had shared highest honors in every class. Edward knew by now that Alfred was a serious artist, and he, too, felt it was important for him to work in Europe, the cultural heart of the Western world. He would give him the same financing he had during the preceding years.

A letter of thanks to Alfred for photographs he sent Mabel Cooke, a friend at Lake George, identifies some of his works in 1885. She mentions her difficulty in choosing a favorite—a task he assigned everyone—among several of Encke's studio; of "trees reflected in the brook . . . at Charlottenburg"; of Salzburg with "snowy mountains in the distance"; of the Berlin canal. She found them all splendid, but she was moved to ask, "Have you ever tried your hand at photographing people? Faces?"

The people and faces would appear in his work the following year, and it was from among these that his first prizewinners were chosen. Selecting seven prints of photographs made during a long hiking tour through Italy and Switzerland in the summer of 1886, he entered them in the 1887 Holiday Work Competition of the prestigious London magazine, *The Amateur Photographer*. Its July 1888 issue announced that he had won the first and second prizes. Meanwhile, and in the ensuing eleven years, he entered every competition he could find; by 1899, he had won more than 150 prizes, in Germany, France, and America as well as England.

He had been right to seek recognition in the international photographic community through having his work reproduced. Before long, he was being asked to act as a judge and to participate in the hanging of exhibitions. It was typical of him to object in many cases to the manner in which winning entries were chosen, even when they were his own. His articles on solving technical problems were published widely in German and English photo journals, and his heated criticisms made him as familiar in Letters-to-the-Editor columns throughout Europe as he would later be in America.

Alfred's insistence on scrupulous honesty in the work of others, as well as his own, was already evident in 1887. Not an especially endearing quality, it would often in the future cost him support. But it also gained him trust. He would not be one to draw back from an encounter for reasons of self-interest; indeed, when he was older, he would provoke

confrontations, most often to illustrate a point, but sometimes from sheer roguishness. In his twenty-fourth year he was already beginning to earn the respect of fellow artists, even those considerably older than he; his very intransigence, they began to realize, was gaining respect for their work as much as for his own. He was becoming a leading champion of the *art* of photography.

All this was marvellously encouraging. But it left out one important factor: how was Alfred going to earn a living?

8

Resolution of the problem of Alfred's livelihood would not be forth-coming for several years. From time to time, when the spirit moved him, he parted with a print, receiving in return "a contribution" to his expenses. In later years, he indicated both that he had "sold" and that he had "never sold" prints. That he would never go into the business of selling his works on any regular basis is indisputable. How he chose to describe exchanges of money for his photographs seems to have been at first a matter of whim, and later in his life, especially after the establishment of his first gallery, a matter of principle. The terms he used aside, it is a fact that he consented to receive payment on occasion for prints that became the property—another word he detested—of others. Payments ranged from $20 in his Europe years to $1,000 or more in his late sixties.

Whatever he earned from photography in the latter 1880s was not enough to reimburse him for materials. His father was able, and willing, to continue to support him, but by the middle of 1888, he was beginning to feel that Alfred, now twenty-four years old, should begin to think about marriage, and about the means to support a family. Flora would be married in the early summer to Alfred Stern, the son of a New York wine importer and vintner whose West Coast operations he directed. Edward sent passage to his three sons for a summer visit to the States.

In addition to Flora's wedding and Edward's wish to talk to Alfred about his future, there was a third reason for summoning his sons. He wanted to show them the rambling Victorian house on the west shore of Lake George that, having rented for the summer of 1886, he had bought that same fall. The perfect counterpart to the New York town house, it would be the family's summer headquarters for the next thirty-four years, capable of accommodating guests as well as his immediate family and the servants brought from the city: Hedwig's personal maid (who doubled as waitress) and the cook. Others on the staff—coachman/gardener, house-maid, and scullery-maid—were "locals."

Named for a superb oak (reputedly over 150 years old at the time of Edward's purchase), Oaklawn was a little less than a mile north of the village of Caldwell, removed from its plebeian life, but within easy horse-and-buggy reach of the railroad terminal, the post office, the pharmacy, the general store, and the butcher. Vegetables and fruits grown at home were supplemented by back-door purchases from an itinerant truck farmer; all other provisions were shipped from New York.

More than five acres sloped eastward to the lake below the main route connecting Albany and Montreal, known locally as the Bolton Road. The lower third was canopied by tall pines and beeches clustered around the house, a three-story gabled structure with restrained gingerbreaded verandas and a hexagonal corner tower balancing a corner porte cochère. There was a small barn, a combined stable and carriage house, and—used only as a supplementary convenience when grandchildren began to arrive—a Gothic outhouse, inadequately deodorized with witch hazel, that became known as The Cathedral. To these existing amenities, Edward soon added a tennis court, a croquet court, a rustic gazebo at lakeside for Hedwig, a bathhouse, and a pier for rowboats. Under his direction, a broad stone wall, low enough to provide comfortable seating for passers-by, was built along the upper edge of the property abutting the footpath of the Bolton Road, with three gate-posted entrances, two for horses and wheels and one for pedestrians. The latter introduced a flight of "Italian" steps, Edward's special conceit, to a path threading its way downhill alongside a brook and a pool, intersected at intervals by other paths embellished with formal plantings and an occasional rustic bench.

Oaklawn resembled many of its well-groomed waterfront neighbors, although it was smaller and considerably less elaborate than some. The Price estate, to its south, Edward bought in 1891, selling it later at cost to the brother of one of his friends, George Foster Peabody, and retaining for himself a generous slice of its woods, field, and waterfront as defense against some future unknown, potentially noisy, neighbor. At about the same time, he persuaded one of his nephews, Eugene Small, to buy a mainland and island estate to Oaklawn's north, bringing into family hands a wide section of the sheltering bay's shore.

Protective though he was of his privacy, Edward was hospitable not only to his friends but also to the small son of the Price estate's superintendent, who recalled many years later the kind avuncular interest he took in the boy's future career as well as Hedwig's invention of tasks that could earn him precious pennies. After nearly fifty-five years, he remem-

bered clearly also "peering through the white cedar hedge in awe" to watch Alfred and his brothers play tennis. His awe was not inappropriate. Stieglitz tennis matches were apparently fierce. A later witness recalls an occasion when Alfred was accused by Agnes of a foot fault that nullified his claim to an ace, and the ensuing duet of tempers was so extreme that, afterward, neither spoke to the other for two weeks.

My own acquaintance with the interior of the Oaklawn house was limited to a single occasion some five or more years after its sale and the family's move to the Hill property on the other side of the Bolton Road. My grandmother Lizzie, having prevailed on the owner of the newly converted Oaklawn Lodge to allow my sister Peggy and me a brief tour of the house in which our mother had spent most of her childhood summers, ushered us up the front steps, across the wide porch, and into the front hall. I found it overwhelmingly gloomy. Oak paneling prevailed, much as if a proper Victorian brownstone had been transplanted and stretched, with every horizontal dimension doubled or tripled. Broad oak stairs rose along the wall of the wide corridor opposite a vast stone fireplace; I immediately imagined great-grandfather's Civil War sword hanging over the mantel, a place I was told much later it had never graced. Darkness on all sides led to obscurity; I refused to move either ahead, to the side, or upstairs. Photographs reveal that my timidity was unjustified. The dining room, the living room, and the library were all spacious rooms opening one into another with sliding doors, and all had generous windows facing the lake side's deep veranda. Furthermore, the walls above the oak wainscoting I remember as tenebrous were of alternately rough white "thrown" plaster and light-flowered wallpaper. I refused adamantly to go upstairs, even with the enticement of a look at the third-floor hexagonal tower room from which Mother had dangled mischievously on a rope ladder as a teenager, to the profound shock of Granny Hedwig.

With the exception of a few favorite pieces, and enough others to roughly equip the Farmhouse up the hill, Edward's and Hedwig's furniture remained in place, antimacassared and scarved. Amid the vast Victorian pieces, there were a few fragile French chairs—remnants of the dining hall at 14 East Sixtieth Street—and assorted sculptures in bronze and marble. Only two of the marble pieces, both works of Moses Ezekiel, accompanied the family up the hill: a bas-relief portrait head of Edward, reminiscent of the medallions of Roman emperors, and an absurd neoclassic Greco-Germanic romantic bust of the biblical Judith, of which Edward had plaster casts made for each of his children.

In the 1888 summer of Alfred's and his brothers' first visit, Oaklawn was already taking on the character of an enclave, as remote from the transient resort atmosphere of its environs as if it were in fact a mountain retreat in Bavaria; this hermitage aspect was to become even more pronounced when the family later moved across the Bolton Road to the farm on the hill. Oaklawn's social self-sufficiency was dictated by practical considerations at least as much as by Stieglitz aloofness. It had taken less than a month after their return from Europe two years earlier for Hedwig and Edward to reestablish their celebrated hospitality, filling first the New York home with friends and relatives, and later the rented Lake George home. People they had not seen in five years were quickly reembraced, drawn into their circle, offered vacations at the lake—with their families. The summer of 1888 was no exception. With Flora's departure on an extended honeymoon in Europe, her room became available; by putting the three boys in a single room, and having Ag and Sel double up, there was room for several guests.

Preparations for the boys' arrival had been made with care. Edward and Heddy had agreed that their old friend John Foord should bring his family for a visit: Edward succeeded in getting Foord, then a senior editor at Harper & Bros., to introduce Alfred to several people in the printing world, a milieu Edward felt would not be offensive to him.

Heddy had a different plot in mind. She was determined that her three sons have female companionship, suitable in age and upbringing. Here again the Foords were the fortuitous providers: they had three daughters who matched Hedwig's requirements. Maggie was undoubtedly "chosen" for Alfred, her sisters Kitty and "Foordie" (who later married a Stieglitz cousin) were allotted to the twins. The plot went only slightly awry: Maggie became the magnet for all three boys.

Alfred was clearly the winner, leading Lee to produce later some jealous verses. He would, he wrote, "love and woo" her for himself, except that

> . . . I've no chance with Maggie Foord!
> I saw her of her own accord
> Entrust both hands to Alfred's care—
> To draw conclusions is quite fair . . .
> . . . He'd play for her Italian songs
> About the moon and lovers' wrongs,
> He'd play and look with dreamy eyes

Around where Maggie sits and sighs
With trembling lips and heaving breast
What all this means, why they know best!

Lee's devotion lasted three months. By January he was addressing poems to Elizabeth Stieffel in Karlsruhe; he would marry her in 1894.

Whether or not Maggie and Alfred were ever seriously involved, they remained bantering and warm, if occasional, friends throughout their lives. And Maggie remained Heddy's choice match for Alfred until O'Keeffe came into his life. Even before the irrevocable breakup of Alfred's marriage with Emmeline Obermeyer, his mother wrote him constant news of Maggie, admitting impulses to let him know whenever she was in New York, and where, but usually thinking better of it.

The return to Europe in October of the three brothers was a return to the lives they had been leading—Alfred to his camera and competitions, Lee and Julius to their universities. Whether or not Edward told Alfred when his support abroad might end, he surely suggested that he ought soon to return to America for good. Alfred's response was to step up his efforts to find a way to remain in Europe. He worked incessantly, not only at his own photography, but furthering exhibitions, making contact with photographic clubs throughout Europe, contributing peppery letters to magazines, looking for something that would justify continued residence in Berlin. He accepted commissions to photograph paintings for Ezekiel's and the Enckes' artist friends, and took pictures of gallery shows. Reluctantly, and discreetly, he let it be known that he would not turn down other assignments if the remuneration, and the conditions, were advantageous. By the end of April 1889, he had worked himself into a state of collapse and become ill.

Until then, however, there had been other, less drastic, interruptions to the grim working schedule he had set himself. Lou Schubart and Joe Obermeyer were not to be deprived of his companionship in their pursuit of life's gayer offerings. It was probably in that spring that Alfred first met Joe's sister Emmeline, who, approaching sixteen, was about to graduate from a Stuttgart boarding school. Alfred's initial impression of her, which he would remember ruefully in later years, was that she was hopelessly extravagant and self-centered. On their first evening together, Joe had bought theater tickets for the four of them. Emmy, noticing that there were seats vacant in the first rows of the orchestra, insisted loudly on being seated there. Alfred and Lou remained implacably at the back where it

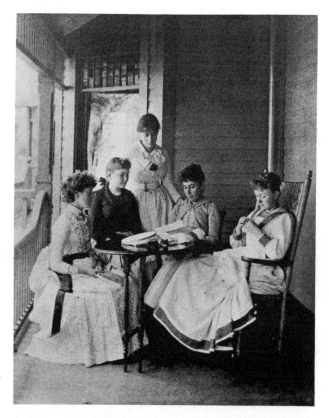

Agnes Stieglitz, Barbara Foord, Selma Stieglitz, Flora Stieglitz Stern, and "Maggie" Foord at Oaklawn, Lake George, 1888 Alfred Stieglitz

was less expensive. Alfred's comment to Lou: "God, I wouldn't want to be married to her!"

Recuperation from his mysterious illness had taken long enough for Alfred to decide he had no time for a summer holiday. He remained in Berlin, working, and trying to resist the mounting pressure from the family to return to America. For a while it seemed he might manage to stretch out his time abroad simply because his parents' attention would be drawn elsewhere. Julius would have his Ph.D. in December and had already been promised a teaching position in Worcester, Massachusetts; they would have him to fuss over. Early in January, Flora was due to present them with a first grandchild, and they were weighing the possibility of visiting her in Los Angeles in time for her confinement. Flora had written dispiritedly about how much she missed Lake George, and even Europe. Her husband's business was in a slump, she found Los Angeles "a hole," and she had made few friends. She spent most of her time gardening and reading. In February Hedwig, with her since mid-December, would write home that it was senseless to be offended that no one had visited her be-

cause "from Jews the way they are with loads of money and lack of every-thing else, nothing else can be expected." Los Angeles was a raw frontier; the Sterns intended to move back to New York as soon as they could.

Alfred's hope that he might be ignored or forgotten was fruitless. Edward was besieged with worries that encompassed his whole family, all of whom seemed to need his help. His son-in-law's business was in trouble. His son Julius would need help in at least the early years of a marriage soon to be consummated with Anny Stieffel of Karlsruhe, whose mother, furthermore, although a liberal Christian, was concerned about the attach-ment of both her daughters to American Jews. She approved the marriage as little as did the Stieglitzes, who were fearful that Anny, ten years Julius's senior, severely asthmatic, and a foreigner, might prove more a burden than a blessing. Agnes and Sel were expensive too: approaching marriageable age, they needed many changes of wardrobe. Lee's expenses through another year at Heidelberg needed to be covered as well. Added to these concerns was the fact that Joe Obermeyer and Lou Schubart were returning to the States; Alfred would have no one to share his Berlin expenses. Finally, as if all that were not enough, new tariff regulations were taking a heavy toll on Edward's remaining investment in Hahlo & Stieglitz. Alfred would have to come home.

Flora wrote Alfred in December: "Understand why you do not look forward to your return to N.Y. with great delight—But everything will perhaps be brighter and more cheerful than you expect." It was one of the last letters he had from her. In February, three days after laboring almost a hundred hours to deliver a thirteen-pound stillborn child nearly five weeks overdue, Flora died.

Alfred was devastated. Joe Obermeyer's cable, "Al bears news man-fully," was undoubtedly true, but it would take him years to recover from the loss, and it would make him unbearably anxious about pregnancies in those he loved. He was torn now between the need to be reunited with his parents and sisters, and the far stronger wish to delay returning to America as long as possible. He accelerated efforts to obtain work, finally winning an assignment under a "Traveling Studentship" from *The Amateur Pho-tographer* in London. In late July, he was sent to Île de Ré, Arachon, Biar-ritz, and St.-Jean-de-Luz to photograph views: "Cathedrals, Castles, Ruins, public buildings . . . beaches, promenades." The remuneration was £25, barely enough to keep him going for more than a few weeks. Real compensation came with the award of the gold medal for the magazine's 1890 competition.

Since the beginning of the 1890 summer, Alfred had been aware that his father was actively pursuing work for him in New York. On June 10, John Foord had proposed that Alfred become an assistant, "at $20 a week" in the new Heliochrome Company he had just founded. Three days later, enumerating his potential consequence to the business, he suggested to Edward that Alfred buy a limited interest in the company: "ten $100 shares, with perhaps an option for more. The entire stock being 200 shares, ¾ of which are already distributed." Whether it was Foord or Edward who first suggested Alfred's participation, it was a *fait accompli* before his return to New York, possibly without his consultation.

It appears that Alfred came home before September, probably with Joe and Lou. Of the Stieglitz brothers, only one now remained in Europe; Lee, at the University of Heidelberg, would receive his M.D. *summa cum laude* the following spring. Julius had already taken highest honors at Berlin, about which he had written home that it had "touched" him "to see white-haired men [his professors] moved to such fervor."

Alfred went to work at the Heliochrome Company with little enthusiasm. Already, in its first months of operation, it was experiencing difficulties. In mid-October, Foord—probably the major investor, although he continued as an editor at Harper & Bros.—wrote to ask why "your friend Mr. Obermeyer did not turn up" with the $250 Alfred had said might be counted on. Four months later, while deploring a lack of funds that made expansion impossible, he assured Alfred that "there is a future for the firm with careful management." Edward, at least, seemed to have confidence; it was probably he who convinced Lou and Joe to invest. Within another year, the venture was owned outright by the three friends; they renamed it The Photochrome Engraving Company.

At the beginning, Alfred accepted his new responsibility as a challenge. For nine years, he had dreamed that the idealism and fervor of the German worker—competent, self-improving, proud of fine craftsmanship—would be matched by his American counterpart. Reality was a rude shock. His patient hours of demonstrating methods new to his employees met with sullen resentment from all but one of them, and his offer to give them a percentage of the profits if they would reduce their demands in slow periods was greeted by most with derisive suspicion. Nevertheless, when he left in 1895, Alfred gave them all his shares in the company. Meanwhile, his cherished illusions about American labor were shattered.

The wrangling and discouragement that Alfred experienced at work were only a fraction of his misery at being home again. Living with his

family at 14 East Sixtieth Street spared him expense, to be sure, but it also robbed him of a good deal of his freedom. His parents intended sincerely to allow him total independence, but their very presence, and Aunt Rosa's, and his sisters', created inhibitions. A night away without advance notice, an evening meal out without explanation would have been unthinkable. Unasked questions about his solitary walks hung reproachfully in the air. The predominantly female preoccupations of the household, the spiteful jealousies of Ag and Sel, the constant reminders of Flora's absence, the loss of privacy even at the piano, led him into deeper solitude and depression.

His later descriptions of his despair during the first two years after his return to New York—from which he insisted often he had been "rescued" by chance encounters with the performances of Duse and the high jinks of Weber and Fields—would leave out the personal elements, and attribute his grave disappointments to the deterioration of his country. Everything seemed crass, greedy, filthy, abrasive, selfish. Instead of life, he found a diseased and directionless kinetics, in which the only energizing force was money, its possession and its lack. A regard for quality was scorned, a feel for beauty laughed at. The comfortable aesthetic cocoon inhabited by his family and friends was lost in an ocean of boastfully ignorant indifference. In his period of mourning, even the camera palled. What was there to photograph? Where in this value-starved city was there a spirit he could possibly want to capture? He went dutifully to work every day; at night he wept.

Around him was an alien world. The marvels of human ingenuity that had seemed so grand—the substantial yet delicate span of the Brooklyn Bridge, the Walkyrie-solid Statue of Liberty—were obliterated from consciousness by the spate of noisy construction throughout the city. The steel-skeletoned Brooklyn Navy Yard (from which another weighty miracle, the battleship *Maine*, was launched only three months after his return) was already echoed in the vertical steel frames of skyscrapers rushing to outreach New York's first, at 50 Broadway. Edward's instinct had been depressingly right: engineers were the indispensable heroes of the new age.

Alfred strove at first to ignore the squalor surrounding his place of business on Leonard Street, between Center and Baxter, an area into which 300,000 new immigrants had been squeezed in the past decade, but there was one inescapable element that drove him nearly mad. Noise, the never-ending racket and clamor of the machine. Nowhere in Europe had he experienced such a continuous din. In no other metropolis was there the

scream and thunder of the els, the whistle and roar of steam at ground level, the crash of sledgehammers (soon to be replaced by that refined tormentor, the pneumatic jackhammer). Alfred yearned for his beloved Europe—for street cafés and flower-boxes; for scrubbed pavements and gleaming doorknobs; for time to linger over lunch with a book or a letter; for walks that were not constantly halted by carriage traffic; for vast choices among plays, concerts, operas, and sporting events at student prices.

Alfred's visit to Lake George in the summer of 1891 was brief; his partners and he agreed that none of them should be away for long. But he wanted to explore at leisure the features of the land up the hill that his father had just acquired. Since buying Oaklawn five years earlier, Heddy and Edward had been forced gradually to realize that it would need an annex; the house was too small to accommodate both family and friends. Furthermore, they had become weary of making excuses for the one dis-agreeable element in their paradise. The cooling breeze that swept down from the west at dusk brought with it an assertive and noxious odor: pigs. In 1891, failing again to persuade the friendly farmer—who had allowed him repeatedly to set up his easel in pleasing settings—to give up his precious swine for other livestock, or for a truck-garden, Edward offered a generous $5,000 for the property. He was triumphant when Mr. Smith accepted.

It was a bargain. With the farm's considerable acreage, he acquired not only a sturdy house (partially rebuilt after a severely damaging fire only a few years earlier) large enough to put up a dozen youngsters and/or not-too-fussy guests, but also the beauties he had coveted since his first visit: the views of the lake and the surrounding mountains that were denied him at Oaklawn; the fields in which solitary elms stood sentinel; the grove of handsome chestnuts at the top of the second rise that he could paint now, again and again, whenever he chose. These same chestnuts, dying, would become potent subjects for Alfred's camera thirty-five years later, as would nearly everything else on the Hill. Almost immediately, Edward planted a screen of poplar seedlings along the drive's right side to protect the Farmhouse, as it would henceforth be known, from the winds, the hot southern sun, and any inquisitive tradespeople proceeding to the kitchen at the back or workmen to the barns on the other side of a connecting driveway oval.

Except for the addition later of two cottages and another small struc-ture higher on the property, the features of the Hill were essentially the

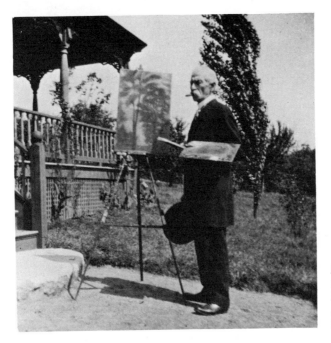

Edward Stieglitz, the Farmhouse, Lake George, ca. 1888 Alfred Stieglitz

same in 1891 as they would be during the sixty-six years of family owner-ship. Rising west from the Bolton Road, the drive that bisected the farm was nearly as steep in its lower third as Oaklawn's drive descending from its opposite side. To the right of the farm drive, the six-to-eight-acre rolling meadow between the Bolton Road and the first plateau, on which the Farmhouse stood, was dotted with apple and pear trees. Except for a brief period in the late teens when my parents established a Victory garden (of which there were more beds higher on the hill), this meadow was the lawn of the Farmhouse, mowed once a year during my childhood to dis-courage saplings but left otherwise to become a sea of wild flowers—sweet peas and goldenrod, cow vetch, black-eyed Susan, daisy, milkweed, devil's paintbrush, and Queen Anne's lace.

In my day too, Edward's shimmering poplars, although turning scrag-gly, were still dense enough to give the climbing pedestrian a full view of little more than the gabled roof and a few upper windows of the base of the stem of the T-shaped Farmhouse. Seen directly from the east—from the meadow or (past the obstruction of Oaklawn's tall pines and birches) from the middle of the lake a half-mile distant—this projecting center portion was taller than it was broad. The attic peak, faced in white fish-scale shingles and stitched with two dusty green horizontal stripes, held a single window over the shuttered three on the second floor, where the

siding was clapboard. The veranda hugging the three sides of this equilateral center portion was swathed in grape vines that obscured brick pilings and green lattice, narrowing in jagged conformation with the slope to a height, on the west side, of a single step. Here the double-storied cross of the T extended on one side to include a hold-all former carriage shelter, a larder, and the back stairs; on the other was an open porch—Alfred's—above which a glassed-in room was added in 1920.

Alfred's porch at the southwest corner was not only his command post but also his classroom for the instruction of the young (when his study was out-of-bounds) and the salon for evening discourse with visitors and friends when the weather was mild and the mosquitoes not too numerous. Roughly twelve by twelve feet, with high turned-wood pillars and a low balustrade, this was both the entry to the house and a toll gate from which, seated in his wicker chair, he collected a kiss or bestowed a pinch.

The sentry aspect of Alfred's porch was due to its position only a few feet back from the juncture of the Hill's sandy roads. The main artery was the stretch that led straight from the Bolton Road, past the Farmhouse, to a county road. The branch that ran right along the west side of the house, completing an oval, looped back again past an erstwhile chicken house, two massive joined barns, and a half-submerged icehouse. Farther up the road, another branch—again to the right—snaked to the next crest, where Edward's grove of chestnuts stood alone until Lee built his first bungalow in 1925.

Beyond that second arm, the major road became abruptly a double track which, spanning the same brook that burrowed underground and emerged below Oaklawn's Italian steps, continued past a shack (known as the Shanty when it became Georgia O'Keeffe's studio in 1920), past low meadows, past deep woods enclosing an old stone reservoir, and through a series of higher pastures where the ground was a crazy quilt of Ice Age sand slides topped by tilted pines, boulders, scrubby grasses, sweet fern, huckleberries, evening primroses, and a tangle of wild blackberries. The track ended at a barbed-wire fence, erected primarily to discourage the pasture-curiosity of neighboring cows; here it was bridged by a stile to the sandy public road.

The problem of trespassing cows would be a sore point to Alfred for years to come. In 1924, when he was the only member of the family in consistent residence, his lawyer brother-in-law (Agnes's husband, George Engelhard) would instruct him on the limitations of his rights. "A propos of shooting stray cows. You know that I told you that the owner of the

land invaded by the neighbor's kine has no right to shoot the kine, they having an inalienable right to live and chew the cud; that all the owner can do is to 'ketch' the kine if he 'kin' and that if he drops dead from heart failure in the attempt so much the worse for him, the chances being very slight that any of the cows will be similarly afflicted . . . Now will you be good!"

Across the Hill drive from Alfred's porch stood the erstwhile potting shed of a greenhouse ruin that was converted eventually into his dark-room, white with black-curtained windows and doorway. The greenhouse floor became part of a rough croquet court that continued for years to sprout slivers of glass after every heavy rain.

Alfred's first long look in 1891 at the family's new property was a welcome interruption to the frustrations of New York, to which he re-turned reluctantly. Aware that all he had to bring to the Photochrome Engraving Company was a passion and talent for fine workmanship that no one valued, he realized abruptly that even their clients were willing to sacrifice quality to quantity and speed. What people referred to as business acumen was nothing more than knavery.

The worst feature of his working days was idleness. Between frantic sessions to complete rush orders, there was literally nothing for him to do but wait, with his partners, for orders, for materials, for the often late arrival of their cynical pressmen. To wait, most of all, to be paid; since the company's formation, the only prompt and honorable client had been the scandalous pink *Police Gazette*. Alfred resolved to waste no more time. If there were no orders on a given day, he would spend it walking.

He began to wander lower Manhattan the way his father had forty years earlier, to open his photographer's eyes to his surroundings. Not to the spectacular tourist sights, but to the squalor and misery of the Tenth Ward, between Clinton Street and Broadway, where those who were lucky earned fifty cents for a sixteen-hour day; where streets rank with uncol-lected garbage were the only escape from the dark, stinking corridors of "home."

Riding down Fifth Avenue atop one of the new double-decker buses, Alfred found the contrasts between the antiseptic spaciousness of his home and the cauldron of the Lower East Side almost overwhelming. There was nothing picturesque about New York poverty, no centuries of old-world peasant forbearance; the exploitation of man by man was raw and relent-lessly visible. He began at last to bring his camera.

Alfred was not a social documentarian. He would never lose the psy-

chological distance of an observer, never be moved to the angry investigative reporting of a Jacob Riis. Although his lunch money went often to some poor fellow on the street, he would not feel compelled to ameliorate the plight of the masses. In his photographs, as in most of his philosophic perceptions, the *individual* would dominate, the person and his work, the tree, the building.

Alfred's insistent recollection that he "found" the Five Points area northeast of City Hall Park, a slum since the early 1800s, echoes his insistence that he found his philosophy without benefit of guidance; both discoveries were testament to his loner image. In fact, most of Manhattan's slums had already been photographed in the late eighties by police reporter Riis and three of his colleagues on the New York *Sun*; in 1888, Riis illustrated his passionate lectures with lantern slides and, in 1890, his first book, *How the Other Half Lives*, was published. Possibly Alfred missed seeing the book as well as the series in the *Sun*, but there is no doubt that he knew Riis. In late 1891, a little over a year before he began his Five Points series, Alfred acceded to the importunings of members of the Society of Amateur Photographers to join their group; Riis was already a member.

Since returning to the States, Alfred had done little more about photography than keep up European ties, send prints to exhibitions, and write an occasional piece for a domestic or European journal. The decision to join the Society was a hint that, although he still felt alien, he was beginning to be integrated into the life of the city. Not only did it bring him into touch with photographic co-enthusiasts—among whom, at the age of twenty-seven, he was already an *Eminence Grise* with an international reputation bolstered by feature articles in American magazines—but it gained him a new position of leadership, and a springboard for a new career as an editor. Before another year was out, he was asked to be a roving volunteer critic and editor for the *American Amateur Photographer*, an admiring but independent follower of London's *Amateur Photographer*. It was a post he filled for three years.

Two major events of 1893 were of long-lasting consequence to Alfred. The first was the appearance on the market of a hand camera capable of producing fine 4 × 5 inch prints. His first cumbersome cameras used 8 × 10 inch plates and required a tripod; an earlier "detective camera" and the first Kodak that appeared in 1888 had won his scorn, the latter both for its poor quality and for Eastman's infuriating ad: "You press the button, we do the rest!" But this lightweight 1892 camera was something else: convenient, mechanically precise, and capable of producing prints of quality.

A few sessions with one borrowed from a friend convinced him to buy one for himself.

The new camera changed Alfred's photographic life. With it, he could walk and photograph at will throughout the city. He began experimenting again, testing its capabilities; he had already pushed his old 8 × 10 to its limits. In a heavy snowfall in February he produced a negative that was a pioneering triumph; prints of *Winter—Fifth Avenue* and *The Terminal* soon circled the globe. He further extended the camera's reach with pictures at night, pictures in the rain, pictures at night in a blizzard, pictures at night in a downpour. His achievements stirred excitement across two continents.

The exhilaration of the second event was more transitory, the effects eventually depressing: he married. For a long time, he had rejected the pleas of his parents and the advice of his friends to join the ranks of husbands and fathers, considering himself a poor risk both financially and emotionally. But the persistence of Joe Obermeyer and his little sister Emmeline finally proved irresistible.

In several versions of their courtship, Emmy's recollection was that she, an unsophisticated schoolgirl innocent, was overwhelmed when this world-famous figure, nearly ten years her senior, took notice of her at all. To her, he was what a movie star would be to a teenager of a later era: handsome, glamorous, a little world-weary, the center of admiration. Furthermore, her favorite brother, her guardian since the death of their parents, was Alfred's unremitting press agent; hadn't Alfred been his best friend for twelve years?

Alfred's recollections varied, but agreed in one major particular; he had been trapped. Yes, he was flattered by lively Emmy's hero-worship—she seemed to wait breathlessly on his every word, his every wish—and yes, she had been able to penetrate his dejection, his pessimism, his solitude. When Joe urged their engagement, however, Alfred suggested that it be for five years, during which time either might withdraw "without prejudice" to marry someone else.

Nothing he said later about Emmy would have led one to believe that he found her attractive, but in fact she bore a resemblance, however distant, to his mother, and she was also amusing, kittenish, uncomplicated, gay. Nor was it a drawback that her inheritance and the income from her shares in her brothers' business—"Obermeyer and Liebmann, Brewers, Malsters and Bottlers," later known as Rheingold's—would relieve Alfred from having to slave for her accustomed comforts. He would not ask her

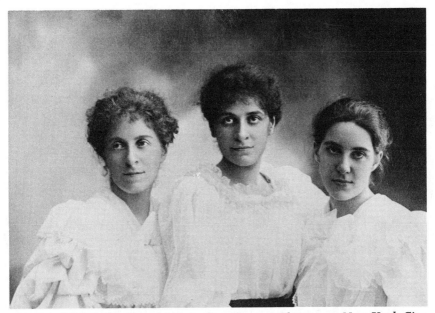

*Agnes and Selma Stieglitz and Emmeline (Emmy) Obermeyer, New York City,
ca. 1888* Studio

for money; the annual three thousand from his father would certainly
cover his photographic needs and possibly their basic joint expenses as
well if she could learn to live within a budget. On the other hand, she was
free to contribute as she wished to the enhancement of their surroundings.
In principle he was not really *against* marrying her, if it would make his
friends and family happy. Emmy and Selma were especially close, even
though his sister had a readier intelligence. Lee seemed also to approve:
although more or less engaged to Elizabeth Stieffel in Karlsruhe, he had
enjoyed a mad flirtation with one of Emmy's cousins during the 1892
summer at Lake George.

Alfred's account of the event that precipitated his proposal had two
versions, in both of which he told of having "compromised" Emmy, in full
view of her brother and friends, during a carriage ride back at night from
a picnic outing in Nyack. In one version his fault lay in having allowed
Emmy's head to rest on his shoulder when she fell asleep. In the other he
was guilty of having sat her on his lap and drawn a robe over her skirts, to
which she responded with a crescendo of squeals and a flushed face. The
net result, he said, was the same; he was entrapped.

In June 1893, Emmy and Alfred announced their engagement, to uni-
versal congratulation. Cousin Adolph's assessment that Emmy was a prize

was clearly shared by Alfred, who quickly found occasions for the picnics *à deux* that their engagement legitimized. Pictures he took of her in a copse on his cousin Small's Tea Island at Lake George—recumbent on a blanket, dishevelled and aglow—are not exactly testimony of his reluctance as a fiancé.

They were married at Sherry's, New York's most glittering society restaurant and ballroom, on the evening of November 16, 1893, leaving the reception for the privacy of their first home, a suite at the Hotel Savoy. With Joe's and Lou's agreement to "mind the store" during the summer, Emmy and Alfred planned a four-month honeymoon through Italy, Switzerland, Germany, France, and Holland, with intermittent reunions with friends or colleagues of Alfred's along the way.

Alfred anticipated with the greatest pleasure introducing to his little wife his favorite photographic scenes and exploring new ones with her. They would hike together, at her pace of course, and she would sit, companionably silent, while he focused, adjusted, timed, and looked for the exact moment. He couldn't wait.

Emmy's anticipation pictured them at the spas, on the boulevards, at the races, at couturiers, theaters, restaurants. She was married, to a famous, a handsome, man. She was Mrs. Alfred Stieglitz.

9

To Emmy, the honeymoon was a bewildering diminuendo of pleasures. The high point had already been reached aboard the S.S. *Bourgogne* at the end of May: a chic crowd, Alfred lighthearted, the gambling fun. But unaccountably, in Paris, Alfred turned moody. He took her to theater and concerts, to the Longchamps track, to the Bois and Barbizon, to Fontainebleau. But he seemed tired, listless. Who wouldn't be, staying up all night talking to the family's old friend Fedor Encke, and then going out with his camera at six in the morning?

To Alfred, trying to camouflage his growing disquiet about having married a frothy creature who detested *Faust* and refused to explore any but the most elegant areas of Paris with him, their honeymoon was a dismal preview. It had taken all too short a time to realize that Emmy was a child, willful, indifferent to his deepest needs. A cozy armful, but empty-headed.

His beloved Venice was a disaster. Emmy was jittery in gondolas, called the canals "sewers," and insisted that "those Italians," waving their arms and screeching, were making fun of her. Her terror of fire, always real, became hysterical; the brigades would never reach them by water. All Emmy seemed to enjoy in Venice were the soufflé music of the Piazza San Marco cafés, the Lido's Bath chairs and pavilions, the shops. And the *haut monde*. If Alfred suggested a dallying prelude to dinner, she swept him to the bustling hotel lobby to see who was wearing what and sitting with whom, to order an *aperitivo* amid maudlin violins and the sibilance of tête-à-têtes and potted palms.

Bellagio was worse. With nothing to do, Emmy's nerves were shattered and her digestion ruined by food she deemed awful. Italy was, as she continued to insist for twenty years, "all grease and dirt."

Interlaken provided at least a brief respite from complaint: she could speak the language, and there was a congenial billiard room where Alfred could show his "stunts" and restore her uxorial pride. Here he convinced

her that, as at Lake George, a walk through the valley could restore a sense of physical well-being, and a picnic, with the Jungfrau as backdrop, could be a treat. But no amount of coaxing would get her to the funicular ride and walk to the thousand-foot Trummelbach Falls or his long-antici-pated excursion to the grottoes of the Rhone glacier. Even Wengen was too high for her. Grindelwald was fashionable enough at least to win a concession; she agreed it was "pretty."

Munich had the reassurance of familiarity and such a plethora of diversions that she, too, welcomed a rest at Hermann Hâsemann's Gutach retreat. But she was appalled that Alfred expected her, Hedwig-like, to chat with peasants at farm gates; what on earth *for*?

At The Hague, their last stop on the continent, the polarity of their tastes was starkly revealed. Emmy dragged Alfred to the crowded beaches at Scheveningen where ladies and gentlemen changed their bathing dress in decorous little tents and lounged under gay umbrellas. Alfred retaliated by taking her to Katwijk aan Zee, where the lonely ocean horizon, the simple fishing village, and the hardhanded fishermen and their wives touched him deeply. And elicited Emmy's scathing derision. Returning alone another day with his camera, Alfred could not help comparing Emmy's spoiled nagging to the quiet patience of the women in the little town, mending nets contentedly, waiting without murmur for their husbands' late return from the sea.

In London in late August, their differences were smudged: Emmy had her share of cosmopolitan entertainments, and Alfred was lionized by the English photographic societies. Both were ready for an uneventful passage back to New York in September.

Reappraising their four months abroad, Alfred began to face the clear portents for their future life together. Throughout the summer, Emmy's spirits had quickened and slumped in direct proportion to the quality of restaurants, the comfort and safety of hotels, the availability of hair-dressers and elegant shops and the frivolities—Alfred's word—so loved by the people she found attractive. Worse, she seemed determined to draw him into similar patterns, and had a temper, when thwarted, that she didn't hesitate to use in public. To his intense embarrassment, she insisted loudly, as she would for years to come whenever they were in a classy dining hall, that he order a substantial dinner even when his appetite dictated a single course. To do otherwise "wouldn't look right." Alfred's wish for domestic simplicity and tranquility was already routed.

During their early years together, Alfred would attempt to involve

Emmy in his professional life at least at the social level, entertaining colleagues and friends with her at hotels abroad and at home in New York. It was soon clear, however, that although Emmy could spread a pretty table, act the hostess smoothly, and flirt beguilingly with the guests, her talk was often out of sync. Unable to understand either the basics or the drift of their conversations, she soon began complaining peevishly about how boring his friends were.

Following Nathanael Greene's tactics, Alfred resolved to win his war, and his peace, by conceding in the skirmishes. The cost to him would be considerable. The increasingly severe depressions and illnesses he suffered in the early 1900s, although attributed by him publicly to the disloyalties of colleagues and the rigors of his battles defending and advancing his artists, were brought on at least partially by the frustrations of his marriage. Yet, until O'Keeffe stirred him out of his profound emotional lethargy after twenty-five years with Emmy, and brought him the promise of a wholly satisfying relationship, he managed somehow to protect even Emmy from realizing the scope of his disappointment. They fought shrilly, or maintained angry silences, through dinners so excruciating to their daughter, Kitty, that she often telephoned her cousin, Dorothy Obermeyer, as late as seven o'clock with pleas for an immediate rescue invitation. These contretemps, however, Emmy seemed to accept as normal, and Alfred, as the years went by, blamed the pressures of work, the shortages of money, the fragility of his health, the death of his father, the intransigence of his friends, the war, the problems of running a gallery and getting out a magazine, for the diminution of his energy at home, sexual as well as intellectual. They continued a desultory sex life for nearly ten years after Kitty's birth in 1898, but eventually Emmy could not ignore Alfred's involuntary signs of repugnance. She protested that he no longer kissed her; he strove to mitigate his offense with paternal affection and homiletic generalities that could save Emmy her self-esteem.

Undoubtedly, Alfred's ability to maintain any sort of peace at home was made possible by the intensity of his working life. And vice versa. The angers and frustrations with Emmy that he managed to suppress flowed into his energy to battle for his various causes, justified his heavy work load, and powered the intransigent attitudes he maintained in his professional life, attitudes that served not only to advance his influence in a serious way but also to widen his reputation. His colossal drive had to be given expression somewhere; it was his career that benefited.

After the end of the 1894 honeymoon, Alfred's involvement in the

Photochrome Engraving Company drew rapidly to an end. Business activity had plunged even lower than it had been in the first struggling year of the firm's existence; by March 1895, Alfred had turned over his shares to the employees. Joe Obermeyer was the next to withdraw; Lou Schubart held on for ten or more years in a fruitless effort to turn a profit. In the company's first four years, none of the partners drew either a salary or dividends. For Alfred, continued participation would have been madness, especially as Edward's periodic rescues had been cut off by the end of 1894.

Since the 1893 growth of the Populist movement and the first cries of "free silver" had sent disastrous shudders along Wall Street, Edward's income had begun to slide drastically. He had been so concerned about his reduced finances, in fact, that he had returned to work, thinking perhaps that Hahlo & Stieglitz's diminishing profits were due at least partially to mismanagement. He was unable, however, to stem the downward trend, and within a year, during which he was also ill, he again retired, his remaining capital cut in half. Nevertheless, he continued to give Alfred his promised $3,000 annual stipend.

It was not an ungenerous sum, and for the first years of Emmy's and Alfred's marriage, it was adequate for their needs. Lee and Lizzie (my grandparents) had been married in April 1894, and maintained a home and office at 571 Park Avenue—the same apartment building in which Selma and Lou had set up residence with their infant son. They had managed nevertheless to save $1,000 of the $3,000 my grandfather earned in that third year of his practice as a physician. Although Emmy's strong suit was certainly not frugality, as it was my grandmother's, she and Alfred were not exactly pinched.

The work that became the center of Alfred's life after the European honeymoon was as unpaid co-editor of the monthly *American Amateur Photographer*. During the summer of 1894, he had been elected a member of London's "Linked Ring Brotherhood," an informal coalition formed some years earlier in opposition to the conservative Royal Photographic Society. While applying to photography some of the aesthetic rules of painting, the group rejected absolutely the prevailing opinion that photography was a mechanical imitation of painting. Its founders included Frederick H. Evans and J. Craig Annan, future stars of Alfred's own later magazine, *Camera Work*, who were already leaders in an international movement to accord photography the status of an art.

Alfred, his zeal and confidence bolstered by his new association with

the Linked Ring, applied the same principles to works submitted to the *American Amateur Photographer.* He refused to reproduce anything he didn't find first-rate. Later he enjoyed recalling that his rejection slips were ruthlessly terse: "Technically excellent; pictorially rotten." But those who sought his guidance were answered with a more detailed critique. Many were advised to give up photography—and not always kindly—but they were also told why, urged perhaps to paint, or to turn their creative yearnings to some other medium. What the recipient of Alfred's advice gained, then and later, was an uncompromisingly honest evaluation. He began to view his role as that of a teacher; it was a role he would play for the rest of his life.

It is no surprise that his scrappy insistence on high standards placed him in immediate conflict with his colleagues at *American Amateur Photographer.* By the end of the following year, there was so much disagreement that he resigned as editor. It was pointless to remain where his voice would be muted, since he had other platforms from which to speak. Already his passionate letters and articles were appearing regularly in photographic journals in Europe and America, together with reproductions of his photographs. He was a troublemaker to the established order on several accounts. He defended the small hand-held camera as a worthy instrument for recording instants of real life straightforwardly against all the academic tenets of acceptable photography and popular taste. He insisted that only photographers were qualified to judge photographs for exhibition, not the painters who had customarily defined aesthetics. Finally, immune to charges of jealousy—he had already won more than half of the 150 international prizes that eventually would be his—he began to blast the premises on which prize-giving in art—any art—were based. In this iconoclastic mood, he turned his attention to the Society of Amateur Photographers, of which he had been a member since 1891.

Alfred's zeal soon exacerbated conflicts within the society. The old guard consisted of founding members who regarded themselves as an elite facing disaster with the introduction of Eastman's new mass-produced, and cheap, Kodak. Although Alfred scorned the notion that an "easy" instrument could make a photographer of *anybody,* he and others in the society held that photography was just on the threshhold of artistic legitimacy and needed serious practitioners from all economic and social levels. The dress suits, as Alfred referred to the society's disaffected dodos, would be happy to replace photography with any new pastime, so long as it was exclusive: why not start a bicycle club? Indeed, there were rumors

that the New York Camera Club now had a cyclist Fifth Column. The enthusiasts in both groups, as Alfred called the *real* photographers, were appalled; they saw both the society and the Camera Club bound for suicide. A joint committee began exploring amalgamation, and in May 1896, the new Camera Club became a reality.

At first Alfred was fearful that the reconstituted Camera Club would perpetuate some of the faults of its progenitors, concentrating on social functions and raising funds to support darkroom facilities for hobbyist members. He declined nomination to its presidency, wanting no part of the parliamentary games and clubby ceremonies he felt could be better administered by a prominent socialite. What he could not ignore, however, was his own compulsion to spread the word in America about photography as an art, to catch up with, and surpass, the growing importance of the medium in Europe. And the Camera Club possessed a potentially splendid vehicle for his crusade—its journal.

In March 1897, Alfred proposed that the journal, designed originally as a house organ to keep members informed of club proceedings, become an illustrated quarterly with a broadened readership. A thousand copies might be published, rather than the three hundred required for members. By carrying advertisements to cover additional costs and by establishing a per-copy price for nonmember subscribers, the venture would soon be solvent. Given carte blanche as editor and manager, Alfred promised an exciting magazine that would serve not only as official organ of the Camera Club but also as a stimulus to the creativity of outsiders, a means to keep in contact with "everything connected with the progress and elevation of photography" throughout the world.

Alfred's proposal was accepted. He was elected vice-president in charge of publications, and the first issue of *Camera Notes* appeared in July. Its success exceeded even his own expectations. Within months, it was the talk of the international photographic community. In the ensuing five years of his editorship, it would grow to two hundred pages, feature the finest photographs Alfred and his chosen co-workers could assemble, and attract articles from noted art critics as well as writers involved in other forms of literature. From the beginning, Alfred's insistence on editorial independence gave *Camera Notes* a vigorous unity and a high standard of excellence.

He did not limit selection of photographs to the naturalistic and direct expressions that were his own preference, but, for purposes of instruction, gave equal weight to the allegorical and the picturesque, the soft-focus and

the impressionistic. His one criterion was that whatever he chose from American and European photographers should be the best, should be, in his term, alive. He applied rigorous standards also to the printing of the magazine, improving the typography and the quality of paper; wherever possible, the photogravures were made from original negatives. It was a performance that would be topped only by his own later publication, *Camera Work*.

His labors during 1897 were prodigious. Beyond the production of *Camera Notes*, he hand-pulled the photogravures for a portfolio of twelve of his own city scenes from the preceding several years; it was published by R. H. Russell under the title *Picturesque Bits of New York*. He organized and hung exhibitions of works by members in the halls of the Camera Club. And he continued to campaign vigorously for a major public exhibition of top-quality American photographers in an established institution of fine arts.

Not surprisingly, by the first week of the new year he had worked himself into a severe case of pneumonia. For better care, he and Emmy moved from the Savoy to the third floor of brother Lee's newly acquired house at 60 East Sixty-fifth Street; they stayed until August. The trip from exhaustion to illness would not be unusual for Alfred and his siblings. Nearly twenty years later, his mother would admonish him not to overwork, accusing him, as she did Lee and Sel, of stupidity. If they had inherited Pa's energy, she wrote, they didn't know how to handle it: "Pa never broke down, he knew what he could stand."

Alfred often flouted common sense during the early years of his career. Waking on a bitter, snowy night during his convalescence in January 1898, he found the outdoor scene irresistible. Somehow he assembled equipment and donned layers of clothes without disturbing the household, then forged across deserted Fifth Avenue to Central Park's encircling wall and set about capturing another first: night *and* snow. The resulting print, *Icy Night*, was soon known throughout the photographic world.

That frigid night became the occasion also for Alfred's gifted storytelling. His account evoked Peary's struggle to reach the North Pole, battling against a "gale from the northwest" at sub-zero temperatures. Although his photograph bears no trace of raging winds—a clear line of shallow footprints lies placidly undrifted, branches are motionless and shadows stark—the ice-sheathed tree trunks are enough to inspire wonder at his determination to leave his sickbed.

The pressures of producing *Camera Notes* and hanging members' work

at the Club, as well as keeping up with a vast international correspondence, impinged on Alfred's time for his own photography. He would never reach the goal he had set himself to produce a hundred different scenes of the city. Still, he managed an occasional important picture, sold an occasional print, and continued to please the family with snapshots. A portrait of Edward in 1897 elicited his father's grateful praise: "[It will] live & speak of your artistic taste, your poetic mind, good judgment & devotion to your father—." He added that he would gladly subscribe to *Camera Notes*, "which I rec*d* with much delight—it proves to be the finest thing of the sort which ever met my eye—Taste—pure good taste in every feature—!"

When Emmy and Alfred joined the family at Oaklawn in August 1898, the tribe had grown considerably. Selma and Lou had brought their six-year-old son, with nursemaid, for a rest before embarking on a half-year tour of Europe; Lee and Lizzie were there with three-year-old Flora and baby Elizabeth (my mother), also with a nursemaid. Werner and Stieglitz nieces and nephews drifted in and out. Aunt Rosa, wasted by long illness —she would die the following spring at fifty-three—continued to insist that the presence of little ones was good for her. While eight-months-pregnant Emmy issued nervous claims for attention and diversion, Alfred wrote letters, swam, sunbathed, read, walked, and enjoyed Hedwig's reproofs about his self-neglect. He decided that his sister Agnes's fiancé would please him as a brother-in-law. And he refused to become entangled in any family squabbles. It was enough that he was able to keep Emmy and his father pacified. Edward, when he wasn't barking at Hedwig, servants, or children, or making his escape with paints and easel, or having a hard gallop on his mare, took pleasure in walking with his favorite son; at night he drafted Alfred for games of pinochle.

Alfred would need his full energies not only for Emmy's confinement —she was due in September—but also for their late August move to new living quarters. He and Emmy had been largely itinerant since their marriage five years before: a half-year at a hotel, five months in Europe, three months with his parents, a month at the New Jersey shore among Emmy's friends, two more at Lake George, back to a hotel, and so forth. Their most recent home had been Lee's third floor. Now, at last, they would have a full-fledged apartment of their own at 1111 Madison Avenue, where they would remain for twenty years. And Emmy's money would begin to be used in earnest.

The apartment was furnished and decorated largely by Emmy's broth-

ers. Alfred's contribution was primarily in art works, many of them long-time favorites from his parents' home at 14 East Sixtieth Street, which was about to be sold: Edward and Hedwig had decided to narrow their expenses, and would move to the Majestic Hotel on Central Park West the following year. Gradually, some of Alfred's own purchases would join his collection, but most of the original group were brooding, melancholy scenes in dark hues, heavily framed; some were the work of Edward's friends and protégés. All excited comment for years to come from Alfred's artist friends and acquaintances. How was it that a promoter of the avant-garde, as Alfred would soon become, a progressive, hung his walls with examples of the most bourgeois nineteenth-century tastes? Alfred never explained.

The apartment gave Alfred the advantage of a separate study where books and papers and photo materials could be kept, on the strict understanding with Emmy that nothing in it was ever to be disturbed. Such an agreement was necessary, he felt, because of Emmy's compulsions about not only the daily sweeping but also the annual cleaning earthquake. Every fall, with an army of painters and paperhangers and the services of three or more cleaning women, Emmy prepared the apartment for winter. Floors were scraped and refinished, walls redone, furniture repaired, recovered, and polished, closets turned out and their contents cleaned and rearranged. During the first few seasons of the process, she and Alfred and baby Kitty spent a cramped fortnight in a hotel. Later, Hedwig persuaded Alfred that it was a good time for him to bring Kitty to Oaklawn for an extra holiday. Wherever he was, however, he would worry about the expense of the operation, and of its follow-up. When the temporary crew was done, Emmy set about hiring a full-time cook, a chambermaid, and a waitress, as well as two cleaning-persons twice a week; they were seldom the same she had had the year before. Only Kitty's governess, the ubiquitous, dependable, and irritating Clara Lauer, was indispensable; she did not leave until late 1914.

Settling into the apartment in the fall of 1898, and even Kitty's birth on September 27, were events that had to take second place to Alfred's work. In the previous spring, his obstinate efforts to get a fine arts institution to sponsor photography had reached its first stages of success. Now, in October and November, America's oldest art conservatory, the Pennsylvania Academy of Fine Arts, was to show the first large-scale international exhibition in America of photography, with the Photographic Society of Philadelphia as cosponsor. Alfred had been instrumental in

making the selections in the spring; now he would go to Philadelphia to supervise the hanging.

Each new task he performed seemed to generate a further responsibility. Henceforth he would be asked to gather works for exhibition at almost every major photographic salon in America and abroad. Only Boston seemed able to get along without him. In Boston, the eccentric publisher and amateur photographer, F. Holland Day, was photography's early champion and entrepreneur. Alfred, who often chose Day's works for exhibition, refused to acknowledge him as a crusading peer, but conceded that Boston was out of bounds. Day or no Day, it was Alfred who eventually persuaded the Boston Museum of Fine Arts to purchase photographs for its permanent collection, the first museum in the country to take the step.

As his activities had broadened, so, naturally, had Alfred's correspondence—every snapshot enthusiast seemed to know whom to address. His work at the Camera Club grew heavier. There were the monthly "demonstrations" of photographs to select and hang: Alfred disliked calling them exhibitions, preferring to connote experimentation rather than finished products. In May 1899 there would be a retrospective of his own works, consisting of eighty-seven prints. There was a second portfolio of members' photographs to publish by the end of the year. And *Camera Notes* continued to expand. He had already begun to invite the participation of outsiders whose judgment he respected, such as the art critics Sadakichi Hartmann and Charles Caffin and the keen-witted literary critic, John B. Kerfoot. Before the end of 1898, he had brought in two outside photographers, who later became members, to serve as his editorial assistants. Joseph Turner Keiley and Dallet Fuguet would eventually become associate editors of Alfred's own magazine, *Camera Work*, and Caffin and Hartmann, regular contributors.

Not surprisingly, Alfred's recruitment of outsiders rankled with a number of the club's members, especially those who did not share his progressive views. The latter group had been reluctant to grant him the powers he asked even at the beginning, and had done so only to increase the club's recognition and to share effortlessly in associative glory. Now they were being told that their pictures were not good enough to be published, their opinions not worthy of an audience, their abilities inadequate even to the mechanics of putting out a quarterly. Who needed an arty publication anyway? If Stieglitz had to force through membership for outsiders whose support he needed, then even he must realize that he was not

carrying out his first responsibility: to serve the wishes of the founding members of the new Camera Club. Instead, he was using them to further personal ambition, and they would not stand for it.

The first organized attack against Alfred came at a special meeting in October 1900. He emerged victorious, but it was obvious that the war was not over. His antagonists had wrested control of that part of *Camera Notes* pertaining to club activities and, as of February 1901, Alfred would be required to gain the trustees' permission to print reviews of members' work. He retained full control, however, of everything concerning matters of broader interest. It was a stopgap solution, and he was certain that his editorial autonomy would be assaulted again before long. He began to spread word among colleagues and friends of the unwarranted attacks on himself and Keiley during 1900; he wanted them to know that he was not the villain depicted by his detractors.

In 1901, as in many of the following years, he managed to withstand pressures and assaults until June. Then, with a holiday ahead, his mother waiting to cosset him at Lake George, and perhaps the dismal prospect of uninterrupted time with Emmy, Kitty, and her nurse, he succumbed to exhaustion, to one of the periodic illnesses that did not bear a label. The 1901 collapse may have been the first of several episodes characterized by the Stieglitzes as a mental breakdown, of which Alfred's most notable would come in 1904. But the term as they used it needs clarification. A Stieglitz breakdown was not the psychological trauma known to others, but an affliction borne with extravagant endurance by those members of the family whose "nerves" and "sensitivity" marked them for special suffering. No ordinary, common-garden nervous breakdown that burst into flower like a malicious and uncontrollable weed, the Stieglitz variety was a well-fertilized hybrid that merited acclaim. Its equally dramatic conquest lay in "brave" self-appraisal and "ruthless" self-control, in a regeneration of "will." Selma, Alfred, and Lee shared honors in the family for full cultivation of its potentials, with Selma the clear champion; having no engrossing interests to take her mind off herself, she could stretch the performance for months at a time.

Whatever the nature of Alfred's 1901 illness, he was—again, typically —cured by fall, and ready to return to work. He found that the earlier challenge to his authority at the Camera Club was having an effect on him that was contrary to its purpose; instead of inhibiting him, it began to liberate him from a sense of heavy obligation. He had already resigned as vice-president in the spring. Henceforth, he would accept more invitations

to participate in, and to lead, activities beyond the scope of the club. He would prepare more exhibits of American works for European salons. And, although he had been prevented by his own scruples in 1900 from undertaking any major responsibility for the widely acclaimed Chicago Photographic Salon at the Chicago Institute of Fine Arts, there was now no reason why he should turn down an invitation to mount the first such showing in New York, at the National Arts Club on Gramercy Park. He would have sole discretion in the selection and hanging; it would mark another milestone in his career.

Among the photographers whose works Alfred chose was a young man from Milwaukee who was also a painter. Alfred had seen several of Eduard (later Edward) Steichen's prints at the second, 1898, Philadelphia Salon, and three had been exhibited at the Chicago Salon. Alfred now chose fourteen for the National Arts Club show. He had met Steichen only once, in April 1900, when the young man had looked him up at the Camera Club on his way to Paris to further his painting studies. At twenty-one, Steichen had saved enough from four years of work as a poster and advertising designer for a Milwaukee lithography company to finance his passage and a year's stay. If he could find photographic portrait commissions abroad, he would stay longer.

Alfred had been impressed. Not only had he liked Steichen's work—he had bought five prints for his collection—but he had immediately liked him as a person. His European heritage (Steichen had been born in Luxembourg), combined with a strictly American idealism, reminded Alfred of himself as a young man. Clearly too, Steichen enjoyed hard work, had set high standards for himself, and was not afraid to experiment. The fifteen years between them seemed to bridge any question of rivalry; Alfred could think of Steichen as a spiritual son. There was, meanwhile, the excitement of having found a young artist who was both a true painter and a true photographer, combining in one person, and in harmony, the two talents and drives that undiscerning critics termed forever incompatible.

For the 1902 National Arts Club exhibition, Alfred chose the finest examples of the works of those pictorial photographers he had supported actively in the pages of *Camera Notes* and in other salons in which he had taken part. Only a handful were members of the club, and no more than a third were New Yorkers. The others crisscrossed the northern United States from Maine to Oregon. The cohesiveness of the exhibitions arose not only from Alfred's selections, but also from a certain loose and still undefined affinity among the photographers: they were all progressives,

rebels against the photographic establishment. Alfred, charged with finding a title for the exhibition, thought suddenly of the new groups of painters in Germany and Austria who dramatized their break with salon art by calling themselves a secessionist movement. He named the National Arts Club exhibit "The Photo-Secession."

The choice of the term was entirely unpremeditated, and almost as perplexing to Alfred when he thought about it as it was to the photographers it was meant to identify. If they had not thought themselves a group before—most of them had been showing independently for some time, not a few with Day in Boston—the appropriateness of the title was intriguing enough to bring them together in person. Those in New York began to see each other regularly, with Alfred; out-of-towners made a habit of dropping in on him. Soon they were sharing their aims, their problems, their methods.

Among them were the three men Alfred had working with him most closely on *Camera Notes*. Through the fall of 1901 and the early winter of 1902, and in spite of heavy work at the club and for the new exhibition, Alfred often surprised Emmy by bringing Keiley, Fuguet, and John F. Strauss home for dinner. Each time, after dessert, they retired to Alfred's study to talk late into the night. Alfred had begun to enlist their support in founding a new magazine.

By February 1902 they had sketched out a prototype issue. The name, *Camera Work*—to celebrate the "Camera Workers" who were Alfred's "serious" colleagues and followers—had been approved. The magazine's principles would continue to promulgate those of *Camera Notes*, supporting the free, the experimental, the individual expression of photographers whose excellence and spirit were exemplified by the Photo-Secession exhibitors at the National Arts Club.

In May, within weeks of the opening of the exhibit, Alfred sent notice to the trustees of the Camera Club that he would resign as editor of their quarterly as soon as he had wound up Volume VI, Number 1. In the hands of his successor, it would last only three more issues. He had already pulled together a basic subscription list for *Camera Work*, and had chosen a printer; the engravings would be entrusted to his old company, under the direction of his Schubart brother-in-law.

June found Alfred in high spirits. He took off for the Jersey shore with Emmeline, four-year-old Kitty, Clara, and camera, and resumed the chronicle of Kitty's development that he had begun, and exhibited in 1900 in London, as *The Photographic Journal of a Baby*.

Katherine (Kitty)
Stieglitz, ca. 1900
Alfred Stieglitz

Once again, however, Alfred's overwork had lowered his resistance. At Lake George in July, he became seriously ill. This time, it seems, the ailment was not psychogenic, and his convalescence was protracted. By the end of August, however, when Steichen, with whom he had maintained a steady correspondence, returned from Paris, Alfred urged him to come to Oaklawn for a working holiday. Steichen was assigned the task of designing the front and back covers for *Camera Work*; throughout the magazine's fifteen years, the back would be an ad for Eastman. Alfred was so pleased with the results that he asked Steichen to collaborate with him on the layout and the typography.

Steichen's quiet demeanor, his extraordinary good looks, his gallantry with Hedwig, and his deference to Edward won him extravagant praise from the Stieglitz family. Alfred was congratulated daily on the virtues of his new young friend, who, in turn, was urged to adopt the elder Stieglitzes as his New York parents. Hedwig was especially grateful that Alfred would have vigorous help in his new venture; perhaps he would learn at last to take care of himself.

The coming year looked brighter than any that had come before. Approaching thirty-nine, and already referring to himself as an old man,

Alfred was about to set out on his second independent career. He would continue to photograph, but, he thought, at a reduced rate. Henceforth, he would be primarily a publisher. At last he would reap the rewards of freedom from the jealous intrigues that had hobbled him as an editor for eight years. And *Camera Work*, with nearly 650 subscriptions in hand before the first issue had been entirely conceived, would be a success financially as well as in substance. It would be the finest art publication that the world had seen.

10

However much Alfred's idealism demanded that *Camera Work* be carried out as a cooperative venture, there is no question that his voice was dominant, both editorially and managerially. The degree to which he deluded himself about the modesty of his role was in direct proportion to the degree of his later suffering and shock when he was accused—as finally he was, almost as much by some of his artist-associates as he had been by his enemies in the Camera Club—of despotism.

Alfred believed sincerely that what he sought were not followers but counterparts, a team of equals who shared principles and tastes by natural, self-generated inclination, and who were endowed with the energy to carry them forward. He encouraged philosophical and artistic controversy among his fellows, believing that their often heated arguments offered signs of life and proof of independence within a democratic and cooperative framework. If, ultimately, it was he who decided what was to be printed or rejected, it was, he insisted, only because the decisions had to be made by someone, and because he was willing to accept the responsibility. Why would anyone call him dictatorial for that?

Disregarding the emotionalism that later attended both Alfred's outraged pleas of innocence and the charges levelled against him—at one point he likened himself to Dreyfus—it is clear that the claims of friends-turned-adversaries had some validity. To begin with, he *knew* that most of the time he was right in whatever he decided. He was as utterly convinced of the reliability of his discernment and the validity of his strategies to enable photography, and later modern art, to attain the standing each merited as once he had been of his prowess as a long-distance runner, leader of games, billiards champion. In the second place, he possessed real power. His international prominence as a photographer, reinforced by his growing reputation as a publisher and entrepreneur, had by the close of 1902 imbued him with a strength that it would have been almost impos-

sible to avoid either flaunting or, occasionally, misusing, however unconsciously.

It was not simply the power of his position that affected others; his intrinsic dynamism was awesome. He maintained—legitimately, for the most part—that despite the pride he took in being contentious and even belligerent vis-à-vis the world at large, with his co-workers he was patience and moderation personified. Yet even his quiet composure could backfire —to the insecure, he seemed condescending.

Furthermore, his insistence on honesty was hazardous, sometimes crossing the fine line that separates exploring the truth with others from wronging them. Although sensitized in his childhood by his father's self-righteously unjust castigations of his mother, Alfred was relentlessly outspoken about the quality of work produced by the men who were his intimates; they ought to be able to take it. The drive for perfection that had been his motivating force since early childhood was a trait he felt all true workers should share. If they showed an occasional disinclination to confront their weaknesses, or work hard, or try something new, he was quick to set them straight. It was not an entirely endearing practice.

His exhortations might have been easier for them to take if they had been able, even sporadically, to accuse him of shirking his self-appointed tasks. But the fact was that, already in 1903, he was carrying out three simultaneous functions, all of them effectively. He was *Camera Work*'s publisher and editor in chief, as well as its proofreader and mailing clerk— who, in the course of fifteen years, he would later recall, personally wrapped and sent out some 35,000 copies, many of them registered. He was impresario of the Photo-Secessionists' exhibitions throughout Europe and the United States. He continued still to be an archivist and collector of photographic images he considered seminal and/or historically important. And, by 1905, he was also the full-time, unpaid director of a gallery founded, with Steichen, to display the works of the Photo-Secession.

Any one of these enterprises might have kept a less prodigiously energetic man fully occupied, but Alfred undertook as well to continue his campaigns in the press to forward acceptance of photography as a serious art, and to further his own photographic work, on however limited a scale his busy days and nights permitted. Meanwhile, and always, there were the problems at home to deal with, problems that now included not only Emmy's complaints about the nightly mess Alfred and his cohorts made of her dining table with *Camera Work* copy, and his indifference to everything she enjoyed, but also the ineptitude she exhibited as a mother.

It might have been different if Emmy could have been more genuinely and more contentedly occupied with their daughter. Unfortunately, motherhood filled Emmy with terror from the start. When Kitty's appetite fell off during teething, Emmy wailed "baby . . . [is] fading away! . . . [and] Lee doesn't know how . . . to save her." (Lee, on his part, would have been delighted to be replaced as Kitty's and her physician; Emmy's panics elicited more rage from him than sympathy.) Every time Alfred was away, Emmy wrote him of her fear of having sole responsibility for Kitty, a circumstance that almost never prevailed, as Kitty had had a live-in nurse from infancy through her fourth year, and thereafter a *Fräulein* who remained with the family until she was sixteen. Alfred, hoping perhaps that exposing his adored "Kits" to his extended family at Oaklawn from time to time and to his own well-intentioned if not very effective fathering would ameliorate the confusion of the child's seesaw between a hysterical mother and an inflexible governess, did what he could to maintain peace by acceding to most of Emmy's demands at home. He would not, however, curtail his working hours.

Organizationally, *Camera Work* proceeded smoothly through its first two years. Alfred had enlisted as associate editors the three men who had served in the same capacity on *Camera Notes* at the Camera Club: Dallet Fuguet, Joseph Turner Keiley, and John Francis Strauss, all amateur photographers and none a threat to Alfred's authority. Fuguet contributed both catch-all articles and verses to the periodical; Strauss wrote (or signed) only one piece and remained, apparently, in the background until his unexplained resignation sometime in 1910–11. A fourth joined the group in 1905: J. B. (John Barrett) Kerfoot, a lighthanded parodist, who stayed to *Camera Work*'s end.

The man who became Alfred's closest friend and ally was Keiley, an idealistic lawyer involved with impecunious clients and radical causes; he spent years trying to seat a radical friend, in a peaceful coup, as president of Mexico. Working closely with Alfred, Keiley took on not only legal and quasi-legal problems, but also the handling of correspondence with contributors, jobbers, advertisers, and subscribers when Alfred was away on a working sortie or a vacation. It was not until 1912 that Keiley was relieved of these latter duties when Marie Rapp (later Boursault), a lively, intelligent, and sensitive girl, was hired part-time. Her appeal to Alfred would far outreach her secretarial functions; she would remain a friend for the rest of his life.

Keiley was a frequent contributor of articles to *Camera Work*, on a

broad variety of subjects. Beyond his official tasks, he was also the unofficial annalist of the Photo-Secession, a judge and codesigner with Alfred of many photographic exhibits in the United States, and a prodigious worker in seeking new contributors and subscribers, especially in England in 1909, where he was the fourth American—after Alfred, Steichen, and Clarence White—to be elected to London's Linked Ring. One of only two men who collaborated with Alfred photographically (the other was White), Keiley was as widely acclaimed for his pictorial talents as for his writing. His affinities with Alfred included a penchant for philosophizing— especially along lines drawn by Henri Bergson—a pastime they indulged often at Oaklawn. He was accepted by the family almost as warmly as Steichen, except by Emmy, who resentfully tore up every photograph he took of her. Only five years younger than Alfred, Keiley was nevertheless content to play a completely subsidiary role. In response, Alfred's affection for him transcended that of mentor for disciple. After Keiley's terminal illness and death in 1914, Alfred referred to him as perhaps the best friend he had ever had.

The first test of Keiley's effectiveness as Alfred's surrogate came in *Camera Work*'s second summer. Alfred was ill in Europe, and Keiley assumed full responsibility for keeping things running in New York. The winter and spring of 1904 had been nerve-wracking for Alfred. In addition to readying two issues of the quarterly, producing a limited-edition set of five of his photogravures, and, with the help of Keiley, Coburn, and Steichen, mounting two major exhibitions of the Photo-Secession at the Corcoran Gallery in Washington, D.C., in January and at the Carnegie Art Galleries in Pittsburgh in February, Alfred had experienced for the first time the vituperative resistance of two of his regular contributors, Roland Rood and Sadakichi Hartmann.

Rood had been infuriated by "orders . . . from Steichen [to] laud him as *the* great gum worker . . . to show him my manuscripts." He resented as well what he interpreted as Alfred's insistence that whatever he wrote for *Camera Work* must "support" the group. This time Alfred managed, at considerable cost to his physical well-being, to heal the rift, and Rood resumed writing for the quarterly. After two years, however, he exploded again, repeated his earlier charges, and promised that he would use whatever new "freedom" Alfred granted him to "run you up [in your magazine] and in others run you down, and that without ever contradicting myself." To this second round, Alfred replied with a sarcastic blast that ended their association for good.

Alfred was far more deeply hurt by the intransigence of Hartmann, an erratically brilliant experimenter in all the literary arts and a prototypical Bohemian, for he had regarded him as a special protégé since the days of *Camera Notes*. In the spring of 1904, Hartmann began to publish a running attack on Alfred that climaxed in the summer, leading Keiley to promise Alfred a defense in print that would see Hartmann "tried, convicted, executed and burned." Sickened by the battle, Alfred turned down his paladin and confined his defenses to answering individual queries from editors around the country about Hartmann's reliability. Seven years later, against Keiley's express advice, Alfred would effect a reconciliation that brought Hartmann back to writing regularly for *Camera Work* until its demise in 1917. (The only major critic sympathetic to Alfred's goals to last the full life of the magazine was Charles Caffin. Three others who were personally fond of Alfred but discomfited by much that he did were Benjamin de Casseres, Arthur Hoeber, and James Huneker. All were quoted often in *Camera Work*; de Casseres, like Caffin, contributed a number of special articles.)

Not surprisingly, Alfred was ill intermittently throughout the spring of 1904. When he and his family arrived in Europe in June, he was forced to cancel his working itinerary and go to a clinic in Berlin for a month. It was this crisis that would later be described ambiguously by Alfred and others as both the most serious illness and the worst breakdown of his life.

There are grounds for suspecting, however, that Alfred was not as critically ill as he and his family broadcast. Nervously clinging Emmy was easily persuaded to take Kitty to Stuttgart to visit elderly relatives while he remained in Dr. Boas's clinic, and her major concern throughout the month was how to take care of his eye trouble and constipation when he was released. Furthermore, despite his suffering, in late June he managed more than one sortie for business purposes. Although he wrote Keiley that the first three-day expedition was strictly against his doctor's orders, it had been arranged, in fact, with the latter's compliance. Released from the clinic in early July, Alfred proceeded to Igls, a small resort outside Innsbruck, where he resumed his original plan to meet his colleague and friend, Frank Eugene. Although Alfred described himself in letters as barely able to stand, and was grateful that Dr. Raab, an old family standby who had looked after his parents in Carlsbad, was also in Igls, before the first week was out he and Eugene were photographing side by side. By August he was catching up on his regular circuit of salon viewing, photograph collect-

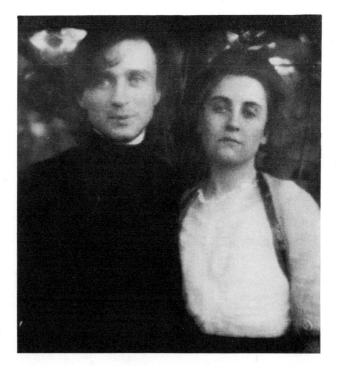

*Eduard and
Clara Steichen,
Oaklawn, (?), 1903*
Eduard J. Steichen

ing, and exhibition planning. In London for a fortnight after touching base with Steichen in Paris, leaving Emmy and Kitty to await delivery of their couture clothes, he followed a heavy schedule and still had time and energy to carry out some of Emmy's shopping demands.

Cured physically by summer's end, he was revisited by worries about increasing friction among the Photo-Secessionists' "stars." He had already had trouble with some of the general members, whose vastly unequal talents generated little that was worthy of publication. As there was prestige and potential monetary gain in having prints appear in *Camera Work*, it was not long before a considerable number of dues-paying members began to wonder why so few of them gained even a page for a single print when others, primarily Gertrude Käsebier, Clarence White, and Steichen, received constant and multiple exposure. Now two of these three were apparently causing trouble. Keiley's regular reports during the summer had referred more than once to a streak of unreliability in Steichen. "Be careful with him," he had warned; "he exaggerates." Käsebier had earned Keiley's censure for blacklisting Alfred's brother-in-law Lou Schubart after

Lou refused to comply with her demand that, as jobber for reproducing prints for *Camera Work*, he "make pulls of her Camera Work things to sell," a clear infringement of Photo-Secession rules.

Alfred was alarmed less by Keiley's cautionings than by his over-zealous stewardship. Their personal relations remained as warm as ever, but Keiley was never again accorded powers to act in Alfred's behalf without close consultation. *Camera Work*—if not necessarily the Photo-Secession—was too important to be jeopardized by an overprotective friend.

Important as *Camera Work* was to Alfred and to its thousand or more subscribers in 1904, during its fifteen tumultuous years it became enor-mously more important to a whole generation of practitioners and sup-porters of the arts. It was a potent force not only in forwarding photography as a serious medium, but also in defining and encouraging the development of twentieth-century modernism in all the arts. As an entity, the periodical has been analyzed more profoundly and described more extensively else-where; here, it merits at least a brief overview.

Between 1903 and 1907, *Camera Work* was devoted primarily to photography. It reported on an international scale the advances being made in the field, featuring superbly reproduced plates and technical guidance as well as lively critiques. Even its advertisements (some de-signed by Steichen and Alfred) were simultaneously striking in design and paradigmatic of restrained good taste. It offered a chronicle, however in-complete, of the development of photography from David Octavius Hill in the 1850s through Steichen at the cusp of the twentieth century to Paul Strand in its second decade, spanning virtually the entire range of serious photography's coming of age.

From 1907 to 1917, *Camera Work* reproduced art works from other media and anthologized reviews of pertinent exhibitions; after 1911, ex-cept in special issues devoted to individual photographers, few photo-graphic prints appeared. In its final decade, it served also as midwife to a modern and genuinely American art and literature, printing in its pages examples of the avant-garde in satire, criticism, poetry, and commentary, as well as in painting, sculpture, drawing, and caricature. Contributors from both sides of the Atlantic filled its pages with radical and often contentious spirit, spurring American artists to reach for new frontiers. A generous leavening of self-mockery rescued it most of the time from indi-gestible solemnity.

A simple listing of the reproduction processes used in *Camera Work* will give some idea of its unique pictorial quality: photogravure, duogravure, hand-toned photogravure, halftone, colored halftone, two-color, three-color, and four-color halftone, duplex halftone, collotype, colored collotype, and two-color letter-press. Typography was often hand-crafted. Sometimes, although not as often as Alfred's self-congratulation implied, the reproductions of photographs outstripped the originals in quality. Alfred's earlier firsthand experience in printing proved its worth: he supervised personally the vast majority of photographic pulls.

Writers who appeared in *Camera Work*'s pages included, among many others of note, George Bernard Shaw (whose photographs were also represented), Maurice Maeterlinck, Oscar Wilde, H. G. Wells, Henri Bergson, and—for the first time in America—Gertrude Stein. Articles by photographers on techniques and aesthetics were regular features, as were the appraisals of art critics Charles Caffin, Benjamin de Casseres, Sadakichi Hartmann, Hutchins Hapgood, H. B. Kerfoot, Roland Rood, and others—men who were all read widely in more commercial publications. Finally, members of the Photo-Secession—and later artists appearing at the gallery founded in its name in 1905—were encouraged to write whenever they had something to say, regardless of topic.

The Little Galleries of the Photo-Secession at 291 Fifth Avenue came into existence almost as haphazardly as had the group for which it was named. Alfred and Steichen later described the reasons that underlay its founding in somewhat different terms, but they agreed that it was initially Steichen's idea to lease space in New York to show photographs that had drawn interested audiences throughout Europe as well as in Chicago, Philadelphia, and Pittsburgh, among which most of the American works had been done by Photo-Secessionists. Both men had been disconsolate over the amount of energy they spent trying to get New York art galleries or institutions to show photography; space of their own, they felt, would solve many problems.

After their friendship had ended, Alfred attributed Steichen's suggestion largely to his fear that the recent attack Alfred had launched against the low standards of socialite Curtis Bell's planned "massive" photo exhibition at the latter's Salon Club would jeopardize Steichen's ability to obtain portrait commissions from New York's old families and the new millionaires whose support Bell had enlisted. Steichen's later recollection was that he had from the start envisioned the showing of photography in

juxtaposition with other media, an enterprise that would be easier to arrange at their own gallery than at others whose proprietors were resistant to the concept.

Whatever the impetus, they agreed that the studio Steichen was about to vacate at 291 Fifth Avenue in favor of a larger one in the adjoining building at 293, together with two tiny rooms that were contiguous, would make an ideal little gallery. Alfred agreed to try it for a year. It was Steichen who designed and carried out the elegantly simple decor, Alfred who paid for it. Operating expenses, it was decided later by the Secessionists, would be covered by their dues, by a small share, to be determined by each member, of whatever they might realize from the sale of prints, and by contributions from outsiders. Discounting the dues, it was fundamentally the same arrangement Alfred would make with the artists he showed for the remainder of his life.

For a considerable time, Alfred was the gallery's lone angel, but he deemed his money well spent. In addition to providing a setting for exhibitions, the new space offered improved working conditions for putting out *Camera Work* and gave him at last, as full-time gallery manager, justification for spending his days away from home. Furthermore, Emmy—probably to avoid complicating her household with unpredictable dinners—gave Alfred an allowance of sorts specifically to take his cohorts and cronies to lunch at the nearby Holland House, starting a Stieglitz Round Table that persisted in one form or another until the last few years of his life.

Not surprisingly, the start of the decline in *Camera Work*'s readership coincided with the introduction of the works of nonphotographic artists—not only because some of them were legitimately avant-garde, but because they were simply new to the periodical's primarily American, and photo-centered, audience. Alfred's new commitment in 1907 to including in *Camera Work* artists active in other media marked, paradoxically, both the beginning of the end of the magazine and its most exciting and seminal period. With the first offerings of sketches by Rodin, Matisse, and Toulouse-Lautrec between 1907 and 1909, subscriptions fell off by half. Matisse's first appearance in 1907 was characterized by readers as outrageous and immoral. Concomitantly, the literary pieces began to be more abstract and demanding, further offending subscribers; they became increasingly infuriated by "their" magazine's new eclecticism.

Critics in the daily press villified the new entries almost as emotionally as did subscribers. Controversy and cancellations arose with the introduction of each new artist. Among those who received their first American

showing under Alfred's wing were, in sequence, Rodin, Matisse, De Zayas, Marin, Toulouse-Lautrec, Rousseau, Cézanne, Picasso, Dove, Picabia, Brancusi, Braque, Nadelman, Severini, and O'Keeffe. Significantly, all but the last five were introduced by Alfred before the celebrated Armory Show of 1913 that is still credited by many with launching modern art in America. By the time the quarterly *Camera Work* (down to just one issue in each of its last two years) ceased publication in 1917, there were only thirty-eight subscribers. In addition to controversy, the magazine had been deprived by the intervention of World War I of both its sizable European readership and the technical brilliance of German and Austrian printers and materials. Both *Camera Work* and its offshoot, the magazine *291*, a more radical counterpart begun in 1915 under Alfred's supervision and sponsorship that lasted only ten issues, wound up literally on the scrap heap in 1917. Eight thousand copies of *291*'s final issue, in which Alfred's most famous photograph, *The Steerage*, had been meticulously enlarged and reproduced on what Alfred called "gorgeous" Imperial Japan paper, brought $5.80 from a scrap dealer. It was harder for Alfred to throw away *Camera Work*. Some issues he managed to sell at fractional rates; others—odd numbers, incomplete sets, overruns, volumes raided of prints that could be sold separately—wound up in crates in the attics at Lake George. Over the years their number dwindled as Alfred awarded a copy now and then to an appreciative visitor.

Although Alfred chose most of the photographs that appeared in *Camera Work*, in almost every issue there was at least one work that exemplified a direction he found personally unconvincing but which he defended as an honest experiment. He honored consistently his promise to present what he considered the best efforts of the Fellows and Associate Members of the Photo-Secession as examples of what might be achieved in pictorial photography. The term, which was at first a catchall used to describe the three major trends in artistic photography current in the first decade of the twentieth century, became confusing in the second. Its initial meaning covered, first, the story-telling tableaux and genre pictures inherited from an earlier period; second, the slightly soft-focus but otherwise "straight" naturalistic images in the vein of Corot or Constable; and third, a more modern attempt to emulate Impressionism by eliminating detail through manipulation of the camera's focus and applying to both plates and prints the pen scratches, brush strokes, gum emulsions, and glycerine that achieved a more painterly effect. Eventually, the term *pictorial photography* took on a fourth and far narrower meaning. Briefly, and confusingly,

it was used to identify the works of the Photo-Pictorialists of America, a reactionary group formed expressly to repudiate the tenets of the Photo-Secession.

There has been considerable controversy over Alfred's personal preferences in photographic method, especially as he himself experimented a few times in altering prints with extrinsic materials between 1898 and 1907. In addition, both the larger measure of space accorded to manipulated prints in *Camera Work* and his earnest defense of their validity, as well as their predominance among the works he bought during the period, seem to attest to a bias in their favor.

Nevertheless, all of his later recollections insisted that, from the start, his inner conviction was that gimmickry was opposed to truth in art, and that he had always been faithful to the most direct possible means of expression. It should not be forgotten that he was a trained chemist, and his curiosity thus led him to grasp opportunities to experiment in photography, to find out what he was capable of producing and by what means, testing the results of others' works against his own. Surely some of his celebration of the wealth of new processes which surfaced during the ten years he played with them derived from the excitement of the scientist. In any event, his manipulations were on a modest scale, barely distinguishable except to a connoisseur from his straight soft-focus prints of the period. Although he praised the venturesome French for their skill and daring, he never went in for their excesses. By 1914, he had rejected the fad entirely. He wrote to a photographic hopeful that the fad for techniques that used oils and gums and blurring tissues to produce "so-called pictorial photography"—for which "diabolical performance," he fumed, *he* was being credited—was in fact meaningless to him, lacking in "living truth."

As early as 1906, responding to letters from subscribers questioning *Camera Work*'s selections, he felt compelled to run an editorial reminder of the quarterly's principles. Although on this occasion applied to articles, the statement was equally valid where photographs were concerned. "Our policy," it read, "consists in printing any point of view or any idea, whether we approve of it or not, provided such point of view or such idea appears to have behind it some gray matter of brain. It seems that some persons believed that the fact of our printing implied our tacit approval. Nothing is further from the truth . . ."

The matter of Alfred's taste in art in general and in photography in particular has spawned considerable confusion; it bears closer examina-

tion. While he himself eschewed discussing aesthetics per se, deploring all attempts at classification that were not clearly scientific, his sometimes oblique remarks in free-flowing sessions among artist and writer habitués of his galleries, together with his own photographs and the art works he chose to collect, provide valid clues to his preferences, and to his growth.

With few exceptions, Alfred's childhood, youthful, and even early adult tastes in art mirrored those of his parents. Edward and Hedwig lined their walls with family portraits, with the works of Edward's protégés, and with brooding landscapes that seemed to illustrate yearnings of the heart. Many of them were swathed in mists; most held a hint of an impending storm, an aura of incipient tragedy. Pastoral scenes featured often a lone toiling or dreaming figure. In portraits, eyes seemed on the brink of tears; even when the mouth curved toward a smile, it was sad, conveying wistfulness or resignation. In a word, they were Victorian.

Prominent among the works from Alfred's parents' collection that found their way to his first home were a plaster cast of the hugely ugly Biblical Judith by Moses Ezekiel—Edward, who owned his protégé's original marble, had had copies made for each of his children; a lithograph of Lenbach's portrait of Duse; and a gravure of Böcklin's *Isle of the Dead* that wound up in the waiting room of my grandfather's office. I used to ponder its effect on his already anxious patients.

Among Alfred's own selections during his early marriage were two large allegorical nudes that Steichen remembered seeing featured in Alfred's apartment living room. They were copies of paintings by his contemporary, the German *Sezession* artist Franz von Stuck. One portrayed a woman, with suitably tortured expression, in the coils of a lustful serpent; in the other, a rapacious Sphinx-woman held a blanched male in her blood-dripping claws. Aside from their shock value, which Alfred surely enjoyed, they were undoubtedly also thinly disguised illustrations of his own eroticism. Perhaps the photograph of a Rubens nude, which may have been the same Alfred had worshipped in the Vienna museum, had been placed by him in his and Emmy's bedroom as inspiration, however short-lived.

To some extent, Edward's own paintings belied the somber nature of those of other artists in his home. His palette was more optimistic, although muted in tone. Nevertheless, the romantic prevailed, and his landscapes bespoke an affinity with English, German, and mid-nineteenth-century American pastoral painting. The same might apply to Alfred's early photographic landscapes, except that here and there a tentative state-

ment, almost a note, forecast some of the quality that would characterize his later sequence of cloud pictures, the *Equivalents*, which were celebrations of an exalted, albeit mysterious, release that rejected any ties to Victorian sentimentality. Most of Alfred's self-portraits, on the other hand, were linear descendants of Victorian romanticism; some of them were even more intense and brooding than the portraits in his parents' home.

Romanticism notwithstanding, Alfred's early genre photographs—from Europe in the eighties, New York in the nineties, Europe in 1898, and both locales in the first decade of the twentieth century—often proclaimed a move toward harsher realism; sentimentality was already being abandoned to the eloquence of "real," naked, faces. By the time Alfred had undertaken a new round of portraits in the late teens, all traces of Victorian soft-pedalling had vanished.

Alfred's lack of a formal education in art may have bound him overlong to his parents' aesthetic coattails, but it also saved him from myopic allegiance to prevailing academic views. From his earliest days he had been an observer, on his own. Accumulating independent impressions, it was easier for him to abandon the predominantly nineteenth-century tastes that followed him into the twentieth century than it might otherwise have been. His seemingly quantum leap, beginning in 1907, toward the European Post-Impressionists and their successors was not entirely surprising.

Steichen liked to believe that he not only introduced Alfred to modern art but also taught him to appreciate it. At various times other artists gathering at 291, as the Little Galleries of the Photo-Secession came soon to be known, saw themselves as similar guides. That there was a modicum of validity to their claims is incontestable, but Alfred's own explanation of the rapid evolution of his tastes, in the form of an analogy, appears the most likely. In 1912, he wrote a puzzled friend that, musical though he was said to be, Bach had meant almost nothing to him until, after years of listening to and absorbing good music, there came a day when suddenly he found Bach "standing at my door, a revelation of beauty and simplicity."

Certainly Alfred's receptivity to new currents was of vital importance to the highly individualistic American artists he championed. If, after the early 1930s, his loyalty to a handful of them became obstinately exclusive, he may be forgiven. He was nearing seventy.

Before 1930, when Alfred turned sixty-six, I had been taken several times by my parents to see works by their special friends on exhibit in his Intimate Gallery at the Anderson Galleries, the successor to 291. I had been the target of his awesome photographic concentration. And I had

been allowed occasional hand-scrubbed investigations, monitored always by an elder, of pictures in my grandfather's collection of *Camera Work*. Nevertheless, until the early 1930s, I had little conception of Alfred's eminence. At Lake George, the amused and somewhat condescending attitude displayed toward him by his brothers and sister Selma, the frowns with which, in his and O'Keeffe's presence, they censored references to anyone's monied success, even the contrast between his rumpled clothing and their crisp tailoring, seemed to proclaim him a failure. The absence of my parents (who supported Alfred's view that money was irrelevant), the silence of my grandmother (who was rudderless in Alfred's artistic sea), the aloofness of O'Keeffe, and Alfred's own shrugging insouciance lent further credence to the impression. It was not until 1932 or 1933, when I was ten or eleven years old, that I began to sense the deep respect in which he was held even by the artist and writer friends who visited him at Lake George; it would take considerably longer for me to learn that references to a worldwide reputation were not hyperbole. The greatest surprise to me was the importance of *Camera Work*, which the family had mentioned seldom, and Alfred never, in my presence.

Among his summer visitors, there was usually one in residence—sometimes, during the Depression years, two, for Alfred and Georgia were unstintingly generous to out-of-pocket friends—and a fairly steady sprinkling of dinner guests as well, resident at a nearby inn for a night or a season. When I was nearing thirteen, I was invited occasionally to sit in on ritual after-dinner seminars under Alfred's direction. On one such evening, someone mentioned having seen robed-and-sandalled Raymond Duncan outside the Fifty-seventh Street Automat, the thirties haunt of the Stieglitz group when he was not available to take them to lunch. The talk wandered from Raymond to his sister Isadora, and then to an excursion into the relationship of her dance to painting. Disagreement surfaced about an article on the subject in *Camera Work* over twenty years before. To settle the dispute, Alfred dispatched the nimblest of the company—my father, by then a summer resident—to the attic to find the article in question. I followed him, inquisitive about this normally off-limits area.

In the glare of a swaying blue bulb, canvases hid their faces against the rafters, and oddments of furniture, battered luggage, trunks, and rolled-up rugs huddled under a ghostly film of dust. A network of tiny footprint trails converged at the large wooden chest that was Dad's goal. Inside it a minute silky nest and a heap of nibbled grey shreds from *Camera Work*'s soft covers attested to its tenant's cozy winter (the pages were mercifully

intact). Putting aside the purpose of his errand and muttering imprecations, Dad waved me down the steep stairs and prepared to confront Alfred with news of the invasion. I was even more apprehensive than he.

Alfred laughed, so freely and robustly that the tears came. "There, you see?" he gasped. "My marvelous, beautiful, *important* work is still food for thought! For fools like us, and a sensible mouse!"

Aware of the intensity of the fifteen years of painstaking effort, the exhilaration and the anguish that Alfred had expended on *Camera Work*, his audience was taken aback by his offhand response. Was he dissembling? No, he seemed genuinely amused. Apparently, too, he was disinclined on a peaceful evening to rehash the battles that had torn him apart in the *Camera Work*/291 years.

And battles there had been. Large or small, Alfred's quarrels with most of his fellow Photo-Secessionists were rooted primarily in differences in values. Alfred believed passionately that an artist could fulfill his promise only if his goals excluded all thought of monetary reward. If a work, completed without accommodation to popular taste, were later to be sold to support the artist in his next wholly independent attempt to produce the finest of which he was capable, that was splendid; an artist had to live. But on no account could the anticipation of a sale determine the nature of the creation. That, to Alfred, was so serious a breach that it amounted to something worse than prostitution; it was blasphemy.

Few in the Photo-Secession, as may be imagined, were as devout in this belief as he. Many who had begun photography as a hobby started, as their work became better known through the salon exhibitions that Alfred promoted, to turn professional. In the process some, inevitably, lowered their sights. As a first step, Alfred attempted to win a backslider's understanding through pointing out how calamitous such a course could be to self-realization. If persuasion failed, a sterner lecture ensued. If that, too, failed, the apostate risked castigation and eventual excommunication. Alfred was not alone in his purist view; many of his colleagues stood firm with him. But he was, as usual, the primary target of the resentment and eventual enmity of the "defectors," a growing contingency that, by 1912, included two of the founding Fellows, Käsebier and White; later, Steichen would join the ranks.

From time to time, the wrangles became public, some making headlines in the press. Attacks and counterattacks were often intense—friends became foes, a few of them for life. In one way or another, all the adversaries based their quarrels on Alfred's despotism.

As late as the 1930s, fifteen and more years after the events, Alfred's replays to friends, interviewers, and sometimes the most casual of acquaintances, people who had wandered into his gallery, were peppered with denunciations of the perfidy of erstwhile friends and colleagues. In his own eyes, he had been a martyr to philistinism, jealousy, and blindness to his aims. By the forties, when a succession of heart attacks had convinced him that excitement was unwise, he had schooled himself to let go whatever—and whoever—was no longer relevant to him. Storage, he said, was expensive, and possessiveness, futile. But even early in *Camera Work*'s existence, he experienced periods of profound despair, during which he pronounced himself a total failure.

The despair was generally hidden from his associates; with them, he claimed overwork or illness as the root of his more-than-occasional depressions. Apparently, however, he shared his deepest fears with his father, still seeking reassurances from the man whose approval he had worked so hard as a child to gain. Edward, answering one of his despairing letters in 1907, wrote: "Permit me to contradict you . . . You have chosen a profession, & you have excelled, & become a leader . . . Is this a fact? or not? . . . I know you like to portrait [sic] yourself [a failure] . . . at times, & I must let you enjoy that pleasure. But if this will give you any comfort, & I know it will not, there are *others* who consider *at times* their life a failure . . ." Edward was quick to recognize the penchant for self-dramatization in his children, especially in his favorites, Alfred and Selma. It is doubtful he recognized the same proclivity in himself.

The contretemps with members of the Photo-Secession were the major cause of Alfred's despair when he wrote his father in July 1907. Discussion over amateurism or purity of motive was only half the issue. The other half, almost as potent, concerned the short shrift many members felt they were receiving both in the pages of *Camera Work* and on the walls of "their" gallery.

The opening exhibition at 291 Fifth Avenue in November 1905 had been, satisfyingly, a group show of the works of thirty-nine members. The ensuing exhibitions of the season—through April 1906—which had alternated works of European photographers with those of only four Secession members, were acceptable but a little less satisfying. The next season began again with a palliating group show of members' work, but in January 1907 there came the offense of a one-woman exhibition of drawings, which Alfred called anti-photography—a major offense. The subsequent four shows of the season were barely an improvement: of the six pho-

tographers represented, one had been catapulted overnight from non-membership to the lofty inner circle of the Fellows—while most members were still waiting out their apprenticeship—and a second was not a member at all. Disaffection among the general membership spread like wildfire. Most had already suffered exclusion from the pages of *Camera Work*, and now the gallery, which their dues were in part designed to support, was treating them the same way. Dues as well as subscriptions fell away.

By May of 1907, the financing both of the two-year-old gallery, for which Alfred had such high hopes, and of *Camera Work*, began to seem doomed. He could barely bring himself to send out bills to forgetful members, whose collective support, in any event, amounted to less than $400 a year. His faith in the Photo-Secession—and, by extension, in photographers in general—was at a dismal low.

To add to his woes as publisher and gallery director, Alfred had experienced difficulty in his first attempts in Europe in late June with the new Lumière color plates; until he learned from Steichen and from his own experiments later in the summer how to prevent "frilling," he was deeply frustrated. Only the realization that he carried in his luggage one "perfect" negative—a picture taken of the crowded steerage while evading Emmy in their steamer's ludicrously lavish first class—kept Alfred from despair with his photography.

The depressingly familiar problems of his marriage continued; for the moment, the most nagging was the financial drain that European summers imposed. His working travels alone were modest, but Kitty's governess's way must be paid, and Emmy's extravagances exceeded by far not only his basic allowance to her but her own funds as well. She had already had one extra week in Paris on her own that summer—to cover the races, the couturiers, and the theater with friends. A second week there with Kitty before their September return to New York could bring disaster. Alfred made a discreet inquiry of Edward about the state of the stock market, perhaps with fingers crossed that his father might volunteer a bonus beyond his usual allowance, but Edward's succinct reply, "Wall Street! I better [not] touch that quarter," dashed any hope he might have had.

Indeed, for Edward and Hedwig, the 1907 summer was filled with calamity. To begin with, the market panic earlier in the year, the worst between 1873 and 1929, had buffeted Edward's investments severely. His several hurried trips to New York in June and early July to try to salvage what he could met with only limited success, and by the end of the year,

Emmy and Kitty
Stieglitz, 1904
Eduard J. Steichen

his capital would be reduced to half what it had been the previous December. Furthermore, Hedwig was seriously ill. A first kidney attack had precipitated plans to go to Carlsbad for a repeat of the cure she had taken two years earlier with Edward, but a second attack in early August necessitated immediate surgery in New York. Knowing Edward's impatience with illness, she insisted he return to Lake George to oversee the customary full house at Oaklawn. He moved at once to the Farmhouse, where he could escape noisy children and fidgety nursemaids, delighted to have quiet pinochle evenings with two gentlemen friends. When Hedwig finally came to the lake in September, she was accompanied by a nurse. It was probably in the fall of 1907 that, responding to their need to reduce expenses, they gave up their apartment and their servants at the Majestic Towers in favor of smaller quarters at the New Weston Hotel.

Despite his earlier despair, by the end of the summer Alfred's spirits had recovered. London's reception of Steichen's Lumière plates was ecstatic, as was its reception of his own and Frank Eugene's July experiments in color. Coming home on the *Kaiser Wilhelm II*, he experienced three "marvelous sensations" within the space of an hour: a demonstration of Marconi's wireless telegraphy, a recorded concert of absent piano virtuosi performed on the liner's new Welte-Mignon player piano, and a look again at "those unbelievable color photographs!"

Four days after landing, Alfred called a press conference to show how splendid Lumière's autochrome process could be in the hands of masterful photographers—Steichen, Eugene, and himself. His description of its wonders had been printed in midsummer in London's *Photography* magazine: "remarkably truthful color . . . wonderful luminosity of shadows . . . endless range of grays . . . richness of . . . deep colors." He had not been able to resist adding: "The difference between the results that will be obtained [by] the artistic fine feeling and the everyday blind will even be [sic] greater in color than in monochrome. Heaven have pity on us."

Getting out the fall issue of *Camera Work*, readying the next, and mounting the six-week exhibition of the Photo-Secessionists' work went without incident. Alfred's excitement was reserved for the January 1908 opening of the Rodin color-wash drawings that Steichen had just brought from Paris. He was not disappointed. Soon he was defending the works against the scorn of press, public, and art schools. One fiery session with students and teachers from the Art Students League drove young Georgia O'Keeffe, on her first visit to 291, into a remote corner.

Public controversy over what he was showing delighted him; it was healthy. What was happening behind the scenes was something else again. In January he had a series of letters from the trustees of the Camera Club demanding his resignation, without stated cause. He ignored them. In February he received notice from the landlord that the lease for the galleries would not be renewed unless Alfred would guarantee four years at twice the rent. The notification came at a disastrous moment. He had already had to make up, out of his own pocket, deficits produced by the Photo-Secession members' defaults in dues—and Edward's cornucopia had dried up. He thought he would have to close the galleries, just when they seemed to offer him more exciting rewards than anything other than his camera had ever done before.

But young Paul Haviland, the French head in America of the Limoges porcelain works that bore his surname, and a gallery regular as well as a

photographer, had just decided to remain in the States after finishing studies at Harvard. He offered a $1,500 guarantee for a three-year lease of the premises across the hall from the first gallery. Alfred, unwilling to let him carry the whole burden, was inspired to gather a group of friends to share the costs. By the time The Little Galleries had to vacate the original rooms to make way for a ladies' custom tailor, a new fifteen-by-fifteen-foot room with a skylighted corridor, a long closet, and a bathroom-*cum*-darkroom was ready to occupy. It was, in fact, at 293 Fifth Avenue, but was entered through 291: an opening had been broken through their abutting walls, and a single elevator served both buildings. This was the moment chosen by Alfred and his friends to name the new exhibition space officially what it had long been called informally—291.

In early February the Camera Club fracas came to a head. The trustees, charging Alfred loosely with "conduct prejudicial to the welfare and interests of the Club," expelled him. Alfred treated the matter as a joke until it made headlines in *The New York Times*—then he sued. The Camera Club, in decline ever since Alfred's founding of the Photo-Secession and *Camera Work*, had acted out of last-ditch pique. In March, the State Supreme Court ordered it to admit publicly the illegality of its action. The club reinstated Alfred as a life member and Alfred promptly resigned. The whole episode was reviewed triumphantly in *Camera Work*'s April issue, coincident with the gallery's most dramatic bombshell to date, the American debut of Henri Matisse.

The summer, too, was filled with drama. Trying to save funds, Alfred decided to skip their usual early weeks at the Jersey shore and bring Emmy, Kitty, and Fräulein Clara to Oaklawn in June. Predictably, Emmy was bored, irritable, and contentious. To make matters worse, in late July Kitty had a sudden acute attack of appendicitis. Lacking time to get her safely to a hospital, Lee commandeered the renowned surgeon Dr. Willy Meyer, vacationing nearby, to perform an emergency operation on the dining table. With Lee administering the anaesthesia, his wife, Lizzie, handling the dressings until she had to take the lamp from Agnes's fainting husband, and Kitty's cousins trembling in the upstairs hall, Alfred took hysterical Emmy as far from the scene as he could. Kitty recovered well, but Emmy did not. She fought with the servants, the children, Hedwig, and even the mild Engelhards. Not-so-mild Lee responded to her charge that "he too raised a row" with " 'I am the son of the house, who are you?' "— ignoring not only Alfred's primogeniture but also his brotherhood. Alfred, who had tried to keep a low profile, was asked finally to send her away. On

the night after her departure, she wrote him from New York: "Thank God I am going to Elberon! . . . Were it not for Kitty, not one of [your family] would *ever* see me again!" Alfred thanked his stars that he would have his gallery to return to when all were back in the city.

The annual group show of Photo-Secessionists that opened the new premises in December 1908 was to be the last of its kind. Already Alfred had begun to think of the widely dispersed membership as fundamentally separate from him, slow to pick up his lead, and resistant to his efforts to expand their vision. Through his new right hand, Paul Haviland, he tried again. The January 1909 issue of *Camera Work* carried Haviland's announcement that the new function of both the gallery and the periodical would be to act as "champion [of] modern tendencies" in all the arts. Haviland, an articulate, attractive, and tasteful man, was also diplomatic. He was welcomed wholeheartedly to Alfred's inner circle. Within a year, he was writing reviews and articles on a wide variety of subjects; within two, he seemed the natural choice to replace the resigning John Francis Strauss as an associate editor. Both Haviland and Alfred continued trying to convince photographers that they had much to learn from modern art, but among the nine ensuing exhibitions of the 1908–9 season, only three were devoted to photographs, and each of these was a one-man show. In one of the others, caricatures and photographs hung side by side. The remaining five ranged from drawings to oils, with one-man shows for each of three young Americans—Alfred Maurer, John Marin, and Marsden Hartley. Fortunately for Alfred, the season's final show, selections from a private collection of Japanese prints, required little exertion from him. His father was terminally ill.

For several years, Edward's health had been deteriorating. Visits to spas had done little to alleviate his increasingly severe attacks of the gout, and even less to counteract his decades of rich cuisine, glorious wines, and segars. By late April of 1909, his kidneys were so deeply affected that a friend wrote Hedwig: "Edward's groans and your sad face 'haunted' me for days." On May 24, two days before his twin sons' forty-second birthday, Edward died. He was seventy-six years old.

Condolences to Hedwig arrived from many parts of the world. Somewhat unexpectedly, given the circumstances, the eulogist at his funeral deplored the extremes of an artistic temperament that led Edward to charm those he found attractive and chastise those he didn't. Insisting that "his genial side . . . did not really represent him at his best, nor was the side presented to those who did not interest him as bad as it

Edward Stieglitz,
Oaklawn, ca. 1907
Alfred Stieglitz

might seem," the speaker celebrated "the keynote of his nature . . . charity . . . No one, friend or stranger, in search of advise [sic] and aid would appeal to him in vain. It was then that the dreamer, the enthusiast, the extremist, became the philosopher, friend and guide."

Alfred's reaction goes unrecorded except for Kitty's report to a friend that he was looking ill. He did not change his plans to take the family again to Europe in June: they sailed a few days after Hedwig went numbly to Lake George to resume her annual duties as housemother. She, writing him in early July, reported that she was "feeling better, but so disconsolate . . . miss Pa terribly." Two weeks later, her patience and stamina sorely tried by a melodrama starring Selma and her husband, she wrote again. "I miss him [Pa], his advice, his good sense. I don't miss his moods." She had decided, she added, "to live alone with maid, keep true to myself, and do what I said for years—"

Whatever she had said she would do, by the end of the summer she had taken rooms for the season at the eight-year-old Hotel Fourteen on East Sixtieth Street, the site of the home Edward had built for his family thirty-eight years earlier. For the remaining years of her life, she parcelled out her love, her worries over health, and her advice in slightly unequal shares to her children. From mid-October to mid-May, she stayed in New York, attending theater, opera, and concerts as often as her modest income from Edward's trust would allow. During the other five months she presided over children, grandchildren, nieces, nephews, cousins, in-laws, and guests at Oaklawn. Loosening ties with Edward's male friends at the lake—among them some of the co-founders, with him, of the Lake George Country Club in 1907—she concentrated her energies on entertaining the family, their guests, and a few of her closest friends. The house, once hushed to ward off Edward's temper tantrums, now became, under her sole reign, a pavilion of entertainments. Rugs were rolled back for dancing. Her grandchildren were encouraged to produce and perform a broad repertoire of operas, with doll puppets and elaborate scenery, costumes and lighting, and my grandmother as orchestra at the piano, making substitutions when she found the music dull or outré. Selma's new admirer, Enrico Caruso, a frequent guest, shouted "Clear the stage!" at the close of every scene, but was only occasionally persuaded to take over an aria. On other evenings, trios, quartets, and vocal recitals filled the air with music.

Beneath her sociability and her preoccupation with the trivia of household management and the health of her offspring, however, two seemingly incompatible strains in Hedwig had gained strength over the years: a basic pessimism about life's meaning, and an unquenchable belief in the magic of love and laughter. Ever since the deaths of her daughter Flora in 1890 and her father in 1896, Hedwig's ruminations about ethics and values, antipodal to those held by Emmy and even by her daughter Selma, had found a sympathetic audience only in Alfred. Now, with the death of her worldly and impatient husband, Heddy's romantic dreams found a focus in Alfred. Somehow, somewhere, she felt, there must be a woman to bring him personal joy. She began to sing the praises of the unattached young women who came to her notice, notably her longtime favorite, Maggie Foord Bonner, recently widowed. Perhaps Emmy could be unseated.

11

Alfred's immediate reaction to Edward's death went unrecorded. Nevertheless, it is hard to imagine that he did not spend some time evaluating his relationship with him. Whether or not he realized fully the extent to which he had measured his own worth against that of his archetypal father, he was surely aware of some of the qualities they shared: passionate honesty of purpose, generosity to those in need, and an insatiable appetite for conversation. Furthermore, judging from the change of direction in his interests that Alfred, at forty-five, embarked on that summer, he must also have brooded over Edward's radical shift from business to the serious pursuit of painting and the arts at the age of forty-eight.

Alfred's long battle to place photography in partnership with other arts was drawing to a close. He still wanted the final victory of assurance that henceforth museums would recognize the parity, but he had found few photographers worthy of such recognition. Many were becoming not only complacent but venal, not only shallow but retrogressive. They had begun popularizing their goals. Worse, they were beginning to institutionalize, to look backward, to prescribe rules, to bind themselves and the future of their art in doctrinaire chains that were every bit as damaging to their progress as those of the painting academies.

Alfred was not alone in his concern. For several years his correspondence with colleagues abroad had reflected a similar disaffection on their part; everywhere there were signs of the inertia of the entrenched. In Paris, Munich, Vienna, and London, the latter-day members of early pioneering groups were proudly celebrating their sterility—a fact that Alfred had already taken into account in 1907 when he had refused, for the first time, to send the Linked Ring in London a selection of Photo-Secession work for its summer salon. Whereas his European friends had expressed their confidence in continued American vigor, Alfred, to his vast discouragement, knew better. His own attempts to challenge the otiose members of the Photo-Secession with the innovative works of artists in other media

had been stubbornly resisted by all except his closest photographic allies, a mere handful. If he were to continue as he had in the past two years, he would find himself with two miserable, and doomed, functions: to force the Photo-Secessionists to reappraise their goals, and to patch the wounded egos of those in whose work he could find little merit. It was time to retire, to regroup his resources, and to set off in a new direction, as his father had done in 1881.

It would take time, perhaps a year or more, but the move was inevitable. He had already regretted succumbing two years earlier, when the first tidal waves of antagonism to the inclusion in *Camera Work* of other arts had struck, to the pleas of friends to continue publication of the quarterly. Now he would justify that continuation by concentrating on the other arts, by providing in its pages a showcase and a forum for artists who were alive, not moribund. Photography had earned a back seat.

Probably it was this line of thought that prompted Alfred to spend more time in Paris, a city he had disliked heartily ever since his honeymoon. It was, after all, the center of the new art. When Alfred, Emmy, and Kitty landed on June 21, they were met by Steichen, who acted as Alfred's guide to the art world of which he was a part during the nearly three weeks the Stieglitzes remained in the capital city.

Steichen began his assignment with a visit to the Michael Steins, whose large collection of Matisse and others Alfred found extraordinary. The following day, they went to visit Stein's sister Gertrude and brother Leo at the rue de Fleurus. There, as Alfred later recalled, he saw El Grecos, Cézannes, and Renoirs in profusion—forgetting until two years later when he visited Picasso in his studio that his works were also in evidence—and listened spellbound to Leo Stein's evaluations of Rodin, Whistler, and the old masters. Steichen, he recounted, was aghast and terrified by Stein's insistence that Matisse (whom he thought a far better sculptor than painter) was a far better sculptor than Rodin, who—together with Steichen's other idol, Whistler—was, in any event, only second- or third-rate. The encounter so excited Alfred that he immediately offered Stein space for anything he might care to write for *Camera Work*, an offer Stein declined on the grounds that he was too busy refining a philosophy of art to take on other work. In Alfred's recollection of that first meeting, Gertrude Stein was simply a stolid figure expressing, remarkably, a silent understanding of everything that was said. He had not caught her name.

Alfred next prevailed on Steichen to take him to the studios of members of the New Society of American Artists in Paris, an anti-establish-

ment coalition Steichen had been instrumental in founding the year before. Among them were two artists whose paintings, selected by Steichen, had been shown recently at 291. Alfred Maurer, the son of a Currier & Ives illustrator friend of Edward's, had leaped from conventional painting to the colorful splashes of the Fauves only two years before. The other artist, John Marin, had begun to find, at about the same time, that watercolors were more congenial to him than the etchings that had been his specialty. In the interim, his works had grown increasingly bold in their departure from strict representation.

To his astonishment, Alfred preferred Marin's more radical works to those Steichen had selected earlier for New York. He urged Marin to forget his sometime agent's counsel to produce salable commodities, and to concentrate instead on freeing himself of all restrictions. To his further astonishment, he heard himself promise Marin that 291 would exhibit whatever works of his he cared to entrust to it, beginning with a one-man show in the coming spring. His promise, and his friendship, would hold for thirty-seven years.

Following the urgings of Max Weber, a young American artist he had met through Marsden Hartley in New York, Alfred sought to extend his acquaintance with the works of other avant-garde painters in Paris whom Steichen neither knew well nor liked. On Weber's advice, too, he saw the African art at the Trocadero and the Oriental collection at the Musée Guimet. For once, Paris was so full for him that he almost regretted having promised to share a fortnight at Bad Homburg with friends while Kitty accompanied Governess Clara to her home in Tieffenstein, Bavaria. Except for a single day and night in Dresden on business, Alfred did not again escape Emmy's insistent presence until she, Kitty, and Clara were assembled at suffocatingly chic Marienbad. Then he was off for a rendez-vous with his favorite aunt—Hedwig's youngest sister, Ida Small—and her daughter and son in Bad Homburg. Disappointed that cousin Flick (Flora) had rushed to Paris for an impromptu whirl with the Steichens, he found compensation in a brief spree with younger cousin Herbert, an antically witty violinist and would-be composer. Both savored the instant crowds drawn to Alfred's performances at the billiard table, among them an admiring Grand Duke Nicholas of Russia.

Alfred's visit with the Smalls was cut short by a summons from Emmy. She had just received the scandalous news that his sister Selma's husband of seventeen years was penniless. Lou Schubart, too craven during Edward's lifetime to confess that in asking for Selma's hand he had reported

*Selma Stieglitz
Schubart, ca. 1908*
Alfred or Leopold
Stieglitz

double the income he actually possessed, had supported Sel's extravagance
and a tottering business during all the years of their marriage on a dimin-
ishing capital and the proceeds of loans. By January 1909, he had ex-
hausted collateral; six months later he was bankrupt.

Faced with the shattering revelation on the very eve of her customary
biennial tour of the capital cities and spas of Europe, hysterical Sel com-
mandeered her men. Brother Lee, barely recovered from a hernia opera-
tion, was summoned to attend her medical needs; brother-in-law Herbert
Engelhard, to offer legal advice; Joe Obermeyer, her lifelong suitor, to hold
her hand; and poor supernumerary Lou, to take the full blast of her fury.
For four days they were in round-the-clock attendance. Then they deliv-
ered her, collapsing, into her mother's arms at Oaklawn. Alfred was
profoundly grateful to have been too far away to be enlisted.

Hedwig, fearful for Sel's health and provoked by her histrionics, con-
fessed to Alfred that she was outraged by her daughter's materialism and

her shrieks about what *she* had lost; she ought to have been comforting her husband, who had suffered quite enough for his lies. Nor was Hedwig entirely in accord with the men's proposed solution to the problem. They would move sixteen-year-old Howard Schubart to Uncle Lee's for proper guidance, for a chance to finish school, and for a quiet home from which to seek work and start paying off his father's debts. And they would support one of two proposals Selma thought appropriate for her future: to "go to Paris to study—and economize there," or to move with Lou into "bachelor quarters" in New York where she might be "free of housekeeping." They agreed she needed a few months in Europe—paid for, probably, by dear Joe Obermeyer—to recover from her "nervous breakdown" and make up her mind.

Alfred was able for several weeks to evade contact with Sel, and as soon as Emmy seemed pacified, he took off for Munich to see his photographer friend, Frank Eugene. There they were joined by another long-time colleague, Heinrich Kuehn—a leader in Austrian photography, exhibitor at the Photo-Secession galleries, and pioneer in color printing research. Steichen came from Paris. For two feverish days the four men experimented with Lumière color; then they repaired to Baden-Baden to argue and laugh and celebrate temporary bachelorhood. There, by Steichen's prearrangement, they bumped into another old friend, Baron Adolph de Meyer. Alfred and de Meyer had not been face-to-face before, although they had been regular correspondents for three years. Alfred had known his works since 1894, had begun buying them in 1906, and had already mounted two de Meyer shows in New York. They were delighted with each other, and de Meyer was invited to travel with the others to Dresden to see Kuehn's selection of works—dominated by the Fellows of the Photo-Secession—for a section of the new International Photographic exposition in that city.

Alfred relayed his enthusiasm about de Meyer to Keiley so vividly that the latter, who had himself been extravagant in praise when he had met de Meyer six months earlier, now aimed a faintly jealous arrow in his direction: "His chiefest [sic] fault from our point of view is that he's inclined to talk too d----d much."

In de Meyer, the predeliction to "talk too much" was a grace; it clothed a nimble talent for diplomacy. As his friendship with Alfred grew, he proved often his ability to salve the wounds Alfred and his once-close associates inflicted on each other in increasing number and severity. If most of de Meyer's patching efforts later came apart, at least he succeeded

in making day-to-day life more bearable. For more than eight years, spanning the First World War, he lived and worked in New York. Close to both Alfred and Steichen, de Meyer with his delicate tact played a major role in postponing the inevitable rift between these two friends; it was a grievous disappointment to him that ultimately he failed. At least a part of the credit for reviving Alfred's enthusiasm for photography in the summer of 1909 belonged to this sophisticated, merry, and talented favorite of European high society, portraitist of kings.

Two more dutiful weeks at Marienbad came to an end when Alfred escorted Emmy to Paris for her round of social pleasures and took Kitty and Clara to Tutzing, a tiny rustic resort a short distance from Munich. There he had ten days' peace with Frank Eugene, and without Emmy. Back in Paris only a week, he was besieged with letters from sister Sel, just arrived in London. Would he meet her, anywhere, alone, so that she could "God—talk to you—and *tell you*—and make things clear . . ." When they met in Paris-Plage on September 22, Alfred, experienced in dealing with hysterics, apparently alternated clarifying sternness with soothing phrases of sympathy. Of these, the most welcome to Sel's ears was his assurance that she and he were *terribly* alike, especially in their susceptibility to spiritual suffering. It was the consequence, he told her, of their unique sensitivity.

Then, and for the remainder of his life, Alfred's feelings about this hypersensitive sister swung between extremes: tender when she seemed most helpless, infuriated when her bids for attention rendered her, as their cousin Flick put it succinctly, "gross." His fights with her were often intense melodramas, calling on the services of an intermediary to resolve. For the most part, the subject of their mutual fury was the style in which Selma lived, supported for the rest of her days by indulgent Joe and her remarkably successful banker son. Alfred attacked her nonstop party-giving in Tiffany-decorated surroundings as frivolous, wasteful, and exhausting ostentation—just what Emmy wanted—and Sel defended her soirées as miniature Chautauquas, feasts of culture. Disapproving though he was of her standards, however, Alfred never stopped prodding her to express herself in writing; more than once, he rewarded her mediocre efforts by printing them in *Camera Work*. Astonishingly, he managed to express pride in the two thin and embarrassingly adolescent volumes of poems and stories she produced in vanity editions in 1924 and 1934. Even more astonishingly, they were not unanimously dismissed by the critics.

Having accorded Sel's 1909 agonies appropriate attention, Alfred re-

alized that—far more important to him—his own goals had achieved new clarification during the summer. The lessons of Paris in June, and again in September, had made him more determined than ever to shock the American critics and public into awareness of the revolutions that were taking place in Europe in etching, drawing, painting, and sculpture. Further, with shows at 291, and discussions in *Camera Work* of the new conceptual possibilities these revolutions were engendering, Alfred intended also to challenge American artists to stretch their frontiers. The season's second exhibit at 291 was the first in America of the works of Toulouse-Lautrec, lithographs from among those Alfred had just begun to collect. They would demonstrate a principle he was now eager to instill in American artists, including photographers: even work done to fill commercial requirements could be true to the artist's purpose if the artist were strong enough to stick to his guns.

Thanks to Kuehn's exhibition in Dresden, the work with Eugene, and the meeting with de Meyer, Alfred's enthusiasm for photography had been rekindled. By the end of October, he was ready to accept a second invitation from the Albright Gallery in Buffalo to mount a comprehensive international show; he had turned down the first in the spring on the grounds that he was unwilling to assemble a repeat performance of the Photo-Secessionists. The sudden death of the curator, Charles Kurtz, and his replacement by young Cornelia Sage were probably also instrumental in changing Alfred's mind. The November afternoon she spent with him at 291 sealed the arrangement, an afternoon she referred to afterwards with the grateful confession that, in him, she had "found a friend . . . in tune with my innermost thoughts." It was not a unique denouement.

Throughout his mature years, and increasingly as the years went by, Alfred was unable to resist initiating a kind of unspecific seduction when confronted by a woman he found attractive, especially if she was young. Abstract conversation would glide subtly toward the personal, the intimate, to the accompaniment of a softening of eyes and voice. Soon his listener would find herself unconsciously making a corresponding effort to charm, to exchange soulful affinities. As a result, Alfred's vision of the idealized woman was reinforced and his unwitting accomplice was both captivated and newly self-confident. Miss Sage's meeting with Alfred seems, at least in part, to have fallen into this category.

Whatever the personal chemistry involved, Alfred's enthusiasm for the Albright task was high. He would make the Buffalo exhibition the finest the world had seen. It would consist of the best pictures in existence,

spanning a broad period in which the development of individual artists as well as the history of photography would be traced. The visitor would move from Alfred's own unmatchable collection of international works to the contemporary giants. He would enlist critic Charles Caffin, photographer Clarence White, and painter Max Weber to act as co-judges. Haviland and Weber would help with the physical hanging of the show.

But that was almost a year away. Meanwhile, 291 had an exciting and varied calendar. A low-key curtain raiser of drawings and monotypes preceded Alfred's prized Toulouse-Lautrecs in December; the artist was featured in the January *Camera Work*. Steichen's wonderful new works in color were the only photographs of the entire season. Marin came from Paris to help mount his one-man show of seventy-one pieces, mostly watercolors. He stayed long enough to be newly bewitched by the Brooklyn Bridge—a subject for the rest of his life—and to be drawn firmly into the Holland House Round Table.

That group's character had changed significantly since its earlier days. The only old-timers remaining were *Camera Work*'s editors and its loyal critic, Charles Caffin. The new blood included only one photographer, Paul Haviland. All the rest, from roughly 1909 on, were artists in other media and writers. When Marin joined the group, Max Weber and Marius De Zayas, a brilliant caricaturist who emigrated from Mexico during the dictatorship of Porfirio Diaz, were almost daily lunchers. Within a year, Haviland and De Zayas, with a third recent recruit, would be Alfred's most powerful supporters at 291. The third, currently studying in Paris at Alfred's and Steichen's urging, was Agnes Ernst, a beautiful young reporter for the New York *Morning Sun* who had spent six hours interviewing Alfred during the run of the first Matisse show in April 1908.

Matisse's second show now included, with drawings in which minimal line was enlivened by color washes, photographs of paintings done between 1905 and 1908. Although these were in black and white, and failed utterly to do justice to his palette, they introduced some of Matisse's most important and revolutionary works to an American audience only slightly more hostile than its Paris equivalent.

In March, Alfred mounted a show of works by the heterogeneous Younger American Painters in Paris, a group that ranged from the relatively conservative (D. Putnam Brinley) to the extremely radical (Max Weber). What was most telling about the exhibition was that, on his own, Alfred had added pieces by two other American painters: Marsden Hartley, whom he had exhibited first the preceding May, and Arthur Dove,

whom he had met at 291 only three months earlier. Dove would become not only the closest of Alfred's confidants but the second, following Marin, of his Big Three (the third would be Georgia O'Keeffe), the artists to whom he would offer annual one-man shows for the rest of his days.

Rounding out the 1909–10 season with another one-man show of Rodin's drawings and watercolors, and a presentation of caricatures by De Zayas, Alfred provoked both a new storm of protest from the Photo-Secession's general membership, and a new spate of cancellations of *Camera Work* subscriptions. The tone of angry suspicion was so intense that it provoked Paul Haviland to administer a scolding in the July 1910 issue of the quarterly. Pointing out both that throughout the year the magazine had offered photographic prints almost exclusively as illustration—the only exceptions had been four caricatures and a flyer by De Zayas—and that the announcement of the impending Buffalo exhibition offered "complete vindication of the fact that the interests of photography have never been lost sight of by the Director of the Photo-Secession" and by those characterized pejoratively by the readership as "That Bunch at 291," Haviland exhorted: "Those photographers who hope and desire to improve their work can derive more benefit from following the modern evolution of other media than by watching eternally their own bellies like the fakirs of India."

Most of Alfred's summer went into preparing the Albright exhibition. At Deal Beach with his family, he was joined several days a week by Max Weber, who had for several months functioned as Alfred's right hand. In midwinter, Alfred had rescued Weber from disaster when the latter was evicted from his studio. He had arranged with 291's neighbor, decorator Stephen B. Lawrence, for Weber to live temporarily in the latter's workroom; he had invited him frequently to share family meals at home; and he had provided direct financial aid. Weber, in gratitude, worked long hours at the gallery, labored industriously over the Buffalo exhibit, and insisted on giving Alfred's daughter, Kitty, drawing lessons during the summer. Kitty was not delighted. She wrote her cousins Elizabeth and Flora (my mother and her sister): "Mr. Weber's an artist and he comes here nearly every week for a couple of days so he gives me drawing lessons, don't like him at all."

Kitty's aversion notwithstanding, Alfred enjoyed Weber's feisty independence. He realized further that at the younger man's hands he was receiving substantive instruction in avant-garde art. In his more than three years in Paris, Weber had developed a vast and spirited eclecticism—in his painting, in his interest in African and oriental art, and in his friends, who

included from time to time most of the leading figures in the Paris art world; his education was the most advanced and copious of anyone in Alfred's circle. Far outstripping in knowledge and foresight what Steichen had to offer, Weber persuaded Alfred to include in his already startling opening show—lithographs by Cézanne, Renoir, Manet, and Toulouse-Lautrec and paintings and drawings by Rodin—the first showing anywhere of works by his recently deceased friend Henri (the Douanier) Rousseau. Weber's small collection—the same that would represent Rousseau two years later at the "First" International Show at New York's 69th Regiment Armory—aroused more intense scorn than that accorded Matisse's debut.

Effective though he was as a prophetic cicerone, Weber earned the hearty dislike of the 291 regulars. Almost without exception, they found him obnoxious: opinionated, rude, intolerant. Not only had he become vituperative about his erstwhile heroes, Picasso and Matisse, whom they were just beginning to discover, but he was unrelentingly scornful of Steichen's output, photographs as well as paintings. During his tumultuous year of association with 291, the only artists for whom he could find praise were Cézanne, Rousseau, and himself. His only lasting friendship, on a personal, as distinguished from an artistic, level, was with Abraham Walkowitz, who had traveled with him in Europe and roomed with him in New York, and who continued to weather the storms of Weber's intolerance even after Weber departed the Stieglitz circle. It may even have been Weber's tirades that led Walkowitz in 1911 or 1912 to press Hartley for an introduction to the "villainous" Stieglitz. The upshot was a warm association that lasted six years, and thereafter waned and waxed at varying intervals.

Weber's and Alfred's intense friendship came to an explosive end in early 1911, a few months after the opening of the Albright exhibition in late November 1910, and only a month after Alfred had given Weber a one-man show at 291 in January. Both exhibitions played a role in the finale.

The Buffalo show had been mounted with great excitement. Alfred was convinced it would be a knock-out. The preparation had involved huge effort on his part, more than he had expended on any other single exhibit. Possibly he recognized subconsciously that it would be his swansong for the Photo-Secession, as he had realized consciously that his patience with the group was running out. For the first time, the major participants were accorded biographical sketches in the catalogue, setting the tone for an explicitly historical point of view. Moreover, the catalogue proclaimed

grandiosely that the exhibition would "sum up the development and progress of photography as a means of pictorial expression."

Had Alfred called the show, more appropriately, a vehicle for "international Secessionists," the event might have been the brilliant success he envisioned. As it was, both his title, an "International Exhibition of Pictorial Photography," and the exclusionary bias of his selections proved monumental gaffes. He had divided the show into two parts. The "Invitation Section" was made up of his accumulation of the works of international luminaries and Photo-Secessionists, with a few later prints added; the "Open Section" was left to those outside the pale, a vast number of photographers, renowned and obscure, who had not joined the Photo-Secession membership because they were either indifferent or openly antagonistic to it. Some were defectors. The show's design was fair enough; the product was egregious inequity. Not only did the "Invitation" section outweigh the "Open" by a ratio of three to one, but within the former a mere fifteen photographers copped 342 of 355 slots, ranging from forty works by David Octavius Hill (produced, in fact, with Robert Adamson, who went unmentioned) to sixteen by Frederick H. Evans; Steichen's thirty and Alfred's twenty-nine ran second and third to Hill. The Open Section, meant to accommodate all other photographers, comprised only 124 prints, few of them noteworthy.

The offended "rejects" were legion. And the exhibition's title precipitated a public furor that was far-reaching in its effects. To use the term *pictorial photography* to feature the rivals of the anti-Stieglitz Photo-Pictorialists of America (PPA) seemed deliberate effrontery. Letters and articles in the press excoriating Alfred kept the issue boiling for weeks. It was not long before both Clarence White—a judge, with Alfred, of the show—and Gertrude Käsebier joined the PPA.

Weber's often abrasive pronouncements that Steichen was inferior to both White and his expatriate colleague Alvin Langdon Coburn (another later defector from Alfred's camp) had already excited the rage of the 291 loyalists. Early in 1911, he began to denounce the Albright show that he himself had helped to prepare. His "treachery" notwithstanding, Alfred honored his promise to give Weber a one-man show at 291 in January. Weber hung the show, but did not attend the opening. Alfred's insistence that, in all honesty, he could not charge up to $1,000 for pictures done on cardboard in impermanent colors—prices that Weber insisted were his due—touched off an argument that quickly went out of control. Weber stormed out, swearing that he would never come back. Although he did, in

fact, return for a single visit at the end of the show, it was not to make peace but to reclaim his works. He had sold only one picture, and that to a detested 291 insider, Agnes Ernst, married a few months earlier to the young financier, Eugene Meyer, Jr. Thereafter, he and Alfred were implacable foes. In subsequent years, when Weber was busy exaggerating his role at 291 and denigrating Alfred's, the mere mention of Weber's name elicited from Alfred a response that would be equaled in vitriol, after another debacle, by the mention of only one other name: Steichen.

Alfred's answer to the personal denunciations that followed the Albright show was to devote most of the January issue of *Camera Work* to a defense of its viability and historical importance. With justifiable pride, it was pointed out that the Albright directors had been persuaded by the show to approve the purchase of photographs for its permanent collection, the first such acquisition in America and a clear tribute to the Photo-Secessionists. Nonetheless, the illustrations in the same issue featured not an American but an Austrian, Heinrich Kuehn. And the ensuing numbers of *Camera Work* became showcases for those few photographers who embraced Alfred's new eclecticism. The Photo-Secession as an entity was in its dotage; in another year, it was dead.

Meanwhile, Weber's exit from the scene—greeted with huzzas by 291's new supporting threesome, Haviland, De Zayas, and Agnes Ernst Meyer—was quickly forgotten at the gallery. In February, Marin's new watercolors garnered cautious praise in the press, and in March, the most abstract paintings yet exhibited at 291—twenty Cézanne watercolors shown for the first time in America—moved the critics to heated public debate. The next artist, however, was the season's real shocker: Pablo Picasso's American debut in April offered eighty-three drawings and watercolors, the majority of them recent ventures in Cubism. To Alfred's disappointment, only two were sold. The drawing he himself bought was so controversial that his purchase received newspaper coverage; the other, also a drawing, had been done when Picasso was twelve. Alfred's appeal to the Metropolitan Museum to acquire the remaining Picassos as the nucleus of a future collection was greeted with derision, as were his efforts to persuade the same institution to buy Cézanne and Van Gogh. The Metropolitan's turndown in each case was as contemptuous as had been its refusal to start a photography collection some years earlier. It is no surprise that Alfred thereafter regarded the Metropolitan as a mausoleum honoring not artists but dead benefactors.

The 1911 spring had been so active, and so economically unproduc-

tive, that, for the first time, *Camera Work*'s April and July issues were merged. Although there were articles dealing with the gallery's shows, most of Number 34/35 was devoted to drawings by Rodin and to Steichen's photographs of the artist and his massive Balzac sculptures. Alfred would meet Rodin, finally, during his summer trip abroad, which would turn out to be his last to Europe. Money was becoming tight. His considerable efforts during the spring to collect promissory notes he had issued rather haphazardly to artists he had no intention of showing were only partially successful, and his legacy from Edward was proving less elastic than he had anticipated. He would soon begin to accept the loans that Emmy's brothers had long offered.

This final trip, nevertheless, turned out to be Alfred's most exhilarating, even though he had little freedom until nearly the end of the summer. With the exception of a few Munich days in late July in the company of several painters from the German *Sezession* (including probably von Stuck, whose large reproductions dominated Alfred's New York living room), he was glued to Emmy and/or Kitty until mid-September. Six weeks had been spent sightseeing in Switzerland and southern France, suffering Emmy's quest for the fashionable and Kitty's burgeoning interest in boys. Alfred had found only occasional solace in his camera.

But Paris on the way home was more than ample reward. Leaving Emmy and Kitty to *le beau monde* American-style, Alfred spent three weeks soaking up art and meeting artists, with Steichen and De Zayas as alternate guides. Later he wrote Sadakichi Hartmann that, while he considered Cézanne, Van Gogh, and Renoir to be the three current giants, Picasso "is the man that will count." Matisse, whom he had found as interesting as Picasso and Rodin, was perhaps still a bit beyond him. But he was grateful that his seven years at 291 had made it possible for him to embrace the "tremendous experience" of Paris. Trying to tell New Yorkers about it, he wrote, made him feel as helpless as Tannhaüser, just back from the Venusberg, trying to make sense of "his colleagues theorizing about love."

The "tremendous experience" would inspire a special issue of *Camera Work* devoted to Matisse and Picasso. Appearing the following summer, it would provide a debut in America for another robust iconoclast, Gertrude Stein, who submitted for the purpose "word portraits" of the two artists. Meanwhile, Alfred tried once more to persuade the Metropolitan—in a newspaper article as well as a direct appeal—to mount at least a loan exhibition of Cézanne, Matisse, Van Gogh, and Picasso. Again he failed.

Paradoxically, considering the still-reverberating delirium of his Paris stay, Alfred made fewer efforts during the 1911–12 season on behalf of European artists than he had for several years past. Of the two out of seven shows that featured a European, one was a first look at Matisse in three dimensions, with twelve sculptures—including *The Serf*, which Leo Stein had called "more important" than any Rodin—pedestalled against a backdrop of twelve Matisse drawings. The other was photographic, presenting prints by de Meyer far removed in character from the polished portraits of his customary repertoire. One other nod to photography was included in the season's scheme: the October 1911 issue of *Camera Work*, designed perhaps as a coda to the Albright show, featured Stieglitz prints made largely in 1910 that both celebrated and questioned man's ingenuity in creating the hard, massive, and vigorous city of New York. (In this issue, *The Steerage* was reproduced for the first time.)

The five other shows of the season were of the works of Americans, two of whom would have far-reaching influence. Neither Dove nor Hartley was found more than "odd" by the critics, but each had embarked on a new path that was important to his development. In a series of pastels—abstractions from nature and architecture that were later titled *Ten Commandments*—Dove had moved from an Impressionist vision to an effort to express through a prism of subjective feelings the inner dynamics of objects. Hartley's new still-lifes marked a departure in style from more or less Cubist experiments to controlled manipulations of color and form in the mode of Cézanne. His intense honesty and progress persuaded Alfred to press Agnes Meyer to guarantee an allowance (through which she acquired several works) that would make it possible for Hartley to realize his cherished dream of going to Europe.

The final show of the season, after Matisse, represented another radical departure from convention. Responding in part to an inner prompting to expose the hypocrisy inherent in the refrain echoed daily at the gallery: "A child could do better than . . ." and in part to the urgings of Walkowitz, who had drawn inspiration from the naïve works of children he taught at a Lower East Side settlement house, Alfred mounted an exhibit that was probably the first of its kind in America, the works of "artists" aged two to eleven. (In the ensuing five years, there would be two more such representations at 291, as well as a corner reserved for the works of Alfred's ten-year-old niece, Georgia Engelhard, during an adult show.)

The inspiration and challenge that Alfred had found in Paris during the summer was leading him to a third turning in his entrepreneurial

career, a turning of which he was probably not yet fully aware. The battle for photography had been largely won, thanks to some extent to the shock-waves produced by exhibitions of contemporary painting; it had become safer to regard photography as art than to imagine that modern painters and sculptors were serious. The battle for post-Impressionist European art was clearly advancing; its "readability" and acceptance were hastened by the more stunning extremes of Cubism and the primitive/naïve. The new battle, for Alfred, would be the championing of American artists, artists without reputations elsewhere. His decision, filled with hazard, to offer continuing support and annual exposure to artists still seeking definition and certainty was concrete evidence of his dedication to experimentation. The "laboratory" that was 291 would soon reach its peak.

12

I have spent many hours trying to extract the real character of 291 from the mountains of description produced by Alfred, by people quoting him, and by others expressing independent recollections. What is clear is that it was far more than a gallery, and that, to its supporters, its proprietor— a benevolent genie—was personally more magnetizing than much that hung on the walls. Nonsupporters often felt alien when they entered and angry when they left, discomfited by the art, and affronted by the aggressive "owner" who took obvious delight in holding them up to ridicule if they didn't subscribe immediately to his own judgments. Some found him a charlatan: often he refused even to sell the goods he displayed. Others found him an anarchist, bent on scuttling tradition, courtesy, and respectable accomplishment. Still others, who might in quiet discourse have shared Alfred's views, were put off by his rude castigation of visitors he didn't like.

Among 291's most vociferous detractors were the once-faithful, the defectors. Poets and sculptors, painters, critics, and photographers who had been almost compulsively regular visitors to 291, some over a span of years—for guidance and, sometimes, for nourishment—later heaped scorn, pity, or abuse on Alfred. Besides Max Weber, who was offensive, there were others who seemed often to forget Alfred's role in their lives. William Carlos Williams comes to mind. Although as late as 1934 he wrote glowingly of Alfred's unique position in the American arts, his autobiography fails to mention what critics have recognized: the profound influence on Williams's own graphic word experiments of the exhibitions, publications, and conversation at 291, a frequent refuge for him at the start of his writing career.

Seeking in 1914, when his own confidence was at low tide, to discover what 291 meant to people, Alfred devoted an issue of *Camera Work* to that end; more than half of the sixty-eight unedited pieces he included were unsolicited. Painters, teachers, writers, critics, collectors, a dish-

washer, 291's elevator man, struggled on equal ground to express their feelings. Financier Eugene Meyer, Jr., in quasi *vers libre*, encapsuled the majority opinion of the place: "An oasis of real freedom . . . a rest when wearied, a stimulant when dulled . . . a negation of preconceptions, a forum for wisdom and folly, a safety valve for repressed ideas." Writer/ critic Hutchins Hapgood called it a salon, "a place where people may exchange ideas and feelings, where artists can present and try out their experiments and where those who are tired of what is called 'practical' life may find a change of spiritual atmosphere." Although one critic bemoaned Alfred's "desertion" of the camera, and one long-time friend was deeply incensed by what he saw as Alfred's impulse to eulogize—Steichen, indeed, found the special issue proof that 291 was dead—all the contributors described it as unique. Paul Haviland prized its "conflicting and irreconcilable points of view" as providing the opportunity to "dump [one's] intellectual baggage, good, bad or indifferent, in the common heap [and extract] what is of value . . . whether you receive much or little or nothing depends not on what is offered to you but on what you appropriate."

Not a little of 291's quality, it appears, lay in the richly varied menu, in persons as well as in works, that it offered all comers. Revealingly, Alfred later wrote the painter William Einstein that, for years after his return from studying abroad, he had yearned for the freewheeling speculations and the camaraderie of European cafés. That yearning, he found, had been sublimated and then killed by 291.

Although conversations often wandered, there is little question that their lasting impact on participants owed much to Alfred's consistently pedagogic, and somewhat lofty, purpose: to explore as thoughtfully and as honestly as possible every mode of creative expression, literary, musical, or visual. In this aim, 291 succeeded remarkably well. The ultimate rebellion against Alfred of some of the seminar attendees could be interpreted —as he did *not* interpret it—as a sign of health, a gaining of maturity. Had he been able to grant that a probable majority of 291's frequenters, especially the younger ones, regarded themselves as his students rather than as his comrades, and that students must graduate, he might have spared himself considerable pain.

At the risk of burdening the metaphor, and going beyond 291's important function as a laboratory for artists, the gallery might be described as a setting for informal group therapy. The patients wandered in and out, contributed or not as they chose, derived what they could, and reacted

variously—worshipfully, appreciatively, perplexedly, resentfully, anti-pathetically, but always intensely—to the therapist, whom they endowed with whatever measure of power they sought in him. Beyond the personal dynamics that would later inspire nostalgia, however, there remains the remarkable fact that this clinic yielded performance: individual artistic growth, a continuous flow of exhibitions, a preponderantly commendable publication, and a cumulative effect on the evolution of modern American art.

One further element of the common nostalgia for 291 merits comment. In the recollections of all those who regretted its demise, Alfred's role was more extensively catalytic than it would be in later years. Perhaps the sass flowed more vigorously at 291 than at his later galleries. In the American Place years, from 1930 to 1946, he was seldom brought up short, seldom challenged—except by a few old friends—to reexamine what he had said. Surrounded in these later days by acolytes and deacons, he launched more mystical generalities than exploratory arrows.

Considering the fact that 291 was never formally advertised, except in *Camera Work*, the gallery drew an astonishingly large and international audience. Between 1905 and 1912 alone, Alfred recalled some twenty years later, 167,000 visitors found their way to 291's tiny rooms. As Alfred was shrewd enough to realize, advertising was superfluous when priceless free publicity accrued from the eagerness of newspapers and periodicals to report controversy, of which he always had a ready supply. He positively relished being lampooned, knowing well that each new caricature, in words or sketches, drew crowds.

Alfred's part-time secretary from late 1911 to 1917 has brought the gallery's physical features and daily functioning vividly to life. A voice student seeking funds to study abroad, eighteen-year-old Marie Rapp came initially to seek employment with her brother's YMCA sponsor, a decorator named Stephen Lawrence, who planned to share her time with the gallery proprietor on his attic floor at 293 Fifth Avenue. She arrived for her preliminary interview on a cold, dark December afternoon, entering a rickety cage into which four people could barely squeeze. Deposited at the unlit top-floor landing, she was directed by the dignified West Indian elevator operator to the dimly lighted end of a hall leading to the back of the building. Her call answered by a faint "Come in," she crossed the threshold of an eerily shadowed but spacious room dominated by a long fabric counter. At its end, a goose-necked lamp revealed a figure in a cloak, huddled in a wing chair near a pot-bellied stove.

In ten minutes, the twinkly, dishevelled man in the cloak had gently dispelled her apprehensions and hired her; apparently Lawrence had left the decision to him. Alfred had asked her nothing about her working skills, and everything about her ambitions, tastes, schooling, and yearnings. Moreover, he had promised to introduce her to a fine voice teacher—the wife of a friend and the mother of a lad who was a frequent guest of the young people at Oaklawn; eventually, George Boursault became Marie's husband.

On her first day at work, Marie noticed some features of the top floor that she had missed on the dark afternoon of her interview. The front windows of the building were virtually blocked by a narrow corridor, leading nowhere, to the left of the elevator in the building's southwest corner. About a third of the way along the left wall of the hall she had taken earlier to the building's rear, she now noticed a door, closed. Behind it, she would learn, was the larger of Alfred's two exhibition rooms, of which the smaller was diagonally opposite—a sky-lighted alcove some eight feet wide and eleven feet long through which the hall itself continued. At the end, on the left, was a door to a bathroom; directly ahead was the entrance to the room in which she had been interviewed and in which she would work. This area, twenty-two by twenty-two feet, was leased by the elusive Mr. Lawrence—here this time to greet her, but more often at the homes of clients, it seemed, or on antique hunts in this country and abroad.

In his workroom she was introduced to her first task, tending the stove that was the sole source of heating for the floor, and to her second, straightening out a mass of Lawrence's disordered papers. For nearly a week, she worked without setting eyes on her other boss. Then, bored and disappointed, she gave notice. On the sixth day, as she was preparing to leave, she met Alfred in the hall. He was sorry to hear that she was quitting, he said, adding that he had been busy all week dismantling one show and pulling together another. Was she interested in art? Not really, she replied, recalling the dullness of her high-school art classes and visits to the Metropolitan. Alfred then led her into the fifteen-foot square room she had passed daily without entering and switched on the cloth-diffused overhead lights. In the room's center was a cube covered in dark green burlap on which rested a large, brightly polished hammered-brass bowl. Newly framed de Meyer photographs stood out against ecru burlap walls above a shelf curtained in the same dark green as the bowl's base. Reaching behind the curtains, Alfred drew out a succession of watercolors from Marin's just-concluded show.

"What do you think of this? of this? of that?" he asked, displaying the

pictures along the shelf and on the floor against the green drapery. He made no reference to her intention to leave but, "like a magician," offered one after another enchanting watercolor. Captivated, she agreed to stay; she would remain until the gallery was forced to close some five and a half years later.

Meanwhile, whenever Lawrence went away, he turned over his workroom to Alfred, who had none. In the mornings, Marie often found him, just arrived from dropping Kitty at school, helplessly facing the dying stove, and still muffled in coat, cape, and porkpie hat. Soon Haviland, Kerfoot, Fuguet, and sometimes Keiley would arrive to discuss the articles, reviews, and prints they and Alfred had collected for the next issue of *Camera Work*. These were gradually organized into piles on Lawrence's massive counter and the collective decision was made as to which to keep, edit, or discard. Sometimes Marie was summoned from her desk between the windows to share a laugh over a phrase, a picture, an anecdote. Such preliminary sessions, she recalls, were only rarely halted by disagreement, even when there were wide discrepancies in opinion. At some later gathering, the counter would accommodate the layouts of accepted compositions and illustrations; once in a while its top would be swept clear for an artist— familiar or aspiring to an exhibition—to display his works for approval or criticism. All comers would be invited to warm themselves at the stove.

Toward noon, "The Men," artists and writers who were regulars, would start drifting into the workroom, having timed their arrival, modestly, for a chance to be taken to lunch. Many of them were needy; at least two habitually used the black ink on Marie's desk to camouflage bare patches on their frayed overcoats, into which they afterward rubbed cigarette ashes. (I remember similar applications at Alfred's An American Place gallery during the Depression.) Alfred kept up a steady flow of questions: What was the artist's aim when he undertook this work? How well had he succeeded? What values underlay his approach? the attempt itself? Where was he heading? Had he grown? Above all, Was this new work "an addition?" Opinions circulated without inhibition, arguments were freewheeling and could lead anywhere. When they became too heated, Alfred often intervened to ask: Was that statement honest? and, If honest, was it also true? The fresh air he introduced usually dissipated hard feelings.

Only rarely were the mornings interrupted by people come to view the art works, although the gallery opened officially at ten o'clock. Most of the public arrived in the afternoon, sometimes staying past the six o'clock

closing hour. When a show was on, Marie could hear the constant wheeze and bump of the elevator, and often the raised voices of Alfred and visitors down the hall, jousting over the validity and skill of artists and their *oeuvre*. Sometimes there would be a class from an art school, herded by a teacher often atremble with apprehension: Alfred's ruthless strafing of art theories and those who promulgated them was well known. Sometimes a group of academicians came to jeer. Usually people arrived singly or in pairs. In one day, as many as 150 might come; in those following an opening, the fifteen-by-fifteen-foot gallery was often so crowded that people had to wait their turn in the hall outside the workroom and in the passage from the adjoining building. The press would have been invited to a special preview.

On rare visitorless days, Alfred might retire to his "darkroom," the bathroom, to process his negatives in the tiny basin and, kneeling on the floor, to wash and rewash his prints in the tub. A neat geometry of strings would appear over the tub to hang prints to dry. Following each printing session, the prints would be subjected, one by one, to Alfred's fierce and silent scrutiny. Few survived the process, and the trash basket was always full. Those he approved might be taken home to be enlarged.

Usually Alfred waited to process his pictures until the gallery was closed for the summer, but when the compulsion to print came over him during the season, he would usually suggest that Marie leave early to beat the rush-hour crowds on the subway home to Brooklyn. When there was need for her to remain, her silence and virtual immobility would be enjoined. He preferred to be alone, as he did during my childhood at Lake George. There his darkroom shed was girded by an imaginary moat that one crossed on pain of his immediate fury if he happened to be working.

Before 1914, when Alfred undertook a deliberate round of portraits, he used Marie occasionally as a model at the gallery, but in 1912 he had little time either for printing or photographing. After the season was over, he remained in New York to put the finishing touches on the special issue of *Camera Work* featuring Gertrude Stein, Matisse, and Picasso, and sent off Emmy, Kitty, and Clara to Lake George for the first time without him. As he worked overtime, ignoring Emmy's harangues about his grunting family and her repeated instructions to "bring Maillard triple-creams—and get a haircut," he found himself often preoccupied with the contradictions in his experience of the past year. His efforts to persuade *Camera Work*'s photography-oriented American readership that Europe's Post-Impressionism was germane to their vision—that the "anti-photographic" attitude of

Picasso, Matisse, and others could inform their taste and inspire their audacity—seemed hopeless. On the other hand, his readers in Europe seemed to be catching on.

Furthermore, he was beginning to find that his own responses to an abstractionist direction were becoming too profound to burden constantly with references to photography. It was the painting itself that excited him now, or at least the painters' vision. Wassily Kandinsky's *On the Spiritual in Art*, which he had come upon a few months earlier, seemed to epitomize his new feeling. Kandinsky's description of Picasso's "mad leap" across methodological chasms that others had wearyingly to descend and climb, and of the resultant "taking to pieces" and reassembling of material that constituted his Cubist dynamic, made profound sense to Alfred. At one and the same time, Kandinsky had analyzed the artist's method scientifically and apotheosized his creative impulse.

The time would come when Alfred's support would go to native American painters rather than Europeans, but in 1912 he was not yet ready. Since the beginnings of 291 in 1905, and especially since the gallery had begun to show European artists in 1907, Alfred had leaned heavily on Europe for guidance and inspiration, albeit on the Europe that was escaping the clutches of the academicians. His closest associates in running 291 since 1908 were rebels against orthodoxy and passionate supporters of the new art emerging on the other side of the Atlantic; they were also either themselves Europeans or enriched, as he was, by European education and experience.

Paul Haviland was a Frenchman. Spanish-descended Marius De Zayas's artistic growth had been fed as much by Goya, Rembrandt, and Velasquez as by Aztec relics preserved in the museums of his native Mexico. In 1914, he would persuade Alfred to open the season with a show that included pre-Columbian pottery, one of the first of its kind in the United States. Agnes Ernst Meyer, although born in New York, had turned internationalist during the year and a half she had spent, at Alfred's and Steichen's urging, educating her eye in Paris. Her seven-year patronage of 291 presaged her eventual emergence, with her husband, as the first major collector in the United States of European avant-garde art; she was also, during those early years, the foremost patron of American artists at 291—Weber, Hartley, Walkowitz, and Marin.

Steichen, whose childhood and youth had been spent in America, found Paris and the nearby village of Voulangis, where he lived from 1904 to 1914, more congenial than the States, to which he and his family

returned only with the advance of German troops in World War I. After the war, Steichen went back to France, where he remained until 1923. Although he organized the Younger American Painters in Paris and retained ties with most of them, he belonged during this period much more to France than to America.

These four, then—Haviland, De Zayas, Meyer, and, to a diminishing extent after 1911, Steichen—were aesthetic mainstays at 291 until 1917. Keiley and Fuguet, although continuing as editors of *Camera Work* and certainly sympathetic to Alfred's growing emphasis on arts other than photography, had little or no say in the workings of the gallery; Kerfoot, even as an editor, preferred serving as a critic/satirist to making policy.

During the 1912 summer, Alfred spent considerable time ruminating about the progress being made by the planners of the massive display of international avant-garde art that was to open in New York the following February. The press would give it its durable name, "The Armory Show." Whether or not its sponsors, officers of the recently formed Association of American Painters and Sculptors, asked Alfred to participate in the show's formative stages is unknown, but later, with Monet, Renoir, and other luminaries, he was named an honorary vice-president, and he did what he could to further its acceptance. Every major European artist he had championed, and every American artist save Dove and Weber, would be represented in the exhibition, which would include also several Matisses and Picassos from his own collection. He later bought its lone Kandinsky.

One of the show's prime movers, Arthur Bowen Davies, elected president of the AAPS in January, had been coming to 291 regularly for years. A somewhat withdrawn person, Davies was liked and respected by Alfred not only for his sensitivity as a painter but also for his serious study of modern artists; Alfred considered him more broadly knowledgeable even than Weber. An admirer especially of Rodin and Matisse, Davies was one of only a handful of regular purchasers from 291, and persuaded others to buy as well. Since 1909 he had supported independent exhibitions elsewhere in New York in which Hartley, Marin, and Alfred Maurer were included and, in 1912, he was instrumental in raising funds for Hartley's first trip to Europe.

Davies might indeed have become a 291-er if he had not already been affiliated with a group of painters who, excluded from the National Academy, had begun showing together at New York's Macbeth Galleries in 1907; they became known as "The Eight." The same group would later be lumped together as "The Ashcan School" for the robustly realistic

street scenes of only half of its members. These four former artist-reporters for newspapers in Philadelphia and New York found that their jobs had become obsolete when, at the end of the century's first decade, mass photoreproduction became feasible. Understandably, they were especially antagonistic to photography, and to Alfred by association; he, in turn, misprized their efforts to realize in paint what he felt a photograph could do better. All of them came to 291 at one time or another, out of curiosity rather than enthusiasm. Only Davies was taken with the revolutionary art on view; the others had managed to stretch their appreciation of the moderns only as far as Manet.

The group's *Eminence Grise*, Robert Henri, Alfred's contemporary, was a fiery leader who felt himself as much a crusader against academic orthodoxy as Alfred; each was certain he was the true Messiah. Although they shared an early conviction that real life was the province of the poor working class, and both counted among their literary gods Balzac and Rabelais, Tolstoy and Dostoevsky, their tastes grew in opposite directions. As scandalized by the Cubists and Abstractionists as Alfred was thrilled, Henri also inveighed against the camera's influence on the academicians both he and Alfred were combating; they strove, after all, to produce photo-meticulous paintings. Gradually, Henri disassociated himself from the AAPS and concentrated on his teaching at the Art Students League, where his instruction to "forget detail, capture the spirit and be yourself" inspired a new generation of painters, among them O'Keeffe.

Alfred's reaction to the planned Armory Show was doubtless filled with ambivalence. On the one hand, he was as opposed to the undiscriminating vastness of its invitation to Americans, under artist William Glackens, as he had been to the lack of selectivity in Curtis Bell's Salon Club exhibition of photography in 1904. On the other hand, he had long held and propounded the conviction that a large public should be introduced to works shunned by the museums. Moreover, since many of "his" artists would be represented at the armory, he had to concede that, in a way, his own foresight would be honored. Strong memories of his Albright Gallery show two and a half years earlier must have assailed him. Just as that exhibition had boasted that it would "sum up the development and progress of photography" on an international scale, the Armory Show now vowed to summarize the evolution of modern European painting from Goya onward. Would the Armory Show match its vast promise where he himself had failed? To add to his apprehension, his unacknowledged elitist leanings were at war with his democratic ideals. Hadn't his uphill struggle

of the past years to educate even a relatively small audience already proved that the American public at large would remain blind?

The peace of Oaklawn, which Alfred had been looking forward to sharing with Emmy and Kitty after his always irritating early summer weeks at the Jersey Shore with Emmy's crowd, was shattered this year by the latest family scandal. This time Lee was the culprit. The roots of the problem stretched back twenty-two years, to the summer of their sister Flora's death, when Lee, home briefly before tackling his final year at Heidelberg, fell head-over-heels in love with a sophisticated New Yorker, a cousin of Emmy and Joe Obermeyer. Returning to Germany, he begged the mercy of Lizzie Stieffel in Karlsruhe, to whom he had been more or less engaged for the past year. Lizzie, with characteristically stoic under-standing, not only forgave him but, when word arrived from the States that his new love would marry someone else, assured him that she would help him get over the pain and would make him a good wife. For nearly ten years after their marriage in 1894, he felt he had made the right decision. In 1902, however, Mrs. X reappeared on the scene, as a patient. Imme-diately, she was Isolde and he Tristan; the fateful affair began. And Lizzie took their two little girls to Egypt for the fall and early winter.

At first the lovers met only during his medical calls at her New York apartment. Then Lizzie, hoping perhaps that socializing would make her rival less compelling, acquiesced to sharing occasional family weekends; she was determined to come out the winner. By the summer of 1905, Mrs. X and her family were included in Lee's biennial supervisory visits to pa-tients at European spas. For propriety, he was accompanied by Lizzie and the children—but not into Mrs. X's bedroom.

The summer of 1912 was an off-Europe year, scheduled to be spent at Lake George. In May or June, however, Mrs. X decided on impulse to go abroad, and insisted that Lee meet her there. His two teen-aged daughters, who had invited friends to Oaklawn, refused to alter their plans, and Lizzie chose firmly to stay. Not to be deprived, Lee set off for Sils-Maria alone. There, without Lizzie and daughters to remind him of the need for circum-spection, he became careless. He was discovered by the cuckolded husband—so the story goes—on the hotel terrace, in full view of every-body, holding hands with the errant wife. The instantaneous scene climaxed with Lee's self-righteous oath never to darken suspicious King Mark's door again. In now uncertain sequence, he returned to the States and suffered his first attack of angina. Lizzie went immediately to New York to take care of him.

At Oaklawn, sympathy for Lee ran high. Whenever the children were out of earshot, the adults were free to rehash and savor the events and consequences of Lee's passionate temperament, "so like Pa." Emmy, for once, could participate on an equal footing: Mrs. X was, after all, her cousin. Besides, she had always found Lizzie too prim. The others, most of whom had known about the affair almost from the beginning, were a little less gleeful, but Stieglitz romanticism ruled out moralistic recriminations. Poor, tragic Lee, was the consensus; poor, tragic Mrs. X; poor, patient Lizzie.

Alfred, too, felt sorry for Lee, not because he had anything against Lizzie, but because he thought Mrs. X wholly unworthy of Lee's devotion, recklessness, and inability to control the situation. Alfred himself had managed to evade lengthy or demanding entanglements with all the women who had entered his embrace—by his own later account, a healthy number. Now he realized that luck as well as prudence had helped him elude discovery. Rested or not after the summer's melodrama, the time came for him to return to New York, away from Emmy's twenty-four-hour surveillance.

The autumn was not encouraging despite the relatively warm reception accorded Abraham Walkowitz by the critics for his first one-man show, the season's second at the gallery; the first had passed with barely a nod. The October issue of *Camera Work*, with fourteen de Meyer photogravures superbly reproduced at Bruckmann Verlag in Munich (under the guidance of Alfred's friend and former employee at the Photochrome Engraving Company, Fritz Goetz—the sole willing beneficiary of Alfred's instruction), came too late to reverse the cancellations that had followed the equally superb special August issue devoted to Matisse and Picasso. With subscriptions down to the low 300s, of which 100 originated in Europe, Alfred settled down to answering an avalanche of letters castigating his judgment, bitterly aware that it was *his* sacrifices in behalf of avant-garde art that enabled these Johnny-come-lately's to organize a vast exhibition at the armory.

January restored his confidence. Marin arrived with some stunning New York watercolors, many of Manhattan's dizzying new skyscrapers, that created a splendid stir. Alfred agreed with enthusiasm to Arthur Davies's plea for help in promoting the Armory Show, using the occasion also to publicize Marin's exhibition. On January 26, the New York *American* published a six-column spread that carried his name. Illustrated with four gravures, it was headlined: "First Great Clinic to Revitalize Art," and

began: "The dry bones of a dead art are rattling as they never rattled before [by] the hopeful birth of a new art . . . [The exhibition] will wring shrieks of indignation from every ordained copyist of 'old masters' on two continents and their adjacent islands." Continuing in this passionate vein, Alfred advised readers that, even if they didn't understand what they saw, they would not thereafter be happy with what museums and galleries had to offer. He counselled them to drop preconceptions and to experience the works for themselves. He couldn't resist expressing his contempt for the schools of painting that would go on "breeding little Chases, little Henris and little Alexanders—and little Alexandrines," and he devoted a full column to the Marin show currently at 291, including excerpts from Marin's own catalogue statement. His digressions notwithstanding, the thrust was a directive to see the Armory Show, to see works that "will help put life into the dead corpse of painting . . . Put yourself in an unprejudiced mental attitude, in a receptive mood, and the chances are that you will see a great light." In the feisty conclusion, he suggested: "If you would rather art stay dead, then go out with your kodak and produce some faithful imitations. Good machine work is always preferable to indifferent hand-made products."

As if to illustrate his point, the January *Camera Work* carried strong photo portraits by Julia Margaret Cameron, and four of Alfred's own prints, forerunners of his own first one-man retrospective at 291, planned as a synchronous contrast to the paintings and sculptures at the Armory Show at Twenty-fifth Street and Lexington Avenue.

The February 17 opening at the armory was for invited guests. The vast open space of the artillery drill floor had been transformed with burlap and greenery: tent-looped bolts of cloth masked the glare of overhead lights and defined eighteen display areas. Between ceiling and floor, a high cornice of evergreens reduced the height to a human scale. Around the lower perimeter and on screens and pedestals dotting the floor, sixteen hundred works of art declared themselves.

The scandal of the first night—the immediate long lines of gapers trying to discern a human figure in Marcel Duchamp's *Nude Descending a Staircase*—and the ensuing outcries of the critics sent people flocking to the armory. In the four weeks of the show's New York run, 40,000 visitors attended; on tour later in Chicago and Boston, it would draw 200,000 more. Nearly all came to hoot and howl, to fulminate about its degeneracy. Alfred's fears of a circus that would block genuine receptivity were realized beyond his imagination. Nevertheless, he expressed his approval

and appreciation to Davies for the great work he had done, and, as an honored guest, attended the AAPS dinner for "our friends and enemies of the press" on March 8. He began at once to plan in detail another special summer issue of *Camera Work*, to celebrate the avant-garde arts so reviled by the Establishment.

Whatever Alfred ultimately felt about the worth of the Armory Show —he was soon distressed that the AAPS lacked the foresight to follow it up with further exhibits consistent with his own educational precepts—he derived several benefits from its appearance. He bought the single Kandinsky work and, regretting that it was too large to show at 291, tried to arrange a one-man exhibition of smaller pieces (an effort in which he failed). He derived new confidence and interest in his own photography, thanks to the great acclaim his contrapuntal one-man retrospective had received. And he made a number of new friendships that were to prove consequential.

The least among these was with Mabel Dodge, whose new salon in Greenwich Village would cosset so many artists and writers during the next four years, including several of 291's regulars. Alfred himself cared little for the wandering conversations at 23 Fifth Avenue, embellished as they were with food, booze, and 3 a.m. philosophy, but he was hospitable to Mrs. Dodge at 291, and was instrumental in supplementing the art education she had begun with the Steins in Paris. Through him, she established contact with Hartley, Marin, Walkowitz, and Hutchins Hapgood; through her, he came to know Carl Van Vechten, Lincoln Steffens, and Andrew Dasburg, among others. Her friendship with Gertrude Stein inspired Alfred to solicit an inimitable "word portrait" of Mabel Dodge from the writer for *Camera Work*.

More fruitful for Alfred was his almost immediate friendship with Francis Picabia and his wife, Gabrielle Buffet, who had been told by friends abroad that they must visit 291. The first major European modernist to follow his works to the Armory Show, Picabia had been lionized and broadly interviewed within days of his January arrival in New York. Two days after the closing of the show, Alfred mounted a one-man exhibit of Picabia's new studies of New York. During its nineteen-day run, some two thousand visitors jammed the little gallery. Alfred quickly persuaded the couple to write for a special issue of *Camera Work* illustrated with reproductions of works by Cézanne, Van Gogh, Picasso, and Picabia; Buffet contributed a highly advanced critical essay. Alfred sang the Picabias' praises in every corner, and felt truly bereft when they returned

to Paris. When Picabia came back to the States in 1915, his friendship with Alfred advanced him to the rank of a collaborator.

The closing show of the 1912–13 season, incisive caricatures by De Zayas, did not spell the end of Alfred's work; again, he postponed his vacation. With De Zayas and Haviland, he put together a *Camera Work* issue devoted to works by Steichen, including a painting of Alfred's sister Selma. In a special note about the plates, tribute was paid to Steichen's "active sympathy and constructive cooperation" in bringing to 291 the works of Rodin, Matisse, and young Americans in Paris, including Marin.

Family demands on Alfred's time had been unusually heavy throughout the year, thanks to urgent meetings to discuss Lee's ever more scrambled life. Notwithstanding the scandal in Sils-Maria, Lee had quickly been called upon to resume his professional role with the X family. In a desperate effort to escape them, he had swept his own family abruptly to Berkeley in November, to start a new life. The experiment lasted exactly ten days, aborted by his refusal to take the California Boards after nearly twenty years of practice. Less than a month after their return to New York, they were off to a new location: Munich. There, Lee was soon serving as visiting professor at the university and consultant at several hospitals; he looked forward to renewing studies in neurology in Vienna. Before the family sailed, Alfred was counselling his favorite niece, fifteen-year-old Elizabeth, to grab the chance for superior instruction in art and music. Obediently, by early January she was taking lessons with the first violinist of the Munich Symphony and art classes at the Schwabinger Künstler. Alfred was delighted to hear from her that her classmates were "swarming around *Camera Work*." Then, in early spring, news came that Lee had stopped work and gone to Baden-Baden for a rest. Hedwig pressed Alfred to find out the truth of Lee's mental and physical condition. Alfred's perceptive diagnosis—that his brother's "ailing nerves" had been caused by "rancor and resentment" against Mr. and Mrs. X—was relayed to Lee and confirmed by his immediate hot response. "Those people are non-existing for me," he wrote, notwithstanding what they had cost him in "trouble, heartache and money."

If Alfred was able to put Lee out of his mind in April, in May he was anguished by his absence: Kitty had come down with diphtheria, and Emmy was unmanageable. Patiently, as Kitty was recuperating, Alfred devised a bargain with Emmy. If she would cease pestering him about their taking a trip together to Europe from August through October, and instead take her nineteen-year-old niece, Dorothy Obermeyer, he would make a

new accommodation. From mid-June until her sailing, he would commute daily between New York and Elberon/Long Branch, New Jersey (a two-hour trip), so that she could have daytime diversions with her friends and the security of his presence at night.

The extremity of Alfred's proposal suggests the degree of his exasperation with the course of their home life; he'd do anything to get her away. His relief at her agreement was so great that, a few days before beginning his daily trek to the shore and back, he was able to write Steichen with equanimity—at four o'clock in the morning—that, summoned rudely from his bed an hour before by the Fire Department, he had found no damage to the gallery in the building's third fire.

Although Alfred's Lake George vacation was delayed by Emmy's massive preparations for her August 8 departure, his freedom thereafter was ample compensation. Friends would learn from him that his stay with Kitty at his mother's was the happiest he had ever had. He enjoyed, first of all, the dual benefits of his banishment to the Farmhouse up the hill to sleep in the all-male preserve assigned to his brothers, Engelhard in-law, and nephews, and his freedom to spend as much or as little of the day as he cared at overflowing Oaklawn. He could read, write letters, enjoy nude sunbathing (without Emmy's nagging reminders of the "delicacy" of his skin), and photograph whenever the spirit moved him, so long as he was on time at meals. Indulgent Hedwig even allowed him to retreat, at the end of the summer, from a large part of the buzz surrounding the new engagement of Lee's daughter Flora, the first of her generation to go to the altar.

On the other hand, he relished the opportunity to spend time with Kitty without her mother's interference. He did battle for her right at fourteen-and-a-half to take out the canoe that, thanks to Granny's fears, was off-limits to her older female cousins. And then, inconsistently and in excited German-English, yelled at her in the rowboat to "Zit Shtill, Putzi!" Together, they hiked, took on—and whipped—all comers at tennis, and swam. At her urging, he taught all his nieces and nephews, from seven-year-old Georgia (Agnes's daughter) to eighteen-year-old Hedwig (Julius's eldest), to play poker, a diversion halted primly by Julius on the grounds that he was corrupting the minds of children with "gambling games." Alfred's furious insistence that they were *not* gambling but it would be a hell of a lot more fun if they *were* brought the brothers almost to blows, their middle age notwithstanding.

As much as anything, Alfred enjoyed the company of Lee's younger

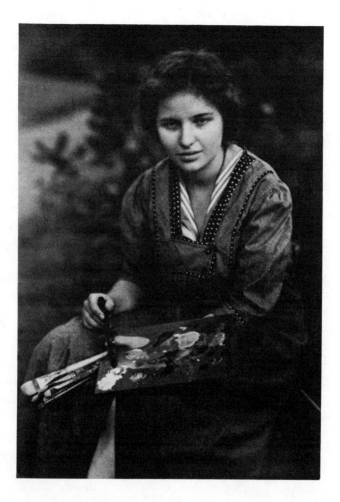

*Elizabeth Stieglitz,
Oaklawn, 1914*
Alfred Stieglitz

daughter Elizabeth, back from Europe with her family only a few weeks before his own arrival in early August. He had always loved the quirky independence of her spirit—had, indeed, done much to nourish it—and saw in her, at sixteen, every sign of maturing into a passionate woman. When one of Lee's wealthier wealthy patients had summoned him back from Europe, with passage paid for his entire family and an invitation for all to spend a month or more at his summer villa at the Thousand Islands, Elizabeth, depressed at the thought of so much suffocating luxury, had gone instead directly to her grandmother at Oaklawn. Hedwig's report to Alfred of her arrival had included the astonishing news that "Elizabeth . . . is so heart and soul with her music and painting that she [has] prevailed upon her father to let her go to Munich alone in the fall."

No news about Elizabeth could have pleased Alfred more, not only

because she was so determined to follow her artistic star that she had persuaded her hopelessly conservative father to support her wish, but also because she had recognized Germany as the proper place to continue her education. Immediately, he set in motion a plan to enrich her stay in Munich. It had already been decided that she would live with the same Träutlein family with whom the twins had resided thirty years earlier; now Alfred arranged for her to be under the intellectual wing of one of his more liberal classmates from Berlin, a painter named Sime Herrmann. Under the rotating tutelage of several prominent professors at the university, Hermann held informal weekly seminars in philosophy at his home; Elizabeth would be invited to join the group. Meanwhile, at Lake George, there were two tasks Alfred set himself with her. He wanted to lead her from a conspicuous lack of enthusiasm for her sister's fiancé, the younger son of the same wealthy patient of her father's Elizabeth had refused to visit, to the realization that Flora's need to follow her own way was just as compelling and valid as hers. And he wanted Elizabeth's help with Kitty.

Belatedly, Alfred was aware that Kitty was more than a little spoiled, a plight in which he recognized his own responsibility. In his determination to try to keep his home life orderly, he had "given" Kitty to Emmy, to soak up Emmy's empty values and Clara's constant attentions, in which servility, severity, and smothering demonstrations of devotion were equally present. He adored his daughter, but he had let her down. Perhaps, with patience, Elizabeth, so close to being his spiritual daughter, could "unspoil" Kitty, who was already her worshipful shadow.

Alfred succeeded only in his first endeavor. If Elizabeth ever took on the second assignment, she quickly gave up, summarizing her assessment of Kitty in a letter to her sister Flora, who had gone back with their mother to Alexandria Bay to prepare for her September wedding there, thus: "Easy to handle as all people are nowadays—little selfish rotter when not tackled correctly." Alfred contented himself with helping Elizabeth improve her photography. Under his direction in the darkroom Hedwig had recently devised for him in the carriage house, Elizabeth gained sufficient proficiency for him to assign to her the duplicate printing of those family snapshots he produced on command; those he took on his own initiative, he printed for himself. Fortunately, the twins volunteered to photograph most family events and annual growth statistics. Much to Alfred's amusement, Lee to some extent, and Julius absolutely, soon believed himself Alfred's equal with a camera.

Emmy's letters from abroad arrived every three or four days. Alfred's

responses were so patently cheerful that in late August she complained that he made her "blue—you always seem to get sporty when I'm not there," an observation he could not refute. Still trying, however, after twenty years of failure, to expand the frontiers of her perceptions and perhaps to bolster her confidence, Alfred had asked her to take on some "work" for him abroad. Emmy dutifully followed his instructions, but she was lost in a sea of worries about "Kits" and the mysterious evaporation of her funds, and her comments said little for her artistic growth. The Hartley show he had asked her to see in Munich gave her "the chills," she wrote. She had not been able to choose which of two Brancusi heads in Steichen's custody Alfred should buy, and was much more concerned that Steichen, blessed with a delightful wife and two lovely daughters, was "terribly moody." Surprisingly, however, she congratulated Alfred spontaneously on the good news that duty on works of art imported into the States would soon be lifted. Page after page about the hardships of travel, the inadequacy of hotels, the clothes she had seen, wanted, and sometimes bought, the races and dinners she had attended, the food she had eaten and how it affected her digestion seemed to omit no detail of her trip. The one detail she had left out, however, was a phenomenon observed by her niece. Hardly a day went by without Emmy's invitation, and thorough enjoyment, of a wholly unsubtle "flirt." To Alfred she wrote of her fears that he might not like to have her back after a crossing she predicted would be grossly unpleasant: "All the Jews in Creation [are] going back with us."

Fortunately, Alfred's eight weeks at the lake had been refreshing. He would need all the strength and patience he could muster for the season ahead. And for several years to come.

PART THREE

PORTRAITS AND PAINTINGS

1914-1929

13

The restorative effects on Alfred in 1913 of a summer without Emmy were quickly dissipated on his return to New York. In the city he was faced with the inescapable fact that, as a result of the Armory Show, dealers eager to capitalize on its fevered reception were jumping on the "new art" bandwagon. Within a year, five galleries were offering avant-garde fare. Alfred wondered how 291 could maintain a leadership role, or even how it could make its voice heard amid the competition. Now that everyone seemed to be Europe-crazy, moreover, the time might be ripe to concentrate on American artists, a thought that had occurred to him more than once.

By early December, however, his worries were focused on Keiley, who had put in an appearance only once in eight weeks. By Christmas, it would be learned that he had Bright's disease; at the end of January, he died. For over sixteen years, he had been Alfred's most loyal defender in every controversy, his most cheerful aide in every task, no matter how picayune. Aside from missing him personally, Alfred despaired of ever finding similar self-effacing devotion coupled with cool intelligence. Certainly this pair of qualities did not seem to be characteristic of the most recent volunteers at 291.

Emil Zoler, a young student painter introduced to Alfred by Marsden Hartley in 1909, was a zealous and skillful helper in anything requiring manual dexterity, but he had such erratic habits that he could never be relied upon to arrive when needed. And Abraham Walkowitz, who, since his debut at the gallery the previous year, was a dependable assistant in hanging shows, was anything but self-effacing. Now, with his second show running for a full seven weeks—thanks in part to a relatively benign reception by the critics and in part to Alfred's depressed inertia during Keiley's mortal illness—he had become almost proprietary. Conversations at the luncheon Round Table began to take on the coloration of the friends he brought from the Lower East Side. These were not the mutely patient

victims of squalor Alfred had thought he was photographing in the Five Points Area in the 1890s, nor did they resemble in any way the contented peasantry he had romanticized in his youth abroad. For the first time, Alfred was exposed to the articulate poor: fervent, if sometimes fuzzy, combatants for a new social order. One—Adolf Wolff, an anarchist poet and sculptor, who was an early exponent of Dada—would be jailed for "seditious activity" before the end of 1914.

Zoler was an immediate ally of Walkowitz's coterie. Stirred by the silk workers' 1913 strike in Paterson that was near his Jersey City home, he had joined the organizers' group, the Wobblies, the syndicalist coalition of unions led by Socialist Eugene Debs. He, too, began to instruct Alfred about the urgency of the class struggle, the despair of thousands—the unskilled, the unemployable, the exploited. Max Eastman's new proletarian magazine, *The Masses*, was cited chapter and verse. As the weeks went by, Alfred grew increasingly somber, prompting Emmy finally to forbid him to bring his new friends home, and soliciting her cross judgment that "all the artists" should go out and get honest-to-goodness jobs "instead of talking at 291." For the better part of a year, she would wail about Alfred's new compulsion to compare his life "always . . . to the poorest and most miserable," blaming his association with the IWW for its depressing effect on him. "In the old days," she wrote him in September, "the conditions of life did not weigh half as heavily as they do now when Zoler, Wolff and Co. are your general companions."

Alfred may have overstated to Emmy the extent of his affinity with the poor in the vain hope that she might be led to curb her extravagances, but he was unquestionably as moved by the stories of privation and injustice exchanged by his new young friends as he was stimulated by the perorations of the anarchist. Although he rejected absolutely any system that would subordinate individual liberty to mass goals, and drew the line at any use of violence, he felt a basic kinship with all opponents of orthodoxy. He would never become a Socialist, or, indeed, join any political party, finding no incongruity between his aloofness from voting and his democratic ideals, but his sympathies would remain on the side of the deprived. Like many other fundamentally apolitical people of good will, he would find the Russian Revolution both an exciting phenomenon and, briefly, a source of hope for the world's oppressed. In any event, he regarded himself as an outstanding example of voluntary socialism; didn't he share the wealth? and work for others? and detest capitalist greed?

Hadn't Keiley, too, in his quiet and gentlemanly way, worked for social justice?

Grieving over Keiley, Alfred reached for the one reliable antidote: his camera. For several years, his New York pictures had been largely of views from 291's windows and records of its exhibitions, with an occasional photograph of a friend or colleague posed informally under the little room's skylight. In February 1914, he began to reexplore portraiture. He was not interested in the studio portraits that were the specialty of Steichen, nor would he accept commissions. But he enlisted more sitters than before. And he began consciously to seek deeper evocations of character, to capture the often contradictory messages of eyes and mouth or set of chin.

His most frequent model during the early days of what would become his second, portrait, phase as a photographer was young Marie Rapp. "I was always around," she relates. "If the light was good, and there were no interruptions—and he was in the mood—out would come the camera. 'Marie, I think I'll photograph you today,' " was all the notice she had.

At first Alfred was relatively modest in demands on his subjects' time —an hour perhaps. That hour was not used to arrange studio lights, drapery folds, or flattering poses, to dust noses with talcum or prepare suitable smiles. Having studied without the camera the lineaments and characters of friends, he knew in advance what he was after. Time was needed, rather, to catch the unpredictable confluence of the finest natural light—heightened occasionally by a reflective screen—and the looked-for expression. An absolute necessity was the complete immobility of the subject. The fast film today's photographer has at his disposal did not exist; Alfred used a time exposure, set sometimes for as long as three or even four minutes. The degree of spontaneity he could snatch from a pose held for an agonizing time was almost as astonishing as the fullness of character he was able eventually to capture in a single image, albeit he believed that no single image could ever be a true portrait. His "portrait" of O'Keeffe would consist of over three hundred prints.

My earliest recollection of him, on my first visit to Lake George, three months before my third birthday, is one of deep resentment at having been made a target of his camera, required to sit perilously on a high lichened stone plinth that may have served as a hitching post in horse-carriage days. Even worse was having to bear in stillness the pricking of tall grasses in the center of the oval roadway between the Farmhouse and the barns; there my only consolation was the firm and willing hand of sister Peggy,

who had already served her apprenticeship as model the year before and who, miraculously, seemed to enjoy the ordeal. Her harvest had been a series of exquisitely joyous prints, golden head framed by sky. I customarily produced scowls.

It is my impression that Uncle Alfred teased me for my grouchiness—or perhaps I was grouchy because he teased me?—but, cause or effect, I remember also being fascinated with the minutiae of his equipment and procedure. The tall tripod, the large wooden box of the camera, the plates carefully inserted and removed, the delicate groan of the advancing and retreating lens as it was tuned into focus, the black muslin under which Uncle Alfred's head dived when at last he was ready, the wheeze of the shutter, and, finally, my reprieve.

Alfred's niece Georgia Engelhard has written feelingly of the "endless fortitude" he required of his models. "I remember once when I was fourteen . . . sitting on the very edge of a cottage window, bending over with an armful of apples clutched to my bosom as if I were just about to leap down. At best a difficult pose to hold even for a few minutes, but . . . for more than an hour [I had] no respite . . . When I became cramped and tried to shift my position, or when I wriggled because a fly was slowly parading down my face, he would roar at me until I was ready to weep with rage and discomfort. The result of all this agony, however, was a perfect picture . . . and if you did not know otherwise, you would never dream that it was [not] a candid shot taken at 1/200 second."

Alfred was not insensitive to the suffering of his sitters, but he took great pride in the degree of naturalness he was able to convey without the use of what he called the Iron Virgin, a head-holding contraption used in portraiture well into the 1920s—even by purist photographer Paul Strand—to ease the discomfort of long poses. Alfred's methods were certainly more taxing for his models, but few seemed to begrudge him his perfectionism, and most realized that the intensity of his concentration made the sessions even more stressful for him than for themselves.

Since 1913's summer, Alfred had been looking forward to Steichen's winter visit to New York. Wrapping up only days before Thanksgiving the April-July issue of *Camera Work* devoted pictorially wholly to Steichen, Alfred wrote him that sending out this particular number had brought him more satisfaction than anything else he had ever done. Together with his genuine excitement about the photographs the issue contained, it may be suspected that he was expressing some measure of relief at being able to pay wholehearted tribute to Steichen as an artist; he had been faced for

some time with the guilty realization that De Zayas's and Haviland's effectiveness in combing Paris for new works to show at 291 had begun to undermine his reliance on Steichen.

Nevertheless, it was Steichen's alertness in 1911 that now made possible the first one-man show in America, at 291, of the provocative sculptures of Constantin Brancusi, and it was Steichen who devised their handsome display in March. The high point of the 291 season, the exhibition provoked a gratifyingly scandalized reception by public and press. Accustomed as they had become to being shocked by two-dimensional avant-garde works at 291, the critics were now almost nostalgic for them. Even the few Brancusi plaster-casts at the Armory Show had not prepared them for the impact of these sensuously tactile and weighted heads and figures in bronze, marble, and wood.

Alfred's nostalgia was for the intoxicating pioneer spirit of 291's early days. And for Steichen, who, in poor health and preoccupied with his mother, in New York from Wisconsin especially to see him, had almost no time for his old friend. Alfred had wanted to do his portrait, and had hoped to share with him his own growing anxiety about *Camera Work* and the threats to 291's preeminence. Instead, he decided not to burden Steichen with his worries and embarked on what he hoped would be rescuing measures. In the magazine, he made a regular feature of an earnest advertisement printed once before—"Are You Interested in the Deeper Meaning of Photography?"—and promised a revival of photographic shows; for the gallery, he gave Haviland's younger brother, Frank Burty, his first exhibition anywhere. Perhaps he hoped that the neophyte painter would be able to persuade his close friends Picasso, Braque, and Gris that 291 would be their best showcase in New York.

Almost a year had passed since Alfred had begun to seek a new direction for 291 and a new way to infuse energy into the faltering *Camera Work*. Often it had seemed that both goals were too distant, and the struggle too much psychologically, physically, and financially; occasionally he sensed himself on the verge of inspiration. In mid-June, he felt he had hit upon a way to plan for the future; he wrote his mother, elliptically, that he had found himself again, that he had a purpose. "I would love to know something more definite," she answered, ". . . but I am satisfied to know you are seeing clearer . . ."

As noted earlier, Alfred had decided to ask the people who had been most devoted to 291 to define, in writing, what it had meant to them over the years. Definition, he reasoned, would bring order to his own thoughts

about its special nature; definition would suggest a path that would rein-vigorate the place and guarantee its continuing leadership. In the tem-porary absence of his major colleagues, Haviland, De Zayas, and Meyer —and Steichen—he tried out his inspiration on sycophantic Zoler and wool-gathering Walkowitz. Their support secured, he began before the end of the month to solicit contributions from his steady group of artists, from critics long acquainted with the gallery, from writers and friends who were habitués. The edition of *Camera Work* that would contain their responses, which he planned to publish in the fall, would be the vehicle of his rescue. If all went well, it might also revive the magazine.

Early replies bolstered his confidence, but underneath, the worries remained intense. Added to them now was uneasiness about the start of the war in Europe. He had not been particularly disturbed by the June 28 assassination of the Austrian Archduke, Francis Ferdinand, and his wife at Sarajevo. Troubles in the Balkans were all too familiar; even three years earlier, he and his mother had discussed the possibility of a major war, and nothing had happened then. Furthermore, Alfred was not alone in believing that the horrors of the Russo-Japanese War of 1904–5 had made future international conflicts inconceivable. The Peace Tribunal functioning at The Hague was surely capable of adjudicating this most recent squabble between Austria and Serbia. Even when Germany refused to join the conference of major powers proposed for late July by Great Britain, Italy, and France, and even when Austria declared war on Serbia on July 28, there seemed still to be a crumb of hope. When Germany declared war on Russia on August 1, however, followed up rapidly with a declaration against France, and on August 4 invaded Belgium, it was obvious that matters were out of hand. The long nightmare had begun.

Throughout July, Alfred's most frequent companions at 291 had been the young radicals "Zoler, Wolff, and Co." Their arguments, and their pamphleteering, cannot be ignored as influential in Alfred's reaction to the first years of World War I. Labor was resolutely pacifist. The IWW, basi-cally Midwestern in constituency, shared that section of the country's adamant isolationism. Alfred found his young friends' socialist explanation convincing. "The war," the economic determinists insisted, "was caused by rivalry for foreign markets and colonies, munitions-makers' zeal to sell their wares, and the bankers' lust to glut themselves on war profits." When, in time, the Allied propaganda began portraying Germans as blood-dripping monsters, Alfred rejected not only that message but its counter-part, Allied innocence, as well. Finally, for the better part of the war's first

two years, he shared with the great majority of Americans the sense that the conflict in Europe was none of America's business. At the start, it had appeared even vaguely ridiculous.

Alfred was also not alone during the first weeks in thinking that a quick bloodbath might bring Europe to its senses, although he was a good deal more outspoken than most. His romanticism and rudimentary psychologizing also somewhat embellished the view. In late August he suggested that a month or two of war might be beneficial, giving outlet to the pent-up aggressiveness of the contenders and cleansing the atmosphere. A Faustian *Walpurgisnacht* to purify the spirit. Being cooped up at 291 during the war's first week had made him restless; Europe was going through such a "tremendous reality."

Romanticism notwithstanding, within a month the war was having an impact on some of his friends. He was not anxious about his niece Elizabeth, for she had returned from Bavaria with her ailing maternal grandmother in April. But Haviland and De Zayas were talking about returning to France—an impulse they both soon decided was premature—and Hartley, although uncertain about how long his funds would last, was determined to stay in Berlin. He was just finding his stride in a period of extraordinary energy, inspired in part by a powerful attachment to a young German officer. The Steichens, however, with the combat line approaching Paris, decided to return to the States. Alfred would cut short his vacation at Oaklawn to meet them in New York in mid-September.

Despite the fact that Steichen had no immediate career plans, there was not much concern among his friends about his getting established quickly. In the first place, his adaptability to new circumstances was widely admired and envied, a favorite morsel for Round Table gossip. His charm and lean good looks, as well as his international reputation, elicited spontaneous hospitality. With waspish but not inaccurate asperity, Alfred's cousin Flick Small answered Alfred's apparently extravagant sympathy with Steichen's predicament thus: "It strikes me that with all his strength, Steichen generally manages to stand on Somebody Else's feet . . . I bet . . . he'll be living in somebody's Fifth Avenue mansion (figuratively speaking) with a valet all of his own . . ." Her prediction was quickly borne out. Leaving his wife and daughters in the hands of his sister-in-law, who would take them to the country, Steichen arrived bag and baggage at 291, and was swept almost at once by the Eugene Meyers, Jr., to their handsome new Gothic villa in Mt. Kisco for which he had designed interiors. There to choose which of seven of his murals he would borrow for an

exhibition of his paintings at Knoedler's in New York in January, he settled in to enjoy, figuratively, "a valet all of his own."

If Steichen was relaxed about accepting hospitality, he was certainly no idler. Within a month of his arrival, he was busy putting his talent and taste to work at 291, redesigning the setting for a loan exhibition of African sculptures from the Picabias' collection brought from Paris by De Zayas for the opening of the season. Presented as "African Savage Art," it was billed as the first show of its kind in America. Its artifacts were termed the precursors of Modernism, the natural forefathers of Cubism. Steichen, who found the original mounting of the show drab beyond belief, had the chair-rail curtains dyed black, and rearranged the pieces against geometrically related paper rectangles and squares in vivid orange, yellow, and black. The Mondrianesque background emphasized dramatically the affinity between the old carvings and the newest art. Steichen's labor was vigorous proof not only of his ability to transform the tired physical and psychological atmosphere he had found at the gallery, but also of his growing impatience with his friend of fourteen years.

That impatience was about to explode. Convinced that he had taught Alfred everything he knew about arts other than photography, Steichen now found his opinions largely unheeded. Instead of being the featured soloist, he had become the lesser voice in a quartet of advisors; Haviland, De Zayas, and Meyer sang the theme. He took his revenge in the answer he penned to Alfred's "What is 291?" for *Camera Work*'s special issue. In effect it was a scathing attack on Alfred for having rejected his, Steichen's, prescription for the revitalization of 291. Alfred printed it, together with the mostly effusive tributes of the other sixty-seven contributors, but it marked an irreversible step in the deterioration of their friendship. Curiously, Alfred hid the extent of his deep sense of personal injury from everyone except, it appears, his mother, his sisters, and Lee: even those closest to him at the gallery were unaware that a subterranean battle had opened between the two men. Nevertheless, from that point forward, both let fly with recriminations that would intensify in ensuing years.

In Alfred's case, it seems clear that the acrimony that marked his later statements about Steichen was in direct proportion to the love he had once felt for him. In the earliest years, every chance to see Steichen had been cause for celebration. In 1900, he was welcomed immediately into the Stieglitz family, and, in 1903, invited to bring his young bride, Clara Smith, to Oaklawn for their honeymoon. This sojourn inspired Alfred in later

years to act out a comic ritual every time Steichen's elder daughter, Mary, visited him at his galleries. Even when she was in her thirties, and long after her father's rancorous estrangement from Alfred and her own some-time residence with Alfred's brother Lee and family during her parents' six-year separation, Alfred would greet her by cutting off all conversation abruptly, putting an arm around her, and declaiming enigmatically to the assemblage, "You see how everything comes full circle? This girl was *conceived* at Oaklawn!" After which, leaving his audience thoroughly bewildered, he would return to whatever he had been saying.

Beyond the personal brotherhood between Alfred and Steichen in the early years of their association, and beyond the professional mutuality of interest first in photography and later in contemporary painting and sculpture, the two men shared the passion of dedicated workmanship. From the beginning, their work together was so effortlessly interwoven as to appear the product of a single imagination, a single view. Alfred left all matters of design absolutely to Steichen. *Camera Work*'s covers, layout, advertisements, and typeface were Steichen's handsome production, as were also the neat, understated, and modest-scaled elegance of the galleries at 291 and 293 Fifth Avenue. Conversely, Steichen left to Alfred absolutely the written content of *Camera Work*, its selection of photographs, and the public expression of 291's position through its catalogues, press relations, and Alfred's own inimitable conversation.

Just the same, there were tell-tale cracks in their cohesiveness even in the early years. Steichen insisted from the start on preserving a degree of independence that was sometimes an affront to Alfred. Even after 1900, he exhibited works, and cultivated a friendship, with Alfred's arch-rival, the photographic entrepreneur F. Holland Day. Further, Steichen's need to earn a living from his photography, which Alfred was spared, found him in pursuit of the prominent to gain portrait assignments. His success in that pursuit led Alfred, impressed at first in spite of himself, to declare soon that such efforts were time-wasting for a true artist and ultimately destructive to "finer" impulses and concerns.

Alfred's reaction to Steichen's professional success was, in fact, amusingly and irritatingly ambiguous. On the occasions when he himself took part in helping Steichen to get paid work, he first praised Steichen's ability to make money without sacrificing high artistic standards, and then castigated him for building new opportunities on the foundation of those favorably concluded.

The first documented occasion on which Alfred helped Steichen gain employment was in 1903. The Stieglitzes' old friend, Fedor Encke, painting a portrait of J. P. Morgan, had asked Alfred to make his task easier by photographing his restive subject. Alfred suggested Steichen for the job, as he did again when Eleonora Duse asked him to photograph her. Steichen's success with both assignments gave him a passport to presidents, luminaries in the arts and letters, and figures in high society.

A somewhat less certain introduction for which Alfred claimed credit was to Frank Crowninshield of *Vanity Fair*. There is no question that Alfred was Crowninshield's long-venerated first choice as monthly portraitist of a prominent figure for the magazine—they had also been friends for years—or that Alfred, declining, suggested Adolph de Meyer, who carried out the assignment during his stay in New York through the early war years. In 1923, long after de Meyer's departure, Crowninshield again asked Alfred for his recommendation; this time he suggested Steichen, just returned from living again in France. Probably Alfred wrote a laudatory letter; perhaps he set up an appointment. But he was not solely responsible, as he later averred, for launching Steichen's long and fruitful association with the Condé Nast organization.

Over a decade earlier, Steichen had done a portrait of Mrs. Condé Nast in Paris. In New York in 1923, he was invited by Crowninshield to lunch with Nast, and together they devised the functions that Steichen would perform: provision of art portraits of celebrities—from writers to statesmen to movie stars—and quality fashion illustrations. Steichen became Crowninshield's prize photographer. It was not long before he was taking on assignments in advertising as well. His creativity seemed boundless, his originality unmatched, his sense of drama faultless. And Alfred began to upbraid him for rank commercialism, equivalent in his art-for-art's-sake lexicon to whoring.

The schism over commercialism was, however, larger than personal friction. Alfred's lifetime insistence on the intrinsic value of amateurism was all-encompassing. Refusing to function as a dealer in the ordinary sense, or to run a gallery that was interested in profits, he sought for his artists a form of patronage on the Medici pattern, and operated his gallery on a collective basis, with the artists themselves contributing what they could afford. Steichen, on the other hand, believed increasingly in the viability of the marketplace. He became convinced as the years went on that more traditional merchandising would benefit not only the artists, to

whom wider recognition and steadier funds would accrue, but also the cause of modern art. Heartbreakingly for Alfred, Steichen's view would be embraced, in 1915–16, by the three remaining stalwarts of 291, Haviland, De Zayas and Meyer.

There were further tensions in Alfred's and Steichen's "partnership" in the management of 291. When Steichen had left for Paris a year and a half after its opening, he clearly regarded the arrangement as giving him the responsibility for procuring all works that were not photographic, leaving to Alfred the selection of photographs, the day-to-day operations of the gallery, and the paying of bills. But on the very first occasion when it was agreed that nonphotographic works would be shown, Alfred invaded Steichen's turf, slipping Pamela Colman Smith into the slot that had been reserved for Steichen's hero, Auguste Rodin. Alfred had already "robbed" Steichen earlier in the year by calling a press conference to show his own first Lumière attempts before Steichen's scheduled premiere of plates that had already excited praise in exhibits abroad.

Nevertheless, for the first few years of 291, and despite occasional differences, Alfred and Steichen worked well together with the Atlantic between them. Soon, however, Alfred's expanding confidence in his own judgment began to erode their harmony. When, in 1909, Alfred invited Dove and Hartley to show at 291 without prior consultation, Steichen— even though he approved the choices—demonstrated testiness by procrastinating needlessly in assembling the Lumière autochromes that were to comprise his third, and final, one-man show at 291 in 1910. When, in that same year, Max Weber replaced him as Alfred's primary "teacher," Steichen's intransigence solidified. For over a year, he battled Alfred over providing the negatives and guide prints the latter had requested for an issue of *Camera Work* that would carry his work exclusively, claiming that old prints would do just as well; the result was a delay in publication until July 1911. Coincidentally, perhaps, 1911 was the first year in which Alfred overrode Steichen's expressed trepidation about Picasso by mounting the radical painter's first one-man show in America. As Steichen's exceptional moodiness during that year made other members of the Stieglitz family wonder if he was having marriage problems (he was), Alfred sympathetically exercised unusual patience with him, but he was persistent in his artistic demands.

Within the next two years, Steichen's role as 291's scout abroad became seriously diminished. By 1913 he had been largely superseded by De

Zayas and Haviland. Within the next three years it would be clear that Alfred's independence of Steichen was complete. Of his eventual stars, only Marin had been introduced directly by Steichen. Hartley had arrived on his own. So, essentially, had Dove. Finally, there was O'Keeffe, whose first exhibition at 291 in 1916 was in no way connected with Steichen. By then, Steichen had openly repudiated 291—and Alfred—as has-beens.

In addition to the more obvious factors in the eventual dissolution of Alfred's and Steichen's friendship, there was one corrosive emotion that each proudly denied in himself and accused the other of harboring: jealousy. Probably not artistic jealousy. Each seemed able to accept the other's luster, and Alfred, at least, maintained generously throughout their friendship that, of the two of them, Steichen was "the master." Nor, it appears, was there resentment over accolades wrongly attributed because of the irritating and inevitable confusion of their too-similar surnames, a coincidence that each acknowledged with a wry disavowal of its importance. But money and age were certainly factors.

Steichen, who had had to support himself since his early teens, was, at least unconsciously, jealous of Alfred's license to lean on his family. He rationalized the feeling by calling Alfred's privilege a convenient, and impairing, means of eluding the disciplining necessity of producing, regularly, works that could sell. And Alfred, condemning Steichen's "materialism" when the latter's fortunes rose in the commercial world, could not resist telling friends the prices his own photographs could command, *if* he were interested in selling them.

It would have been almost impossible for Alfred not to have been jealous of Steichen's comparative youth. When Steichen returned to America in 1914, invidious comparisons of their respective ages forced their way into Alfred's consciousness. It had been amusing to think of Steichen as a son when he himself was only thirty-six, but entering his second half-century when Steichen was not yet thirty-five made Alfred feel positively ancient. Three years later, when Steichen volunteered for the American Expeditionary Forces and turned up at Alfred's home in his custom-made uniform, Alfred remarked not only on how much he had "impressed the ladies" but also on how good-looking an officer he himself might have been were he not "Just *Old*."

In earlier years, Steichen may well have been jealous of Alfred's age, or at least of the massive self-confidence that seemed to accrue from his role as elder. Until he was able to break free of his junior role, Steichen's occasional daring was followed often by trepidation; had he been impru-

dent? In the first decade of the 1900s, at least, Alfred seemed better able than he to shrug off rebuffs and frustrations and to steam ahead in the certain knowledge that he was right.

The resentment of Alfred that Steichen displayed in the years of their estrangement—between 1917 and an eventual rapprochement in the early forties—might have arisen partially also from Alfred's relative indifference to the paintings that Steichen produced, in various periods of intensity, until the early twenties. In Paris, Steichen's artistic circle was composed almost exclusively of sculptors and painters who were scornful of the claim that photography enjoyed parity with their own media; in effect, they challenged him to prove his creativity in their territory. There is no question that his photography and his painting benefited mutually from his double assault. His enthusiasm for color photography, which peaked after the Lumière discovery, was undoubtedly spurred by his painting; his painting, in turn, reflected his eagerness to transfer to canvas the subtle and seemingly endless range of nuances of light that were so readily available to the camera's sensitivity.

Alfred praised Steichen's dual creativity—it added weight to his argument about photography's stature—but, with one bizarre (and questionable) exception, he never showed his paintings. Others in New York did; at roughly two-year intervals between 1902 and 1915, Steichen's canvases were exhibited, sometimes in conjunction with photographs, in well-attended galleries. The sole Steichen painting to appear (perhaps) at 291 was a "Cézanne" he faked—with Alfred's impish connivance—in the first year of their acquaintance with Cézanne's work, before the latter's shorthand seemed anything but lack of skill to their freshman understanding. Steichen's "Cézanne" was—or was not, according to the teller of the tale —shown with the real Cézannes at 291 in the spring of 1911. Alfred later maintained that, thanks to Steichen's lack of nerve, the picture was discarded before the show. Steichen, however, related in detail not only his anguished terror at its inclusion in the exhibition, but also his vast relief when he burned the canvas after the show was over.

By far the greatest blow to the long closeness between the two men came when, in the fall of 1914, Steichen at last responded to Alfred's early summer request for his contribution to the "What is 291?" issue of *Camera Work*. Apparently finding disingenuous Alfred's insistence that he wanted to avoid any suggestion of personal eulogy, Steichen launched a direct attack on Alfred, labeling "this inquiry into [291's] meaning . . . impertinent, egoistic and previous." Deeply hurt by the general tone of the

piece, Alfred took what crumbs of comfort he could from Steichen's bow to his "broad and generous understanding and support" and his "greater importance in our personal development than . . . any single unrelated individual could possibly be." And then printed the otherwise searing in-dictment of 291's—for which he read, correctly, "Stieglitz's"—current failure. The effusive tributes of the vast majority of other contributors did not heal the wound.

Steichen's emotional and muzzy diatribe charged that 291 had not only abdicated its responsibility in leaving to others the organizing of the Armory Show but was now, through Alfred's despotism and inertia, on the brink of abandoning everything it had once stood for by failing both "to realize its relationship to the great unforeseen, the War, [and] to make of itself a vast force instead of a local one." Leaving people with the idea that 291 was merely "a rival to the Old Camera Club [or] Mr. Stieglitz's Gallery for the newest in art," Steichen, firing wildly in all directions, castigated 291 most severely for not "consigning . . . to the scrap heap of History an art movement such as futurism [together] with anarchy and socialism . . . Church and State . . ."

Steichen's inclusion of "futurism" in the new "dogma" he found at 291 was a curious involuntary disclosure of some of his inner distaste for Cubism, and for the angular tensions, related to the new Italian Futurist movement he had come to know in Europe, that seemed to have infected even his favorite 291 painter, John Marin. Although Steichen would later claim foresightedness in appreciating Picasso, Braque, and other Cubists who became famous, there is little question that when their works appeared at 291 he found them disquieting. He never truly liked the creations of Dove, whom he called "Stieglitz's favorite 'wild man' "; he would not be taken with O'Keeffe's abstractions. He disliked openly the Dada spirit of Picabia's work, especially when Picabia arrived in New York in the spring of 1915, was welcomed warmly by Alfred, and became another potent artistic "guide" for 291.

Steichen later wrote in his autobiography that Alfred's unwillingness to broaden 291's function, to make it "a civilizing force in the world," had spelled its ruin. Had he accepted Steichen's vague program—to make poets like Alfred Kreymborg, musicians like Edgard Varèse (both fre-quenters of 291), and representatives of other arts "Fellows of the Photo-Secession," or of a "new organization," for example, Alfred might, Steichen implied, have saved 291. Close scrutiny of Steichen's *Camera Work* screed, however, purveys quite another message. What it reveals is

that his deepest battle with Alfred was not about futurism, not about poets and musicians, not about anarchy or socialism, church or state; it was about the absolute polarity of their positions concerning the war.

Steichen was both a Francophile and a passionate American patriot. Alfred, with his long attachment to Germany and his disillusionment with American marketplace values, was sympathetic at first to what he perceived as Germany's battle for moral independence in a degenerate world. The anarchistic nature of his individualism and the socialism inherent in his yearnings for universal justice were fundamentally legacies from his student days, reinforced afresh by the intransigence of Zoler, Wolff, and Co.

Paradoxically, Alfred and Steichen shared a certain romanticism about war, albeit from antipodal positions. As we have seen, Alfred envisioned war at first as the ultimate terrible Faustian crucible from which purity might be distilled, a social catharsis, a resolution to the irrationalities of which all parties were guilty. It was a naïve perception, to be sure, but a natural outgrowth of his earlier glorification of the American Revolution, combined with a total ignorance of the reality of war. To Steichen, war seemed a test of manliness, as well as, in this instance, of patriotic fealty.

To add, furthermore, to Alfred's long respect for the hard work, basic decency, and careful craftsmanship that Germany had personified in his youth, which had been bolstered in more recent years by his close contacts with German and Austrian artists and photographers, he found his family in complete accord. Hedwig was hospitable not only to friends caught in the crosscurrents of allegiance—remembering perhaps Edward's accounts of his Civil War experiences among Germans who remained unpopular despite their devotion to their new country—but also to Germany's ambassador to Washington.

As late as the summer of 1916, Count Johann-Heinrich von Bernstorff was a visitor on several occasions to Oaklawn, the guest of Alfred's sister Selma. Intimidated at first by his noble heritage, Hedwig quickly found him "simple and democratic . . . amusing, full of humor," and Alfred enjoyed talking with him at Lake George. Von Bernstorff was, in fact, a tireless proponent of greater understanding between Germany and the United States and continued to support Wilson's efforts to find a way to end the conflict without America's full involvement against the express instructions of his government until his ouster from Washington three days before America's declaration of war. The Count's coincidental presence with Selma on the Lake George Country Club golf course on the

day of the Black Tom munitions explosion (the work of German sabo-
teurs) would earn Selma discreet federal surveillance for the balance of
the war, an epilogue out of which Alfred made teasing capital for years.
It was not so entertaining to Selma's son Howard and his new bride,
Dorothy Obermeyer, when a Secret Service agent joined their honeymoon,
or when, as a consequence of his mother's flirtation, Howard was threat-
ened with the withdrawal of his new commission in the Navy—a punish-
ment from which he was rescued by the intervention of the New York State
Supreme Court Judge who had officiated at his wedding, Benjamin Cardozo,
his uncle George Herbert's former law partner.

Steichen was horrified by the liberal attitude of the Stieglitzes, and
infuriated by Alfred's defense of Germany as no more villainous than any
of the other Western powers. He later recalled that it was Alfred's re-
sponse to the torpedoing of the *Lusitania* in May 1915—"It served them
right. They were warned in advance that the ship would be sunk"—that
made him decide to enlist, although he would have to wait two years for
Wilson's April 1917 call for troops. By then Steichen had found a way to
unite service to his country with candidly expressed service to himself.
Named a lieutenant in the Historical Section of the Signal Corps and
assigned duty as a photographic reporter, he was sure to gain valuable
experience in his métier. In rapid sequence, he was trained in aerial pho-
tography, advanced to the rank of lieutenant colonel, transferred to the
Photographic Section of the new Air Service, and placed in command of its
unit in France.

Alfred, envying Steichen's exciting experience abroad, thought briefly
of seeking war work, too. His brother Julius, by then a power in research
for the government, reported talk in the War Department of asking Alfred
to head research in speed photography. Before he could make up his mind,
however, Alfred heard that the military had scotched the offer; he was too
well known as a "hell-raiser," he said. He made no further effort to seek
active service, content to give moral support to his family's Victory garden.

Even before Steichen entered the service, he was aware that twenty-
seven-year-old Paul Strand was Alfred's new photographic protégé, and
that his own position was decidedly peripheral. When he returned to Eu-
rope in 1919, he and Alfred barely corresponded, limiting their contact for
the most part to brief meetings during his occasional visits to New York.
Within months of his resettlement in New York in 1923, he was firmly
established in his new career with Condé Nast. Henceforth, it seemed,

Alfred would think of Steichen as part of a hurtful past, and Steichen would be too busy to give Alfred more than a passing thought.

Until their final rapprochement in the early 1940s, the caustic mode in which each referred to the other gave telling evidence of how close they had once been, and how much residual bitterness resided in each toward the other. If Alfred overplayed somewhat his recital of Steichen's "betrayal" of him and the values they had once seemed to share, and if Steichen overdrew a portrait of Alfred as a failed leader whose despotic egoism had preordained "failure," it was because their ties were never entirely severed.

Years would pass when they ignored each other. Each was busy with his own concerns: Steichen had a fifteen-year post as Condé Nast's chief photographer, during which period he was also J. Walter Thompson's photographic advertising star, a designer of photo murals and fabrics, and a recognized hybridizer of delphiniums (a hobby dating from 1910 in France) while Alfred strove stubbornly to bring himself and his camera as near as possible to creative perfection and worked furiously to keep a showcase, and an income, going for his artist "fellows."

It was in the late 1930s, when Alfred's health was failing and it took all his energy simply to stay at his post as majordomo of his last gallery, An American Place, that he began to live half in the past, to replay for himself and others the events of his earlier life. To a few intimates, and to young nieces willing to listen, he revealed his profound disappointment in Steichen in conversations that usually began in a low key but could rise to fortissimos of vituperation. On one occasion, a close friend reported, his rage slipped out of control: he had pored over one of Steichen's advertisements side by side with one of his own portraits of O'Keeffe's hands and found them to be almost identical in composition. Now plagiarism was added to the list of Steichen's sins.

At the same time, Steichen was on the brink of further triumphs. Soon he would serve his remarkable stint in the United States Navy in the Second World War, moving from the organizing of a small photographic aviation unit to eventual command of all Navy combat photography. For the next fifteen years, he served as the director of the Museum of Modern Art's Department of Photography, an association that culminated in his famous exhibition, *The Family of Man*.

It was Steichen who, learning of Alfred's first severe heart attack, initiated their reconciliation in the early 1940s. Both had been mellowed

by life's batterings. Their meeting, witnessed by Alfred's special friend, supporter, and chronicler, Dorothy Norman, was touchingly gentle and free of rancor. Steichen's attitude was one of near-reverence and appreciation, the posture of a former pupil with a beloved master. After his departure, Alfred remarked, "Steichen will be my greatest mourner."

Not until a few years after Alfred's death did I come to know Steichen without the marring disparagement of the family as a barrier; my grandfather Lee, in fact, referred to him usually as a "rotter," as much for having left his wife and daughters as for any injuries he had dealt Alfred. Others were sometimes more charitable, but nearly all remained cool.

I was as charmed by him as my great-grandparents and Alfred must have been. On the threshold of eighty, shaggily handsome, youthful and energetic in outlook, witty and lightly rakish in manner, undisguisedly self-centered, he looked forward to tomorrows with a vigorous curiosity a man a third his age might have lacked. At our final meeting, he referred slightingly to the stroke he had suffered the year before and the operation for cataracts that he had recently undergone, and went on quickly to rejoice in having taken up painting again as a less taxing outlet for his creativity; he was having fun again after all those years devoted to photography. His only cautionary note was advice to me not to marry for a third time, a step he himself took two years later. By then, he had turned from painting to another experiment, a moving picture log of the seasons enacted by a shadblow tree across the lake from his Redding, Connecticut, home. He continued at the Museum of Modern Art until he was eighty-three.

In our conversations, Steichen's praise for Alfred was at first almost suspect in its extravagance. After he learned that we had other topics to share, whatever he said about him was usually less flattering but always genuinely warm. So warm that I was taken aback when his 1963 informal autobiography took scant notice of Alfred's role in awakening his contemporaries to the validity of either photography or modern art, and ascribed to himself a far larger responsibility. Alfred's complaint that Steichen had let him down seemed suddenly more valid than it had before.

But in one area, even in print, Steichen's praise was unqualified. "Stieglitz's greatest legacy to the world," he wrote, "is his photography, and the greatest of these are the things he began doing toward the end of the 291 days."

14

Steichen's 1915 prophecy about the death of 291 was somewhat premature, but he was not alone in wanting to change its direction. Meyer, Haviland, and De Zayas had been arguing with Alfred for some time about extending the gallery's horizons. They were especially interested, as Steichen was not, in the latest experimentation in Europe, including the first stirrings of Dada. A change in the gallery's publications seemed in order as well. The new graphic structures of poetry and the biting satire that characterized Guillaume Apollinaire's avant-garde journal, *Les Soirées de Paris*, sparked a collective desire to see similar pieces in *Camera Work*, but it was clear that the latter's dwindling subscribers might be frightened into total desertion if they were faced regularly with irreverent and caustic wit as well as eccentric typography and illustration. What was needed was a new monthly, simpler in layout, less expensive to produce.

Knowing Alfred's delight in satire—he had always enjoyed tweaking the noses of conformists, and now counted the pious war-paralogists fair game—the three enlisted his financial and editorial support for a new periodical they hoped to call *291*. Its first issue could be ready for January 1915. With De Zayas's caricatures a regular feature, it promised to launch arrows at all targets, including themselves and Alfred.

Alfred was entranced with the concept, and deeply pleased with the evidence that this group of youngsters was on its toes. He gave his consent enthusiastically, insisting that the work be carried out in 291's (Lawrence's) back room; he would supervise the printing, contribute to its text, help with the editing, and provide a third of the funds anticipated in its modest budget.

Although the magazine may not have become as satirical as Alfred wished, sidestepping for the most part broadsides against wartime "nonthink" and its more general social counterparts, it proved to be the most avant-garde publication of its day. Experiments that laid out verse in pictorial design or wedded caricature to words, spontaneous prose that

performed dazzling leaps of association, portraits in which human and mechanical features were juxtaposed, and musical notations that formed pictures, filled its twelve-by-twenty-inch pages, together with iconoclastic criticism and drawings that included reproductions of the latest works of Picasso, Braque, and Picabia with others created especially for the magazine by many of 291's group of artists. Even when Alfred was not directly involved, the back room buzzed with the almost daily conferences and work sessions of Haviland, De Zayas, Meyer, and the latter's painter friend, Katharine Rhoades, a new recruit. With another young painter friend, Marion Beckett, Rhoades and Meyer formed a trio so eye-filling that they were called "The Three Graces."

Underlying a number of *291*'s illustrations and literary pieces was a new freedom in sexual imagery, in varying degrees of subtlety. Alfred's images in three prose-poetic renditions of dreams were romantic and circumspect. Some of Picabia's drawings, however, bordered on the explicit. In one "portrait" of Alfred, *Ici, c'est ici Stieglitz*, in which a camera is focused with *"foi et amour"* on the word "Ideal" in German script, the bellows droop unmistakably like a postcoital penis. Alfred may not have enjoyed the message of his loss of artistic virility, but he undoubtedly relished the *double-entendre*.

In his schoolboy days as a spellbinding storyteller, there is little question that Alfred spiced his tales with sexual references. Whether or not they had been repressed meanwhile and were released by Picabia's arrival, or whether he had continued to indulge a bawdy streak privately with male companions, is moot. What is inescapable is that, in his later years, he was far from inhibited. If his riposte to a woman visitor to his gallery in the thirties who wondered why she was left unmoved by the pictures on display —"Can you tell me this: Why don't you give me an erection?"—was primarily the result of an always irresistible impulse to *épater les bourgeois*, the choice of simile was not unique. When Alfred found evidence in a listener of a robust attitude toward sex, he was not reluctant to respond in kind. With men friends, he was unfettered in expression: with women, he was prone usually to euphemism. Some of his letters, and some of the conversations I myself remember, were masterpieces of innuendo, unexceptionable in language, usually comedic, and often self-ridiculing. Only very occasionally, in his sixties and seventies, did he become prurient, and I doubt that he was ever deliberately pornographic. What is astonishing is not so much that he gave free reign to ribaldry with some friends as that he managed wholly to convince others that an impure thought never entered

his head. There remain to this day a few acquaintances who respond with outrage to any suggestion that he was not totally innocent.

Enthusiastic though he was about the magazine *291*, Alfred was still uncertain in 1915 about the direction that the gallery 291 should take. Throughout the season, he tried to accommodate the preferences of his three younger associates. He supported De Zayas's enthusiasm for African sculptures and ancient Mexican artifacts. He gave space to paintings by Agnes Meyer's friends, Beckett and Rhoades, and was genuinely enthusiastic about showing the three large Picabia canvases De Zayas had brought back from Paris at the end of the 1914 summer. Finally, he was delighted at the turn of the year to present Picassos that were more advanced than those the latter's own agent in Paris had consigned to the rival Washington Square Gallery. This sweet stratagem was effected by Picabia, who was also instrumental in arranging for 291 the later startling American debut of Georges Braque.

Meanwhile, changes in the New York art scene had begun to take shape. Coincident with Picabia's exhibition in January, a sizable contingent of European artists had arrived in the city to wait out the war. A circle headed by gently madcap Marcel Duchamp (free of military service for medical reasons) had already begun to gather at the commodious apartment of Louise and Walter Arensberg, where Duchamp was the star boarder until he was able to find a studio of his own. The Arensbergs' hospitable home was a hothouse for avant-garde painters, poets, sculptors, and composers, in which exotic Europeans and venturesome Americans cross-fertilized brave new trends. It was here that American Dada was born. Alfred was an occasional participant in almost nightly festivities and became devoted to Duchamp. In 1917, he would produce a photograph and briefly display the original of the latter's "ready-made" artwork titled *Fountain*, a urinal, that so horrified even the progressive board of the year-old Society of Independent Artists that they quarantined it behind a screen at their first exhibition in New York.

In June, Picabia himself appeared, to be welcomed again by Alfred with open arms. As purchasing agent for sugar for the French Army, he had been sent to Cuba; *en route*, he would manage to spend nearly six months in New York, where he became immediately involved in the production of *291*, contributing ideas, drawings, and inspiration; through him, the monthly took on a distinctly Gallic flavor.

Picabia did more than restore Rabelaisian zest to Alfred's life; he contributed materially to his new friend's acquaintance with and enthusi-

asm for nonobjective art. Fifteen years Alfred's junior, Picabia had a Paris coterie that included his contemporaries Villon, Gleizes, and Léger as well as the much younger Marcel Duchamp, all members of a loosely organized group that called itself *Les Putaux*. Not only had he been a source, while still in Europe, for many of the avant-garde works shown at 291, but his articles in *Camera Work* had been eye-openers. The analogies Picabia drew between painting and musical improvisation were so congenial to Alfred that he adopted them as his own. In 1923, he called his first abstract photographs of the sky *Music—A Sequence of Ten Cloud Photographs*.

Throughout the 1915 spring, activity at the gallery had a somewhat frenetic quality, having less to do with mounting exhibitions than with pushing *291* out on time. Alfred was heavily engaged as well in perfecting the gravures of his *The Steerage* that would crown the new magazine's September issue. In the excitement of novelty, *Camera Work* was temporarily shelved—an unsettling feeling for Alfred, who began soon to realize that the easy cooperation of January was rapidly deteriorating. Squabbles over the future surfaced more and more frequently over the growing insistence of Meyer and De Zayas that, in order to survive, 291 would have to become an overt competitor to other galleries, would have to go commercial.

Alfred's lieutenants were beginning to talk like generals. Haviland, as always, soothed ruffled feelings as best he could, but his days were numbered. Urged by his father to return to Limoges to manage the family's porcelain works, he would be back in France by mid-July. In the meantime, however, he, too, expressed his conviction that 291 must begin to market modern art and deemphasize educating a reluctant public. When Picabia arrived in June, he took up the same theme.

Alfred, offended by his star pupils' misunderstanding of all he had tried to teach them, hid his wounds from all except Marie Rapp. To her he admitted finding their behavior dreadful—precipitous and destructive. Temporarily he found succor in two experiences of glorious freedom: the first was a full month in New York without Emmy, who was touring New England with a companion, and without Kitty, who was at camp; and the second was the realization of a persistent dream at Lake George. Unsupervised at last, he took to swimming at night, alone, and in the nude. He was so dizzied by the sensation that, after his second adventure, he wrote Marie four pages of sensuous description of his feelings of bodily intimacy with mountains, sky and water, with stars. In this euphoric mood, he invited Picabia and De Zayas to Oaklawn in mid-August, thinking perhaps

that in a less stressful setting they might resolve some of their differences.

Their acceptance of his invitation was a move of diplomacy; neither was fond of country doings. Accepting gracefully Alfred's demonstrated superiority on the tennis court and in his sleek new racing gig, they concentrated on their purpose. They were there to test Alfred's reaction to a new hypothesis. How would it be, De Zayas asked, if, instead of changing 291's character, he, Picabia, and Meyer were to open a new gallery that would serve as 291's commercial arm, selling the works of Alfred's regular stable as well as other moderns? While they were there, a less tactful approach from Agnes Meyer arrived, in the form of a harsh letter. Without the new gallery, she wrote, 291, already floundering in "inactivity and aimlessness," would soon die "an involuntary and nasty death." What all three failed to mention was that the "hypothesis" was already a *fait accompli*. They had leased space at 500 Fifth Avenue for an October opening; they had found backing, largely from Agnes Meyer's husband; De Zayas would serve as director.

Infuriated though he was by Meyer's high-handed tone, Alfred agreed that De Zayas's idea was "fine," and consented to come to New York early to discuss the particulars of an arrangement between the two galleries. Hope stirred in him that at least two of his artists could find their financial difficulties eased. He was disappointed that Picabia and De Zayas were not interested in taking on perpetually broke Hartley, but Marin and Dove, equally impractical, could gain enormously. Marin, ending a tightly budgeted second summer in Maine with his wife and infant son, had just catapulted himself into debt by buying an island which, lacking fresh water, was uninhabitable. And Dove, farming sixteen hours a day to support his wife and son in Westport, Connecticut, could not make enough to meet mortgage payments, far less to find money for materials or time to paint. If a new gallery could effect more sales for both men than 291, Alfred would be free of anguish about them. The philosophical compromise would be worth it.

For a while after the Modern Gallery's October 7 opening, it seemed the partnership might work. Despite lingering doubts, Alfred gave what help he could. He informed friends that, if they missed him at 291, they were almost certain to find him at 500, where he took over lunch-hour duties on alternate days.

To help pass the time when there were no visitors, Alfred brought along his camera. One of his young student devotees, Anita Pollitzer, came upon him one day "hopping around on tables and chairs taking pictures of

Fifth Avenue looking down"; the eighth-floor windows offered intriguing angles, especially over the Forty-second Street Public Library across the way. An ebullient cricket of a girl, bright and just argumentative enough to be fun, Miss Pollitzer had been in the habit for at least a year of dropping in at 291 whenever she was in the area. Over the summer, Alfred had taken special pains to send copies of *291* to her friend and former classmate at art school, a Miss O'Keeffe, currently teaching at a small southern college she found suffocatingly dull.

As he faced 1916, it was something of a surprise to Alfred that 291 was continuing at all. Although he had arranged debuts for two new artists, Oscar Bluemner and Elie Nadelman, he had half decided to close 291 at the end of the year, a thought that was dislodged, in fact, by De Zayas's suggestion to operate two galleries in tandem. Everything had become too expensive for Alfred. He was carrying at least a third of the cost of 291 and its publications, to say nothing of his monthly stipends to Hartley and Dove; in the 1915–16 season, his borrowings required him to pay out over $1,100 in interest to banks alone. Furthermore, his energy seemed low, psychologically as well as physically. He was tired of introducing the new to an America that was sluggish, indifferent, often antagonistic, and increasingly caught up in wartime greed. Plans he had made for *Camera Work* had fizzled. The magazine *291* had lost money on every issue, and by the end of February he would have to withdraw his support; that month's issue would be the last.

In late December, notwithstanding his earlier hopes, Alfred decided abruptly to sever 291's connection with the Modern Gallery. The more he had seen of the cajoling, bargaining, and hustling that dominated discourse there with the public, the more alien he had felt. For three months, he reasoned, he had been used in a profoundly distasteful way. His name, his reputation, his experience had been courted and his physical help accepted; what he had to say was ignored. He would still wish De Zayas and Meyer well—Picabia was back in Europe—but he would no longer be associated with their methods.

As in other periods of stress, Alfred had been sustained through the fall by his renewed pleasure in the camera. Even more exciting, he had been shown some extraordinary new works by a young photographer who had from time to time sought his critiques. Young Paul Strand had frequented 291 since his enrollment in a new course with Lewis Hine at the Ethical Culture School had convinced him that photography was his single goal. Clerking in his father's modest import business for two years after

graduation had enabled him to save enough for a summer in Europe; on his return, he had set up shop as a commercial photographer.

At first, Strand had emulated the soft-focus imagery of Clarence White. In time, Alfred told him gently that what he was seeking to express would be served far better if he gave up using the soft-focus lens and concentrated on bringing out clearly the variety in texture, form, and light that only a sharp focus could capture. Suddenly, in the summer of 1915, it had seemed imperative to Strand to discover for himself, in photographs, the principles underlying abstract art. In the fall, he brought his experiments to Alfred.

Alfred was ecstatic. Immediately, he promised Strand a one-man show at 291, to stand as antithesis to the thesis of the coming Forum Exhibition of Modern American Painting he was helping to organize for the spring, just as his own exhibition three years earlier had counterpointed the Armory Show. Strand's astonishing abstractions would be shown at 291 in March and April. Alfred's excitement over the twenty-five-year-old's accomplishment led him to resume publication of the suspended *Camera Work*. The October 1916 issue would carry six Strand prints, an unprecedented number for a newcomer, and the next issue, the periodical's last, would be a stunning solo that included, among eleven prints, seven of the most renowned pictures of Strand's career.

While Alfred was celebrating the enormous strides made by Strand, Anita Pollitzer was trying to contain her excitement over some charcoal drawings sent her by her friend Georgia O'Keeffe with the warning that she herself had wondered if she had been sane when she did them. Anita was transfixed. For two weeks she kept them to herself, as Georgia had requested. Then, on January 1, Alfred's fifty-second birthday, unable to resist any longer asking him what he thought of them, Anita brought them to 291. "I had to," she confessed the same day to Georgia. "I'm glad I did." Going on to describe Alfred's rapt perusal—and his oft-quoted "Finally a woman on paper"—she relayed his message to "this girl . . . 'Tell her they're the purest, finest, sincerest things that have entered 291 in a long while . . . I wouldn't mind showing them in one of these rooms one bit—perhaps I shall . . .' "

Far from being displeased at her friend's indiscretion, Georgia was thrilled, more by Alfred's approval than by the remote possibility that he might display her experiments; she would rather they be shown at 291 than anywhere else. She wanted to know why he had liked them.

If her first observance in 1908 of Alfred lecturing her classmates from

the Art Students League had left Georgia terrified of his bellicosity, her subsequent visits to the gallery six years later, when she was studying with Anita under Arthur Wesley Dow at Columbia University's Teachers College, had engendered respect for his discernment and honesty, as well as the sense that if this man could choose and hang all the crazy, wonderful things she saw on the walls, there was something about him to be prized.

The report from Anita of Alfred's enthusiasm for her drawings came at just the moment when Georgia had almost made up her mind never to try anything like them again. She had spent the fall exorcising frustrations—both with the rigid Methodist college in Columbia, South Carolina, where she taught and with a suitor who inspired alternately feelings of passion and perverse inclinations to laugh—by taking long walks, playing the fiddle, dressmaking, reading, and producing inconsequential sketches and watercolors. Suddenly, in December, she had set off compulsively in a new direction. Without a clear objective, without understanding what appeared day after day on paper, she knew only that some deep need was being satisfied. She was doing what she wanted to do instead of what teachers had always demanded of her. She thought she must be mad.

From her earliest years in Sun Prairie, Wisconsin, Georgia had deferred to the proscriptions of her Catholic home and even more to her teachers; under them she had learned to suppress "wilfully" independent and contradictory perceptions. Through secondary schools and art schools where she won prizes and scholarships for meticulously representational drawing and painting, through jobs that ranged from commercial design in Chicago to teaching in Amarillo, Texas, and at the University of Virginia, she had learned that disciplining her impulses and respecting the wisdom of teachers and supervisors were obligatory tolls on the road to becoming an artist. She had acquiesced to the rules even when she felt them to be wrong.

The explosion into artistic freedom had come just after her twenty-eighth birthday; it had been a heady, and frightening, experience. Alfred's approval restored *terra firma*. She was so eager to know more about *why* he approved that she couldn't wait for Anita's second-hand reports. She wrote him directly.

Apparently, his immediate answer provided not only reassurance but stimulus. Before the end of January, she had a second batch of pictures in the new vein to send Anita, together with the intoxicating news that she had received an offer to teach in the fall in the area she loved the best, the soul-stirring land of vast emptiness and bracing winds, Texas. The

contract from the West Texas State Normal School in Canyon was accompanied by a suggestion that she use the summer to take a course in Methods under Dow at Teachers College. She couldn't wait that long. Before the end of February, she had quit her job in South Carolina and arranged with "Pa" Dow to take his course in the next semester. By early March she was in New York, broke, staying with Anita's aunt and uncle, and wildly happy about the unanticipated chain of events that had brought her there.

Oddly enough, Georgia seems not to have visited 291 during the first months of her stay in New York. When she did go, at the end of May, it was because she had heard that her drawings were on exhibit, with watercolors, drawings, and oils by two other young artists, Charles Duncan and René Lafferty. Despite having known well in advance that there was a possibility that Alfred would show them, the reality was a shock. She went to demand their removal.

This was not what Alfred had in mind. From time to time before the opening of the exhibition on May 23, he had shown them privately to "the fellows"; their reactions had been widely divergent but uniformly powerful. The opening, although arranged carefully to take place after the close of the regular season to spare the "youngsters" exposure to the critics, had caused a minor sensation.

When O'Keeffe appeared—"thin, in a simple black dress with a little white collar. She had a sort of Mona Lisa smile"—Alfred did not know at first who she was. When, having identified herself, she instructed him to take down her drawings, he refused, saying she had no right to withhold them. They argued. He probed for the feelings she had had when she made the abstractions; she told him it was none of his business. He took her to lunch, during which he extracted her promise that she would send him whatever she produced in the future. The drawings he had shown would remain in his custody indefinitely.

It was not love at first sight. Although Alfred admired her forthrightness, her resistance to compromise, her independence and determination, the high standards she set for herself, the openness in her that amounted to a rare innocence and, not least, her unusual beauty, he was far too preoccupied with other problems to give her more than a passing, if appreciative, thought.

Uppermost in his mind was the continuing problem of finding support for his artists, especially for "difficult" Hartley. The progressive deterioration of his relationship with De Zayas and Meyer preyed nearly as heavily. It is a tribute to De Zayas's tact that he would be spared, by and large, the

vilification that Alfred heaped on other deserters, including Agnes Meyer. Nevertheless, Alfred had been wounded by his withdrawal from 291; boring Walkowitz and sycophantic Zoler were no substitutes for a true collaborator, a man whose vision and intellect had bolstered Alfred's confidence. There was little overt friction now with either De Zayas or Meyer, however, who continued to offer ideas for future issues of *Camera Work*. One that reached the planning stages was designed to explore the role of the unconscious in art, with a lead article by psychoanalyst A. A. Brill, whose translations of Freud were beginning to be published, and color illustrations by some of his patients interspersed with those of some of the children exhibited at 291. This was one of several projects abandoned in part because of the wartime inaccessibility of Bruckmann's color printing.

Indeed, America's relations with warring Europe were cause for Alfred's further irritation. He was still convinced in mid-1916 that President Wilson had the option to refuse armaments and nonmilitary supplies to *both* sides, a sure way, he felt, to end the stalemate that was so obscenely costly in lives. Sharing another Lake George visit with Count von Bernstorff during the summer, Alfred was more impressed with the German's statesmanlike efforts to persuade his government to come to the peace table than he was with Wilson's politicking for reelection in the fall. Relief from irritability came with the arrival of a surprise package from Charlottesville, Virginia. It was a new lot of drawings and watercolors from O'Keeffe, sent—in frugal defiance of Alfred's admonitions to consign a sturdy case to Railway Express, collect—by ordinary mail in a flimsy cardboard tube to which she had affixed a six-cent stamp.

O'Keeffe had been in his thoughts increasingly since her departure from New York. He had already sent her some of his favorite books, as well as the best back numbers of *Camera Work*. In Lake George the pace and volume of his letters grew, and the degree of his self-revelation. By the time Georgia arrived, with her sister Claudia for company, in Canyon, Texas, to start work, she had written her friend Anita that she was scared sometimes that the mail might bring her still another letter from Alfred. In one week she had received five, each almost unbearably intense and full, wonderful but exhausting.

Alfred's otherwise candid soul-sharing probably did not yet enumerate the failures of his marriage, although Georgia's acuity surely filled in the gaps. If he was reticent in this regard, it would have been because he was afraid to admit the slightest duplicity to Georgia, to whom he had sworn

total honesty: he was still closing his almost daily letters to Emmy—hotel-hopping in New England—with messages like "much love and a big kiss." If intimations of deeper feelings for Georgia flavored his thoughts, and perhaps his letters, he had not yet allowed them to threaten the shaky home structure he had worked so long to buttress.

Refreshed by a generally peaceful summer, Alfred returned to New York ready to do battle. But what battle? There were neither clear-cut adversaries nor muscular and/or skilled adherents to be found, and certainly there was too small an audience to lend grandeur to any combat. *Camera Work*'s subscribers were down to thirty-six loyalists who had at least not cancelled since receiving the January issue. The first number to appear in a year and a half, and the first since the controversial "What is 291?" issue, it had been somewhat thin in text (the only article that reached beyond gallery doings was De Zayas's "Modern Art in Connection with Negro Art") but it had introduced Strand, and that was important. A playful addition appeared in a *sotto voce* drama tucked between advertisements at the back.

This drama opened with Alfred's announcement, in one breath, of the January founding of the magazine *291*, the October founding of the Modern Gallery (designed to remedy his failure to deal with buyers at 291), and the December dissolution of the partnership between the Modern and 291. He attributed the split to "Mr. De Zayas's [discovery] that practical business in New York and '291' were incompatible." Next came a reprint from *291*: in sententiously caustic tones, De Zayas scolded America for failing to absorb or create modern art—and Alfred for educational efforts that were ill-conceived and unproductive—and declared Picabia the New Redeemer. Then came a five-line Hartley "Epitaph for Alfred Stieglitz."

The imputation of playfulness to the process of putting together public pronouncements of Alfred's failure, death, and succession is my conjecture, but other explanations for his acquiescence are hard to find. Conceived probably as satire, the somewhat heavy-handed three-piece sequence suggests that for Alfred it was also a kind of therapy. For nearly two years he had been hearing from his juniors (not always subtly) that he was dying as champion of modern art and that his only choice lay between following their prescriptions and abdicating in their favor, a choice he had refused to make; he had neither made a will nor died. What he seems to have done in this instance was to transmogrify his hurt feelings into a sardonic public nose-thumbing. A new hobby of composing his epitaph

seems to have begun around this time, and it is not hard to imagine him trying out on his perfidious young colleagues forerunners of the two that would eventually become his favorites:

"Alfred Stieglitz: Still Waits
And Is Waiting Still"

and

"He lived for better or worse,
He's dead for good."

The gallery 291 was indeed on its last legs. Alfred coped, but essentially alone—De Zayas was busy with his own gallery, and by mid-spring Agnes Meyer would move to Washington with her husband. The 1916–17 opening was a motley selection of six painters, five of whom—the Synchromist Stanton MacDonald-Wright, Marin, Hartley, Walkowitz, and O'Keeffe—would each have a one-man show later in the year; the sixth was Alfred's ten-year-old niece, Georgia Engelhard. Whether it was the absence of De Zayas and Meyer, the appearance on the scene of O'Keeffe, or Alfred's conviction during the past several years that Dove and Marin especially, developing indigenous themes with the rude vigor and muscular inventiveness peculiar to Americans, could stand on their own, he was determined by now that he would concentrate his efforts henceforth on helping American artists. The lone European in his 1916–17 season was Gino Severini, a leading figure in the Italian Futurist movement, to whom Alfred gave his American debut in March. To his surprise, Severini gained the highest sales in 291's recent history. But public interest was ephemeral, and Alfred's steady backers were disappearing. In February, he had rashly signed a new lease, but this time there was no Haviland to come to his rescue. He would not be able the following year to mount the three one-man shows he had promised—for Alfred Maurer, Strand, and himself—and the June 1917 issue of *Camera Work* would be the last.

A mere ten weeks after signing the new lease, Alfred was frantic. Unable to borrow, unable to find new angels, he scrabbled for pittances. Daily, Marie sent out a stack of letters to former 291 supporters and readers of *Camera Work*, offering unprecedented bargains to the prompt: 60 to 85 percent savings on back numbers of the periodical, 50 percent on original prints of Alfred's photographs. With the exception of two or three orders, there were no takers.

Alfred should not have been as surprised as he apparently was. To the great majority of Americans, including his most dedicated friends, the uppermost concern was the war. Within five months of Wilson's November reelection on the slogan, "He Kept Us Out of War," patriotic zeal, raised to fever pitch by U-boat attacks on American merchantmen and the revelation of the "Zimmermann Telegram," was demanding America's entry into the war. The President's call to make "the world safe for democracy" was ratified by Congress on April 6. At 291, O'Keeffe's first solo—paintings and drawings from Texas—had been open three days.

Although crowds did not flock to this exhibition as to her later shows in Alfred's subsequent galleries, most of those who encountered her works for the first time were moved in ways that were hard to verbalize. Her abstractions, and the landscapes, emboldened in line and color by the omission of everything that was not essence, struck deep. Reverberations between picture and observer seemed to intensify qualities in both, in precisely that rapport which Alfred had often described as the perfect relationship between work of art and beholder. Excited by finding his own responses echoed in visitors, Alfred rushed his photographs of the exhibition to O'Keeffe in Texas.

Hers was the last show at 291. As talk increased of conscription, of shipping only essential goods, of an act to prohibit the sale of alcoholic beverages—an act that could well end Emmy's income from her brothers' breweries—Alfred came to the abrupt conclusion in mid-May that his enterprise must come to a halt. Two days after taking down O'Keeffe's show, he informed his landlord that the gallery would vacate the premises before July 1. The following week he arranged to lease a tiny office on a lower floor at the front of the building in which to store his photographs, the unsold issues of *Camera Work*, and those creations of his artists he failed to consign to such other galleries as the Modern, the Daniel, and the Montross. He still needed a place as well in which he could continue, in microcosm, the independent life that had become essential to him.

From the latter half of May to the middle of July, Alfred, Marie, Zoler, and a miscellany of student habitués cleared out the gallery, the latter with a zeal that drove Marie to distraction. "Every time I started to systematize a little," she wrote in frustrated apology when she set off for her vacation, "I was assisted by wholesale disorderly help—and in consequence got nowhere." The frenetic exhilaration Alfred felt in sweeping everything away, repeated at other stages in his life, but with a little more

control, would be paid for dearly in aggravation. Years later, he was still trying to explain to the Internal Revenue Service how checkbooks and sales slips had been torn up and carted away.

Closing the gallery and ending *Camera Work* were not enough to assuage Alfred's money worries. With Kitty entering Smith College in the fall, and the prospect of severely reduced income from the Obermeyer and Liebmann Breweries, Alfred announced to Emmy that their apartment would have to be exchanged for something more modest. In terror, Emmy ran to her friends to say he had gone mad; her story, coming back to Alfred, did nothing to improve his perception of what the future held for him.

In that despairing season, there was only one happy respite: O'Keeffe came to New York from Texas for a brief recess between her regular session and summer school in Virginia. Alfred rehung her show, for her eyes only. They talked, walked, ate together. He made his first portraits of her, face and hands separately. On the last day of May, he took her to Coney Island with Strand and an inventor friend, draping his black Loden cape around her when she grew chilly. After she was gone, remembrance of their time together brightened Alfred's gloom. Some days he wrote her twice, taking time out from fixing himself up a darkroom (a table under shelves with room for a water pitcher) in the office he called the Vault, or the Tomb. He wrote Marie that he could fit in nine visitors at once. "How?" she asked. "Two on the window sill—one on the bookcase, three on the shelves, two on the white stool and one—yourself—in the chair?"

At Lake George in August 1917, he found significant change. The house up the hill now presided over a working farm, with nearly an acre of vegetable garden. The resurrection had been effected by niece Elizabeth, working since early June with two friends brought from New York: Alie Mörling, a sculptor at the Art Students League, where Elizabeth was now a proctor, and Alie's occasional lover, a somewhat older artist and man-of-all-trades whom Elizabeth had persuaded her grandmother to hire as gardener. She liked Donald Davidson, especially for his unconventionally mystical Gaelic turn of mind. Alfred, sharing the Farmhouse bachelor quarters with him, found that they had in common a passion for uncompromising honesty and craftsmanship, and a deep pleasure in mutual silences. They spent little time together—Davidson's days were given to hard labor and gentle admonitions to the plants to grow well, and Alfred's to his mother and Kitty, as well as to entertainments with Flick and

Herbert Small, vacationing at their elder brother Eugene's nearby home. But it was with Elizabeth, Mörling, and Davidson that Alfred shared first the new excitement engendered by O'Keeffe's next tube of work. Soon, he had also persuaded Elizabeth to start up a correspondence with the apparently lonely young painter.

Alfred was in New York early to escort Kitty to Smith and to devise ways for Emmy to economize at home. She, complaining her way contentedly through New England for the third summer since a 1914 blowup with Alfred's family ended for good her visits to Oaklawn, had rejected a smaller apartment. As soon as he could, Alfred rushed to his tiny downtown room to welcome friends, a surprising number of whom were new. Many were writers, some drawn by his outspoken defense of the young journal *Seven Arts* for its persistent pacificism six months after America's entry into the war. Among its contributors who now visited Alfred whenever they were in New York were its editors, Van Wyck Brooks and Waldo Frank; its *Eminence Grise*, Theodore Dreiser; its waspish star, H. L. Mencken; Sherwood Anderson, an advertising man who had just completed his first bucolic memoir; and John Dos Passos, a recent graduate of Harvard who aspired to life as a poet. Paul Rosenfeld, a budding music critic writing for *Seven Arts* as "Peter Minuit," had been coming to 291 for two years.

Frank, Anderson, and Rosenfeld, finding Alfred's brand of philosophy not only congenial but inspiring, became his close friends. All three regarded as influences on their own thinking Alfred's twenty-year campaigns against materialism, exploitation, hypocrisy, and bigotry in America. And, although Frank would soon veer sharply to the left, all three shared his yearning for America to fulfill its promise as an honest, vigorous, self-aware, and free society. Rosenfeld and Anderson were the major beneficiaries of Alfred's recipe for bolstering confidence: gentle needling, questioning, urging, and quick praise when he felt they had reached their potential. All three writers later acknowledged their indebtedness to him in tributes that approached veneration. Other friends from gallery years who continued to see Alfred often in his cubbyhole and occasionally at marathon Arensberg gatherings were William Carlos Williams and poet-playwright-critic Alfred Kreymborg. In 1925, under Alfred's aegis and virtually under his nose at Lake George, Rosenfeld and Kreymborg would hatch the new magazine, *American Caravan*.

Alfred's lure to writers rested not only on his insistence on individual

artistic integrity, courage, and skill but also on the fact that some quite clearly discernible threads in the broader philosophic fabric of his fifty-year monologue—a monologue that was to some the embodiment of wisdom and to others a paradigm of flatulence—had been carded and spun not by the experience he repeated was his only teacher but by writers. Two reading influences he acknowledged: his childhood immersion in American history and his annual pilgrimages in *Faust*. He barely admitted deriving anything, however, from even the vague and stormy sessions with Berlin classmates over Karl Marx and the fecund psychological and social novels they all read. There is little doubt that my effort to discern even stronger influences would have infuriated him, but an examination of his reading as he himself described it to friends reveals quite clearly that there were at least three.

The first and perhaps strongest philosophic thread derived from the metaphysical constructions of Henri Bergson which, in the most elementary terms, might be described thus: Reality is change and motion, energized by an *élan vital*; time is a continuum in which the past, filtered through memory, coexists with the present; an understanding of life is more readily apprehensible through intuition than intellect. Possibly Alfred knew Bergson's works already in Berlin; certainly he knew them later. *Creative Evolution* dominated many of the Round Table discussions of the Photo-Secessionists and the *Camera Work*ers—with most of the dissenters lined up with Steichen on the side of Maeterlinck—as well as the painters and writers. Alfred and Dove, at least, were spurred to further explore philosophies congenial to Bergson, notably those built on Eastern thought.

The second strand derived from his continuing interest in science, both applied and pure. Alfred never lost the imperatives of a chemist moving through controlled experiments toward new formulas; his emphasis on experimentation in the arts was based on a scientific method. The laboratory that was 291 was founded on the concept that, with a primary and thorough familiarity with established rules, an artist could, and should, break them deliberately to achieve a significant addition, remaining alert meanwhile to the possibility of chance discovery. At the same time, he was deeply interested in the search of the pure scientists for answers to cosmological questions that might yield scientific understanding of the basic spatial, motive, and material principles of the universe, principles that he extrapolated to lend his philosophical speculations greater weight. In this search, Einstein's theory of relativity was probably both the ore and the catalyst for Alfred's further readings in J. B. S. Haldane and Bertrand

Russell as well as inspiration for his more personal ruminations. Everything, after Einstein's discovery, could be viewed as relative. (Curiously, although Arthur Stanley Eddington's *The Nature of the Physical World* was a strong influence in a number of other artistic and intellectual circles in the late twenties, it seems not to have been especially significant to Alfred's group.)

The third strand derived from the expanding body of lore concerning human psychology, beginning, for Alfred, probably with Krafft-Ebing's *Psychopathia Sexualis*, continuing through Havelock Ellis's growing number of works (of which Alfred eventually owned a complete set), and culminating in the investigations of Sigmund Freud (which Alfred sampled like a smorgasbord). Oddly, considering his engagement in the arts and his bent toward Oriental philosophy, Carl Jung remained for Alfred a minor pundit; he considered *Psychological Types*, the only work of Jung's he seems to have read with any concentration, fine bathroom reading.

Most of Alfred's reading was contemporaneous; the past did not interest him much except in the form of biography, from which, no matter how uncongenial the subject, he was usually able to extract some edifying or cautionary kernel on which to chew. He was as enthusiastic about Frank Harris's *Oscar Wilde* and, later, his scandalous *My Life and Loves* as he was about John Stuart Mill's autobiography (in which he found similarities to his own condition), Georg Morris Brandes's *Voltaire* (which he read in German), and Hermann A. Keyserling's *Diary of a Travelling Philosopher*. In the last years of his life, two favorites would be Hesketh Pearson's *GBS* and George Santayana's autobiography, *Persons and Places*.

Once he was released from the pedagogical obligations that were a part until 1917 of putting together *Camera Work*, it appears that Alfred's formerly wide reading of art and literary criticism was focused more on publications in which his friends were the subjects of criticism, or on the writings of critics who were themselves friends: Paul Rosenfeld, Herbert Seligmann, occasionally Henry McBride and later Ralph Flint, Louis Kalonyme, Jerome Mellquist, and William Einstein, among others. He continued also to enjoy those critical writings produced by authors whose major thrust was creative—George Bernard Shaw, H. G. Wells, and D. H. Lawrence were among those whose literary and artistic appraisals earned his approval—or by those who addressed themselves to social issues: Shaw again, propounding Fabianism, Thorstein Veblen, Norman Thomas, and a number of those who joined the Stieglitz Round Table, notably the young Lewis Mumford and even younger Matthew Josephson. Shaw held

top honors throughout Alfred's life not only, one suspects, for his acid attacks on materialism, but also for the gleeful shared sport of shocking unwary listeners with outrageous remarks.

Poetry occupied a small but special niche in Alfred's enthusiasm; he dipped into Shakespeare's sonnets and William Blake from time to time, as well as Goethe's poetic drama *Faust*, but he was not noticeably drawn to the English lyric poets. He admired Emerson and Whitman as much for their philosophies as for their mode of expression—Emerson for his luminous view of the individual soul and Whitman for his defense of American freedoms that included escape from European intellectualism. Far more interesting to Alfred in the early twentieth century were the experiments in poetic form that defied earlier principles of prosody and gave voice to both free association and an angular modernism. It was not accidental that, besides Marianne Moore and Mina Loy, such young poets as William Carlos Williams, Alfred Kreymborg, Hart Crane, Jean Toomer, and others (including, briefly, E. E. Cummings) would be drawn to his circle.

Excepting the novelists who had something "true" to offer, like James Joyce and D. H. Lawrence, or something socially powerful, like Knut Hamsun and Upton Sinclair, Alfred was inclined sometimes to imply that he succumbed to fiction only when he was too tired for weightier matters or when it was the work of one of his friends. Whether or not he honored all books and authors with a mention in a letter, however, he devoured practically everything brought into the house, as I myself saw; and whether or not he was attracted to adventure stories *per se*, he revelled in the fateful and often violent engagements of Jack London's heroes as well as in the trails followed by Philo Vance, the sleuth created by S. S. Van Dine (a.k.a. Alfred's friend Willard Huntington Wright).

Beyond, roughly, the influences of Bergson, Einstein, and Freud & Co. on Alfred's philosophy, it would be as hard to identify others as, say, to find the source of an allergic reaction suffered only once. Nevertheless, there was one perceptible and marked change in Alfred's manner of expressing himself that seems to have been linked not only to the racy style of Picabia and De Zayas, but also to his discovery of Frank Harris, D. H. Lawrence, and James Joyce: his attack on listeners both casual and intimate became far less polite. From the early twenties on, metaphors and references that were bluntly sexual and even scatalogical appeared more frequently in his discourse, used, it seems, both for shock value and as a kind of litmus test of the degree to which members of his constant audience were willing or able to drop pretense or prettification in favor of

candid self-revelation. On the surface, at least, there was nothing in his sometimes scandalously vulgar pronouncements that was related even remotely to what George S. Kaufman would call the single *entendre* in a dirty story; unconsciously, however, there was almost certainly a wish to titillate and embarrass a cool beauty, especially as increasing age—and the broadly accepted view of concomitant diminished sexuality—granted him a license for eccentricity.

Aside from the writers who congregated around Alfred, the painter "fellows" of 291 continued to visit him as often as they could—Marin, with his mock-severe ascetic's face and roguish eyes; Dove, all gentleness in his farm-hardened frame, with a chuckle always ready to surface; Walkowitz, a snub-nosed troll with flat straw hair and a poet's black tie nudging his chin; awkward Hartley, with pale aquamarine eyes forever pained. Pipe-smoking Strand, young for his twenty-seven years, was a frequent presence, trying to cope with an unsettled draft status. For a while, Alfred helped him gain deferment as an agricultural worker—first with Dove, and then with Elizabeth and her two artist friends, who started another farming venture in March 1918 at Elmcroft, the weekend estate in Westchester just bought by Lee. By summer's end, however, the hay-pitching jobs would run out and Strand, reclassified, would be assigned to a medical unit in the army. Before that time came, he carried out a sensitive and important mission for Alfred.

It was a tribute to Alfred that he had so many visitors during the cruel 1918 winter; the Tomb was virtually unheated. Without his cocoon of garments, and without his extravagant caution about germs (coughers and sneezers were banished immediately, and the healthy were sent down the hall to scrub with his ever-ready Synol soap), Alfred might well have fallen prey to the influenza epidemic that would claim, by the time it had run its course, nearly a half-million American lives. When he was alone (he had had to let Marie Rapp go, and missed her indomitable cheer), it must have been hard to convince himself that the future would take care of itself.

Much of his time was spent thinking about O'Keeffe, and about her growing problems. Emotionally and intellectually isolated from the townspeople and school personnel of Canyon, Texas, she had become acutely lonely when her sister Claudia had decided to leave. In December, when he and Elizabeth heard from her that she had fallen ill after her failed attempt to dissuade a local shopkeeper from selling Christmas cards that advocated annihilating Germany had unleashed a spate of cruel gossip about her, he was seriously worried. He was convinced that her greatest

Family, Westchester, 1918 Alfred Stieglitz

need was to get away from small-town life, and teaching, and to have the time, freedom, and concentration to develop her talents fully. She ought to be in New York.

Since the summer, he had been using Elizabeth's studio, leased for her a year before by her father, as a darkroom whenever she was at home with her parents or at the Art Students League. When he suggested in March that it might serve as temporary quarters for O'Keeffe if she decided to come to New York, Elizabeth agreed willingly. Feeling above all that Georgia must decide for herself, Alfred refused to urge her; all he would say was that the means could be found to house her and provide a modest stipend for a year of independent work.

By April, however, he knew that some of his plotting was rationalization of the fact that he was in love: in the midst of his distress about her, he was walking on air. Fortunately, he could share his feelings with his favorite youngsters, Elizabeth and Marie. Marie had just become engaged

to her voice teacher's son, George Boursault, and Elizabeth and Davidson had begun to discover that they both wanted to ease Mörling out of the way, gently and with minimum pain all around. Uncle and niece cautioned each other to be patient; Alfred had decided that he must soon leave Emmy. He began by moving himself and his personal articles out of their shared bedroom into his study.

Tentatively, fearsomely, he started trying to disabuse Emmy of her belief that their life had meaning now that Kitty was grown up and away from home. Without mentioning Georgia, who was both a latecomer to their incompatability and by no means a sure bet for him, and exonerating Emmy of any blame for the failure of their marriage, he tried to show her how much happier she would be without the challenge to her values that his very presence, even mute, manifested. She would be free to be herself at last.

In mid-May, Alfred had a letter from Georgia that he decided needed some kind of immediate action. She had quit her job in February and gone to stay with friends in Waring, Texas, but had not recovered either her health or her equilibrium. Instead of wiring her to come immediately, as he wished, however, he dispatched Strand, who had a brief reprieve from his draft board, to feel out her mood. And then waited on tenterhooks. He had told Strand to use every argument to keep her from coming, so that any decision would be entirely hers. What if Strand was too persuasive? What if she mistrusted Alfred's efforts to leave Emmy? What if Emmy refused to let him go? What would the family think? Maybe he was wrong even to try. Elizabeth reassured him that everything was right—his sending Strand, his staying, his determination not to sway Georgia's decision—and urged him only not to "disconnect. Because of the way others who don't count see things."

Poor Strand. Agreeing to go partly to escape Elizabeth, with whom he had fallen in love, he now found himself suddenly infatuated with Georgia. His youth seemed decidedly against him. Georgia was only three years older than he, but Davidson was his senior by twelve years, and Alfred by twenty-six. By September he would welcome being assigned to "full military service—[having] nothing else to look forward to particularly." On Sunday, June 10, he delivered Georgia into Alfred's hands. And Alfred began a new life.

15

When Alfred met Georgia at Pennsylvania Station, neither of them could have anticipated that a month later they would be living together. Georgia was exhausted, feverish, and coughing; Alfred rushed her to Elizabeth's studio and ordered her to bed. For the next ten days he came to see her daily, mother-henning her, clucking about the dread possibilities of influenza or tuberculosis (from which her mother had died only two years earlier), learning from a bachelor friend how to boil the eggs he imported fresh from Dove's farm, and making certain the room was properly aired. Meanwhile, he continued his regular routines, spending the greater part of his day at 291, and taking long evenings walking with one or another un-attached friend, a new habit to make certain that Emmy was asleep when he arrived home.

Wherever he was, whatever he was doing, the new focus of his life was O'Keeffe. After her first week in New York, he wrote Dove of her uncom-mon beauty, spontaneity, clearness of mind and feeling, and the marvelous intensity with which she lived every moment. Reassured finally by Lee's report that she was well again, he began to introduce her to the people he cared for the most: Dove, Marin, Elizabeth, Marie. His visits were now scheduled to give her defined hours for painting—the purpose, after all, of her coming to New York.

A stark white atelier might have suited Georgia better for painting than the flower-bright rooms Elizabeth and her "Mr. Sunshine" (Davidson) had devised, but she found the yellow walls and orange floors cheerful and stimulating. The skylight in the north room atop the brownstone gave perfect light; the darker little room at the back was a bonus; the bathroom in the hall was okay. She was just beginning to feel thoroughly at home when, a month to the day after her arrival from Texas, she acquired a roommate: Alfred.

A few days after shepherding Kitty to camp, on a morning when Emmy was conveniently busy shopping for her summer wardrobe, Alfred

had brought Georgia to his study at home to photograph her. Unpredictably, Emmy returned and exploded. Georgia and Alfred beat a hasty retreat. That evening when he came home, Emmy was waiting up for him. Either he must stop seeing O'Keeffe, she shrieked, or he must clear out; she was through with him. Although in later years Alfred fulminated against her "unreasonable" attitude—"We weren't doing anything!" was the injured defense he offered in retellings of the drama—her ultimatum was a golden opportunity. Forty-eight hours later he was gone.

He made quick work of it. In two hours, he moved all his personal and photographic equipment to the Fifty-ninth Street studio and talked Mitchell Kennerley, the director of the Anderson Galleries around the corner, into guaranteeing him use of a portion of the auction house's vast subbasement for storing his library from home and everything he had at the Lincoln Warehouse. He telephoned his brother-in-law Engelhard to start divorce negotiations immediately. For Alfred, who liked to plan everything well in advance, it was a lightning performance. It felt like a game. He and Georgia rearranged furniture and divided the sleeping quarters into "his" and "her" areas with a comically discreet hanging blanket that fooled none of Alfred's friends.

Suddenly, Alfred found himself with energies he had imagined lost to age. He plunged into photographing at a rate unmatched since his student days, starting the encyclopaedic portrait of Georgia that would occupy him intermittently for the remaining years of his physical ability to handle a camera. He was wildly happy, so happy that he wondered what kind of man he could be to ignore the continuing slaughter in Europe. He described himself, and Georgia, as children, "either intensely sane or mad." Notice from Hedwig that he should bring Georgia to Oaklawn in a day and a half—a veritable *augenblick* in Stieglitzian terms—had him spinning. He packed through that afternoon and most of the night; the following day, he supervised the carting of all his things from 1111 Madison Avenue and from storage to the Anderson's basement, went to 291, to his shirtmaker, to his friend George Of (a painter and collector who did his framing) to ask him to forward the mail and, still not tired, photographed Georgia. Sharing her frugality, he found his most satisfying *coup* the negotiation of a free pick-up of their trunks and other paraphernalia—and a ride to the station for themselves—on the express wagon that had arrived hours later than the agreed and prudently early appointed time.

Hedwig greeted Georgia with all the ebullience of Juliet's nurse, perfectly happy to incur the desertion of a number of puritanical friends, the

unbridgeable enmity of Emmy, and even the deep resentment of Kitty. She revelled in the unusual spectacle of Alfred cavorting on the lawn, spooning in public, behaving altogether like an uninhibited tom. She was astonished to witness his beamish glow when Georgia, patting him on the cheek, said "Isn't he *cute?*" Suddenly, Alfred was the life of the party on picnics and a Pied Piper on hikes, entirely changed from the morose ghost he had been with Emmy. Other members of the family reacted to the pair according to their own bias. Some found it sweet that they headed for a row on the lake every evening after dinner; others complained that it was disgusting that their holding hands on the porch led them soon to more intricate convolutions and suddenly to a mad dash into the house. In my day, seven years later, an occasional exchange of winks could trigger Georgia's blouse-unbuttoning sprint up the stairs and Alfred's laughing pursuit—and the red-faced elders' rush into conversation to stifle Peggy's and my childish questions.

Two heavy clouds remained on Alfred's horizon: Emmy and Kitty. The speedy divorce he had hoped for would take six long years, with Emmy, and her progressively wearied brothers, fighting each inch of the way. Within three days of ordering him out of the apartment, Emmy had begged for his return, promising every accommodation save one: O'Keeffe must not be at the lake when Kitty came for her annual visit. All things considered, it was a pathetically modest restriction, to which Alfred agreed at once; reconciliation, however, was out of the question. For the first time in twenty-two years, he had decided that *his* happiness was paramount.

Kitty was almost immediately hostile to O'Keeffe's presence in her "dear old Papsy's" life. At first she seemed to accept his move from home, but soon she was pressing so persistently for her parents' reunion that Alfred felt obliged to visit her at camp and set her straight. Five "terrible" hours of seemingly "cruel" and "selfish" talk with her convinced him that he had made his point; a quiet morning discussing the future with her and her mother—for once not hysterical—convinced him that she was reconciled. Now he worried about "O," left with Hedwig at Oaklawn to face Selma, her husband, and her dog for the first time.

He had reason to feel apprehensive; Georgia found them repugnant. If Lou, by this time habitually but quietly in his cups, could be ignored, Selma could not. Floating in sprigged chiffon, imperious and kittenish by turns, she embodied everything Georgia deplored in a woman. Even worse was her intractable Boston terrier, a recent gift from her devoted flame, Enrico Caruso. "Prince Rico's" sudden attacks on guests (more than one

suffered a shredded trouser cuff and a bleeding ankle) earned him the sobriquet "Rippy," and prompted Alfred's conspicuous placement of a bottle of iodine with the salt and pepper in the middle of the dining table. Rippy would live to a toothless old age, his weaponry undone by chocolate creams. Eventually, his ashes occupied one of three antique Chinese urns enshrined on Sel's mantel: the other two held the similar remains of her canary and her husband.

Reunited with Georgia, Alfred was so euphoric that he either forgot or decided to ignore his early promise to Emmy. Perhaps he imagined that Kitty would respond favorably to Georgia once they met. In any event, they were still at the lake when Kitty arrived, precipitating scenes that drove Alfred and Georgia back to New York. A week later, brother-in-law Engelhard hand-delivered, at midnight, a letter from Kitty that demanded Alfred's return next morning to the lake. What took place between them in the two days he was there can only be imagined. Kitty finished out her holiday at Oaklawn with her Chicago cousin Edward, Julius's son, with whom puppy love was growing more serious, and went off to college without seeing her father again. For several years thereafter, her letters to him were guarded and only distantly affectionate. Clearly, she was unwilling to listen to further special pleadings.

Fundamentally, it was the end of what had always been a rather tenuous father-daughter relationship. They continued to be conventionally solicitous and even tender, but the reserves of a more profound connectedness on which both might have drawn during this crisis were almost empty. For too many years, Alfred had ceded Kitty's instruction and care to Emmy, to fourteen years of Governess Clara, to teachers and camp counsellors, emerging only rarely in a parental role in which he was both uncomfortable and unpredictable. Bewildered observers had seen him at one moment acquiesce to her most outrageous whim and at the very next fly into a disciplinary tirade that shocked her to tears. He had been slavishly attentive whenever she was ill, but so uncommunicative about his activities away from home that she was well into her teens before she had more than a vague notion of what constituted his life's work—a vagueness reinforced, no doubt, by Emmy.

After the September debacle, father and daughter corresponded only sporadically. Alfred, it seems, waited for overtures from her, initiating contact only on her birthday, Christmas, and Easter, when he tucked a modest check into a note bearing his greetings. Kitty was usually "too busy" to see him when she came to the city, once allowing six months to

pass without their meeting. She reported dutifully on her academic standing, her athletic prowess, and her succession of beaux (cousin Eddie having married in 1920) and protested her continuing affection and concern for him. But until her graduation from Smith in 1921—which, by prearrangement, he did not attend—her persistent message was: When are you coming "back home?" It was as if she had never listened to him at all. He soon gave up trying to penetrate her deafness, and sought only to maintain a gentle truce. He left the door open to her confidences—which, surprisingly, sometimes came—and weaned himself from vestigial feelings of fatherhood. There were more important things in life.

Returning to New York after the ordeal with Kitty, Alfred found himself involved in another family storm. This one, however, delighted him. Elizabeth had announced calmly to her parents that she would marry Davidson, "the gardener," in the spring. Sabotaging her father's plan to link her with a wealthy and inappropriate suitor, rejecting Lee's bourgeois criteria, and holding resolutely to her own values, Elizabeth demonstrated again that she was Alfred's spiritual heir. Predictably choleric, Lee rushed to Alfred. Everything was wrong about Davidson as a son-in-law, he fumed. That he had been born and raised a Presbyterian was not the issue: after all, Lee and his twin had married Protestant sisters. What was unthinkable was that Davidson, coincidentally a few years before meeting Elizabeth, had embraced the same alien religion—Hinduism—that had infatuated her since *Alfred's* friend Sime Herrmann in Munich had allowed some irresponsible professor to introduce her to the Bhagavad-Gita. What Lee had thought a phase in his daughter now seemed doomed to permanence.

To make matters worse, Davidson was nearly penniless, had no profession, no business acumen, and no conventional ambitions. When he was not yet fifteen, his family had lost a considerable fortune, depriving him of the college and graduate degrees two older brothers enjoyed and thrusting him into whatever employment he could find. He was, Lee cried—well, he was the *gardener*! And the last straw was his age. With a son from a previous marriage who was Elizabeth's junior by only four years, Davidson was only eleven years younger than Lee. This, of course, was hardly an argument to win Alfred's help in countering Elizabeth's headstrong decision: Alfred had been born three weeks before Georgia's mother.

Alfred found his deplorably Philistine brother's efforts to prevent the marriage as pitiable as they were outrageous. Lee had begun with Victorian threats to Elizabeth: I'll never see you again, talk to you again, give

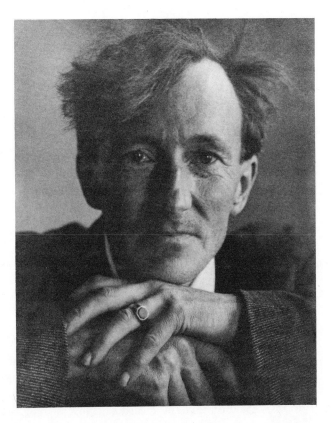

*Donald Douglas
Davidson, ca. 1919*
Alfred Stieglitz

you another cent . . . *et cetera*. Then cajolery: promises of ocean voyages, new ventures in Europe as soon as the war was over. Finally, in desperation, he had become crude, offering Donald ten thousand dollars to get out of his daughter's life. When all his clumsy efforts failed, Alfred was moved to help "the poor fellow" pick up the pieces of his defeat. If Lee believed, as he had often boasted, that Elizabeth was "the sanest, clearest person imagineable," Alfred told him, he must accept her choice as right for her, whatever his own biases. Furthermore, Donald was gentle, honest, and conscientious. Finally, there was no question that Elizabeth was deliriously happy.

Whether or not Alfred's counsel persuaded Lee to capitulate, the dialogue between the two brothers ushered in a climate of warmth that was never thereafter seriously disrupted. They would continue in manifold ways to misunderstand and disapprove of each other, they would fight shrilly and often over the management of the Lake George property, as well as over politics, art, money, principles, and education, but there was a newly tender concern for each other that would be profoundly supportive

to both in the years to come. Their rapprochement, and Elizabeth's and Donald's marriage in March 1919, would also make it feasible for Alfred and Georgia to move, late in 1920, from the studio to Lee's and Lizzie's house in the city, an arrangement that would last nearly four years.

Alfred's commiseration with Lee's wretchedness over his daughter's impending marriage had contained a *soupçon* of guilt; he had played a more active role in her romance than he would ever tell Lee. For nearly a year he had been her and Donald's only confidant, had helped them cover the traces of their meetings, had acted as mail-drop for their surreptitious notes and, when Elizabeth was whisked away for a summer holiday with her parents, had kept a watchful eye on her " ✿ ☀ "—all functions in which O'Keeffe had joined willingly when she arrived in New York. He had observed Donald's and Elizabeth's efforts, in the spirit of the flower children of a later era, to share an undifferentiated love three ways with Alie Mörling, the friend who had brought them together. When, inevitably, those efforts failed, he had been moved by the compassion with which they had dissolved the threesome.

The storms with Kitty, Emmy, and Lee were upsetting but ephemeral; Alfred's happiness with Georgia was transcendent. Beyond shared insights and attitudes, beyond matching impulses of creativity, passion for work, and insistence on careful craftsmanship, beyond the steps each took toward self-revelation, followed by declarations of rights to privacy, there was for both Georgia and Alfred an erotic tension that heightened and informed everything they did together.

Alfred's eye became insatiable, feasting on the slender but voluptuous contours of his love. The need to photograph her became exigent; the studio skylight made it possible at almost any time. Georgia's every mood and every gesture—sultry or virginal, gay or sullen, teasing or angry, drowsy or blazingly alert, quizzical or amused, clothed, nude, tousled or coiffed—propelled him to the camera. He choreographed her hands—stitching domestically, at rest, sometimes seeming to soar, sometimes lifting her breasts like twin offerings (a pose that, with almost comic predictability, he later instructed nearly all his nude subjects to assume). He sat her in a chair, propped her on pillows in the bed, stood her on the low radiator, leaned her against a table. His "portrait" of her became a love song with a new melody to record every day.

The experience must have been somewhat disconcerting for Georgia. In the first place, the requirements of long immobility demanded not only Spartan patience but also a kind of formal acknowledgment of this unique

and continuous use of her body; even had Alfred been inclined to work rapidly, long exposures ruled out the impromptu and the casual. She, the most private of persons, was constantly on display, albeit at the time only to the three loving eyes of Alfred and his camera. The only periods she had entirely to herself were when she was working or when Alfred was engaged in some activity that took him out of the studio. Nevertheless, Alfred reported, she pored over the proofs eagerly and fell in love with the images of her many selves.

Possibly it was her perusal of these images that led Georgia gradually to resume some of the stark simplicity that had excited comments in her student and teaching days that she was odd and mannish. In 1918 she concealed her forehead under a softly feminine loop of hair; three years later, with hair slicked back and brow revealed as it had been in Virginia, South Carolina, and Texas, her look would announce not timidity but unabashed strength. In clothing, too, brief concessions to 1918's almost prudish styles would be replaced by the cleanness of line I remember from my childhood. In 1918, the black and white she had favored since convent days were reflected in prim throat-hugging collars, but soon the neckline was more open, the bodice loose instead of imprisoning, the skirt wide instead of modishly step-mincing. The drama of Alfred's black cape and hat were repeated in hers.

My images of Georgia remain most vivid from the twenties and thirties at Lake George. I see her on cool mornings or evenings hugging her slenderness in a near blanket-size shawl or a too-large rough cardigan. Even with the strap of an undershirt invading a wide neckline, she brings an unaffected elegance to everything she wears, including the most ordinary housedress. Her predominant white is often enlivened with a bright sash; her homespun skirt, after her first trips to the Southwest, is sometimes a throbbing Navaho red. Never a frill or a corset, those *de rigueur* fittings of her Stieglitz sisters-in-law. Her carriage—head high, nape cupped in the coil of black hair that she covers from time to time with a triangle of vivid cotton—lends the austerity of her profile the proud look of a ship's figurehead or a thoroughbred tasting the wind.

Her walk along the dusty roads is purposeful and smooth, her footfalls silenced in canvas espadrilles. She strides across the heat-hazed meadows of noon, through seas of wildflowers and sour grasses. Sometimes she stoops to pluck a single flower, sometimes to build an armful of blossoms. She returns to the Farmhouse with skeletal branches, weathered stones, a feather. Later, when her travels have taken her to New Mexico deserts and

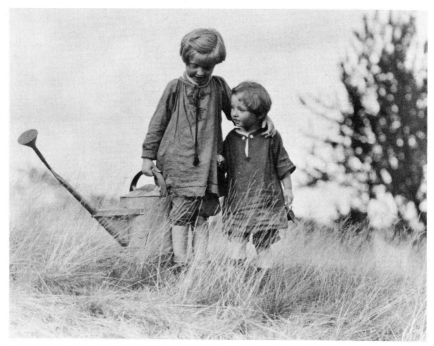

Peggy and Sue Davidson, Lake George, 1925 Alfred Stieglitz

Caribbean beaches, she will ship bones and shells to deploy on the Farm-house tables and bookcases and highboys she has swept clear of Stieglitz bric-a-brac.

I see her usually walking alone, at a distance, but sometimes she is arm-in-arm with Alfred, her sleek head inclined toward his unruly thatch of grey. They talk in low conspiratorial tones or are silent; occasionally a pause in stride is filled with an expository gesture or a burst of giggles. Often I see her under one of the gnarled apple trees that have been topped in order to open views to the lake. Arms wrapped about knees, skirt drawn to ankles, she sits in motionless contemplation of some distant crag, or cloud, or idea.

During Peggy's and my first summers on the Hill, deposited with our grandparents for the peak season of our parents' labors on the fruit farm they acquired in 1925, our only regular encounters with Georgia are at the Farmhouse dining table at which we eat twice a day. Amid great-aunts and -uncles, house guests, and occasionally cousins of our mother's gener-ation, we are the only children. I watch Georgia with caution in the earliest weeks of our acquaintance, for our first meeting has been a disaster.

Rehearsed by grandmother Lizzie, and with all the concentration of a not-quite-three-year-old, I offered my hand, performed my curtsy, and pronounced on cue, "How do you do, Aunt Georgia?"—to which her instantaneous response was a cheek-stinging slap and a blazing "Don't ever call me Aunt!" It has taken me a while to realize that we are not really enemies, that beneath her seriocomic teasing there is warmth. Nevertheless I watch, from a safe distance, for signs of an impending explosion—a frown gathering over narrowed eyes or a tightening corner of her mouth. The circumspection of other adults is unknown to her; everything about her is direct.

I am mesmerized by the routine she has perfected for circumventing the salads ordered by my grandmother, whose cook is in the kitchen and whose menus are depressingly uninteresting. While each of us is served, on a bed of helpless lettuce and coated with a gruel of anemic pink that is supposed to be French dressing, either a blob of tomato aspic or a cluster of avocado and grapefruit wedges, Georgia receives an empty bowl. Into it she tears fresh lettuce and watercress she has gathered from the brook; wonder of wonders, she adds onions and garlic, items strictly prohibited in Stieglitz households; a few deft tossings with oil and vinegar and she is done. Then, in haughty silence, she rises to take her fragrantly polluted creation to the porch overlooking the lake. Often she does not return for dessert.

Georgia's and Alfred's return to Oaklawn after Kitty's departure in 1918 stretched into weeks; the pace at the nearly emptied house was congenial, the fiery display of autumn foliage exhilarating, the air brisk. Both realized that the Fifty-ninth Street studio—although a conveniently located oasis in the pretentious and artistically parched Park Avenue desert, and, perversely, beguiling just because it was impossible to avoid spilling over into each other's territory—was really too small to serve both well in their work. They dreamed briefly of a larger place, but an unblinking appraisal of their resources made it clear that they had better stay. Lee had offered to continue paying the rent. Alfred tried at first to leave the studio to Georgia's new experiments with oils and bold colors that were challenges to his outspoken preference for her black-and-white drawings, and to spend his days at his 291 "Vault." But he had begun to hate it.

The room was too confining for visitors, too cramped for printing, too full of echoes of the past. Furthermore, except for necessary storage space, it was becoming superfluous. Arranging exhibits for his small group of artists could be carried on as well, or better, at the participating galleries;

transacting exchanges of their works for "contributions" from friends and family toward their welfare (by the end of the winter Lee would "earn" his first Hartley and his fourth Marin) didn't require an office; friends could be met anywhere. Soon Alfred was going to 291 primarily to pick up the mail. But it was hard to let go entirely until some unrecorded moment in the fall of 1919, when the building was slated for demolition. Alfred would have little regret for the loss of the "Tomb"; what he would continue to miss were the hordes of visitors, the talk, and the visual feast of the gallery that had already been closed a year and a half.

Meanwhile, experiencing a full-blown resurgence of artistic vitality, what he needed was a place in which to work. Less than a month after returning from Lake George in the fall of 1918, and notwithstanding his promises to Georgia that her painting came first, he began to take over the studio for an occasional blitz of printing that threw everything into disarray. In one session in mid-November, he filled the studio, bedroom, and bathroom with bottles, bowls, and clotheslines and, while workmen were installing new shades under the skylight, printed for five and a half hours straight. Some prints, he exulted to Strand, "will sing the high C."

Barely two weeks earlier he had been wondering if he and Georgia should follow Strand's suggestion that they take some active part in the war effort. About to go overseas, he thought, with his Minnesota Medical Corps group, Strand had envisioned Georgia as "a great nurse" and Alfred as a sort of "rehabilitator . . . a conscience." And then, suddenly, the war was over. Aside from the huge relief that the slaughter had finally come to an end, and the profound desire to see Germany demonstrate again its finer qualities now that the Kaiser was out of the picture, Alfred harbored the more self-serving hope that renewed international competition might restore decent standards to photographic materials.

It was a vain hope. For the remainder of Alfred's photographing life, he would find unhappy verification for his conviction that American corporations put profit ahead of quality. Each "improved" paper devised by Eastman to meet mass-market preference for simple and speedy printing and developing would turn out to be less versatile than the last, he moaned, and more susceptible to the ruinous vagaries of the weather, a situation that would drive him to distraction, especially at Lake George, where summer humidity was a near constant. Nor did the same company's photochemicals escape his wrath. To placate one of his bursts of fury in late 1919, his brother Julius forwarded him a small bottle of the chemical Rodinal that he had had made up from a "secret formula," asking Alfred,

patriotically, "not to criticize publicly 'American made' Rodinal" even though he himself agreed that "it would be a relief to have the German Agfa brand again!" Alfred had never made a secret of his wars with Eastman Kodak. He boasted freely of turning down its offer of a lucrative job because of its slipshod standards, and his criticisms were so widely familiar that, in 1915, the United States Department of Justice sought his help in preparing a suit against the company.

Through the early winter of 1919, despite problems with materials and space, Alfred continued to work vigorously. Georgia too, after recovering from the shocking news of her estranged father's death following a fall. Alfred warned Strand, as he would warn all his friends henceforth, never to mention death in Georgia's presence, a constraint he imposed on himself as well; her reaction was bound to be traumatic. In January, however, both were pleased enough with their progress to begin setting up informal showings of their works to people more notable for their art patronage than for close ties of friendship. Leo Stein, Frank Crowninshield, Arthur Davies, Charles Sheeler, and Walter Arensberg all came to see, and to admire. Arensberg, Alfred crowed to Strand, was interested in Georgia's work but was "taken off his feet" by Alfred's. Six years after what many supposed to be his last show, Alfred was eating up praise.

Generally, however, his and Georgia's nonworking hours were spent in less exalted company. They shared many congenial evenings with Hedwig, were fed frequently at Lee's and Lizzie's and at the Engelhards, and visited the newlywed Davidsons at Lee's Westchester house, their home for the next six years. The art galleries—Ruell, Bourgeois, Arden, Montross, Daniel, and De Zayas—were on their list for regular scouting, and they went to theater and to concerts that Georgia later called the beginning of her musical education. From time to time they succumbed, dramatically and with immediate bedrest, to sore throats, coughs, and colds, a winter/spring pattern that would continue annually throughout their years together. Apparently Alfred's hypochondria was contagious. Until Georgia removed herself from his solicitude, years later, she was not even aware of her basic robustness: Alfred had convinced her, himself, and the rest of the world that together they hardly constituted one fit person. It was one more attempt, doubtless unconscious, to bridge the years between them: if *he* was growing old, *she* at least was fragile.

Colds or not, he and Georgia were working so well in 1919 that they postponed going to Lake George until July. Then it became necessary: the family had decided it was time to sell Oaklawn. Its upkeep, and Hedwig's

uncontrollable hospitality, had become too heavy a drain on her resources. As senior executor of his father's trust, Alfred was charged with overseeing the sale, a task he accepted only on the assurance that Lee (busy in New York with his medical practice) and brother-in-law George Herbert (on a business trip in Europe) would advise him in every particular. Following their suggestion that the farm up the hill could be retained for a few years, Alfred listed the large Oaklawn house and outbuildings and the greater part of its waterfront—reserving a strip for hill-dwellers' use—with a local agent, with the admonition that Ma should realize at least $25,000. A serious buyer would not show up, however, until the very end of the year.

Alfred's role as executor, assigned him by reason of primogeniture, would be repeated in the management of Hedwig's estate after her death in 1922, but in both cases it was titular. Practical operation of each trust rested with Lee and George Herbert, much to Alfred's relief, and his sole responsibility was to sign papers and checks sent to him. Often these went astray, were forgotten, or were forwarded by him to their intended recipients unsigned. A fair proportion of his correspondence with his brother (who, with the advice of banker and broker patients, supervised the investments) and his brother-in-law (who handled the bookkeeping as well as legal problems) was devoted in the years following Hedwig's death to tracking down checks Alfred had mislaid.

In this second summer of their life together (when, fortuitously, Kitty was touring the West with her cousin Edward), Georgia and Alfred began to set up a pattern for Lake George that they would follow, with minor variations, for years. Later, their first weeks would be spent unraveling the kinks and weariness of city tensions in exercise and sleep, in tending to household refurbishments at the Farmhouse like the painting of outdoor furniture, and—for Georgia—in gardening.

In 1919, at the Oaklawn house with Mama, her friend Mrs. Bender, Agnes and her daughter, and Sel, they made their escapes in and on the lake, and on long hikes. Alfred's stock went up with all the neighbors in August when, in the middle of a sudden storm, he rescued a twelve-year-old whose eighteen-year-old companion drowned when the boys' canoe capsized. By mid-August in ensuing years, the gradual buildup of their creative energy nudged them toward work again, Georgia painting and Alfred developing, printing, and mounting those photographs taken during the winter that he thought worthy of further effort: occasionally he exposed new plates and film. Their hikes, swimming, and boating continued,

if anything more vigorously, but generally on a reduced scale. Once a week at least, there was a hike up Prospect Mountain—the smallest Adirondack foothill—which began on a back street of the village. The routine was still in effect when Peggy and I were children. Prospect's dirt road was kept in better shape than the Stieglitz roads, as the fire warden and his family had to negotiate it year round to reach their home at the summit, so the footing was unexcitingly secure. But the upgrade was steady, the walk just challenging enough to inspire self-congratulation in the relatively sedentary, and the view from the fire tower, with 360-degree topographical maps as reference guides, was moderately awesome. On a clear day, one could see a large part of the Adirondack Range and a long slice of the Green and White Mountains as well.

The mornings were usually a catchall for Georgia and a routine for Alfred. The extensive vegetable garden (untended in 1919 by Davidson, who remained in Westchester with pregnant Elizabeth) was Georgia's domain; here she spent a part of each day, with the aging coachman as helper. Her solo walks, extra swims, flower picking, and shampoos were accomplished while Alfred tackled his voluminous correspondence. After dinner, Alfred sometimes read aloud while Georgia caught up on her sewing. Sometimes, working together, they spotted Alfred's photographs; sometimes, against a background of music from a hand-cranked Victrola, Alfred read to himself while Georgia stretched canvases.

After Hedwig's death in 1922, Alfred and Georgia had at least one guest in residence at the Farmhouse during the summer, but usually they waited until the rest of the family had returned to the city. Then, for six or eight weeks, they were in absolute charge. This was the season of their greatest productivity. Friends who came were workers intent on their own creations, the weather was snappily invigorating, and conversation was free of the contentiousness in which the Stieglitzes as a whole excelled. The only family members they welcomed at any season were Agnes—with daughter and husband—and the Davidsons.

Georgia's and Alfred's first visitor was Paul Strand, mustered out of the Army in August 1919. In him, Alfred had found another young photographer with whom to share the frustrations and triumphs he had once shared with Steichen. As with Steichen, each seemed to spur the other's creativity and, as with Steichen, at the start of their relationship, intimacy and companionship overrode rivalry. Strand was eased gently into a more comfortable sociability with Georgia, whom he had not seen since her rejection of him fifteen months earlier. The weaning was doubtless facili-

tated by the lingering presence of Agnes and her irrepressible daughter, Georgia, about to gain her magical thirteenth birthday.

Referred to by her mother as Babe, and by herself usually as Georgia Minor or The Kid, this was the ten-year-old who had been accorded a watercolor show at 291 the year before. Not only did she now provide Alfred with the latest *tabula rasa* for his philosophizing and serve as a splendid model for his camera, but her relations were so good with O'Keeffe, whom she affectionately dubbed Gok, that she was allowed to paint side by side with her. Spirited, witty, and talented in photography and writing (she would later be published widely) as well as in painting, the younger Georgia would become in her early twenties a prizewinning equestrienne in international competition. Before then, she had had to conquer a paralyzing fear of heights. With her father as adored model, she embarked on mountain-climbing disciplines at twenty, leaving behind forever the once shrieking child unable to descend a four-step stile and gaining in the next decade worldwide eminence as the first, and for many years only, woman to scale most of the major peaks in the Canadian Rockies. In later years she would add many of the United States Rockies and Alpine peaks to her roster.

From her twelfth to her twenty-second year, The Kid and Alfred corresponded vigorously. As always, he was a nearly perfect confidant. A later grandniece, similarly close to him, would characterize his special talent as a listener. "If I have daughters," she wrote him in 1940, "[I will tell them] to tell everything to your Great-Uncle . . . Tell it to your Alfred, for it matters not that it is too trivial, too great, too crazy, too intimate . . . [He will] accept it with just the right seriousness to make it dignified— and just the right humor to minimize an exaggerated seriousness." His problem lay in his own susceptibility, in the turgid feelings his imaginings led him ultimately to express. Helpless to resist the innocent beauty of unfolding femininity, he fell in love again and again, dreaming his dreams aloud, in person and on paper. A Freudian might say that he sought repeated compensation for his loss of Kitty in avuncular ways which were, in principle, socially acceptable. In practice, the parents and grandparents of all Alfred's postpubescent friends were discomfited, at one time or another, by the long hours their little girls shared with him. Those few who prohibited *tête-à-têtes* unknowingly helped their daughters and granddaughters to become adepts at clandestine rendezvous.

The experience for the young participants, although skirting some hazardous shoals, was a generally salutary rite of passage, thanks to a

peculiar equilibrium in the swings of their emotions. By the time their bodies' maturing had excited Alfred to tiptoe toward forbidden territory, their new sense of control over emotional turbulence had brought them to calmer appraisals of him. The most successful graduates, with the unsubtlety of the young, led him back to safer ground either with the irreverent banter The Kid indulged in freely or, like my mother, Elizabeth, with the rapturous praise of another man. In any event, with one possible exception, Alfred's being in love with them was, as he knew well, only relative. An exhilarating and harmless catharsis was had by all.

The autumn of 1919 saw a change in pattern at the studio in New York. Confident that among their works were many that were "additions," Alfred invited more and more people to see them; co-artists like Dove, Marin, and Strand were allowed also to see Alfred's "failed" experiments —never Georgia's. Conversation went on into the small hours, especially after Saturday night gatherings at the new Round Table established by Alfred at a modest Chinese restaurant overlooking Columbus Circle. From the beginning, Georgia, who was the only woman in constant attendance, was bored. She, who spoke only when she had something "real" to say, sought amusement in trying to follow the wine-warmed circumlocutions of the men. As I remember from later sessions elsewhere, most of the regulars, with marvelously serious demeanor, scratched at ideas as disconnectedly and insistently as at insect bites. It always surprised Georgia when Alfred, following the same pattern, managed somehow to extract an insight worth pursuing.

Ever so slightly at first, Alfred's inability to resist companionable and convoluted discussion began to intrude on his private paradise with Georgia. He expressed undiminished wonder at the miracle of their affinity—in work, in spirit, in play—and insisted that his concentrated relationship with her was enough to fill his life. But it was simply not true. It would not be long before his need for a wider audience, even for crowds, returned.

16

It would be several years before Alfred would find himself plunged once more into a public life that would have lasting consequences for both him and Georgia, but the intervening time fertilized the ground in which his eventual rebirth as impresario would take place. Among the factors in this regeneration was the series of changes that took place in their physical living arrangements.

The first such change was the refurbishing of the forty-acre Lake George Hill to make it suitable for occupancy six months or more a year. When Oaklawn was sold in late 1919, it was clear immediately that, to accommodate an ailing and aging Hedwig and the few servants she retained, the Farmhouse would need considerable overhauling. Work began in the spring of 1920, financed by some of the proceeds of the Oaklawn sale and minor contributions from Hedwig's children.

Except for a second-story addition of a solarium-*cum*-sleeping porch atop the small porch at the southwest corner, the house remained essentially as it had been when Edward took title thirty years earlier. Now, rotting timbers, shingles, and siding were replaced and the exterior was sealed with fresh white paint. Indoors, the joists were jacked up, a small coal furnace was installed, the attic flooring was scrapped, a new bathroom was created downstairs next to a small corner bedroom for Hedwig, and the kitchen was refurbished to include a larder, a pantry with running water, and dining space for the servants, who again had their own veranda. The summer cook and coachman (Ella and Fred Varnum, long-time employees at Oaklawn) were local, as was Ella's housemaid helper. Hedwig's personal maid was brought from the city, and slept in one of the tiny rooms above the back stairs. Later these would be quarters for Alfred's working guests of a month or more when family members claimed the larger bedrooms. When Lee and Lizzie deemed it indecent for their son-in-law to share with his wife and daughters the single dormitory guest room in what Elizabeth called the "bungle-house" her father built up the hill in

1 *Self-portrait, ca. 1894* Alfred Stieglitz

2 *Edward Stieglitz, ca. 1894* Alfred Stieglitz

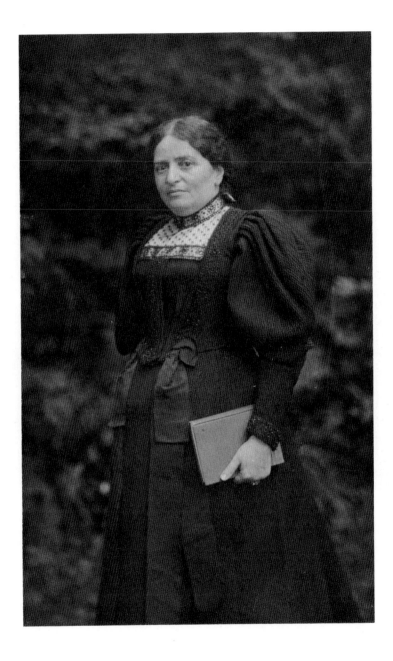

3 *Hedwig Stieglitz, 1895* Alfred Stieglitz

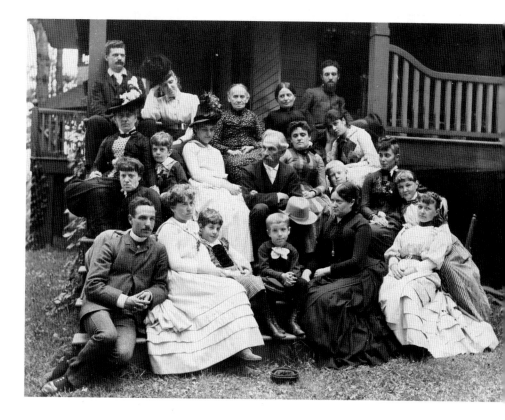

4 *Family at Oaklawn, 1888* Alfred Stieglitz

5 *Self-portrait, Bavaria (?), 1887* Alfred Stieglitz

6 *Agnes and Selma Stieglitz, Oaklawn, 1888* Alfred Stieglitz

7 *Julius and Leopold Stieglitz, Oaklawn, ca. 1900* Alfred Stieglitz

8 *Oaklawn, ca. 1900* Alfred Stieglitz

9 *Flora and Elizabeth Stieglitz, ca. 1906* Alfred Stieglitz

10 *Kitty and Alfred Stieglitz, Oaklawn, 1908* Alfred Stieglitz

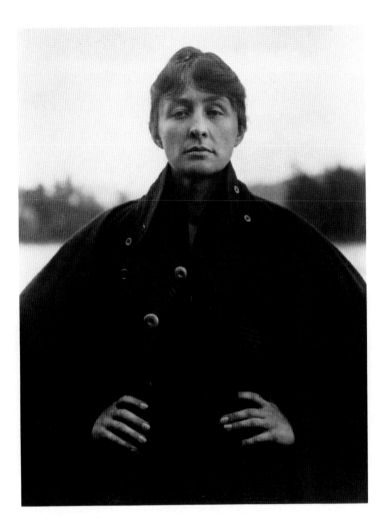

11 *Georgia O'Keeffe, Oaklawn, 1918* Alfred Stieglitz

12 *Georgia Engelhard, ca. 1911* Alfred Stieglitz

13 *Cousins, Oaklawn, ca. 1916* Alfred Stieglitz

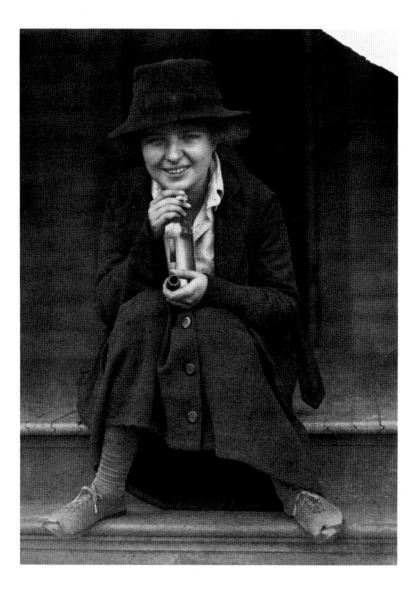

14 *Elizabeth Stieglitz, the Farmhouse, 1917* Alfred Stieglitz

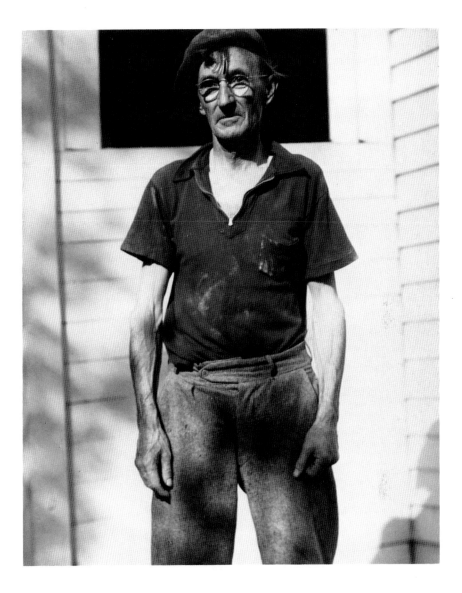

15 *Donald Douglas Davidson, the Farmhouse, ca. 1922* Alfred Stieglitz

16 *Hedwig Stieglitz, the Farmhouse, 1922* Alfred Stieglitz

17 *Sue Davidson, Lake George, 1925* Alfred Stieglitz

18 *Peggy Davidson, the Farmhouse, 1924* Alfred Stieglitz

19 *Sue and Peggy Davidson, the Farmhouse, 1925* Alfred Stieglitz

20 *Elizabeth Stieffel Stieglitz (Lizzie), the Farmhouse, ca. 1932* Alfred Stieglitz

21 *Leopold Stieglitz, the Farmhouse, ca. 1934* Alfred Stieglitz

22 *Arthur Dove, ca. 1917* Alfred Stieglitz

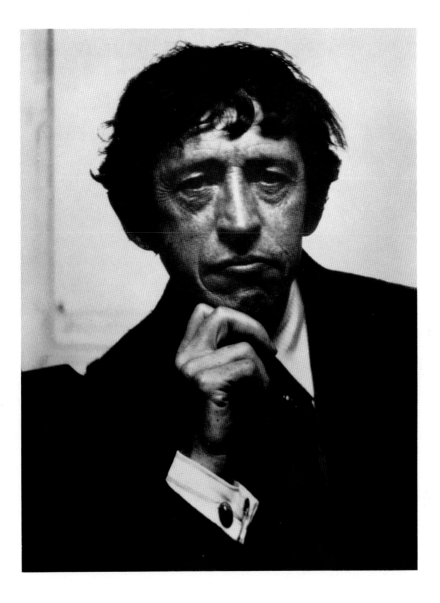

23 *John Marin, ca. 1921* Alfred Stieglitz

24 *Dorothy Norman, 1932* Alfred Stieglitz

1925, one of these Farmhouse cells was assigned to Davidson. The arrangement became permanent in the early thirties, as Elizabeth's deepening Hinduism led her to celibacy.

The entire restoration was supervised by George Herbert and Agnes Engelhard. The large barn—in which there were stalls for the cow and an aging cart-horse—the chicken house, and the ice house were buttressed, and the carriage house was modified to accommodate an occasional automobile. The remainder of the outbuildings were left to totter, sigh, and perhaps collapse. The Farmhouse interior, in Agnes's hands, took on the delicacy of calcimine pastels and flowered papers. Of the furniture withheld from the Oaklawn sale (basics for the Hill and a few bizarre treasures nobody had room for at home), only a few were Alfred's selections. These included an eighteenth-century desk for his study and a group of overstuffed armchairs he placed in strategic corners for his comfort. Twenty-five years later, with hazardously jutting springs, they were still upholstered in their original velvet, their tatters largely hidden under handsome Navaho rugs from O'Keeffe's Southwest collection.

While the Farmhouse was undergoing renovation, Georgia, finding New York unbearably confining after the winter, accepted the invitation of Stieglitz friends to spend several weeks at York Beach, Maine. She would need all her energy on her return to pack up the contents of the studio; she and Alfred had just learned that the Fifty-ninth Street house would be gutted during the summer. Fortunately, brother Lee had decided that, with a little juggling, space for them could be found in his house at 60 East Sixty-fifth Street. After five years of school-season boarding with "Uncle" Lee and "Aunt" Lizzie, Steichen's elder daughter Mary would not be returning. Lee proposed assigning the maids to a shared bedroom on the top floor, releasing the large front room "with a couch" for Alfred. Georgia could have the "very sunny room" at one end of the floor below where Lizzie's nonagenarian mother was quartered. So as to avoid upsetting Lizzie's household, Lee suggested, they could make their own breakfast and dine out as they had at the studio, thus preserving "the independence and privacy" of all.

Georgia and Alfred would have preferred total independence, but realized that their meager funds really gave them no choice. Free to devise rules that would guarantee their autonomy, promised a telephone of their own, and allowed to adapt their new quarters to their needs (new electric outlets, creation of a serviceable darkroom in an alcove, new paint for the walls—Lizzie would be paralyzed with fear that the painter would not

match *exactly* the shade of pale grey Georgia wanted), they found the prospect not unpleasing. They would move into their temporary home in December; they would remain until the house was sold nearly four years later.

At Lake George, recuperating from weeks of crating, wrapping, tying, labeling, and dispatching to Kennerley's Anderson Gallery and the Hill all the contents of the studio, Alfred was pleased to discover that he did not miss Oaklawn. Georgia, however, sharing the Farmhouse with Hedwig, her maid, and the Engelhards, missed acutely the privacy of the year before. Her solitary walks became deliberately longer. Early mornings found her striding up the cart track beyond the barns to the county road that cut across the back of the property, over the water-cressed brook, through the fence-threaded stand of trees, past the juniper-studded meadow where a ramshackle structure leaned and buckled, into the deeper woods that sheltered an old stone reservoir erupting in waterlilies and susurrating with mosquito fiddles, out again into higher meadows webbed with blackberries where an unexpected sand cliff stretched, overhung with the roots of tilted pines and sweet ferns. Often she crossed the weathered stile over the barbed-wire fence and proceeded some miles along the sandy public road.

If she returned the same way, she usually paused in the first meadow at the tumbledown shanty that suggested conversion to a studio, a refuge from the family presence she could not bring herself to enjoy as Alfred did. If the meadow was too circumscribed to answer the nostalgia for the plains of Texas that her first encounter with the sea in Maine had reawakened, at least she could be alone. She consulted Alfred about fixing up the shanty; he consulted with the Farmhouse contractors, Mr. Goodness and Mr. Blessing. Unhappily, the four to five hundred necessary dollars were beyond their reach.

Georgia did not give up. When the Davidsons came in August for a visit, she spoke of it again. This time she had the right audience. Alight with enthusiasm, Donald raided the woodpiles and the old barn for reusable boards, for doors, windows, hinges. Within only a few days, he had realigned the eighteen by twenty-four-foot structure, now officially called the Shanty. Georgia and Elizabeth, clad in bloomers and chemises to survive the August heat, were the roofers, replacing rotted shingles with tar paper. When the heat became too intense for Elizabeth (only recently released from nursing infant Peggy), she was assigned indoors to help Alfred and visitor Margy Frank lay the floor and oil the rafters. Alfred's letters to friends were spiced with accounts of the "event" that grew suc-

Elizabeth and Donald Davidson, Georgia O'Keeffe, the Shanty, Lake George, 1920
Alfred Stieglitz

cessively more extravagant in praise of Georgia's and his accomplishment. She had her studio.

Still, the mood to paint was erratic. Even out of sight, the presence of others impinged. Not those she and Alfred had invited, including the Davidsons, who knew instinctively when to leave her to herself, but Julius, his daughter and son-in-law, Lee, and the stream of visitor-neighbors come to see "Mama." Alfred, who was as oblivious to Farmhouse chatter and bustle as he was to the few tiptoers and whisperers Georgia found even more irritating, continued photographing and, until the frigid and gritty water in the old potting shed grew too painful and frustrating to work with, printing. Georgia gave up the hope of painting and threw her energies into pruning and gardening; Alfred withdrew contentedly to letter writing and reading.

Then, abruptly, the situation changed. In late September, Georgia came upon Hedwig in the throes of a stroke; within hours, the house was filled with doctors and nurses. Six days later, Hedwig, with doctor, nurse, and maid, was rushed by ambulance to Albany, there to be met by Lee

with another nurse and ambulance for the trip to New York. The rest of the family, with the exception of Alfred and Georgia, followed by train. Momentarily, Alfred felt disoriented, "queer" about staying at the lake. Overnight, however, he found himself feeling more energetic than he had all summer, and within a week he was rhapsodizing about the weather, the peace, and especially about Georgia's loveliness and contentment as, free of schedules imposed by the presence of others, both returned to working and eating when they chose. When Paul Rosenfeld and Charles Duncan came for a week's stay, they fit in unobtrusively, for each was absorbed in his own work. Alfred drafted them to lug lumber up the steep stairs to the attic; in a burst of confidence derived from his carpentering debut under Davidson's supervision, he had decided to install the new flooring with local Fred. In fact, neither of the young men was suited to strenuous activity—Duncan was positively emaciated, and Rosenfeld was as soft as a pillow—but, under Georgia's prodding, they joined her and Alfred for walks on the deserted roads and rows on a lake free of summer traffic. Together the four relished the warm days and cold nights, and the eerie splendor of the Northern Lights electrifying the sky.

Georgia and Alfred remained on the Hill for six weeks after their guests' departure. While it was still warm enough, she painted in the Shanty and he developed and printed in the potting shed. With colder weather, Alfred learned from Fred how to operate the coal furnace in the house, and Georgia set up her jars, brushes, paints, canvas, milk-glass palette, and easel in a sunny bedroom upstairs overlooking the lake. At work, Alfred resumed his Pavlovian pacing from kitchen to pantry to bathroom and back for as long as six uninterrupted hours. Sometimes they put in as many as sixteen hours of work, with Alfred feeling he could go on twice as long with the same unwearying intensity he had experienced during his youthful billiards matches. Often he took up his pen to write letters at ten in the evening, considerably past his regular bedtime, or read aloud to Georgia from *Madame Bovary* or *Winesburg, Ohio* while she stitched a blouse or whittled a frame. He had already read her those passages in Waldo Frank's new book, *Our America*, of which he was the esteemed subject. Unembarrassed by Frank's overblown praise, he had been puzzled nevertheless by attribution to him of characteristics that Frank described as Jewish. "Suffering is his daily bread," Frank had written. "Sacrifice is his creed; failure is his beloved." Alfred didn't know what he was talking about. A few years later, Clarence Freed of *The American Hebrew* concluded after an interview that, as a result of being

devoted to "truth and righteousness [Stieglitz] has been mistaken for a socialist, a nihilist, an iconoclast, or an anarchist. But he says he is 'nothing.' "

One suspects that Georgia acquiesced to being read to partly to humor Alfred as self-appointed instructor and partly because she could carry on minor domestic tasks simultaneously. Reading alone had been a longtime habit and, in South Carolina and Texas, a form of escape from provincialism. Feminist pamphlets, *The Masses, 291* and *Camera Work*, Nietzsche, and Dante had been quite as important to her as the iconoclastic art texts by Arthur Jerome Eddy and Arthur Wesley Dow with which she challenged her students and supervisors.

Whatever appetite she had had for reading, however, would become heavily surfeited in New York. The very air around Alfred was word-laden; logorrhea was endemic. With each year's passing, Georgia's aversion to words grew. By 1938, when Alfred printed some of her letters in a catalogue for her annual show, she would protest to Dove that she hoped one day to be able to function entirely without the written or the printed word. Alfred, meanwhile, remained as voracious a reader as his mother, brother Lee, and sister Agnes, but from a far broader spectrum. Although some of the pages of the French, German, and English art and literary periodicals to which he subscribed remained uncut, his hardcover intake numbered an average of two or three books a week through the year, and, in the nonworking weeks of summer, sometimes as many as one or two a day.

Although he and Georgia disagreed about the value of words, they were in complete accord about the stupidity of collecting *things* for sentiment's sake. One distasteful task that took Alfred three October days in 1920 was the move of cartloads of pictures, sculptures, and books from Oaklawn to the Farmhouse attic. "Space-eaters," he called them derisively. Nevertheless, on an impulse that nobody, including Alfred, was ever able to make seem reasonable, he singled out for display the original *echt-Romantisch* Ezekiel bust of Judith so prized by his father. In white marble and nearly three feet tall, Judith's tortured pyramid of Greco-Victorian hair, assertively bared breast and masculine face commanded a whole corner of his crowded study. Alfred guarded her presence perversely through all the humiliating uses to which she was put by Farmhouse residents and guests. Usually she was submerged beneath coats, sweaters, and random paint rags. Sometimes she was festooned in beads and feathers swiped from one of Selma's trunks of summer essentials; during one

Judith, 1920
Alfred Stieglitz

insufferably hot period, she wore Alfred's hernia truss on her head; and at least once, Georgia Minor sneakily applied an incongruous ensemble of lipstick, eye shadow, and crayoned mustache. Judith remained in place for seven full years; then, suddenly, she was gone. The story of her disappearance has been so embroidered that a fully accurate reconstruction is no longer possible. The only certainties are that, pledging silence, the two Georgias and Davidson hatched the plot and, with Davidson acting as grave-digger, interred Judith at such a depth that her resting place—within six feet of Alfred's porch—remained undiscovered through several treasure hunts instigated by the villains themselves.

The long autumn stay on the Hill in 1920 accomplished more for Alfred and Georgia than a prodigious volume of creative work. Thanks as much to an abundance of home-grown produce as to Georgia's frugal housekeeping, they managed to get along, according to envious Agnes, on an average of "$28 for a whole month." The crops had been so good, in fact, that they dispatched barrels of Hill potatoes and local apples

(Edward's practice in earlier days) to the family in New York, together with crates of legumes that Georgia and Agnes had put up in jars and bottles of cider vigorously pressed by Georgia. Considering, however, the cost of their labor, the express charges, and barrels at five dollars each (a scandal that led Alfred to rail against the capitalist system and speculators in general and Henry Ford and Bernard Baruch in particular), their savings cannot have been as splendid as they seemed. More important to their future pleasure in the Farmhouse were the electricity that made possible putting in heaters upstairs and down in place of the one coal stove that had proved inadequate the previous year, and pull-string lights instead of lamps forever running out of oil. Alfred finished the attic floor with Fred, opening up storage space for the knickknacks that Georgia banished each year, and together they painted two tiny upstairs bedrooms and the downstairs bathroom white, the first of Georgia's steps to brighten the whole house. Later, overriding the protests of all except Alfred, she would have a section of the veranda roof removed to admit more light to the downstairs rooms, strip the windows of curtains, paint the interior walls and trim her favorite pale grey, and introduce blue incandescent bulbs to lamps and overhead fixtures to simulate daylight.

Only Georgia was reluctant to leave, however, when the legitimacy of the tasks they were setting themselves became questionable even to them. Despite the joys of shared isolation and productivity, Alfred was restless for his winter center. Although he expressed his feeling at the start of every summer that New York was a kind of prison-*cum*-lunatic asylum, he was eager again for the city's hard pavements and strident cacophony, for the gatherings of friends and co-workers. Early in December—after days of packing Georgia's materials and new paintings, Alfred's photos, paraphernalia, and books, of assembling the personal belongings they had sent from the studio in July, of trips with Fred in the horse-drawn cart to the Post Office and the Railway Express—they headed for New York.

Thanks in part to Lee's preoccupation with a busy practice and Lizzie's terror of getting in the way, Georgia and Alfred found the move into their house surprisingly easy. Before the start of the new year, the red-carpeted top floor living room had become a haven for old friends and newcomers seeking Alfred's counsel and the stimulus of uninhibited conversation. Here, too, Alfred held private showings for one or another of Lee's tycoon patients with a view to selling an O'Keeffe or a Stieglitz. The evening gatherings numbered as many as twenty people, especially after a meal at the Columbus Circle Chinese restaurant; talk often continued well

past midnight. On other evenings, when Alfred and Georgia—"twins" in black hats and capes—had dined in a cocoon of silence at one of the modest Third Avenue Italian bistros they favored, oblivious to the stares and whispers of other patrons, they would return to Sixty-fifth Street to find two or three acolytes waiting patiently on the brownstone steps.

In addition to these evenings that nourished Alfred and tried Georgia's patience, and days divided between independent work and trying to set up gallery exhibitions for the other artists of his coterie, Alfred spent many hours in the Anderson Galleries cellar sorting and filing old materials. A week after their return from Lake George, Mitchell Kennerley interrupted his dusty task to suggest a retrospective show of his photographs in two large rooms on the building's top floor, concurrent with a planned exhibition and auction of "Old Master" prints. Could Alfred be ready by February?

Immediately, Alfred sent prints to George Of for framing and initiated a drive for magazine publicity. By January 1 he had pinned down articles in *The Nation* and *The Dial* and a piece by Waldo Frank in a Paris periodical. Frank Harris asked for a mid-January preview while he was in America so that he could ready an April article for *Pearson's* magazine in London, of which he was editor. Walter Lippmann at *The New Republic*, however, although a fan of Alfred's and a frequent visitor to the top floor "salons," rejected an article by another regular on the grounds that people unacquainted with Alfred's particular brand of talk (which had been quoted liberally) and who had not seen the pictures would find it virtually unintelligible. His assessment was not without merit. Even with the photographs before them, many visitors to Alfred's show would find his introduction to the catalogue completely bewildering.

A relatively straightforward opening section argued both the virtue of destroying hundreds of prints of a single negative to gain one that was unique and the desirability of mass-producing "numberless prints [that are] indistinguishably alike." This was followed by a terse self-description: "I was born in Hoboken. I am an American. Photography is my passion. The search for Truth my obsession." Then came the Alfredian flood. "PLEASE NOTE: In the above STATEMENT the following, fast becoming 'obsolete,' terms do not appear: ART, SCIENCE, BEAUTY, RELIGION, every ISM, ABSTRACTION, FORM, PLASTICITY, OBJECTIVITY, SUBJECTIVITY, OLD MASTERS, MODERN ART, PSYCHOANALYSIS, AESTHETICS, PICTORIAL PHOTOGRAPHY, DEMOCRACY, CEZANNE, '291,' PROHIBITION. The term TRUTH did creep in but may be kicked out by anyone."

The show was a blockbuster. Critics, reporters, and the public—several thousand in barely more than a fortnight—were electrified. Of the 145 prints Alfred had chosen to demonstrate his development over nearly forty years, only seventeen had been exhibited before. Of those on view for the first time, seventy-eight had been taken in the previous two and a half years, and forty-five of them were golden-toned sepia prints from Alfred's loving portrait of O'Keeffe—some wrapped to the chin, some half-clad, some nude. Although Alfred had withheld the most intimate images of Georgia after dress rehearsals before family and friends had elicited fears of censure, those that remained spoke vibrantly of his passion for her. Women who saw the prints were often moved to tears. And some men, inattentive to the implications, asked Alfred to make similar portraits of their wives.

The applause of the critics for Alfred's resurrection as a photographer was universal; it was apparent that they had thought his retrospective at 291 eight years earlier his last. They were astonished not only by his prolific output since 1913 but by elements in his photography that were new. Where once he had incorporated the whole of a building, a tree, a body, a face, he now concentrated on fragments that were mysteriously far more evocative. The reduced field, with more intricate and dramatic plays of light, shadow, and tone, had enhanced tactile effects. Instead of discarding an accidental double exposure, a full-face portrait of Georgia's erstwhile classmate Dorothy True over an image of her leg in profile, Alfred had intensified the contrasts so that a portion of the sultry face seemed to grow out of the silk-sheathed calf; the dim halo of bobbed hair hovering over the sharp high-heeled patent-leather pump characterized the start of the flapper era as eloquently as it suggested his subject's personality. (Alfred, recognizing the accident for what it was, did not try to duplicate it: other photographers, however, were inspired to experiment with superimpositions.)

Whatever else the critics found to praise in Alfred's work, it was his portrait of O'Keeffe that sent them into rhapsodies which were only slightly less effusive than those of the general public. Alfred was miffed by suggestions that his ability to hypnotize his model was as responsible for the wonder of the photographs as was his artistry—a factor contributing to his summer undertaking, in 1922, of photographing unhypnotized clouds. Meanwhile, he savored his triumph, announced that he would not part with a particularly sought-after nude for under $5,000, and revelled in Georgia's stardom.

If the public was soon gossiping about the affair between the still-married photographer and his model, the critics were led to speculations of another sort. They were reminded by the photographs that O'Keeffe, whose works had not been exhibited for almost four years, was also an artist. In nearly half the images of her, Alfred had posed her deliberately with her paintings as background, not to titillate curiosity in an audience he did not foresee, but because they were an intrinsic element in her portrait. Now, however, critics and art enthusiasts alike were drawn into trying to decipher the dim paintings half-obscured by her figure. The experience led Henry McBride, the witty critic in the twenties for the New York *Herald*, the New York *Sun*, and *Dial* magazine (a friend to both Alfred and modern art since the beginnings of 291), to comment wryly that Alfred's campaign was triply successful. He displayed mastery of the camera; he introduced a powerful romance; and he arranged an extraordinary debut for a young artist. The show, he wrote later, "put [O'Keeffe] at once on the map. Everybody knew the name. She became what is known as a newspaper personality."

For Georgia, the experience was profoundly upsetting, one whose pain she would relive to some degree with each of her own annual shows after 1923. It was not so much the nature of Alfred's photographs of her, from which she felt oddly detached, as it was the insatiable appetite of press and public for scandal in general, and specifically for the one in which she was the unwilling star. Thereafter, every exposure to the public became an ordeal, thanks not only to natural stage fright about the progress of her yearly output and a reluctance to part with her offspring in paint but also to feeling battered. America in the Roaring Twenties, despite the hedonism implicit in the term, was quite as self-righteously scandalized as had been the Victorians. How was Georgia to defend her native directness and spontaneity against the sensationalist slaverings of Hearst journalism that, together with editor Arthur Brisbane's homilies, daily fed the prurience of New York's readers? How was she to ensure being taken seriously as an artist if she was notorious for her private life? How, even, was she to ward off the effusions of those who romanticized the "daring" nature of her "great love?" Eventually, her answer was to cloak herself in the apparel of a recluse—austere, cool, unassailable. Meanwhile, the tortures of her yearly exposure would leave her limp and physically ill after almost every opening; sometimes it would be months before she felt well again.

Alfred, as the man in the case, was not so deeply affected by the notoriety; he was used to it professionally, and he had long argued success-

fully that his home life was off limits by virtue of irrelevancy. In the current circumstances, however, the issue of privacy was far more complex. Georgia's sudden thrust into the limelight might be offensive to her, but it could hasten her recognition as an artist. Moreover, with his firm position in the art world and his reputation for honesty and perspicacity in discovering new talent, her linkage to him in public would soon have artistic legitimacy. Nevertheless, it would be wrong to leave the impression that she was merely an adjunct to him; her identity as an artist had to be established independently. Even after their marriage in 1924, she would never be known as Mrs. Stieglitz; she must always be O'Keeffe or Miss O'Keeffe. In later years, Alfred would meet all questions about whether or not they were married with a bland "What do you think?"

The show signalled not only a return to center stage for Alfred but a second start for Georgia. Alfred quickly made the inclusion of three of her paintings in a show devoted to "the Later Tendencies in Art" at the prestigious Pennsylvania Academy a condition for his help in choosing and/or lending, and then hanging, the works of artists he had shown at 291—twenty percent of the exhibition's participants. Too late to place a reproduction of one of her paintings with Paul Rosenfeld's rave review of his photographs and praise of him as a person in the April issue of *The Dial*, he succeeded in assuring its inclusion with Rosenfeld's December rhapsody over O'Keeffe in the same magazine. Without a New York show of her own for two more years, when Alfred arranged that an even hundred of her works be exhibited in one room at the Anderson while his own new prints hung in another, the fragments of her paintings visible in his photographs in 1921 impelled collectors to join the ranks of visitors to Lee's top floor. Within a few months, several of her canvases had been sold.

Alfred's daily appearance at Anderson's during almost all the hours the galleries were open drew a host of younger artists and writers that included many who had not been a part of the 291 entourage; after the show closed, they continued to seek him out at home. There the conversation turned often to the frustrations many of them were experiencing in finding outlets for poems, stories, sketches, and serious or satiric appraisals of current trends and problems in the arts and society. Soon Alfred persuaded several of them to undertake a new periodical of their own, following the same collective principles that had guided the operation of the gallery 291: each writer or artist who contributed to a particular issue would also bear a share of that issue's costs; each would be free of

editorial interference once an article or poem had been accepted; some articles might be solicited, others would be voluntary offerings; financial support from outside would be welcomed.

MSS, issued on a schedule dictated by how much material had been gathered, would appear six times between February 1922 and May of the following year, in printings of two thousand. Alfred was advisor; Paul Rosenfeld and Herbert Seligmann served as editors except for an issue devoted to "The Significance of Photography as Art," which was edited by Strand; O'Keeffe designed one striking cover. Readers were asked to send "ten cents a copy if you like it, or Subscribe One Dollar for Ten Numbers to be issued in Ten Days—Ten Weeks—Ten Months—or Ten Years. The risk is yours. Act at once if you want to be One of the First 100,000 Subscribers." If they had complaints about the magazine's contents, they were asked to address them directly to the authors.

Squeezed into an average of twelve pages, without typographical distinction but with considerable imagination in layout, the little periodical offered challenging pieces by a surprising number of current and later luminaries including, alphabetically, Sherwood Anderson, Ernest Bloch, Kenneth Burke, Charles Chaplin, Charles Demuth, Dove, Waldo Frank, Gaston Lachaise, Walter Lippmann, O'Keeffe, Carl Sandburg, Herbert Seligmann, Charles Sheeler, Leo Stein, Strand, and William Carlos Williams. Some of the contributions, including one or two of Alfred's effusions, were self-indulgences of little intrinsic merit, but the majority were meaty, thought-provoking, and sometimes prescient. In the pages of *MSS*, for example, some of the earliest favorable criticism of the composers Arnold Schönberg and Edgard Varèse appeared.

Alfred's efforts during the year to help his 291 artists met with mixed success. Dove, who for over a year had been deeply in love with a young married artist in Westport and was now living with her on a houseboat moored in the North River, had little new to show and even less to sell. Alfred agreed with him that, for the time being, he should go on with magazine illustrating. Marin did considerably better, with two gallery shows and fourteen paintings included in a Brooklyn Museum exhibition of American watercolorists. The triumph of the year, however, belonged to Hartley, in New York again after years of wandering. Broke as always, he told Alfred that if he could get twelve hundred dollars for all his paintings in storage, he would "go to Florence, write a book of hate . . . [and] commit suicide." Alfred persuaded Kennerley to add a room of Hartleys to a May auction at the Anderson scheduled for another painter, and, with

Georgia, hung all Hartley's 117 paintings in it, floor to ceiling, for the one-week preview.

The auction, a smashing success, netted Hartley nearly $5,000 (the equivalent fifty years later of almost $30,000). On the proceeds, Hartley went to Florence, wrote a book—not the "book of hate" he had promised—and cancelled his plan to commit suicide.

Despite the tactful navigations of Lee, Lizzie, Georgia, and Alfred at Sixty-fifth Street, family life had not been free of strain. From late December until early July, Georgia and Alfred were barraged with Sel's angry and jealous demands for attention. Accusing them of purposely avoiding dinners at Lee's, the Engelhards', and Mama's to which she was asked, she insisted they come together to spend an evening with her; one or the other alone would not do. They declined. The situation hardened. Sel complained to intermediaries that Alfred's attitude would bar her from reaping the summer benefits everyone else enjoyed at the Farmhouse. Alfred responded truculently that she could go whenever she wished; he and Georgia would stay away. When Ella and Fred opened the house in mid-May, Sel moved in for a week of loudly advertised solitary exile. Finally, sensing a disastrous summer, brother-in-law Engelhard volunteered as referee, drawing immediate fire from both sides, a sequence that would be repeated for the rest of his days. Pointing out that family relationships were being destroyed by a universal lack of humor, he convinced Alfred that Hedwig, recovering from her stroke, would be the ultimate victim of his and Sel's pigheadedness. Peace was restored, Alfred went to the lake in late June as planned; in September, Sel, with the obnoxious Rippy but *sans* Lou, arrived for a few chastened days, mourning the recent death of Caruso.

In itself, the contretemps was trivial, but as a symptom of Stieglitz behavior that would become increasingly unacceptable to Georgia, it was significant. George Herbert's observation that oversolemnity was largely to blame for the winter's impasse identified a fundamental problem in Georgia's relations with the family. And with Alfred. When he and she were alone and working at Lake George, or when their chosen companions were cheerful or droll, she was able to tease Alfred out of his doldrums. But as the abrasive family presence became entrenched, and as Alfred's re-emergence as *Eminence Grise* in the art world drew larger numbers of earnest followers, Georgia became not only a less effective counterforce but herself fell victim to the disease. Eventually, the only recourse would be to escape.

Although Alfred described the start of the 1921 summer as orderly

and peaceful, in fact the atmosphere was both gloomy and strained. In spite of improvement, Hedwig remained partially paralyzed from her stroke, and spent large portions of the day on the porch with a blanket wrapped about her knees, trying to knit, staring into the distance of an irretrievable past, and interrupting Agnes's patient reading aloud often to upbraid her for not running the Farmhouse as efficiently as she herself had run Oaklawn. Her spirits rose only when children, grandchildren, cousins, nieces, nephews, and Oaklawn neighbors came for brief visits.

In fact, Hedwig was deeply despondent. She had "lost" her favorite son. Alfred—her confidant, her lieutenant, her joy—had become cruelly indifferent. The few minutes she begged of him were given grudgingly or not at all. If she asked him to fetch something for her, he reminded her that she had a maid. If she sought to talk to him about Georgia or Kitty, his work or his friends, he answered roughly that he was too busy to sit and chat. If she told him she knew she had become a nuisance and wished only to die, he yelled at her, claiming no patience with martyrdom. The Engelhards, coaxing her gradually into activities that included even a halting form of croquet, tried to compensate for his "horrid" behavior but, like Alfred, failed to identify its source. It was the first time since Aunt Rosa's terminal illness twenty-two years before that he had been exposed for more than minutes to even a semi-invalid. Now, moreover, it was his eternally dependable mother who was virtually helpless. *She* had deserted *him*.

Unaware of his childishness, Alfred knew only that, with suddenly unsteady heartbeats keeping him awake at night, he had no energy. Completely lacking in initiative, he wrote letters, read undemanding novels, and left unused the developer he had prepared for printing his winter's work. Even Donald's prods to get him to paint the rowboat and Elizabeth's funny/sour anecdotes to illustrate her deteriorating relations with her parents failed to rouse him. When the Davidsons' two weeks were over and Seligmann came to finish doctoring the galleys of Hartley's book, Alfred fell into dark reveries about 291. Had his ideals been childish? Would he ever really grow up? All he could talk about were the downward slide of the economy, the unemployment among veterans, the xenophobia in the Sacco and Vanzetti proceedings.

It took Georgia a month to coax him into rowing, climbing Prospect, swimming—timorously now, frightened by his arrhythmic heart—and finally getting back to his camera and darkroom. In direct proportion to the lightening of his mood, Hedwig became less querulous, and the Engel-

hards, free of her sorrowing mien, returned to their independent hiking and golfing. Alfred, struck suddenly with a passion to print postal cards, developed in the upstairs bathroom, washed in the Shed, and dried in the attic or over the stove.

In New York at the end of October, after another productive month alone with Georgia—she had completed her twenty-fifth oil of the season—Alfred failed again to find a gallery for anyone but Marin. All he managed was to talk Kennerley into holding a group auction at the Anderson in late February. With works by forty contemporary Americans, including all the 291-ers, Alfred called it, as if to imbue it with instant success, The Artists' Derby. It was not a winner.

Once again, worry over money became Alfred's constant companion. He could get little now from his brothers and brother-in-law, burdened as they were with providing round-the-clock nursing for Hedwig. He knew he ought to cut down on Saturday night communal dinners at Columbus Circle, but he couldn't. To do so would be to rob Peter to pay Paul; he had to give his group *something*. Reducing his already modest diet would likely make him ill, and curtailing the purchase of materials for either Georgia or himself would be counterproductive. For Georgia, just hitting her stride, it would be disastrous. Although he had sold a few of her paintings, and was still receiving his thousand-dollar income, they were strapped. Gritting his teeth, Alfred accepted a commission to photograph an unbeloved patron for a thousand-dollar fee; he vowed it would be the last time.

Pessimism over money contributed heavily, no doubt, to the firmness with which Alfred turned down repeated importunings to grant Georgia's wish to have a child. But it was not solely economic fear. And it was not because Emmy had refused so far to divorce him; whether or not he and Georgia were married was immaterial to him.

The campaign to have a baby had been mounted strongly by Georgia and even more strongly, perhaps, by her friends, including Elizabeth, who was finding motherhood even more mystically satisfying than Alfred had assured her it would be. "Service hardens the muscles—the Will," she wrote him in early February 1922, after one of many conversations in which she had seconded Georgia's plea. Apparently, Alfred's first argument against letting Georgia "enjoy the pulse of life itself," as Elizabeth put it, had been on the grounds that conception was not deliberate but accidental, and pregnancy no more than an "emotional" experience. For a man who placed so much value on the unexpected "now" of every moment as well as on the purity of emotion, it seemed a contrived reversal. "Carry-

ing a child may have its roots in emotionalism," Elizabeth countered, but rearing one is "A conscious experience—a spiritual registering." He ought not to forget, she continued, either "the marvellous human studies you could make—photographic records," or the potential for genius in a child with such "unique parentage and temperamental background."

Alfred's next rationalization was his proven failure as a father. Not from indifference but from cowardice and lack of time; then, as now, he had been involved in larger tasks. Furthermore, Georgia's work would suffer irreparable damage from being interrupted. Kitty had been his failure; he would not risk another. "Photography does not cease with a broken or an imperfect plate," Elizabeth scolded. Too busy? She had an answer for that, too. "I would gladly act as infant nurse—kindergarten— everything you both have no time for . . . You could guide . . . and be sure that an effort is being made to obey the spirit of your vision." Her offer was not totally altruistic; pregnant again herself, she knew she would be running her own kindergarten anyway.

One last defense from Alfred. At fifty-eight, he declared, he was too old. But Georgia is not, parried Elizabeth, adding, with youth's disregard for middle-aged intimations of mortality, "In later years Georgia will have few enough sunbeams." The argument would continue along these lines, intermittently, and with diminishing steam, for a little over a year. Then, circumstances beyond everyone's control put an end to all controversy.

In spite of Alfred's claim of total failure with Kitty, they had achieved a rapprochement of sorts after her June 1921 graduation from Smith. In the year that followed, during which Kitty lived and traveled with her mother and nibbled at courses at Columbia, having been instructed by Uncle Lee to turn down a "too-risky" job in a hospital pathology laboratory, her warmth toward Alfred grew. She still refused to meet Georgia, but she no longer complained about her; in letters and in visits, Alfred was "Father dearest" again. When she married her quietly persistent suitor of several years, Milton Sprague Stearns, in a brief Unitarian ceremony safely distant from all family, and took up housekeeping first outside Boston and then in White Plains, New York, Kitty pressed Alfred to visit as often as he could. Until the birth of her son in June 1923, her letters were celebrations of both her marriage and her renewed contact with her father.

There could have been no preparation for the catastrophe that overtook her within days of her delivery; she succumbed, tragically and permanently, to what was then called post partum dementia praecox. Alfred's grief, intensified by the recent harmony of their relationship and accom-

panied by an overwhelming sense of guilt, was so profound that he could barely bring himself thereafter to speak her name even to friends. There was no more talk of having a child with Georgia.

Kitty remained institutionalized until her death forty-eight years later. Although Lee, who attended her medically, was in constant touch with her doctors and visited her several times a year, Alfred, who was enjoined from visiting her lest he provoke one of the terrible episodes of rage and self-directed violence that afflicted her periodically, never saw her again. He kept abreast of her condition through Lee and his son-in-law. He sent her notes; he sent her gifts of candy and fruit; he mailed modest checks to Milton, asking him to pick out something she might want for Christmas or her birthday, a date he underlined yearly in his grandson's consciousness with a few dollars for his savings account. Kitty responded with thanks expressed in the vocabulary and handwriting of a seven-year-old. With the manifest aid of an attendant, she also sent him greetings regularly on his birthday, Valentine's Day, Easter, Father's Day, and Christmas.

Emmy, emerging from the crucible of despair with greater courage and selflessness than she had ever shown before, visited Kitty almost weekly until her own terminal illness in 1953, having assumed meanwhile, with generosity and unaccustomed tact, a more active role as mother-in-law and grandmother. She and her bachelor brother Joe were dependable stalwarts in the childhood years of Milton, Jr., often hosting vacations at the shore to compensate for Milton, Sr.'s rejection of monetary aid.

Alfred made no effort to bring his grandson into either the Stieglitz family orbit or that in which he and O'Keeffe functioned. Doubtless he felt that Emmy's closeness was more legitimate, more necessary, and certainly more useful than his own. Nevertheless, he maintained a steady correspondence with father and son, sending whatever small gifts he could afford, and welcoming them whenever they came briefly to New York. He never brought them up spontaneously in conversation within my memory, but occasionally his pride in Junior's academic and athletic prowess at Phillips Exeter and Harvard, and his pleasure in the boy's courtesy and humor, surfaced after a visit or the arrival of a letter. Certainly, he was deeply relieved when young Navy Lieutenant Milton, Jr., returned unharmed from action in the Second World War.

To the end of his life, devastated Milton clung to the hope that Kitty would be able "soon" to pick up the strands of their interrupted happiness together, at least to finish out her days with him. He saw her as frequently as she or the doctors at the sanatorium on the Hudson allowed, although

time and again he found when he arrived from Boston, with or without Junior, that permission had been cancelled. In her greyly thickening and ravaged features twenty years after the onset of her illness, he still saw the youthful dark-haired beauty of his bride, preserved inviolate no less in his eyes than in Alfred's pictures. His dream of their reunion would never be realized.

17

An unanticipated dividend for Alfred in a generally unprofitable season was a growing closeness to Strand. Soon after the February 1922 debut of *MSS*, he persuaded Paul, who was unusually articulate about their medium, to serve as editor for an issue devoted to a theme long dear to his heart. CAN A PHOTOGRAPH HAVE THE SIGNIFICANCE OF ART, *MSS* Number Four would be in the works for over six months. Critics and composers, poets and painters, editors and performers, were invited to address the question; Strand was the single photographer. With the exception of Hartley, all the members of Alfred's inner circle of painters, and a good many others not so close, labored to put down on paper what it was in a photograph that spoke to them. Nobody worked harder than Georgia, who battled with words so assiduously through the summer that Alfred complained the assignment was stealing precious time from her painting.

Putting their heads together over the issue in New York during the spring, and corresponding through the summer, made it inevitable that a more intimate dialogue would develop between the two photographers, especially about their métier. For the magazine, Alfred advised repeated stretchings of the deadline to accommodate important late respondents (including Georgia) and went over the neatly typed copies Paul's new wife, "Beck" Salsbury, forwarded to him. But the major portion of his letters to Strand touched on photography. Added to the admonition to capture every moment—dispensed to every young photographer—was a new element: he now advised Strand to accept every commission he could find that paid well. No doubt Georgia's lectures to Alfred about the realities of earning a living had a greater impact on him than Dove's years of humorous letters describing his own truly marginal existence. In any case, he was certain that Strand would be less susceptible to the lures of commercialism than Steichen.

Energized in part by Strand's activity, Alfred was in high working gear throughout the winter, spring, and summer. In the city, he experi-

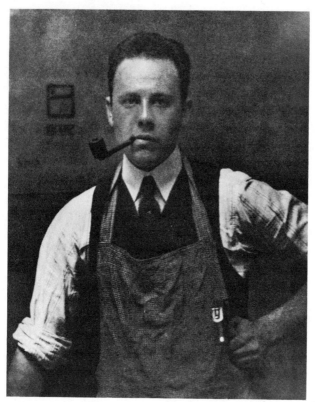

Paul Strand, ca. 1917 Alfred Stieglitz

mented with portraits of his friends (Marin, Frank, Demuth, and others) that would consist ultimately of up to a dozen pictures of each taken over a number of years; the most recent showed the effects of his four years' concentration on Georgia. In many prints, he found manifestations of hitherto veiled qualities in his sitters that he speculated could be useful to them in understanding themselves. None showed a trace of sentimentality. In the following year Charles Demuth, wasted by diabetes, wrote him about the new portrait Alfred had taken of him: "You have me in a fix: shall I remain ill, retaining that look [and] die, considering 'that moment' the climax of my 'looks;' or, live and change? I think the head is one of the most beautiful things I have ever known in the world of art."

For most of his life, Alfred had resisted the thought that a studio of his own, separate from the mainstream of activity, might contribute substantially to his working freedom. Except for his darkroom in Oaklawn's carriage-house, which was invaded by his brothers, nieces, and nephews, he had always worked in corners, near other people who were working, or talking, or cooking, or sleeping. In 1908, he described himself as a

"photographic vagabond [working] here there and everywhere," a situation that had been essentially the same ever since. In 1922, however, he undertook to turn the potting shed into a real darkroom, with blackout curtains, benches, tables, proper lights, and a refitted sink. Perhaps he was inspired partly by the alien presence of Hedwig's two German nurses, whose cluckings about American waste as they harvested windfall "oppulls" would tempt Alfred to call the Hill "Oppullhill." He had too much work to do to wait for Farmhouse privacy in the fall.

Before mid-July, he was in a frenzy of printing portraits, "snapshots" of little Peggy Davidson, recent pictures of Beck, and others of Georgia taken the previous fall, using up old Palladio paper he had come upon unexpectedly and wishing he had more, aware that what replaced it would be frustrating and disappointing. Weeks of photographing and developing followed: a new portrait of Davidson, experiments with the barn, close-ups of leaves he wished facetiously he could immobilize with Strand's neck-supporting "Iron Virgin." He tried out his 4 × 5 camera on a tripod for the first time, and began to find some satisfaction in what he could coax from the new film packs he had hated. All of this experimentation he described minutely to Strand. "One . . . negative print 47 minutes in the sun & developed in nearly straight bichromate! ! . . . another . . . in 47 seconds!" Racing back and forth between bright sunlight and the darkened Shed played havoc with his eyes and led him to interrupt his photographic binge for a few days. For once he did not mind spending time with Hedwig, cranking up the new Victrola for her and relishing performances of the new *Chauve Souris*, and of Jeritza singing arias from *Tannhäuser*. Then came a spate of reading: Edith Wharton's *Glimpses of the Moon* devoured in a day; Clive Bell's *Since Cézanne*, socialist Edward Carpenter's *Towards Democracy*, van Loon's *Story of Mankind*, and Gilbert Cannan's *Sembal* finished. He caught up on the current issues of *Vanity Fair*, in which Paul Rosenfeld now appeared regularly (the September issue would carry his piece on Georgia), and dipped into the collected letters of Mozart and Beethoven, which he enjoyed the most.

The "resting" of his eyes over, he returned to the camera, seeking the solution to a problem he had set himself six weeks earlier. What he wanted, he wrote Strand, was to capture sharply in a single shot the shaded interior and sun-flooded exterior of the barn, possible only in a few moments of a brilliant morning, with the sun at a particular angle. "Proper exposure for exterior would be about two seconds, f/64 & interior about five minutes!" Keeping at it only because he had *almost* succeeded, he

added wryly that if and when he finally got it, "it won't be particularly beautiful—or even interesting." But he wouldn't give up.

Nor would he give up his determination to do some nudes out of doors. He had intended to use Georgia as a model, but was reluctant to break her painting stride, already disrupted by her continuing struggles to finish her contribution for *MSS*. Instead, he pressed his sixteen-year-old niece, The Kid, into posing for him as she had the year before. Obedient though she was to his instructions, however, and shapely beyond her years, there was one quality she could not provide: maturity. For this he would have to wait for his next model, of whom he would take "a quintillion" pictures. Early in the summer, he and Georgia had suggested that the Strands vacation at the lake, taking rooms nearby and sharing days and evenings at the Hill. When the time came, only Beck was free to come. Paul, completing an assignment in Maryland, would be able to spend only a weekend when Beck came to the Farmhouse for a second visit at the end of September.

Beck's full-breasted but lean body, as confident and unself-conscious in repose as in motion, was exactly what Alfred had been looking for. With a clean-boned, freckled face, red-highlighted dark, long hair already turning prematurely grey that she would soon clip into a flapper's bob, and with hints in her of fire and ice, she could have been an understudy for Georgia. Some friends, indeed, remarked that Strand must have picked her for the resemblance; certainly he urged her to copy Georgia's mode of dress. But Beck had a mind of her own. Nothing would persuade her to exchange for Georgia's loose-flowing skirts the men's trousers she wore in the country, to censor an impulse to yodel across the hills, or to give up nude sunbathing. Nude swimming was an enthusiasm she and Georgia shared, although they learned quickly to indulge that pleasure only at night. On the one occasion when both Strands followed Alfred's rash suggestion to try it by day, they were arrested despite Alfred's insistence that the "crime" was his fault; he paid their fine.

Beck's independent spirit was as appealing to Georgia as it was to Alfred, and the two women found much to agree upon, including what it was like to live with an unpredictably touchy man prone to solemnity. Although they would never become close friends, in 1929, when Georgia's need to get away from Lake George was greater than her obligation to stay with Alfred, she and Beck went to Taos together. Meanwhile, whenever Beck visited, the atmosphere crackled with good humor—except for the

"cursy" periods when she became as gloomy and ill as Georgia, whose periods Alfred had learned to anticipate with foreboding. Sharp-witted and impudent, hard-working and joyously indolent by turns, restless, sometimes sensitive—and sometimes flatly indifferent—to the undercurrents of jealousy and tension that moiled around Alfred, Georgia, and Paul, Beck would seem tough to many of Alfred's friends. Selma thought her as brash as her showman father Nate—producer, manager, angel, partner, and self-described creator of *Buffalo Bill's Wild West Show*—but Alfred, as usual, found her vulnerable core and became her confidant. Probably he wished to be more. He found it impossible not to flirt with her, and his letters to her are filled with blithely sexual allusions. Doubtless Paul fumed (Alfred insisted his letters to Beck were meant for him as well), and one may wonder at his reaction to a 1923 letter in which Alfred equated his spotting a print of Beck nude with more than slightly erotic "tickling." Significantly, perhaps, his titillating references were far more subtle in the following year, and disappeared altogether before 1925.

Even in 1922, Alfred shared with Beck, as he did with his other major confidants, Dove and Marin, not only subjects ranging broadly from trivial gossip to sports, art, and politics but also deeply personal confidences that bespoke at least intellectual intimacy. Yet, curiously, none of his friends was privy to the somber reflections and undercurrent of sorrow that Alfred would later reveal had dominated his summer. To Rosenfeld he wrote excitedly of his reunion in New York—to which he had gone in mid-October to celebrate Hedwig's seventy-eighth birthday—with the English photographer, R. Child Bayley, whom he had not seen in fifteen years. Bayley, Alfred crowed, had been transfixed by the photographs he had shown him. Page after page of his letters celebrated his pleasure in the prints he made after his return to the lake, noted his grudging approval of the new Palladio paper and his satisfaction in having his large camera back after repairs made necessary by its absent-minded desertion in the rain. There was no hint of depression. Nor, even more curiously, was there more than fleeting reference to the important new direction his photography had taken over the summer.

Probably those who had been with him at Lake George—except perhaps Beck and Strand, to whom he played the genial host—were aware of a thread of melancholy in Alfred's silences; possibly, too, they observed that he took his camera often to more solitary places than usual. In letters, his preoccupied mood went unmentioned until November 21, when he

wrote Rosenfeld that the summer had "clarified much . . . very much" for him. His mother had died that morning, five days after suffering a massive stroke.

Presumably, Alfred's "clarification" had evolved from watching Hedwig grow progressively weaker, from coming to terms with the inevitability of her death. Certainly, he had made peace with her. Even before she left the Farmhouse on October 1, he had posted two letters to greet her on her arrival in the city; thereafter, for nearly two months, he wrote at least once a day. His visit to her on her birthday brought her acknowledgment of the deep pleasure she had taken in being with him through the summer. Admonishing him for the last time not to swim in cold weather and to eat enough *good* food, she wished herself twenty again, and him an infant. Then sent him love, in a barely legible hand, "from your Old, old Ma."

A full explanation of Alfred's inner experience during the summer, and its effects on his photography, would come in a long letter that Bayley published as an article in *The Amateur Photographer* in London the following September. Throughout the 1922 summer, Alfred wrote, he had watched his mother dying, ". . . Our place going to pieces. The old horse of 37 . . . being kept alive by the 70-year-old coachman. I, full of the feeling of today; all about me disintegration—slow but sure: dying chestnut trees . . . the pines doomed too—diseased; I, poor but at work; the world in a great mess; the human being a queer animal—not as dignified as our giant chestnut on the hill." He had photographed his mother, moribund. He had photographed raindrop tears on apples. He had photographed the faces and bodies of friends. And found them all too close, too intimate.

Then one day, looking for that light "rightness" he had sought for the barn experiment, he became enthralled with the movement of clouds. Their confluence, their dispersal, their play with shafts of light, their menace, their dance, their shadows sweeping across the land, their stream, their feathery disappearance and, ultimately, their grandeur, their peace, the distance that freed them eternally from puny human travail. Gradually he was drawn by them into forgetting, or at least diminishing in importance, the dying he saw all around him. The clouds were music, fleeting and reappearing in new forms; they expanded him, they exhilarated him, as music had always done. He began to photograph them, to capture their ephemeral passage, through them, he wrote Bayley, to "put down my philosophy of life."

Recalling that he had experimented in Switzerland thirty-five years

earlier with sky pictures, seeking then to define the capabilities of ortho plates, he wrote Bayley of his new experiments. "Daily for weeks" he photographed clouds. "Every time I developed I was so wrought up, always believing I had nearly gotten what I was after—but had failed. A most tantalizing sequence of days and weeks. I knew exactly what I was after. I had told Miss O'Keeffe I wanted a series of photographs which when seen by Ernest Bloch [would make him] exclaim: Music! Music! Man, why that is music! How did you ever do that? And he would point to violins, and flutes, and oboes, and brass . . ." which was how, indeed, Bloch greeted them. Even more important to Alfred, however, was that he had succeeded in transmogrifying, in sublimating, the storm of his emotions. Hedwig's death could be absorbed in relative tranquility.

Remaining in New York after Hedwig's funeral, Alfred spent a few more evenings than usual with the family, sharing grief and going over the provisions of her will with George Herbert. Other than a minuscule income, her only asset had been the Lake George property; this had been divided curiously into thirteen shares that were distributed among her five heirs according to the use they made of the place. He and Georgia visited Elizabeth and her new baby in the hospital and then plunged into the major work he had planned for the winter.

Nearly six years had passed since Georgia's solo debut at 291, the gallery's swansong. Now all Alfred's energies were focused on the late January opening of a two-week show he arranged at the Anderson. In the ringing tones of the impresario, his announcement read:

Alfred Stieglitz Presents
One Hundred Pictures
Oils, Watercolors
Pastels, Drawings
by
Georgia O'Keeffe
American

With the critics' reminders that this was the same artist who had surfaced as Alfred's sultry photographic model two years earlier, with articles that described her as an unrepressed goddess of love, the rooms at the Anderson were jammed from the moment the doors opened. Five hundred people a day came to see what this young woman—liberated, as one critic put it, not by Freud but by Stieglitz—had produced. Shuddering at the persistent references to the sensuality of her paintings as well as at the smarmy

attitudes of visitors to the gallery, Georgia quickly took to her bed. The pleasure would come later, when she had $3,000 in her pocket from those who took her work seriously. Her 1918 decision to leave teaching was finally justified.

It was difficult for Georgia to absorb without flinching the sexual interpretations of her paintings: at first she called them ridiculous, and eventually she dismissed them with sour amusement. But it was far more frustrating to deal with the continuing suggestion that she was a Galatea brought to life by Alfred's Pygmalion, a suggestion to which, in some subtle measure and despite his unwavering defense of her talents, Alfred himself seemed secretly to subscribe. If, after the 1920s, Georgia did not harbor within herself those fears of insubstantiality without him that he attributed to her in trying to explain her compulsion, after 1928, to get away from him annually for extended periods, there is no question that the assumption of so many in New York that she was a kind of extension of the genius Alfred was both painful and real. The slights she suffered at the hands even of her fellow artists in Alfred's circle, The Men, were not the imaginings of a hypersensitive woman. With the exception of Dove, who was as respectful of her abilities and skills as he was incapable of mean-ness of spirit or jealousy, every male artist among the 291-ers (including, at times, Marin) expressed the opinion that, *for a woman*, she was a pretty good painter but that, by definition, what she created could not really be on the same plane as the work of a man. There were variations in empha-sis, but the slighting imputation was the same: without Alfred, it whis-pered, Georgia might not have been recognized as an artist at all. The wonder, to this day, is not that Georgia displayed wry scorn for their male solidarity but that, thanks to an abundant sense of humor, she man-aged to achieve genuine camaraderie with several of them.

The assessment was, of course, absurd. Eventually, Alfred or no Al-fred, her gifts would have declared themselves. It would be equally absurd, however, to suppose that she could have flourished as rapidly as she did without the climate he created for her. It might be said that he fought for her exactly as he did for all his wards—in the shows he mounted, in his dialogue with the public and the critics, in seeing to it that she received as much freedom from financial worry as he could provide at a time when she needed it most. But in fact he felt he was doing more than that. Aside from the extra steam his love for her contributed to his championing, he saw the task itself as unique. In fighting for her, he was preparing the way for Woman to be recognized as Artist on a level previously enjoyed by men

only. By making Georgia a symbol, by exploiting those qualities he designated peculiarly feminine in her work, he attracted an essentially new public in which women were in a significantly larger proportion than before. And the fact that Georgia gained exposure and recognition before she was thirty-five was due, at least in part, to the special case he made of her in the early years. (Later he would admit to Dove, however, that it was "easier" to fight for her works, to find a sympathetic audience for them, than for the others in his group, including Marin, who was an early and durable star. He did not have to say that, of the paintings of all except Demuth among his artists, Georgia's were almost always the most readily understood, her subjects the most reassuringly recognizable, no matter how surprising in size, placement, or texture.)

It would be a mistake to assume that Alfred's conviction of the fundamental equality of men and women meant that he felt them comparable in every way; he did not. The major difference between them, he argued, was in the way in which they perceived the universe. Capabilities might be essentially the same, but he never lost the belief that, at their best, men were uniquely the thinkers, the dreamers, the philosophers, scientists, inventors; they experienced the world through their minds. Women, on the other hand, were the direct conduit of the unconscious, the repository of the Life principle, by nature both practical and mysterious. They were elemental, none more than O'Keeffe. Echoing Alfred's pronouncements on the subject, Rosenfeld had written in his 1921 article on O'Keeffe in *The Dial*, "Women, one would judge, always feel, when they feel strongly, through the womb." Alfred never changed that opinion.

The theme, well developed before Alfred reached his fifties, had its less exalted uses as well; it was a *concerto appassionato* in his repertoire of seduction. Most of the time, its effectiveness in his hands owed much to the fact that he was as dizzied by the grandeur of his motif as was his listener. Nevertheless, he was conscious enough to switch to self-parody when the full orchestra failed to move, resorting then to the mocking tones of the piccolo. With some women, he had discovered, a hearty laugh was more appetizing than a sigh.

Seductions aside, Alfred's idealization of women, and of Georgia specifically, had the power on a personal level both to benefit and to victimize. On the positive side, for Georgia, was his insistence that, endowed with gifts equal to those of her male counterparts, she had an obligation to work constantly at improving her craft and expanding her production, with allowances always for the gestation periods he knew were essential to the

creative process. If he did not verbalize his nudging, he exemplified it; his own working fire acted as a catalyst to hers. Even more important to her, perhaps, was the way his rock-solid belief in her vast potential reinforced her self-esteem. She felt safe with him, knowing that she could trust his experienced taste, even when she might disagree with it, and that the honesty of his appraisals would never be compromised by tenderness for her feelings.

At the same time, however, his idealization of her specialness carried negative burdens. In the eleven or so years they were together nearly year-round, it seemed often that her very struggle for self-realization was tied, like Gulliver, by the myriad tiny threads of his perception of her. Every effort at true independent growth seemed to tighten his hold, to make her more, rather than less, dependent on his support. It was the same paradox, magnified many times by the peculiar tensions of love, that Alfred's closest associates at almost every stage of his life confronted. Sooner or later she, like them, would have to break away.

Georgia's 1923 show was followed in April by another of Alfred's work that again created a stir. Of the 116 prints, only one had been shown before. Portraits included twenty-five of Georgia, up to four each of other women, and a number of others of men among Alfred's acquaintance, including Marin, Sherwood Anderson, Marcel Duchamp, and Demuth. A second section was composed of the barns, the chicken house, trees, and grasses at Lake George. Finally, there was the group called *Music—A Sequence of Ten Cloud Photographs*, forerunners of the series known later as *The Equivalents*, the crowning achievement of Alfred's final period of active photography. The effect of these early cloud pictures in 1923 on the curator of Indian and Islamic art at the Boston Museum of Fine Arts, Ananda K. Coomaraswamy, who was an enthusiastic shutterbug and friend of Alfred's as well, was as profound as that experienced by Ernest Bloch. To Alfred's astonishment, Coomaraswamy asked him to select a dozen representative images to give the museum, one of the most prestigious and conservative in the country and the least likely among the major institutions, one would have thought, to take the lead in welcoming photography. Alfred would work fourteen months assembling, printing, reprinting, and mounting the twenty-seven pictures he gave in the spring of 1924. He grumbled then about spending $300 for framing, but he wanted everything to be of "AA-1" quality.

The pattern of the New York winter and spring was much the same in 1923 and 1924 as it had been for several years. Gatherings on the top

floor of the Sixty-fifth Street house ebbed and flowed, with some new-comers lofted ashore, some familiars swept away, and others left unmoved by tidal shifts. New Jerseyite Marin came more often; he was trying out the bold centering of his idiosyncratic "interior frame" in new paintings of Manhattan skyscrapers and bridges that had been so effective in his 1922 seascapes. Dove, nesting with "Reds" Torr aboard his houseboat and grinding out hated illustrations for necessary funds, avoided large gather-ings and came seldom. Demuth arrived whenever he was well enough to leave his Lancaster, Pennsylvania, home, and stayed in the city until his orgy of New York galleries, parties, and forbidden menus made him ill again. Hartley's visits were squeezed into the four 1924 months out of seven years in Europe that he spent in New York. Walkowitz and Zoler were Saturday-nighters in search, usually, of a Chinese dinner. Of the ten writers among those drawn to Alfred's circle who had participated as founders, editors, and contributors for *Secession*, a periodical begun in 1921 to further experimental literature, only three remained as regulars after 1923: Hart Crane, Gorham Munson, and Jean Toomer. The others —Kenneth Burke, Malcolm Cowley, E. E. Cummings, Matthew Joseph-son, Marianne Moore, Wallace Stevens, and William Carlos Williams— moved on.

Few even of those who remained subscribed totally to Alfred's some-times overbearingly principled opinions, of which some were argued— often passionately and, tactfully, beyond the reach of his ears—and some dismissed as quirks. What those who stayed gained most of all was his unstinting and unpatronizing support, for their freedom to work in their own way and at their own pace as well as for the substance of their output. He offered empathy but no advice to Marin when he was in the doldrums; he seconded Dove's every creative notion, including his ephemeral wish to write a book about modern painting; he bolstered Rosenfeld's vacillating self-confidence with praise for his critical acuity and the single admonition that he not allow perfectionism to slow him down; and he so heartened Sherwood Anderson in his first faltering steps as a writer that the latter dedicated *A Story Teller's Story* to him. If he was not always so dispas-sionate with those who, like Hartley, Strand, and O'Keeffe, offered him occasional overt resistance, he nevertheless continued to be their champion.

Substantial changes were ahead in Alfred's relationships with his art-ists. In 1924, for the first time in seven years, he found himself actually running a gallery. Montross, who had fallen ill shortly before the opening of his annual Marin exhibition, asked Alfred to take over. "Once more

291 on deck," he wrote Dove, and boasted to others that he had managed to sell one of Marin's watercolors for $1,500, or $300 more than he had quoted to a scandalized Montross two weeks earlier. This was proof that a practical man could be bested on his own ground by an idealist, he boasted to Beck Strand.

Realizing that it was his face-to-face contact with the public that had gained from one picture nearly half what Marin needed for a year, in contrast to Montross, whose commercialism involved offering bargains to favored clients, Alfred considered the possibility of managing a group show for those painters who had been rejected by dealers. When his stewardship of Georgia's new pictures at the Anderson, in tandem this time with a collection of his photographs, brought in enough money to relieve them of anxiety about the coming year, he was convinced that it would be a good idea. Immediately he asked Kennerley to reserve space for a large group show the following year, and immediately he notified Hartley, Demuth, and Strand (none of whom had had an important New York show in several years) to get busy.

Almost as soon as this plan became a certainty, Alfred learned that fifteen months hence a small corner room on the Anderson's top floor of little showcase shops for jewelry, tableware, and antiques would become vacant. If the rent were reasonable, he told Kennerley, he might take it on as a tiny gallery. Two thousand for the year, Kennerley replied. Alfred would not broadcast the possibility until he had raised enough to guarantee the first year, but he discussed it with Elizabeth, who was delighted with the prospect. Among the advantages, she felt, was the formation of "a new group of students at '303,' " the number of the Anderson room. "Something too personal at 65th Street somewhat modified its workings."

Sixty-fifth Street was already in the past tense. By the end of October 1923 Lee, whose first heart attack on September 1 had made him fearful of stairs, had accepted a profitable offer for his house, on the proviso that it need not be vacated until June 1924. Briefly, Alfred had toyed with the idea of moving wholly to Lake George, but the notion was a will-o'-the-wisp: he needed New York too much. Furthermore, although a "maddeningly beautiful" blizzard at the lake in November had pushed him and Georgia into a frenzy of work, the 1923 summer at the Hill had not been ideal.

It had begun with the news of Kitty's tragic postpartum crisis, received on the very day of Alfred's departure for the Hill. Even before then, the thought of going there had been anguished. Not only would Lake George

abound in the ghosts of fifty years, but there was a very real possibility that it might soon be out of his reach entirely. All winter there had been talk in the family of selling the place, in which no one but Alfred seemed interested. Julius, in Chicago, was certainly not; Sel was going to Europe; Lee was renting a house for his family at Ogunquit, Maine; and Agnes, confessing cowardice about missing "Muttie," could be persuaded only to spend a short time at the end of the summer.

Expecting the worst, Alfred booked the Farmhouse like a worried innkeeper. Beck Strand opened the season, and was invited to return in late August. "Red" Rosenfeld came. In a mood of generosity unusual even in him, Alfred pressed a ten-week holiday on Marie Boursault—whose husband, far from well, was job-hunting—and their two-year-old daughter. The invitation was inspired. Not only did little "Eeyonne" (as Yvonne spoke her name) distract and entertain Alfred, but her presence convinced Georgia beyond question that she was not cut out for motherhood. Agreeing readily that Hedwig's former maid should relieve her of the housekeeping, she fled to the Shanty.

Through August the guests came: Strand for two weeks, commuting daily to Saratoga by trolley, seeking commissions to photograph racehorses; for briefer stays Anita Pollitzer, Lillias and Herbert Seligmann, and others. And Alfred wrestled with his ghosts. Painfully, he tried to accept the reality that Kitty—swinging between love and hate for him and, according to Lee and Milton, often believing him dead—was not only in better hands than his but was as truly beyond his reach as his mother. By the end of July he was pushing himself to printing up to ten hours a day, sleeping sometimes as little as four. When the printing fever ended, the cameras came out again for a new round of cloud pictures.

The anticipated arrival of Beck at the end of August and, in early September, the classically beautiful painter from the days at 291, Katharine Rhoades, accounted partially for an upswing in his mood. A sure sign was his renewal of vigorous exercise; he would have to be in shape for his harem.

Through most of the summer, Georgia humored his insistence on a full house. At the least, it kept him from sinking into dreaded melancholy; at best, it fueled his energies. She, however, who became restive eventually in the presence even of people with whom she felt truly close, was finding the experience cumulatively irritating. In previous years, she had managed to endure the legitimate family presence at the Farmhouse from July to September in the certainty that she and Alfred would have it to themselves

in June, October, and November. This year, with guests of their own choosing and free entirely of those family members who were uncongenial, she felt frustrated and impatient beyond control. The worst of it was that the possibility of not returning next summer was as appealing to her as it was devastating to Alfred; she had begged him to try out *her* kind of country—the plains and the deserts, or at least the rough seacoast of Maine that was so different from the combed resorts of the Jersey Shore that he detested—but he refused absolutely to listen. Suddenly, Georgia found the intimacy of the Lake George community—human and environmental—claustrophobic. On September 8, she packed her materials and took off for York Beach, Maine. Relying on the stabilizing influence of Elizabeth and Donald, who were due soon at the Hill, she stayed nearly a month, missing their entire visit.

The Davidsons, meanwhile, had been waiting for the chance to spill to Alfred their accumulated frustrations with life at Elmcroft, her parents' Westchester home. Elizabeth described it as "lace curtains and Chinese vases . . . four in help . . . crushing." Present only for weekends, Lee and Lizzie were blind, she cried, to the "unity and simplicity of human relationships—To them salt must always be in a little glass dish, on the table—the ocean has nothing to do with their salt. [They feel] that we *ought* to be—not that we *are*." Instead of harmony, money set their standards, "Mother saving it—Daddy trying to get his 'money's worth' of 'efficiency'—with a big stick." The purity, the transcendent affinity with Nature she and Donald sought in farming a corner of the estate was forever being sabotaged; the best that could be said for their effort, she concluded, was that it was a "most maddening experiment." Without their own funds, however, they were trapped. Alfred was inspired. If they moved year-round to the Hill, they could make a real farm of it, raise the children in an atmosphere free of artifice, and, coincidentally, save the place for the entire family. He and they would have everything they were looking for.

When they were gone, Alfred's optimism evaporated. The only clear "addition" to his summer, he felt, was his reward for following Elizabeth's suggestion that he write D. H. Lawrence directly to express his enthusiasm for *Studies in Classic American Literature*. Lawrence's response came within a week (so exciting Alfred that he sent the Davidsons a longhand copy) and initiated a warm correspondence that lasted until the writer's death in Europe seven years later. The only time Alfred "met" him, he later

recalled, was when, at Frieda Lawrence's request, he claimed her husband's ashes for her at U.S. Customs.

Other than Lawrence's new friendship, he could find nothing to celebrate in September 1923. All he could think of were Kitty's misery, to which he felt chained, and Georgia's distance from him, which seemed to grow with each day. His own misery brought Rosenfeld to tears, and Beck to a sense of sorrow that lingered long after her return home. Longer by far than Alfred's, it seems, for as soon as Georgia was back, cheerful and energetic, he was completely restored. Meanwhile, and for the year that followed, the Davidsons were possessed by the farm idea. They sent Alfred their egg money to bank for the "Farm Fund," and waited for the right moment to persuade Lee that the step was appropriate. Finally, at the end of the 1924 summer, Alfred volunteered to prepare the way, inviting Lee and Lizzie to spend the better part of a week at the Farmhouse when they returned from a European trip. Their visit, which Alfred made as comfortable and serene as he could, bore unexpected fruit. Lee was so pleased with the Hill's peace and quiet that a month later he announced his intention to sell Elmcroft and make the lake his summer quarters. The Farm-on-the-Hill idea immediately lost its appeal for the Davidsons. But for Alfred there was one clear profit from his brother's visit: Lee agreed to give him $250 a quarter "as long as I retain my health." In return, he suggested, Georgia might paint him a picture of the lake that he could understand.

Lee's decision to invade the Hill came as even more of a shock to Georgia than to Elizabeth and Donald. There were more to come. Lee's interest stirred up claims for equity from Sel, and even from Julius, who had not spent more than a few days of any year at Lake George since Edward's death in 1909. Now suddenly, in anticipation of his retirement eight years hence, Julius decided to retain the shares in the property Lee had offered to buy. Georgia, who had just begun to feel that she and Alfred had some control over the selection of summer inhabitants, realized that they would have less voice even than when Hedwig was alive. Could she never persuade Alfred to move?

Two events in the 1924 spring had already shaken her. In April, Alfred had suffered the first of several increasingly severe kidney attacks following the strain of mounting three shows at the Anderson in a month —Marin's, hers, and his own. And, in early June, after nearly six years of wrangling, Alfred had been granted an interlocutory divorce decree from Emmy; final judgment would be rendered in early September. Although

Alfred had written Dove after his illness that he was growing old and could look forward now only to "x's, y's & z's—no more a's or b's or c's," he had recovered quickly. Recovery from the shock of the divorce seemed to take longer.

Almost at once, Alfred and Georgia began talking marriage. One wonders why. Alfred had already persuaded Georgia that her career and motherhood were inimical, so there was no question of need to legitimize a child. It is doubtful that pressure from the family would have mattered even had it been heavy, which it probably was not; even Julius had given up his lectures. Certainly Alfred's years with Emmy had demonstrated that marriage could be a disaster. Finally, all his observations had convinced him that possessive lovers were inevitable losers, and married partners were prone to the delusion of owning each other.

Only three arguments in favor of remarriage seem plausible, one almost certainly unconscious. Obviously it would protect whatever estate he had to leave Georgia from the claims of siblings less altruistic than Agnes and Lee; his income was minuscule, but he was well aware that the art works he owned, as well as his share in the Lake George property, would have increasing value. Less obviously, but possibly, Alfred was not wholly liberated from bourgeois values. Knowing themselves that they were married, both would be free to thumb their noses and say: So what? More deeply hidden from him would be the most potent argument of all. In January, Alfred had had his sixtieth birthday; Georgia was not yet thirty-seven. He was certainly becoming more frail; she, the Ultimate Woman, had not yet reached her prime. Would he be able to hold her? The possessive impulse he deplored in others still lurked within him.

Georgia was surely ambivalent about marrying, painfully so, one suspects. If she didn't feel the girlish uplift of spirits that the anticipation of matrimony was supposed to produce, regardless of her age, she felt at least that she would be doing something to please Alfred. She cared deeply for him. Nevertheless, she was fearful of being tied, of no longer having a free choice, of being saddled with wifely obligations. Already she found daily housekeeping boring beyond belief; how would she feel when nursing joined her duties, as inevitably it would? His sudden exhausted frailty in the spring had been truly frightening. On the affirmative side was the undeniable fact that, for six years, they had really done very well together. They had found it possible to be generous about each other's foibles and angers as well as appreciative of each other's gifts and capacity to love; they continued to share goals; and, although no longer as exigent a need as

once it had been, sex together was still pleasurable. With continued good will, they ought to be able to make even marriage work. Furthermore, the removal of all their belongings from Sixty-fifth Street and the realization that they had no idea where they might live on their return to the city in November had brought back a sense of freedom and a youthful spirit of adventure that had been missing for some time. Still, she was hesitant.

The summer had gone smoothly after early July, when Georgia, on strike against housekeeping for four guests within ten days, suffered a loss of appetite so severe that Alfred called it a breakdown and sent for the Davidsons, with little Peggy and a Swiss *au pair* girl in tow, to set her on her feet again. Thereafter, with Hedwig's Katherine reinstalled in the kitchen, Georgia concentrated on her painting, following up the first of her experimentally large flower pictures, called "silly but lovely" by Alfred, with others in the same vein. The house that Alfred didn't like to see empty accommodated friends through October, including Georgia's sister Ida—a painting teacher recently graduated from nursing school—who stayed for over a month. Talk of marriage resurfaced with the arrival on September 9 of Alfred's divorce decree, but was soon shelved. The decree banned his remarriage within New York, but left him free to be wed in any of the neighboring states. It would have been possible in little over an hour for Georgia and Alfred, with resident Ida and Rosenfeld as witnesses, to slip into Vermont and return to Lake George. They did not.

Eventually, something had to be done about living quarters in New York. George Herbert inquired about rates at the more modest hotels in the Anderson Galleries' orbit; offers came from friends willing and eager to put them up. Nothing seemed quite right. What hastened them, perhaps, to solve the problem was the arrival of a preposterous offer from Selma, who was sulking in Paris over her book's mixed (mostly dismal) reception as well as a spoiled rendezvous with a lover in London. "I wish," wrote Selma from the I^er arrondissement—in which she said she would gladly keep a simple hotel bedroom and "a little sitting-room" in exchange for her "10-room apartment and servant trouble" on the sixth floor of the 1211 Madison Avenue building where the Engelhards occupied the opposite flat—that "you and Georgia could be at 1211 until you find a place—Georgia at Ag's and you at mine—You know Al *anytime* [sic]—just say so—you can *always* be there. I know there is no use saying it to Georgia—but she at Ag's—it seems simple." Obviously they had to find a place of their own, and soon.

It is conceivable that the decision to be married hung on so slender,

although perhaps essential, a thread as the need to produce a license when signing a lease. In any event, by late November they were in New York, and by mid-December they had found temporary quarters at 38 East Fifty-eighth Street. They had been married in Cliffside Park, the New Jersey town where the Marins made their home, on December 11.

The performance had been accomplished in jig time. Marin, drafted as witness, had taken his touring car to Weehawken to meet the ferry bearing Georgia, Alfred, and George Herbert (the other witness), driving, as he always did, inattentively, erratically, and fast. The brief ceremony—made a bit briefer by the bride's requested omission of the promise to honor and obey—had been performed by a justice of the peace. On the way back to the ferry immediately after the wedding, Marin turned to toss a quip to Georgia and Alfred in the back seat, sideswiped a grocery wagon, spun across the street, and lightly bumped a telephone pole. There were no injuries but, in later years, Georgia would tell of her grim feeling—in the middle of the ensuing hubbub of policemen, witnesses, angry grocer, and laconic Marin —that she had lost something, like a limb. The mishap seemed a fitting climax to a strangely out-of-joint day.

18

"Seven Americans," the group show for which Kennerley provided almost a whole floor of the Anderson for three weeks in March 1925, was characterized as a twentieth anniversary celebration of the introduction of paintings to the gallery at 291 Fifth Avenue, but it was not a retrospective. Georgia's paintings (including the giant flowers Alfred had resisted showing at all), Marin's watercolors, and Demuth's still-lifes and poster/portraits of the exhibitors, had all been produced within the year, as had Alfred's photographs, of which the majority were additions to his cloud series. Although for Dove it was the first full New York exhibition since 1912, and for Strand the first since 1916, half or more of their works had been done during 1924. The catalogue, containing brief statements by Alfred, Sherwood Anderson, and Arnold Rönnebeck, was enlivened by a poem by Dove that Alfred termed a classic. Addressing himself to the bewilderment of people uncertain of the meaning of an abstraction, Dove had written, in part:

> We have not yet made shoes that fit like sand
> Nor clothes that fit like water
> Nor thoughts that fit like air . . .
> Works of nature are abstract,
> They do not lean on other things for meaning . . .
> That the mountainside looks like a face is accidental.

The show opened to mixed reviews. The most favorable, by Edmund Wilson in the *New Republic*, mentioned Demuth's name only in passing, ignored Strand entirely, and found Hartley's watercolors "embrown[ed] or dully empurple[d] with his characteristic sullen felicity." Only Dove was found in any way comparable to O'Keeffe, for whom—as for Alfred —Wilson reserved his highest accolades. O'Keeffe, he wrote, "quite outblazes [Marin's] masculine masterpieces" as—with peculiarly feminine brilliance and intensity and using "vagueness and edge [in] mutually

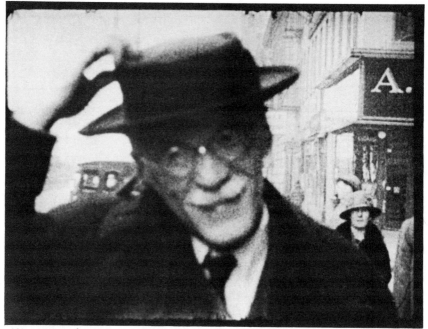

Alfred Stieglitz, New York, 1925 Flora Stieglitz Straus

repellent colors—[she creates] dissonances . . . analagous to modern
music and poetry." Stieglitz's "amazing genius," Wilson continued, "is
pushing his mastery . . . further and further from mechanical reproduction
and closer to the freedom of plastic art . . . Certain of the [cloud] prints
are among the artist's chief triumphs."

Wilson would have more to say about Alfred when, in 1957, his
review became part of an anthology, *The American Earthquake.* His later
description is so tangibly accurate of Alfred as entrepreneur and educator
in all of his galleries that it merits citing at length.

Alfred Stieglitz was something of a mesmerist, [who] deliver[ed] a
monologue, a kind of impalpable net in which visitors and disciples
were caught from the moment they came within earshot . . . To in-
terrupt or to change the direction of this monologue [was impossible
as it] wandered from subject to subject but . . . never for a second
slackened—the ribbon of talk was as strong as a cable—and . . .
influenced the mind of the listener in a way that was not accidental.
On the occasion [of the 1925 show], he was expecting me and took
me in hand at once. He gave me a program of the exhibition, then
saw that it was slightly smudged, took it away and gave me another.
"I'm sure you're like me," he said. "You like to have that kind of

thing clean." This and the program itself were characteristic of him—the Germanic love of neatness, good craftsmanship. We now passed from picture to picture, and his somewhat nasal voice, interrupted at the time by the sniffles, droned and drawled along but never relinquished its dominance. He was then sixty-one years old, with wiry gray hair, nickel spectacles and a wiry white toothbrush mustache; he may have worn, as he sometimes did, a pepper-and-salt suit . . . There was more in his outward appearance of the expert "technician" than the artist. Still less did he give the impression of the dedicated spiritual teacher. I had been prompted by one of his disciples to see in his darkened skies the emotions with which I associate them; and when I talked about my visit later with an acquaintance who had also gone as critic to one of the Stieglitz exhibitions: "Yes," he agreed, "when I came away, I couldn't help wondering a little whether it hadn't been a case of the innocent young serpent being swallowed by the wily old dove."

In a July reappraisal, the "wily old dove" concluded that the show had not been a failure in spite of widespread resistance to Georgia's huge flowers and multiple knocks delivered to Dove and Hartley. He was convinced, in fact, that had he not been absent from his usual ten-to-six post at the gallery thanks to illness, he would have been able to alter the perceptions of a number of the critics as well as the public. He had suffered a series of severe episodes of kidney colic that started in March and climaxed in June with the passage of several kidney stones, leaving him weak and exhausted. To make matters worse, Georgia too was ill, suffering a reaction to a vaccination that swelled her legs and feet so painfully that she took to her bed soon after reaching Lake George. Each was so slow in recuperating that Alfred was still complaining in mid-July that, in seven years together, they had seldom experienced a single day in which both were well. His wild exaggeration was a symptom of a growing hypochondria on Georgia's behalf as well as his own that would engender deepening problems between them.

Left to her innate good sense and skill in joshing Alfred out of oversolemnity, Georgia might have been able to disperse the hospital atmosphere of the first half of the 1925 summer had it not been for Lee's arrival in mid-June at his just completed bungalow up the hill. Lee's word to his patients—including Alfred and, for a number of years, Georgia—bolstered by a secure reputation for diagnostic brilliance, was the word of God. If the first reaction of a patient who was not critically ill was guilt for

contracting an ailment, the next was grateful recognition that rescue was possible if every detail of "Stiegie's" prescribed treatment was obeyed punctiliously. The cure, more often than not, inspired worship. And dependency. Lee's retirement in 1942 after fifty years of practice resulted in the transfer of only a few patients to the successor he had chosen, and he continued to make house calls and hold consultations in his home until weeks before his death at eighty-nine. More than a few of his longtime patients would find themselves several years thereafter still consulting him.

It was Lee who confined Georgia to bed with her legs bound, and it was Lee who monitored her activities for weeks after she was permitted to get up. And under Lee's watchful eye, Alfred's stomach trouble, eye trouble, foot trouble, neuritis, sinusitis, and what-have-you grew ever more ponderous. A two-day interruption of morning regularity, for example, could mean the prescription of an enema or castor oil for fear of blockage brought about by the Lake George water, which, marvelously tasty and loaded with minerals, was also punishingly constipating. Despite ailments, Alfred wrote to most friends that the Hill was peaceful. To Beck, however, he confided feeling as though it had been "slashed to pieces" by changes he did not enumerate. Of these, the most radical was the invasion by Lee, Lizzie, their cook, their chauffeur, and their two Davidson granddaughters, deposited for the six weeks Elizabeth and Donald needed to ready an old Rockland County Dutch farmhouse for occupancy. As Lee's new "Red Top" had neither dining room nor kitchen in its first three years, the Farmhouse was subject to this sextet's daily intrusions for noon and evening meals. Alfred's and Georgia's serene privacy was certainly "slashed to pieces."

With "Red" Rosenfeld only an occasional buffer (he spent most of his resident visit between July and October working with Alfred Kreymborg), our inescapability was a source of constant irritation to Alfred, and especially to Georgia. Things might have been different if Peggy and I had come with our parents; Peggy had established herself the year before as "a wonder," and, at two-and-a-half, I was still dependably shy. In any event, childish spontaneity, if not too noisy, was not intrinsically offensive to either Alfred or Georgia. What they found immeasurably annoying was that the strict behavioral instructions of our grandmother Lizzie, in terror even more of Georgia than of Stieglitzian storms, had turned us into little automatons. Before coming to table, we were to rescrub our clean hands with Synol soap in clear view of Uncle Alfred because "he is very careful about germs." Unless addressed directly, our only words were to be "thank

you" when served. We were not to wriggle or giggle, and we were to finish everything on our plates. We were not to leave the table until excused *without* our request. We were never to run in the house, sit when an adult was standing, interrupt a conversation, or let a door slam. Even invited by Uncle Al to sit and chat, we were not to stay long or we would be bothering him. In the following year, when both great-aunts were in residence during our two-week stay, there were more rules. If Aunt Sel showed us her jewels, we were not to ask where they came from; if Aunt Ag offered us candy from her inexhaustible supply, we were not to accept more than one piece.

Poor self-effacing, self-deriding, stoic Lizzie, an even more alien figure in the Stieglitz landscape than Georgia, was, in fact, the unwitting cause of a large portion of the friction among her in-laws. Keeping under rigid control the fire, passion, and independence of spirit that had led her to join the bloomer-girl contingent of the suffragettes, in the presence of Stieglitzes she wore docility and sweetness as if they were the hair shirt of some penance. The very generosity with which she took on the demeaning tasks thrown in her direction militated against her, and the humility with which she accepted every criticism, especially from Lee, succeeded only in engendering further beratings. Alfred and Selma might advertise their martyrdom; Lizzie was the genuine article. Used as a wailing wall by Ag and Sel in their endless jealous wars, she was berated by both for the "meddling" of her peacemaking efforts; neither had the imagination to recognize cruelty in their constant demands on her, their disdain for her ignorance of fashion, their laughter at her expense. Whereas Ag was simply unthinking, however, Sel was outrageous. The justification she offered once for having slammed a door painfully on her daughter-in-law's foot when Dorothy had the effrontery to arrive early for a party was typical. "I didn't know it was you," Selma snapped. "I thought it was Lizzie!"

For many years, Alfred's only common ground with Lizzie was their shared passion for the piano. A teacher before she was twenty-one, at twenty-three she had been an accomplished enough recitalist to win appointment as pianist/lady-in-waiting to Elizabeth of Rumania (the eccentric poet and radical "Carmen Sylva") at her summer court in Baden-Baden. It was only in 1932, when Lizzie ended years of unarticulated misery by divorcing faithless Lee, that Alfred discovered other affinities. Until then he had thought her so conventional that he had quickly abandoned attempts to persuade her of his own life views—or, indeed, of a more relaxed relationship with her daughter Elizabeth. And although he sometimes

scolded his sisters for their gibes at her, he did nothing in the 1920s to protect her from Georgia's open hostility.

The blandness of Lizzie's cuisine and her insistence on petty formalities at table were the smallest ingredients of Georgia's dislike for her. What she found unforgivable was that Lizzie epitomized the good wife. No matter that she spoke (in a soft voice and hardly ever in the presence of men) of the rights of women to vote and to earn, Lizzie never wavered from the position that a woman's paramount obligation was to her family, starting with obedience to her husband and deference to men in general. Day after day, evening after evening, Georgia witnessed, with ill-concealed annoyance, Lizzie's capitulations to Lee. And to Alfred. Even to noncombative Rosenfeld. Georgia *knew* that there was steel, not jelly, at Lizzie's core, and that she possessed the intelligence to support an independent opinion. But there was never a crack in Lizzie's acquiescence to a moral absolute that, by implication, made Georgia's liberties with Alfred reprehensible. To Georgia, Lizzie's rectitude was insufferable, far worse than Alfred's, or Lee's, or even Selma's, patent self-centeredness.

Selma's August arrival in 1925 gave Peggy and me our first demonstration of the histrionics at table of which Lee, Alfred, and Selma were capable. Alfred's and Selma's shouting matches, literally painful to the ears, were almost always about trifles and often evaporated as quickly as they had begun. More serious issues found Sel capitulating finally to Alfred's seniority but never to the justice of his argument. Taking her dinner plate and her injured vanity to Alfred's adjoining study, she continued to fire salvos in his direction, effectively spoiling whatever victory Alfred thought he had won. The exhausted silences that followed such skirmishes were seldom broken by the meek—Agnes, or Lizzie, or even Rosenfeld, who, away from the table, was a tireless expostulant, using restless baby hands to pluck thoughts from the air like invisible fruits. With a redhead's fragile complexion, his moon face, incongruously embellished with a square mustache, was often suffused with blushes. Behind his back, we called him Pudge.

The largest of the ground-floor family rooms and the hub of the Farmhouse, the dining room was an effective battle arena. Its leaved round table and eight assorted chairs (supplemented when the occasion demanded) took up nearly half its floor. In the first year of communal dining, one of Georgia's contentions was over Lizzie's insistence that courses be served "properly" from heavy platters. Moving clockwise around the table, the cook or a maid risked collisions almost as soon as she had stepped over

the furnace grate and passed the stairs and the bathroom door. A heavy Empire sideboard and a Victorian linen chest along the same wall were the first obstacles. The next wall's broad opening to a cluttered library/sitting room offered freedom for a distended rump, but the third wall required a squatting sidle past an armless chaise-longue under the porch windows. To regain the kitchen's swinging door, she had to skirt a mute grandfather clock, the entrance to Alfred's study, and a shoulder-bruising wall telephone—a bright maple box with black, almost facial, features that prompted Alfred year after year to say he would do its portrait.

In my memory, Alfred sits beside Georgia with his back to the porch windows. He eats only the hard outer crust of a roll, twirling the soft core into little pellets that he deploys around his plate as the meal wears on, sometimes wreathing the salt and pepper dishes and the iodine bottle that stands at the ready for Rippy's misdemeanors. He has tucked his napkin into his open shirt collar and anchored it under the knitted edge of the long-johns he wears year-round; with its free-hanging corner he dabs at lips and mustache fringes. Frequently he forgets to remove it and may be found an hour or more after dinner chewing absently on its hem, a habit he shares with his brothers. He eats sparingly; his appetite, like Georgia's, is depressed by an overabundance of food.

When there are no adult dramas in session and we children become, briefly, people, Alfred's attentions to Peggy and me are nearly always gentle and remotely affectionate. His greeting is usually accompanied by a pat on the cheek, a smile, a pinch, a pleasantry. He teases me for my customarily solemn mien, hoots with pleasure when I offer in earnest response to every disappointment the phrase he has taught me: "Such is life!" and enjoys positing the conundrum: "When tomorrow is today, will today be yesterday?" Our encounters during the first summer are few, however, other than in the dining room and the occasions when he has summoned us to pose for his camera.

In later years after dinner, we—children and adults—repair sometimes to the back of the Shed for a game of croquet. Among the sexagenarian players, Aunt Sel, rigid in corsets and afloat in chiffon, whacks the ball with authority. Diminutive Aunt Ag keeps tight-lipped watch over potential infractions of the rules and pins offenders with a sharp rebuke. Uncle George Herbert plays the deliberate buffoon whenever Stieglitz testiness portends temper. Grandmother Lizzie, with the knitting that accompanies her everywhere, sits Peggy and me beside her on the bench until we are summoned to retrieve an opponent's ball grandfather Lee has dispatched

ferociously into a scraggly hedge of ancient lilacs, with a *"Ha!"* reserved otherwise for his execution of a fly. Uncle Alfred, waiting his turn in a baggily Chaplinesque lean on his mallet, switches unpredictably from irritability to laughter to cool calculation to huffy departures from the field. O'Keeffe has usually taken off for a solitary walk. The sport echoes palely the one-time ritually fierce matches of brothers, sisters, and offspring at Oaklawn.

Much of Alfred's 1925 summer was spent in ruminations about Room 303 at the Anderson. The rent money had been in hand since spring; the room would be his before the end of November. Would its size allow anything more than mediocre storage space? Had he been unwise to take on such a responsibility again? Might he be inviting a painful reenactment of the closing days of 291? Adding to his uneasiness was the dispiriting news that Elizabeth and Donald, embarked at last on the independent dream they had cherished for nearly seven years, had had their first serious quarrel. Was the peace compact they worked out, granting Donald periodic "leaves of absence," really the right solution?

All troubles were forgotten as he went back to work in October's brisk air, autumn colors, northern lights, and first early snow. If the 38° water in the Shed was punishing to his hands, if 300 of 350 prints were consigned to the wastebasket, if the paper he used proved again that Eastman was "a fiend," it did not seem to matter. Not even the news that the hotel in which he and Georgia had been planning to spend the winter was "full up. Sorry!" could dampen his spirits. By mid-November, he was ready to face the city and the work that lay ahead at Room 303.

Fortunately, the full-up hotel turned out to have accommodations for them after all. For nearly two years, Georgia had watched its construction, from excavation to riveted steel to granite and brick sheathing. For the better part of a year, she had dreamed of an aerie in one of its high corners. The thirty-four-story Shelton, on Lexington Avenue between Forty-eighth and Forty-ninth Streets, was the first skyscraper built in conformance with New York's (and the nation's) first zoning resolution (a 1916 answer to the behemoth Equitable Building at 120 Broadway) that limited height and mass by mandating setbacks in design that would provide one foot more of air space for every four feet of additional height.

The idea of living in a skyscraper appealed as much to Alfred as to Georgia. If she sought the sweeping distances as well as intimacy with clouds, he coveted the bird's-eye view of Manhattan's fever to diminish the size of man with ever-taller giants. Already the forty-two-story Ritz

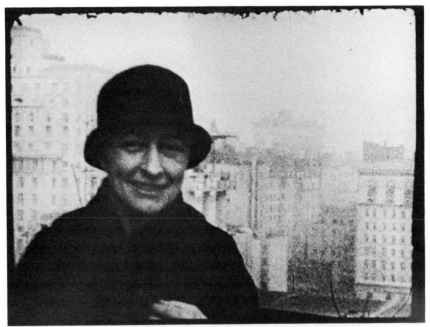
Georgia O'Keeffe, Hotel Shelton, New York, 1925 Flora Stieglitz Straus

Tower, completed in 1925, cast its long shadow on the Anderson Galleries two blocks north. In the next five years, Georgia, watching from the Shelton's roof solarium and terrace, would see the seventy-story Chrysler Building rise to become the world's tallest and then, in only ten months, cede its title to the Empire State Building, a third again as high.

Suite 3003's modest two rooms and bath at the Shelton would be Alfred's and Georgia's winter home for ten years. Numerologically, it was an auspicious twin to the Anderson's 303, which pleased Alfred—and especially those friends (like Djuna Barnes and Davidson and Dove) who persuaded him more than once to seek the guidance of an astrologer. The living room—facing north and east, windows uncurtained, walls painted Georgia's preferred pale grey, furniture (including Alfred's deep arm-chairs) draped in uniform off-white—was essentially Georgia's studio, a bower of light. The dawns were theatrical, with the sun's rays picking out the toy-sized tugboats and barges on the East River as they skimmed or fought the swift tides against the silhouetted high industrial chimneys of Queens on the river's far side. At night the water was patent-leather; the low, clustered dwellings fanning out to the north and east were a net of stars.

Here the snow, and sometimes even the rain, fell often in upward-

reaching gusts; fog erased the streets; the gargoyle corner rainspout disgorged loudly or wore a cap of snow in silence. Here Georgia could work undisturbed until daylight slipped away, or until restlessness or a sense of the day's achievement invited her descent to the streets to walk. Here there was no interrupting housekeeping; the hotel's sixteenth-floor cafeteria offered reasonable if unexciting meals to residents and guests. Theoretically, at least, except for summonses to choose and hang shows, to join Alfred for lunch, and occasionally to meet a special visitor, Georgia's time was her own. In practice, at first, she spent more than the required hours at the gallery, listening from a silent corner to the unreeling thread of Alfred's talk, observing for the first time his ability to engage strangers as well as friends in revealing conversation. Soon, however, her fascination gave way to boredom, and her appearances became less and less frequent.

Room 303—known to the public as The Intimate Gallery and to insiders as "The Room"—claimed Alfred's and Georgia's energies as soon as they arrived in New York. The high black-velour walls of the roughly twelve by twenty foot room, suitably traditional background for gilt-framed academics or old masters, were dismal in their eyes. Georgia set to work immediately tacking white cheesecloth from picture rail to wainscot. The light streaming through the long north and west windows and reinforced by electric overhead fixtures revealed every nuance of the pictures soon crowding the walls.

Alfred drew up a flyer describing the gallery as "not a business . . . but a Direct Point of Contact between Public and Artist . . . [to which] Alfred Stieglitz has volunteered his services and is its guiding Spirit." Its purpose was to serve as the exclusive outlet for "Seven Americans: John Marin, Georgia O'Keeffe, Arthur G. Dove, Marsden Hartley, Paul Strand, Alfred Stieglitz, and Number Seven (six + X)" and to offer "students, artists, collectors, real connoisseurs and, naturally, some curiosity seekers" the opportunity to see and study "the complete evolution and the more important examples of these American workers." In italics at the bottom of the page it announced curiously canonical *"Hours of Silence: Mondays, Wednesdays, Fridays, 10–12 A.M."* "Communion" with pictures, and respite from Alfred's rolling monologue, were guaranteed.

Even before the Marin show that opened the gallery on December 7—to fine reviews and the sale of two paintings to the Brooklyn Museum —Alfred had decided to repeat a 291 practice: any artist's recent pictures for which there was no hanging space would be arranged around the black carpet's perimeter, tilted against the walls. Miraculously, regardless of

crowds, no painting ever suffered damage from an errant foot. As at 291, he insisted too that the door remain unlocked. It was not until late 1929— when he opened his third and final gallery, An American Place, in an office building—that management and friends alike persuaded him to lock up. The decision never ceased to irritate him.

Between six o'clock and shortly after midnight of January 11, the Marins were down and Dove's show up, ready to open at ten o'clock the following morning. A similarly swift schedule of dismantling and hanging would prevail in most of the years of Alfred's stewardship. In the intervening hours, gofers passed hammer and nails, fetched sandwiches and coffee, and held up one or another painting until its perfect spot was found. Fundamentally, Georgia was in charge. Alfred relied more on her sense of spatial, compositional, and color relationships than on his own, and throughout the ensuing years, except for the few occasions when illness or extraordinary distance kept her away, Georgia and the represented artist would share in the mounting of shows, with Alfred serving as referee when rare disagreements arose. In this regard, he would become almost totally dependent on her.

Much to Alfred's chagrin, the only newspaper critic to put in an appearance at Dove's show was Henry McBride of *The Sun*; only two or three magazine critics responded. Although a respectable 900 people came in the four weeks of the exhibition, Alfred was disappointed. Not only had Dove chosen unusual surfaces on which to paint his still radical and incomprehensible pictures—glass and sheets of metal and rough wood panels—but he had also introduced an entirely new category, a group of highly individualistic collages he called assemblages. Scraps of fabric, newspaper clippings, nails, rope, shells, paper flowers, metal screening, twigs, fishbones, cork, and even a carpenter's rule were juxtaposed, subtly and dynamically. Many were metaphoric portraits, lighthearted, poignant, or satiric.

It would be twelve years before the first of these assemblages would find a buyer—the same buyer who during this show advised Alfred to tell Dove "not to do such things." A presumptuous remark for a man who was acquiring his first Dove, but apparently Alfred let it pass. Wisely, it turned out; Duncan Phillips, the multimillionaire collector and founder of the Phillips Memorial Gallery in Washington, became not only Dove's major collector but also a consistent buyer of O'Keeffes and Marins. Although Dove's and Phillips's relationship, exacerbated but also cemented by Alfred, would have its ups and downs over the next twenty years, both would

benefit from the association, Dove in gaining an extremely modest but essentially steady income as well as exposure, and Phillips in being able to add wonders to his collection for relative pennies.

The first day of Georgia's 1926 show—a garden of huge flower canvases that would draw crowds to its full seven-week run—brought her a triumph of a very special nature: her first Manhattan picture, *New York with Moon*, was sold. She had successfully challenged The Men on what they considered strictly masculine territory, the city, and she had proved to Alfred that he had been mistaken in rejecting its inclusion in the group show of the preceding year. Partly in celebration, and partly to escape the stifled feeling she experienced whenever her works were displayed, she accepted an invitation to spend a few late February days in Washington, leaving Alfred alone in New York for the first time since 1918.

Stunned to discover how quickly her absence altered his perception of the city, Alfred told Seligmann that on his walk back from taking her to Pennsylvania Station, "the streets and the city became unreal, and disappeared, and everything took on the aspect of O'Keeffe's whiteness. He . . . felt her as white, himself gray by comparison, and no one could ever be for him the white thing O'Keeffe was." The "white thing" was soon relishing the lavish colors of a precocious Washington spring, and glorying in her freedom. Even the initially frightening pretext for her trip proved enjoyable. Prodded by Anita Pollitzer to address a convention of the National Woman's Party, she exhorted the nearly five hundred assembled women to end their dependency on men, to run their own lives, earn their own support, develop their own capabilities. Simultaneously, in New York, Alfred was expounding to one and all the extraordinary connectedness of his and Georgia's relationship. As one proof he offered the mysterious coincidence of each having occupied the same room at Lake George—he in 1880 when his father had rented the house for the summer, and Georgia in 1908 as the winner of an Art Students League vacation prize. It had been her only visit to the lake prior to meeting Alfred.

He told and retold the circumstances of their meeting. He described the genesis of some of her paintings and some of his photographs in particular shared experiences, moods, conversations. Some of his pictures of clouds and sky, he said, were his way of holding her hand or corroborating an earlier exchange. Similarly, a picture she had painted specifically for him would seem to both sometimes to be so much their child that parting with it would be an anguish. Feeling obliged once to show one of these special pictures, he had decided initially that a buyer might have it for

$600 but found himself raising the price, first to $1,200 and finally to $2,700. Vastly relieved that no one bought it, he vowed never again to put up for sale anything Georgia had created for him.

While Georgia's show was on, Alfred, in his element—orchestrating the conversation, the pauses, the solos, duets, themes and variations for the changing body of his audience—continued his serenade to her. Often his rhapsody took the form of a disclosure, a sentiment or a moment between them that Georgia would have preferred left private, indiscretions that made her increasingly reluctant to come to The Room. Interwoven with his daily melody, however, his regular observers began to note the emergence of a contrapuntal theme. More and more as the weeks went by, Alfred found justification for bringing out his photographs, especially his more recent cloud prints; talking about them, he placed less emphasis on their relation to Georgia than on the individuality of his artistic vision. To some it seemed that, engulfed in her huge flowers, he was compelled to reassert his independent strength. He took further pleasure in devising a game he would play for the rest of his days. Proffering an unmounted cloud print without saying in which direction it was meant to be seen, he insisted knowingly but without elucidation that the recipient's choice proved something profound about his or her character and sensitivity.

The Intimate Gallery's first season closed with a show of Demuth's watercolors and oils; pellucid, immaculate, and sensual, they were more complex in composition than Georgia's works, and more formal than Marin's. Cubistic or literal, satiric or lyrical, all his pictures seemed imbued with a white light that was not so much cold as refreshing, as refreshing indeed as Demuth himself. Georgia in particular relished his rare visits to New York. The sparkle and elegance that were counterpoints to his somewhat crippled frame, the wit that veiled his artistic discipline, and perhaps also the absence in him of the underlying masculine challenge offered by Alfred and the other painters (save Hartley, whose homosexuality was dark and tortured) provided her much needed relief from the earnestness of Alfred's dilations before a growing set of "pupils" at the gallery.

The plan to use The Intimate Gallery as the annual showcase for "six Americans . . . plus 'X' " was never to be fully realized. In its four seasons, Marin and O'Keeffe were the only regulars; Alfred's works were not exhibited at all. Dove missed the second year, Strand and Hartley the first three. In the first and fourth years, Demuth was "X"; in the second, the European sculptor Gaston Lachaise assumed the role; in the third, there

were three who qualified: two old friends, Oscar Bluemner and Francis Picabia, and newcomer Peggy Bacon, a young American making her debut with pastels and drawings. But Alfred continued to put in his daily stint, bringing out on request the creations of all his artists, unreeling his subtle web of talk, and presiding over an occasional artistic drama, of which there were two in the 1926–27 season.

The first was the sale of a Marin, a month after his November opening, that would set the art world on its ear. In the first days of the show, Duncan Phillips bought two watercolors not on exhibit (one done in 1922, the other in 1924), but he was waiting for McBride's review before committing himself to a more recent picture. When the critic singled out for special praise one titled *Back of Bear Mountain*, Phillips returned on December 3 for a second look. Alfred, naturally, had read the same review. Such accolades, he decided, merited asking a staggering $6,000 for the painting, nearly three times the price he had attached to any other Marin. To Alfred's astonishment—as he told a few trusted friends, swearing them to secrecy—Phillips met his price.

Or did he? When word leaked out, and spread like wildfire, that $6,000 had been offered for a single Marin watercolor, Phillips protested inaccuracy. Alfred defended his statement; their contretemps reached a point where Alfred felt obliged to answer in print. Well hidden in their excited exchanges were the *probable* facts: for a total approaching $7,500, Phillips acquired four 1925 watercolors; one was *Back of Bear Mountain*; another was a "gift" offered by Alfred in Marin's name. Alfred continued to contend, and Phillips to deny, that the one prize painting had gone for the record-setting figure Alfred had asked. When, in April 1927, Alfred put out an explanatory flyer that did little to clarify, it was in a tone of wearied injury. Phillips's denials, he sighed, proved only that the art patron had failed to grasp the spirit of the gallery—which, defined anew, remained as mysterious as it had always been.

Alfred's regenerated missionary zeal was no doubt instrumental in effecting the next triumph. He sold six of Georgia's canvases for an aggregate of $17,000; one had clearly brought the magical $6,000. Her victory, he proclaimed, was evidence of a newly congenial climate for women artists, a climate assisted in no small measure by The Intimate Gallery's foresightedness.

In the 1927 season, he engineered another coup for Georgia. A group of six calla lily paintings, executed five years earlier, attracted the attention of an American collector resident in Paris; he had found nothing to equal

them abroad. Astonishingly, he agreed immediately to Alfred's consciously outrageous price of $25,000, as well as to Alfred's insistence that the paintings hang together in the buyer's home for the remainder of his life; they were not to be treated as a mere investment.

It was not only the extraordinary sum that constituted Alfred's triumph. It was also the fact that for the first time France, which had been the Mecca for so many years for American and European collectors, had proved wanting. Now a native American painter, a woman—who had never been abroad or experienced European influence,—had achieved international recognition for expressing freely only what she herself wanted to say. Alfred couldn't stop talking about it.

Within days, the story was picked up by *The New York Times*, proof of its newsworthiness; the other New York papers followed. Georgia, recovering from a recent bout of illness, was besieged with requests for interviews. She was barely civil, but she agreed; she wanted to correct the ludicrous image of overnight success attributed to her in the tabloids. Nevertheless, with the exception of the art magazines, which again portrayed her as a goddess of feminine creativity, and one sympathetic if puzzled article in the Brooklyn *Eagle*, the press played up exactly what she had hoped to nullify and, worse, spiced its copy with references to her school-mistressy eschewal of makeup and her severely unfashionable clothes. In the center of flapper chic, she was certainly an anachronism.

Horrified by the publicity, and finding little support from Alfred—who airily dismissed the exaggerations, reveled in the uproar that sent new crowds to experience the spirit of the Room, and announced that he would privately reexhibit the lilies as a special farewell after the gallery's scheduled season was over—Georgia fled to Bermuda. Although only marginally sympathetic to her impulsive departure when he had three more exhibits to mount, Alfred wondered briefly about the intensity of her reaction. Then he put it out of his mind.

Georgia had felt compelled to escape from him for a month before, at the end of August 1926. The summer had started in a low key. Alfred, who had been hospitalized for two weeks in June after another long series of kidney attacks (to his infinite relief, the tyrannical stone had passed once again without benefit of surgery), was a quiet convalescent. With Lee's and Lizzie's cook taking over the housekeeping (they were in Europe on the X family circuit), with Rosenfeld in Santa Fé, and the Strands in Taos as guests at Mabel Dodge Luhan's ranch, the only extra resident on the Hill had been Georgia's sister Ida. The erosion of peace began in

early August, when Selma, who had announced her imminent arrival throughout July, cancelled and postponed for the umpteenth time; she would not, in fact, arrive until nearly the end of September. Kept on tenterhooks, Georgia found the working mood she had been enjoying since June dissipated; she began to squabble with Alfred.

Sel's excuse for her endless postponements had been the "real nervous breakdown" she had suffered; mercifully, she had taken her ailing psyche to friends on the New Jersey shore. Alfred, in an attempt perhaps to distract her from her solipsism, and envisioning, as well, the consequences of his own progressively failing health, wrote her that he might remain "useful" if he opened the Farmhouse to a rotating group of "pupils and students." Georgia was currently giving lessons to a young girl from Texas who boarded at a nearby inn. Others might follow suit, with an informal faculty of teaching fellows like Rosenfeld, or other friends, perhaps, to tutor writing and he himself as a guide in photography.

Whatever his intention, Sel took the bit in her teeth and was off. Why didn't he and Georgia run a real summer art school between June 15 and August 15, she wrote, leaving the place free in the spring and fall for the family? It could be managed "with one *decent servant*—And in time a *few Bungalows*" for students. Obviously, she envisioned herself as one of the staff, perhaps poet-in-residence or dance instructor; she had recently taken up dancing by herself, to the strains of her Victrola, as a means of quieting her nerves.

A digression: her "dancing" was unforgettable. Isadora-Duncaning at Red Top to Lizzie's piano accompaniment with Brahms's *Liebeslieder* waltzes, for once uncorseted, and in a toga of her own design, Sel would raise supplicant, limp-wristed arms slowly above her head, stretch her neck in a would-be swan's arch, lift pointed toes in flat, suede dancer's sandals, and drift in slow circles around the living room. Eyes half-closed, she dreamed herself a naiad, but she resembled nothing so much as an up-ended baby whale on a lunge-line.

If Alfred was misled by Georgia's willingness to take on a single self-effacing student, or to share the Shanty occasionally with The Kid or Sel's handsome and fun-loving daughter-in-law Dorothy—who was not only a professional designer of book jackets but also a co-sufferer of Stieglitz self-indulgence—into the belief that she would greet the notion of a full-fledged summer school with enthusiasm, he was quickly disabused. It was bad enough that she was stuck at the lake with his family; it was worse that she couldn't lure him to travel anywhere with her; it would be hell if she were

to lose all her summer freedom. In late August, when Lee and Lizzie arrived with Peggy and me, Georgia packed her things abruptly and took off for Maine. This time Alfred followed her. It was the longest trip he had taken alone since the days of fetching Kitty from camp. Georgia refused to return with him to a house in which he had agreed his nephew Edward could honeymoon with a new bride and thereafter his brother Julius could visit. The improved mood she brought back after four weeks was ruined by a fortnight of "the family Medusa" (The Kid's name for Sel) caterwauling about a boil in her nose to which she had "given birth." Alfred, forced to take Sel to New York for treatment, and leaving her "on her death-bed with it," returned to a frustratingly short period alone with Georgia, barely enough to reestablish companionability.

In many respects, the 1927 summer was even worse. Alfred was in better health than he had enjoyed for several years, but from the start he was resolutely deaf to Georgia's acrimony toward Lee's and Lizzie's twice-daily takeover of the Farmhouse table, compounded by a succession of their boringly genteel or smugly materialistic guests (Peggy's and my visit had been reduced to three weeks in 1927). They had arrived barely two weeks after Georgia and Alfred; within days, "rheumatism" had halted her painting, and inertia had brought his printing to a standstill. Nevertheless, he remained resolutely cheerful, refusing Georgia sympathy even for the long suspension of her ritual escapes for sunbathing, swimming, or rowing: the Hill was swarming with local workmen, cementing the floor of the larger barn to make it safe for automobiles, and scraping and oiling the roads from lake to hilltop. She was not entirely reluctant, in spite of her fears and Alfred's sudden panic, when Lee checked her into Mount Sinai Hospital in mid-August for the surgical removal of a breast lump, fortunately benign. Her ten days in hospital were a respite that proved creatively fruitful; three weeks after her first experience of general anaesthesia, she painted its emotional analogue, *Black Abstraction*, one of her most compelling oils.

There were three consolations awaiting Georgia on her return to the lake that Alfred did not celebrate with her. The first was her secret interment with Davidson and The Kid of the loathsome bust of Judith. The second was the news that Lee and his family would have their own dining and kitchen facilities next year, in a tiny separate house (known later as the Bread Box) on Red Top's knoll. The third was finding that The Kid was a strong ally in her struggle against Alfred's overwatchfulness—in which Lee's prohibition of overexertion was a heavy weapon. As soon as

Lee was gone, the two Georgias plunged into a regimen of strenuous boating, swimming, and hiking; horseback riding was left to The Kid alone, in answer to Alfred's pleas. Georgia was positively delighted with his discomfiture when The Kid, back in the city, exploded over Lee's having berated her for losing weight from "too much exercise . . . He makes me sick," she wrote, "wants one to spend one's life in a rocking chair—Woman's place is in the home, etc. Really, I could have slain him!" Exactly what she had been telling Alfred.

Alfred continued to report to his friends that Georgia was great and working well, that he was tinkering, and that everything was peaceful. Sel was quiet for a change during her visit: the death of her husband, Lou, during the year—he was now gratifyingly resettled in his urn on the mantelpiece—had robbed her of her major excuse for complaint. Georgia was doing her best to mask her aversion to alternately mute and fustian Zoler, a guest for the same fortnight—whose sole redeeming features in her eyes (and, incidentally, in mine) were personal cleanliness, dexterity at wrapping packages, and a stupidity so bumptious that one could laugh at his misadventures without feeling either sympathy or guilt. She had enjoyed far more the company of Rosenfeld for a mid-October week, matching her recollections of the Santa Fe she and her sister had fallen in love with ten years ago against his more recent, but equally loving, experience.

Peaceful the summer's end may have been. There was one thing about it, however, that was entirely new: Alfred and Georgia had scheduled virtually no time alone before returning to the city. In five months, they had had only seventeen days of solitude, of which eleven had come before June 18. It was not an auspicious omen.

19

There were other troubles brewing over which neither Alfred nor Georgia would have any control. It appeared that, in a year of unprecedented prosperity, there was almost no market for art. In the first two weeks of Marin's opening show of the 1927–28 season, 1,200 visitors crowded the Room, but nobody bought. Although a few paintings were optioned, cash, Alfred found, was as hard to extract as teeth.

Prosperity, in fact, had already begun to breed a few Cassandras (including, of all people, Herbert Hoover) issuing lonely warnings of disaster should the government fail to institute controls over the fever of speculation that impelled even little people to pour their modest savings into new ventures. The passion for newness in everything, spawned by the end of the war eight years earlier, was reaching a peak. A new business founded on new credit offered more new profit than the stodgy old reliables; banks were opening their coffers to every forward-looking entrepreneur. Within the coming year, even tiny Lake George Village would boast new fleets of rentable speedboats, new bars, a new arcade with slot- and pinball-machines, a new miniature golf course, a new movie house, and new colonies of roadside cabins for growing hordes of motorist vacationers; a new appetite for the thrill of flying, engendered by Lindbergh's spectacular crossing of the Atlantic, would lead several go-getters to invest in two-seater planes for daring sightseers. In the intervening frantic year of expansion, it was those who balked at embracing the exciting future with increased borrowing who were forced into bankruptcy. The cash that Alfred found so difficult to collect from even his wealthy patrons was being funneled, more and more, into stock-market speculation. Despite Alfred's spectacular sale of Georgia's *Calla Lily* series, there was little he could boast of for his other artists.

During Georgia's show, there had been several visits from William Ivins, curator of the Metropolitan's print collection, the last in the com-

pany of the museum's director, Robert de Forest. For a number of years, Ivins had been asking Alfred to contribute a representative few of his prints to start a photography section; Alfred had refused on the grounds that the museum ought to purchase them, as it did works in every other medium. In May 1928, however, wanting to bolster photography's standing after three years of neglect—he had not exhibited either his own or Strand's prints since 1925's "Seven Americans" show, although everything Paul had shown him had won his warmest praise—he hit upon a way to accede to the museum's request without compromising his principles.

Periodically during and after the 291 years, a small group of backers had given him funds to help both the artists in his circle and others he thought promising. Each time, in appreciation, he had given the benefactors one or two of his photographs of an equivalent value, but always with the feeling that his thanks were inadequate. In May 1928, when David Schulte, the tobacconist magnate who was also a friend and patient of Lee's, responded to a new plea with an unusually large contribution, Alfred realized that there was a way finally to show the true depth of his gratitude not only to Schulte but to his other donors as well. With their permission, he could make a gift to the Metropolitan of a small collection of his finest images in their names, bringing them public recognition commensurate with their generosity and, at the same time, according honor to photography. His angels were delighted. When, at the end of the year, the prints were formally presented to the museum, Ivins expressed his warmest appreciation, adding, in a somewhat wry reference to earlier contentious negotiations, "It makes me feel as though a great victory has been won without the discharge of a single gun, [meaning] so much more than any amount of carnage possibly could."

Pleased though he was with his Solomonic solution, Alfred was dismayed to find that Georgia's weeks in Bermuda had not restored her good humor: she was still edgy, still suffering the aftermath of finding herself a newspaper caricature. Her mood did not improve when a half-comic mishap rendered Alfred helpless just before their departure for Lake George. Removing his underdrawers, he managed somehow to tear a ligament in the middle finger of his right hand; it would be splinted for ten weeks. Her irritation at the realization that Alfred would be useless not only in packing and traveling but also at the Farmhouse left Georgia unable to cobble up any sympathy even for the most disquieting news of the year. The gallery would probably have only one more season; the Anderson was due for demolition in June of 1929. Georgia, who had almost come to the

conclusion that life would be a great deal more tranquil if she never had to have another show, couldn't have cared less.

What should have been a truly peaceful time for Georgia and Alfred at the beginning of the 1928 summer became instead a period of increasing tension. They were alone except for congenial local Margaret Prosser as daytime housekeeper for a second year (as a teen-ager she had served at Oaklawn, and she would return to the Farmhouse every summer of Alfred's remaining eighteen years) yet somehow the strain between them seemed more palpable with Lee and Lizzie absent from the dining table than it had been with them present. Perhaps, as with Elizabeth and Donald, the very lack of a common irritant intensified the problems they were having with each other. Already disabled, Alfred complained of new ailments in justification of his refusal to allow Georgia to go to Wisconsin to see her frail and elderly maternal aunts, favorites she had not visited in twelve years; Georgia complained that his opposition ruined her wish to paint. Instead of finding distraction in the visits of Georgia Two and then the Davidsons, they found that their dissension grew. In a temporary reshuffling of alliances, teetotallers Alfred and Elizabeth joined forces against the nightly withdrawals of the two Georgias and Donald to the Shanty—where, joined sometimes by nearby summer resident Dorothy Schubart, The Kid and Donald tippled surreptitiously and Georgia wished she dared, and all four vented their frustrations in giggles over the humorless Stieglitzes.

Persuaded finally by Elizabeth that Georgia, like Donald, needed a leave of absence, Alfred granted her permission to leave for Wisconsin in mid-July. The two ensuing weeks, alone, before her departure, were the happiest they had had since the autumn before their marriage in 1924. Georgia returned to her easel and Alfred, with his finger still immobilized in a rude gesture, painted tables and chairs and retackled the sorting of neglected files.

Georgia's month away left Alfred alone at the Farmhouse for the first time in ten years. To his surprise, he found himself contented. Freed of her antagonism to the family, he renewed daily horse-talk with Lee, accompanied him to the opening of the Saratoga track, and joined his morning walks to the village with Peggy and me. His delight in the chocolate ice-cream cone that was his and my reward at the end of the final rise (Peggy was a strawberry fan) equalled my own. Astonishingly, he was persuaded several times to dine at the "Upper House" and listen afterwards to Lizzie's emotional renditions of Beethoven and Brahms. His days fell into a

pattern of reading and—still awkwardly—mounting prints and writing letters. In the week of the Davidsons' return to pick up their daughters, he enjoyed the easy conviviality of earlier years with Donald, quartered now and henceforth at the Farmhouse.

For nearly two weeks after Georgia's return, she and Alfred reveled in being together again, each surprised to learn how much the other had been missed. There was some poignancy in Georgia's reaction to her homecoming, however. Alfred was looking oddly more fragile than she had remembered him, and Lake George's familiar vistas seemed unbearably puny, pretty, and tame compared to Wisconsin's prairies and the broad plains of Texas for which she was incurably nostalgic. She found herself painting canvases that were smaller than anything she had done in years.

And then it happened. On the evening of the very day Alfred was celebrating the return to full use of his hand, his heart set off on what he likened to the uneven pace, tension, and speed of a steeplechase. Clutched in pain and terror, he called for Lee. He had suffered his first attack of angina. (Possibly this was a full-fledged heart attack. Lee continued to employ the term "angina" widely even after the electrocardiograph six years later narrowed its meaning to paroxysms of the heart muscle that were not necessarily evidence of cardiac failure. Possibly, by continuing to use the less dire term, he intended also to diminish Alfred's anxiety; obviously the "heart attacks" Alfred described as conquered in twelve hours were angina episodes as defined today.)

He was confined to bed for three weeks of round-the-clock care, first under Lee's daily supervision and then, when Lee could no longer delay return to his New York practice, under that of a trustworthy local doctor. Swearing to Lee that she would carry out his instructions to the letter, Georgia persuaded him after the first few days that she and her sister Ida, for whom she had sent immediately, could responsibly replace the two local nurses he had commandeered. Even with Ida's cool competence, however, Georgia found that the depth of her concern for Alfred was no match for the frustrations of confining all her activities to this frail little body, this white-haloed sunken face—so defenseless without glasses—this *old* man whom she loved but to whom she felt suddenly alien. Quickly sensing her ambivalence, Alfred felt alternately guilty that she was hobbled by his illness and resentful of the obvious struggle it was for her to remain patient and attentive.

The physical effects of his first attack were more ephemeral than the psychological: in six weeks, he resumed matting prints at Lake George;

in eight, he was ready to reopen The Intimate Gallery. Meanwhile, however, he had made a resolution which, only dubiously useful to his health, would have unfortunate consequences in both his relationship with Georgia and his career. His resolve to quit spending his efforts on every "Tom, Dick & Jane"—to concentrate only on those who were closest to him— would make Georgia feel increasingly confined and would seal him off from vital contact with most of what was new and experimental in the art world. A vigorous champion always of his small band of artists, he would continue to experience elation at their successes and despair at their defeats, but Alfred the avant-garde leader would become inevitably Alfred the also-ran. That he was still far ahead of his time in his appreciation especially of Dove, whose works would not be recognized as seminal until a generation after his death, would be ultimately beside the point; he would be perceived as reliving the past. Meanwhile, he stuck to his guns.

The 1928–29 season, the last at Room 303, opened with a Marin show for which the stage had already been set in two illustrated articles in the October issue of *Creative Art*. A laudatory essay by critic Louis Kalonyme was accompanied by an imagistic autobiographical piece by Marin. Self-mocking in tone but utterly serious in message, Marin had written that the artist must start by being a loving observer of the familiar —circles, triangles, lines, light, color, and from time to time "the elemental . . . Sky, Sea, Mountain, Plain." Tension between "things that clash . . . a jolly good fight [and] big quiet forms" must be held in "a Blessed Equilibrium" of weight, rhythm, and focus. Differentiating the modern painter from his predecessors, he continued, are the pace of his life— "electric, staccato"—and the materials of his times: "Glass, metals . . . lights brilliant, noises startling and hard . . . people movements, much hard matter." Scornful of "the discussionists" (Marin never, within my memory, joined in the theoretical arguments in which so many of Alfred's circle indulged, especially in the thirties and forties), he warned: "In the seethe of this [act of painting], in the interest of this, in the doing of this, terms, abstract, concrete, third and fourth dimension—bah. Don't bother us."

As in the preceding year, there was a paucity of buyers, but Marin's show was at least a *succès d'estime*. Hartley's, which followed, was both a critical and a financial fizzle. Alfred had not shown Hartley for four years, had not given him a one-man exhibition since 1917. A bitter falling-out in 1923 over Hartley's omission in an autobiographical article of any credit to Alfred or 291, as well as the painter's continuous whine for money— and his ingratitude when it was gained—had led Alfred almost to exclude

him from The Intimate Gallery's opening, and to vow often thereafter to drop him for good. Yet he was moved by Hartley's helplessness, by his repeated prickly alienation of friends, and by the self-doubts at the heart of his arrogance. His support was intermittent, but it lasted until Hartley's death. In 1929 he urged Hartley (as did the critics) to give up his debilitating expatriate wanderings, forget his memories of a painful childhood, and go gack to his native New England granite. Hartley heeded the advice reluctantly in the following year, but it would take him seven years, interrupted by long sojourns in Mexico, Bavaria, and Bermuda, to feel even minimally at home in New England.

Georgia's disappointment in her show—for the first time she had had to supplement the year's small crop of paintings with works from earlier years, the critics had been gentle but hardly thrilled, and only two or three of the over six thousand visitors had bought a canvas—had induced a lethargy from which she was stirred only by Strand's first exhibition in four years. Together with photographs that bore an affinity to her own paintings —close-ups of flowers, branches, roots, stones, and cobwebs—there was a series of prints from Colorado and New Mexico.

Georgia's yearning for the Southwest was growing stronger, piqued by Rosenfeld's descriptions of his stay in Santa Fé in 1926 and, most recently, by her and Alfred's new friend, Lady Dorothy Brett, the painter who had accompanied Frieda and D. H. Lawrence to Taos in 1919 and remained there since. Brett had brought paintings to New York, where she had spent the winter; now there were Strand's photographs. What had staying at Mabel Dodge Luhan's ranch in 1926 really been like? Georgia wanted to know from Paul and Beck. Alfred had just turned down an invitation to spend the summer there with her, pleading that he could not be so far away from Lee (who had warned him, in any event, that the high altitude could be fatal), but Georgia was still interested. The family council, convening on its own to seek a cure for her restlessness, proposed a trip to Europe, the conventional remedy for more than sixty-five years for Stieglitz wanderlust. She was not interested. Nor was Maine the answer. It was the Southwest or nothing.

By early April, Alfred had convinced himself that it was his idea that Georgia go to Taos without him, and that it was his idea that Beck go with her, freeing Strand to make his photographic way around the Gaspé Peninsula unimpeded by concern for Beck's comfort. Furthermore, Georgia and Beck got along well, and Beck had loved Taos in spite of Mabel's over-

energetic hostessing. Finally, Beck was his special friend, and would keep him fully informed about Georgia. They could leave as soon as Dove's show was hung, Alfred promised—and promptly took to his bed with a cough. Stifling an impulse to play invalid, and fearing that the new "contra-stream" Doves would not attract buyers without his boosting, Alfred was on deck again within a few days. Nevertheless, Georgia waited a full two weeks before going, determined to see him past any possible relapse.

Three weeks after arriving in Taos, Beck reported that Georgia was "a different person." She *always is* when she's healthy and free of responsibilities, was Alfred's somewhat testy reply. Crediting himself with knowing for years that the Southwest was *the* place for her—it had just taken a while for a plan to "crystallize"—he pronounced himself "of course . . . very glad." Had he known that Georgia would spend all but three of his remaining seventeen summers in the Taos vicinity, without him, he would surely not have expressed gladness at all.

Even ignorant of the future, he was not quite as glad as he wished to sound. With The Intimate Gallery coming to a close, the hundreds of Marins, Hartleys, Doves, Demuths, O'Keeffes, and Stieglitzes for which Kennerley had provided space at the Anderson had now to be packed and sent to the Lincoln Warehouse. Despite the help of Zoler, Marin, Selig-mann, Strand, a number of other volunteers, and, for once, a professional packer, Alfred felt that Georgia had deserted him. Looking over his 1918 portraits of her, the last to be packed, he remarked disconsolately to Seligmann, "I never want to see that work of mine again. It makes me sick that I have not carried on my Photography. I have not had the chance to do what I might have done." It was not an unfamiliar complaint, but this time its bitterness clearly implied that Georgia's four months of freedom had been won at the expense of his own.

It would be years before Alfred could accept the *fact* of Georgia's need to be completely away, for long periods, in order not only to grow but to survive. Even after he had accepted the fact intellectually, offering broad evidence of his understanding, his emotional acceptance lagged. Eventually, the reasons he offered to defend her absences were many: the high altitude and thin atmosphere of New Mexico that would have spelled suicide to him were essential to her health, physical and mental; her creative energies needed the crucible of solitude; her artist's eye craved expanded vistas and distant horizons unavailable at Lake George—which in any case was not the best milieu for her. In 1929, however, he spoke

only of her wish to visit the Southwest again. And strove to keep from everyone, himself included, the dreadful message his imagination conjured: she meant to leave him.

Throughout her absence, his emotional fever shot up and down. Two early weeks at Lake George with Zoler passed without a word from Georgia, two weeks in which he tried not to think of her lost somewhere in the parched desert, freezing under the stars or—equally frightening—dancing away the night in the strong young arms of another guest at Mabel's luxurious ranch, riding under the great bowled sky she loved at the side of a handsome, silent Indian like Tony Luhan.

Desperate for something mechanical to do, Alfred began burning an accumulation of papers—books and pamphlets, magazines (including many issues of *Camera Work*), negatives, and prints. "A wonder I didn't burn up cameras & even house," he would write Dove at the end of the summer. Meanwhile, trying to reconcile the patent immensity of her happiness away from him with new letters in which she claimed concern for his health, Alfred realized abruptly that he had allowed his physical handicaps to gain the upper hand. Waking one July morning from a pill-induced eleven-hour sleep, he found himself "reborn." He resumed his village walk; he ate a heartier breakfast; he got his defective new Victrola working so that he could hear Bach and Beethoven; he resolved that when the Davidsons arrived with the children, he would get Elizabeth to teach him to drive. The news from Georgia that she had bought a Model A Ford and was learning to run it herself—news that had made him feel at once desolate and abandoned—was suddenly a challenge. What he needed was to recapture the sense of freedom and vigor that eleven years ago had made him feel young enough for Georgia. He expressed himself ready to reach for a higher plane with her, confident again of her love.

His confidence was short-lived. By the time the Davidsons came, and Strand soon thereafter, it was clear that he was forcing himself to stay up past his usual bedtime to share "fun and laughter" with Donald and Paul; to Elizabeth he confessed that it was only with the strictest self-discipline that he was able to conquer his hurt over Georgia's inattention. But he worked at it, and felt happily rewarded when Georgia wired that she would come home immediately if he wanted. How wonderful of her, and how wonderful to be able gratefully and generously to wire that she should stay.

Barely a week later, with the Davidsons gone and Strand miserably reviewing the flaws in his own marriage, Alfred hit bottom again. And again bounced back, after Strand was gone, when Georgia's next letters

suggested a new interpretation of her feelings. What he inferred now was that she had feared his love for her diminished by his concentration on The Room, not realizing, as he had believed she must, that to him the gallery was simply an extension of her, loved as she was loved. Now that he held the key, he was confident that he could do his job again, his only job—to make her happy.

Within two weeks, his new confidence had evaporated. This time, however, he was more fortunate in the character of his houseguest, Louis Kalonyme, who arrived in August during the Davidsons' second stay before taking the children home. Thanks to Kalonyme, Alfred took his village walks daily and learned to play miniature golf; he rowed; and he exercised his mental muscles, in vigorous and friendly arguments—witnessed sometimes by Peggy and me then, and repeatedly over the years—that ranged from baseball to music, prizefighting to politics, philosophy to the relative succulence of green and blue plums. Always they argued about art. Kalonyme was only beginning to be converted to the proposition that photography could be regarded as aesthetically worthy. On one subject only did they agree consistently: collectors and supporters who "nibble 'appreciatively' at the arts." Two years earlier, Kalonyme had delivered himself of a lower-case diatribe. "i haven't met one who wasnt [sic] fundamentally lousy, spiritually," he had fumed, "for all their gestures. not that i believe there ought to be a special dispensation for 'artists.' . . . the art-tasters pretend that art is more important to them than fornication," but they don't help. "when you tell them—as they were told about Duse when it was all over—they say our hearts are breaking why didn't you tell us before it was too late . . . no one really gives up anything. all our mercy . . . is either conscious, designed, or easy. its like giving someone a pair of shoes when you don't want them."

Thanks to Kalonyme as well, Elizabeth and Donald spent at least part of every evening with Alfred, enfolding him in conversation and music (his familiar classics and Kalonyme's jazz) played at full volume on the reactivated Victrola. When the Davidsons had gone, Kalonyme cajoled Alfred into taking him for a ride in the car, off the Hill and to a town well beyond the village, at a speed approaching thirty-five miles an hour. And there was one more item in his program to build Alfred's self-reliance.

Since the summer of 1922, one pest had come under increasing Stieglitz censure. By 1929 it ruined several hours each day as one after another small seaplane ferried sightseers for a half-hour tour of the lake's splendors, descending on its return leg directly over the Hill. Although the noise

was far less irritating than the endless buzz of an armada of outboards, it intruded more intimately on the Hill's privacy. Lee petitioned to have the route changed. And Kalonyme persuaded Alfred to have a ride.

The challenge helped. When Alfred hit the depths again after Kalonyme's departure—he had had no word from Georgia for six days, and had not been reassured by a telegram on the seventh announcing her intention to write the following day when she was back in Taos from a trip—he despatched the twelve letters he had put aside with a wire announcing his intention to fly to New York the following day. Let Georgia have a taste of worrying, he seemed to imply. Or guilt, should he not survive. In that event, he instructed Lizzie, she should forward all his mail to Elizabeth; the summer had shown that Georgia should not have the responsibility.

The answer to his telegram, waiting for him in New York, turned him completely around again. Georgia was coming home, everything was wonderful, his love transcended life itself—and he was passionate about flying, as he wrote immediately to friends he had not felt like writing all summer. To Dove he insisted, ignorant of cost, that if he were younger he'd buy a plane of his own. His rapturous account to Marin touched off a typical Marin response: "Where's Stieglitz? He isn't here? No, he went up a few hours ago. When will he be back? Hell, we don't know . . . How'll I get to see him? Well, you might go up. You see he transacts most of his business up there now. That's his latest test, for those who really want to see him and those who [only] think they do . . ." Marin's whimsy had a cutting edge. Publicly he defended Alfred's hard-to-get games with buyers; privately he gave voice occasionally to resentment.

Not so Dove, who had a harder time by far than Marin in making ends meet, forced as he was to contend not only with Alfred's quixotic selling techniques but also with his inefficiency as a collection agent (despite his ranting about the insensitive negligence of Duncan Phillips, it often took Alfred a year to elicit cash for sales already made) and with the more complex problem of a generally puzzled and often hostile audience for his works. In thirty-three years of correspondence, a bare handful of Dove's letters pressed Alfred, and then only with apology, calling himself a "damn fool for taking such close chances" as to be within sight of no food. His gratitude to Alfred was boundless, for both monetary and artistic support. In 1930, when he was extremely hard up, he would write in an autobiographical statement for a book on contemporary artists, "Had it not been for the patient efforts of this one man [Stieglitz], modern painting might

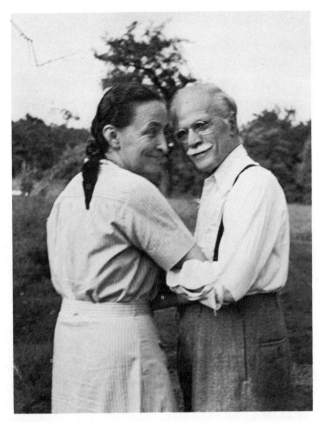

*Georgia O'Keeffe
and Alfred Stieg-
litz, Lake George*
Josephine B. Marks

still be in the dark ages,"—and promptly paid him for the photographs that would be used as illustrations. Somehow he managed both to accept his many misfortunes and crises with good grace and to describe them usually in near-comedic terms, in marked contrast to the stoical lamentations that were Alfred's habitual music.

Astonishingly, for both Georgia and Alfred, the end of the outrageously muddled 1929 summer was rapturous. She, whose enjoyment of Taos and its surroundings had come partly from her freedom to do whatever she wanted whenever she chose and partly from the never-ending feast for her eyes—old Spanish churches, huge crosses, and commanding pueblos; wrinkled mountains and mesas slashed with chasms; greys and reds and browns and oranges and blacks; white; and blue, blue, blue—had felt as sorry for Alfred as she had felt irritated with him. Sorry that he couldn't leave his overcultivated, overtreed, overbuilt and overpeopled, talked-out world to stand, with her, beside dignified and earth-congenial Indians. And irritated beyond belief by the image Alfred projected, wit-

tingly or not, of the lonely little old man enduring his abandonment with forbearance and generosity. She was furious at his possessiveness, worried about his health and state of mind, and she missed him. When he sounded blue, it was she who asked Beck and Lady Brett (who lived at the Lawrences' Kiowa Ranch while they were abroad) and Marin, spending his first summer on the Luhan compound, to spice their letters to Alfred with comedy.

Not knowing what to expect when Alfred met her at the station in Albany on the morning of August 25—he had spent the night at a hotel to make sure he was on time—Georgia was astonished to find him more robust than he had been in years, bubbly with good humor, patient, curiously mellowed, and positively cocky about having ventured, as she had not, to take to the skies. He had, indeed, somehow consolidated all the better pieces of advice he had tried to give himself all summer, and was now genuinely free to enjoy her at her best—relaxed, bursting with energy, lighthearted, and more beautiful than ever. For most of September they remained without guests at the Farmhouse, working and enjoying the continuing luxury of Margaret's capable housekeeping. To her surprise, Georgia discovered that the Lake George themes that had seemed so pallid and overprecious to her the year before once again possessed charm, and Alfred was so pleased with her contentment that he soft-pedalled his perennial complaints about inferior Eastman products. When the young man Georgia had commandeered to drive her Model A back from New Mexico appeared on the scene, all three went delightedly to surprise the Schauffler family and Rosenfeld, their guest, at York Beach, Maine—with Alfred consenting at last to admire the sea. On their return, Georgia got her New York State license (she had not needed a license in New Mexico) and insisted Alfred drive to the barber and back. Her praise was worth all the agonies of learning.

In fact, Alfred was ill-suited to driving: timorous and foolhardy by turns, impatient, easily rattled, and, oddly, uncoordinated. Hand and eye were matchlessly in tune with camera or billiard cue, but when the foot was brought along as a third element, everything went agley. Elizabeth was his first patient instructor in July—Donald refused to drive anything but his tractor and Strand quickly disqualified himself as too exacting—and when they were gone, he enlisted Lee's chauffeur. Kalonyme had been the first daring soul to accompany him off the Hill. No one in the family would have had the courage. The knowledge that he was on the roads, wheeled and powered, was enough to propel everybody into the safety of houses—

up steps if possible—especially after his first collision with the section of the barn where cars were kept. On that occasion, eye and foot were teamed but hand chose the wrong gear. Instead of backing out as planned, the car leaped through the barn wall and stalled only inches from the preferred footpath, mercifully at a moment when no one was using it. (For a long time thereafter, caution dictated a wide detour of the barns.)

Despite the setback to his confidence, Alfred persisted. At last, triumphant, he was allowed to solo: up the hill, around the Red Top drive, down again and around the Farmhouse oval, a route that he managed repeatedly, in 1929, without mishap. It was, indeed, no mean feat for any beginner, considering the fact that there was a booby trap along the way. At the Farmhouse corner, within inches of the convergence of the Hill's major drive and the loop to the barn, there stood a foot-high water spigot that indifferent grass-cutting left concealed much of the time. Drivers familiar with the course were adept at avoiding it, but at least once a summer some innocent stranger or tradesman knocked it silly, requiring the immediate attention of Blessing, the plumber. Every year, Blessing pleaded with Alfred to let him move the pipe a foot or two farther back from the driveway. Every year Alfred refused. Any change in his immediate landscape was excruciating. The velvet-weathered barn siding could be on the verge of rotting before new stain was allowed; there was a two-year battle over the placement of telephone poles that Alfred insisted would ruin his vista; and even when a giant limb crashed within inches of Lee's guest-filled dining house, Alfred refused to permit the felling of the three dead chestnut trees he considered a special legacy from Edward. The driveway pipe would not be moved.

Alfred's Waterloo came in the 1930 summer when, with Georgia away again, he resumed his lessons. This time overconfidence did him in. With an audience of no-longer-terrified family members (including me) standing on his porch to cheer him over the finish line, he struck the obtruding pipe head on at the exact angle needed to slice off its top; there was an immediate geyser. His response was appropriate, typical, and *fortissimo*. Alfred never drove again, and the pipe was moved.

Even during his summer of roller-coastering emotions, Alfred had had to give serious consideration to a decision he had promised to render in September. Weeks before the Anderson building was vacated, Strand and a few other friends had asked him whether, if they raised a fund sufficient to underwrite three years of operation, he would open another gallery. The subject had come up repeatedly for discussion, often in tandem with the

impending opening of the new Museum of Modern Art in New York in early November. Of the MOMA, Alfred could find little good to say. He had objected to Georgia's promise, from Taos, to lend five paintings to its second exhibition (works by nineteen contemporary American artists), citing two major reasons for his disapproval: the self-love of most of its directors, and the Hobson's choice between successful institutionalism, which, he stated, was "contrary to the spirit of art," and a well-intentioned group like the Société Anonyme, which had recently died. Even though he liked Katherine Dreier and Marcel Duchamp, he had declined their invitation to join the Société's board in 1920. And even though he approved of Lillie Bliss for having shared the funding of Hartley's first European trip and Duncan Phillips for his recent interest in Dove and Marin, he could not approve their millionaire cronies on the Modern board. Chaired by Mrs. John D. Rockefeller, Jr., they were by definition far less interested in helping living artists than they were in fixing up what Dove called "the new 'Luxembourg' in the Heckscher building" and parading their munificence in behalf of culture.

It was the living artist that concerned Alfred and, after talking it over thoroughly with Georgia, in mid-September he gave his conditional consent to a new gallery. Before the first week in October, Strand had pulled together over $16,000 in pledges and, with Dorothy Norman, an exceptionally devoted young regular of The Intimate Gallery for several seasons, had begun the hunt for new premises. Rejecting all they saw on Fifty-seventh Street's Gallery Row, Paul and Dorothy agreed at last on a corner suite of rooms on the seventeenth floor of a new office building on Madison Avenue at Fifty-third Street.

Arriving at Lake George with the floor plans, the Strands were stunned to hear Alfred express unwillingness to accept full reponsibility for the new gallery. It was time for others younger than he to do their share, he argued. Affronted by his apparent lack of gratitude for their generosity in time, money, and effort over nearly a decade—and especially in recent weeks—Paul exploded. Tempers raged, accusations flew, misunderstandings deepened, and the entire plan was nearly aborted. Departing in a huff, the Strands found a letter from Alfred waiting for them in New York in which he apologized for having treated them in a roughshod manner. He had not meant to imply lack of appreciation for their contributions in the past, he wrote. What he had meant was that he didn't want the future to be a repeat performance; he didn't want the new enterprise to be "Stieglitz's Room."

He would certainly give it everything he could, but he wanted "the young ones" to do more than they had before.

Persuaded probably by Beck to accept Alfred's somewhat ambiguous explanation, Paul let the matter drop, but he was not entirely mollified. The plan for the gallery would go forward, but Strand's participation and his interest would diminish rapidly. Even more rapidly, Alfred's definition of "the young ones' " role would exclude any share in artistic management.

One hurdle remained. Through the year, the stock market had been subject to wild fluctuations. Now, in mid-October, it began to decline so swiftly that Alfred offered to release his backers from their pledges. The plunge on October 24 known as Black Thursday was followed on the twenty-eighth and twenty-ninth by even more terrible declines. The reports of suicides in lonely offices and from the high windows of finance grew daily more shocking. But Alfred's supporters held firm.

If Alfred could or would not turn over to others basic daily responsibility for the new gallery, he at least won the promise of regular assistance from young Dorothy Norman, who, with a wealthy husband and few domestic demands, had considerable time on her hands. Further, he arranged with fund contributors that they, or their representatives, would sign the lease *and* arrange for its extension if, after three years, they agreed to continue their support. Two conditions they had to accept from him: he would not become a picture salesman just to pay the landlord, and he would be free of interference in all matters concerning the gallery's operation.

Alfred's excitement about the new gallery was heightened by the realization that, for the first time, he would be ensconced in quarters that were brand new. When he and Georgia emerged from the elevator on the seventeenth floor of 509 Madison Avenue for the first time, they were struck immediately by the cool cleanness of unadorned plaster walls, scored cement floors, and heavy frosted-glass doors in dark metal frames. Opening the door marked 1710, they stepped almost at once into what would become the gallery's major exhibition space, a room approximately eighteen by thirty feet, with near-ten-foot ceilings and a trio of large windows rising over radiators at its far (west) end; plastered steel beams overhead sharpened its clean-edged lines. On both sides of the room's far end, floor-to-ceiling openings of substantial width and depth led to small but equally bright rooms. The one to the left would become Alfred's office/study. The one to the right, with a window to the north as well as the

west, would be another exhibition area; a narrower opening in its east wall led to a third room of somewhat larger size that began as exhibition space but, after three years, was converted into a work and storage area dominated by a large counter, shelves, and perpendicular racks for paintings. A narrow area to the left of the entry, containing more storage space, and Alfred's first honest-to-goodness darkroom, completed the suite.

An American Place, as Alfred named it, would be described by Dorothy Norman as having, simultaneously, the quality of light of a cathedral and the walls of a laboratory, hospital, model workroom. Alfred would describe it more simply as having an austere and clean feeling, at its best when empty and freshly painted—floors, ceilings, and walls—as it was every autumn. O'Keeffe devised the color scheme: a high-gloss strong grey on the scored cement floor; walls and ceilings uniformly white. Later, mixing the paint herself, she introduced a subtle greyish pearl to the walls of the larger room. White shades rolling upward from the window ledges could be adjusted to soften the afternoon sun; when they were left open at the top to a sliver of sky, brilliance washed across the ceiling. Hugging the ceiling beams, banks of blue-bulbed floodlights with mirror-intense reflectors reinforced or supplanted daylight as needed.

Cathedral or laboratory, The Place, as it quickly became known, offered a spacious, architecturally strong, but anonymous setting for art that was as close to ideal as any I have seen. It was not a place in which a work could hide; the test for an artist was sometimes cruel. To the viewer it offered a communion that was naked, untheatrical, complete. Furthermore, the equilibrium between a work and its surrounding frame of emptiness—and, again, between it and its variably sized neighbors—as well as the interacting reverberations of color and line and mass, made of each wall a new and gratifying composition. The wonder is that it was achieved time and time again, albeit the hanging was almost always the collective work of at least two discrete visualizations, the featured artist's and O'Keeffe's, joined sometimes by Alfred's, the Strands', and others'.

My own appreciation was delayed by the terror I experienced at every show of at least the first three seasons. Until I was ten, the overhead lights, always glaring in my memory, unmitigated by the sun's glow, were the harsh lights of interrogation. I was the specimen, trapped and examined.

Surely this was not the effect Alfred intended. I assume, in fact, that he was attempting to be gracious, to demonstrate to me, and to whoever else was present, that children should not be treated condescendingly. Or something. In any event, the scenario was always the same. Receiving a warm

kiss from Alfred when I entered with a parent (not always accompanied by Peggy), I was detached from safe harbor to make a first round of the pictures with him. Then I was launched on my own, instructed to choose the one I liked best. If the exhibition was of Doves or Marins, the choice was excruciatingly difficult, for both artists were special friends. Dove, visiting us on the farm, spent patient hours whittling wooden shoes for Peggy and me, accorded us dignity even while sharing with Dad uproarious stories we did not understand, and produced the best popovers in the land. Furthermore, no matter how hard up he and Reds were, they always had a Christmas gift for us—sometimes only a few tiny feathers pasted to a card, but always a message of love. Marin too was cherished, although I knew him less well in childhood than in the late forties and early fifties. Perched birdlike with Dad (whose frame was similar) on a porch rail or balanced on the edge of a chair, all he had to do to dissolve me in laughter was to wink a mischievous eye and say something—anything—in a simulated down-East drawl. To exclude any Dove or Marin from the pinnacle of "favorite" seemed unfair, but Alfred would not accept "I love them all."

After the allotted time, Alfred would place a hand on my shoulder and walk me slowly around the gallery again, asking for my comments. Not intrinsically cruel, you say, except that during my solitary round I would have heard him dilating on children with a bunch of total strangers. "Now that child," he might say, "will have a *true* reaction to what she sees—no preconceptions, no theories. She doesn't *know* anything." Or: "See that child? She knows more about what you call Art than you'll know when you're a hundred." Or: "Do you want to experience purity? *There* is purity! That child!" Or: "Now *there*'s concentration! That child hardly knows we're here!" "That child," meanwhile, hearing everything, was simply wondering how to get through the coming ordeal.

"Which do you like best?" would catapult me, empty-headed, into a choice. "Why?" would touch off the wildest invention: "Because it looks like runny ice cream" of a Dove abstraction, or "Because I like the way the tree is dancing" of a Marin landscape. Perhaps my responses were, subconsciously, genuine; perhaps they were echoes of things I had heard said that seemed to please Alfred. But to be the focus of the hushed attention of a group of unknown adults wearing silly grins and nodding like marionettes, all waiting for "that child" to enunciate innocent wisdom, was, for me, agony. It would take years for me to gather courage enough to say anything spontaneous at The Place, to get over feeling like a pinned bug.

But I too would learn to love coming. For refreshment. To sweep

cobwebs from my mind in this immaculate space. To wander from picture to picture, looking for motifs and structure or simply letting my sense and imagination drift. Mostly, in Alfred's words, to let the pictures happen to me. When I found Alfred alone in his office, reading in his moldering armchair, resting on the narrow cot under the bookshelves, or bent over correspondence at his table-desk, I sometimes stayed for an hour of usually dilatory conversation; there was no pressure. Sometimes, to his irritation, for he rejected the tyranny of appointment books, I remained for only a few minutes. Sometimes I came alone, sometimes I brought a friend from school, from college, from work. If he were engrossed in conversation with one or another disciple or a group, I usually made my round of the gallery and withdrew with a wave. I had had my fill of philosophic circumlocutions at Lake George before I was sixteen.

But it didn't matter, really, what was said, even when, as sometimes happened, Alfred was incalculably rude to people in the interests of provocation or instruction or whatever impulse governed him at the moment. The Place, with its ever-changing walls and spirals of misty argument, had nevertheless the flavor of permanence, tolerance for all sorts of absurd extremes, of peaceable equanimity, of a passionate engagement with life—loving and doing with all one's vitality—that made Alfred's increasing physical debility and querulousness ultimately truly heartbreaking. If the ideal gathering place, the perfect laboratory, had been for Alfred The Little Galleries at 291 in the peak years of his memory and if, to him, neither The Intimate Gallery nor An American Place ever quite measured up, this final roost was nevertheless in a class of its own. It was very much Alfred.

PART FOUR

EQUIVALENTS AND AFTER

1930-1946

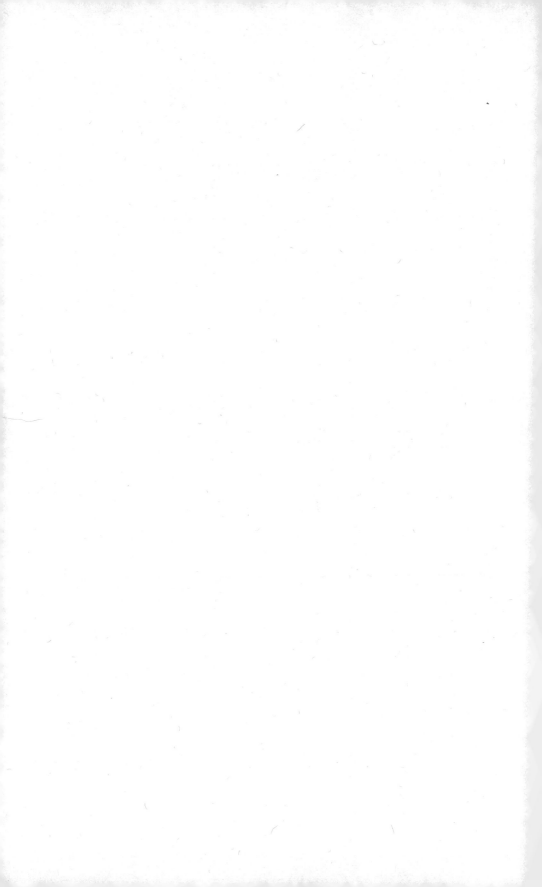

20

An American Place opened a week before Alfred's sixty-sixth birthday. To introduce the new gallery, he had prepared a statement that was a sly parody of the ballyhoo released by the Museum of Modern Art. Engraved formally on a stiff ivory card was the following message:

No formal press reviews
No cocktail parties
No special invitations
No advertising
No institution
No isms
No theories
No game being played
Nothing being asked of anyone who comes
No anything on the walls except what *you see there*
The doors of An American Place are ever open to all.

On Mondays through Saturdays from nine to six, Sundays from three to five, Alfred was ready to take on the world again.

And the world came, by the thousands. Not just to see the highly praised opening exhibit of Marin's new watercolors, but to see where Stieglitz had landed this time. The art world's grapevine buzzed with speculation about how he had managed, in these days when everybody was hurting, to open a spacious, spanking-new gallery. Either it was inherited money, the word sped from dealer to dealer, or the Old Man must take bigger commissions from his artists than even they; obviously the paragon who swore he never took a percentage for himself was a charlatan. The calumny, which Alfred ignored, would never die.

A fair portion of An American Place's new audience came probably thanks to the very institution Alfred was so busy castigating. The MOMA's second exhibition in the fall had included not only O'Keeffe's five oils but also six Marin watercolors. The cross-traffic, limited though it

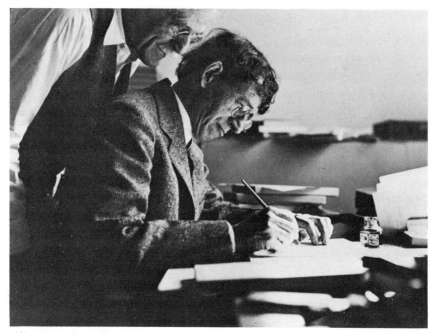

Alfred Stieglitz and John Marin, An American Place, 1931 Herbert J. Seligmann

was, presaged a tense ambiguity in Alfred's relationship with the museum. It seconded his faith in Marin and O'Keeffe; he was proud that it sought their works repeatedly for group shows and gave each a one-man show during his own lifetime; he was flattered as well that some of his prints were requested to help launch the opening of its photography division in January 1940. Nevertheless, he was angered again and again by its lack of appreciation for Hartley, for Strand, and especially for Dove.

What Alfred found most infuriating was the politics of institutions *per se*. Rivalries between institutions created situations like Hartley's when, adopted later by the Whitney Museum of American Art, he found access to the Modern virtually blocked. Alfred did not fault the MOMA's sympathetic young director, Alfred Barr, for this or for the second disease of institutions: the need to compromise, to capitulate to the tastes of trustees or, worse, to the tastes of whatever potential benefactor was being wooed at the moment. Year after year, Barr tried to effect the purchase of a Dove; year after year, he was overruled.

The three one-man shows that dominated the opening season of An American Place—Marin, Dove, and O'Keeffe—attracted critical praise, crowds, and virtually no cash. Alfred's late April hope that a retrospective group show of these three plus Demuth and Hartley (his big five) would

make up for the earlier drought was unavailing. Through the summer, and for all the years of the Depression, the question of his ability to keep his adoptees afloat was a source of constant worry. Obviously, he realized in 1930, recovery was *not* just around the corner, as the Washington and Wall Street pundits insisted. Even Rosenfeld, whose capital had once been ample, found it virtually impossible to pull together the modest price he had pledged for a Dove.

As if the problem of money were not enough, a new frustration had arisen that Alfred would find increasingly infuriating. Early in the winter he had come under fire for maintaining, in a time when thousands were losing their livelihood, that the artist must at all cost remain true to his individual star, even when that cost might appear to be the well-being of his fellow man. The argument that artists should be working for the proletariat, ceding individual goals to those of the community, had been gaining wider and more vociferous support ever since the start of Russia's revolution. Now, with the debacle of American capitalism, the argument was becoming strident; even malleable Zoler was returning to the clichés of his Wobbly days.

To Alfred, the argument was not only insane but deeply offensive. All true artists contributed to the common good by virtue of producing the best of which they were capable, he insisted. To subordinate their personal truth to propagandistic aims, however worthy, would be criminal and, in the end, a disservice to society. Above even the answering of material welfare, society needed to provide a climate in which the highest individual aspirations might grow, in which quality and truth were the goals, not the appeasement of the lowest common denominator. He had fought long and hard against the sacrifice of quality to expedience by which the few profited at the expense of the many; he would not now give up the battle because the self-appointed spokesmen of the many accused him of being elitist.

Georgia had taken up the cudgels in behalf of his position on at least one podium during the winter. In the spring, she determined again to give priority to the principle of obligation to her own star by returning to New Mexico for the summer. She was certain that her independence would give her the opportunity not only to produce paintings of the Taos environs that had haunted her through the year but also to sweeten her reunion with Alfred in September. Touched by his relatively calm capitulation, she went to Lake George in early May to plant the garden and ready the Farmhouse for his June occupancy. There, thrusting up from the damp

bank of the brook near her Shanty, she found a robust jack-in-the-pulpit that seemed to her a perfect subject for a love-note painting for Alfred. The jack-in-the-pulpit, of which she painted six versions, would be the most frankly explicit of all Georgia's works. There is little question, notwithstanding later furious disclaimers, that the message was deliberately erotic.

Georgia timed her return from Taos to coincide as closely as possible with the emptying of family from the Hill. Anticipating another joyous reunion with her frisky bridegroom of the year before, she found instead an Alfred wallowing in self-pity and pills—palliatives for his again arrhythmic heart and pain-killers for the neuritis that had struck his arthritic arms. He, who had described his summer to friends as delightful, peaceful, and lazy in the sometime company of Zoler, Kalonyme, and Rosenfeld, and himself as grateful that Georgia had her freedom, had, in fact, spent most of his time fretting about her, his health, the gallery, the economy. He had almost no work to show: a few cloud prints, some portrait shots of Kalonyme and Zoler, some candids of Peggy and Sue. He hoped, he told Georgia, that she had gotten over having to be away so long.

She had not, of course. And in the coming year, she would find the need more exigent even than before, thanks to a new dimension in her problems with Alfred. In twelve years with him, Georgia had learned to put up with his flirtations—and probably his flings—with a number of more or less attractive women. Most had been of short duration; none had been particularly serious. A little over a year ago, however, she had begun to notice a change in his attitude toward young Mrs. Norman, a regular at The Intimate Gallery since its first season, and now a major benefactor of The Place.

When Dorothy Norman had first arrived at the gallery in 1926, a Philadelphian transplanted to New York the year before with her young husband, both Georgia and Alfred regarded her as a child; she was seven years younger than Kitty, eighteen younger than Georgia. It was soon evident to both of them that she was developing a crush on Alfred: her eyes lingered over him; she recorded what he said in a notebook. She told him how wonderful it was for a man of his stature to give so much attention to the insecurities and dreams of other nobodies like her.

This nobody, however, possessed not only the physical characteristics that had always drawn Alfred's attention—the dark eyes and hair, sensitive mouth, expressive hands, and pale complexion of his mother—but also an air of romantic melancholy, a fragility of health, a seriousness, an

artlessness that was essentially virginal. And, my God, how she listened, how thirsty she was to *learn*, how willing to take on any task or errand, even anticipating its need.

In The Intimate Gallery's last year, Dorothy came almost daily. Never intruding on his conversations with artists, critics, collectors, writers, or even casual visitors or family, she was nonetheless intensely *there*. If she did not appear, Alfred began to worry about her, telephoned, or wrote her a note. When she was away, she sent him long, solicitous, self-revealing letters; he responded in kind. At just the moment in his marriage when Georgia reached for distance, Dorothy reached for connection. This child, too, needed to be brought to Womanhood, needed *him*. As Georgia, apparently, did not.

When Georgia came back to the Hill in 1930, Dorothy was nearing the birth of her second child. Alfred, who viewed any pregnancy with alarm, was unbearably anxious about her; he had already shared concern for her chronic anemia with her husband. The closer she came to delivery, the more intense became Alfred's suffering, mental and physical; in the last weeks, severe stomach pains joined his other ailments. Not surprisingly, within days of his learning that she had produced a son without mishap, Alfred's health was measurably better. A fortnight later, after a two-day trip to New York to supervise the gallery painters that had included an opportunity to see her, he found that all his symptoms had miraculously disappeared. His week of renewed isolation with Georgia, so recently a cause for celebration, passed excruciatingly slowly; he couldn't wait to be back in the city.

Georgia's secret hope, and Alfred's secret fear—that Dorothy's visits to The Place would be curtailed by the demands of a new infant—proved idle. She was back to her former schedule before December. Wishing neither to run into her nor to suffer the rambling talk the young woman found so enthralling, Georgia retreated. Her increasingly rare visits to the gallery were soon confined to the hanging of shows, in which Dorothy did not participate.

Georgia retreated from Alfred as well, with a new set of conditions from which she derived considerable satisfaction. There were enough people hanging around The Place to do his daytime bidding; henceforth, she would give up all but one wifely chore beyond those directly affecting his health and his modest comforts at the Shelton. She would play hostess at dinners in the hotel cafeteria when he asked her, but she would not be trapped any more in his social and family obligations. And, whether or not he chose to

join her, she would accept evening invitations from friends outside his circle, many of whom she had met in Taos. Had she trusted him to resume responsibility for his appearance, she would have given up supervising his clothing too. Affecting complete indifference to the way he looked, Alfred thought it funny now that he had once been a dandy, but he was still finicky about the quality of what he wore; Georgia knew she could not leave shopping for his clothes to others.

She selected his white shirts, black ties, fine-denier socks, and woolen underwear. She dragged him to fittings for the suit and topcoat needed to replace what he had worn threadbare. The new suit must be *exactly* the same pepper-and-salt or pinstripe, the new coat *exactly* the same grey herringbone; both would look too new *for years*. She sat with him through endless tryings-on of the black high-laced or elastic-sided shoes that would never give enough comfort to feet punished by concrete floors. The replica of the overmended grey sweater she had exiled to the Hill must be a superior machine-made product that held its shape; he would not accept Lizzie's handmade affairs. Once or twice, with abundant pleasure, Alfred allowed Georgia to give him a bright-colored vest, preferably red, like those he had sported as a student. The only clothing transactions he carried out on his own were those concerning his cape and his hat. The Loden purchase, an international undertaking, was probably repeated only once in fifty years; the porkpie acquisition, nearly as rare, could take place only when chance found him at the door of Knox the Hatter on Park Avenue. Parting with his old hat was like saying goodbye to a lifelong friend.

Any resentment Georgia bore Alfred for responsibilities she wished he would carry had nothing to do with money. As soon as she was able, and until the end of Alfred's life, she took on paying the major portion of his expenses as well as her own, with as little fuss or fanfare as breathing. Furthermore, enjoining Alfred from praising her "generosity" in his spiel about "happenings" or "fine moments," she regularly bought the works of her co-exhibitors, providing, sometimes, their only income for many months. The artist was never to doubt that her motivation had been *her need* to have the picture.

As soon as Alfred was reasonably certain that Georgia would not appear unannounced at The Place, he began photographing Dorothy. Attached still to the reach and ballet of hands in Georgia's pictures, he found in his new model qualities he had superimposed on Georgia: a natural solemnity and hesitancy, a pensiveness suggestive of romantic mystery. There was no sexual challenge, no temper lurking behind Dorothy's eyes,

dark and limpid as a doe's. Furthermore, she participated eagerly in what he was hoping to achieve: she had already tried her hand at the camera, and would start soon to take his instruction in the darkroom. Meanwhile she was as interested as he in seeing what could be produced by the strong new light conditions at The Place. She moved compliantly from window to window, shades drawn or open to brilliance, anticipating excitedly the film's revelations: filtered soft modulations, silhouettes, dramatic contrasts that bisected her face.

Later, she would report in some detail his lessons in photographic technique and developing processes, which were, in fact, extraordinarily simple. "All he will say at first is to shut down my lens as far as possible, take the longest exposure I [can] and then just go ahead: photograph, photograph, photograph . . . [In the darkroom,] he lifts a bottle of developer to the weak light, reads the directions . . . and repeats exactly . . . 'Use three parts water to one part developer.' The label indicates that the water should be a certain temperature. Stieglitz: 'Forget about that. You will soon sense how hot or cold it should be and how your negatives should look.' He advises that I keep shaking the pan in which the [negatives] lie . . . place them in hypo for a certain time and finally wash them much longer" than the instructions indicate. For Alfred, as for Dorothy, the teaching would be exhilarating. Although he had given Elizabeth guidance some fifteen or more years earlier, sufficient to trust her with printing family copies of many of his pictures of them, Dorothy was his first—and last—full-time pupil.

Through the busy but frustrating 1930–31 season, Alfred had fewer opportunities to photograph her than he wished. Still, he was reluctant to let Georgia set off for the Southwest at the end of April, pleading his need for her assistance in sorting out the large number of paintings he intended to remove from storage—some to farm out to the Downtown Gallery, some to transfer to The Place, and the remainder to return to their creators. Georgia's response was to press him into five intensive days at the warehouse and to depart on schedule, leaving him annoyed, exhausted, complaining widely of feeling old, and hardly fit to concentrate again on photographing Dorothy.

He might well have succumbed to his customary doldrums had it not been for a cluster of needling letters from his erratic cousin, Herbert Small. Protesting Alfred's self-pity after one of their infrequent reunions, Herbert had already written: "You 'old man,' at your most weary and discouraged . . . could use up any average, strong phlegmatic youth." Now his letters

urged him to give up his taxing responsibilities toward others in favor of "the one thing that really removes the curse from being 'chosen an artist' —Irresponsibility . . . the enlightened selfishness [that] is the most unselfish in the end." If Alfred heeded his cousin's perceptive advice and, suddenly energetic, dived into several weeks of photographing Dorothy before she left for her summer at Woods Hole, Massachusetts, Herbert was himself apparently unable to follow suit. In December, only weeks before his fiftieth birthday and just beginning to find confidence as a composer, he committed suicide, leaving in his wake not only a grieving widow and eighteen-year-old son but also a guilt-shattered Elizabeth Davidson, with whom he had fallen suddenly and hopelessly in love in the spring.

Alfred emerged from focusing uninterruptedly on Dorothy reinvigorated personally as well as artistically; he was wholly captivated by her. Less than three weeks after arriving at Lake George, he accepted her invitation to visit Woods Hole for a few days. On his return to the Farmhouse, his correspondence with her increased in both tempo and fervor; anything omitted from his daily letters was shared in daily telephone calls. He made no secret of his intoxication, of his sense of being reborn. Visitors Rosenfeld and Gerald Sykes and Margaret, too, were engulfed in his paeans to the wonders of Dorothy: the full-hipped Child-Woman with soul-brimming eyes, the Essence of the Female Spirit, imbued with an understanding that was modest and pure. He proclaimed, furthermore, that his involvement with her was an enrichment for everyone around him, not excluding Georgia—a bizarre conclusion that showed him more adept at rationalization than the ruthless honesty with himself of which he boasted.

Elizabeth and Donald greeted his effusions with little sympathy, albeit they agreed to store "Mrs. N's" current and future letters until, as Elizabeth put it, he had "worked [his] way through this tangle." They were themselves trying to work their way through a tangle in which Alfred's romanticizing had played a role. During the past year, the twin pillars of his Lawrentian dream in their behalf—the joys of rural simplicity, and the capacity of love to bridge all differences—had suffered cruel damage. The farm had become too hard physically for Donald to run without help they could not afford; neighbors treated their Hindu guests with a bigoted rudeness hitherto reserved for the family of the lone Jewish shopkeeper in the community; the local school proved barren of values Elizabeth felt essential for the children. Teachers and parents who favored knuckle-rapping and soapy mouthwash as cures for the "impudent" questions of five- and six-year-olds were openly horrified by Elizabeth's pleas for adoption of

even the least radical precepts of Alfred's friend John Dewey. Hoping to compensate ten-year-old Peggy for the paucity of local educational opportunity, she and Donald had already sent her to New York for the year, to live with Lee and Lizzie and attend a progressive private school. To be reunited with her only on weekends had been a wrenching experience for all but Sue, who took inordinate pleasure in her week-day dominion.

In the same period, the long-discounted differences between Elizabeth and Donald—of background, experience, and intellectual appetite—had begun to acquire potency. The appearance at the farm in May of music-making, book-loving, nimble-witted Herbert Small had rendered Elizabeth giddy—and Donald ferociously jealous. By the time they had gone to Lake George, their equilibrium had not yet returned, but they had agreed to try a new solution. In the fall, with the financial aid of Lee and his daughter Flora, they would move to a modest apartment in the city that was conveniently around the corner from the school at which Sue would join Peggy. Equally important was the promise of being within easy reach of the Vedanta Society that both found a stabilizing spiritual home. For as long as they could manage, they would keep the farm as well. Meanwhile, the city, offering opportunities for each to taste some independence, seemed to be the key to remaining together.

"Either people become so all in all to each other that they can share everything," Elizabeth wrote Alfred at the end of their visit, "or they have to content themselves with a fine contact, allowing for much that is not shared—excepting through the contact." Indirectly, she was counseling Alfred to decide which category was occupied by Dorothy, and which by Georgia. He would have none of it. Relieved of her earnestness, he slipped back into the daydreams, letter-writing, phone calls, and rejuvenating diet and exercise that had been inspired by his visit to Woods Hole.

Georgia's return at the end of July undoubtedly increased his circumspection, but it did not materially affect his euphoria. He accepted with better grace than the year before her second shipment of souvenirs from the desert—twelve months earlier he had raged at the sixteen-dollar freight charge for a large barrel of bleached skulls and skeletal fragments of horses and cattle cushioned in paper Mexican funerary flowers—and even found himself amused by the displays she created on tables, windowsills, and porch steps. He was grateful that she was in a working mood and seemed indisposed to discuss Dorothy. Within days of getting resettled, she was back to her painting, and he to long sessions of printing.

Georgia had had three months to sort out some of her feelings about

the hot rumors in New York surrounding Dorothy and Alfred, and had taken care that none would follow her to New Mexico; as insurance, she had rented a cottage some forty miles distant from "Mabeltown." There, after a long pack trip with friends in June, she had enjoyed almost complete solitude, free to explore the Alcalde hills on foot and in her Ford, to greet stars and dawns at will, to paint. When she returned to Lake George, her head was still so full of pictures waiting to be set down on canvas that Dorothy seemed irrelevant; she barely even took notice of the heavy traffic from Red Top in the busy excursions of Lizzie, her daughter Flora with her two daughters, and the Davidson girls. So long as they kept out of her path, it didn't matter.

But they didn't. One suffocatingly hot day, a tribe of four little squaws aged four to ten, dressed in fringed chintz buckskins of Lizzie's devising, dared the ultimate hazardous mission into forbidden territory: scouting Georgia's Shanty. Peering through the window, we were dumfounded to find her naked at her easel, a tableau for which nothing in our essentially prudish upbringing had prepared us. Georgia's momentary shock turned to immediate rage. Shrieking—and still naked—she flew out, brandishing a paintbrush, to chase us away. To her, we were prurient little horrors. To us (or at least to me) she was as magnificent and awesome as a goddess.

It was the last straw. Within days, Georgia was off on a motor trip to Maine with Kalonyme—assigned by Alfred to deal with "emergencies," and welcomed by Georgia as a liberated companion willing to share a tipple with the Marins on the way home. When she returned, she found Alfred, who had reactivated the telephone, on the verge of leaving for Boston for a few days. And Woods Hole. In the ensuing two weeks together, both were too heavily involved in work to mend ruptured feelings. When Georgia drove Alfred to the city in early October, she stayed only long enough to hang the Marin show before fleeing back to the lake. Intermittently through November she did the 400-mile round trip several times to deliver paintings to the framer, but after a fierce scolding from Alfred for having appeared unannounced at the gallery—or at the Shelton, to which he had begun bringing Dorothy—she found a single night's stay in the city more than enough.

Dorothy, meanwhile, had made herself increasingly useful at The Place. She organized Alfred's files, paid the bills, consolidated diminutive forgotten bank accounts, and unobtrusively took over minutiae he had formed the habit of postponing or forgetting. Gaining courage, she began also to show him poetry she had written.

The fruit of Georgia's persistent work through the summer and fall created a sensation in her late December exhibition reminiscent of that elicited by her first flower pictures. Interspersed with a few relatively tame shells and abstractions, her paintings of bones—parched skulls, some stark, others sprouting flowers—threw the critics into a frenzy of speculation. Was she a neo-Surrealist? (In fact, she had paid no attention to the movement, if she was acquainted with it at all.) What was the meaning of her symbols? Was she necrophilic or necrophobic? (To her, the bones were simply something "beautiful . . . and keenly alive in the desert [that] . . . vast and empty and untouchable, knows no kindness with all its beauty.") Freudians among her acquaintances read into her paintings, especially after they had seen the show that followed hers, a death wish that could have been directed against any one of three targets: herself, Alfred, or Dorothy Norman.

Alfred had announced the next exhibition in the fall, considered cancelling it in early January, thought it too expensive to mount, hated the thought of it, and wished it were over as soon as he decided to go ahead with it. Among his 127 photographs spanning forty years of work were three new groups that drew excited comment. One consisted of dramatic renditions of skyscrapers—in construction and completed, hard-edged in sunlight and shadow, silhouetted at dusk, sparked with illumination at night—that were interpreted by some as not only a protest against Manhattan's depersonalized monoliths, but also as evidence of a cold withdrawal in Alfred from human engagement, of loneliness. The more likely truth is that his new subjects were, yes, commanding and dramatic, but also conveniently *there*, easily available to a camera perched on the Shelton roof wall or on a tripod at The Place. He had always taken pictures from the windows where he worked or lived. Even greater public excitement focused on the other two groups: portraits of Georgia taken since, nine years earlier, her face and body had been thrust into the limelight; and portraits of Dorothy. If speculations about Alfred and his new, much-younger-than-Georgia model did not reach the press, they were carried in thundering whispers by those who crowded the gallery. No matter how pure the relationship between Dorothy and Alfred—the ultimate consensus of his family and close friends was that it probably was—in the public view, Georgia had ample reason to feel homicidal.

Chance soon offered Georgia at least a symbolic revenge. Work on the vast new Rockefeller Center had started the previous year, accompanied by wide publicity about the developers' intent "to spur both business and

culture to new heights." In December 1930, it was announced that the Mexican muralist, Diego Rivera, already chosen for the RCA building, would be commissioned for Radio City Music Hall decorations as well. New Yorkers, enraged, called for his replacement by an *American*. Jumping on the bandwagon, the Museum of Modern Art invited sixty-five native photographers and painters, including Georgia, to submit alternative designs that they promised to exhibit; the unofficial message implied that the winner would capture a contract with the Music Hall. In six weeks, Georgia completed drawings for a triptych and painted a sample panel seven by four feet. Alfred blew up. Not only was she flying in the face of his principled fight against contests, implied or formal, but she was asking to have a work unveiled on other premises, in an *institution*. She was betraying her obligation to An American Place, and to him. A snide reference to her defection printed in the magazine *Creative Art*, of which he had been a member of the advisory council since its inception, propelled his immediate resignation.

Worse was in store. Georgia won the prize. Without consulting him, she signed a contract in April with the Music Hall commission to furnish a design for the walls and ceiling of the roughly eighteen-by-twenty-foot second mezzanine powder room, and to paint it in the fall, all for a fee of $1,500. Alfred, beside himself, swept into the commission offices and demanded first that the contract be abrogated and then, failing, insisted that her expenses—he would waive the fee—be covered to the tune of $5,000. He had not spent fourteen years establishing a market for paintings that now brought between $4,000 and $6,000 apiece to have his efforts undermined by a commerical enterprise. He was ignored. The subject would detonate explosions between him and Georgia throughout the summer.

Georgia went on with helping to hang the next show, and the next (both, ironically, husband-and-wife affairs: paintings by Dove and Helen ["Reds"] Torr first, and then the Strands—Paul's photographs since his last show, most from New Mexico, and Beck's small paintings on glass, produced over the last several years). Then, still smarting from Alfred's peremptory actions and unrelenting arguments over the Music Hall contract, Georgia departed for Lake George. She would leave for the Southwest directly from the Hill, she announced, on June 5. She was sick of Alfred. And she was sick of Dorothy, who was engaged in a new enterprise.

By the end of the year, the funds guaranteed two and a half years

earlier to pay the rent would run out: Dorothy had taken it upon herself to raise new capital. Agreeing with Alfred that The Place belonged to a group far broader than the original handful of guarantors, and cognizant also of the reluctance of even the wealthy to commit large sums in this rock-bottom year of the market, Dorothy initiated pleas in the press, wrote hundreds of letters, and pursued every remotely possible donor in Alfred's now orderly files. Before the end of May, nearly half the amount needed for another three-year lease was in hand, contributed by close to a hundred small donors. When the new lease was signed toward the end of the year, and thereafter until Alfred's death, it would be in Dorothy's name; from 1932 on, a variable percentage of fees collected for artists' work would go to the "Dorothy Norman Rent Fund."

On the morning of June 5, a day after going to the lake and back to say goodbye to Georgia, Alfred was surprised to get a wire announcing her intention to stay, a decision based perhaps partly on his revelation that Lee and Lizzie would not be at Red Top: Lee was staying in New York; Lizzie had gone to Reno.

Since the late-summer 1930 death of Mr. X, his widow's demands on Lee had become increasingly clamorous. First she leased and decorated a tiny love nest on Lexington Avenue at which she insisted he spend at least one night a week with her—a situation that inspired him to even more preposterous lies to Lizzie, and considerable grumbling to his discreet secretary. Then, in 1931, she booked them a "honeymoon summer" in Europe, in which he also complied. Finally, in 1932, she demanded he get a divorce. Wearied for several years of playing Tristan to a now dumpy Isolde (in 1928 his heart had found another, more congenial, home) Lee tearfully broached the subject with Lizzie, hoping against hope that she would refuse. By his own later account to me, Lizzie responded evenly and with towering dignity: You have dreamed and waited forty years to have her for your own. Now you will marry her; it's your duty. I shall go to Reno, where you will rent me a nice room and a good piano. And I want Red Top. You make the arrangements. Lee had never been more impressed with her.

Nor had Alfred, who answered her first rather timid letter from Nevada with reassurances that he not only understood her decision, but believed in her utterly as a person. "Believing in me . . . makes me feel spiritually free," she answered gratefully. "I do not know either how 'it will work out'—Lee is such an unaccountable character . . . I don't think we can be more unhappy than we have been these last two years [but]

there will be at least no more make-believe and fear." Her relief, in fact, far outdistanced her expectation; she was in effect reborn. Within only a few weeks she found herself in a holiday mood, enjoying her freedom in ways that would last the rest of her life. On the July day her decree became final, she tossed her wedding ring lightheartedly into the Truckee River, unaware that the Reno ritual promised not only good luck but a new husband. That was a boon she never wanted again. Maintaining compassion for Lee, however—and finally a tender friendship—she agreed as part of her settlement to spare him potential wrangles in his new life by assuming responsibility for Alfred's quarterly allowance, a function she performed with punctilious promptness even when Lee's market speculations or his new wife's unanticipated extravagance delayed her own alimony payments. Alfred was thenceforth her "dear brother," not her in-law.

Georgia's presence at the lake in 1932 gave Alfred the opportunity to try out two new strategies for improving their relationship. With several new disciples visiting the Farmhouse, he enlisted their support, seriatim and in tandem, in offering their "independent" opinions that she should give up both the "prostituting" mural at the Music Hall and, even more important, her antagonism to Dorothy. His dual undertaking was remarkably foolish and gauche. Georgia was as absolutely determined to go ahead with the mural as she was absolutely opposed to having anything whatever to do with Dorothy. Her resistance was strengthened, furthermore, by her staunch ally, The Kid; together, they found Alfred's campaign a side-splitting farce.

His new troops, aghast at the sometimes violent storms between their general and his intractable wife, retreated almost at once to the sand cliffs beyond the Shanty to argue the pros and cons of their position. Earnest and gloomy, "The Happiness Boys," as they were quickly dubbed by the two Georgias, tried one by one to lure The Kid into Alfred's camp. One by one they invited her to discuss the issues on walks they dared only as far as the Sand Pile; the Master, as they actually referred to Alfred, might misread their intentions if they wandered farther afield with this vibrantly attractive young blonde.

My indelible impressions of some of the troop date to that summer. Cary Ross, the youngest and least confident, was also the least doleful in appearance. Battling a lock of blond hair that constantly invaded his right eye, he echoed the latest consensus with a deprecatory smile and sometimes a giggle. Although in subsequent years Ralph Flint proved capable of humor, he was the dean of gloom that summer, supremely uncomfort-

able at having been dragged into the fray. Literally an egghead, shiny-pated, Flint seemed ill at ease with his body, awkward in a way that suggested he felt it impolite to be taller than Alfred, to whom he deferred usually from gentlemanly habit rather than from agreement. Fredrick Ringel, a writer who had recently joined Alfred's circle, I remember only as having dark and somewhat ferret-like features. There may have been other recruits, but I remember only these three, plodding the Hill roads with a solemnity matched only by the cassocked figures of the Paulist fathers in their retreat across the lake. "Pudge" Rosenfeld disqualified himself; he could find no merit in Alfred's cause.

Alfred's and the troika's windy sermonizing hastened Georgia's escape in early August to an exploration of the Gaspé. This time her driving, camping, and hiking companion was The Kid, side by side with whom she painted the dark crosses, white barns, and grassy plateaus of the peninsula and the golden cliffs of Cap Rosier. Heading home, they were so exhilarated that they tried smuggling in some whiskey for evening nips at the Shanty. At the border, their booty found and confiscated, they were fined. Bureaucratic efficiency in the form of a mailed receipt divulged their secret to Alfred, whose rage was impervious to Georgia's charge that he had opened something addressed to her. Thereafter, the two conspirators confined themselves to brewing largely unpalatable home wine, an enterprise they soon gave up in the fear it might be poisonous as well.

During their absence, Alfred, urged by Rosenfeld to drop his opposition, and aware perhaps that promising young Stuart Davis would do the murals for the men's lounge, had managed to reconcile himself to the Music Hall inevitability. He began now to write friends of the splendid opportunity Georgia had wanted and gained, of the tranquil relations on the Hill he attributed to his self-restraint (a marvel of self-delusion considering the shrill dominance of his voice in the earlier brouhaha), and of his delight in the fine canvases Georgia had brought back from Canada. Nevertheless, he was depressed. He was worried by the resumed misbehavior of his heart—the result, he thought, of toting his big camera; he had failed to win Georgia even an inch along the way to friendship with Dorothy; he was convinced that the economy would be weakened even further by the probable election of Franklin Roosevelt to the presidency; and he deeply regretted having to turn down holding a posthumous show of paintings by Alfy Maurer, a recent tragic suicide, whose works he had not shown for fifteen years. He was going to have a hard enough time doing anything for the artists he had been showing regularly.

Alfred was not sorry when Georgia's wish to see the half-completed site for her murals brought them to New York in the last week of September. Nor was he sorry when she returned to the lake after helping put up the opening show. Appalled by the scope of the job she had taken on—hundreds of square feet to fill, much of it arching to a domed ceiling—she had known that she would need solitude to complete the designs in time to start six weeks of painting in mid-November. The Music Hall was to open December 27.

During her absence, Alfred found himself more than ever impressed with Dorothy, who was energetically expanding the range of her activities. She had not only thrown herself into fund-raising for The Place, but had come up as well with a sheaf of poems he thought ravishing. He began writing letters in her behalf to all the publishers he knew; to one, at least, he implied that she was a discovery on the same plane as O'Keeffe. As further evidence of his confidence in this "grand kid" (as he described her to all his friends: she was not yet out of her twenties), he handed over to her the editing of a new series of leaflets. Titled variously *It Has Been Said* and *It Must Be Said*, the series' intent was to inform gallery visitors of past and current criticism of the artists on view. Alfred the Impresario was in full swing; as Georgia was his star with paint, Dorothy would be his star with words.

Then, without warning, everything fell apart. On November 16, the day before starting work on her murals, Georgia was taken by Radio City's head interior designer to see the readied powder room. Just as she was envisioning her giant flowers on the pristine walls, to her horror the canvas began to sag, to tear, and suddenly to peel, loosening an avalanche of plaster. It was too much. All the accumulated tensions of the past months—her fears about the murals, Alfred's opposition, his obtuse attempts to foist upon her an impossible friendship—exploded. She became hysterical, raged, and wept. She fled—to Alfred.

Claiming that criminal negligence on the part of the Radio City Commission had caused her to suffer a breakdown, Alfred cancelled Georgia's contract the following day, threatening to sue if she were not released. Then, worriedly, he sent for Lee. Georgia was short of breath, could barely speak, had pains that resembled angina. Shock, Lee diagnosed, not a terminal illness; bed rest would put her right again. In a few days, she was urging Alfred to go back to The Place; in a few more, she was on her way to Lake George to pull together paintings for her impending show.

She was back before the middle of December, feeling wretched, suffer-

ing all her earlier symptoms and blinding headaches as well; she cried for no reason at all. Lee's specialists disagreed about causes: one diagnosed a heart disorder, one a kidney malfunction, and Lee himself menopause—Georgia was, after all, forty-five years old. But they agreed that bed rest and a bland diet were called for. No nurses, but Lee would visit her morning and evening. Alfred went back to work again, with a zeal that gave at least superficial credence to Georgia's later statement: "Alfred once admitted that he was happiest when I was ill in bed because he knew where I was and what I was doing." On this occasion, however, his happiness was short-lived.

A few days before Christmas, Georgia was moved abruptly to her sister Anita's commodious apartment—on the advice, probably, of Anita's doctor—away from Alfred's jittery and useless attentions and, more than likely, his exhortations to pull herself together. Five weeks later she was in hospital, under the care of a "psycho-neurotherapist"; for two months, Alfred was allowed to visit her only once a week, for ten minutes. Punctiliously obedient, he made his permitted time as tangible as he could, bringing her photographs he had taken of her show (the critics had raved about the Canada paintings) and sometimes a single flower, hoping for a spark of pleasure in her clouded eyes. Grateful finally to be allowed to bring her briefly to the gallery to see her pictures on the walls, he tactfully avoided mention of when she might be home again. To his closest friends, he wrote that he was more worried about her than he dared admit.

She went from hospital directly to Bermuda, with a woman friend, at the end of March, and did not see Alfred again until the end of May. Despairing over her continuing listlessness in June, and wrestling with the guilt that had engulfed him when he had realized that she was really ill, he wrote Dove that he felt like a murderer. First Kitty, now Georgia. He despaired of her ever picking up a brush again.

21

The emotional seesawing between Georgia and Dorothy that peaked for Alfred in 1932 owed much to the ways in which each served the basic dichotomy within him—the solitary visual artist on the one hand and the gregarious word-magician on the other. Georgia was the perfect companion when he was photographing and printing and she painting, when they both worked contentedly along parallel lines and shared delight in leisure that was either preparation or reward for concentrated independent labor. Dorothy's support, meanwhile, was for the very things Georgia shunned: his appetite for public contact, his drive to seek and examine truths, his missionary zeal. Furthermore, he derived constant satisfaction from her willingness as a gallery volunteer and her attention to his teachings.

Drawn initially to both women by, among many other qualities, their apparent need for his help in finding strength to stand alone, Alfred undertook their battles as energetically as he did those of his other artists, unheedful as always of the probability that, once their confidence and freedom had been won, their ties to him would begin to loosen. Whereas Georgia's goals had always been clear to her, however, Dorothy's were just beginning to be formulated. In the autumn of 1932, when Georgia's footing seemed secure, he turned his attention to Dorothy's first independent efforts and decided that, since her poems had not found a publisher, direct intervention was in order. Her first book of verses, *Dualities*, was released by An American Place in March 1933.

Had Alfred been a younger man, or had he had even one of the strong male colleagues of his forties and fifties with whom to work consistently, in all likelihood his preoccupation with Georgia and Dorothy would have absorbed less of his energy. The wonder is that his efforts in behalf of his artistic wards and literary friends did not flag in spite of his emotional distractions, thanks in part to the work habits of a lifetime. The twelve shows he had mounted and monitored at The Place in its first two years

had brought at least something to each in his group, notwithstanding the ravages of the Depression. Much of what had been earned had come through Alfred's needling and cajoling of the gallery's regular clientele, a task from which he excluded Dorothy's direct involvement, except as a purchaser. He had seen Hartley through the trauma of showing his first New England paintings in over twenty years, and Marin through the vilification that greeted his oils despite enthusiasm for his watercolors. He had nursed Seligmann through editing a collection of Marin's letters (published by The Place) that gave colorful evidence of the artist's ability to use words as he used paint, in sprightly dashes that were often more vivid than conventional structures. And he had managed to garner funds to see Dove through the first two of seven exceptionally harsh years. In the next five, Dove would wrestle impossible odds against making something of the 180-odd acres left in his care when his mother died early in 1933. During that time, one after another parcel of land and building was foreclosed: farmhouses, stables, an abandoned tile factory, and a large commercial building in downtown Geneva known as the Dove Block, that housed, consecutively, a dance hall, a roller-skating rink, a radio station, Dove and Reds, and a group of apartments. Dove survived, and produced stronger and stronger art works, but at the irremediable cost of his health.

For the first six months of Georgia's illness, Alfred immersed himself in work. He was confident that her hospital rest and two subsequent months of Bermuda convalescence—in the company of a sensible, tactful, and unexcitable Stieglitz friend, Marjorie Content, and her teen-age daughter—would restore her to full health. His greater unease lay with finding dollars for his wards in an economy turned over now to newly elected Franklin D. Roosevelt—a patrician dilettante he predicted would make an even worse mess of the country than Hoover. The ominous January appointment of Adolf Hitler as Chancellor of his second fatherland went unheeded.

In March, Alfred undertook to finish the job he had undertaken two years earlier: emptying out his rented space at the Lincoln Warehouse, this time of his own things. Walkowitz's unexpected return to the fold had precipitated Zoler's disappearance, and left his ill-arranged package room open to Alfred's housekeeping attack. Alfred's fever for order quickly extended to transforming the seldom-used northeast exhibition room into work and storage space. With the help of Walkowitz, Dorothy, and Cary Ross, the room sprouted shelves, partitions, and counters; there was plenty of room for everything he had at the warehouse.

Everything, that is, except the 418 prints in his collection of works by twenty-seven other photographers; acquired between 1894 and 1911, it had cost him something over $15,000, including storage, Alfred calculated. Excepting some Steichens and virtually all the Strands, Alfred had for years found nearly every print not only uninteresting but supremely distasteful. When his things arrived from the warehouse, he decided abruptly that there was room neither in his life nor in his gallery for the collection; he would throw it out. It happened, as it had "happened" a decade earlier when he threatened to destroy his photographic library, that among those who heard his new ultimatum was Carl Zigrosser of the Weyhe Gallery. Predictably, Zigrosser called the Metropolitan's Curator of Prints, who promptly dispatched the museum's "hearse" to pick up the remains. Alfred was delighted.

He was not so delighted with the season's next happening. Back from Bermuda in late May, tanned and no longer emaciated, Georgia was still not ready to face New York. During a two-day absence to escort her to the lake and Margaret Prosser's care, Alfred, forgetting that they had in fact met in 1911, was convinced that he had missed his single chance to meet one of the giants of his life. Henri Matisse, the first revolutionary painter shown at 291 twenty-five years earlier, had dropped in, unannounced, to see him. Had their meeting been prevented by anyone but Georgia, Alfred, who reckoned quickly that he had not missed a single one of the preceding 257 days at his post, would have been enraged. As it was, he accepted Walkowitz's playing host as an ironic joke. He was vastly amused when Matisse, assuming that, like other dealers, Alfred made annual trips to Europe, invited him to visit in Nice.

When Alfred went to the Hill in late June, he was alarmed at Georgia's condition, having little conception either of the full scope of her earlier melancholy or of the considerable gains she had made since. Now, dramatically, he wondered if the fault lay with him; it was now that he spoke of feeling like a murderer, as he had once with Kitty. Notwithstanding such loud assertions of nonspecific culpability, however, it is doubtful he ever recognized the destructive power he possessed, least of all his despotism. He began, nonetheless, to look earnestly for ways in which he might help her, for remedies that might restore her wish to paint as well as improve their relationship.

A part of his strategy to help, perhaps more unconscious than deliberate, was a shift in his relations with Dorothy. Whether out of guilt for his initial infatuation, or because there would in any case have been a *ritar-*

dando in the gallop of his imagination, or even because a sense of responsibility for Dorothy's self-realization predicated a different direction, henceforth he would not indulge so freely in romantic musings in which she was the central figure. Being Alfred, he would complain from time to time about her increasing absences from The Place, even when they were occasioned by his prescriptions for her progress as an editor and writer, but all her undertakings received his blessing.

The nonprofit journal she started in 1938, *Twice A Year*, a collation devoted to "Literature, the Arts and Civil Liberties," was published from his gallery's address, was dedicated to him, and bore its title in his strong, free-flowing hand. In five of its fifteen issues over ten years, articles about him were featured, one at least accompanied by reproductions of his photographs. Unstinting in his praise for her energy and enthusiasm as well as her talents, he could nonetheless be heard muttering about one aspect of her work from time to time. Her painstaking transcriptions of the conversations and interviews that were the source of most of her early writings about him, he complained, showed lapses both in accuracy and understanding. What he failed to recognize, of course, was that the assignment was virtually impossible. His talk was usually so prolix—or so naïve—that the point was often either deliberately absent or maddeningly obscure, especially as he seemed to give equal weight to the trivial and the profound. The game, for him, was to observe the different lessons that different listeners could extract from the same general text. And the text did not lend itself well to transcription.

Whatever occasional divisions arose over interpretations of his gospel, there seem to have been few other conflicts in the maturing and less heated relationship between Alfred and Dorothy. Albeit more and more of the Rent Fund was underwritten by his artists—primarily by O'Keeffe and Marin but also by Alfred and, later, Dove—Dorothy continued until his death to raise outside contributions and to contribute on her own. She handled as much of his quotidian correspondence as he permitted until her own projects became so demanding that she turned the task over to first one and then two of her secretaries, and she anticipated more than a few of the special needs attendant to his failing health. He, in turn, rewarded her unstinting generosity with art works that included paintings as well as his own photographs, the same pattern he followed with his family.

Through the summer and fall of 1933, Alfred's concern for Georgia's recovery took precedence over everything else. Until late August, when Kalonyme and Davidson were permitted brief stays, he kept all visitors

away from the Farmhouse—including those staying at Lizzie's: his brother Julius and a grandson, and Peggy and me and our guests during the month we were not alternately away at camp. Excusing Georgia from sitting for additions to his yearly photographic chronicle, he concentrated on reprinting stacks of old negatives he had found in the attic. His attempts to compensate on new paper for the lost qualities of the old platinum he had used for thirty-five years added fuel to his condemnation of Eastman. Although worthy in itself, the latter's recent founding of a music school, he felt, had been financed at the cost of incalculable damage to photography.

Finally, he agreed without hesitation to Georgia's late September wish to spend the fall and early winter at the Farmhouse with Margaret. Anything that would bring her pleasure was worth trying, including the detestable presence of cats. His early summer order to Margaret to stop feeding a meowing white nomad had brought Georgia to tears; he promised at last that she could keep it as a house pet when he returned to the city.

Georgia did not venture to the city until mid-December, between two Marin shows—the first a twenty-five-year retrospective of watercolors and the second new paintings that included immediately castigated oils. Although Georgia clung to his side during her few days in New York, Alfred was deeply pleased with the extent of her progress since his second weekend visit to the lake. Not only did she respond warmly to the surprise appearance at The Place of novelist Jean Toomer, whom she and Alfred had not seen since a congenial 1925 week at the Hill, but she invited him to go back there with her. A recent widower, Toomer seemed to harbor some of the aching solitude of her own siege. Now she offered him snow, silence, music, the amusing antics of the cat, Margaret's unobtrusive housekeeping, a chance to work if he chose.

Alfred was delighted when Toomer accepted, and even more delighted when, joining them for Christmas at the Farmhouse, he found Georgia markedly improved. The uncertain smile of two weeks ago had blossomed into laughter; there was life in her eyes, a spring to her step. Clearly, she was on the road to recovery. If he also sensed a connection between her new buoyancy and his handsome young friend, he did not change his mind about leaving them together again.

However much Georgia missed Toomer when he left three days after Alfred, she did not lose her new equilibrium. The contrasts at Christmas between his virile youthfulness and Alfred's pale frailty had been poignant, but had not altered in any way her primary need for autonomy. What was

most important was that she had gained the strength to travel without a companion to Bermuda in February for a thawing-out that stretched into May, and that she carried back with her, at last, some charcoal sketches. And two strong desires: to go back to the Southwest in early June, and to paint.

Alfred told friends that Georgia was not quite ready for such grand independence, but he yielded to everything she asked. Yes, she could go to the lake only to pack up her painting paraphernalia; Margaret would ready the house for him. Yes, Marjorie Content—who was soon to marry Toomer —was the perfect companion for the arduous drive to Taos. Yes, indeed, it was fortunate that she needn't worry about money. The Metropolitan's well-publicized first acquisition of an O'Keeffe during the third week of her February show had attracted enough other sales to cover her expenses for the rest of the year. No, she need not worry about his health; hadn't he been fine during all her long illness? No, he would not worry about her. She had a colony of nearby friends to help in case of need. Furthermore Beck, who spent only an occasional weekend with Strand in Mexico and stayed otherwise in Taos, would send him regular reports. She could go with his blessing.

Relations with and between the Strands had taken a difficult turn during the past half year. Not only was their marriage on the rocks (with Alfred leaning toward Beck's side), but Strand seemed on the verge of defection. Living in Mexico for a year, as chief of photography and cinematography for the Ministry of Education, Strand was deeply involved in making his first major film, *The Wave*. The experience, with its daily and gut-churning contrasts of wealth and poverty, had awakened in him a profound commitment to leftist ideology. Although a later disillusioning trip to Russia would lead him to reject communism, he would remain true to a very personal, and nondoctrinaire, vision of socialism. To a politically reborn Strand, Alfred began to seem irrelevant. In a depression, in a world where the overwhelming majority of people were not only at the brink but often over the precipice of starvation, Alfred's battle for his handful of artists—even if they were worthy, and even if they were Strand's friends—smacked not of nobility but of ivory-tower myopia. Strand's new singleminded dedication to taking up cudgels for the poor and disenfranchised—together with Alfred's adamant refusal, more than once, to exhibit his friend Diego Rivera at An American Place—precipitated increasing tension between them. Finally, reached perhaps by rumors that Alfred, now crediting Dorothy Norman with having been the sole

recruiter of backers for The Place, showed a remarkably short memory for the role Strand had played, Strand blew up. In a newspaper interview in December 1933, his anger at Alfred spilled over. Naturally, someone forwarded a clipping to New York.

Alfred responded with the forbearance of an ill-treated parent but not, apparently, directly to Strand. In language that was far more stilted than was his wont, he wrote Beck of his deep regret over their "misunderstanding" and of his vast appreciation of Paul's loyalty to himself and "the Idea" over the years. If Beck sent the letter on to Strand, as Alfred obviously hoped, it accomplished little more than a truce. In spite of the fact that Strand refashioned an article published originally in *MSS* in 1922 as his contribution to a book about Alfred that Dorothy and other friends were pulling together, in which he praised Alfred's photographic genius, his accomplishments on behalf of his and other arts, and the high moral standards under which he operated, it was years before he and Alfred felt warmly toward each other again. Certainly during the eight or more years of Strand's almost exclusive involvement with cinematography, as producer and/or cameraman, he felt far removed from Alfred's orbit.

Alfred was not entirely uninterested in films. Besides his somewhat uncritical enthusiasm for the Hollywood variety, he was hospitable to at least one experimentalist, a young cinematographer named Henwar Rodakiewicz, to whom he gave a screening at The Place in the early thirties. During one of several visits from Charles Chaplin, moreover, he confessed to having once considered making a motion picture to reveal the whole emotional range of a woman's life through alternating close-ups of her nude body with footage of clouds in motion. No actors; no text. Of course, he added, it was too late for him to try a new direction.

Charges against Alfred for inhabiting an ivory tower grew widespread when he excoriated the Federal Arts Project of the Works Progress Administration which, he fumed, was wrong on three counts. It lent credence to the ill-founded assumption that America had a great many artists; it required work that any true artist would find demeaning; and it paid peanuts. It was more likely to turn out assembly-line bargains in the mode of Henry Ford (Alfred's Public Enemy Number Two, after George Eastman) than anything of lasting value.

Although he made no effort to sway his artists' participation in the F.A.P., Alfred was pleased when Dove, remarking that a bull's "creative work" was better paid, turned down an F.A.P. offer of $34 for a forty-eight-hour week painting murals in a public bulding. Dove would

rather accept Duncan Phillips's offer of half that amount to work as he chose without a time clock. On the other hand Hartley, who had been pressing his friends for at least a year to lobby for government support of the arts such as existed in Germany, was delighted in 1933 to collect $55 a week from the F.A.P. for similar work between February and May. His enthusiasm was added at once to Alfred's long list of his sins, and was one more element in the extremes of squabbling and sulking that characterized his and Alfred's mutual behavior for the next several years. Through 1935, their relationship was all but incomprehensible to their friends. Battling fiercely all the while, Hartley, like Strand, wrote for the 1934 book a movingly generous tribute to Alfred that won them a brief reconciliation; and Alfred, while refusing to show his works at The Place, was the only one of Hartley's friends and acquaintances to invite him to dinner regularly through early 1935, providing the proud and near-starving artist his one full meal each week for nearly six months.

During the same early thirties years, Alfred's irritation with the "control" over American art exercised by wealthy women, in particular Mrs. Whitney and Mrs. Rockefeller, matched the way he felt about the F.A.P. These two phenomena—the privately supported museums and the publicly subsidized W.P.A.—would mark the beginning not only of a trying period for him but also, in fact, the start of the decline of his influence. Although he would never give up the fight, his enemy would turn out to be Hydra-headed, ironically deriving some of its energy from his own greatest victories. His early crusade for modern art had spawned galleries which, exploiting the receptive audience he had helped to create, became his hottest competitors. The very taste for the avant-garde he had helped to foster was beginning to militate against providing stability for his small band of artists by whetting the public's appetite for the ever-new, for this year's discovery. His forceful arguments to open the doors of museums to modern art and photography were being answered in the growth of dreadful institutions designed for just that purpose. Somehow he, who had been the lonely frontrunner in the race, was finding himself in the middle of a field of hundreds. Seventy years old in 1934, he lacked the energy for a new burst of speed. But he would not drop out.

The book Dorothy, Waldo Frank, and Paul Rosenfeld had begun working on in the fall of 1933 was designed to celebrate Alfred's seventieth birthday on January 1, 1934. Edited by them, together with Lewis Mumford and Harold Rugg, *America and Alfred Stieglitz, A Collective Portrait* was published finally in December of that year. Some of its longer

essays examined the social and cultural aspects of the America from which he had sprung and in which he functioned, and others recapitulated his personal background and career, paying tribute to his photography, his pioneering support of avant-garde art, and his multifaceted ventures as a quality publisher. Briefer contributions formed a garland of praise from artists, writers, and miscellaneous enthusiasts for his particular set of principles. When Dorothy showed Alfred the final proofs in October, she was fearful of his reaction. The original publisher, citing overlong copy, had pulled out abruptly in September; the rush job undertaken jointly by the Literary Guild and Doubleday was flawed both in typography and photographic reproduction. Alfred greeted it, however, as "a miracle." Viewing it at first as though he were not its subject, he was soon inveighing against the malicious bullying and cowardice of critics who used the occasion to attack him personally. Thomas Craven dismissed the book as the magniloquence of a Stieglitz clique, and Thomas Hart Benton castigated him for supporting antisocial and decadent art. The snipers were few, however, and most critics accorded it a generous reception.

To coincide with its publication, Alfred mounted an exhibition of his photographs—new prints of the fifty-year-old negatives he had found the year before in the Farmhouse attic, together with a respectable number of recent images of the city and Georgia; there were none of Dorothy. Over 1,400 people pushed their way into The Place during the show's first week, many of them drawn perhaps as much by the book's composite portrayal of Alfred as the latter-day Socrates and Diogenes of the American art scene as by the photographs on the walls. With a dependable guardian in the workroom (lanky Andrew Droth, skillful, unassuming, and soon totally committed to Alfred, had been hired for six fall weeks to help with matting and framing; he would remain twelve years), Alfred held court in his little office. He tended to his mail, greeted friends, and welcomed the occasional newcomer bold enough to cross the threshold and meet his level gaze over eyeglasses.

The freedom to enjoy his new limelight—wryly sometimes, as he recognized how much respect was engendered by his age—derived to some degree from the realization that Georgia's summer had been consistently beneficial. Almost too beneficial, for she had begun immediately after her October arrival at the lake to plan her April 1935 return to the little house she had rented at Ghost Ranch, a private community some seventy miles west of Taos that had been built by Arthur Newton Pack for the use of his cosmopolitan friends. Ghost Ranch was heaven, she announced, compared

to the dinky claustrophobic rooms at the Shelton, where her work was constantly being interrupted by chambermaids. Alfred, with the same naïve audacity of his long and personal letters to the Internal Revenue Service describing his work, his health, and his aims, immediately wrote his American Place landlords. Citing Georgia's unchallenged eminence as a "woman painter," her long illness, and the beneficial publicity that would shortly accrue to 509 Madison Avenue with the publication of his book, he suggested that they let her have, rent free, a small studio in the same building. As might have been expected by anyone but Alfred, his appeal fell on deaf ears. Georgia came to the city to help hang his show in late December and her own in late January, fled to Washington friends in late February, and was on the verge of organizing her April escape to Ghost Ranch when she was struck with acute appendicitis; she would not be able to leave until early June. Dove, at least, benefited from her delay; she bought six watercolor sketches from his mid-May show.

To fill the March slot, Alfred had hung, for the first time in seven years, the works of a European artist, George Grosz, a recent refugee from Nazi Germany. Considering the fury of Grosz's satire, Alfred's assignment of the writing of the catalogue to the one man who retained, as he did, a romantic attachment to the old Germany was distinctly odd. But once again, Marsden Hartley had won his sympathy. Not only was he in truly desperate financial straits, but he had been ostracized by his and Alfred's old friends Florine and Ettie Stettheimer, who charged that his undiminished love of Bavaria was tantamount to endorsing Hitler's attacks on the Jews. Finding the sisters' position hysterical, Alfred was as unwilling as Hartley to ascribe collective fault for Hitler's diabolic vision to the German people as a whole. Indeed, he would never repudiate his long-held conviction that what America needed most to fulfill its early ideals were the virtues he found in the German character: "soul," passion, conscientiousness, and pride in craft.

My first direct exposure to Alfred's convictions began in the summer of 1935, when my wish to see my father, then and thereafter in quasi-exile from the Red Top nunnery, increased the number of my visits to the Farmhouse. Often I found him on Alfred's porch, perched on the balustrade while Alfred basked in his wicker armchair. Their conversation was intermittent, their silences congenial. Sometimes I found them deploring the crassness of American life, sometimes gossiping about the regulars at The Place, sometimes inveighing against the sexual inconsistencies of women, sometimes speculating bawdily about Sel's latest beau—or chauf-

feur. They vied for the most colorful expression of their shared contempt for Lee's new wife; they sighed together over Mother's continuing beauty and erstwhile passion, lost now to her cloistering Hindu disciplines.

In the long hiatuses between my visits to schoolmates and theirs to me, my impromptu stops at the Farmhouse became increasingly regular, even when Dad was off on one of his periodic leaves. Alfred, who responded to the approach of my thirteenth birthday with special charm, became the major attraction. My visits were solo. Peggy, whose thirteenth birthday had passed uncelebrated by an Alfred deeply anxious over Georgia, found it *infra dig* to accompany me. Her surrender to his Pied Piper lure would come two years later, when she served as occasional scribe for his dictated reminiscences.

Alfred's conversational monologues ranged from the mysteries of Womanhood to the relations between art and society. Did I realize, he might begin, that America's high purpose had been undermined by its obscene scrabble for wealth? Even worse than the industrial and personal greed that ruined nature's grandeur and dehumanized cities was the avarice that wrecked man's sense of his own unique value. Some generous impulses might emerge from the Depression, but it was absurd to suppose that any federal arts project would enhance art, or that institutionalizing charity, which he detested as primarily a sop to the conscience of the haves, would rescue dignity. Americans, under the guise of seeking "security," cared fundamentally only about possessions. A race of Joneses vying jealously to surpass the material excreta of neighbors, Americans valued only things with price tags, and to hell with their minds, their spirit, their emotions, their ability to love. Craftsmanship was already beyond recall. A man's more noble qualities would shrivel up, unused, leaving only covetousness, suspicion, and hate. Power was in the hands of the rich and the insane. Look at Hitler!

I offered Alfred my reactions to Germany, garnered on my first visit the previous summer with my parents, sister, and grandmother Lizzie, who had financed our nongrand European tour literally with pennies saved from her housekeeping years with Lee. At first, forgetting the blond and shockingly handsome Princeton student who, on his way home to Berlin aboard the freighter on which we crossed, had argued Hitler's cause with chilling seductiveness, I had been struck by the weighted history of Heidelberg, the scenic beauty of the Black Forest, and the robustness everywhere. Then, suddenly, shattering the spacious elegance and gentle greenery of Munich and Karlsruhe, the cradle of Mother's philosophy and the core

of Lizzie's early life, loudspeakers from second-story cornices and the high crotches of trees blared martial music. Townspeople rushed to curbs to cheer or huddled against walls with closed faces. Troops of Brownshirts and Hitlerjugend burst around a corner, goose-stepping, glassy-eyed, proud. Later, invited to tea by one of Lizzie's childhood friends, we were swept into the garden for whispered conversation. She was terrified by what her maid of twenty years might pick up to report to the authorities.

Horrible, horrible, Alfred agreed. But people had better pay attention to what Hitler was saying. He was a fanatic, a degenerate, a madman, but he possessed genius. We had better stop lampooning *Mein Kampf* and heed its message. Anything could happen. Oh, God, what had happened to Germany! Not just with Hitler, but years, years before. When he had been a student, Germany had been a wonder: warm, open, rich in music, painting, science, literature, sports. Man was making the highest use of his mind, his spirit, his imagination. Then America ruined it all.

America? I was stunned. What had America done to Germany?

Now, see here! he shot back. Pay attention; I've just told you. America is a whore. Her pursuit of money, of possessions, will destroy the world. I saw it when I came back in '92; I *wept* with rage and sorrow. Eleven years, dreaming of my return. To find what? Only dollar signs. People who had money, and people who wanted it. Squalor. Filth. Emptiness. Bigness. Success. Garbage! Do you know what America's biggest export is? Greed. Capital G-R-E-E-D. *That*'s what we did to Germany. We sent it there, and they loved it. They put it into production; they became its biggest and most efficient manufacturer. We shouldn't have been surprised by the Great War—certainly our munitions makers weren't, they loved it!—and we shouldn't be surprised when the next one comes.

Oh, God! (a whisper). My heart . . . no, no, it's all right. Get me some water, there's a good child . . . Not cold! It's bad for the bowels.

When I returned, frightened, with the tepid water, his eyes were closed, his right hand thrust into his shirt. "Uncle Al?"

His eyes opened; a satyr's twinkle. His other hand grasped my knee. Nice firm leg, he said approvingly. Don't ever shave. No, you're not a child any more. Run along, or your grandmother will be scolding me again. Come again tomorrow.

By 1935, with a few exceptions, the Lake George pattern and rhythm were set for the next ten years. In 1934, when we had been abroad, Lizzie had given Lee and his new in-laws the use of Red Top on the proviso that they were not to intrude on Alfred. This year, Lee's wife insisted he buy a

Westchester vacation house (which he called Millstone). In 1936, however, he found a way to return to the lake. With the exception of one summer, Georgia spent from three to six months in New Mexico, timing her Farm-house visits as best she could to avoid the entrenched family.

Lizzie, the staunchest regular, was at Red Top from mid-June to mid- or late September, usually with Elizabeth and the girls, until their interests led them on lengthening sorties and eventually to marriages. Alfred's ar-rivals and departures varied according to his pace in the elaborate routines for closing the gallery, his health, and Georgia's plans, but for a good part of every summer he was at the Farmhouse, with Donald the part-time mandatory male presence in his backstairs cell, taking his meals up the hill. For most of the summer, too, Agnes inhabited the small downstairs bedroom, switching possession of the larger bedroom and sun porch up-stairs with Selma only when The Kid and/or George Herbert arrived. Selma, usually *in situ* for three weeks, came in a chauffeured limousine jammed with valises, hat- and shoe-boxes, and coats to supplement what she had shipped in a trunk. Who knew what she might need if Casanova materialized to sweep her off to Newport or Lake Como? Her costumes for every occasion, in silk, linen, chiffon, and cashmere, with appropriate jewels, contrasted markedly with her sister's delicately matronly wardrobe, and with the plus-fours Agnes donned for hikes that her lanky husband scaled down to her capacity. With their daughter, The Kid, he was more enterprising; at sixty-five, he tramped forty-three miles with her to lunch with friends.

Peggy and I were often the objects of jealous contests for our attention between Sel and Ag. Aunt Sel's bait was the chance to rummage in her personal boutique and hear her formulas for having brought men—of all ages and multiple backgrounds—to the altar of her femininity, apparently without giving up the Grail; she claimed that her son was conceived in innocence, a true virgin birth. (Nevertheless, a lapse in prophylaxis in her seventies sent her scurrying to Lee in fear of pregnancy, only to be told that she was more likely to have contracted "a dose" from her current Clark Gable, a purser on a cruise ship.) When, inevitably, our attention strayed, she assaulted our lack of poise, taste, and *savoir faire* with lectures on seductive but ladylike deportment, and with angry rearrangements of our hair to disguise overintelligent brows. Aunt Ag—blonde, green-eyed, diminutive as a chickadee, and just about as exciting—was at the opposite pole from dark Selma with the Stieglitz bedroom eyes, in both appearance and character. She was fearful always of losing us to her glamorous sister,

Alfred Stieglitz, the Farmhouse, ca. 1942 Georgia Engelhard

but her docility and patience usually won us to her private corner even after we had lost interest in the dolls' tea parties and sessions of cat's cradle she had offered us as tots. Both sisters took pride in luring us away from Alfred.

Alfred's active day began with sorting the first Farmhouse mail, delivered soon after his early breakfast. Letters to his sisters and guests were left on the dining table. Before reading his own in his study, he addressed envelopes for his replies—a pernicious habit that resulted all too often in missent checks and mixed messages, and was not cured even by Georgia's wrath in 1935 when she received a tender note meant for Dorothy. I was allowed sometimes in my early childhood (when Georgia was away) to pass a rainy morning in his study with a book that I often found less engrossing than Alfred's performance. He wrote at a table in the center of

the room; the marred Chippendale desk behind his chair, too high for comfort, was a repository for paper, first-aid remedies, collar buttons, string, manicure scissors, ink bottles, unread periodicals, a huge pastepot, and the tall new hand telephone. Stacking his addressed envelopes to one side and chewing a handkerchief edge, scratching his head, exploring a tufted ear with a gnarled finger, Alfred snorted and chuckled, hooted and sighed his way through the pages he had smoothed and collated on his large blotter. Those not thrown out or set aside, he answered at once in broad, almost impatient gestures, swiftly covering leaf after leaf of eight-by-eleven-inch bond in powerful calligraphy.

Correspondence dispensed with, he either set off for the post office, his round of miniature golf, and his chocolate ice-cream cone or for his wicker chair on the porch—to read, to catnap, to talk with guests, or to photograph with his eyes the grasses, trees, barns, and sky to which he might later bring his camera. The years of his active photography were drawing to a close. Although he sometimes toyed thereafter with a dinky borrowed camera, by 1938 his large cameras were retired for good. By the end of 1940, he would give up printing as well.

Preferring to hear the passionate Brahms and Beethoven of Red Top's Sunday musicales from the muting distance of his porch, Alfred rarely consented to join the more immediate audience. He found the amateur fervor and skill of the participants admirable (the only professional was the ex-Philharmonic cellist who came on alternate weeks), but he wearied quickly of their interruptions to resynchronize. Trios with Lizzie at piano, Elizabeth at violin, and Mr. Schenck at cello usually went smoothly, but autocratic Lee's violin and laughing George Herbert's second violin or viola in quartets or quintets could emit squeaks so excruciating that everyone was thrown into confusion.

By the end of the 1935 summer, my sporadic sessions with Alfred had left me sufficiently at ease with him, except when sexuality was the topic, to realize that I need no longer fear adult ridicule at The Place. If I never felt close enough to share my innermost secrets with him—as had, and would, other postpubescent girl relatives—my affection for him was nevertheless secure. And if, thinking him old and frail, I avoided challenging him with high-school political passions, I never again thought him awesome or remote.

Alfred's 1935–36 season at The Place was more productive than many before, although he suffered at its start the loss, within days, of two old friends, Lachaise and Demuth. Marin's star was in the ascendant despite

renewed attacks on his oils. The watercolors he had produced brought nothing but praise; a book of which he was the sole subject was published; and the Museum of Modern Art solidified plans to give him a one-man show in the fall of 1936. He was the first of Alfred's nurtured few to receive the MOMA's imprimatur. Alfred's view of institutions may have been harsh, but he recognized a coup when he saw one.

Hartley was back in the fold, after a Bermuda summer that replaced his customary dour tones with pinks, blues, and golds, and after an autumn living with a Nova Scotia family with whom he had fallen in love. Alfred, described by Hartley as "dearer than ever [with] quite a halo [emanating] from his smile," was heartened by the critics' unusually kind words for at least some of Hartley's paintings but pessimistic, as usual, about sales.

Unexpectedly, Dove's exhibition was a greater success than any he had had to date, although the $1,000 he received from the University of Minnesota's art gallery (twice the amount paid by Phillips for any equivalent oil) came too late to save the farmhouse he and Reds had been occupying. His wish to be rid forever of Geneva and the tangled Dove estate was yet to be fulfilled.

Best of all, the seventeen new oils Georgia brought back from New Mexico inspired critics to celebrate her recovery with praise for her new brilliance. Although direct sales were slow, her show's éclat won her a handsome commission for a large mural in Elizabeth Arden's new salon. Pleased this time with the fee (reputedly $10,000), Alfred consented even to accompany her to a glittering soirée at Arden's Fifth Avenue home. There, relieved of his shabby loden cape and battered porkpie by a supercilious butler, Alfred smiled up at him sweetly. "Sorry," he said, "they're the only ones I've got," and turned to accept the deferential greeting of his hostess.

The commission from Arden brought Georgia the confidence at last to insist that she and Alfred have their own apartment. In the fall, they moved to a penthouse at 405 East Fifth-fourth Street that, although small, had a terrace along three sides, with a commanding view of the Queensborough Bridge and the East River over the rooftops of Sutton Place's genteel mansions and more modest townhouses. Here Georgia created an environment that was a dress rehearsal of sorts for her eventual houses in New Mexico.

I remember well the brilliant whiteness of the uncurtained north- and east-facing living room, contrasting starkly with the near-black varnished

floor and charcoal-cushioned benches along two contiguous walls. Behind the benches, a long white shelf held Georgia's changing display of two or three favorite shells, or bones, or stones, with a pottery jar sprouting naked branches or sometimes flowers of a single color. Bright Navaho rugs were sometimes on the benches, sometimes on the floor; red or blue pillows accented the corner. Joining an occasional Saturday night at-home in winter, I never really saw the largest terrace section to the east; I think there was a low fireplace on the west wall, with perhaps the room's single displayed painting hanging over it. Was it a Dove? Georgia's easel, draped in a sheet, stood in a corner. As in the gatherings at Lee's house in earlier years, Georgia put together a large saw-horse table for breads and cheeses, wines, crudités, and fruit. And candles. I doubt I ever saw her room, or the room Margaret occupied during two winters of housekeeping —the same, perhaps, that later housed the friend Georgia arranged to have sleep in when she was in New Mexico and Alfred in New York: Davidson usually, or Zoler, or Ross. Alfred's room was a cell facing south, where the terrace was narrow, and furnished as he chose with a spindly bed, small table, battered armchair, and usually his steamer trunk, ready for transport to and from Lake George. Possibly there was a small chest as well.

Except for the renewed pleasure of his Saturday night gatherings, Alfred found little to please him at the penthouse. The heating was undependable, he complained, and he started wearing his coat, cape, and even hat indoors, as he did sometimes at The Place. The terrace he found unsafe; Georgia had rejected a safety rail, preferring the previous tenant's clipped privet and low white pickets. The whole thing was too expensive— not just the rent, but the need also to taxi to the gallery and back. *Everything* was too far away for easy walking: his favorite restaurants—one German, one strictly American (Child's), and the Café St. Denis, to which he had just been introduced by a new young artist friend, William Einstein. And his habitual movie houses too: the double-feature Loew's Lexington so convenient to the Shelton, and the Translux newsreel theater he had just begun visiting for an hour on Sundays on his way to The Place. Even when, stuck in the city for the better part of the next two summers, he was forced to acknowledge that a high and remote terrace was almost as quiet as the country, he continued to refer to its refreshing breezes as drafts.

Alfred's new young friend, Einstein, a painter and illustrator who was also a distant cousin, although they didn't know it until they met, quickly became the most active volunteer at The Place now that Dorothy's daily stints were a thing of the past. The two men had hit it off immediately.

Inside the unprepossessing features of a small bespectacled teddy bear with pudgy hands and a thin tenor voice, Einstein was a sprightly and passionate man. Quick of tongue and wit, knowledgeable about both the techniques and the history of art, a respectable if not a major talent, he was as scrappy and opinionated as Alfred. Winning Georgia's affection as well, he was invited in 1940 to share a month or more of her first summer as owner of the Ghost Ranch house she had rented for years. And in 1977, five years after his untimely death, Georgia credited him with having persuaded her finally to write about her life and work.

Soon Einstein was a friend as well of two generations of Doves and Marins, of Davidson and his daughters, of Kalonyme, Flint, and most of the others in Alfred's constellation. Between him and Dorothy, however, there was an immediate antipathy, based perhaps partly on subliminal rivalry for Alfred's highest regard. Clearly, Alfred was aware of it. Einstein seems to have been the only correspondent to whom Alfred expressed any misgivings about Dorothy's talents, her tact, her comprehension of his work, and, indeed, her understanding of himself. His implied attribution to Einstein of sensitivity and intelligence that was greater than hers arose probably in part from an embryonic wish that the young painter, the only person he seems ever to have considered seriously for the role, might be his worthy successor at The Place.

He would be cautious. First he would invite him to the lake for a few summer weeks in which to observe his abilities and reactions more closely. With time for a leisurely look, he would decide whether or not some of his paintings and drawings merited showing, and whether or not the manuscript he was working on matched the lively insightfulness of his conversation. Perhaps it *was* time to slow down a little; he was nearly seventy-three, and William was barely thirty. Unimportant maybe, but it was nice, too, that Einstein's grandfather had married a cousin of Hedwig's mother. Patience, he counseled himself. Time will tell.

22

Einstein's introduction to Lake George coincided with the eruption of family tensions that, although they had been simmering since the beginning of the 1936 summer, Alfred had chosen characteristically to ignore. As soon as Georgia had gone to the Southwest, and leaving the closing of The Place confidently to young William, Alfred had come to the lake in mid-June with Zoler—whom he described to William in mid-July, after a month in which Zoler had barely spoken a word, as the non-plus-ultra of some unidentifiable species. During that time he wrote friends of perfect harmony on the Hill. The single interruption had been a meeting at the MOMA at which he had taken over supervision of the four-color halftone reproductions of Marin's watercolors for his catalogue; Alfred wanted a quality job. Otherwise, he reported, he had no worries. Georgia was well, painting, and happy to see young Ansel Adams again—whose works Alfred had decided, after several years of critiquing, to show in the fall. Dorothy's new house seemed finally to be completed; Dove was optimistic, Marin in high spirits, and Hartley more than ever in love with his Nova Scotia hosts.

As Einstein's mid-August arrival approached, however, Alfred apparently thought it wise to caution him that the peace on the Hill was as queer as that prevailing among members of the League of Nations, which had been waffling since spring over what to do about Italy's annexation of Ethiopia, Germany's reoccupation of the Rhineland, and the hostilities in Spanish Morocco. Stieglitz hostilities were over the uses, not the possession, of land. To the family's continuing consternation, a spuriously rustic log cabin had sprouted on the Hill, obliquely equidistant from Red Top and the Farmhouse. It was Lee's; he and his wife were coming in the first week of August.

Throughout its construction, arguments had surfaced over the appropriateness of Lee's solution to his need for Lake George. Astonishingly, Lizzie had taken his side. He had as much right as any of them to use the

property, she insisted—or more, as he paid a larger share of the taxes. Why should he be deprived of the bracing Adirondack air, of his familiar walks, of the Saratoga track, of spins on the lake in his sporty Gar Wood speedboat, or of the chance to see Elizabeth and his granddaughters? Modestly, she declined to add that he now unabashedly missed her good sense and noncombative nature; Isolde had turned out to be a termagant.

To Alfred, Lee's gaucherie was far less offensive than the solidity of the cabin—called variously, according to Lee's mood, "Green Nook" or "The Last Ditch"—and the moving vans, supervised by one or another of Isolde's children, that raised clouds of dust on the road before and after debouching polished mahogany and English chintz. Lizzie's acquiescence, and his own wish for peace, led Alfred to be civil to Lee's stepchildren, but friendliness with the new "Mrs. Dr." was out of the question: among other sins, she was one of Emmy's more unattractive cousins. He went to childish lengths, in fact, to avoid addressing her. At least once, on a postprandial stroll with Davidson, he did an about-face when she appeared directly ahead, not ten yards away, and then claimed not to have seen her. Lee was so enraged that he refused to talk to Alfred for a month.

The real family battles began with the arrival of Sel, who refused to accept Alfred's ban on communication with their new sister-in-law. The two had been friends since childhood, she argued, and she was delighted that finally there was someone on the Hill besides herself who cared about proper table settings and the right way to do things. In fact, even without the Green Nook goad, Sel was on her very worst behavior—railing at Margaret to exchange sneakers, rolled socks, and housedress for correct servant attire, berating her chauffeur for not rinsing her voluminous bathing costume before hanging it on the line, howling at Lizzie for being late to crochet a cover for her hot-water bottle, needling Agnes to daily tears, and attacking Alfred for his selfish refusal to accompany her to the new Shirley Temple movie. Alfred wrote Dove grumpily that he hoped this crazy life was his only one. His slender hold on maintaining peace rested increasingly on warnings about aggravating his "rotten" heart.

It was this peaceful household that greeted Einstein on his first visit. There was worse to come. In the third week of August, with Lee temporarily absent, Alfred, his sisters, Margaret, Davidson, and Einstein watched in mounting horror as a telephone company crew planted four creosoted poles in a line from the Farmhouse, past the barn on the road's near side, to a fifth and sixth on its far side leading across the fields to Lee's cabin.

It was too much for Alfred. Proceeding up the chain of command from the installers to the head of the company in Glens Falls, he demanded the immediate removal of these desecrations to his beloved landscape. Impasse. Next he attacked Lee, long distance, and a few days later in person. Further impasse. Lee and the telephone company agreed that Alfred's suggestion to relocate the poles along the wooded south edge of the property some hundred or more yards from the road would be prohibitively expensive if not impossible.

Alfred exploded. The goddamn poles had to go! They ruined his barns, his meadows, his Hill; he would never be able to sit on his porch again; he might as well be dead. If he had a heart attack, it would be their murdering fault! He won. It would take the implied threat of legal action by George Herbert, but the next year, the poles were reset unobtrusively enough to win Alfred's acquiescence.

Einstein weathered the storm well, displaying just the right proportions of sympathy, levity, and tact to restore Alfred's equilibrium, and redirecting his attention to the defense of his title as miniature golf champion. All went well until the eve of William's departure, when a bizarre accident shattered the hard-won peace. An exceptionally cool September day prompted Green Nook's Danish housekeeper/cook to welcome her briefly absent Madam and the Doctor to their final country weekend with a good warming fire. Unaware that the builders had neglected to remove the chimney's interior framing, she ignited her generous pyre. Flames roared high into the sky, spewing a fountain of incendiary fragments over the roof.

Thanks to the quick response of the volunteer Engine Company, the fire was doused in a matter of minutes but, just as quickly, the Hill was aswarm with all manner of sightseeing vehicles. Trucks and cars and motorcycles, headlights bouncing and horns blaring, thundered past the Farmhouse and over the meadows in an unstoppable tide, ignoring the road. The townsfolk were not about to miss their first opportunity in nearly fifty years to invade the Stieglitz enclave. It took the local constabulary the better part of an hour to disperse the unwelcome traffic. In the morning, the grounds resembled the site of a tank battle. And an already shaken Lee was met with Alfred's stentorian charge that his goddamn house had invited the rape of the Hill—a blast from which Lee emerged stone-furious and Alfred insolently gay.

Whatever impact the family storms had on Alfred's mood, it was clear that Einstein continued to enjoy his favor. Without great enthusiasm either for the Maine seascape oils William had brought to the lake or for the

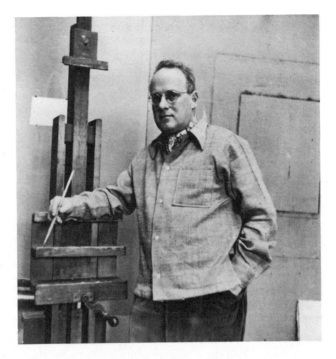

William Einstein,
ca. 1955 (?)
Anonymous

small portraits he saw later in New York, Alfred agreed nonetheless to launch him in the same opening show that marked Ansel Adams's debut at The Place in October. The Einsteins in the small room elicited little critical comment, but their display served at least to tie William to the gallery when Alfred had need of his daily assistance.

Adams's show, on the other hand—an eclectic group of still-lifes, portraits, barns, houses, streets, and a few forerunners of the Yosemite and Sierra Nevada landscapes that would become his hallmark—gained wide and profitable acceptance. Expecting the critics to react with "90% slams, 9% milky comment, and 1% approval," Adams was astonished to receive a far heavier proportion of both praise and dollars. Four prints were acquired by David McAlpin, a MOMA trustee with whom Adams and Beaumont Newhall would establish the museum's photographic department in 1940. Alfred's pleasure, meanwhile, was heightened by a sense of personal kinship. He and Adams were well matched both as photographic philosophers and artists, sharing affinities in technique and intent that, albeit compositionally divergent, easily bridged the nearly forty years between them.

There would be only one other photographer to whom Alfred felt as close. In December 1938, after four years of occasional critiquing, he

provided a debut for thirty-seven-year-old Eliot Porter, whom he had met through his painter brother, Fairfield, and of whom he had heard through Adams. A Harvard Medical School graduate and bacteriological researcher, Eliot was encouraged by both Adams and Alfred to work harder at his photographic hobby. At the end of his highly acclaimed three-week show (from which, again, McAlpin bought the largest number of prints), Alfred wrote Porter that some of his images were the first he had ever seen that, incredibly, expressed his own photographic spirit. The show marked a new beginning for Porter, who thenceforth devoted full time to photography—and a swansong for Alfred, who would never again exhibit photographs except for a few of his own in a mixed-media group show in 1941.

Alfred's need for Einstein's regular presence at the gallery in the fall of 1936 was nearly as strong psychologically as it was practically. Dorothy, formulating plans for a new publication, was a rare visitor, although she and Alfred communicated daily by telephone and she continued to manage the Rent Fund. Georgia, who had returned briefly to Lake George to pack up and supervise the transfer to the city of a modest miscellany of household essentials, her sizable collection of bones and stones, and another old armchair for Alfred, had let Alfred know that he would only be in her and Margaret's way if he tried to help in the move to the penthouse. Briskly efficient, she found time somehow to participate in hanging the 225 works selected for Marin's October solo at the MOMA as well as the nearly simultaneous Adams/Einstein show at The Place. In late November, after Alfred and William had installed a group retrospective of Demuths, Doves, Hartleys, Marins, O'Keeffes, and Beck Strands, Georgia was ready to launch the penthouse with a series of Saturday night gatherings for Alfred and his friends. Of the several I attended, as adjunct to my father, I remember only one clearly.

Counting me, there were three women. Georgia, refusing to allow herself to be pinned in any discussion, concentrated, as did Margaret, on maneuvering refreshments, returning regularly to the kitchen for replenishments. Among the men were a number of newspaper critics and arts reporters I had not met before. Doing my best to elude Zoler, who vaguely unsettled me, I focused on the people I liked: Marin, who joked with Dad and me and talked earnestly with Alfred; Cary Ross, Ernest Guteman, and Jerome Mellquist, who argued the finer points of aesthetics in a corner with Fred Ringel; and Kalonyme, who, in a gesturing, impassioned flow of sorrow and anger over the taking of Madrid by Franco's forces, held the

attention of a somber group at the far end of the room. Among my familiars, the only absentees were Dove, marooned in Geneva, and Einstein, visiting his family in St. Louis.

Seated near the door to his room amid a shifting cast of hoverers, Alfred seemed frail and perceptibly weary but exhilarated as he was usually in the presence of friends. Barely three weeks had passed since the January 10 death of his brother Julius in Chicago. Alfred had blunted the sharpness of his sorrow in work, but he was still haunted by the reminder of his own vulnerability and by considerable fear for Lee: excepting this occasion, the twins—separated for forty years by a thousand miles—had suffered simultaneous and identical illnesses. Alfred's worry this time was unfounded. There were nearly ten years ahead for him, and twenty for Lee.

Alfred's habitual worry about his artists—their bouts with illness, emotional trials, fallow periods, and finances—were not so readily allayed. Marin's MOMA show, its follow-up tour, and the solo exhibition its success generated at the Phillips in Washington attracted a new following to the sixty-six-year-old artist—and to An American Place, when his new works were shown in January 1937—but even the virtuosity that would lead Henry McBride two years later to call him "The Prince of Watercolorists" did not guarantee him security. Or, indeed, satisfaction. His oil "children" would not gain a cordial reception until 1942, when he abandoned, temporarily, his earlier heavy impasto for an almost transparent gouache effect —lacy with areas of unpainted canvas—that was closer to his watercolors. Dove, of course, was a perennial source of worry. Although in 1937 he garnered a more sympathetic reception than before, and more cash, it was not enough to prevent foreclosure on all the remaining Geneva property save modest quarters for his younger brother Paul. The most difficult of all, though, was Hartley, whose late spring show would be his last at The Place: he was becoming too much for Alfred to handle at all.

Failing in health, and deeply depressed since the fall drowning of both young men in his Nova Scotia host family, Hartley's near hysteria and lack of direction might have gained Alfred's sympathy had it not been for the hostility that accompanied them. Hartley had written for his catalogue that he was hoping for a prodigal's welcome from "patient and forgiving Maine," but he was still seething over the critical roasting the year before of his German landscapes for which, paranoiacally, he held Alfred responsible. Why else would Alfred's advice to return to his roots have been echoed in the press? By the time his show was over, his squabbles with

Alfred had become so hot and his words so vituperative that both were ready to call it quits. Justifiable or not, Alfred's anger spurred him to give Dorothy a scathing letter he had written Hartley after their first falling-out in 1923 for inclusion (without naming Hartley) in the first issue of her impending magazine, *Twice A Year*. Obviously, he felt that the gross insensitivity, ingratitude, and destructiveness he had attributed to the artist fifteen years earlier was still an accurate assessment. Obviously, too, he was relieved when Hartley was taken on by another gallery.

Nevertheless, in 1941, they made up again. Hartley, in residence for the next three winters at the Hotel Winslow, a few blocks away, took to visiting The Place almost every day. Without the contentions over exhibitions and money that their earlier relationship had suffered, he and Alfred were able at last to achieve a certain quiet companionability. I came upon them once on a spring Saturday in 1942 or 1943. Alfred was lying on the cot Dorothy had installed in his office, and Hartley was sitting stiffly in what Alfred called "his" chair, his overcoat still on, his once protuberant electric-blue eyes pillowed in cheeks no longer lean, swollen hands clasped loosely in his lap, and ankles, shapeless, spilling painfully over the rims of his shoes. Greeting me in a near whisper, Hartley returned to his unseeing squinted stare at the shaded window while Alfred raised himself for my anticipated kiss. At just that moment, the wail of the air-raid siren, tested daily at noon, rose deafeningly from a nearby rooftop. Alfred, as was his habit, quickly lay down, pulled a cover over his head, and remained motionless until the all-clear signal sounded. I used the time to make a round of the gallery. When I returned, Hartley had not moved except to open his eyes. Alfred, his white hair as frazzled as an old feather duster, was sitting on the edge of his cot, intently tying a second or third knot in the worn lace of a crumpled shoe. There was something so domestically comfortable, so cosy, about their silence that the remembered years of Alfred's fulminations about Hartley seemed wholly unfitting.

When Hartley died in September 1943, Alfred conceded that the transferral of his works to other hands had not only relieved Alfred of worries that were greater than those he felt on behalf of all his other artists together but also had helped bring Hartley more money and greater acclaim than he might have had if he had stayed. He missed him.

Pleased as Alfred was by the cheers that greeted Georgia's 1937 show, he resented the widely drawn inference that the exuberance of her new canvases—especially of the one she had stubbornly called *Summer Days*, a deer's skull floating against fluffy clouds in a blue sky over red

hills, sniffing a posy of brilliant wild flowers—was attributable largely to her freedom in New Mexico. Dorothy's new freedom from him, immersed as she was in *Twice A Year*, was nearly as galling. Only he and Einstein, he felt, had derived anything positive from The Place in a long and busy season. It was a bittersweet conclusion: during the spring, young William had tactfully withdrawn his candidacy as Alfred's heir to The Place, citing as reasons an incurable wanderlust and ambitions both to paint and to publish on his own. For a moment, Alfred wrote Einstein, he had thought of resurrecting an earlier dream that Dorothy might take over the reins, but had come to the conclusion that she must follow her own star. There was no way out for him, he sighed; it was his job to preserve the absolutely "clean edge" of the gallery for his irreplaceable triumvirate—Dove, Marin, and O'Keeffe. Beneath the air of resignation, a triumphant note suggested that no one but himself was suitable, not Dorothy or Einstein or X—or, once, Strand; he alone was indispensable. He would never again consider a deputy.

Georgia's insistence on a real home in the city, removed from the transient atmosphere of the Shelton, was a promise of sorts to Alfred that she would not suddenly desert him, but it required a *quid pro quo*. Once and for all, he must come to terms with the fact that her summers in New Mexico were not subject to annual negotiation. Voluntarily, then, she accompanied him to Lake George for two weeks before leaving. There she found an unexpected ally for her cause in the head of the new Hindu center in New York that Elizabeth and Donald had helped to found. Young Swami Nikhilananda, boarding at Oaklawn Lodge for the 1937 summer while completing a book, was one of the few new visitors to the Hill to be welcomed wholeheartedly by both Alfred and Georgia. Brilliant, sophisticated, and witty, he was also deeply understanding of the stubborn imperfections, his own included, of the human animal. He now offered the age-old counsel of Hindu philosophy: contentment in later life rests on the ability to become emotionally disengaged. It was exactly the message Georgia was trying to convey to Alfred.

Notwithstanding his affection and respect for the young guru, however, Alfred resisted the broader implications of this particular advice. Conceding that growing old was an indecent performance to which some adjustments had to be made, he insisted nonetheless that *he* was too damnably young at heart to welcome monasticism. And fell, privately, to musing about Dorothy, the beautiful kid with the sensitive mind and soul, preoccupied now with her magazine. Two weeks after Georgia's departure, as if

to prove absolutely that age would not defeat him, he was reeling with joy over three days of revealing talk with Ann Straus, a grandniece not yet fifteen whom he'd barely known before. This new child/woman, he wrote Einstein, was just [what he needed . . . etc.] now. He felt reborn.

Over the next four years, feeling alternately young and old, healthy and desperately ill, Alfred carried on a steady correspondence with this "100% alive" kid. Counting her visits as gifts, he applauded her birthdays (she turned sixteen when he was nearly seventy-five), saw her through her first loves, and fell more than a little in love with her himself. He would not entirely regain his equilibrium until the end of the 1941 summer, when she introduced him to her fiancé. O'Keeffe, when she met her, was amused to find, to Alfred's incomprehension, that she strongly resembled Dorothy.

As the 1937 summer wore on, Alfred's exhilaration gave way to a melancholy so transparent that Georgia offered to return early from the Southwest. Having won her sympathy, he assured her that he was all right, and declined. But his megrims persisted. He could not get over the realization that, having for years rationalized his refusal to travel with Georgia as a matter of principle, he had forfeited his last opportunity. While she hiked, rode horseback for days on end, camped out beneath the stars, he was virtually housebound. Notwithstanding the renewed exercise inspired by his "rebirth," he was able to spend at most two hours in the darkroom, and was too exhausted by noon to face the rest of the day without a nap.

To make matters worse, there were daily reminders on the Hill of the chasm separating youth and old age. Lee's wife was incurably ill with Bright's disease (she died two years later), and Lee himself was moving perceptibly slower. Julius was dead. Lizzie stumbled arthritically up and down the hill. Selma's flirtation with visiting Ralph Flint, the startled paradigm of New England reserve, was grotesque. And Ag, inching from chair to chair with her book, feared that her irregularly beating heart, like Alfred's, presaged trouble. Alfred's whole generation was effortlessly outstripped even by nonathletic Elizabeth and her Swami. Worse still were the teen-aged Davidson girls, partying every night with their spry father and Einstein, and rising bright-eyed next morning to swim, canoe, and play tennis at the club. Worst of all was the offense to Alfred's teetotal sensibilities provided by William—*his* William—inescapably a more raucous and less cautious drinker than Dove and Reds, who made bathtub gin during the Depression; than Marin, who daily cured a late morning "weakness in

the knees" with a pony of whiskey; than Davidson, whose Scotch-nipping rarely produced anything more undignified than a slight list, a dispensation of clairvoyant advice to astonished strangers, and a spate of Gaelic verse.

When Alfred returned to New York, nostalgic for the old days, he prepared a retrospective for the opening of The Place. With a catalogue written by Dorothy, "Beginnings and Landmarks, 291: 1905 to 1917" was on view for two months. It was virtually ignored. For the first time in Alfred's gallery life, a Saturday afternoon, customarily the most crowded time of the week, produced not a single visitor. Bewildered, he wrote Dove wryly that The Place must be under Hitler's ban. He'd have had a mob, he conjectured, if he had called the show "Original Sin."

He was wrong. The fact was that, no matter how exciting and revolutionary it still seemed to him, a backward look at pre-World War I art held little interest for a public restlessly attracted to novelty or, if it was to be given a history lesson, to the museum-certified. Furthermore, the shockwaves of the times were coming not from art but from world events that impinged gradually and irrevocably on even those who tried their utmost, like Alfred, to remain aloof. By the end of 1937, the Spanish Loyalists had been forced to withdraw to Barcelona, their penultimate retreat before Franco's victory. On the other side of the world, the Japanese had seized Shanghai, driven Chiang Kai-shek to Hankow, and, by a probably calculated mistake, sunk a U.S. gunboat and several American tankers.

If the vast majority of Americans still ignored events abroad, it was not particularly surprising. For eight years they had been preoccupied with the slow and difficult climb out of the Depression. Although extremists had gained heavy support during the process (Father Coughlin and the German-American Bund on the right and the Communists on the left), most Americans sought homogenized security. They were convinced, as they had been in 1914, that if the conflagrations overseas were ignored they would burn themselves out. In 1937, furthermore, they had repeated assurances from Britain's Prime Minister Neville Chamberlain that Germany, like the rest of Europe, desired only peace.

Outside New York and a few other East-Coast cities hosting German refugees, Americans were either indifferent to or skeptical of the plight of the Jews, whom they regarded generally, in any event, as a queer, self-isolated race of merchants, usurers, intellectual snobs, and communist provocateurs. Even in New York the early efforts of refugee committees to awaken moral indignation and financial generosity often backfired. The

first waves of relatively well-off refugees, indeed, were perceived as arrogant and rude—ingrates who considered themselves a cut above ordinary Americans.

The perception did not go unshared by second- and third-generation German-American Jews, who welcomed scientists, musicians, scholars, and writers, but were not so hospitable to others. Unless relatives were in danger—and even relatives might better be helped to reach "safe" England than one's own doorstep—it was hard to contemplate responsibility for Jews *qua* Jews. This apparent indifference, mirrored, incidentally, by that of American Catholics toward their coreligionists in Nazi concentration camps, had roots in the nineteenth-century German-Jewish attitude to the rest of European Jewry. In Germany, their ghetto was largely cultural. Accepted as functional merchants, teachers, and professionals of a larger society, they had not for generations been the victims of pogroms. In America, furthermore, the nineteenth-century immigrants were assimilationist at least to the degree of exchanging orthodoxy for the less visible Reform movement that had been born in Germany and the Low Countries.

The children of Edward and Hedwig Stieglitz felt no connection at all to Judaism, either familial or religious. Those American cousins with whom they maintained contact had either, like themselves, abandoned religion entirely, or had substituted for Reform Judaism an affiliation with the humanist Ethical Culture movement. Temple-going cousins were dropped. From time to time, Alfred and his brothers and sisters might boast that their intellectual superiority came from Jewish genes, but their tone implied remote forebears. In the 1930s, they identified neither with the victims of Nazism nor with their would-be rescuers. Sometimes, on moral grounds, they gave vocal and/or financial aid, but it was impersonal. Although even Selma was finally shocked by the Nazis into curbing her more venomous remarks, her new sympathy was barely stronger than that she felt for animals in a pound. At the other extreme, Lee, in a moment of blind fury, proposed that the potential mothers of the Master Race should be sterilized, earning Alfred's comment that his brother would out-Hitler Hitler.

Although moved always by individuals suffering injustice, Alfred did not readily empathize with groups. It was some time before he believed that reports of Nazi brutality were anything more than new expressions of anti-German propaganda; even then, he did not feel that the German people could be held responsible. They had been duped by an evil regime.

Had it not been for his lifelong inability to express his deepest anguishes, as over his sister Flora's early death and Kitty's catastrophe, his silence later about Hitler's "final solution" might have been taken for cold indifference instead of the strategy for personal survival that he had always practiced: to concentrate on the tractable world of his ongoing responsibilities.

The mob that was conspicuously absent from the 291 retrospective at The Place appeared as if by magic as soon as Georgia's show opened. It was a phenomenon that would be repeated in every ensuing year, regardless of the state of the world and regardless even of the critics who, in the 1938 winter, scolded her for repetitious focus on skulls and flowers, the very ingredients that won her her first spread in *Life* magazine in the spring.

Battling weariness, Alfred carried on virtually alone at The Place through the next two shows. Einstein, eager to paint again after completing lithographs for an art press book, had returned to his beloved France; Dorothy was feverishly readying her magazine; Georgia was pulling together a special exhibition for the College of William and Mary, from which she would receive her first honorary degree in May. Shrugging off as insignificant his own receipt of City College's Townsend Harris award for "conspicuous post-graduate achievement," Alfred struggled again to bring Marin and Dove enough to see them through the year.

For Marin, it was unusually difficult: his uncharacteristically somber paintings reflected a year so dark that Alfred was moved to suggest, for the first and last time in their relationship, that he abandon this new direction, if that was what it was. For Dove, however, it was surprisingly easy. In the year of his calamitous loss of everything in Geneva, Dove's paintings, sunlit and jubilant, brought warm praise from the critics and a check large enough for his and Reds's purchase of the tiny vacated post office in Centerport. But he was worn out. Before the end of their first week in their new home, he succumbed to a pneumonia so severe that his recovery would take nearly a half-year.

Within only days of Dove's collapse, Alfred, equally exhausted, was stricken with a near-fatal coronary. Two weeks later, he developed double pneumonia. Five weeks passed before he was able, with a nurse at his elbow, to stagger to a chaise on the penthouse terrace; another six weeks went by before he was strong enough to pick up his pen and resume contact with the outside world. For once, he did not dramatize descriptions of his illness. His major complaint, suffered also by Dove, was a plague of

genital/scrotal itches that may have been a side effect of the medication for pneumonia. For a year or more, they compared symptoms and swapped remedies with therapeutic ribaldry.

For something over a year after Alfred's coronary, it appeared that his illness had gentled him, as if his earlier view of himself as an embattled young man handicapped by age had been exchanged for peaceable acceptance of his years. His contentiousness faded. Shortcomings in others he had once classified as personal disloyalty or violation of the Spirit of The Place were taken with a more philosophic calm. At Lake George after mid-July, he dealt equably with family disputes over his nephew Edward's divorce and Elizabeth's decision to go to India with Woodrow Wilson's daughter Margaret and another woman friend, under the guidance of the Swami. He empathized with Lee's guilt over being inadvertently absent from his wife's death-bed. His serenity soothed Georgia, suffering a bursitis attack that delayed her departure for the Southwest, and helped make their three weeks together at the Farmhouse quietly idyllic. His only two regrets, he wrote Einstein, were having come to the lake without his photographic equipment for the first time in fifty-five years—he wanted especially to photograph Georgia, whom he found more beautiful than ever—and having lost a measure of his self-confidence to the conviction that another coronary was inevitable.

When Georgia was gone, he enjoyed a new pastime: dictating isolated reminiscences to Cary Ross, some of which would be edited and printed later by Dorothy in *Twice A Year*. Now the sole editor, she had already decided that the first issue, to appear in November, would contain reproductions of some of Alfred's well-known prints. An August visit from the child/woman who had so entranced him the year before awakened new fantasies, and opened his eyes to the ripening forms of the Davidson girls when they returned from camp. "Two busters," he described them to Dove, noting also that he thought the world pretty swell despite its ubiquitous blunders. He would not participate in arguments over Chamberlain's Munich peace pact that erupted at his first Saturday gathering at the penthouse. Nor, indeed, would he allow himself to get excited over the portentous events of the ensuing year: Franco's victory in Spain, and Hitler's occupation of the Sudetenland, Bohemia, and Moravia, his conquest of Czechoslovakia, his alliance with Mussolini, or even his surprise nonaggression pact with Stalin. He would try instead to learn to pace himself, to concentrate his daytime efforts on his remaining Big Three, and to limit his Saturday evening revels to taking a few of "the fellows" to the Café St. Denis

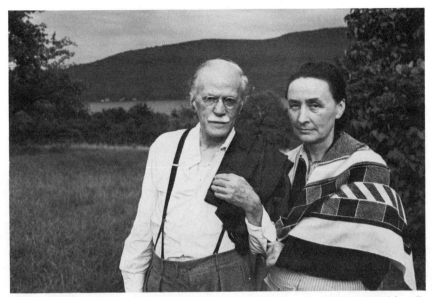

Alfred Stieglitz and Georgia O'Keeffe, Lake George, ca. 1938 Josephine B. Marks

for dinner and dispatching them thereafter to Child's for drinks and conversation while he went home to bed, or welcoming them to the penthouse around eight o'clock, remaining with them until about nine-thirty, and then retiring to his room to listen on the radio to the Toscanini NBC Symphony broadcasts that Georgia attended in person. Like as not, he would be asleep long before conversation in the living room had ceased. From time to time, the gatherings included Davidson accompanied by one or the other daughter, home for a weekend from college or boarding school. The arrangement suited all. Georgia and Alfred could both escape, while their hospitality provided his friends with the chance to pick up where they had left off the week before.

The rave notices that greeted Georgia's January 1939 show provided her less excitement than the trip on which she embarked a week later. During the summer she had been one of several artists asked to undertake a commission for the Dole Company. In exchange for two paintings, not necessarily of pineapples, that could be used thereafter as advertisements, she had accepted an expense-free sojourn in Honolulu. Alfred had acquiesced with relative calm, aware that this was a once-in-a-lifetime opportunity and determined not to worry over her. He was, however, worried about Dove, whose routine tests following a heart attack had revealed that

he was suffering also from Bright's disease. The news had been kept from him, but the outlook was grim. Alfred urged him not to fret about postponing his show until Georgia returned at the end of March to hang it. He would simply extend her exhibition, and Dove would have time to produce a few more pictures, if he liked, even though he was confined to bed.

In Hawaii, Georgia was intoxicated with nature's extravagance but balked at Dole's refusal to allow her to live among its plantation workers rather than in the suitably classy Honolulu housing provided her. Being Georgia, she moved herself to Maui to live as she pleased, drove a banana wagon, and painted whatever took her fancy—almost everything but a pineapple. A month late in returning (Alfred had meanwhile hung Dove's show alone), she chose two small oils for Dole from among her resplendent crop: a ginger flower and a papaya tree. When Dole, whose major competitor marketed papaya, rejected the second, she was justifiably furious; they had told her she was free to choose her own subjects. Dole immediately shipped a huge pineapple plant to the penthouse by air, and Georgia, still fuming, agreed reluctantly to paint it. She had to admit it was beautiful, but it was symbolically offensive. Daily for three weeks she tackled the assignment. Then—frustrated, sleepless, suffering the severe headaches that had preceded her 1932 breakdown—she gave up, and was put to bed for a rest cure.

Complying with her need for quiet, Alfred increased his hours at the gallery. He installed a radio so that he could tune in on horseraces, baseball games, and concerts, bought a new pile of books, and began rummaging through twenty-two large boxes of his prints. Phillips had asked him to make selections for a November show at his Washington gallery. Deciding that it was pointless to make plans for the lake until Georgia had finished her assignment for Dole, he called in Cary Ross to resume his growing collection of reminiscences.

Perhaps it was this exercise that changed Alfred's attitude toward Georgia's torpidity from the profound concern and guilt he had felt six years earlier to an uncomfortable impatience, a faint suspicion that she might be malingering. Reconstructing his past with Ross, he was struck repeatedly by stoic images of himself. The lad accumulating laps around the furnace despite excruciating weariness; the youth staggering hundreds of miles over mountain trails under heavy cameras and plates, working through lonely nights in Vogel's laboratory; the man in middle years, conquering adversity and the desertion of one after another colleague. Hadn't he now, at seventy-five, overcome a major heart attack and re-

turned, by force of will alone, to his post? Look at Dove. Felled repeatedly through the year and working now from a wheelchair, he had finished more than forty watercolors in less than five months. If Georgia would only summon up her will power and finish the damned picture, she'd be on her feet again! (Amusingly, nearly fifteen years after Alfred's death, Georgia would exhibit the same impatience with me when, confined to bed in a fruitless effort to avoid spinal surgery, I failed to conquer helplessness. "Oh, get up!" she said. "Walk! Staying in bed never did anything for anybody!")

Laid up for the better part of eight weeks, during which Alfred vacillated between worry and impatience, Georgia finally finished the Dole pineapple, and was ordered immediately to her doctor's country rest home for a fortnight. The separation was salutary for both of them. In her absence, Alfred resumed preliminary work on a job he thought might never come to fruition. In late May, he had been asked by David McAlpin to pull together some of his prints for the scheduled December 1940 opening of the MOMA's new department of photography, of which he was Trustee Chairman. Refusing either to consent or to refuse absolutely, Alfred had ordered thirty-six large boxes for a reassortment of his *oeuvre* that he decided was necessary in any event. Surprised by the quality of images he had not seen in years, and stunned by McAlpin's immediate payment of $1,000 for three of the five of his prints that were the museum's first photographic acquisitions, Alfred found himself in high spirits once more. When Georgia, on her return, suggested spontaneously that she take him to Lake George in the new car she had decided to buy, he was delighted. There, free of tension despite the presence of his sisters, he felt so well that he resumed his rounds of miniature golf. Two weeks later, on September 2, he suffered a severe attack of angina.

Eighteen days later, convalescing in New York, he attributed his collapse to a year of stupid overexertion—carrying on all alone at The Place, worrying about Dorothy's magazine and about Dove's and Georgia's maladies—and to the news on September 1 of England's and Germany's declaration of war, on the heels of Hitler's invasion of Poland. Once again he described himself as having lost all feeling for the Hill. The only thing he wanted was to get back to the darkroom.

He would have his wish, in short sessions, during the ensuing year, but there would be no more photographing, even with a borrowed camera. The deprivation would spur his envy of the advantages shared by composers and writers and even Dove: *they* could work in bed.

Alfred's clock was slowing down. He would experience occasional sudden bursts of energy, but they would be brief. And without energy, there was no way for him to buck the tide of America's increasing involvement in the war and its concomitant quickened tempo in everything—not least, where he was concerned, in the art community's leap into international waters. An American Place would become a kind of backwater. A haven, to be sure, for those who sought the reassurances of continuity, but a backwater nonetheless. While, perforce, America's energies were being sucked into every corner of the world, Alfred's universe was becoming increasingly circumscribed. His final years would be spent in an isolation far more numbing, immutable, and bewildering than he had ever dreamed possible. Despite all his efforts, the desertion he had protested so often, so illogically, and so loudly, would finally come to pass.

23

Admonished by brother Lee not to overdo, Alfred opened the 1939–40 season with a thirty-three-year retrospective of Marins that were not for sale. They were drawn largely from his own collection, in which one representative work taken annually from each of his three major artists formed a chronology of progress that he intended should remain intact. Uncontrolled dispersal of their work, he felt, would have been tantamount to parcelling out individual speeches from a Shakespeare play. Mindful nonetheless of Marin's need to earn, he consigned twenty watercolors to the Downtown Gallery for simultaneous exhibition and sale. His ability to obey Lee's orders was enhanced by Dorothy's contribution of the cot in his office, mentioned earlier, and the part-time help on weekdays of her two secretaries. By December, he would be vigorous enough to rally to the defense both of Marin's abandonment of an earlier Oriental delicacy for a weightier statement in oils and watercolors and of his painstakingly hand-carved and painted frames. Furious at the press for castigating or ignoring the new paintings, Alfred blamed New Yorkers for being Finland- and Picasso-minded. Picasso's *Guernica*, which Alfred later found extraordinary, had just been unveiled at the MOMA; Finland had been invaded by the Russians.

It was the first of a combination of simultaneous but unrelated events on the art scene and on the world's battlefields that would draw attention repeatedly from the measured continuity of An American Place, where, by 1942–43, exhibitions would be reduced to three a season—one each for Marin, O'Keeffe, and Dove. Except when one of them was deemed personally newsworthy—as when the World's Fair Commission in 1939 named O'Keeffe one of the twelve most outstanding American women of the previous fifty years—there would be few headlines about Alfred's group. To be sure, there were feature articles in magazines from time to time, and newspapers paid tribute to age (Marin turning seventy in 1940 and Alfred eighty in 1944) as well as to the accumulation of honorary degrees, mu-

seum acquisitions, and exhibitions, but the focus was less on the artist's *oeuvre* than on his or her person. Although O'Keeffe's pelvis-and-flower compositions of 1943–44 and Marin's lighthearted introduction of bouncing nudes to his 1942–43 seascapes were deemed good copy, they elicited more speculation about motivations than commentary on artistic merit. The happenings at Alfred's gallery that had brought reporters to the door for nearly four decades were henceforth given sometimes as little as a perfunctory listing by a desk-bound editor. Had it not been for Phillips's small but now regular payments to Dove and Marin, as well as for the gradual rise in museum acquisitions effected by such people as Alfred Barr and Philip Goodwin at the MOMA and Francis Henry Taylor at the Worcester, Massachusetts, museum, the growing isolation of The Place might have been a serious handicap to both artists. Georgia's situation was significantly better. Despite Alfred's annual fretting over the procrastinations even of her fans in translating praise into cash, from the end of the thirties on her finances were secure.

In the winter and spring of 1940, notwithstanding his usual complaints, and his worry over the relapse Dove suffered following his first visit to the gallery in over a year, Alfred found much to enjoy. An acquaintance with Henry Miller blossomed into friendship, more than compensating for the huffy withdrawals from his orbit of Dahlberg and Waldo Frank. Occasional evenings alone or with Davidson at *infra dig* double features were happy escapes from the real and troubled world. And throughout the long season, he experienced the mixed emotions of a young man secretly in love. Every visit, every letter, every phone call from his treasured Ann, now seventeen, who would begin the following year to extricate herself from his concentrated devotion with gentle tact and precocious maturity, was occasion for youthful dreams that were marred only by the realization that any overt advance from him would send her skittering away. Sometimes his tumultuous feelings about her spilled over to a sympathetic stranger; he told his familiars only that he was delighted to have another "fine kid" as a friend. His deepest regret, however, was the knowledge that he would never photograph her; his eloquent camera was out of reach for good.

Through months that saw Hitler's sequential invasions of Norway, Denmark, the Netherlands, Belgium, and Luxembourg as well as the Panzers' lightning breach of the "impenetrable" Maginot Line, Alfred strove to defend the German people as co-victims with the rest of humanity of the obscene exploitative greed of all nations, of which the Fuehrer was

merely the ultimate manifestation. After the costly disaster of Dunkirk and the start of the heavy bombing of England, however, he seems to have given up seeking support for his view. It was too late; he was too old and tired for lengthy jeremiads. He would conserve his energies for the work that lay ahead. Accompanied by Zoler, he headed for Lake George in mid-July—for peace, fresh air, rest.

And boredom. No camera, no printing. Minimal reading. No miniature golf. Walking limited to the level ground in front of Lee's house; by summer's end he would manage a measured daily mile. Mute Zoler stayed a fortnight, and loquacious Einstein, back from Vichy France, for a similar period. Davidson, whose intuitions had gained him a reputation as a soothsayer of sorts, spent much of his time answering the long letters of strangers seeking his metaphysical guidance. Margaret tended Alfred and her garden.

Of the family, Elizabeth was now almost as rare a visitor as the Swami, whose summer household of student devotees and distinguished guests some twenty miles distant she supervised, and whose annotated translations of Vedantic works she copy edited and typed. Peggy, recently graduated from Sarah Lawrence, became Alfred's new scribe, taking down recollections and refinements of thrice-told tales. At twenty, she was experiencing for the first time his gentle reception of confidences, his counsel, and the not-so-avuncular pinches and pats he reserved for the nubile. My own visits were more fleeting. About to change colleges after an unsatisfactory, and unsatisfying, freshman year—I had cut history and French classes to binge on fictional classics, had flirted with my zoology professor, tossed off essays and poems for an undemanding English instructor, danced away weekends, and yearned for a role more challenging than the lead in a vapid class play—I found myself out of sync with Alfred. He was sweet, but he lived too much in the past, was too critical of lipstick and nail polish, and far too inquisitive about my sex life. Embarrassing.

Lizzie was always on the run—keeping house for Elizabeth, her daughters, and their friends, for Flora's children, for nieces and nephews and their offspring as well as a string of impecunious aging waifs; catering to her sisters-in-law and to Lee; practicing her beloved piano; gardening, writing letters, knitting, mending, and lending withal an attentive ear to the stream of petty woes her gracious hospitality uncorked—but she visited Alfred daily. He found her energy at seventy-five appalling; as soon as she was out the door, he had to lie down.

Alfred's sessions with Lee were confined to the races, the weather, and

matters of health. By mutual agreement, discussions of the war were taboo. Interventionist Lee, incensed by the slowness of That Man in the White House to come to the aid of beleaguered England, skirted the issue not only to spare Alfred overexcitement but also to spare himself debate over British imperialism, already a sore subject with India-advocate Elizabeth.

Alfred paid as little attention as he could to the events overseas. His reading of the newspapers was cursory, and he was glad that the bulletins from Agnes's crackling radio were barely intelligible. Although he now went habitually to a newsreel theater in New York, he was determined to disengage himself as much as possible from the heavy speculations and anxieties expressed by family and friends, to maintain personal neutrality, and to preserve The Place as an oasis of peace and sanity in a world gone mad. The task would not be easy, especially after Pearl Harbor and the gradual involvement of youngsters among his acquaintance and in the family, some of whom would lose their lives, but it would be essential to him. And the quiet continuity at the gallery would be spiritually satisfying to many others beside himself, his artists, and their devoted following. During the early forties, a new audience would materialize among weary servicemen on leave. Some would return several times to buy another O'Keeffe, Marin, or Dove small enough to carry in their gear or hang in their lockers. Their spontaneous preference for the true and alive over what critics instructed them to admire would be continually gratifying to Alfred.

He had been similarly pleased with the judgmental independence shown by Georgia Two's climbing partner and future husband when she brought him to the lake for a visit ("an INSPECTION," she called it) in the summer of 1940. Alfred's catechism began with a directive to Tony (Oliver Eaton) Cromwell to name his three favorite artists. Anticipating that a scion of the Stotesburys would claim preference for such old masters as Rembrandt, Rubens, and Raphael, Alfred found Tony's choice of Vermeer, Van Gogh, and Remington delightful evidence of an unconventionality that was corroborated (for reasons known only to Alfred) by his response to Alfred's private Rorschach: which way around he elected to hold a Stieglitz *Equivalent*.

Invigorated by Tony's visit, amused by Sel's subsequent rage at having arrived too late to demonstrate that at least one member of the family was on his social wavelength, and overjoyed by unexpected hours shared with his bubbly young beloved, Alfred returned to the city filled with dreams of

getting back to his darkroom. He was at the penthouse only a week, however, when he suffered a mild angina attack. A second, serious enough to require the care of two nurses, followed a month later—coincident, tellingly, with Georgia's distant closing on the purchase of the Ghost Ranch house she had rented intermittently since 1934. He had managed meanwhile to mount a group show of his Big Three, and was back at The Place by mid-November, but his hopes for his artists were low: in forty days, no more than 150 people had turned up, most of them insiders.

Yet there were compensations. After an absence of nearly seven years, Strand came to make peace; Georgia was back in time to hang Marin's December show; and, working together, Ansel Adams and Beaumont Newhall came to collect Alfred's prints for the opening show of the MOMA's photography department. Alfred had already had the profound satisfaction of receiving, and declining, Newhall's and Adams's invitation to take an active part in their new enterprise. Without questioning their sincerity, one may imagine that they probably did not expect him to agree. They knew both that his health was fragile and that, constitutionally, he could not accept a subsidiary or ancillary position in an arena he felt he had created.

Nevertheless, the gesture was productive. Thenceforth, despite Alfred's continuing lectures on the inimical relationship between museums and art, there would be a truce of sorts between him and the MOMA. Its director, Alfred Barr, was already a regular visitor. In the ensuing years he would press Alfred repeatedly for a one-man Stieglitz show, which Alfred would try repeatedly to assemble; he would see to it that Alfred's wards were represented in the MOMA's permanent collection as well as in its far-ranging tours of contemporary works; and, finally, in the spring of 1946, he would give O'Keeffe a one-woman show on the same massive scale as Marin's ten years before.

Meanwhile, Alfred praised Adams and Newhall for the enthusiasm of their endeavor—if not particularly for the product of their efforts. Forwarding the catalogue of the show's opening to Einstein, he used the same all-purpose phrase he and Georgia had adopted years ago to fend off ill-considered requests for approval. "What am I to say?" left a petitioner feeling incomparably the fool for having asked at all; obviously, the evasion implied, a straight response would have been either too harsh to accept or beyond the reach of his or her comprehension.

On January 1, 1941, Alfred turned seventy-seven. Agnes, who visited him at the gallery on his birthday, as did most of his close relatives,

straggling in independently, found him in splendid shape. "You seemed so much like your old self," she wrote him happily that night, "with an expression that only *you* have." His good spirits lasted through the winter and spring. Customary fretfulness over his artists' sales was shortened by Duncan Phillips's more responsible attitude toward Marin and Dove, and by Georgia's spectacular sale of a pastel for $3,000, a by-product, perhaps, of the handsome reproduction in *Vogue* of two of her paradisaic Hawaiian landscapes.

With a year's security guaranteed his charges and The Place, Alfred was free to enjoy some unusual pleasures. Long-lost deserters, realizing perhaps that he would not be around forever, showed up for his benediction. Other friends with whom he had not quarreled but who had been distant, some for as long as twenty years, came to reminisce. There were visitors he had only dreamed of meeting: novelists, movie stars, poets, composers, scientists. Their mysterious arrival filled him with delight; their deference and willingness to listen awoke in him the heady sensations of the early days, when he had led a trusting band into alien territory. In June, at last, he welcomed the true prodigal, Steichen, with open arms.

Not the least of his satisfactions during the season was the harmony that prevailed between him and Georgia. She had convinced him to replace the old Saturday nights with an occasional low-key dinner for one or two mutually congenial guests at home, and they themselves spent more quiet evenings together. And more hours together, undisturbed, at The Place. During March and April, by agreement, Georgia spent Sunday mornings alone at the gallery, making a preliminary selection of paintings that might be called representative of her development over the past twenty-three years—without Alfred peering over her shoulder. Her initial selections were then reviewed with him. In May, together, they tackled the thirty-six cartons of Alfred's finest prints. Presumably their joint review was undertaken with an eye to preserving an organic collection of the best of each as part of Alfred's legacy, but it is doubtful they talked much about the death both anticipated with fear. What they did share in the long hours of going over each other's crop was a strengthening of the artistic rapport that had held them together through periods of splintered trust, and a new measure of tenderness and generosity.

Reconciled to the necessity of Georgia's departure for New Mexico in late May of 1941, Alfred nevertheless missed her more acutely than he had in years. It was six weeks before he roused himself from lonely lethargy to go to the lake with Agnes. This time the country benefits did little

to enliven him. There were no overnight guests at the Farmhouse save Agnes and, in two widely spaced visits, her husband. Exercise consisted of slow laps of the croquet patch behind his unused darkroom house. In good weather, he ruminated and dozed in his wicker chair on the porch; in bad, he huddled in his decaying study armchair with a book, or lay blanketed on the daybed. Letter writing had become a chore. No more impassioned screeds swallowing six, seven, and eight pages; now he cramped a paragraph or two into a vertical half-page. The high point of his day came with the delivery of Georgia's letter, or with Dorothy's telephone call. Briefly, in their wake, his talk was free of the usual litany of complaints: his unalleviated itches, his sinusitis, his malfunctioning eyes. In eight country weeks, he roused himself to animation only once, when his youngest sweetheart arrived to introduce the young man who would later be her husband. On the day of their departure, he suffered an angina seizure that Lee was able to arrest with an immediate injection; he was on his feet again in twenty-four hours.

Returning to the city two weeks later, Alfred felt almost as drained as he had when he had left it in July. Day after day, he stared at the empty walls of The Place, unable to imagine what he could hang that could possibly compete with an art world dominated by "humbug," and "THE LABEL." Finally, he decided to spice the annual group show of his three regulars with Picassos from his collection and a few of his own photographs. Feverish on the night of its opening, he went home to ride out the grippe; a few days later, he suffered the first of a string of angina attacks that again required nursing. Forcing himself soon after he was up to return to his post for a few hours a day, during which he dictated all but the most personal notes to Dorothy's secretary—Dorothy herself had answered his mail while he was bedridden—he delayed his full recovery. Weeks after Georgia's mid-November return from New Mexico, he was still on a limited schedule.

The shattering news on December 7 of the Japanese attack on Pearl Harbor caused momentary vacillation about opening the Marin show Georgia would hang on the ninth, but Alfred insisted that The Place remain a haven. Let the rest of the world go mad; here Life, Truth, and Love—between man and nature, man and creativity, man and the ineffable moment—would go on. Not a very convincing message in the aftermath of global declarations of war. During the seven weeks of the show, fewer than 200 visitors came.

When Georgia's mid-February to mid-March show failed to bring the

usual crowds, she and Kalonyme persuaded Alfred to mount an impromptu second Marin exhibition to coincide with the release of three publications in which he was starred: a *New Yorker* feature; the new issue of *Twice A Year*, which contained both Henry Miller's "Stieglitz and Marin" and Alfred's retelling of "Four Marin Stories"; and Jerome Mellquist's book, *The Emergence of an American Art*. With a sprightly title for a sprightly show, "Pertaining to New York, Circus and Pink Ladies," accompanied by a catalogue praising fourteen museums for owning Marins, did manage to spur sales for all three of Alfred's artists, including Dove, whose show followed—but only among familiar collectors. Attendance was virtually nil. The war, Alfred wrote Dove despondently, was raising hell.

It was, at home as well as abroad. Overseas, by the end of May, Japan had taken control of nearly 20,000 square miles of the Pacific, from her island homeland nearly to Australia, from Malaya and Sumatra to Wake and the Gilbert Islands; and Germany continued to advance across North Africa and deep into Russia in spite of having been prevented, at terrible cost, from invading England. At home, the lives of all Americans had been altered, to greater and lesser degrees, by conscription and military training, war production and rationing.

Georgia's worry about the increasing scarcity of gasoline-rationed taxis and the heavy cuts in heating oil that could make the penthouse truly unbearable for Alfred sent her on a new apartment hunt. The one she found, at 59 East Fifty-fourth Street, was a short block from The Place. It elicited heavy criticism from the family: no view, rooms that were both smaller and furnished more sparingly than those at the penthouse. It looked cold, they grumbled, impersonal and transient, as if Georgia didn't expect to be there very long. Alfred cared little. He had his things around him as soon as Georgia effected the move in October; he was warm; and The Place was just around the corner. There was work to do.

During her winter show, Georgia had accepted the offer of a solo retrospective twelve months later at Chicago's prestigious Institute of Fine Arts—with some trepidation, having first to convince Alfred (who grew homesick for each canvas leaving his hands) that something over fifty works, spanning her entire career, could travel a thousand miles safely, be tended carefully during their exhibition, and return unharmed. Surprisingly, Alfred was quick to approve. He would not deprive her of the stardom he had worked twenty-four years to help her achieve, and he would supervise the crating himself. Naturally, he would insist that the

Institute buy a major painting for its permanent collection, a precondition exacted from every institution mounting a one-man show of any of his artists, and that she be given *carte blanche* in hanging her show, with all the time and help she needed. He only wished he were strong enough to accompany her.

Spared participation in the October 1942 move to the new apartment, Alfred found himself unusually busy at The Place, glad in retrospect that the five weeks he had spent at the lake had restored his vitality. That he had gone at all was due probably as much to a surprise act of Dove's as to any halfhearted incentive to get to the Hill. In July, receiving a bonus from the unexpected sale of a painting, Dove had sent Alfred a down payment on an *Equivalent* he and Reds had decided years before would be their first extravagance should they ever be blessed with good fortune. Immensely touched, Alfred had roused himself from heavy lethargy to choose two he said they might exchange if they wished, to have them framed, packed, and sent off. Aware of what the transaction meant to Dove's modest pride, he had not turned down payment. Rather, determined anew to guarantee Dove a future free of fear, he had resolved to get himself in fighting trim again at Lake George, even though it was certain to be stupefyingly dull without guests.

At The Place again in the fall, he began at once to select Doves requested for group shows by both the Metropolitan and the MOMA; he spent long hours as well with the charming emissary of the Baltimore Museum—with whom, briefly, he fell in love—choosing a Marin for its permanent collection. And for six weeks, he and Georgia held evanescent rehearsals of her Chicago show. Pictures were brought out, ranged along the base of the empty walls, shifted, banished, replaced, and finally selected. When the casting was complete, Georgia withdrew to supervise their framing and to finish settling into the apartment. She returned to the gallery only to hang Marin's mid-November show. The next, Dove's, would await her return from the triumphant January 31 opening of her Chicago exhibition.

Through December, maintaining his lonely vigil at The Place—there was only a trickle of visitors to the Marin show, despite its fine reception by the press—Alfred found himself hosting only one consistent familiar: Hartley. Failing in health but optimistic about his future, Hartley came almost daily to crow about the new success that severing his connection with The Place had wrought; his works were ensconced in a fashionable gallery, and a prize from the Metropolitan had brought him more money

than he had seen since his desperate auction in 1921. Alfred became increasingly nostalgic for uncomplaining and undemanding Dove, wishing bitterly that he had the energy for just one more forceful campaign, to win for him a victory comparable to Hartley's.

Consoling him for feeling stupidly worthless, indomitable Dove, who was too weak himself to dare a trip to the city, advised Alfred to halve what he was doing, instead, like himself, of cutting in half "what they tell us we *can't* do." In spite of doctors' orders, he was painting large and powerful canvases in wax emulsions that in their calm flatness were harbingers of acrylics that would not reach the market until many years later. Poor health would not prevent him from experimenting; he had tried, over the years, nearly every paint recipe recorded since the fifteenth century, grinding his own pigments and noting meticulously the ingredients and proportions used on every canvas. A week before these paintings' debut, in March 1944, he wheedled his doctor's permission to visit The Place—to see O'Keeffe's show, which he had missed the year before, and to embrace Alfred for having achieved an eightieth birthday. Typically, Dove would consider their "great" time together more than adequate compensation for the relapse he suffered in the days following; surely he did not imagine that they had seen each other for the last time. Soon, and for the remainder of his life, he would be confined to bed or a wheelchair.

He continued nevertheless to work cheerfully, and to enliven his letters to Alfred with vignettes of his circumscribed life, an embellishment rarely indulged thereafter by Alfred, whose notes were often one-liners enclosed with a Phillips check. Dove passed lightly over the continuing hardships of his life, and rejoiced repeatedly in the benign influence of Alfred's *Equivalents*, as well as in his unwavering support over the years. "I don't know what would have happened had we not had such friends as you and Georgia," he wrote in 1945. "It is a marvel . . . All these wonders have come to pass, and I am still allowed to have Reds here with me when all I do is keep a roof over our heads and buy the food." Sixteen years younger than Alfred, he would outlive him by only four months.

Called eventually the first genuinely independent American Abstract Expressionist, a tag that would have amused him quite as much as it would have infuriated Alfred, Dove would be valued by only a handful of collectors and museums until 1958 (twelve years after his death), when a year-long traveling retrospective gained him nationwide recognition. It would not be until 1974 that a broadly inclusive show, organized by the San Francisco Museum of Fine Arts and culminating at the Whitney in

New York a year later, accorded him finally the standing Alfred had envisioned for him nearly sixty years earlier.

The fame that accrued to Marin meanwhile, in the wake of his 1936 MOMA exhibition as well as with the inclusion of his paintings in many museum collections and the appearance of widely read feature articles, was a phenomenon the artist found astonishing. In spite of the gradually escalating prices Alfred attached to his paintings, however, his income remained relatively modest, which satisfied him, for the most part, as he had few material ambitions beyond furnishing basic needs for his family and buying supplies for his work. He was as content with the unpretentious house in Cliffside Park, New Jersey, that enabled him to go easily to Manhattan (but was somehow gratifyingly awkward for unwanted visitors to reach) as he was with his unelectrified and unplumbed summer home at Cape Split, Maine, where his luxuries were a scarred concert grand and a reconditioned lobster boat.

Marin needed Maine every bit as much as Georgia needed New Mexico and Alfred needed Lake George: the salt-heavy air, the bouldered shores of his island-studded bay, the mossy turf and dense evergreens; the freedom to go clamming, to chop wood, to clamber in sneakers over rocks and tussocks, to squint at blazing sunsets and track the undulations of porpoises and loons; the friendships with hard-handed lobstermen and their beautiful, unfancy wives—these were more than ever the ingredients of his solace during the war. When his son shipped out for the Pacific in 1943, and again in 1945 after the death of his wife, Marin's loneliness and grief were so transformed by the timeless affirmations of his Maine surroundings that he produced some of the most vigorous, as well as most lyrical, paintings of his career.

Marie Marin, whose personality and appearance had none of the fire of a Beck Strand or a Reds Dove, had been neither awed by nor especially interested in the Stieglitz circle, which she had largely avoided. I remember her as a small, tidy, calm woman whose warm contentment lay in making life comfortable for her two "Jawns." Marin described her as just right for him. His mourning for her was as private as had been their thirty years together. In my many long visits with him before his death eight years later at eighty-two, he spoke little of her, except to boast of her incomparable wood-stove baked beans, and of her equally incomparable haircuts, her quick scissors guided by an inverted bowl on his head. (He tried, and failed, to persuade my father and me to emulate her technique.) Once only, amid reminiscences of the quick affinities he had shared with Dad, who died in

1948, he stopped suddenly to tell me of sitting at Marie's bedside as she lay dying, compelled to limn a final portrait of her beloved features. He showed it to no one, probably destroyed it, and never mentioned it again.

In 1943, as in the previous summer, Alfred spent barely a month at Lake George. Although Georgia had left abruptly for New Mexico at the end of April—Alfred complained immediately that he was all alone, discounting the daily presence of Andrew Droth and ephemeral appearances of Zoler at the gallery and the overnight company at home of Davidson, whom Georgia drafted to monitor pills and meals—Alfred had taken three months to get to the Hill. There, again without visitors, he gravitated between the table (at which he no longer tried to arbitrate his sisters' squabbles) and his cot, between armchair ruminations on the porch and slow pacings on the road to try to stir his sluggish circulation; he was cold, now, all the time. His greatest pleasure, aside from Georgia's letters, derived, surprisingly, from his daily visits with Lee, who had become remarkably gentler and more understanding in the past few years. Perhaps the change had begun imperceptibly even before his second wife's death; certainly it had blossomed with his 1942 retirement after fifty years of practice. Now the brothers celebrated the return of silence to the lake since gasoline rationing's banishment of traffic, reminding them of Oaklawn days and earlier, of homes overflowing with guests and servants and aunts and uncles and cousins. When there was a big race on, or a specially fine concert, Lee drove Alfred up the hill to Lizzie's superior radio; sometimes they remained for weak tea or an early dinner. If Alfred described to friends as boring his stay among only old people—Elizabeth was barely there, Peggy was married, and I came for only one weekend—he found himself at least rested. And reassured. Although he had had some angina twinges again before leaving the city, he had not had a real attack in two years.

Georgia's early departure had been simplified by Alfred's relatively good health, by the turn of the tide in the war in Europe, and by the end of her responsibilities at The Place since hanging her show in late March. Her need to go to the Southwest was exigent. Not only was she dissatisfied with the paintings she had done in New York after her frigid stay in Chicago, but she was eager to conclude long negotiations to buy a second home.

Several years before buying the Ghost Ranch house, she had fallen in love with a deserted adobe hacienda in the mountain village of Abiquiu some sixteen miles away, the site of an Indian farming pueblo several centuries old. She had tried at once to buy it, but the owner's price was too

high. By the time she had the money, he had died, leaving the property to the church, which had no better use for it than as a shelter for village livestock. Every year Georgia pressed the bishop to let her have it; every year he balked. Now she *had* to have it. Ghost Ranch had been frustrating since the war's beginning. Its soil was inhospitable to the greens she wanted to grow, and long trips for provisions used up nearly all her gas coupons. Furthermore, FBI agents were always poking around for information about her neighbors—something to do with a mysterious laboratory at Los Alamos, twenty miles away.

To her intense disappointment, she found on her arrival that the bishop had died. It would take until 1945 to gain his successor's approval to her ownership of the three acres and hodge-podge of tumbledown buildings. She would not be able to live at Abiquiu until 1948, when her idiosyncratic plans for reconstruction were nearly complete. But she visited it often even before taking title, sometimes astride a motorcycle or a horse, and camped out to taste its views of the verdant valley in moonlight.

When Georgia returned to New York in mid-October 1943, laden with her first curiously exhilarating depictions of desert-bleached animal pelvises afloat in the heavens—many observers of her spring show would interpret them as mystical affirmations of life and eternity in a destruction-dominated world—she found Alfred considerably aged. Not ill, but subdued, slow. Friends dropping in intermittently over the past six weeks had come upon him usually stretched out on his cot, often asleep over a book. He had little to do but muse, as he wrote a friend, on the follies of man and the misapplications of genius—his own included. Dorothy's arrivals with copy for the next issue of *Twice A Year* had been generally hurried; her secretary needed little time to catch up on his correspondence. Even when Marin's again lively paintings were on the walls in late November and December, hardly anyone had come.

Nevertheless, when I came to wish him a happy eightieth birthday on January 1 (a few weeks before marrying USAF Cadet Peter Geiger in Georgia), he was surrounded by other well-wishers. Flushed and vigorous, he was holding forth on the ridiculously obligatory nature of the salaams to his age and accomplishments in periodicals—even his "enemy," Thomas Hart Benton, had paid him tribute—and now in the press. His scolding words were belied, however, by an almost boyishly jubilant mood that, spilling over in letters, endured for several months. The new and inquisitive audience drawn by his resuscitated notoriety swelled to as many as 150 a day when Georgia's new paintings went up on January 9. Inter-

Alfred Stieglitz, An American Place, 1940 Ansel Adams

mittently through the winter, moreover, he was occupied in helping envoys from the Philadelphia Museum of Fine Arts choose and correlate a sampling of his private collection for a large show. "History of an American: Alfred Stieglitz, 291 and After" would open in September. When Georgia took off in early June, he was still doing preliminary work on the catalogue, still had to supervise the crating and handling of the works. Exhausted, and worried again about traveling, he suffered another string of minor angina attacks that made Georgia resolve to settle him at the lake herself the following year. This year, escorted to the Hill just before the end of July, he was barely strong enough to hold anything heavier than a magazine.

Six weeks of sleep, fresh air, and boredom revived him enough to find energy on his return to trundle out of the storeroom a considerably larger number of Marins, O'Keeffes, and even Doves than the year before. The increasing fame of the first two, and recognition of the third, together with the Philadelphia show and Alfred's revived celebrity, lured an increasing group of buyers even before the season began. Old as he was, and growing visibly more feeble, Alfred was the envy of dealers, especially for the high prices he continued to extract for living artists. Poisonous rumors

of his dishonesty grew louder. In New York again, after my young husband's transfer overseas in September, I met a widely respected Fifty-seventh Street dealer at a party, to whom I introduced myself innocently as Alfred's grandniece. The vitriol unleashed by my confession of kinship was profoundly shocking. I had seen this same man before, fawning, in Alfred's presence. Furthermore I knew that sometimes when he was ill Alfred had given him pictures to sell at the high prices Alfred had established from which he, the dealer, effortlessly picked up 25 percent commissions. Other dealers who defended Alfred's probity nevertheless regarded his methods as crackpot, unaware, perhaps, that the variable contributions of his artists toward expenses at 291 had undergone some changes at The Place. There, in the thirties and forties, well-to-do purchasers were asked to make out a second, tax-deductible, check to the Rent Fund that would be credited to the artist's share of overhead. Alfred and the Internal Revenue Service had long since agreed that An American Place was a non-profit educational enterprise.

December 1944 was a profoundly depressing month for Alfred. His recently commissioned grandson would soon be on his way to the Pacific, where his grandnephew Bill Schubart had just been lost. Marin's wife was dying and Dove's condition obviously deteriorating. Stunning defeats were driving the Allies, who had advanced steadily since June, all the way back to central Belgium. When I dropped by to see Alfred before taking off for a pre-Broadway tour with my first theater job, he immediately attacked my confidence that my husband Pete would remain where he was stationed, in Hawaii. How could I imagine that he would not be sent into combat when every inch of Japanese-held territory had extracted such terrible losses? I had better prepare myself. All this in a near whisper from his cot, covered to the chin with a blanket and his outspread cape. One almost fever-hot hand lay upon my own; the other, resting on the pillow behind his head, held his folded eyeglasses. I wondered, wrenchingly, if he might die before I returned.

Three weeks later I found him on his feet, his dark eyes snapping with good humor. Quickly steering from one Marin to another the actor friend I had brought, Alfred teased from him more personal information than I had learned in two months of the quickly intimate revelations of theater friendships—including Eddie's passion for painting clowns in his spare time. Pressed to return the following week when the new O'Keeffes were up—pelvises again, but this time almost abstract windows on an infinity of blue sky—we found him perkily wandering from room to room, addressing

one after another rapt observer with: Beautiful, aren't they? *She* is too! The Marin clowns, he whispered to us, could be visited in the back room.

Over the past several years, the prevailing ingredient in the relationship between Alfred and Georgia—a mutual generosity that many failed to perceive—had grown. In some ways, they had exchanged roles. Georgia now worried about his physical frailty as he had fretted about hers. Beyond her affection for him, she wrote Henry McBride in the forties, it was her recognition of his role in helping her find her special place that made holding his hand as he faced what lay ahead especially important to her. On his part, Alfred, although often querulous and unreasonable, was increasingly insistent that she have her fill of her summer desert. In 1945, it was he more than she who pressed for her departure in early May, as soon as the Doves were up.

They had approached serious disagreement about only one issue: whether or not she should accept the invitation of the MOMA for a one-woman show in 1946. Ambivalent, Alfred had at first resisted. To have a museum show in Chicago was one thing; to have one only a block away from The Place was quite another. Georgia, unwilling to retreat an inch, was patient in her persistence. Finally she convinced him that the public's awe of the Modern's imprimatur, right or wrong, would not only further her career but would also focus new attention on The Place, the greenhouse and home in which other artists too had been helped to grow. The resolution of their disagreement had left them both wearied, if no longer tense, as had also the world-shaking events of April. On the twelfth, two months after the Yalta conference, Roosevelt died, plunging a stunned America into mourning and a shaky Truman into the presidency; on the twenty-eighth, a defeated Mussolini was executed by Italian partisans; on the thirtieth, realizing that their *Gotterdämmerung* had materialized, Hitler and Goebbels committed suicide.

For the first time in four years, Alfred was in Lake George before mid-July, without having suffered a single angina spasm. He had waited only to close the gallery, and to fulfill two pleasurable obligations. The first was to sit again for The Kid's camera; she had written and illustrated a piece about him for April's *American Photography* and now had a similar *Coronet* assignment. The second was to wind up a round of sessions with Nancy Newhall, the wife and colleague of Beaumont Newhall, the MOMA's curator of photography. Nancy Newhall was the first person to seriously undertake a biography of Alfred. Presumably he found the exercise of sharing his recollections with her stimulating. Soon after his arrival

at the Farmhouse, he was rousing himself not only to read and sit in the sun but also to write long letters to friends again, especially to those from whom he had not heard in a long while: Paul Rosenfeld and Leo Stein, among others. He wrote page after page to bring Stein up to date, mentioning the war only to say that he doubted the validity of the opinions others expressed about it; he himself had none. It was three days after Hiroshima, to which he made no reference either then or, apparently, later.

His silence on both Hiroshima and Nagasaki is puzzling. Although he seldom lingered over current matters outside the art world, he usually gave them brief acknowledgment. Possibly, in this case, the shock of America's ultimate misuse of its genius was literally too much for him to bear. Or, possibly, Lee succeeded in keeping at least the immediate news from him —lost the papers, had his radio removed for repairs, or forbade others on the Hill to tell him, as he forbade their mentioning in his presence the notice of Pete's death overseas that had reached me the day after Hiroshima.

I was away almost a month, with Pete's family and other dear friends. When I returned, Lee warned me to steer clear of anything to do with the war when I visited Alfred. Moments after our greeting, however, he paused to peer at me over his glasses. "Your Peter. Yes, I know; nobody had to tell me. I'm sorry, child. I don't know what to say." He reached for my hand and looked toward the barns.

"*You* are alive," he went on. "That matters. Alive and young." Another pause. He sighed, and closed his eyes. "Why do I linger? What am I good for? Old as the Hill, with nothing to do but sit here. And wait. What for? And so what?" A silence so long I thought he had dozed off; carefully, I extricated my hand.

"Going?" He seemed to welcome the possibility. "Here, give me a kiss. And go to your mother. She's a fine woman, Elizabeth." Leaning back in his chair, he fumbled with the top buttons of his exposed underwear, rested his hand on his heart, closed his eyes again, winced, and hissed an indrawn breath. I had to smile; the pantomime was so familiar. On cue he whispered, "It's nothing. I'll be all right. Run along."

A few days later, back in a New York reeling with victory celebrations, Alfred was at his post at The Place. He resumed his sessions with Nancy Newhall, brought out pictures on request, dictated sometimes or talked on the phone, lay on his cot and watched the shifting axis of moted sunshafts. He slept a lot. Sometimes a friend brought a flower, a book, shoelaces. Dorothy came. And Zoler, redolent of Lifebuoy, tuning the radio to the hillbilly music that set Alfred's teeth on edge, and vanishing—

for an hour-long shave, for a half-hour more to darn his pants in a lighted closet, for a whole afternoon to exchange (again and again) the tutti-frutti ice cream Alfred loathed for the chocolate Zoler swore on his mother's grave he had ordered.

Alfred was happy to have Georgia back in mid-October, full of health and bounce and talk about Abiquiu. Together they went over her summer's work to choose what to hang in February as prelude to her May-through-October retrospective at the MOMA. Marin's new paintings went up in late November. Then, a few days before Christmas, Alfred suggested that Georgia stay away from The Place for a while: the family was hovering. His dearest brother-in-law, George Herbert, cruelly stricken with a rapidly metastasizing cancer, had just died.

Marie Rapp Boursault was pleased to note how well Alfred was looking when she came to see him a few days before his eighty-second birthday, and when I visited him on January 1, I was delighted to find him ruddier and more chipper than he had been at Lake George. His appearance may have been deceptive, however. Late in the spring he would tell Dorothy how amused he had been when someone remarked on his robust look immediately after he had been quite severely ill. "It would be superb," he told her, "to die, and upon entering Heaven, have the Lord greet me with, 'My, but you are looking well.' "

In early May, Georgia hung the new paintings Dove had managed to complete in a brief period of remission, and then went on to supervise the chronological arrangement of her thirty-three-year retrospective at the Modern. She attended her gala preview dinner without Alfred, who had not been out in the evening for several years. His consolation came with McBride's review, in which the critic paid tribute to Alfred's role in bringing "Stardom at last!" to his fifty-eight-year-old protégée and enduring love. Georgia, resenting the implication that she might not have come so far so quickly without Alfred, stayed in the city only long enough to take down Dove's exhibition. On June 6 she left for Abiquiu, so thrilled by her first long flight to Albuquerque that Alfred immediately wrote a new client/collector that the experience would help her with the painting the latter had commissioned for his office. He had come a long way since his tantrums over the Music Hall deal.

It was three more weeks before Lee and Lizzie succeeded in nudging Alfred to start packing for the lake with the help of his temporary housekeeper. Ready on July 6 to leave two days later, he went to The Place to

enjoy the peace of its empty white walls and to wait for an afternoon visit from Nancy and Beaumont Newhall. When they arrived, bearing a *bon voyage* chocolate ice-cream cone, they found him on his cot. He had not been able to move, he whispered, since a sudden sharp pain over his heart had made him lie down in the morning. He would be all right, he insisted, if they would just help him home. First, however, he wanted them to read—aloud please—what James Thrall Soby of the MOMA had written about Georgia.

At home, he was sedated and put to bed. At the end of three days, feeling better but still in slippers and robe, he persuaded his friend Jerome Mellquist to come to dinner. Next day, having postponed his trip to Lake George until he felt genuinely stronger, he dressed to go to The Place. In the hall, on his way to the living room, he suffered a massive stroke. His gallery helper, Andrew, coming to bring him the mail around noon, found him on the floor, unconscious.

Rushed by ambulance to Doctor's Hospital, Alfred lingered in a coma for the next two and a half days. Georgia, who had flown east on the first available plane from Albuquerque after learning of his stroke, was with him when he died soon after midnight on Saturday, July 13. She spent the sweltering Saturday morning tracking down an unadorned pine coffin to have delivered to Frank E. Campbell's plush funeral home on Madison Avenue. There, far into the night, she worked alone, stitching the plain white linen she had found to replace the detestable pink satin lining she had torn out in the afternoon.

When mourners began arriving in the morning, they found the casket closed and draped in black muslin; I seem to remember a few white flowers in remote vases. Georgia accepted condolences in calm dignity, her self-containment making the extravagant tears and sobbing embraces of some around her seem grotesque. In accordance with Alfred's wishes, there was no ceremony, no eulogy, no music; people filed past the coffin in silence. Tearful Steichen, with a tinge of theatricality that almost misrepresented his genuine grief, laid a pine bough atop the black cloth and moved on. On the sidewalk later, amid a growing buzz of clustered conversation, Georgia, with a majesty I shall never forget, eluded the hands of sympathizers and entered the limousine that would carry her behind the hearse to the crematorium in Queens.

Later that month Georgia, bearing Alfred's ashes, was driven by David McAlpin to Lake George. There, with Elizabeth, she removed them from the

canister, and buried them among the roots of an aged tree at the water's edge. He would not be consigned to the planted grove on the upper hill that had been added to, tree by tree, with the death of each Stieglitz.

Georgia and Elizabeth were as secretive about the exact location of Alfred's interment as Georgia and Donald had been about the grave of the marble Judith. Even when Lee agreed a year or two later to give the Lake George township a shore site for a small water-pumping station (in exchange for maintenance of the lower road), and was frantic to discover where *precisely* his daughter and sister-in-law had mixed Alfred's ashes with the soil, they remained stonily silent.

Perhaps the pump itself is his mausoleum. If so, as The Kid remarked recently with nimble, affectionate pride, "Alfred, although dead, is dynamic still." He could hardly have devised a better epitaph.

CHRONOLOGY

1833 Edward Stieglitz (henceforth ES) born in Saxony

1844 Hedwig Werner (henceforth HWS) born in Offenbach

1849 ES to New York

1852/3 HWS to New York

1861 4/21–7/29(?): ES sees Civil War service in 6th Reg., New York Militia
August: ES resumes business, Hahlo & Stieglitz, at 4 Murray Street, New York City

1862 12/21: ES marries HWS; couple reside at 1 Seaview Place, Hoboken, New Jersey

1864 1/1: Alfred Stieglitz (AS) born
8/23: Family moves to 109 Garden Street, Hoboken, New Jersey

1865 7/1: Flora Stieglitz (later Stern) [FSS] born

1866 February through mid-May: Stieglitz family in Berlin; through July, travels include Frankfurt, Rigl, Lucerne

1867 5/26: Julius Oscar Stieglitz [JS] and Leopold Otto Stieglitz [LS] born

1868 Rosa Werner [RW] joins household
September: Family visits family of Siegmund Stieglitz at Highland Falls and West Point, New York
October: AS begins school

1869 1/21: Agnes Stieglitz (later Engelhard) [ASE] born
August: Family at Highland Falls; ES moves business to 42–44 Murray Street, New York City

1870 July: Family at Highland Falls; ES moves business to 21–23 White Street, New York City

1871 5/12: Selma Stieglitz (later Schubart) [SSS] born
June: Family moves to 14 East Sixtieth Street, New York City
October: AS, LS, and JS start school at Charlier Institute

1872 August: AS on holiday with ES at Sharon Springs, New York, joined by HWS and RW. AS continues with ES and HWS to Niagara Falls and Saratoga Springs, New York. Overnight visit to Lake George

1873 July–August: AS on holiday trip with ES to Newport, Rhode Island, through New Hampshire, to Lake George, Saratoga, and Catskill, New York
10/20: Emmeline Obermeyer (later Stieglitz) [EOS] born

1874 August–September: AS, ES, HWS, and RW at Saratoga and Lake George

1875 July: Stieglitz family at Fort William Henry Hotel, Lake George, New York

1876 June–September: Stieglitz family in cottage on Fort William Henry Hotel grounds

1877 Winter, Spring, and Summer: Fedor Encke lives with Stieglitz family at 14 East Sixtieth Street and at Lake House cottage at Lake George.
Fall: AS, JS, and LS attend grammar school #55

1878 January through August: Moses Ezekiel lives with Stieglitz family at 14 East Sixtieth Street and Lake House cottage, Lake George

1879 ES moves business to 20–22 White Street, New York City
Spring: AS graduates from Townsend Harris High School
June through August: Family in cottage at Lake George
September: AS enrolls at City College of New York

1880 AS ranked tenth in class at CCNY
June through September: Family at "Crosbyside" cottage, Lake George

1881 AS ranked sixth in class at CCNY
Spring: ES retires, closes New York City home
6/18: Family embarks for Europe, meets Joseph Obermeyer and Louis Schubart aboard ship
Summer: Family travels in Europe, spending August in Baden-Baden
Fall: AS, JS, and LS start Realgymnasium in Karlsruhe; AS lives with Professor Karl Bauer

1882 Easter: Family meets in Lichtenthal; AS visits Hermann Hâsemann in Gutach (Black Forest)
May through September: Family convenes in Badenweiler; travels include Schlangenbad, Mittenwald, Innsbruck, the Engadine, Vienna, Lucerne
Mid-September: AS in Berlin
October: AS begins engineering studies at Polytechnikum
December: AS audits courses at Berlin University; parents and RW winter in Paris

1883 January: AS sees and buys first camera, takes first photos; starts photo-chemistry courses with Professor Hermann Wilhelm Vogel
June and July: AS and family in Gutach
August: AS returns to Berlin, works as lab assistant, conducts experiments in night photography
Fall: AS takes rooms with Obermeyer and Schubart; studies chemistry

with Von Hoffman at Berlin University, and dye chemistry with Karl Liebermann at Charlottenburg Institute

1884 Summer: AS meets family in Mittenwald, travels to Engadine, Innsbruck, Vienna, Grinzing. AS reports walking 550 miles with camera
November: AS, Obermeyer, and Schubart room at Behrenstrasse 1, Berlin
Fall: HWS, and RW in Vienna, through Spring 1885

1885 May: AS gives up engineering, leaves Polytechnikum, joins family in Mittenwald, then travels alone
Fall: AS and roommates at Dorotheanstrasse 82, Berlin; articles by AS appear in German photo periodicals
Fall: ES, HWS, and RW in Rome, through Spring 1886

1886 AS photographing friends, self, Vogel, et al.
Late spring: ES returns to United States with HWS, daughters, and RW; rents Oaklawn for summer; buys it in fall
Summer: AS hikes through Italy, Switzerland, Bavaria, photographing Chioggia, Cortina, Sterzing, Mittenwald, etc.
Fall: AS enters first photo contest and starts saving prints

1887 Summer: AS in Italy, photographing Pallanza, Lake Como, Bellagio, Venice; wins first competition: London *Amateur Photographer* "Holiday Work"; German and other English photo journals start reproducing AS prints

1888 AS joins German Society of Friends of Photography (yr. uncertain); demonstrates speed photography at Berlin Jubilee Exhibition
AS wins first and second prizes with seven entries printed in London *Amateur Photographer*
Late July: AS, LS, and JS to United States for wedding of FSS to Alfred Stern; spend August and September at Oaklawn
September: AS has job interviews in New York
October: AS, JS, and LS to Europe; AS arranges photo exhibitions and enters contests

1889 January: AS rejects partnership in New York color process firm
April(?): AS meets Emmeline Obermeyer
Summer: AS in Berlin

1890 2/17: FSS dies in childbirth
July: AS accepts assignment for London *Amateur Photographer*; Biarritz photo wins gold medal
Late September: AS returns to United States
10/17: AS starts work at John Foord's Heliochrome Company

1891 AS produces first slides, some prizewinners
Summer: At Oaklawn, ES buys neighboring Price estate and Smith homestead up the hill
September: AS, Obermeyer, and Schubart buy Heliochrome Company at 162 Leonard Street, rename it The Photochrome Engraving Company

10/27: JS weds Anny Stieffel

November: AS joins Society of Amateur Photographers after giving lantern slide exhibition of his pictures

1892 AS featured in *Cosmopolitan*; becomes critic/contributing editor of *American Amateur Photographer*; acquires first 4 × 5 inch "hand camera" and begins photographing New York street scenes

SSS marries Lou Schubart

LS starts medical practice in New York; JS starts career at Chicago University

1893 February: AS takes first snowfall pictures: *Winter—Fifth Ave.* and *The Terminal* reproduced internationally

11/16: AS and Emmeline Obermeyer [EOS] wed at Sherry's; live at Savoy Hotel

1894 AS takes first photos in rain

4/29: LS marries Elizabeth Stieffel [ESS]

5/5–10/?: AS and EOS honeymoon abroad: SS *Bourgogne* to Le Havre, Paris, Longchamps, Fontainebleau, Barbizon, Venice, Bellagio, Interlaken, Grundelwald, Gutach, The Hague, Scheveningen, Katwyk, Antwerp, London

Summer: AS first American to be elected to Linked Ring

Fall: AS co-editor of *American Amateur Photographer*

1895 March: AS withdraws from Heliochrome Company to concentrate on photography; has pneumonia

Fall: AS withdraws as co-editor of *American Amateur Photographer*; works for Society of Amateur Photographers

1896 AS takes first pictures of streets at night

April: AS wins gold medal and shield at international exhibition in Cardiff, Wales

May: AS works on merger of Society of American Photographers with Camera Club to form Camera Club of New York (3–7 West Twenty-ninth Street, New York City)

1897 March: AS becomes vice-president of Camera Club, in charge of publications

July: AS directs publication of *Camera Notes*, Camera Club quarterly

Joseph Keiley becomes close friend of AS

AS publishes first night cityscapes; also portfolio of twelve scenes, *Picturesque Bits of New York*

1898 January: AS and EOS move into LS's house at 60 East Sixty-fifth Street; AS ill; does first night and snow picture, *Icy Night*

ES and HWS sell 14 East Sixtieth Street; move to Majestic Hotel, Central Park West

3/17: ASE marries George Herbert Engelhard

September: AS and EOS move to apartment at 1111 Madison Avenue

9/27: Katharine Stieglitz [KSS] born

October–November: AS plays leading role in first Philadelphia Salon

1899 4/11: Rosa Werner dies
 5/1–5/15+: AS has major retrospective at Camera Club, eighty-seven
 works
 5/12: AS gives demonstration of 138 lantern slides
 Fall: AS publishes portfolio of Camera Club members' work; super-
 vises second Philadelphia Salon
 AS one-man show at Camera Club displays first orthochromatic plate
 prints

1900 April: AS meets Eduard (later Edward) Steichen
 Summer: AS exhibits *Photographic Journal of a Baby* in London
 Fall: First charges against AS filed by Camera Club

1901 AS's second portfolio published by Camera Club

1902 February: AS starts planning *Camera Work*
 April: AS mounts first New York photo salon at National Arts Club,
 Gramercy Square, calls it "Photo-Secession"; Round Table lunches
 start at Holland House and Mouquin's
 June: AS, EOS, and KSS at Jersey Shore
 July–August: AS severe illness
 September: Steichen visits AS and family at Oaklawn, starts *Camera
 Work* design
 AS and Photo-Secession group win top prizes at Turin (Italy) Expo-
 sition of Decorative Arts
 12/15: *Camera Work* Number 1 (January 1903) published

1903 Steichen weds, honeymoons at Oaklawn
 AS arranges ten Photo-Secession loan exhibitions (five abroad include
 St. Petersburg)

1904 Winter: AS publishes limited edition of his photogravures, puts on
 Photo-Secession shows: Corcoran Gallery in Washington, D.C. and
 Carnegie Art Galleries in Pittsburgh
 May to October: AS, EOS, and KSS in Europe
 5/27–7/1: AS ill in Berlin clinic of Dr. Boas; visits Photo-Secession
 show in Dresden (one of six abroad he arranged)
 July: AS accompanies Boas to Igls bei Innsbruck, works with Frank
 Eugene; meets Heinrich Kuehn
 8/22–10/3: AS in London for photo conference and shows

1905 Winter: AS arranges for Photo-Secession summer shows in Berlin,
 Brussels, London, and Vienna
 Summer: ES and HWS in Carlsbad, tended by friend, Dr. Fritz (?)
 Raab
 October: AS sends Photo-Secession work to Lewis and Clark Cen-
 tennial Exhibition in Denver
 11/24: with Steichen as cofounder, AS opens The Little Galleries of
 the Photo-Secession at 291 Fifth Avenue; AS full-time director

1906 Steichens move to Paris/Voulangis
 Paul B. Haviland joins AS inner circle

1907 1/5–27: First nonphotos shown at Little Galleries
Paul Strand visits Galleries for first time
May to September: AS, EOS, and KSS in Europe; AS photographs *The Steerage* (probably near Southhampton or harbor of London)
6/20–7/17: At Baden-Baden, AS makes first experiments with Lumière color
7/18–8/9: At Tutzing, AS experiments in color with Frank Eugene
In London, *Photography* magazine publishes AS article on color
Fall: Marius De Zayas joins group at Little Galleries
October: HWS and ES move to New Weston Hotel

1908 1/2: Georgia O'Keeffe [GO'K] visits Rodin exhibit at AS galleries with class from Art Students League
February: Camera Club expels AS; AS sues, is reinstated, resigns
4/26: Agnes Ernst (later Meyer) interviews AS, soon joins group
12/8–30: last group show of Photo-Secession opens new gallery—henceforth known as 291—at adjoining 293 Fifth Avenue

1909 Spring: AS meets Max Weber
April: Marsden Hartley brought to meet AS
5/24: ES dies
June–October: AS and family in Europe; in Paris in July, AS meets Gertrude and Leo Stein, John Marin, and Alfred Maurer; in Munich 7/31–8/3, AS meets Steichen, Eugene, Kuehn, and Adolph de Meyer
December: Arthur G. Dove introduces himself to AS

1910 Summer: AS, EOS, and KSS at Jersey Shore
Fall: Abraham Walkowitz brought to meet AS
11/3–12/1: AS arranges last large photo show, "International Exhibition of Pictorial Photography," at Albright Gallery, Buffalo, New York

1911 January: Weber leaves AS circle
May–October: AS, EOS, and KSS take last trip to Europe; in Paris, AS meets Rodin, Matisse, and Picasso
December: Marie Rapp (later Boursault) [MRB] starts work at 291

1912 AS honorary sponsor of 1913 International Show at Armory
Photo-Secession disintegrates after AS quarrels with Käsebier and White

1913 2/24–3/13: AS show at 291, only one-man show at gallery, simultaneous with Armory Show
Francis Picabia joins 291 circle
June through July: AS commutes daily between Long Branch, New Jersey, and New York
8/8: EOS to Europe with niece; AS to Oaklawn with KSS

1914 1/21: Keiley dies
February: AS begins new portrait series
Round Table lunches move to Le Marquis Hotel
June and July: EOS and KSS at Elberon, AS commuting
Marin's first summer in Maine

7/30+: Haviland returns to France

August: AS and KSS to Oaklawn; EOS travels in New England

September: Steichens return to New York; de Meyers come for war's duration

1915 March: First issue of *291* published

8/10–9/10: AS to Oaklawn with KSS

Paul Rosenfeld joins 291 circle, brought by Waldo Frank

October–December: 291 in informal partnership with Modern Gallery (500 Fifth Avenue) operated by De Zayas, Agnes Ernst Meyer, and Picabia

1916 1/1: AS sees GO'K works for first time

3/13–25: AS aids Willard Huntington Wright in mounting "Forum Exhibition of Modern American Painting" at Anderson Galleries

March/April: AS helps arrange first "European and American Artists in New York" show at Bourgeois Gallery

5/23: AS hangs GO'K works in group show at 291. First formal meeting between AS and GO'K

September: GO'K to Canyon, Texas

AS at Oaklawn through October

1917 4/3–15: GO'K's first one-woman show anywhere is closing show at 291

April: last issue of *Camera Work*

5/25+–6/2?: GO'K visits New York, then returns to Canyon, Texas

7/1: 291 gallery closes; AS moves into small office in same building

KSS enrolls at Smith College

October: Sherwood Anderson joins AS circle

1918 6/10: GO'K arrives in New York; moves into Elizabeth Stieglitz (later Davidson) studio at 114 East Fifty-ninth Street

7/8: AS leaves EOS, moves in with GO'K

8/1: AS and GO'K welcomed to Oaklawn; return for second visit September–October

1919 Winter: AS and GO'K living and working at studio, showing pictures; Elizabeth Stieglitz marries Donald Douglas Davidson

Summer: AS and GO'K at Farmhouse on the Hill, Lake George, with ASE and daughter; Strand visits

Fall: 291–3 Fifth Avenue razed; Round Table moves to Chinese restaurant on Columbus Circle

Late fall: Oaklawn sold

1920 Marin buys house in Cliffside (later Cliffside Park), New Jersey

Dove and Helen "Reds" Torr Weed on houseboat in North River

GO'K visits Maine for first time

July–November: AS and GO'K at Farmhouse; with ASE and HWS (to October)

Late September: HWS suffers stroke

October: Paul Rosenfeld two-week guest

December: AS and GO'K move to LS's New York house, 60 East Sixty-fifth Street

1921 2/7–14(?): 146 AS photographs exhibited at Anderson Galleries, 489 Park Avenue
 Spring: AS meets Demuth
 June–October: AS and GO'K at Farmhouse; visitors include ASE, Herbert J. Seligmann, Rosenfeld, and Davidsons

1922 AS starts new series of portraits
 February: first issue of *MSS* magazine published; AS arranges "The Artists' Derby" at Anderson Galleries (41 painters include all American artists from 291)
 6/22: KSS marries Milton Sprague Stearns
 7/2: AS and GO'K to Farmhouse; also ASE and HWS. Visitors include Rebecca Salsbury ("Beck") Strand [RSS] and Davidsons
 July: AS uses first negative film packs
 11/11: HWS dies

1923 1/20–2/5: GO'K shows 100 paintings at Anderson
 4/2: AS's photos at Anderson include first Cloud series
 AS Photo Library accepted by Metropolitan Museum
 6/18: KSS suffers postpartum collapse
 6/19: AS, GO'K to Lake George; visitors include Beck Strand [RSS], Strand, Seligmanns, Davidsons, Marie Rapp Boursault with daughter and Katharine Rhoades
 September: Rosenfeld visits Lake George
 October–November: Ida O'Keeffe at Lake George
 Dove buys yawl "Mona" as home with "Reds" Torr Weed
 11/26: AS and GO'K return to New York

1924 January: AS wins Royal Photographic Society award
 2/28–3/14?: AS photos and GO'K paintings shown at Anderson simultaneously
 Spring: AS gives twenty-four photos to Boston Museum of Fine Arts (first major museum collection of photographs)
 6/11: AS and GO'K to Lake George. Visitors: Arthur Schwab, Strands, Davidsons with daughter Peggy, Carl Zigrosser, and RSS
 9/9: AS divorce from EOS final
 AS visitors: Rosenfeld, Ida O'Keeffe, Arnold Rönnebeck
 11/14+: AS and GO'K to New York, move to studio at 35 East Fifty-eighth Street
 12/11: AS and GO'K wed

1925 2/26: GO'K addresses National Woman's Party convention in Washington, D.C.
 6/11: AS and GO'K at Lake George; visited by SSS, Rosenfeld, Frances O'Brien, Jean Toomer. Also six weeks sharing meals with LS, ESS, and Davidson granddaughters
 11/15+: AS and GO'K move into Suite 3003, Shelton Hotel (Lexington Avenue between Forty-eighth and Forty-ninth Streets)
 12/7: AS opens The Intimate Gallery in Room 303 at Anderson Galleries

1926 Dorothy Norman starts visiting gallery
 6/9–25: AS at Mount Sinai Hospital for observation
 6/25: AS and GO'K to Lake George; 8/20–9/3: sharing meals with LS,
 ESS, and Davidson girls; GO'K at York Beach, Maine 8/28–9/27
 11/1: AS and GO'K at Shelton

1927 Spring: Louis Schubart dies
 6/8: AS and GO'K to Lake George; 6/19–8/10: meals with LS, ESS,
 and Davidson girls
 8/1–10: GO'K at Mount Sinai Hospital
 10/5–30: Lake George visitors include Zoler, Rosenfeld, SSS, George
 Biddle, C. Kay Scott
 11/2: AS and GO'K in New York

1928 March: GO'K to Bermuda following sale of calla lily paintings for
 $25,000
 6/8: AS and GO'K to Lake George
 7/15–8/15+: GO'K visits family in Wisconsin
 9/15(?): AS has first severe angina attack; Ida O'Keeffe helps GO'K
 to nurse him
 10/15: Dove caretaker of Pratt Islands, Noroton, Connecticut
 11/15+: AS and GO'K to New York
 December: AS arranges gift of small collection of his "finest" prints to
 Metropolitan

1929 4/23: GO'K and RSS to Mabel Dodge Luhan ranch in Taos, New
 Mexico
 Summer: Dove and "Reds" living at Ketewomoke Yacht Club, Halesite,
 Long Island
 6/1: Intimate Gallery closes
 6/10(?): Marin to Luhan ranch, Taos
 7/1+: AS to Lake George with Zoler; visitors include Davidsons,
 Strand, and Louis Kalonyme
 8/25: GO'K back at Lake George
 9/18–22(?): AS and GO'K visit friends at York Beach, Maine; return
 to Lake George
 11/7: AS and GO'K to New York
 12/15: AS opens An American Place at 509 Madison Avenue

1930 April: Dove and "Reds" wed
 May: GO'K to Lake George; thence to Taos, 6/17–9/5; return to Lake
 George
 By 6/17: AS at Lake George. Visitors include Rosenfeld and Kalonyme
 10/15: AS and GO'K to New York

1931 4/25(?): GO'K drives to Taos, rents cottage on Marie Garland's ranch
 6/17: AS to Lake George. Visitors include Rosenfeld, Gerald Sykes,
 and Kalonyme
 7/7+: AS visits Dorothy Norman at Woods Hole
 Late July: GO'K to Lake George, thence York Beach (three weeks),
 back to Lake George 8/23
 8/28: AS visits Woods Hole

10/7: AS and GO'K to New York; she returns to Lake George after AAP opening 10/11

1932 March: GO'K wins MOMA competition for Radio City Music Hall mural

5/15(?): GO'K to Lake George for summer

6/23: AS to Lake George. Visitors include Cary Ross, Ralph Flint, Fred J. Ringel, and Rosenfeld

August: GO'K to Gaspé Peninsula with Georgia Engelhard

9/24: AS and GO'K to New York

October–mid-November: GO'K at Lake George; to New York 11/15

December: GO'K ill, to end of March 1933

1933 January: Doves move to Geneva, New York

3/25: GO'K to Bermuda

March: AAP publishes D. Norman, *Dualities*

April: Ansel Adams comes to AS, who critiques his work

May: AS photo collection (418 prints, 1894–1911) "rescued" by Metropolitan

5/22: GO'K to Lake George

6/20+–9/29: AS at Lake George; Davidsons and Kalonyme visit

August: Marins rent house in Addison, Maine

10/1: AS to New York; GO'K remains at Lake George

12/15+: GO'K visits New York, returns to Lake George with Jean Toomer

12/23–1/2/34: AS at Lake George

1934 February–April: GO'K in Bermuda

Spring: Eliot Porter comes to AS, AS critiques his work

With AS encouragement, SSS publishes poems

Summer: Marins buy summer home at Addison, Maine

June through September: GO'K rents cottage at Ghost Ranch, near Taos

6/21: AS to Lake George, visited by Ralph Flint (two months)

October to late December: GO'K at Lake George

10/3+: AS to New York

December: *America and Alfred Stieglitz* published

Last AS one-man show at AAP

1935 Spring: AS sends photos to Cleveland Museum (anonymous gift to permanent collection). William Einstein appears at AAP

April: GO'K appendectomy

Mid-June: GO'K to Ghost Ranch; returns to New York 11/10

6/22: AS to Lake George; returns to New York 10/10

Demuth dies

1936 Winter/spring: GO'K receives Elizabeth Arden commission

6/15+: GO'K goes to Ghost Ranch; to Lake George 9/23

6/18+: AS to Lake George; visited by William Einstein

9/28: AS to New York; GO'K follows a few days later

10/1+: AS and GO'K move to penthouse at 405 East Fifty-fourth Street

1937 1/10: JS dies
3/20?: GO'K to Palm Beach
6/7: AS has one-man show at Cleveland Museum of Fine Arts
6/26: GO'K and AS at Lake George; visitors include Swami Nikhi-
lananda, Flint, Ringel, Harold Clurman, Elia Kazan, Frances
Farmer, Leif Erickson
Mid-July–December: GO'K at Ghost Ranch
9/24: AS to Shelton Hotel, New York
10/22: AS wins CCNY Townsend Harris Medal (ceremonies 11/13)
12/2+: AS joins GO'K at Fifty-fourth Street penthouse

1938 April: Doves move to Centerport, Long Island; Dove ill
4/22–7/1: AS has major coronary, followed by pneumonia
Spring (year?): GO'K receives Stokowski commission
5/7: GO'K receives honorary degree from College of William and
Mary
7/14: AS to Lake George with nurse; visited in August by Cary Ross
7/18: GO'K to Lake George; 8/7: GO'K to Ghost Ranch
9/27: AS to Shelton Hotel, New York
10/4: AS to penthouse with housekeeper
11/2: GO'K back in New York
11/15+: D. Norman publishes first issue of *Twice A Year* from AAP

1939 February–April: GO'K in Hawaii on Dole commission
April: World's Fair Commission names GO'K one of twelve most dis-
tinguished women of past fifty years
May: AS asked to prepare show of his works (never completed) for
opening of MOMA photo division December 1940
5/15: GO'K unwell (two months)
8/17: AS and GO'K to Lake George
9/2: AS suffers angina attack
Mid-September: AS and GO'K to New York
October: AS places some paintings at Downtown Gallery to sup-
plement AAP sales

1940 2/12+: GO'K to Nassau, one month
6/3: GO'K to Ghost Ranch; returns to New York 12/8+
7/12–9/20+: AS at Lake George, visited by Einstein, Zoler
9/29: AS suffers slight angina attack
10/30: GO'K buys Ghost Ranch house
10/31: AS has more severe attack
AS made honorary Fellow of Photographic Society of America
Strand reunion with AS after six-year estrangement

1941 5/22: GO'K to Ghost Ranch; returns to New York 11/17
6/18: AS reunion with Steichen after twenty-year quarrel
7/18–9/18: AS at Lake George
10/10: AS has severe angina attack

1942 May: GO'K honorary Doctor of Letters at University of Wisconsin
6/5: GO'K to Ghost Ranch, through September
6/10–8/31: "Alfred Stieglitz: His Collection" at MOMA

7/28–9/1: AS at Lake George
10/1: GO'K in New York, moves from 405 East Fifty-fourth Street to 59 East Fifty-fourth Street

1943 1/31: GO'K one-woman show at Art Institute of Chicago
2/2?: Joe Obermeyer dies
4/28–10/15: GO'K at Ghost Ranch
August–September: AS at Lake George
9/2: Hartley dies

1944 4/15+–10/15: GO'K at Ghost Ranch
Early July: AS has series of minor angina attacks
7/29–9/5: AS at Lake George
September: "History of an American: Alfred Stieglitz, 291 & After," major exhibition at Philadelphia Museum of Art

1945 5/2–10/15+: GO'K at Ghost Ranch; buys second home in Abiquiu
7/7–9/5+: AS at Lake George
12/20: ASE husband, George Herbert Engelhard, dies

1946 Mid-May–August: GO'K one-woman show at MOMA
6/6?: GO'K to New Mexico
1/6: AS has angina attack
7/10: AS suffers stroke; GO'K flies to New York
7/13: AS dies at Doctors' Hospital

NOTES

Unless otherwise indicated, all correspondence cited resides in the Alfred Stieglitz Archives, Collection of American Literature, The Beinecke Rare Book and Manuscript Library, Yale University. Authors and recipients of more than five letters are identified by initials after the first three entries, except where initials are shared by two people, in which case the name of the referent cited less frequently is spelled out each time. Alfred Stieglitz is referred to throughout as AS, the author as SDL.

Printed material referred to, or quoted from, is listed in the Notes in shortened form; full information appears in the Bibliography.

Whether published or unpublished, references of one sentence or less are identified by opening or closing words only; longer references contain both.

Chapter One

[4] amateur champion: Herbert Seligmann, *Alfred Stieglitz Talking*, p. 23.
[8] "dear little Alfy": Rosa Werner to Edward Stieglitz, 4/16/1866.
[8] Aunt Ida wrote: Ida Werner Small to Hedwig Werner Stieglitz, 4/28/66.
[8] "one of the finest": Seligmann, op. cit., p. 9.
[9] The trip from New York: Alfred Stieglitz, *My Journal 1873*, n.p.
[9] "Wrote according": Hedwig Werner Stieglitz to Edward Stieglitz, telegram, 7/10/73.
[10] "I would not": Hedwig Werner Stieglitz to Edward Stieglitz, 7/17/73.
[11] change his bosume: Alfred Stieglitz to ES, bill for services, 8/6/73.
[11] "à la Alfred": Ernest Werner to ES, 7/21/75.
[11] Hedwig underlined: HWS to ES, 7/24/73. Dr. Abraham Jacobi, known as America's first pediatrician, began taking care of the Stieglitz children in 1872, and was a friend for life. Dr. Mary Putnam, whom he married in 1873, was a frequent guest of the Stieglitzes before that year. A daughter of a founder of the Metropolitan Museum, she was the founder of the Women's Lying-In Hospital in New York.
[11] "well and hearty": Rosa Werner to ES, 7/20/73.

[13] "in a year": Rosa Werner to ES, 8/6/73.
[13] "Papa? Papa": RW to ES, 7/20/73.
[13] "Ally should": RW to ES, 7/27/73.

Chapter Two

[15] "first & last": Alfred Stieglitz to ES, 12/8/1877.
[16] "Be the servant": ES to AS, in *Autographs*, vol. 1, Yale. Through his twenties, and intermittently thereafter, Alfred was a serious collector.
[16] "If you love me": HWS to AS, Ibid, and HWS to ES, letter 12/2/62.
[17] "Order of Dancing": "Grand March, Galop, Sauciers, Waltz, Quadrille, Redava, Schottische, Sauciers, Waltz, Quadrille, Galop, Polka, Sauciers, Waltz—Repeat to 'Home Sweet Home' —Unmask at signal," Edward Stieglitz Miscellany, Yale.
[17] Loeb Stieglitz: his parents were Nathan (Nahum) Stieglitz, dates unknown, and Gutel (surname unknown), 1/1/1750–1/8/1828. Apparently, Loeb had brothers and sisters; two sisters are mentioned in correspondence: Hannah, b. 1795, and Rosa (dates unknown). References in letters to an Aunt Frida (ES to Siegmund Stieglitz, 5/21/1861) and Aunt Isidor (Siegmund Stieglitz to ES, 7/17/61) probably pertain to in-laws.
[17] Her inconclusive: Loeb Stieglitz's

grandfather seems to have been a Siegfried Stieglitz from Leyden, the Netherlands. The grandfather, or a granduncle, of the two Barons von Stieglitz —emigrants to Russia who adopted Christianity, amassed fortunes in shipping, contributed heavily to the coffers of Czar Nicholas I, and received hereditary peerages in gratitude—was also a Siegfried Stieglitz from Leyden. Two of the barons' brothers remained in Germany (one in Leipzig, the other in Hanover), became Christians, and achieved distinction as professionals— one an architect, the other a physician. The "Russian" barons broke irrevocably with their Jewish relatives.

[18] "in the manufacture of": Edward Stieglitz Miscellany, Yale.

[18] Moritz Isidor: He may also have been an in-law (viz. "Aunt Isidor" referred to above) of Loeb Stieglitz.

[19] "as dear . . . :" Siegmund Stieglitz to ES, 4/22/61.

[19] "in the business": Contract between ES and Hermann Hahlo, 1/29/56; Yale.

[20] he and his wife Sarah: Marcus Stieglitz to ES, 7/4/61. Marcus's linen business, in difficulty in 1861, seems to have recovered in 1866, when he and his family were once again living in New York. His wine business "partner" in 1861 seems to have been a "Leckdu [? illegible] in Anders," a wine-producing hamlet in the Rhone Valley. Whatever Marcus's business in 1889, he seems either to have participated with or backed his son Albert in the founding of the prominent brokerage house Halle & Stieglitz, which became active on the New York Stock Exchange 8/15/90, nine years before Marcus's death. Source: New York Stock Exchange.

[21] "6th Regiment": Letterhead, Colonel J. S. Pinckney to Major General Banks, 7/22/61. Edward Stieglitz papers, Yale.

[21] "unique in": SS to ES, 4/22/61.

[21] "dreary . . . to complain": ES to Marcus and Sarah Stieglitz, 5/21/61.

[22] "two boxes": SS to ES, 5/3/61.

[22] "daily duties . . . our tongues": ES to Marcus and Sarah Stieglitz, 6/3/61.

[22] in the second,: Colonel J. S. Pinckney to Major General Banks, loc. cit.

[22] For his pains: "Line Officers' " thanks to Captains Fay and Baker and Lieutenant Stieglitz, 7/10/61.

[23] "The 'Dutchmen' . . . good citizen": SS to ES, 5/11/61.

[23] "One must . . . of glamor": SS to ES, 5/3/61.

Chapter Three

[25] A skit: Author unknown, private collection.

[25] "You know": HWS to ES, 7/12/73.

[26] Hoboken Academic: Bills to ES, 5/10/63 and 8/31/63. Private collection.

[27] "decided to": Abraham Werner to Flora Collin, 3/1/1841.

[27] . . . "excellent and beautiful" . . . Abraham Werner to Flora Collin. 12/3/41. The clothing business, a going concern, was inherited by Abraham's brother Edward J. from his mother-in-law, Mrs. Abraham Bernhard Schlesinger of Frankfurt.

[27] "My precious": Abraham Werner to Flora Collin, 1/30/42.

[28] "I would rather": HWS to ES, 8/11/62.

[28] "like German": HWS to ES, 8/18/62.

[28] "always in . . . write in verse": ES to HWS, 9/2/62 and 10/12/62.

[28–9] "an age . . . you want?": ES to HWS, 10/12/62.

[29] Not only: By 1866, Ernest Werner was an accountant of sorts at Hahlo & Stieglitz. Edward seems often to have depended more on his assistance and reliability than on his partner's.

[29] "At Sharon": Ida Werner Small to ES, 8/1/72.

[29] "In future": Ida Werner Small to ES, 7/22/73.

[29] "That glorious . . . on fire": ES to Ida Werner Small, 7/30/73.

[29] "All my . . . from me": Ida Werner Small to ES, 8/18/80?

[29–30] "[Although I] have": RW to ES, 8/2/73.

[30] "I have since": RW to ES, 8/6/73.

[31] "the happiest": HWS to AS, 9/28/98.

[31–2] "My dear . . . $100,000." ES to HWS, 8/23/64.

[34] her husband's winery: Flora Stieglitz Stern to ES, 10/20/89.

Chapter Four

[36] 550 miles: Mabel Cooke to AS, 8/8/1885.

[37] "6½ in the morning": Ernest Werner to family, 2/12/66.

[37] "It seems . . . can be": Ernest Werner to family, 3/13/66.

[38] There was one . . . gift to himself:
As recalled by SDL.
[38–9] "How long": Paul Rosenfeld,
"The Boy in the Dark Room," in
America and Alfred Stieglitz, p. 65.
See also Dorothy Norman, *Alfred
Stieglitz: An American Seer,* pp. 22–
24.
[39] "Stieglitz tongue": Known also in
the family as a "geographic tongue,"
the taste buds in its "rivers and val-
leys" were extraordinarily sensitive to
heat and strong spices.
[41] In the course: How much of the
partners' success was attributable to
the Chicago windfall is unknown, but
their gross receipts grew from $20,000
a month in 1866 to six times that
amount or more in 1872. Edward's
nephew Norbert (a son of his brother
Siegmund), working for him, voiced
distress over "a decline in July sales"
in 1872 to $119,000. Norbert Stieglitz
to ES, 8/3/72.
[42] "Heddy, Eddy and Ally": RW to
HWS, ES and AS, 8/27/72.
[42] "come up": HWS to ES, 10/16/80.
[42] "the rocky": RW to ES, 10/18/80.

Chapter Five

[46] Fedor Encke: Primarily a portraitist,
Encke was a native of Berlin who
lived with the Stieglitzes whenever he
was in America, beginning probably
in 1877. In 1879 and 1880, ES paid
Encke's rent and other expenses for a
year in Paris and summer tours
throughout Europe. Encke painted
many portraits of Stieglitz family mem-
bers, some of which may be seen at the
Philadelphia Museum of Art as well as
the Museum of the City of New York;
a few of Alfred were done from photo-
graphs taken probably by Fedor's
brother Erdmann Encke. In Paris,
Fedor Encke's works sold at Druet.
His works were described by ES as
just falling short of "the first rank."
ES to AS, 9/21/81.
[46] Moses Ezekiel: Knighted "Sir Moses"
in Germany and Italy and a resident
of Europe for most of his adult years,
Ezekiel was born in Virginia. His
works in the U.S. include the monu-
ment to the Confederate dead at Ar-
lington National Cemetery. In 1878, he
lived with the Stieglitzes in New York
and accompanied them to Lake George
for the summer, during which time he
completed sketches for the façade of
Corcoran House (the predecessor to

the current Corcoran Gallery), ordered
by William Corcoran. ES advanced him
the funds to carry out in marble the
commissioned statues of Michelangelo,
Raphael, Phidias, Homer, Dürer, a
group of angels, and some others un-
identified in correspondence. One
rendering of the biblical Judith wound
up at the Cincinnati Museum; a second,
also in marble, was in ES's collection.
[47] his heroes: *Autograph* books, Yale.
[48] lecturer: Hermann Lind to ES, 5/18/
77.
[49] It would not: Letters from Hedwig
to Edward after 1872 hint at that pos-
sibility.
[50] private schooling: Alfred and the
twins attended Charlier Institute until
the fall of 1877 when, for "democratic"
rather than financial reasons, they were
enrolled in Grammar School 55, at
which Siegmund's daughter Louisa
("Lillie," the genealogist), aged six-
teen, had just begun to teach. Alfred
finished his secondary schooling at
Townsend Harris.
[50] Majestic Hotel: Opposite the Dakota,
and its counterpart in elegance, the
hotel was replaced by the Art Deco
Majestic Towers in 1930.
[51] "hospitable and generous": Adolph
Werner to AS, 1/1/1913. Werner's let-
ter paraphrased questions Alfred had
set him concerning "the relation of
parents and children," and, specifically,
the inconsistencies of fathers—"a hun-
dred thousand men like the Hoboken
gentleman whom you observed," is the
way Werner put it.
[53] In 1917: Julius Stieglitz to AS,
10/29/17. Julius, who had started at
the University of Chicago as a docent
in chemistry in 1892, had been named
head of the department in 1915, elected
president of the American Chemical
Society in 1917 and during the first
World War, carried on experiments
for the War Department. In addition,
he decided which drugs formerly im-
ported from Germany should be pro-
duced in the U.S. and by which com-
panies.
[53] "I hope": Julius Stieglitz to AS,
10/29/17.
[53] "The man": Ibid.
[53] A belated birthday: Julius Stieglitz
to AS, 9/1/18.
[54] rented cottages: In 1874, ES took
the family to the Fort William Henry
Hotel for an August week. In 1875 and
1876, he rented a cottage on the hotel
grounds for the summer, large enough

to accommodate friends as well as family. In 1877, three months were spent at "The Lake House"; in 1878 and 1879, a like period was spent in an unidentified house on the lake's east shore. In 1880, the family stayed at Crosbyside, an inn with cottages celebrated in their recollections as the location at which many long-lasting friendships with Bolton Road landowners began. Presumably, these latter helped ES to find Oaklawn, the estate he rented in 1886 and bought at the end of the summer.

Chapter Six

[58] "Pa, Ma": AS to family, 9/19/79.
[60] nearly a half-million: In 1982's inflated terms, equal to about $5 million. [This equivalent figure, and those that follow in other notes, are derived from computerized extrapolations.]
[61] "heart nearly broken": HWS to AS, 6/22/13.
[62] "a turning-point.": Ibid.
[62] "in England . . . more so": Joseph Obermeyer to AS, 8/7/08.
[63] a master at: AS to Adolph Werner, 10/15/1881.
[63] "My dear . . . Edward Stieglitz": ES to AS, 9/12/81.
[63] *"take more pains"*: HWS to AS, 9/13/81.
[64] Alfred's autograph collection: Eventually, this included the autographs of a number of the crowned heads of Europe (from Louis IV to Queen Victoria), some of their ministers, a string of princes, princesses, grand dukes and duchesses, Prussian and Austrian field marshals from the eighteenth and nineteenth centuries—as well, naturally, as the artist and writer acquaintances of Edward and his friends. After 1885, autograph collecting was unthroned by photographic pursuits.
[64] "cardinalian black . . . too late": *Mental Photographs, An Album for Confessions of Tastes, Habits and Conviction.* Private collection.
[64] "in Venusberg . . . changeable": Autograph book, unnumbered, Yale.
[64–5] "public institutions . . . inner mind": ES to AS, 9/21/81.
[65] "a striking . . . their ease": HWS to AS, 4/17/82.
[65] "the Notterdam": Selma Stieglitz (Schubart) to AS, 4/17/82.
[65] Alfred wrote: AS to Selma Stieglitz (Schubart) 5/17/82.

[66] Books were: AS to Adolph Werner, 10/15/81.
[66] The teaching method . . . was impossible: AS to Adolph Werner, 11/13/81.
[66] Discipline as . . . for misconduct: AS to AW, 12/23/81.
[67] . . . "jolly": AS to Selma Stieglitz (Schubart), May 1882.
[67] From Gutach: AS to AW, 4/18/82. Hâsemann was later credited by Alfred with producing the first picture postcard—a portrait of Alfred. AS to Rebecca Salsbury Strand, 10/16/23. [According to *Antiques and The Arts Weekly*, 7/11/80, the picture postal was invented in Germany in 1895.]
[67] "loose-living": Rosenfeld, op. cit., p. 65.
[68] At the end of May 1882: Their starting-point, Badenweiler, lies in the southwest corner of the Black Forest, near the borders of France and Switzerland. From there, apparently, they proceeded east through the Mittenwald in the Bavarian Aips, south to Innsbruck in the Austrian Tyrol, east through the Engadine—an area bordering the Inn River that would be revisited often—and probably through the Salzkammergut to Vienna.

Chapter Seven

[71] "as a messenger": Minerva Brace Norton, *In and Around Berlin.*
[72] "it's very contagious": RW to AS, 1/24/83.
[72] "$3,000 a year": Leopold Stieglitz to AS, 9/20/82. Equivalent to about $30,000 tax-free in 1982. (In 1893, a depression year, the figure would be closer to $27,000.) Alfred's memory about his allowance after his marriage in 1893 was also variable, ranging from $1,200 (Seligmann, *Alfred Stieglitz Talking*, p. 34) to $3,000 (Norman, op. cit., p. 40).
[73] By the end: The following year, he used a forty-inch chrome "wheel." Possibly the broken nose so noticeable in photographs in subsequent years (unexplained during my time) was the result of a fall from this hazardous early bicycle.
[73] "XYZ" people: Norman, op. cit., p. 25.
[73] he continued . . . to face: AS to AW, Spring 1883.
[74] In a Chaplinesque: Accounts of his early photographic experiences appear in greater detail in Rosenfeld, op. cit., and Norman, op. cit.

[78] fifty-five years later: F. L. Ferwerda to AS, 10/3/37.

[81] "a process": W. H. Patten to AS, 1/11/89.

[81–2] In 1908: L. H. Baekland to AS, 12/24/08.

[82] The writers: Du Bois-Reymond to AS, 4/29/84.

[84] "trees reflected . . . faces?": Mabel Cooke to AS, 8/8/88.

Chapter Eight

[88] "peering through": Charles E. Gordon to AS, 3/13/1944.

[89–90] "I've no . . . know best!": Leopold Stieglitz, notebook, 1888. Private collection.

[91] By the end: Possibly this was one of a number of attacks of "kidney colic" he had suffered since having an unspecified "dread disease" in childhood; after 1926, when he passed a kidney stone without surgery, the "dread disease" seemed to evaporate. Most of his "heart attacks" in later life were episodes of angina of varying intensity; possibly in 1928, and definitely in 1938, he suffered a coronary. Until 1938—notwithstanding complaints of having been "handicapped" all his life —whenever he was working well, or in love, his energy was prodigious and his health excellent.

[91] "God, I": Dorothy Obermeyer Schubart, in interview with SDL, 5/14/75.

[91] "a hole": Flora Stieglitz (Stern) to ES and HWS, October, 1889.

[92] "from Jews": HWS to ES, 2/10/90.

[92] "Understand why": Flora Stieglitz Stern to AS, 12/6/89.

[92] "Al bears": Joseph Obermeyer, cable to ES, 2/18/90.

[92] "Cathedrals, Castles": Charles W. Hastings, ed., *The Amateur Photographer, London*, to AS 7/17/90.

[93] "at $20 a week": John Foord to ES, 6/10/90.

[93] "ten $100 shares . . . already distributed": John Foord to ES, 6/13/90.

[93] *cum laude*: Lee would also win License No. 1 in the first, competitive, New York State Medical Board examinations.

[93] Julius had: JS to ES, 12/6/89.

[93] "your friend": John Foord to AS, 10/17/90.

[93] "there is": John Foord to AS, 1/13/91.

[97–8] "A propos . . . be good!": George Herbert Engelhard to AS, 10/31/1924.

[93] all but one: The exception, Fritz Goetz, apprenticed himself to AS. In 1905, he joined the Bruckmann Verlag, in Munich, where he supervised many of the finest reproductions for *Camera Work* until World War I halted operations temporarily. According to Rosenfeld, op. cit., p. 77, Goetz brought to Bruckmann some of the innovative methods for three-color reproduction used by AS at his Photochrome Company before 1895, methods that contributed also to the remarkably faithful four-color reproductions of Lumière plates in 1908 and later.

Chapter Nine

[103] "all grease": EOS to AS, summer 1913, from the Grand Hotel, Rome.

[104] To his intense . . . look right": SDL interview with Dorothy Obermeyer Schubart, 5/14/75.

[105] They fought: SDL interview with Dorothy Obermeyer Schubart, 7/22/82.

[107] "Technically excellent": Edward Steichen, *A Life in Photography*, n.p.

[108] "everything connected": *Camera Notes*, July, 1897.

[109] "Pa never": HWS to AS, 7/27/16.

[109] His account: See Norman, op. cit., pp. 43–5.

[110] "[It will] live . . . every feature!": ES to AS, 7/10/97.

[113] He retained: AS to Camera Club confirming terms of agreement, 2/21/1901.

[113] at Lake George: AS's illness is substantiated; where he was ill is not. My assumption is based on his habits of other years and his certain presence there when Steichen arrived from Europe.

Chapter Ten

[120] "baby [is]": Emmeline Obermeyer Stieglitz to AS, May?, 1899.

[121] "orders . . . from": Roland Rood to AS, 6/24/1906.

[121] "run you": Ibid.

[122] "tried, convicted": Joseph T. Keiley to AS, 8/16/04.

[123] "Be careful": Joseph T. Keiley to AS, 7/18/04.

[124] "make pulls": Joseph T. Keiley to AS, 6/22/04.

[124] As an entity: See Jonathan Green, ed., *Camera Work: A Critical Anthology*, and Marianne Fulton Margolis, ed., *Camera Work: A Pictorial Guide*.

[125] After their . . . had enlisted: As

recorded in *Alfred Stieglitz: Conversations* [ms], Yale.

[125] Steichen's later: Steichen, op. cit., n.p.

[127] Both *Camera Work*: The magazine *291* was edited and supported by Marius De Zayas, Paul Haviland, and Agnes Ernst Meyer.

[127] Eight thousand: AS to American Waste Paper Company, 4/12/17.

[128] "so-called pictorial": AS to Mr. Gledhill, 6/8/14.

[128] "Our policy . . . the truth": Editorial, *Camera Work*, Number XXV (January 1909).

[129] Among Alfred's: Steichen, op. cit., n.p.

[130] "standing at": AS to John Aspinwall, 1/9/12.

[131] Disagreement surfaced: Charles Caffin, "Henri Matisse and Isadora Duncan," *Camera Work*, Number XXV (January 1909).

[132] "There, you see? . . . sensible mouse!" Paraphrased, obviously, but the gist is well remembered.

[133] "Permit me . . . a failure": ES to AS, 8/12/07.

[134] to prevent "frilling": A fairly common problem in either the developing or fixative stages of processing dry plates, frilling produces a rippled effect starting at the edges, which may overtake the entire image. AS's problems arose partly from using solutions and water at temperatures higher than the 60° F. recommended by the Lumières and others. He solved the problem in a series of experiments with formalin, as recorded in *Camera Work* Number XXIII (July 1908), pp. 49–50.

[134] "Wall Street!": ES to AS, 8/12/07.

[136] Coming home . . . "color photographs!": AS to editor of *Photography* magazine, London. As reprinted in *Camera Work*, Number XX (November 1908).

[136] "remarkably truthful . . . pity on us": Ibid.

[136] a remote corner: Laurie Lisle, *Portrait of an Artist/A Biography of Georgia O'Keeffe*, p. 41.

[137] bathroom-*cum*-darkroom: When AS resigned from the Camera Club that spring, a group of forty photographers—a majority of whom resigned with him—leased working space at 122 East Twenty-fifth Street. Calling itself "The Camera Workers," the group sought the participation of up to one hundred members. In 1912, however,

it disbanded. 291's bathroom became an intermittent darkroom for AS.

[137] "conduct prejudicial": Camera Club to AS, 1/18/08; reprinted in *Camera Work*, Number XXII (April 1908).

[137] The whole episode: Ibid, pp. 42–3.

[137] "he too . . . are you?' ": Emmeline Obermeyer Stieglitz to AS, 9/10/08.

[138] "Thank God . . . me again!": Emmeline Obermeyer Stieglitz to AS, 9/11?/08.

[138] "Edward's groans": Selma Loewenstein to HWS, 6/5/09.

[138–9] "his genial . . . and guide." Author unknown. Edward Stieglitz papers, Yale.

[139] looking ill: Margaret Foord Bonner to HWS, 6/?/09.

[139] "feeling better": HWS to AS, 7/5/09.

[139] "I miss . . . for years": HWS to AS, 7/30/09.

[140] Edward's male friends: These included George Foster Peabody (founder of the Peabody Awards, who mourned deeply the loss of his "dear and revered friend:" GFP to HWS, 5/28/09); his partner, Spencer Trask (founder with his wife of the art colony, Yaddo, in Saratoga); Charles Jones Peabody (GFP's brother, who bought the former Price estate from ES at cost); the recently deceased Galloway C. Morris of Philadelphia; and Edward Morse Shepard, a lawyer and close friend of GFP in Brooklyn Heights.

Chapter Eleven

[142] There, as Alfred: AS *Conversations* [ms], Yale.

[143] His promise: With one notable exception, the arrangement they made in 1909 held until Alfred's death in 1946. The exception was AS's refusal to show any of Marin's landscapes from New Mexico that used the exact same vista of any of O'Keeffe's paintings. According to Marin [in one of many conversations with SDL], O'Keeffe was unaware of AS's decision. The New Mexico Marins referred to were shown for the first time at the Downtown Gallery, years after AS's death.

[145] "go to Paris . . . housekeeping": Joseph Obermeyer to EOS, 7/20/09. From 1909 until his death in 1943, Joe Obermeyer gave Selma an allowance that was as generous as he could manage, refusing to allow her to sell her

jewelry, and insisting that she make use of his car and chauffeur.

[145] Heinrich Kuehn. In early numbers of *Camera Work*, the photographer's name appeared as "Kühn;" I am using the more frequent, later, spelling.

[145] "His chiefest": JTK to AS, 8/25/09. The attaching to adjectives of a superlative suffix was common currency among members of the Stieglitz circle at this time.

[146] "God—talk": Selma Stieglitz Schubart to AS, 9/18/09.

[146] TERRIBLY alike: AS to SSS, 10/4/09.

[146] "gross": Flora Small (Lofting) to AS, 8/28/24.

[146] Astonishingly, he: *Random Rhythms* (1924) and *Nothing New* (1934) were published under the pseudonym "Rodney Blake."

[147] "found a friend": Cornelia B. Sage to AS, 10/5/09, as quoted in Weston J. Naef, *The Collection of Alfred Stieglitz: Fifty Pioneers of Modern Photography*, p. 192.

[149] "complete vindication . . . fakirs of India": Paul Haviland in *Camera Work*, Number XXXI (July 1910), p. 41.

[149] "Mr. Weber's": Katherine Stieglitz (Stearns) to Elizabeth Stieglitz (Davidson) and Flora Stieglitz (Straus), Summer 1910. Private collection.

[150–1] Moreover, the catalogue: Naef, op. cit., p. 186.

[152] He had sold: William Innes Homer, *Alfred Stieglitz and the American Avant-Garde*, p. 135.

[153] "is the man . . . about love": AS to Hartmann, as quoted in Norman, op. cit., pp. 109–10. [Order changed by SDL for emphasis]

[153] Appearing the following summer: Other than *Three Lives*, published at her own expense in 1909 and reaching an extremely narrow audience, the pieces in *Camera Work*, Special Number, (August 1912), were the first of Gertrude Stein's writings to appear in America.

[154] In a series: For some cogent considerations of Dove's works, see Barbara Haskell, *Arthur Dove*, and Homer, op. cit. (also a forthcoming catalogue raisonnée by Ann Lee Morgan.)

Chapter Twelve

[156] Although as late: William Carlos Williams, "The American Background," *America and Alfred Stieglitz*, p. 32.

[156] The profound: Bram Dijkstra, *The Hieroglyphics of a New Speech: Cubism, Stieglitz and the Early Poetry of William Carlos Williams*.

[156] Seeking in 1914: Dated July 1914, *Camera Work* Number XLVII did not appear until January 1915. The delay was occasioned in part by Steichen's procrastinations and/or reluctance to submit his contribution to the text.

[157] "An oasis": Eugene Meyer, Jr. in *Camera Work*, Number XLVII, p. 40.

[157] "a place": Hutchins Hapgood in *Camera Work*, Number XLVII, p. 11.

[157] "conflicting and . . . you appropriate": Paul Haviland, *Camera Work*, Number XLVII, pp. 31–2.

[157] That yearning: AS to William Einstein, 7/16/36.

[158] Between 1905: Norman, op. cit., p. 16. A more modest estimate is offered by Herbert J. Seligmann ("291: A Vision through Photography," *America and Alfred Stieglitz*, p. 109) in which he states that, in the twelve years of its existence, 291 had drawn "tens of thousands."

[158] He positively: Teaching its readers "How to Become a Highbrow," *Puck* magazine suggested that they "profess admiration for Alfred Stieglitz's Little Galleries and other artistic fakes" (*Puck*, 1/8/16).

[158–61] Alfred's part-time . . . would be enjoined: Marie Rapp Boursault, in an interview with SDL, 10/31/78.

[161] "bring Maillard": EOS to AS, Summer 1912.

[162] Kandinsky's *On the Spiritual*: Excerpts were quoted in *Camera Work*, Number XXXIX, p. 34, apparently before the book's official translation into English.

[163] "The Eight": The others were Robert Henri, John Sloan, George Benjamin Luks, William Glackens, Ernest Lawson, Everett Shinn, and Maurice Prendergast.

[164] Only Davies: Glackens, with the help of Alfred Maurer and Leo Stein, was chief adviser to Albert Barnes, the "Argyrol King," in selecting Impressionist paintings for the latter's renowned collection. He (Glackens) was appalled when Barnes bought four Hartleys at an auction arranged by AS in 1916.

[164] Gradually, Henri: Bennard B. Perlam, *The Immortal Eight: American Painting from Eakins to the Armory Show*.

[166] the first had passed: Caricatures by

Alfred Frueh, a cartoonist for the New York *World* and, later, *The New Yorker.*

[166] "First Great": The by-line attributing authorship to Alfred was amended in small type: "contributed . . . in the form of an interview." Penned probably by one of two sympathetic critics on the newspaper's staff (Charles Caffin and Guy Pène du Bois), the article was prefaced by the following tribute: 'Alfred Stieglitz is recognized in the world's chief centers as one of the earliest prophets and most active champions of the new and astonishingly revolutionary movement in art." New York *American,* 1/26/13.

[167] "The dry . . . adjacent islands": Ibid.

[167] "breeding little": Followers of the academician William Meritt Chase, the "realist" Robert Henri, and the popular portraitist John White Alexander.

[167] His digressions . . . "hand-made products": New York *American,* 1/26/13.

[167] on tour later: Alfred seems to have withdrawn his loans before the tour began. The Chicago exhibition catalogue, 3/24 to 4/16, omits mention of them.

[168] "our friends": Nigel Gosling, *Paris 1900–1914, The Miraculous Years,* p. 216. (Unfortunately, this slickly entertaining volume often lacks accuracy, especially in its accounts of 291.)

[168] "word portrait": Gertrude Stein, "Portrait of Mabel Dodge at the Villa Curonia," *Camera Work,* Special Number, June 1913, pp. 3–5.

[169] "active sympathy": Unsigned "Our Plates," *Camera Work,* Number 42/43 (dated April–July 1913, published November 1913), p. 68.

[169] "swarming around": Elizabeth Stieglitz (Davidson) to AS, 1/10/13.

[169] "Those people": Leopold Stieglitz to AS, 4/7/13.

[169] Dorothy Obermeyer later married Alfred's nephew (Selma's son), William Howard Schubart.

[170] he was able: AS to Steichen, 6/14/13.

[171] "Elizabeth is": HWS to AS, 7/13/13.

[172] "Easy to handle": Elizabeth Stieglitz (Davidson) to Flora Stieglitz (Straus), August 1913. Private collection.

[173] "blue—you always": EOS to AS, 8/28/13.

[173] "the chills" . . . be lifted: EOS to AS, 9/25/13. Until late 1913, 291's im-

ported works were admitted under bond furnished by the gallery as an "educational institution," so recognized by the U.S. government, but duty had to be paid by the purchaser of any imported work. Appraisals were left to an agent (any agent) at the pier in the presence of Alfred or his representative, usually either Keiley or Haviland. Duty was 15 percent of value, the bond a fraction of that amount.

[173] Hardly a day: Dorothy Obermeyer Schubart in interview with SDL, 6/12/81.

[173] "All the Jews": EOS to AS, 9/19/13.

Chapter Thirteen

[178] The Wobblies: (Industrial Workers of the World) began as a socialist group. It was not until the early twenties that a splinter group turned Communist.

[178] "all the artists": EOS to AS, 8/23/14.

[178] "always . . . general companions": EOS to AS, 9/2/14.

[179] "I was always . . . you today": Marie Rapp (Boursault) to SDL, 5/27/79.

[180] "I remember . . . 1/200 second": Georgia Engelhard (Cromwell), "Alfred Stieglitz," *Popular Photography,* No. 46 (1944), p. 9ff.

[180] The Iron Virgin: AS to Rebecca Salsbury (Strand) 7/15/22.

[180] Just before: AS to Steichen, 12/4/13.

[181] Frank Burty: He dropped the Haviland name for professional purposes.

[181] "I would": HWS to AS, 6/14/14.

[182] Troubles in: HWS to AS, 9/12/11. She had written: "The papers speak so much of war between France and Germany that no doubt it will come to pass—Many a war has been made by the press."

[182] "The war": Samuel Eliot Morison, *The Oxford History of the American People,* p. 849.

[183] In late August: EOS to AS, 8/25/14.

[183] "tremendous reality": AS to Marie Rapp (Boursault), 8/7/14.

[183] "It strikes . . . his own": Flora Small (Lofting) to AS, 10/15/14.

[184] "African Savage Art": In fact, African carvings had been shown the previous spring at the new Washington Square Gallery, whose proprietor, Robert J. Coady, would soon show also

works by Matisse, Picasso, Braque, and Gris, and would publish, for one year, a periodical promoting avant-garde art. Although his gallery was, briefly, one of 291's "rivals," it is doubtful that he and AS were consciously in competition. On this occasion, at least, their presentations seem to have been coincidental.

[185] "You see how": Mary Steichen Calderone to SDL; interview, 2/12/76.

[186] But he: AS had left his secretary/assistant with the impression of his sole responsibility. Marie Rapp Boursault to SDL; interview, 10/30/78.

[188] "impressed the . . . Just *Old*": AS to MRB, 7/23/17.

[189] Apparently finding: AS to Steichen, 7/6/14.

[189–90] "this inquiry . . . and State": Steichen, in *Camera Work*, Number XLVII (July 1914; issued January 1915), pp. 65–7.

[190] "Stieglitz's favorite": Steichen, *A Life in Photography*, n.p.

[191] "simple and democratic": HWS to AS, 7/27/16.

[192] It was not . . . law partner: DOS to SDL; interview, 7/22/82.

[192] "It served": Steichen, *A Life in Photography*, n.p.

[192] the Signal Corps: It included an "Aeronautical Division," organized in 1907 as the first army air group—a mere four years after the Wrights' first successful flight.

[192] His brother: JS to AS, 4/17/18. See Notes, Chapter 5, for details.

[192] a "hell-raiser": Seligmann, *AS Talking*, p. 81.

[194] "Steichen will": Dorothy Norman to SDL; interview, 10/24/78.

[194] "Stieglitz's greatest": Steichen, *A Life in Photography*, n.p.

Chapter Fourteen

[196] Beckett and Rhoades: Katharine Rhoades was a favorite of both AS and Steichen; some eyewitnesses have suggested that both men were infatuated with her. Rhoades left New York for Washington in 1915 to work at the new Freer Gallery of Oriental Art; in 1919, Steichen's first wife, countering his initiating divorce proceedings, named Rhoades as corespondent.

[196] "portrait" of Alfred: Printed in *291*, Number 5–6, July/August, 1916.

[196] "Con you": Norman, op. cit., p. 208.

[197] In 1917: Homer, op. cit., p. 183.

[198] Villon, (Jacques): The pseudonym

of Marcel Duchamp's older brother, Gaston, whose work had appeared also in the Armory Show.

[198] Urged by: Although Haviland never returned thereafter to the States, he remained a loyal friend to Alfred and continued to write him over the years. In Europe he did not enter the art world, as might have been expected, but applied his taste and acumen to running the Haviland Limoges factories and to reorganizing the crystal works of René Lalique, whose daughter he married in 1917. In later years, he became a viniculturist.

[198] to her he admitted: AS to MRB, 7/16/15.

[198] He was so dizzied: Ibid.

[199] "inactivity and": Agnes Ernst Meyer to AS, 8/16/16; as quoted in Homer, op. cit., p. 195.

[199] "fine": AS to MRB, 9/8/15.

[199–200] "hopping around": Anita Pollitzer to Georgia O'Keeffe, 11/8/15.

[200] . . . $1,100 in interest: Equivalent to about $9,000 in 1982.

[200] The magazine *291*: In 1917, Picabia and his wife, Gabrielle Buffet, founded a new magazine in Barcelona, to which they had moved. Modeled directly on *291*, they called it *391*. In the 1940s and 1950s, other magazines based freely on *291* appeared briefly in Paris, titled, in sequence, *491*, *591*, and *691*.

[200] In late December: As related in Norman, op. cit., pp. 128–9.

[200] He would still: The Modern Gallery continued to show nearly all the artists associated with 291, including AS, emphasizing linkages between modern art and the art of ancient Africa and Mexico. When Meyer went to Washington in 1919, her role as "angel" was taken over by Walter Arensberg; the gallery became the De Zayas Gallery and concentrated on Van Gogh, Derain, Modigliani, Gris, Rivera, and other, less celebrated, moderns.

[201] In time: Homer, op. cit., p. 245.

[201] The October: *Camera Work* XLVIII, released December.

[201] the periodical's last: *Camera Work* Number XLIX–XL, published June 1917.

[201] . . . with the warning: Georgia O'Keeffe to Anita Pollitzer, 12/13/15.

[201] "I had to . . . 'perhaps I shall' ": AP to GO'K, 1/1/16.

[201] She wanted: GO'K to AP, 1/4/16.

[203] "thin, in a": Norman, op. cit., p. 130.

[204] In one week: GO'K to AP, 9/20+/16.

[205] "much love": AS to EOS, 8/6/16 et al.

[205] This drama . . . 'Epitaph for Alfred Stieglitz' ": *Camera Work*, Number XLVIII, pp. 63–4; 69–70.

[206] "Alfred Stieglitz: Still": Seligmann, *AS Talking*, p. 128.

[206] "He lived": AS to Arthur Dove, 1931?

[206] Daily, Marie: AS to J. W. Gotshall, 5/3/17; AS to Marianne Moore, 5/7/17 & 5/17/17; AS to Charles Schaufler, 6/26/17, et al.

[207] "Zimmermann Telegram": Zimmermann, Germany's foreign minister, had cabled his representative in Mexico to negotiate an alliance with Mexico should the U.S. enter the war, offering as spoils the return to Mexico of Texas, Arizona, and New Mexico. Intercepted and decoded by the British, the text hit American headlines 2/27/17.

[207] "Every time . . . got nowhere": MRB to AS, 7/17/17.

[208] Years later: AS to IRS, draft of letter, 6/30/20.

[208] In terror: HWS to AS, 7/8/17.

[208] O'Keeffe came . . . grew chilly: Georgia O'Keeffe, *Georgia O'Keeffe*, n.p.

[208] "How? . . . in the chair?": MRB to AS, 7/21/17.

[209] All three writers: Anderson dedicated *A Story Teller's Story* to AS in extravagant terms; Frank sang his praises in quasi-Biblical prose in *Our America*; Rosenfeld acclaimed him in articles and books. As early as 1899, Theodore Dresser hailed him as "an American genius" ("A Master of Photography," *Success*, 6/10/1899, p. 471).

[209] *American Caravan*: An annual compilation of poetry and fiction, the magazine's first issue appeared in 1927; later issues came out at irregular intervals. Among its editors was Rosenfeld's coeval, Lewis Mumford, another long-time Stieglitz fan.

[210–11] In this search: In 1924, AS referred to reading Haldane's *Daedalus: Science and the Future*, and Russell's *Icarus, the Future of Science*. AS to Arthur Dove, 6/23/24.

[211] *Psychological Types*: AS to Rebecca Salsbury Strand, 10/3/24.

[211] John Stuart Mill's: AS to Arthur Dove, 7/18/23.

[214] By April: AS to MRB, 4/3/18.

[215] Elizabeth reassured . . . "see things": ESD to AS, 5/?/18.

[215] "full military": Paul Strand to AS, 9/14/18.

Chapter Fifteen

[216] After her: AS to AD, 6/18/18.

[216] A stark: O'Keeffe, op. cit., n.p.

[217] He made . . . negotiations immediately: AS to MRB, 7/9/18.

[217] "either intensely": AS to AD, 8/15/18.

[217] Notice from . . . appointed time: AS to MRB, 8/1/18.

[218] "dear old": Katherine Stieglitz Stearns to AS, 7/21/18.

[218] "terrible" hours . . . first time: AS to MRB, 8/8/18.

[219] Eventually, his ashes: In the thirties, one of the urns was inadvertently emptied and scrubbed by an unfamiliar "daily." To produce an equivalent quantity of ashes, she and Sel's terrified maid, Tsillie, spent the rest of the January day, with windows open wide, in a frenzy of chain-smoking.

[221] "the sanest": Seligmann, op. cit., p. 17.

[222] watchful eye: Elizabeth's rebus for "Davidson" has already led at least one bewildered researcher at Yale to the amusing conclusion that she had developed a sudden and passionate interest in Judaism.

[223] Nevertheless, Alfred: AS to AD, 8/15/18.

[226] "will sing": AS to Paul Strand, 11/17/18.

[226] About to go: Paul Strand to AS, 11/3/18.

[226–7] "secret formula . . . brand again": JS to AS, 11/15/19. Julius was in a peculiarly sensitive position as both President of the American Chemical Society and special adviser to the Federal Trade Commission in 1917. From early 1918 to sometime after the end of the war, he was the War Department's "Special Expert on Arsenicals," and carried on experiments for the government in dye intermediates, the class of chemicals that includes "starting materials" for explosives, poison gases, synthetic drugs, and photochemicals. Association with DuPont during the war would lead him in 1923 to defend the interests of the "Chemical Foundation" (a DuPont offshoot) against a government suit, even though he turned down the company's offer of an exalted position.

[227] Department of Justice: Mark Hyman, Special Assistant to the Attorney General, to AS, 1/2/15.

[227] "taken off": AS to Paul Strand, 5/20/19.

[227] fit person: AS to AD, 11/11/28.

[228] $25,000: In 1982 terms, about $190,000.

[230] "If I have . . . exaggerated seriousness": Ann Straus (Gertler) to AS, 1/25/40.

[233] The arrangement: The exception was during Davidson's terminal illness in 1948, through which Elizabeth nursed him in her Red Top room.

Chapter Sixteen

[233] "with a couch . . . privacy": LS to AS, 5/11/20.

[234] Margy Frank: Margaret Naumburg, founder of the Walden School, had married Waldo Frank in December 1916. In the summer of 1920, they vacationed at a Lake George boardinghouse near AS.

[236] disoriented, "queer" . . . when they chose: AS to PS, 10/9/20.

[236] Charles Duncan: Duncan was one of several young painters exhibited in the first group show at 291 to include O'Keeffe, in May 1916.

[236] "Suffering is . . . his beloved": Waldo Frank, *Our America*, as quoted in letter from Mabel Cooke to AS, 7/26/20.

[236–7] A few years . . . "is 'nothing' ": Clarence J. Freed in *The American Hebrew*, 1/18/24.

[237] By 1938: GO'K to AD, late December 1937 or early January 1938.

[237] "Space-eaters": AS to PS, 11/3/20.

[238] "$28 for": Agnes Stieglitz (Engelhard) to AS, 11/7/20. The figure, supplied no doubt by AS, covered a month in which an average of three meals for three people was served daily. Possibly it included electric and telephone charges but—as AS in ensuing years allowed such bills to lapse for months—probably did not. Coal and staples bought at the start of the summer, and fixed charges like insurance and taxes, were certainly not included. Over the years, Alfred's claims to extraordinary frugality seem to have included little beyond food and clothing.

[239] Considering, however: AS to PS, 11/10/20.

[240] Walter Lippmann: Walter Lippmann to Herbert Seligmann, 1/16/21.

[240] "numberless prints . . . by anyone": Catalogue, AS show at the Anderson Galleries, February 1921.

[241] Although Alfred: Julius had urged him to eliminate even more than he did, as well as to change the catalogue introduction. JS to AS, 1/20/21.

[241] sought-after nude: Apparently a unique print from a plate AS had either destroyed or contemplated destroying. Henry McBride, "Modern Art," *The Dial*, April 1921, p. 480.

[241] under $5,000: About $30,000 in 1982 terms.

[242] "put [O'Keeffe] . . . newspaper personality": Quoted in Laurie Lisle, op. cit., p. 110.

[242] Arthur Brisbane: A much-admired patient and a friend of Lee's, Brisbane was the subject of monumental arguments between Alfred and Lee for years.

[243] twenty percent: The 4/16–5/15 show included works by Beckett, Demuth, De Zayas, Dove, Frueh, Hartley, Lachaise, Marin, Maurer, O'Keeffe, Walkowitz, Weber, and Wright.

[243] same magazine: "American Painting," *The Dial*, December 1921, pp. 649–70. A reproduction of Dove's *The Cow* appeared in the same issue.

[244] "ten cents . . . 100,000 Subscribers": *MSS*, February 1921 and ff.

[244] "go to Florence": Norman, op. cit., p. 165.

[245] On the proceeds: The book, *Adventures in the Arts*, a collection of essays, contained a reprinted article interpreting O'Keeffe's abstractions in Freudian terms that made her feel she looked "absurd." See Lisle, op. cit., p. 133.

[245] Finally, sensing . . . Sel's pigheadedness: George Herbert Engelhard to AS, 6/10/21.

[246] Had his ideals . . . Vanzetti proceedings: AS to PS, 8/4/21.

[247] Alfred, struck: AS to PS, 9/2/21.

[247] thousand-dollar income: Equivalent to approximately $5,800 in 1982.

[247–8] "carrying a . . . temperamental background": ESD to AS, 2/10/22.

[248] "Photography does . . . your vision": ESD to AS, late February or early March, 1922.

[248] "In later . . .": Ibid.

[248] post partum dementia praecox: An irreversible, and sudden, deterioration of an originally intact mind brought on by childbirth, often unassociated with any previous mental disorder. In today's terms, her illness would be de-

scribed as *hyperphrenic schizophrenia*, possibly biochemical in origin.

Chapter Seventeen

[252] "You have . . . of art": Charles Demuth to AS, 5/2/23.

[253] "photographic vagabond": AS in *Camera Work*, Number XXIII (July 1908), p. 49.

[253] "Oppullhill": AS to Rebecca Salsbury Strand, 8/19/22.

[253] "One . . . negative": AS to PS, 8/12/22.

[253] "Proper exposure . . . even interesting": AS to PS, 9/7/22.

[254] "a quintillion": AS to Rebecca Salsbury Strand, 10/28/22.

[254] paid their fine: AS to ESD, 10/1/22.

[255] *Wild West Show*: Justifiably, it seems. Salsbury was the experienced and successful producer of "The Salsbury Troubadours" before he met Cody in 1882.

[255] "tickling": AS to RSS, 8/6/23.

[255] Bayley, Alfred: AS to Paul Rosenfeld, 10/18/22.

[256] "clarified much": AS to Paul Rosenfeld, 11/21/22.

[256] "from your Old": HWS to AS, 10/19/22.

[256] "Our place . . . the hill": AS to R. Child Bayley, as printed in the *Amateur Photographer*, 9/23/23; reprinted in Seligmann, "291: A vision through Photography," *America and AS*, pp. 118–19.

[257] "Every time . . . and brass": Ibid.

[259] "easier": AS to AD, 4/4/29.

[259] "Women, one": Paul Rosenfeld, "American Painting," *The Dial*, December 1921, p. 666.

[261] he seconded Dove's: AS to AD, 10/9/23. The book was never written, although Dove continued to write insightful articles.

[261] he bolstered: AS to PR, 7/10/23. At the time, Rosenfeld was working on *Port of New York*.

[261] *A Story*: Anderson's dedication read: "To Alfred Stieglitz, who has been more than a father to so many puzzled, wistful children of the arts in this big, noisy, growing and groping America, this book is gratefully dedicated."

[261–2] "Once more": AS to AD, 2/21/24.

[262] This was proof: AS to RSS, 2/18/24.

[262] "a new group . . . its workings": ESD to AS, 8/20/24.

[262] "maddeningly beautiful": AS to RSS, 11/26/23.

[264] "lace curtains . . . maddening experiment": A sampling of ESD complaints in letters to AS, dated in sequence of use, 7/31/24, 9/29/23, 8/15/24, 6/20/24.

[264] . . . a longhand copy: AS to ESD & DDD, 9/24/23. Private collection.

[265] . . . felt chained: AS to DDD, 10/10/23. Private collection.

[265] His own misery: RSS to ESD, 11/5/23. Private collection.

[265] They sent: ESD to AS, 9/9/23.

[265] "as long as": LS to AS, 10/3/24.

[266] "x's, y's & z's": AS to AD, 2/21/24.

[267] "silly but": AS to RSS, 6/18/24.

[267] "I wish . . . seems simple": SSS to AS, 11/3/24.

Chapter Eighteen

[269] termed a classic": AS to AD, 2/5/25.

[269] "We have . . . is accidental": Arthur Dove, "A Way to Look at Things," in catalogue for exhibition "Seven Americans" at Anderson Galleries, 3/9 to 3/28/25.

[269–70] "embrown[ed] or . . . chief triumphs": Edmund Wilson, "The Stieglitz Exhibition," review in *The New Republic*, 3/18/25.

[270–1] "Something of . . . old dove": Wilson, *The American Earthquake*, Farrar, Straus & Giroux, 1979, pp. 98–102.

[271] in seven years: AS to RSS, 7/14/25.

[272] "slashed to": AS to RSS, 7/30/25.

[273] "I didn't": SDL interview with DOS, 5/14/75.

[276] "a fiend": AS to AD, 11/9/25.

[276] "full up": AS to RSS, 11/9/25.

[278] "not a business . . . *Fridays, 10–12 A.M.*": For a full reproduction, see Norman, op. cit., p. 169.

[279] 900 people: Without a guest book, no exact count could be kept, but Alfred's round-number guesses were to prove remarkably accurate whenever volunteer "registrars" kept track.

[279] "not to do": AS to AD, 3/28/37.

[280] seven-week run: Scheduled for four weeks, O'K's show was extended when Hartley proved unable to come up with enough pictures for the time reserved for his exhibition.

[280] "the streets . . . O'Keeffe was": As

quoted by Seligmann, *AS Talking*, pp. 63–4.

[280] Prodded by: O'Keeffe had become a member of the National Woman's Party in 1913 at the urging of Anita Pollitzer (the organization's secretary in ensuing years) and remained active until her permanent relocation to New Mexico.

[282] *probable* facts: Unfortunately, an "accounting" offered by McKinley Helm in his biography, *John Marin*, pp. 59–60, succeeds only in compounding the confusion.

[283] $25,000: Today's equivalent would be roughly $113,000.

[284] "pupils and students": SSS to AS, 8/6/26.

[284] at a nearby inn: AS to ESD, 6/5/26. Private collection.

[284] "with one": SSS to AS, 8/6/26.

[285] "family Medusa . . . death-bed with it": Georgia Engelhard (Cromwell) to AS, 10/11/26.

[286] "too much . . . slain him!": GEC to AS, 9/15+/27.

Chapter Nineteen

[287] cash, Alfred: AS to AD, 12/7/27.

[288] "It makes": William Ivins to AS, 12/28/28; as quoted in Norman, op. cit., p. 173.

[290] On the evening: AS to AD, 10/18/28.

[291] "Tom, Dick": Ibid.

[291] "the elemental . . . Don't bother us": John Marin, "John Marin, by Himself," *Creative Art* (October 1928); reprinted in *The Selected Writings of John Marin*, pp. 124–7.

[293] "crystallize . . . very glad": AS to RSS, 5/17/29.

[293] "I never . . . have done": Seligmann, *AS Talking*, p. 136.

[294] Two early weeks: AS to ESD, 7/2/29. Private collection.

[294] "A wonder": AS to AD, 9/9/29.

[294] Waking one: AS to ESD, 7/2/29. Private collection.

[294] Model A Ford: One of her instructors, Charles Collier, introduced her to the Abiquiu hacienda she bought eventually as a permanent home.

[294] He expressed: AS to ESD, 7/22/29. Private collection.

[294] "fun and laughter": AS to RSS, 7/19/29.

[295] make her happy: AS to ESD, 7/28/29.

[295] "nibble 'appreciatively' . . . want them": Louis Kalonyme to AS, 7/25/27.

[295] ride in the car: AS to ESD, 8/18/29. Private collection.

[296] When Alfred hit: AS to ESD, 8/18/29. Private collection.

[296] To Dove: AS to AD, 9/9/29.

[296] "Where's Stieglitz? . . . think they do": John Marin to AS, 8/25/29. Reprinted in Marin, *Selected Writings*, p. 131.

[296] "damn fool": AD to AS, 3/22/30.

[296] "Had it": AD essay for Samuel M. Kootz, *Modern American Painters*; copy included in letter from AD to AS, 3/22/30.

[298] Not knowing: AS to ESD, 8/25/29. Private collection.

[300] "contrary to": AS as quoted in "Writings and Conversations of Alfred Stieglitz," *Twice A Year*, No. 1, (Fall/Winter 1938), p. 89.

[300] "the new 'Luxembourg' ": AD to AS, 9/11/29. The building was at 730 Fifth Avenue, at Fifty-seventh Street.

[300] $16,000: The first contributors were Beck and Paul Strand and Strand's father; collectively they pledged $4,000 for the three-year period, bringing in an additional $3,000 from their friends, Elsie and Jacob Frederick DeWald, who had been drawn first to 291 by Paul's debut at the gallery. LS, his daughter Flora, and her husband, Hugh Grant Straus, each gave $1,500; $2,500 came from an unidentified source; and, finally, a $3,000 pledge from Dorothy and Edward N. Norman brought the total to the $16,500 cited by PS in his report to AS, 10/3/29.

[300–1] he apologized . . . "young ones": AS to RSS, 10/22/29.

[301] terrible declines: In six days, the Dow Jones Industrial Average lost nearly 200 points. The slide would continue until the middle of 1932, by which time about 200 more points had been lost. Put another way, the stock value of twelve leading corporations fell an average of 88% between 1929 and 1932.

[302] An American Place: Norman, "An American Place, *America and AS*, p. 128.

[303] "Now that . . . why?" AS's words here are reconstructions, not direct quotes.

Chapter Twenty

[308] Nevertheless, he: Posthumously, Hartley shared a two-man show with Feininger in 1944–5; Strand received his first one-man show at the MOMA in 1945. Dove's works were virtually ignored until his inclusion in a group show in 1951, six years after his death; in 1968, the MOMA circulated a show of his works that traveled the country for a year but was not shown in New York.

[309] Georgia had: In mid-March, she engaged in a public debate with Michael Gold, editor of *New Masses*.

[309] early May: O'Keeffe's 1970 recollection (as published in her 1976 book) that she had found the jack-in-the-pulpit in March is surely erroneous; in the northeastern U.S., this marsh plant does not bloom until May and June.

[313] "All he . . . much longer": Norman, *AS: American Seer*, p. 204.

[313] Downtown Gallery: After the closing of An American Place, the Downtown, run by Edith Halpert (wife of the painter Samuel Halpert), became the home of the paintings of Marin, Dove, and O'Keeffe, for variable terms. From 1930 to 1946, AS often consigned their paintings, as well as Hartley's, for Mrs. Halpert to sell on commission.

[313] "You 'old' ": Herbert Small to AS, 4/21/31.

[314] "the one thing": Herbert Small to AS, 5/15/31.

[314] he accepted: AS's visit included two days in Boston and possibly time with his grandson in Marblehead.

[314] Gerald Sykes: a reviewer for the New York *Herald Tribune*, was a member of AS's and O'K's circle for a number of years.

[314] "worked [his] way": ESD to AS, ca. 7/15/31.

[315] "Either people": Ibid.

[317] "beautiful . . . its beauty": Lloyd Goodrich and Doris Bry, *Georgia O'Keeffe*, exhibition catalogue, Whitney Museum, 1970, p. 23. Source of quote attributed to O'K not given.

[317] Alfred had: AS to AD, 1/9/32.

[317–18] "to spur": Paul Goldberger, *The City Observed: New York*, p. 168.

[318] Diego Rivera: Rivera's murals were later removed from the RCA Building—on orders from John D. Rockefeller, Jr.—when the artist refused to paint out a portrait of Lenin.

[318] In six weeks: The painting, titled *Manhattan*, was bought by the Metropolitan in 1934.

[318] A snide: AS to Associate Editor, *Creative Art*, 6/10/31.

[318] Alfred, beside: I am indebted to Laurie Lisle, op. cit., pp. 203–5, for details of AS's encounters with the Radio City Commission.

[318] Georgia went: Following the death in October 1929 of Dove's wife, Florence, "Reds" Weed filed for divorce. She and Dove were married in April 1930.

[318] Beck's small: AS, in appreciation probably more of her person than her talent, gave her two of his "Equivalents" in exchange for one small painting.

[319–20] "Believing in . . . and fear": Elizabeth Stieffel Stieglitz to AS, 6/28/32 and 7/6/32.

[320] Ralph Flint: Besides serving *The Christian Science Monitor* as art critic in the twenties and early thirties, Flint free-lanced as he could—with diminishing assignments in the Depression years, when he was offered use of the Hill as a working sanctuary for a month or more over several summers.

[322] he implied: AS to Benjamin Huebsch, Viking Press, 11/14/32.

[323] "Alfred once": As quoted by Leo Janis, "Georgia O'Keeffe at 84," *Atlantic Monthly*, December 1971.

[323] First Kitty: AS to AD, 6/25/33.

[326] $15,000: The probable equivalent in 1982—counting fluctuations over the years—would be about $120,000.

Chapter Twenty-One

[326] "hearse": AS to RSS, 12/22/33. After AS's death in 1946, the Metropolitan received a further bequest via O'K. Eventually, the collection included 580 prints by 50 photographers.

[326] Henri Matisse: AS to AD, 5/16/33. Matisse was in the U.S. to execute murals for Albert Barnes in Philadelphia.

[326] He was vastly: AS to AD, 5/26/33.

[328] the latter's recent: AS to Peter Henry Emerson, 10/9/33.

[329] *The Wave*: For *Redes* (released in the U.S. as *The Wave*), Strand was both producer—for the Mexican government—and cinematographer. Other major films for which he later served as cinematographer were *The Plough that Broke the Plains* (1936) and *Native Land* (1942). For more de-

tailed information see Strand, *Paul Strand: A Retrospective Monograph: The Years 1915–1968.*

[329] Diego Rivera: In 1941, the painter William Einstein would suggest again that AS show Rivera; again AS refused.

[330] "misunderstanding . . . the Idea": AS to RSS, 12/22/33. The reference to a newspaper interview (which I have been unable to trace) appears in this letter.

[330] a book about Alfred: *America and Alfred Stieglitz: A Collective Portrait.*

[330] Henwar Rodakiewicz: *Portrait of a Young Man* was the film AS showed; I have been unable to discover the date.

[330] During one . . . new direction: AS's "confession" seems contrived. Unquestionably, he enjoyed the movies as a spectator and was interested sometimes in techniques, but I have found no further evidence that he ever seriously considered trying his hand at cinematography.

[330] "creative work": AD to AS, 1/12/34.

[331] On the other hand: Possibly the discrepancy in pay offered Dove and Hartley reflects a formula intended to equalize compensation for rural and urban areas; possibly it reflects a difference in tasks.

[332] "a miracle": AS to AD, 10/2/34.

[332] Viewing it: AS to AD, 12/20/34.

[332] Arthur Newton Pack: Publisher of *Nature* magazine, Pack counted among his resident friends the Leopold Stokowskis, the Charles Lindberghs, and the president of the giant pharmaceutical company Johnson & Johnson, and his family.

[333] Alfred, with: AS to U.S. Internal Revenue Service, 6/20/20, 9/8/20, 2/10/21, 6/22/28, 5/19/41, 5/21/41.

[333] Counting Georgia's: AS to Douglas Elliman & Co., 10/23/34.

[333] Not only: On his fifty-eighth birthday, Hartley had destroyed 100 or so paintings for lack of money to pay for their storage.

[334] Did I: My reconstructions of conversations with AS are based on vivid memory; I did not take notes.

[335] She was terrified: To my astonishment, a letter from my mother (ESD to AS, 8/28/34) mailed in Zurich, gives a rosy and jovial picture of the same visit Peggy and I recall with shudders. Possibly she was fearful that the letter might be intercepted and produce unpleasant repercussions.

[339] the sole subject . . .: E. M. Benson, *John Marin, The Man and His Work.*

[339] "dearer than ever": Marsden Hartley to RSS, Winter 1936, as quoted in Barbara Haskell, *Marsden Hartley*, p. 99.

[339] Best of all . . .: Lewis Mumford in *The New Yorker*, 1/18/36.

[339] reputedly $10,000: In today's terms, about $46,000.

[339] "Sorry," he said: GEC to SDL, 4/6/76. In this same period, O'K executed murals of huge daffodils in the dining room of Evangeline and Leopold Stokowski's New York apartment in the East Eighties.

[340] a distant cousin: Einstein's paternal grandfather's mother, née Collin, was a sister of Alfred's maternal grandmother, Flora Collin Werner.

[341] And in 1977: O'K, *Georgia O'Keeffe*, Acknowledgments.

Chapter Twenty-Two

[342] non-plus-ultra: AS to WE, 7/30/36.

[342] as queer as: AS to WE 8/9/36.

[343] Alfred wrote: AS to AD, 8/16/36.

[345] "90% slams": Ansel Adams to AS, 10/11/36, as quoted in Naef, op. cit., p. 240.

[346] Alfred wrote Porter: AS to Eliot Porter, 1/21/39, as quoted in Naef, op. cit., p. 250.

[346] solo at the MOMA: Marin's exhibition was spread over two floors of the museum, which occupied a wide limestone town house just west of the first Modern building, which opened in the 1939–40 season.

[347] "The Prince of Watercolorists": Henry McBride, "John Marin's Watercolors," N.Y. *Sun*, 10/28/39.

[347] "patient and": Marsden Hartley, "On the Subject of Nativeness—a Tribute to Maine," American Place, 1937.

[348] Obviously too: One of the sources of the friction between AS and Hartley was Hartley's insistence through the years on allowing a number of dealers to sell his works at prices well below those AS was trying to establish for him. Between 1938 and 1940, Hartley was represented by the Hudson D. Walker Gallery; in the fall of 1942, he was taken on by Paul Rosenberg & Co.

[348] He missed: AS to WE, 9/24/43.

[349] Only he: AS to WE, 6/4/37.

[349] "clean edge": AS to WE, 6/9/37. AS's references in this letter to "Böcklin—Hâsemann—Lautrec—Rodin," etc., suggest that Einstein was preparing an article on the evolution of AS's tastes.

[349] Young Swami: Nikhilananda (1895–1973), a monk of the Ramakrishna Order of India, founded the Ramakrishna-Vivekananda Center in New York in 1933. He was a translator from Sanskrit and Bengali of key Indian scriptures and *The Gospel of Sri Ramakrishna*; a lecturer and occasional instructor at major universities in the United States; and an early generator of ecumenism through his friendly contacts worldwide with leading figures in religion, science, literature, and government.

[349] beautiful kid: AS to AD, 7/5/37.

[350] felt reborn: AS to WE, 8/4/37.

[350] "100% alive": Ibid.

[351] "Original Sin": AS to AD, 12/3/37.

[351] Father Coughlin: By 1934, Coughlin—offering as bait the villainy of Wall Street "Jew" bankers and "Rosenvelt" in the White House—had a radio audience of 10 million and contributions of $500,000 a year, and the Bund's erstwhile fraternal nature had begun to adopt Hitlerian violence.

[351] the Communists: Communist "opposition" to fascism in Spain and in W. W. II, its alliance against the Axis, drew fully a million ingenuous supporters willing to accept or ignore brutal Soviet purges as preludes to an ideal society; its wholehearted converts, however, were relatively few.

[352] out-Hitler Hitler: AS to WE, 10/14/38.

[353] art press book: A special edition of Anatole France, *L'Affaire Crainquebille.*

[354] wife's death-bed: Lee had taken his wife to her former Southbury, CT. home to be with her children while he took part in pretrial hearings at Lake George in a suit against him for injuries to passengers in a sightseeing boat struck by his speedboat. She died while he was away.

[354] more beautiful: AS to WE, 8/16/38.

[354] "Two busters": AS to AD, 9/12/38.

[356] In Hawaii: My account is based on Lisle, op. cit.

[357] to the darkroom: AS to WE, 9/20/39.

[357] work in bed: AS to AD, 8/24/39.

Chapter Twenty-Three

[359] Downtown Gallery: The Downtown's show was advertised as offering "20 Marins at $500 each." Alfred had agreed that Mrs. Halpert take a 25 percent commission. AS to WE, 10/12/39.

[359] Finland- and: AS to WE, 12/10/39.

[359] fifty years—: Others similarly honored included Eleanor Roosevelt and Helen Keller.

[359] honorary degrees: In May, 1938, O'K received an honorary doctorate of fine arts from the College of William and Mary; in the spring of 1942, a doctorate of letters from the University of Wisconsin. Elected to the American Academy of Arts and Letters in 1962, she would eventually receive awards from Harvard, Columbia, Brown, and Bryn Mawr.

[360] Alfred Barr and: Alfred H. Barr was the MOMA's first director, a post he held until 1943; Philip L. Goodwin, a coarchitect with Edward Durrel Stone of the MOMA's 1939 building, and a major collector of modern art, was a museum Trustee from 1934 to 1958.

[360] Francis Henry Taylor: would become director of the Metropolitan Museum of Art in 1940, remaining until his death in 1954.

[360] Waldo Frank: Dahlberg and Frank had recently withdrawn as editors, with Dorothy Norman, of *Twice A Year.* Mary Lescaze became DN's assistant editor.

[362] gradual involvement: Einstein, an early volunteer, became eventually an officer attached to Eisenhower's SHAEF headquarters in Paris. Dove's son Bill moved from war production work in 1942 to the Army in 1943; John Marin, Jr., also in the Army, took part in the 1945 invasion of the Ryukyus nearly a year after Margaret's son, Frank Prosser, served in the D-Day invasion of Normandy. Alfred's grandnephew, Bill Schubart, who had enlisted in the Navy in 1940, lost his life as a lieutenant in a December 1944 engagement in the Pacific; by then his sister, Diana, was also serving in the Navy. Six months after Bill's death, Alfred's grandson Milton Stearns, Jr., who had earned his Navy commission at Harvard, saw combat in the Pacific as well. Peggy's husband in 1943, John McManus, in the Signal Corps, was editor under Frank Capra of the "Why

We Fight" series; my husband, Peter E. Geiger, died test-flying a reconditioned B-25 in Hawaii nine days before Hiroshima.

[362] "an INSPECTION": GEC to SDL, 4/6/76.

[363] in forty days: AS to WE, 11/24/40.

[363] "What am I": AS to WE, 1/1/41.

[364] "You seemed": Agnes Stieglitz Engelhard to AS, 1/2/41.

[365] "humbug": AS to AD, 9/30/41.

[365] "THE LABEL": AS to Paul Manship, 10/9/41.

[366] New Yorker feature: Matthew Josephson, "Leprechaun on the Palisades," The New Yorker, 3/14/42.

[366] Twice A Year: Numbers 8–9 (Spring/Summer and Fall/Winter 1942), pp. 146–72.

[366] raising hell: AS to AD, 5/1/42.

[366] Institute of Fine Arts: The formal request appears to have come in February or March, 1942. Georgia's winnowing of her paintings in the previous year suggests, however, that she may have had earlier discussions with the Institute's curator of paintings, Daniel Catton Rich, an acquaintance since 1929.

[367] good fortune: AD to AS, 7/7/42.

[367] Rather, determined: AS remained convinced to the end of his days that his "toughness" was needed to keep Phillips in line. In fact, both Marin and Dove had been corresponding fairly freely with Phillips for some time, and probably granted Alfred his intermediary role largely to give him something to do.

[367] prize from the Metropolitan: Hartley was awarded $2,000 for taking second place in a show titled "Artists for Victory."

[368] feeling stupidly: AS to AD, 2/3/43.

[368] "what they": AD to AS, 2/4/43. [Italics mine.]

[368] "I don't know . . . the food": AD to AS, 5/5/45.

[369] In spite: Larger than Dove's by far, Marin's income was nevertheless considerably smaller than O'Keeffe's. He sold more watercolors than oils that commanded higher prices, he took on no commissions, and he did not invest in the stock market—an avocation of O'K's since seeking Lee's instruction in the 1920s.

[370] He showed: I have no idea what became of this second portrait, which Marin may have destroyed. He described the circumstances to me in the winter of 1952 while visiting us—my second husband, David Lowe, and infant daughter, Ellen—at our home in Huntington, Long Island, a site from which he also produced a number of paintings.

[370] 1942 retirement: Commemorations of Lee's retirement included a party given and attended by the "babies" he had delivered over the years; a bachelor dinner, attended by Alfred, arranged by Lee's colleague and friend, the dapper surgeon and bibliophile, A. A. Berg; and the establishment by grateful patients of a Chair for Visiting Lecturers at the Medical College of New York University.

[370] war in Europe: Stalingrad was retaken by the Soviets in January 1943; Rommel's Afrika Korps was turned back in April.

[371] But she visited: GO'K to DDD, 7/18/44. Private collection.

[371] He had little: AS to Webb, 12/15/43.

[374] Beyond her: GO'K to Henry McBride, 1940s, exact date unknown. As quoted in Lisle, op. cit., p. 261.

[374] Nancy Newhall: Presumably, Alfred also gave Mrs. Newhall copies of the "stories" he dictated in the 1930s to Cary Ross and my sister Peggy, a number of which had appeared also in edited form in DN's Twice A Year. The intended biography never appeared in print. Its opening chapter, "Stieglitz and His Family," was published by permission of her husband Beaumont as a part of the first chapter of Homer, op. cit.

[375] He wrote: AS to Leo Stein, 8/9/45.

[375] "Your Peter . . . Run along": Reconstructed from SDL's memory, not verbatim.

[376] Marie Rapp: For twenty-nine years, Marie had visited Alfred as often as she could. He, in turn, had kept track —with greetings and usually gifts—of her birthday and those of her children.

[376] "It would": As told by Norman, AS: An American Seer, p. 228. [Quote corrected in interview with SDL, 3/25/82.]

[376] "Stardom at last!": McBride, "O'Keeffe at the Museum," New York Sun, 5/18/46.

[376] Alfred immediately: AS to Robert Dowling, 6/8/46.

[378] "Alfred, although": GEC to SDL, 4/6/76.

NOTES ON ILLUSTRATIONS

Frontispiece Contemporary gelatin silver print from original negative. Copyright ©
by, and courtesy of, Georgia Engelhard
p. 5 Contemporary gelatin silver print from original negative. Copyright © by,
and courtesy of, Georgia Engelhard
p. 12 Ferrotype; print reversed to correct orientation. Private collection
p. 33 From the Collection of Dorothy Norman, Philadelphia Museum of Art,
'69–83–92
p. 41 Corliss and Bancroft studio. Given by Mrs. William Howard Schubart, Phila-
delphia Museum of Art, '68–45–11
p. 46 From the Collection of Dorothy Norman, Philadelphia Museum of Art, '67–
285–197
p. 54 Ferrotype; print reversed to correct orientation. Private collection
p. 78 Loescher and Petsch studio. From the Collection of Dorothy Norman, Phila-
delphia Museum of Art, '69–83–99
p. 82 From the Collection of Dorothy Norman, Philadelphia Museum of Art, '69–
83–97
p. 91 From a copy. Private collection
p. 96 Given by Mrs. William Howard Schubart, Philadelphia Museum of Art, '68–
45–3
p. 101 Albumen print. Private collection
p. 116 From a copy. Reprint from AS, "The Photographic Journal of a Baby," 1900.
From the Collection of Dorothy Norman, Philadelphia Museum of Art,
'69–83–41
p. 123 Photogravure from *Camera Work*, Special Supplement, April 1906, made
from original 1908 print of 1903 negative, grey pigment gum-bichromate
over platinum or gelatin silver. Private collection
p. 135 1908 gelatin silver print from 1904 negative. The Metropolitan Museum of
Art, the Alfred Stieglitz Collection, 1933 (33.43.19)
p. 139 Arturo (?) print. Private collection
p. 144 From a copy. Private collection
p. 171 Copy print from contemporary separation negative of original Lumière Auto-
chrome plate. Private collection
p. 214 From a copy. Private collection. Reading left to right, *standing*: Elizabeth
Stieglitz, Agnes Stieglitz Engelhard, George Herbert Engelhard, Alie Mörling,
Selma Stieglitz Schubart, Hugh Grant Straus, Mary Steichen, Elizabeth
(Lizzie) Stieffel Stieglitz; *seated, chairs*: Hedwig Stieglitz, Jacobine Sterck
Stieffel; *seated, ground*: Leopold Stieglitz, Georgia Engelhard, Flora Stieglitz
Straus
p. 221 Bromide (?) print. Private collection
p. 224 Gelatin silver print. Private collection

Following p. 232
1 Albumen print. Private collection
2 Platinum print; winner of silver medal, *Photographic Times*, London, January
1895. Private collection

3 Arturo print. Private collection
4 Copy of albumen print. Private collection. Reading left to right, *top row*: Ernest Werner, Theresa Werner, Fredrika Dietz Werner (Mrs. Abraham), Hedwig Stieglitz, Julius Stieglitz; *next row*: Ida Werner Small, Herbert Small, Fanny Collin Einstein, Edward Stieglitz, Sarah Werner, Selma Stieglitz; *next row, left corner*: Jane Werner, Arthur Werner (child), and *right corner*: Flora Stieglitz Stern; *front row*: Leopold Stieglitz, Agnes Stieglitz, Flora Small, Edward Werner, Rosa Werner, Barbara Foord, Margaret (Maggie) Foord
5 Gelatin silver print. From the Collection of Dorothy Norman, Philadelphia Museum of Art, '69–83–98
6 From a copy. Private collection
7 From a copy negative. Private collection
8 From a copy negative. Private collection
9 From a copy. Private collection
10 Bromide print. Private collection
11 Gelatin silver print. Purchased: Lola Downin Peck Fund, Philadelphia Museum of Art, 1978–91–1
12 Arturo print. Private collection
13 Copy of gelatin silver (?) print. Private collection. Reading diagonally, lower left to upper right, *left*: Kitty Stieglitz, Edward and Hedwig Stieglitz (Julius's children); *center*: Georgia Engelhard, Elizabeth Stieglitz, Flora Stieglitz Straus; *right*: William Howard Schubart
14 Arturo print. Private collection
15 Gelatin silver print. Private collection
16 From a copy. Private collection
17 Gelatin silver print. Private collection
18 Gelatin silver print. Private collection
19 Gelatin silver print. Private collection
20 Gelatin silver print. Private collection
21 Gelatin silver print. Private collection
22 From a copy. Courtesy of William C. Dove
23 Copy print from *Alfred Stieglitz Memorial Portfolio*. Courtesy of Dorothy Norman
24 Gelatin silver print. Courtesy of Dorothy Norman

p. 235 Platinotype (?) print. Private collection
p. 238 Bromide print. Private collection
p. 252 © 1976 The Paul Strand Foundation, as published in Paul Strand: *Sixty Years of Photographs* (Millerton, N.Y.: Aperture, 1976)
p. 270 From 16mm. film. Copyright © by, and courtesy of, Flora Stieglitz Straus
p. 277 Copy print of frame from 16mm. film. Copyright © by, and courtesy of, Flora Stieglitz Straus
p. 297 Contemporary gelatin silver print from original negative. Copyright © by, and courtesy of, Josephine B. Marks
p. 308 Gelatin silver print. Lent by Mrs. Dorothy Norman, Philadelphia Museum of Art, 2–1975–88. By permission also of Herbert J. Seligmann
p. 337 Contemporary gelatin silver print from original negative. Copyright © by, and courtesy of, Georgia Engelhard
p. 345 Copy print. Courtesy of Josianne Einstein
p. 355 Contemporary gelatin silver print from original negative. Copyright © by, and courtesy of, Josephine B. Marks
p. 372 Gelatin silver print. Lent by Dorothy Norman, Philadelphia Museum of Art, 2–1975–89. By permission also of Ansel Adams

BIBLIOGRAPHY

In addition to letters in the Stieglitz Archives at the Beinecke Rare Book and Manuscript Library of Yale University and in private hands that constituted my major written resource (identified individually in the Notes), I consulted the following works:

BOOKS

Anderson, Sherwood. *A Story Teller's Story.* New York: B. W. Huebsch & Co., 1924.
Baedeker, Karl. *Berlin and Its Environs.* 6th ed. New York: Charles Scribner's Sons, 1923.
————. *North Germany.* 13th ed. Leipzig: K. Baedeker, 1900.
————. *Southern Germany including Würtenberg and Bavaria.* 8th rev. ed. Leipzig: K. Baedeker, 1895.
Bailey, George. *Germans.* New York: Avon, 1974.
Benson, E. M. *John Marin: The Man and His Work.* Washington, D.C.: The American Federation of Arts, 1925.
Berger, Meyer. *The Story of the New York Times: 1851–1951.* New York: Simon and Schuster, 1951.
Blake, Rodney [pseud. of Selma Stieglitz Schubart]. *Nothing New.* New York: Publishers Press Association, 1934.
————. *Random Rhythms.* New York: Publishers Press Publishing Co., 1924.
Brown, Milton W. *The Story of the Armory Show.* Greenwich, Ct.: Joseph H. Hirshhorn Foundation, 1963.
Bry, Doris. *Alfred Stieglitz: Photographer.* Greenwich, Connecticut: New York Graphic Society/Boston Museum of Fine Arts, 1965. (Hard cover exhibition catalogue.)
Catton, Bruce. *The Coming Fury,* Vol. I of *The Centennial History of the Civil War.* Garden City, N.Y.: Doubleday & Company, Inc., 1961.
Dijkstra, Bram. *The Hieroglyphics of a New Speech: Cubism, Stieglitz and the Early Poetry of William Carlos Williams.* Princeton: Princeton University Press, 1969.
Eddy, Arthur Jerome. *Cubists and Post-Impressionism.* Chicago: A. C. McClurg and Company, 1914.
Eliot, Alexander. *Three Hundred Years of American Painting.* New York: Time Incorporated, 1957.
France, Anatole. *L'Affaire Cranquebille.* Stamford, Ct.: Overbrook Press, 1937. Special edition, illustrated by William Einstein.
Frank, Waldo; Mumford, Lewis; Norman, Dorothy; Rosenfeld, Paul; and Rugg, Harold; eds. *America and Alfred Stieglitz: A Collective Portrait.* 1935. Reprint. New York: Octagon Books, 1975.
Frank, Waldo. *Our America.* New York: Boni & Liveright, 1919.
————. *Time Exposures.* New York: Boni & Liveright, 1926.
Fredericks, Pierce G. *The Great Adventure: America in the First World War.* New York: E. P. Dutton & Co., Inc., 1960.
Goldberger, Paul. *The City Observed: New York.* New York: Vintage Books, 1979.

BIBLIOGRAPHY

Gosling, Nigel. *Paris 1900–1914: The Miraculous Years.* London: Weidenfeld and Nicolson, 1978.

Grafton, John. *New York in the Nineteenth Century: 321 Engravings from* Harper's Weekly *and Other Contemporary Sources.* New York: Dover Pictorial Archives, Dover Publications, Inc., 1977.

Green, Jonathan, ed. *Camera Work: A Critical Anthology.* Millerton, N.Y.: Aperture Inc., 1973.

Hapgood, Hutchins. *A Victorian in the Modern World.* New York: Harcourt Brace, 1939.

Hartley, Marsden. *Adventures in the Arts.* New York: Boni & Liveright, 1921.

Helm, MacKinley. *John Marin.* New York: Pellegrini & Cudahy in association with The Institute of Contemporary Art, Boston, 1948.

Hill, Paul, and Cooper, Thomas. *Dialogue With Photography.* New York: Farrar, Straus and Giroux, 1979.

Homer, William Innes. *Alfred Stieglitz and The American Avant-Garde.* Boston: New York Graphic Society, 1977.

Kandinsky, Wassily. *Concerning The Spiritual in Art.* First published in English translation by Constable and Company Limited, London, 1914, as *The Art of Spiritual Harmony.* Reissued in new translation and with a new preface by M. T. H. Sadler. New York: Dover Publications, Inc., 1977.

Kootz, Samuel M. *Modern American Painters.* New York: Brewer and Warren, Inc., 1930.

Kouwenhoven, John A. *The Columbia Historical Portrait of New York: An Essay in Graphic History.* 1953. Reprint. New York: Harper & Row Publishers, Inc., 1972.

Lane, James W. *The Work of Georgia O'Keeffe: A Portfolio of Twelve Paintings.* New York: Knight Publishers, 1937.

Lisle, Laurie. *Portrait of an Artist: A Biography of Georgia O'Keeffe.* New York: Seaview Books, 1980.

Lowe, David G. et al., ed. *New York, New York.* New York: American Heritage Publishing Co., Inc., 1968.

Marin, John. *The Selected Writings of John Marin.* Edited by Dorothy Norman. (Incorporating *Letters of John Marin* ed. by Herbert J. Seligmann, q.v.) New York: Pellegrini & Cudahy, 1949.

McCausland, Elizabeth. *Marsden Hartley.* Minneapolis: University of Minnesota Press, 1952.

Mellow, James R. *Charmed Circle: Gertrude Stein & Company.* 1974. Reprint. New York: Avon Books, 1975.

Mellquist, Jerome. *The Emergence of An American Art.* New York: Chas. Scribner's Sons, 1942.

Morison, Samuel Eliot. *The Oxford History of the American People.* New York: Oxford University Press, 1975.

Morris, Lloyd R. *Incredible New York: High Life and Low Life of the Last Hundred Years.* New York: Random House, 1951.

Naef, Weston J. *The Collection of Alfred Stieglitz: Fifty Pioneers of Modern Photography.* New York: Metropolitan Museum of Art and The Viking Press, 1978.

Newhall, Beaumont. *The History of Photography from 1839 to the Present Day.* Rev. ed. New York: Museum of Modern Art, 1964.

———, and Newhall, Nancy. *Masters of Photography.* New York: George Braziller, Inc., 1958.

Norman, Dorothy. *Alfred Stieglitz: Introduction to an American Seer.* New York; Duell, Sloan and Pearce, 1960.

———. *Alfred Stieglitz: An American Seer.* New York: Random House, 1973.

———. *Dualities.* New York: An American Place, 1933. Limited edition of 400 copies; nos. 1–30 with Stieglitz photograph of Norman.

Norton, Minerva Brace. *In and Around Berlin.* Chicago: A. C. McClung & Co. 1889.

BIBLIOGRAPHY

O'Brien, Kathryn E. *The Great and the Gracious on Millionaires' Row.* [Charming but almost wholly inaccurate about Stieglitz, O'Keeffe, etc.] Sylvan Beach, N.Y.: North Country Books, 1978.

O'Keeffe, Georgia. *Georgia O'Keeffe.* 1976. Reprint. New York: Penguin Books, 1977.

Perlam, Bernard B. *The Immortal Eight: American Painting From Eakins to the Armory Show.* New York: Exposition Press, 1962.

Phillips, Duncan. *A Collection in the Making.* New York: E. Weyhe, 1926.

Reich, Sheldon. *John Marin: A Stylistic Analysis and Catalogue Raisonné.* 2 vols. Tucson, Arizona: University of Arizona Press, 1970.

Rose, Barbara. *American Painting: The Twentieth Century.* New York: Skira, Rizzoli, 1977.

Rosenfeld, Paul. *Port of New York: Essays on Fourteen American Moderns.* New York: Harcourt, Brace and Co., 1924.

Schubart, Selma Stieglitz. (*see* Rodney Blake)

Seligmann, Herbert J. *Alfred Stieglitz Talking.* New Haven: Yale University Library, 1966.

———, ed. *Letters of John Marin.* New York: An American Place, 1931.

Shirer, William L. *Berlin Diary: The Journal of a Foreign Correspondent 1934–1941.* New York: Alfred A. Knopf, 1941.

Steichen, Edward J. *A Life in Photography.* Garden City, N.Y.: Doubleday & Company, Inc., with The Museum of Modern Art, 1963.

Stieglitz, Julius. *The Elements of Qualitative Chemical Analysis.* New York: The Century Co., 1911.

Strand, Paul. *A Retrospective Monograph: The Years 1915–1968.* The Philadelphia Museum of Art, City Art Museum of St. Louis, Boston Museum of Fine Arts, Metropolitan Museum of Art, M. H. DeYoung Memorial Museum of San Francisco with Aperture, Inc., 1971.

Taylor, Joshua C. *Futurism.* New York: The Museum of Modern Art and Doubleday & Company, Inc., 1961.

Thornton, Gene. *Masters of the Camera: Stieglitz, Steichen and Their Successors.* New York: Ridge Press and Holt, Rinehart, Winston, 1976.

Tomkins, Calvin. *Merchants and Masterpieces: The Story of the Metropolitan Museum.* New York: E. P. Dutton & Co., Inc., 1970.

Tuchman, Barbara W. *The Zimmerman Telegram.* 1958. Reprint. New York: Ballantine Books, 1979.

Valentin, Veit. *The German People.* New York: Alfred Knopf & Co., 1946.

White, Norval, and Willensky, Elliot, eds. *AIA Guide to New York City.* New York: The MacMillan Company, 1967.

Williams, William Carlos. *Selected Essays.* New York: Random House, 1954.

Wilson, Edmund. *The American Earthquake.* New York: Farrar, Straus and Giroux, 1979.

———. *Upstate.* New York: Farrar, Straus and Giroux, 1971.

Woodbury, Walter E. *The Encyclopedic Dictionary of Photography.* New York: Scovill & Adams, 1896.

ARTICLES

Bruno, Guido. "Alfred Stieglitz: Photographer." *Bruno's Review of Two Worlds,* June 1921.

Bry, Doris. "The Stieglitz Archive at Yale University." *The Yale University Library Gazette,* April 1951, 123–30.

Coke, Van Deren. "Why Artists Came to New Mexico: 'Nature Presents a New Face Each Moment.'" *ARTnews,* January 1974, 22–5.

Barker, Virgil. "Notes on the Exhibitions." *The Arts* 5:4. Reviews of O'Keeffe exhibition (with illustrations) and of Stieglitz *Sky-Songs* prints in *MSS,* no date.

Dreiser, Theodore. "A Master of Photography," *Success* (June 10, 1899), 471.

Eldredge, Charles. "The Arrival of European Modernism," *Art in America* (July–August 1973), 35–41.

Engelhard, Georgia. "Alfred Stieglitz, Master Photographer," *American Photography* (April 1945), 8–12.

———. "The Face of Alfred Stieglitz," *Popular Photography* (September 1946).

———. "Grand Old Man," *American Photography* (May 1950), 18–19, 50.

Flint, Ralph. "Review of Marin Show," *Art News* 30 (October 17, 1931).

———. "Lily Lady Goes West," *Town and Country* (January 1943).

———. "What is '291'?" *Christian Science Monitor* (November 17, 1937), 5.

Freed, Clarence J. "Jewish Men Who Have Arrived," *The American Hebrew* (January 18, 1924).

Goossen, E. C. "Georgia O'Keeffe," *Vogue* (March 1967), 174–9, 221. With photographs by Cecil Beaton.

Hellman, Geoffrey T. "Profile of a Museum," *Art in America* 52:1 (February 1964) 26–39.

Homer, William Innes. "Alfred Stieglitz and An American Aesthetic," *Arts Magazine* 49:1 (September 1974), 25–8.

———. "Stieglitz and 291," *Art in America* (July–August 1973), 50–7.

Janis, Leo. "Georgia O'Keeffe at 84," *Atlantic Monthly* (December 1971).

Josephson, Matthew. "Leprechaun on the Palisades," *The New Yorker* (March 14, 1942), 26–35.

Jzarkowski, John. "A Different Kind of Art," *The New York Times Magazine* (April 13, 1975), 16–19, 64–8.

Kalonyme, Louis. "John Marin," *Creative Art* (October 1928).

———. "Georgia O'Keeffe: A Woman in Painting," *Creative Art* (January 1928).

Keiley, Joseph T. "The Stieglitz Exhibition," *Camera Notes* (October 1889), 76–7.

Kozloff, Max. "Photography: The Coming of Age of Color," *Artforum* (January 1975), 30–5.

Kramer, Hilton. "Georgia O'Keeffe." *The New York Times Book Review* (December 12, 1976).

———. "Is a Museum the Only Place for Art," *The New York Times,* Section D (April 13, 1975), 29.

———. "Marsden Hartley, American Yet Cosmopolitan," *The New York Times* (June 20, 1968), 25.

Lancaster, Bruce. "Struggle for the South," in *The American Heritage Book of the Revolution.* New York: American Heritage Publishing Co., Inc., 1958.

Lefson, Ben. "O'Keeffe's Stieglitz, Stieglitz's O'Keeffe," *The Village Voice.* (December 11, 1978).

Maddox, Jerald C. "Photography in the First Decade," *Art in America* (July–August 1973), 72–9.

Malcolm, Janet. "Two Photographers," *The New Yorker* (November 18, 1974), 223–33.

Mannes, Marya. "Gallery Notes," *Creative Art* 2:2 (February 1928), 7.

Marin, John; Duncan, Charles; Strand, Paul; and Stieglitz, Alfred. *Manuscripts Number Two.* New York, (March 1922). Published by the authors.

Marks, Robert W. "Photography of Alfred Stieglitz," *Gentry* 7 (Summer 1953), 65–72.

Mason, Anita. "The Met's Stieglitz Collection Is Great," *Antique Monthly* (July 1978), 7c.

McBride, Henry. Review of Marin exhibition at The Intimate Gallery (Anderson Galleries) New York *Sun* (December 12, 1925).

———. Review of Marin exhibition of Associated American Painters, New York *Sun* (November 19, 1932).

———. "Georgia O'Keeffe's Exhibition," New York *Sun* (January 14, 1933).

———. "O'Keeffe at the Museum," New York *Sun* (May 18, 1946).

————. "John Marin's Watercolors," New York *Sun* (October 28, 1939).

————. "Modern Art," *The Dial* 70:4 (April 1921), 480–2 [Re Stieglitz].

————. "Modern Art," *The Dial* 72:3 (March 1922), 329–31. [Re Marin at Montross Gallery.]

————. "Modern Art," *The Dial* 72:4 (April 1922), 436–7. [Re "the Artists' Derby."]

————. "Modern Art," *The Dial* 74:2 (February 1923), 217–18. [Re Demuth.]

McCausland, Elizabeth. [Re Dove,] "It Has Been Said." An American Place reprint of review in *Springfield* [Mass.] *Sunday Union and Republican,* April 22, 1934.

McJunkin, Penelope Niven. "Steichen & Sandburg," *Horizon* 22:8 (August 1979).

Mellow, James R. "Gertrude Stein Among the Dadaists," *Arts Magazine, Special Issue: New York Dada and the Arensberg Circle* 51:9 (May 1977), 124–6.

Meyer, Agnes Ernst. "New School of the Camera," New York *Morning Sun* (April 26, 1908). [Interview with Alfred Stieglitz.]

Miller, Henry. "Stieglitz and Marin," *Twice A Year* 8/9 (Spring/Summer and Fall/Winter 1942), 146–55.

Moore, Clarence B. "Leading Amateurs in Photography," *Cosmopolitan* 12:4 (February 1892).

Morgan, Ann Lee. "Fires of Affection: the Paintings of Marsden Hartley," *The New Art Examiner,* East Coast edition 8:3 (December 1980), 6–7.

Mumford, Lewis. "Autobiographies in Paint," *The New Yorker* (January 18, 1936). [Concerning Marin and O'Keeffe.]

Norman, Dorothy. "Alfred Stieglitz: Writings and Conversations," *Twice A Year* 1 (Fall/Winter 1938), 77–110. [With photographs by Alfred Stieglitz.]

Norton, Thomas E. "The N'th Whoopee of Sight," *Portfolio* 1:3 (August/September 1979). [Concerning Demuth.]

O'Doherty, Brian. "The Silent Decade," *Art in America* (July/August 1973), 32.

O'Keeffe, Georgia. "Can a Photograph Have the Significance of Art?" *MSS,* (December 1922).

————. "Stieglitz: His Pictures Collected Him," *The New York Times Magazine* (December 11, 1949), 24–30.

————. "Portraits of the Artist as a Young Woman," *Life Magazine* (November 1978). [Excerpt from *Georgia O'Keeffe,* by Georgia O'Keeffe, 1976.]

Pollitzer, Anita. "That's Georgia," *Saturday Review* (November 4, 1950).

Pollock, Duncan. "From Zane Grey to the Tide of Modernism: Artists of Taos and Santa Fé," *ARTnews* (January 1974), 13–21.

Reich, Sheldon. "John Marin and the Piercing Light of Taos," *ARTnews.* (January 1974), pp. 16–7.

Rosenfeld, Paul [as "Peter Minuit"]. "291 Fifth Avenue," *The Seven Arts* (November 1916), 61–5.

————. "American Painting," *The Dial* 71:6 (December 1921), 649–70.

————. "Stieglitz," *The Dial* 70:4 (April 1921), 397–409.

————. "The Paintings of Georgia O'Keeffe," *Vanity Fair* (October 1922).

————. "Alfred Stieglitz," *Twice A Year* 14/15 (1946), 203–5.

Roth, Moira. "Marcel Duchamp in America: A Self Ready-made," *Arts Magazine* 51:9 (May 1977), 92–6.

Rubinfien, Leo. "Stieglitz's Cul-de-Sac," *Voice* (June 12, 1978). [Review of Metropolitan Museum Show of AS Photography Collection.]

Schiffman, Joseph. "The Alienation of the Artist: Alfred Stieglitz," *American Quarterly* (Fall 1951), 244–58.

Seiberling, Dorothy. "Horizons of a Pioneer: Georgia O'Keeffe in New Mexico," *Life* (March 1, 1968), 40–53. [Photographs, including cover, by John Loengard.]

Sekula, Alan. "On the Invention of Photographic Meaning," *Artforum* (January 1975), 36–45.

Seligmann, Herbert J. "John Marin and the Real America," *It Must Be Said* 1 (November 3, 1932). [Pamphlet of An American Place.]

————. "Georgia O'Keeffe, American," *MSS* (March 1923).

————. "Port of New York, by Paul Rosenfeld," *The Dial* 76:6 (June 1924), 544–7. [Book review.]

Sheeler, Charles. "Recent Photographs by Alfred Stieglitz," *The Arts*. 3:5 (May 1923), 345.

Soby, James Thrall. "Alfred Stieglitz," *Saturday Review of Literature* 39 (September 28, 1946), 22–3.

Stewart, Patrick L. "The European Art Invasion: American Art and the Arensberg Circle, 1914–18," *Arts Magazine, Special Issue: New York Dada and the Arensberg Circle* 51:9 (May 1977), 108–12.

Stieglitz, Alfred. "Four Marin Stories," *Twice A Year* 8/9. (Spring/Summer and Fall/Winter 1942), 146–72.

————. "Letters to Heinrich Kuehn, (1922–1923)," *Camera* (June 1977), 39–41.

————. (quoted) "Soon the World Will Be Colour-mad," *The Sunday Times Magazine* (London: March 9, 1975), 26. [Illustrations from BBC2 series, *Pioneers of Photography*, aired March 26, 1975.]

Strand, Paul. "Georgia O'Keeffe," *Playboy*. (July 1924), 16–20.

————. "Alfred Stieglitz, 1864–1946," *New Masses* 60 (August 6, 1946), 6–7.

————. "Alfred Stieglitz and a Machine," *MSS* 2 (March 1922), 6–7.

Tancock, John. "The Oscillating Influence of Marcel Duchamp," *ARTnews* (September 1973), 23–9.

Tarshis, Jerome. "Alfred Stieglitz, Editor," *Portfolio* 1:3 (August/September 1979).

Thomsen, Barbara. "Alfred Stieglitz," *ARTnews* (January 1974), 88. [Review in "Photography" section of Stieglitz exhibit at Light Gallery, New York.]

Tomkins, Calvin. "The Rose in the Eye Looked Pretty Fine," [Profile of Georgia O'Keeffe.] *The New Yorker* (March 4, 1974), 40–66.

(unsigned) "Georgia O'Keeffe Turns Dead Bones to Live Art," *Life* (February 14, 1938).

(unsigned) "The Stieglitz Exhibition," *Camera Notes* 3:2 (October 1899), 76–7.

Weiss, Margaret R. "The Presence of the Past," *Saturday Review World, 50th Anniversary Issue* (August 1974), 86–8, 111.

Wernick, Robert. "Whitney Museum Is an Enduring Vanderbilt Legacy," *Smithsonian* 11:5 (August 1980), 92–100.

Wilson, Edmund. "The Stieglitz Exhibition," *The New Republic*, March 18, 1925. [As reprinted in Wilson, *American Earthquake*. See Bibliography "Books.")

Zigrosser, Carl. "Alfred Stieglitz," *Twice A Year* 8/9 (1942), 137–45.

EXHIBITION CATALOGUES AND PORTFOLIOS
(listed chronologically by artist)

Charles Demuth:

(unsigned) *Recent Paintings by Charles Demuth*. New York: Daniel Gallery, 1922–1923.

Stieglitz, Alfred. "Introduction," *Seven Americans*. New York: Anderson Galleries, March 9–28, 1925.

(unsigned) *Recent Paintings by Charles Demuth*. New York: The Intimate Gallery, April 5–May 2, 1926.

————. *Charles Demuth*. New York: The Intimate Gallery, April 29–May 18, 1929.

————. *Recent Paintings by Charles Demuth*. New York: An American Place, April–May, 1931. Also, group show, May–June.

————. Group show: New York: An American Place, May 15?–June 15+, 1932.

————. Philadelphia: Mellon Galleries, 1933.

————. Group show: New York: An American Place, November 27–December 31, 1936 (posthumous).

————. *Charles Demuth and Eliot Porter*. December 29, 1938–January 19, 1939.

————. *Charles Demuth: Memorial Exhibition*. New York: Whitney Museum of American Art, 1937–1938.

Ritchie, Andrew Carnduff. *Charles Demuth.* Museum of Modern Art, New York, 1950. Tribute by Marcel Duchamp.

(unsigned) *Charles Demuth, The Early Years—Works from 1909–1917.* New York: The Washburn Gallery, 1975.

Arthur G. Dove:

Dove, Arthur G. "A Way to Look at Things." "Seven Americans" exhibition, Anderson Galleries, March 9–28, 1925.

————. "Statement." Intimate Gallery exhibition, December 12, 1927–January 7, 1928.

————. "Statement." Intimate Gallery exhibition, April 9–28, 1929.

Wight, Frederick S. *Arthur G. Dove.* The University of California Press, Berkeley and Los Angeles, 1958. Retrospective exhibition arranged by the Art Galleries of the University of California, Los Angeles.

Haskell, Barbara. *Arthur Dove.* The San Francisco Museum of Art exhibition, November 21, 1974–January 5, 1975 (Albright-Knox Gallery, Buffalo, New York, January 27–March 2, 1975; St. Louis Art Museum, April 3–May 25, 1975; Art Institute of Chicago, July 12–August 31, 1975; Des Moines (Iowa) Art Center, September 22–November 2, 1975; Whitney Museum of American Art, New York City, November 24, 1975–January 18, 1976).

Marsden Hartley:

Simonson, Lee. Foreword to "Hartley Exhibition" catalogue at Intimate Gallery, January 1–31, 1929.

Hartley, Marsden. "Return of the Native" (poem), *Pictures of New England by a New Englander: Exhibition of Recent Paintings of Dogtown, Cape Ann, Massachusetts.* The Downtown Gallery, April 19–May 1, 1939. [Actual exhibition dates 4/26–5/15.]

————. "An Outline in Portraiture of Self: From Letters Never Sent," and "This Portrait of a Seadove—Dead" (poem). Hartley at An American Place, March 22–April 14, 1936.

————. "On the Subject of Nativeness—a Tribute to Maine" and "Signing Family Papers" (poem). Hartley at An American Place, April 20–May 17, 1937.

————. "Statement," *Marsden Hartley/Stuart Davis* exhibition at Cincinnati Art Museum, October 24–November 24, 1941.

————. Posthumous quotations, Marsden Hartley. *Feininger/Hartley* exhibition, Museum of Modern Art, New York, October 24, 1944–January 14, 1945.

Haskell, Barbara. *Marsden Hartley.* Whitney Museum of American Art, New York, March 4–May 25, 1980 (Art Institute of Chicago, June 10–August 3; Amon Carter Museum of Western Art, Fort Worth, Texas, September 5–October 26; University Art Museum, University of California, Berkeley, November 12, 1980–January 4, 1981).

John Marin:

Marin, John. "A Letter of John Marin," reprinted in catalogue for show at The Intimate Gallery, November 9–December 11, 1927.

Hartley, Marsden. "Recent Paintings by John Marin," Intimate Gallery, November 14–December 29, 1928.

Seligmann, Herbert J. "John Marin and the Real America," *It Must Be Said,* pamphlet/catalogue for Marin show at An American Place, November 7–December 17, 1932.

————. "Frames—With Reference to Marin," *It Must Be Said,* No. 3, An American Place, January 8, 1934, as "introduction" to Marin show December 20, 1933–February 1, 1934.

Hartley, Marsden. "As to John Marin and His Ideas," *John Marin: Watercolors, Oil Paintings, Etchings.* Museum of Modern Art, New York, opening October 21, 1936.

McBride, Henry; and Benson, E. M. *John Marin: Watercolors, Oil Paintings, Etchings.*

New York: Museum of Modern Art, 1936. With commentary by M. Hartley, "As to John Marin and His Ideas."

Marin, John. "To My Paint Children," *Marin Exhibition*. An American Place, February 14–March 27, 1938.

Wight, Frederick S.; and Helm, MacKinley. *John Marin: A Retrospective Exhibition*. Boston Institute of Modern Art, 1947. (Phillips Memorial Gallery, Washington, D.C.; Walker Art Center, Minneapolis.)

Exhibition Catalogue (Installation): National Institute of Arts and Letters/American Academy of Arts and Letters, January–February, 1954.

James, Philip; and Phillips, Duncan. *John Marin: Paintings, Water-colours, Drawings and Etchings*. London: Arts Council Gallery, 1956.

Reich, Sheldon. *John Marin: Drawings, 1886–1951*. University of Utah Museum of Fine Arts, Salt Lake City, 1969. (Exhibition starting September 13, 1969, at Munson-Williams-Proctor Institute, Utica, New York; thence to Minneapolis: University of Minnesota Art Gallery; Trenton, New Jersey: State Museum; Cincinnati: University of Cincinnati; Austin, Texas: University Art Museum; Brunswick, Maine: Bowdoin College Museum of Art; Oklahoma City: Oklahoma Art Center; Corning, New York: Corning Museum of Glass; Champaign, Illinois: University of Illinois Art Museum; and Fort Worth, Texas: Amon Carter Museum of Western Art, October 17–November 15, 1970.)

Zigrosser, Carl. *The Complete Etchings of John Marin*, catalogue raisonné. Philadelphia Museum of Art, 1969. Part I of *John Marin: Oils, Watercolors and Drawings*.

Reich, Sheldon. *Etchings and Related Works*, Part II of *John Marin: Oils, Watercolors and Drawings*, Philadelphia Museum of Art, 1969.

Curry, Larry. *John Marin, 1870–1953*. Los Angeles County Museum of Art, July 7–August 30, 1970. (Thence to: San Francisco: M. H. de Young Memorial Museum; San Diego: Fine Arts Gallery; New York: Whitney Museum of American Art; Washington, D.C.: National Collection of Fine Arts, April 23–June 6, 1971.)

Georgia O'Keeffe:

O'Keeffe, Georgia. "Introduction," *Alfred Stieglitz Presents One Hundred Pictures: Oils, Water-colors, Pastels, Drawings by Georgia O'Keeffe, American*. With an extract from Marsden Hartley, "Some Women Painters," *Adventures in the Arts* (q.v. under "Books"). Exhibition at Anderson Galleries, January 29–February 10, 1923.

———. "Statement," *Alfred Stieglitz Presents Fifty-One Recent Pictures: Oils, Watercolors, Pastels and Drawings by Georgia O'Keeffe, American*. The Anderson Galleries, March 1924.

Hartley, Marsden. "A Second Outline in Portraiture," *Georgia O'Keeffe: Exhibition of Recent Paintings, 1935*. An American Place, January/February, 1936.

Lane, James W. "The Work of Georgia O'Keeffe," *A Portfolio of Twelve Paintings*. New York: Knight Publishers, 1937.

O'Keeffe, Georgia. *Georgia O'Keeffe: Catalogue of the Fourteenth Annual Exhibition of Paintings with Some Recent O'Keeffe Letters*. Exhibition at An American Place, December 26, 1937–February 12, 1938.

———. "About Myself," *Georgia O'Keeffe: Exhibition of Oils and Pastels*. An American Place, January 22–March 7+, 1939.

———. "Statement," *Georgia O'Keeffe: Exhibition of Oils and Pastels*, An American Place, January 30–March 25, 1940.

Rich, Daniel Catton. *Georgia O'Keeffe*. The Art Institute of Chicago, exhibition opening January 31, 1943.

O'Keeffe, Georgia. "About Painting Desert Bones," *Georgia O'Keeffe, Recent Paintings*. An American Place, January 9–March 18, 1944.

Rich, Daniel Catton. *Georgia O'Keeffe: Forty Years of Her Art*. Worcester, Massachusetts: Worcester Art Museum, 1960.

Wilder, Mitchell, ed. *Georgia O'Keeffe* (retrospective, 1915–1966). Fort Worth, Texas: Amon Carter Museum of Western Art, 1966.

Goodrich, Lloyd. *Georgia O'Keeffe Drawings*. Limited edition portfolio, New York: Atlantis Editions, 1968.

————; and Bry, Doris. *Georgia O'Keeffe*. Whitney Museum of American Art, October 8–November 29, 1970. (The Art Institute of Chicago, January 6–February 7, 1971; San Francisco Museum of Art, March 15–April 30, 1971.)

O'Keeffe, Georgia. *Some Memories of Drawings*. Portfolio, 21 plates. New York: Atlantis Editions, 1974. Assembled and with an introduction by Doris Bry.

————. (Introduction) *Georgia O'Keeffe: A Portrait by Alfred Stieglitz*. New York: Metropolitan Museum of Art, 1978.

Edward (Eduard) J. Steichen:

(unsigned) *The Second Philadelphia Photographic Salon*, October 21–November 19, 1899. Pennsylvania Academy of Fine Arts.

————. *The Third Philadelphia Photographic Salon*, October 22–November 8, 1900.

————. *A Photo-Secession Exhibition of Photographs*, Washington, D.C.: The Corcoran Art Gallery, January 1904.

Stieglitz, Alfred. (Introduction) *A Collection of American Pictorial Photographs as Arranged by the Photo-Secession*. Pittsburgh: Camera Club of Pittsburgh at the Carnegie Institute, February 1904.

(unsigned) *American Exhibition of Photographs Arranged by the Photo-Secession*. Philadelphia: Pennsylvania Academy of Fine Arts, 1906.

————. *The Steichen Book*. A Portfolio of 26 plates. New York: Published by Alfred Stieglitz, 1906.

————. *Special Exhibition of Contemporary Art*, the National Arts Club, New York: March 12–April 2, 1908.

Maeterlinck, Maurice. (Foreword) *International Exhibition of Pictorial Photography*. New York: The National Arts Club, February 2–20, 1909.

(unsigned) *The International Union of Art Photographers*. Dresden, May to October, 1909. [Only exhibition held by this group.]

————. *Eduard J. Steichen, Photographs*. Little Galleries of the Photo-Secession (291), New York: January 21–February 5, 1910.

————. *Paintings and Photographs by Eduard J. Steichen*. New York: Montross Gallery, March 21–April 15, 1910.

————. *International Exhibition of Pictorial Photography*. Buffalo, New York: Albright Gallery, Buffalo Fine Arts Academy, November 3–December 1, 1910.

————. *Murals by American Painters and Photographers*. New York: Museum of Modern Art, 1932.

————. *Paintings and Photographs: Steichen*. Retrospective at Baltimore Museum, June 1–30, 1938.

Sandburg, Carl. "Prologue," and Steichen, Edward. "Introduction," *The Family of Man*. New York: Museum of Modern Art, opening January 24, 1955. [Exhibition arranged by Steichen as Director of MOMA Department of Photography, with aid of Wayne Miller; captions chosen by Dorothy Norman.]

(unsigned) *Steichen The Photographer*. New York: Museum of Modern Art, exhibition opening March 27, 1961.

Alfred Stieglitz:

Picturesque Bits of New York and Other Studies. Portfolio of 12 signed photogravures. New York: R. H. Russel, 1897.

Keiley, Joseph T. (Foreword) *Exhibition of Photographs by Alfred Stieglitz*. New York: Camera Club, May 1–15, 1899.

(unsigned) *American Pictorial Photographs by Members of the Photo-Secession*, New York: National Arts Club, March 1902.

Stieglitz, Alfred. *Original Photogravures: The Work of Alfred Stieglitz*. Limited edition (forty) portfolio of five "Japan proofs, numbered and signed." January 1904.

BIBLIOGRAPHY

—————. (Introduction) *A Collection of American Pictorial Photographs as Arranged by the Photo-Secession*. Pittsburgh: Camera Club of Pittsburgh at the Carnegie Institute, February 1904.

(unsigned) *American Exhibition of Photographs Arranged by the Photo-Secession*. Philadelphia: Pennsylvania Academy of Fine Arts, 1906.

—————. *Special Exhibition of Contemporary Art*. New York: The National Arts Club, March 12–April 2, 1908.

Maeterlinck, Maurice. (Foreword) *International Exhibition of Pictorial Photography*. New York: The National Arts Club, February 2–20, 1909.

(unsigned) *International Exhibition of Pictorial Photography*. Buffalo, New York: Albright Gallery, Buffalo Fine Arts Academy. November 3–December 1, 1910.

Stieglitz, Alfred et al. (Introduction) *International Exhibition of Modern Art*, Association of American Painters and Sculptors, 69th Infantry Armory, N.Y., February–March, 1913. (AS not a participant; a sponsor, honorary vice-president, and lender.)

Stieglitz, Alfred. (Foreword) *The Forum Exhibition of Modern American Painters*, New York: Anderson Galleries, March, 1916.

—————. (Statement) *Alfred Stieglitz Photographs*, New York: Anderson Galleries, February 1921.

—————. (Statement) *Alfred Stieglitz Photographs*, New York: Anderson Galleries, April 1923.

—————. (Statement) *Alfred Stieglitz Photographs*, New York: Anderson Galleries, March 1924.

—————. "Introduction," *Seven Americans* (including Stieglitz), New York: Anderson Galleries, March 9–28, 1925.

—————. (Introduction) *Gaston Lachaise*. Retrospective exhibition, New York: Museum of Modern Art, January–March 1935.

—————. (Statement) *Alfred Stieglitz: Photographs*. An American Place, February–March, 1932.

—————. (Statement) Stieglitz Photographs. An American Place, December 1934–January, 1935.

Norman, Dorothy. "Beginnings and Landmarks, 291: 1905 to 1917." Exhibition catalogue, An American Place, October 27–December 24, 1937.

—————. (Statement) Group show, (including AS photographs), An American Place, October 10–November 20+, 1941.

(unsigned) *Alfred Stieglitz: His Collection*, Museum of Modern Art, June 10–August 31, 1942.

Zigrosser, Carl and Clifford, Henry. *History of an American, Alfred Stieglitz: 291 and After*. Selections from the Stieglitz Collection at the Philadelphia Museum of Art, September–October, 1944.

(unsigned) *Art in Progress*, 15th Annual Exhibition, New York: Museum of Modern Art, 1944.

—————. Alfred Stieglitz: *His Photographs and His Collection*, New York: Museum of Modern Art, June–September 1947. (Posthumous exhibition.)

Norman, Dorothy et al. *Stieglitz Memorial Portfolio*. New York: Twice A Year Press, 1947. [Tributes—in Memoriam.]

(unsigned) Stieglitz, Memorial Exhibition. Art Institute of Chicago, 1948.

—————. *Selections from the Stieglitz Collection*, Art Institute of Chicago, 1949.

—————. *Alfred Stieglitz Collection for Fisk University*, Nashville: The Carl Van Vechten Gallery of Fine Arts, November 1949.

—————. *20th Century Painters, U.S.A*. New York: Metropolitan Museum of Art, 1950. (AS and other photographers exhibited with print division.)

—————. *Climax in 20th Century Art: 1913*. New York: Sidney Janis Gallery, January–February, 1951.

Bry, Doris. *The Stieglitz Archive at Yale*. Exhibition commemorating the opening of the archive in the Collection of American Literature, The Beinecke Rare Book and Manuscript Library, Yale University, 1951.

(unsigned) *History of an American, Alfred Stieglitz: 291 and After.* Selections from the artists shown by him from 1900 to 1925. Cincinnati: Taft Museum, February 1951.

———. *Alfred Stieglitz: American Pioneer of the Camera.* Art Institute of Chicago, June–July 1951.

Norman, Dorothy. *Alfred Stieglitz.* An address dedicating Stieglitz Hall at the South Campus of the College of the City of New York, March 15, 1956.

Bry, Doris. *Alfred Stieglitz: Photographer.* Photographs from the key set. Washington, D.C.: National Gallery of Art, March–April, 1958.

———, *Alfred Stieglitz: Photographs.* Rochester, New York: George Eastman House, 1957.

(unsigned) *The Stieglitz Circle,* Claremont, California: Pomona College Galleries, October–November 1958.

———. *The Photo-Secession.* Rochester, New York: George Eastman House, 1959.

———. *Alfred Stieglitz Centennial,* Wellesley College, 1964.

Bry, Doris. *Alfred Stieglitz: Photographer.* The Stieglitz Collection at Boston: Museum of Fine Arts, 1965.

[Alfred Stieglitz Memorial Lectures established at Princeton University, 1967.]

Norman, Dorothy. "Evolving Environments of Art," *Selections from the Dorothy Norman Collection.* Special exhibition opening the Alfred Stieglitz Center at the Philadelphia Museum of Art, May–September 1968.

Kettlewell, James K. "Modern Art at Lake George," *Artists of Lake George, 1776–1976.* Bicentennial exhibition at the Hyde Collection, Glens Falls, New York, 1976.

(unsigned) *The Eye of Stieglitz.* New York: Hirschl & Adler Galleries, October 1978.

O'Keeffe, Georgia. (Introduction) *Georgia O'Keeffe: A Portrait by Alfred Stieglitz.* New York: Metropolitan Museum of Art, 1978.

(unsigned) *Alfred Stieglitz and An American Place.* New York: Zabriskie Gallery, 1978. Also Zabriskie Gallery, Paris.

———. *Alfred Stieglitz.* Exhibition at the Centre Pompidou, Paris, 1978.

Hoffman, Michael; and Chahroudi, Martha. *Spirit of An American Place,* Photographs by Alfred Stieglitz, at the Philadelphia Museum of Art, 11/22/80–3/29/81.

Paul Strand:

Strand, Paul. "Statement," *Photographs by Paul Strand.* New York: The Little Galleries of the Photo-Secession (291), March 13–April 3, 1916.

Stieglitz, Alfred. "Introduction," *Seven Americans.* New York: Anderson Galleries, March 9–28, 1925.

Lachaise, Gaston. *Paul Strand, New Photographs.* New York: The Intimate Gallery, March 19–April 7, 1929.

Clurman, Harold, et al. *Fotografía Paul Strand: Exposición de la Obra del Artista Norteamericano.* Mexico City: Sala de Arte de la Secretaria de Educacion Publica, 1933.

Roy, Claude. *La France de Profil.* Lausanne: La Guilde du Livre, 1952.

Hurwitz, Leo. *Photographs of Mexico,* a portfolio. New York: Virginia Stevens, 1940.

Newhall, Nancy. *Paul Strand: Photographs 1915–1945.* New York: Museum of Modern Art, 1945.

Siqueiros, David Alfaro. *The Mexican Portfolio.* New York: Aperture, 1967.

Strand, Paul, et al. *Paul Strand: A Retrospective Monograph, The Years 1915–1968.* Philadelphia: Museum of Art, November 23, 1971. (Also St. Louis: City Art Museum; Boston: Museum of Fine Arts; New York: Metropolitan Museum of Art; Los Angeles: County Museum of Art; San Francisco: M. H. de Young Memorial Museum.) Published New York: Philadelphia Museum of Fine Arts and Aperture.

Miscellaneous Works edited, published, or sponsored by Alfred Stieglitz (in chronological order):

Stieglitz as co-editor with F. C. Beach: *The American Amateur Photographer,* monthly periodical: 5:7 (July 1893) to 8:1 (January 1896). New York: The Outing Co., Ltd.

————, as Chairman of Camera Club Publications Committee, editor and manager: *American Pictorial Photography, Series I,* a portfolio of members' work, eighteen photogravures; 1899.

————, as Chairman of Publications Committee, editor and manager: *Camera Notes,* the official organ of the Camera Club of New York. Monthly periodical: 1:1 (July 1897) to 4:4 (April 1901).

————, as manager and editor: *Camera Notes* 5:1 (July 1901) to 6:1 (July 1902).

————, as publisher and editor: *Camera Work,* 1 (January 1903) to 49/50 (June 1917).

————, as publisher: *The Steichen Book,* portfolio of 26 plates by Eduard J. Steichen, 1906.

————, as publisher and editor: *The Photo-Secession,* booklet issued irregularly in seven issues from first in December 1902 to last in June 1909.

————, as editor: *Work by Pamela Colman Smith*; a limited edition portfolio of twenty-two platinum prints by AS of PCS works (only seven completed, + one special number with twenty-nine prints). Published by the Photo-Secession, 1907.

————, as publisher and editor: *The White Book,* portfolio of twenty-three plates by Clarence H. White, 1908.

————, as publisher with Haviland (officially published by 291: De Zayas, Marius; and Haviland, Paul B. *A Study of the Modern Evolution of Plastic Expression,* 1913.

————, as sponsor and one-third publisher, with Agnes Ernst Meyer and Paul B. Haviland (officially published by 291): *291,* a monthy: 1 (March 1915) to 12 (February 1916).

————, as sponsor: *MSS,* an irregular bimonthly: 1 (February 1922) to 6 (May 1923). Published by author/contributors.

———— & An American Place, publisher: *It Must Be Said,* series of leaflets issued irregularly: 1 (1932) to 7 (1937). Also: *It Has Been Said,* 1933 and *It Might Be Said,* 1937.

————, as sponsor: publications of An American Place: Seligmann, Herbert J., ed. *Letters of John Marin,* 1931; Norman, Dorothy. *Dualities,* 1933; Norman, Dorothy, ed. *Twice A Year.* A Semi-Annual Journal of Literature, The Arts and Civil Liberties, issued from 1 (Fall/Winter 1938) to 14/15 (Fall/Winter 1946–1947).

Miscellaneous Museum Catalogues Consulted:
Metropolitan Museum of Art, New York. *Masterpieces of Fifty Centuries.* Foreword by Theodore Rousseau; Introduction by Sir Kenneth Clark. Published in association with E. P. Dutton & Co., Inc., 1970.

Museum of Modern Art, New York. *Florine Stettheimer.* Text by Henry McBride, 1946.

————. *Futurism.* Text by Joshua C. Taylor. Published with Doubleday & Company, Inc., 1961.

Spencer Museum of Art, University of Kansas, Lawrence, 1981. *Marius De Zayas: Conjurer of Souls.* Text by Douglas Hyland.

Whitney Museum of American Art. *Photography Rediscovered: American Photographs 1900–1930,* Exhibition, September 19–November 25, 1979.

APPENDIX I

CAMERA WORK

For the convenience of the reader, the following compilation includes a listing of all the illustrations and most of the articles to appear in the fifty-two issues (forty-eight regular, one double, and three special) of the periodical. The numeral preceding the name of an artist or photographer indicates the number of his/her works included in the issue; where Stieglitz photographs appear, they are further identified by title and, where known, the date of exposure.

Founder and Editor:	1902–17:	Alfred Stieglitz
Associate Editors:	1902–17:	Dallet Fuguet
	1902–17:	Joseph Turner Keiley
		(continued on masthead after 1914 death)
	1902–10:	John Francis Strauss
	1905–17:	John Barrett Kerfoot
	1910–17:	Paul Burty Haviland

Number I, January 1903
Photographs: 6 Gertrude Käsebier; 1 Stieglitz: *Hand of Man*; 1 A. Radclyffe Dugmore. *Paintings* (b&w): 1 D. W. Tryon; 1 Puvis de Chavannes. *Text*: by AS, Charles Henry Caffin, Fuguet, Kerfoot, Sidney Allan (Sadakichi Hartmann), Eduard J. Steichen, Keiley, others.

Number II, April 1903
Photographs: 12 Steichen (+ 1 ad for Kodak). *Text*: articles on Steichen by Caffin and Hartmann; miscellaneous by R. Child Bayley, Fuguet, Kerfoot, and Eva Watson-Schütze.

Number III, July 1903
Photographs: 5 Clarence H. White, 3 Ward Muir, 1 Strauss, 1 Keiley, 1 Stieglitz: *The Street: Design for a Poster*, 1 Alvin Langdon Coburn. *Paintings*: 1 Mary Cassatt, 1 Boudin, 1 Rembrandt. *Text*: Caffin on White; miscellaneous by Kerfoot, Fuguet, Muir, others; quotations from James McNeil Whistler, Peter Henry Emerson. *Inserts*: Facsimile of handwritten piece too late for previous issue by Maurice Maeterlinck, "Je Crois"; principles and membership list of Photo-Secession: "Fellows" including "Founders and Council"; Associates.

Number IV, October 1903
Photographs: 6 Frederick Henry Evans, 1 Stieglitz: *The Flat-iron Building*, 1 Arthur E. Becher. *Text*: George Bernard Shaw on F. H. Evans; miscellaneous Hartmann, Fuguet, Kerfoot, Caffin, Keiley, Steichen.

Number V, January 1904
Photographs: 6 Robert Demachy, 1 Prescott Adamson, 1 Frank Eugene (Smith). *Text*: Keiley on Demachy; Hartmann on criticism; miscellaneous by Evans, Fuguet, others; quotations from Whistler.

Number VI, April 1904
Photographs: 6 Alvin Langdon Coburn, 2 Will A. Cadby, 1 W. B. Post. *Text*: Caffin on Coburn; Hartmann on Carnegie exhibit; miscellaneous by Cadby, Fuguet, others.

Number VII, July 1904
Photographs: 6 Theodor and Oskar Hofmeister, 2 Demachy, 1 Steichen, 1 Mary Devens. *Text*: Ernst Juhl on Hofmeisters; Demachy on gum prints; miscellaneous by A. K. Boursault, F. H. Evans, others; appeal to subscribers.

Number VIII, October 1904
Photographs: 6 J. Craig Annan, 1 A. L. Coburn, 1 F. H. Evans, 6 silhouette portraits by J. B. Kerfoot. *Text*: Keiley

on Annan; Kerfoot on silhouettes and satire; Stieglitz on foreign exhibits; miscellaneous others.

Number IX, January 1905
Photographs: 5 C. H. White, 1 Steichen, 4 Eva Watson-Schütze. *Text*: Keiley on Watson-Schütze; John W. Beatty on White; Evans on 1904 London photographic salon; Kerfoot (satire); new feature: reprints of New York critics, here on "First American Salon in New York"; miscellaneous others; quotations from Sebastian Melmoth.

Number X, April 1905
Photographs: 7 Käsebier, 2 C. Yarnall Abbott, 1 E. M. Bane. *Text*: Roland Rood on plagiarism, Charles Fitzgerald [generally antagonistic critic on New York *Sun*, reprinted often later in *CW*], "Eduard Steichen: Painter and Photographer"; miscellaneous others. *Other art*: 1 Outamaro print, paintings by Thomas W. Dewing (1) and Botticelli, *Primavera* (b&w).

Number XI, July 1905
Photographs: 6 David Octavius Hill, 2 Steichen, 1 Demachy, 2 A. Horsley Hinton. *Text*: J. C. Annan on D. O. Hill; Fuguet on art and originality; Kerfoot (satire); various technical pieces; Stieglitz announces *CW* 1906 plans.

Number XII, October 1905
Photographs: 10 Stieglitz: *Horses* (1904), *Winter Fifth Avenue* (misdated 1892, taken February 1893), *Going to the Post* (1904), *Spring* (1901), *Nearing Land* (1904), *Katherine* (1905), *Miss S.R.* (1904), *Ploughing* (1904), *Gossip—Katwyck* (1894). *September* (1899); 3 F. Benedict Herzog. *Other art*: reprinted hieroglyphics and cave sketches (½ page), 2 Giotto, 1 Botticelli (detail from *Primavera*), 1 Valasquez. *Text*: Caffin on "Verities and Illusions"; Rood on Evolution of art; announcement of opening of Photo-Secession Gallery ca. November 1; miscellaneous others; quotations from Melmoth.

Number XIII, January 1906
Photographs: 3 Hugo Henneberg, 4 Heinrich Kuehn, 5 Hans Watzek; *Other art*: Steichen poster for Photo-Secession. *Text*: F. Mathies-Masuren on Henneberg, Kuehn, and Watzek; Caffin "Verities & Illusions II"; Evans on 1905 London Salon (with list of American photos shown); miscellaneous others.

Number XIV, April 1906
Photographs: 9 Steichen, 4 Stieglitz: *Exhibitions at 291*—Steichen in March, White and Käsebier in February, opening exhibition November–January (2 images). 1 Steichen *Cover Design* (woman with globe). *Text*: Shaw, "The Unmechanicalness of Photography" and review of the London exhibit; Kerfoot (satire); reprints of critics on Photo-Secession Gallery shows; calendar of shows.

Special Steichen Supplement, April 1906
Photographs: 16 Steichens, including portraits of Eleanora Duse, Maeterlinck, J. P. Morgan, Rodin, and several halftones (hand-colored). *Text*: Maeterlinck, "I Believe."

Number XV, July 1906
Photographs: 5 Alvin Langdon Coburn, 1 Shaw (portrait of Coburn), 1 Steichen (experiment in 3-color photography: unretouched halftone plates printed directly by engraver from 3 diapositives), 1 George Henry Seeley. *Text*: articles by Caffin and Rood; Shaw on Coburn; Kerfoot, "The ABC of Photography, A–G"; miscellaneous others include report on First Pennsylvania Academy photo show arranged by Keiley, Steichen, and Stieglitz; sales of ca. $2,800 for prints averaging $45+ from gallery shows during 1905–6.

Number XVI, October 1906
Photographs: 7 Demachy, 3 C. (Émile Joachim Constant) Puyo, 2 René LeBègue. *Text*: Demachy on Rawlins oil process; Caffin on recent shows; Kerfoot, "The ABC of Photography, H–N"; miscellaneous others.

Number XVII, January 1907
Photographs: 6 Keiley, 2 Herzog, 1 Harry Cogswell Rubincam, 1 Dugmore. *Other arts*: 2 James Montgomery Flagg (2-color satiric watercolor "portraits"). *Text*: Caffin on Herzog; Kerfoot, "The ABC of Photography, O–T"; Evans on London Salon 1906; miscellaneous others.

Number XVIII, April 1907
Photographs: 6 George Davison, 2 Sarah C. Sears, 2 William B. Dyer. *Text*: Caffin, "Symbolism and Allegory"; Bayley on pictorial photography; Kerfoot, "The ABC of Photography, U–Z"; Demachy on "modified" prints, answered by Shaw, Evans, and Sutclyffe; miscellaneous others, including references to the gallery's first exhibit of nonphotographic works—drawings by Pamela Colman Smith.

Number XIX, July 1907
Photographs: 5 Annan, 1 Steichen. *Text*: Demachy on the "Straight Print"; miscellaneous by Fuguet, Caffin, Kerfoot, others.

Number XX, October 1907
Photographs: 6 Seeley, 3 Stieglitz "snapshots": *From My Window, New York* (post-1898), *From My Window, Berlin* (1888–90), *In the New York Central Yards* (1903), 1 W. Renwick. *Text*: Stieglitz, "The New Color Photography" (first report on Lumière Autochromes; his first experiments with process in June 1907); Keiley on Käsebier; C. A. Brasseur on color photography; miscellaneous others.

Number XXI, January 1908
Photographs: 12 Coburn. *Text*: (unsigned) "Is Photography a New Art?"; Caffin, others. Delay of a color issue explained.

Number XXII, April 1908
(Color Number)
Photographs: 3 Steichen: *BS, On the Houseboat, Lady H.* (reproduced in 4-color halftones by A. Bruckmann & Co., Munich). *Text*: Steichen, "Color Photography"; Caffin and Strauss on expulsion of AS from the New York Camera Club; list of 40+ members of The Camera Workers, new group of photographers resigned from Camera Club, with headquarters at 122 East Twenty-fifth Street; miscellaneous others, including reviews of Rodin drawings at the gallery in January.

Number XXIII, July 1908
Photographs: 16 Clarence H. White. *Text*: Caffin on White and Seeley exhibition; reprints of critics on Matisse exhibition; Stieglitz, "Frilling and Autochromes"; miscellaneous others.

Number XXIV, October 1908
Photographs: 7 Baron Adolph de Meyer, 1 William E. Wilmerding, 2 Guido Rey. *Text*: George Besson interviews artists (including Rodin and Matisse) about "pictorial" photography; Caffin, "The Camera Point of View in Painting and Photography"; miscellaneous others.

Number XXV, January 1909
Photographs: 5 Annie W. Brigman, 1 Emma Spencer, 1 C. Y. Abbott, 2 Frank Eugene (including portrait of AS). *Text*: Caffin, "Henri Matisse and Isadora Duncan"; Kerfoot on Matisse; J. Nilsen Laurvik on Brigman; miscellaneous others; Photo-Secession members' list.

Number XXVI, April 1909
Photographs: 6 Alice Boughton, 1 J. C. Annan, 1 George Davison. *Text*: Benjamin de Casseres, "Caricature and New York"; Sir (Caspar) Purdon Clarke on "Art" and Oscar Wilde on "The Artist"; Laurvik on show of "International Photography" at the National Arts Club; miscellaneous others.

Number XXVII, July 1909
Photographs: 5 Herbert G. French, 4 White and Stieglitz (collaboration). *Text*: H. G. Wells, "On Beauty"; de Casseres on Pamela Colman Smith; Caffin on de Meyer and Coburn shows; New York critics on Maurers and Marins at gallery; quotations from Wilde; miscellaneous others.

Number XXVIII, October 1909
Photographs: 6 David Octavius Hill, 1 Davison, 1 Paul Burty Haviland, 1 Marshall R. Kernochan, 1 Coburn. *Text*: unsigned piece on Impressionism; Caffin on Steichen's Rodin-Balzac pictures and on Dresden international photo show; quotations from Nietzsche, "To the Artist Who Is Eager for Fame"; miscellaneous others.

Number XXIX, January 1910
Photographs: 10 George H. Seeley. *Caricatures*: 4 Marius De Zayas. *Text*: Hartmann, Meier-Graefe on Toulouse-Lautrec lithographs; other critics on Photo-Secession Galleries exhibition; miscellaneous others.

Number XXX, April 1910
Photographs: 10 Frank Eugene. *Caricature*: De Zayas (of AS). *Text*: William D. MacColl on art criticism; Hartmann on composition; Caffin on Steichen; New York critics on Steichen, Marin, Matisse; miscellaneous others, including announcement of Albright Gallery show in Rochester (November).

Number XXXI, July 1910
Photographs: 14 Frank Eugene. *Text*: Max Weber, "The Fourth Dimension from a Plastic Point of View" and "Chinese Dolls and Modern Colonists"; Haviland in defense of including other arts at gallery and in *CW*; Hartmann on De Zayas; New York critics on Younger American Painters show; others.

Number XXXII, October 1910
Photographs: 5 Annan, 1 White, 1 Coburn (ad). *Drawings*: 2 Henri Matisse (nudes), 1 Gordon Craig (stage design). *Text*: Hartmann on Puritanism; Annan on photography as "artistic expression"; de Casseres on

"Decadence and Mediocrity"; Elie Nadelman, "My Drawings"; miscellaneous others.

Number XXXIII, January 1911

Photographs: 15 Heinrich Kuehn (some mezzotint, some duplex halftone). *Text*: Caffin, Keiley, Coburn, and others on Albright show; Hartmann, "What Remains?"; Max Weber, poem to primitive Mexican art; miscellaneous others.

Numbers XXXIV–XXXV, April–July 1911

Photographs: 4 Steichen (Rodin and his Balzac). *Drawings*: Rodin: 2 gravures, 7 colored collotypes. *Text*: de Casseres, Agnes Ernst Meyer, Hartmann on Rodin; Shaw, "A Page from Shaw"; De Zayas on Paris Salon d'Automne; Caffin on Cézanne; De Zayas on Picasso; L. F. Hurd, Jr., "* * * *"; miscellaneous others.

Number XXXVI, October 1911

Photographs: 16 Stieglitz: *The City of Ambition* (1910), *The City Across the River* (1910), *The Ferry Boat* (1910), *The Mauretania* (1910), *Lower Manhattan* (1910), *Old and New New York* (1910), *The Aeroplane* (1910), *A Dirigible* (1910), *The Steerage* (1907), *Excavating—New York* (1911), *The Swimming Lesson* (1906), *The Pool—Deal* (1910), *The Hand of Man* (1902), *In the New York Central Yards* (1903), *The Terminal* (1892), *Spring Showers, New York* (1903). *Drawing*: 1 Picasso. *Text*: de Casseres, "The Unconscious in Art"; quotations from Henri Bergson and Plato; Coburn, "The Relation of Time to Art"; miscellaneous others.

Number XXXVII, January 1912

Photographs: 9 David Octavius Hill [and Robert Adamson]. *Text*: de Casseres on modernity and decadence; Hartmann on originality; Bergson on the object of art; Archibald Henderson on Shaw and photography; Maeterlinck on photography; Caffin on de Meyer; Gelett Burgess, "Essays in Subjective Symbolism"; miscellaneous others.

Number XXXVIII, April 1912

Photographs: 5 Brigman, 8 Karl F. Struss. *Text*: de Casseres, "The Ironical in Art"; Hartmann, "The Esthetic Significance of the Motion Picture"; reprints of New York critics, miscellaneous others.

Number XXXIX, July 1912

Photographs: 6 Haviland, 1 H. Mortimer Lamb. *Paintings*: 2 John Marin watercolors (3-color halftone). *Drawings*: 2 Manolo. *Caricature*: 1 De Zayas (of AS). *Text*: De Zayas, "The Sun Has Set"; Hartmann on Matisse; quotations from Wassily Kandinsky's "On the Spiritual in Art" (pre-English translation); Laurvik on Marin; Hartmann on children's drawings; miscellaneous others.

Special Number, August 1912

Paintings: 5 Matisse, 3 Picasso. *Drawings*: 2 Picasso. *Sculptures*: 2 Matisse, 2 Picasso (all halftone photo reproduction). *Text*: Editorial on contents; Gertrude Stein (debut in U.S.), "Henri Matisse" and "Pablo Picasso."

Number XL, October 1912

Photographs: 14 de Meyer. *Text*: John Galsworthy, "Vague Thoughts on Art"; Hutchins Hapgood, "A New Form of Literature"; quotations from letters of Van Gogh; miscellaneous others.

Number XLI, January 1913

Photographs: 5 Julia Margaret Cameron, 4 Stieglitz: 2 *A Snapshot, Paris* (1911), *The Asphalt Paver, New York* (1892), *Portrait—S.R.* (1904). *Text*: De Zayas, "Photography" and "The Evolution of Form—Introduction"; reprints from New York critics; miscellaneous others.

Special Number, June 1913

Paintings: 3 Cézanne, 1 Van Gogh, 2 Picasso, 1 Francis Picabia; *Drawings*: 1 Picasso (all halftone photo rep.). *Text*: Gertrude Stein, "Portrait of Mabel Dodge at the Villa Curonia"; Mabel Dodge, "Speculations"; Gabrielle Buffet, "Modern Art and the Public"; Picabia, *"Vers L'Amorphisme"*; de Casseres, "The Renaissance of the Irrational"; miscellaneous others; first "Are You Interested in the Deeper Meaning of Photography?"

Numbers XLII/XLIII, April–July 1913 (published November)

Photographs: 14 Steichen (incl. duogravures). *Paintings*: 3 Steichen (reproduced in 3-color halftones). *Text*: De Zayas, "Photography and Artistic Photography"; Mary Steichen poem; New York critics on 291; John Marin, "Statement on his Show"; Francis Picabia, "Preface to His Show"; De Zayas, "Preface to His Show"; John Weichsel, "Cosmism or Amorphism?"

Number XLIV, October 1913 (published March 1914)

Photographs: 1 Steichen, 1 Stieglitz: *Two Towers–New York*; 1 Brigman. *Drawings*: 7 Abraham Walkowitz (collotype repro.). *Text*: Tributes to Joseph

T. Keiley (d. Jan.) by: Fuguet, Kerfoot, Bayley, William Murrell (Fisher), the editors; Oscar Bluemner on Walkowitz; reprints of New York critics; others.

Number XLV, January 1914
(published June)
Photographs: 8 J. C. Annan. *Text*: Mina Loy, "Aphorisms on Futurism"; Marsden Hartley foreword for his exhibition; M. Dodge on Hartley; Gertrude Stein, "From a Play by Gertrude Stein on Marsden Hartley"; reprints of New York critics; notice of photo shows planned for 291; others.

Number XLVI, April 1914
(published October)
Photographs: 2 Haviland, 1 Frederick H. Pratt. *Caricatures*: 10 De Zayas. *Text*: Weichsel, "Artists and Others"; poems by Katharine N. Rhoades and Mina Loy; De Zayas on caricature; Haviland on De Zayas; poem by "S.S.S." (AS's sister Selma); shows planned, etc.

Number XLVII, July 1914
(published January 1915)
No illustrations. *Text*: AS, "What is 291?" Replies: Mabel Dodge, Hutchins Hapgood, Charles E. S. Rasay, Adolf Wolff, Hodge Kirnan, Anne Brigman, Clara Steichen, Ward Muir, Abby Hedge Coryell, Frank Pease, Stephen Hawes, Rex Stovel, Alfred Kreymborg, Francis Bruguière, Ethel Montgomery Andrews, Frances Simpson Stevens, Djuna Barnes, Paul B. Haviland, Charles Demuth, Konrad Cramer, Charles Daniel, Anna C. Pellew, Helen R. Gibbs, H. Mortimer Lamb, Marsden Hartley, Arthur B. Davies, Arthur G. Dove, John W, Breyfogle, William Zorach, Velida, Max Merz, Eugene Meyer, Jr., Arthur B. Carles, E. Zoler, J. N. Laurvik, S.S.S., Christian Brinton, N. E. Montross, Hugh H. Breckenridge, Helen W. Henderson, Ernest Haskell, Frank Fleming, Lee Simonson, Arthur Hoeber, William F. Gable, A. Walkowitz, F. W. Hunter, Oscar Bluemner, C. Duncan, Katharine N. Rhoades, Agnes Ernst Meyer, Marion H. Beckett, Clifford Williams, Samuel Halpert, Man Ray, Marie J. Rapp, Charles H. Caffin, Dallett Fuguet, Belle Greene, Eduard J. Steichen, Hippolyte Havel, Henry McBride, Torres Palomar, John Weichsel, J. B. Kerfoot, Francis Picabia, Marius De Zayas, John Marin.

Number XLVIII, October 1916
Photographs: 1 Frank Eugene, 6 Paul Strand, 1 Arthur Allen Lewis, 1 Francis Bruguière, 6 Stieglitz: *Exhibitions at 291: Negro Art, Nov. 1914; German and Viennese Photographers, March 1906; Detail, Picasso-Braque, January 1915; Nadelman, room 1, December 1915; Nadelman, room 2, December 1915.* *Text*: 291 exhibitions 1914–1916; De Zayas, "Modern Art in Connection with Negro Art"; A. E. Meyer on Beckett and Rhoades; Nadelman on his show; Walkowitz on his show; Hartley on his show; C. Duncan and Evelyn Sayer on "Georgia O'Keeffe, C. Duncan and René Lafferty"; New York critics reprints; announcing "291—a new publication"; reprint from *291*, July/August 1915 of De Zayas piece; "291 and the Modern Gallery" (unsigned); Hartley, "Epitaph for A. S."

Numbers XLIX/XL, June 1917
(final issue)
Photographs: 11 Paul Strand (including *The White Fence, Abstraction—Porch Shadows*, and *Abstraction—Bowls*). *Text*: Paul Strand, "Photography"; W. Murrell Fisher on O'Keeffe drawings and paintings; Caffin on 1916–17 season shows at 291; Stanton MacDonald Wright, foreword to his show; extract from letter from Frank Eugene Smith; miscellaneous others.

APPENDIX II

EXHIBITIONS ARRANGED BY STIEGLITZ 1902–1946

Where possible, the following information is included: the date and location of the exhibition, the name(s) of the participating artist(s), the number of works shown, the medium of expression and subject matter, and the relative prominence or obscurity of the artist(s) as indicated by group or solo, debut, etc. exhibit.

1902–1905

The first exhibition of photography at the National Arts Club on Gramercy Square in New York City in April 1902 marked the debut of the Photo-Secession, a group of photographers not formally organized until July 1903. Works by its members were also in the collection assembled by Stieglitz in 1902 at the request of General Luigi Palma de Cesnola, Director of the Metropolitan Museum of Art, for the Turin (Italy) International Exposition of the Decorative Arts. The exhibition, in October/November 1902, brought AS and the group the King's Prize, but not the showing at the Metropolitan promised by de Cesnola, who died early in 1903.

In all, between the founding of the P-S in 1903 and its dissolution in 1912, AS received 147 requests for loans to exhibitions. Among those to which he dispatched works were international shows in Berlin, Bradford (England), Brussels, Buffalo, Cleveland, Cincinnati, Denver, Dresden, Haarlem, The Hague, Hamburg, Leipzig, London, Minneapolis, Munich, Paris, Philadelphia, Pittsburgh, Portland (Ore.), Rochester, St. Petersburg (Russia), San Francisco, Toronto, Vienna, Washington, Wiesbaden, and Worcester, Mass.

291 (The Little Galleries of the Photo-Secession); 291–293 Fifth Avenue

1905–1906
11/24–1/5 *Photographic prints* (selected from summer 1905 P-S section at the London salon, from P-S prints in the Fine Arts department of the Lewis & Clark Exposition at Portland, Oregon, with others by P-S Associates and Fellows): Jeanne E. Bennett, Alice Boughton, Annie W. Brigman, John G. Bullock, Sidney R. Carter, Alvin Langdon Coburn, Mary Devens, William Buckingham Dyer, J. Mitchell Elliot, Frank Eugene (Smith), Herbert Greer French, W. F. James, F. D. Jamieson, Gertrude Käsebier, Joseph Turner Keiley, John Barrett Kerfoot, Marshall R. Kernochan, Chester A. Lawrence, Helen Lohmann, William J. Mullins, Jeannette E. Peabody, William Boyd Post, Frederick H. Pratt, Landon Rives, Harry Cogswell Rubincam, Eva Watson-Schütze, Sarah C. Sears, Katharine A. Stanbery, Mary R. Stanbery, Eduard J. Steichen, Alfred Stieglitz, W. P. Stokes, John Francis Strauss, W. Orson Underwood, Mary Vaux, S. S. Webber, Clarence H. White, S. L. Willard, W. E. Wilmerding (The opening followed an informal dinner for P-S members at Mouquin's restaurant.)

1/10–1/24	*French Photographers*: Maurice Brémard, G. Bresson, Robert Demachy, Georges Grimpel, A. Hachette, Céline Laguarde, René Le Bègue, Emil Joachim Constant Puyo
1/26–2/2	*Photographs*: Herbert Greer French
2/5–2/19	*Photographs*: 27 each by Gertrude Käsebier and Clarence H. White
2/21–3/7	*Three British Photographers*: David Octavius Hill, James Craig Annan, and Frederick H. Evans
3/17–4/5	*Photographs*: Eduard J. Steichen (some pigmented)
4/7–4/28	*German and Austrian Photographers*: Heinrich Kuehn, Hugo Henneberg, Hans Watzek, Theodor Hofmeister, and Oskar Hofmeister

1906–1907

11/8–1/1	*Photographs*: Members, Associates, and Fellows of the P-S—Bennett, Boughton, Brigman, Bullock, Coburn, Carter, Dyer, Elliot, French, Adelaide Hanscom, J. P. Hodgins, Spencer Kellog, Jr., Käsebier, E. Keck, Keiley, Kerfoot, Kernochan, Lawrence, Lohmann, Charles H. MacDowell, Charles Peabody, J. E. Peabody, Pratt, Rives, H. T. Rowley, Rubincam, George H. Seeley, Steichen, Stieglitz, Edmund Stirling, Webber, White, Myra A. Wiggins, Willard
1/5–1/22	*Drawings*: 72 by *Pamela Colman Smith* (debut at gallery—first non-photographic show at 291)
1/25–2/12	*Photographs*: 23 each by Baron Adolph de Meyer (debut at 291) and George H. Seeley (a new Fellow of the P-S)
2/19–3/5	*Photographs*: 23 each by Alice Boughton, William B. Dyer, and C. Yarnall Abbott
3/10–4/10	*Photographs*: Alvin Langdon Coburn

1907–1908

11/18–12/30	*Third Annual Members' Exhibition—Photographs*: W. P. Agnew, Bennett, Brigman, Boughton, Bullock, Carter, A. L. Coburn, Fannie E. Coburn, Elliot, French, Hodgins, Keiley, Kernochan, Lohmann, Mullins, Post, Pratt, Rubincam, Seeley, Emma Spencer, Steichen, Stieglitz, Elizabeth R. Tyson, Underwood, White, Wiggins, Willard; White and Stieglitz collaborations; color transparencies by Eugene, Steichen, and Stieglitz shown daily by AS in person
1/2–1/21	*Auguste Rodin*: 58 drawings (first exhibition in U.S. of drawings)
2/7–2/25	*Photographs*: 51 by George H. Seeley
2/26–3/11	*Willi Geiger*: Etchings and bookplates; *D. S. MacLaughlan*: Etchings; *Pamela Colman Smith*: Drawings
3/12–4/2	*Photographs*: Eduard J. Steichen (47 photographs, 15 autochromes)
4/6–4/27	*Henri Matisse*: Lithographs, drawings, watercolors, etchings, 1 oil (debut in U.S.)

1908–1909

12/8–12/30	*Fourth (last) Annual Members' Exhibition: Photographs*
1/4–1/16	*Photographs*: J. Nilsen Laurvik (autochromes), shown with 25 caricatures by Marius De Zayas (first exhibition anywhere)
1/18–2/1	*Photographs*: Alvin Langdon Coburn
2/4–2/22	*Photographs*: Baron A. de Meyer (monochromes and polychromes)
2/26–3/15	*Allen Lewis*: Drypoints, bookplates, and etchings (first show)
3/16–3/27	*Pamela Colman Smith*: Drawings
3/30–4/17	*John Marin*, 24 watercolors from Meaux, Nanteuil, Paris, Issy, London, Chartres (debut in U.S.); *Alfred Maurer*, 15 oil sketches (debut in U.S.)
4/21–5/7	*Photographs*: Eduard J. Steichen (images of Rodin's *Balzac*)
5/8–5/18	*Marsden Hartley*: 33 oils (debut at gallery)
5/18–6/2	*Japanese Prints*: 21 from the F. W. Hunter collection

1909–1910
11/24–12/17 *Eugene Higgins*: Monotypes and drawings (single show at 291)
12/20–1/14 *Henri de Toulouse-Lautrec*: Lithographs (debut in U.S.)
1/21–2/5 *Photographs*: Eduard J. Steichen (color transparencies—simultaneous with show of paintings and photographs at Montross Gallery)
2/7–2/25 *John Marin*: 43 watercolors, 20 pastels, 10 etchings from Voulangis, Paris, and Rouen (first one-man show anywhere)
2/27–3/20 *Henri Matisse*: Drawings and photographs of paintings (second of three shows at 291)
3/21–4/15 *Younger American Painters in Paris*: D. Putnam Brinley, Arthur Beecher Carles, Lawrence Fellows, Marin, Maurer, Steichen, and Max Weber (AS adds paintings by Hartley and a debut—first show anywhere—for Arthur Garfield Dove)
3/31–4/18 *Auguste Rodin*: 41 drawings and watercolors
4/26–5/? *Marius De Zayas*: 25 caricatures (first one-man show)

1910–1911 [No photographs exhibited during season]
11/18–12/8 *Cézanne, Manet, Renoir, Toulouse-Lautrec*: Lithographs; *Rodin*: paintings & drawings. (In separate room) *Henri (Le Douanier) Rousseau*: 4 or 5 oil paintings, 2 ink drawings, decorated vase (first one-man show anywhere)
12/10–1/8 *Gordon Craig*: 46 drawings and etchings (U.S. debut, only show at 291)
1/11–1/31 *Max Weber*: 32 works (oils, watercolors, charcoal and crayon drawings, only show at 291)
2/2–2/22 *John Marin*: Watercolors from the Tyrol, lower Manhattan, Weehawken
3/1–3/25 *Paul Cézanne*: 20 watercolors (one-man debut in U.S.)
3/28–4/25+ *Pablo Picasso*: 83 drawings and watercolors (first one-man show
(extended) anywhere)

1911–1912
11/18–12/8 *Gelett Burgess*: Watercolors (debut and only show at 291)
12/18–1/15 *Photographs*: Baron Adolph de Meyer (portraits, genre, and landscapes)
1/17–2/3 *Arthur B. Carles*: Paintings
2/7–2/26 *Marsden Hartley*: "Recent Paintings and Drawings" (still-lifes)
2/27–3/12 *Arthur G. Dove*: Paintings and pastels, including *Ten Commandments* series (first one-man show anywhere)
3/14–4/6 *Henri Matisse*: 12 drawings and 12 sculptures (first sculpture show anywhere)
4/11–5/10 "Unguided Children Aged 2 to 11" (first of three at 291; promoted as the first of its kind anywhere)

1912–1913
11/20–12/12 *Alfred J. Frueh*: 50 or more theatrical caricatures (first one-man show; only show at 291)
12/15–1/14 *Abraham Walkowitz*: Drawings and watercolors (debut at 291, first one-man show anywhere)
1/20–2/15 *John Marin*: 28 watercolors (Berkshires, lower Manhattan, Brooklyn Bridge, Hudson River)
2/24–3/15 *Photographs*: Alfred Stieglitz (first and last one-man show at 291)
3/17–4/5 *Francis Picabia*: 16 "studies" of New York (first one-man show in U.S.)
4/8–5/20 Marius De Zayas: 10 charcoal caricatures

1913–1914

11/19–2/3 *Abraham Walkowitz*: Drawings, pastels, and watercolors

1/12–2/12 *Marsden Hartley*: 17 paintings (abstractions done in Paris; first Berlin paintings)

 Arnold Rönnebeck: Bronze sculpture (debut at 291, possibly in U.S.)

2/18–3/11 *Untaught children*: pastels and watercolors, including works by AS's niece Georgia Engelhard and Steichen's daughter Mary

3/12–4/1 *Constantin Brancusi*: Sculptures—6 heads in marble and bronze, figure in wood, bird in brass (first one-man show anywhere)

4/6–5/6 *Frank Burty* [Haviland]: Paintings and drawings (first show anywhere and only show at 291)

1914–1915 [The January 1914 issue of *Camera Work*, issued in June, promised four photography exhibitions, of which none were held: British photographers Hill, Cameron, and Annan; French photographers Demachy, Puyo, and Le Bègue; Austrians Kuehn, Henneberg, and Watzek; and Americans Brigman, Eugene, Keiley, Steichen, and Stieglitz. World War I interfered with the presentation of the first three; there is no explanation for cancellation of the fourth.]

11/3–12/8 "African Savage Art:" 18 sculptures from the Ivory Coast, Nigeria, and the Congo (first major showing in U.S.)

12/9–1/11 *Georges Braque* and *Pablo Picasso*: Recent charcoal drawings and oils from the collection of Gabrielle and Francis Picabia; pre-Columbian pottery and carvings; "Kalograms" by *Torres Palomar* (debut and only show at 291)

1/12–1/26 *Francis Picabia*: 3 large non-objective oils

1/27–2/22 *Marion H. Beckett*: Portraits; *Katharine N. Rhoades*: paintings (first and last show for both at 291)

2/23–3/26 *John Marin*: 47 works: watercolors, oils, etchings, and drawings (skyscrapers, land- and seascapes)

3/27–4/17 "Children's Work": Drawings by boys aged 8–14 from a New York public elementary school

1915–1916

11/10–12/7 *Oscar Bluemner*: Paintings and drawings "based on" New Jersey landscapes (debut in U.S.)

12/8–1/18 *Elie Nadelman*: 15 sculptures in marble, bronze, wood, and plaster; and 10 drawings (debut in U.S.)

1/18–2/12 *John Marin*: More than 30 recent watercolors, oils, drawings, and etchings

2/14–3/12 *Abraham Walkowitz*: Recent drawings and watercolors; abstractions

3/13–4/3 *Paul Strand*: Photographs, platinum prints (debut at 291); last photographic show at 291

4/4–5/22 *Marsden Hartley*: 40 oils—German military series, 1914–1915

5/23–7/5 *Georgia O'Keeffe*: 10 charcoal drawings; *Charles Duncan*: 2 watercolors and 1 drawing; *Réné Lafferty*: 3 oils (debut at 291 for all three artists)

1916–1917

11/22–12/20 *Georgia Engelhard* (10 years old): Drawings and watercolors included in group show of paintings and drawings by *Hartley, Marin, O'Keeffe,* and *Walkowitz.* (In separate room) Synchromist paintings by *Stanton MacDonald-Wright,* (debut at 291)

12/27–1/17 *Abraham Walkowitz*: Watercolors

1/22–2/7 *Marsden Hartley*: Recent work—Provincetown abstractions and earlier paintings

2/14–3/3 *John Marin*: Watercolors, including Delaware County, Pa. [Appar-

ently none of the nearly 100 oils Marin painted during the year—see Sheldon Reich, *John Marin*—was shown at 291.]

3/6–3/17 *Gino Severini*: Paintings, drawings, and pastels—25 Futurist and Cubist works (debut in New York—probably in U.S.)

3/20–3/31 *Stanton MacDonald-Wright*: Watercolors, drawings, and oils (first full one-man show)

4/3–5/14 *Georgia O'Keeffe*: Watercolors, drawings, and oils (first one-woman show); last show at 291

7/1/17 Gallery closed [Planned for the 1917–1918 season were: *Alfred Maurer*: oils; *Stieglitz*: portraits, and scenes from 291's back windows; *Strand*: recent photographs; a special issue of *Camera Work* devoted to the works of O'Keeffe.]

[Between about 1908 and 1917, the works of artists other than those exhibited were sometimes on hand. These artists included: Wassily Kandinsky, Manolo, Man Ray, Felicien Rops, and Theophile Steinlen.]

1917–1925 [Without a gallery of his own, Stieglitz arranged exhibitions for his artists at a number of New York galleries, including: the Daniel, Montross, Bourgeois, and Weyhe galleries. Outside New York City, he helped Marin and/or Hartley to be seen in shows at the Albright Academy in Buffalo, the Baltimore Museum of Art (beginning with its inaugural in 1923), the Brooklyn Museum, the Los Angeles Museum of History, Science & Art, the Milwaukee Art Institute, the Pennsylvania Academy of Fine Arts in Philadelphia, the Carnegie Institute in Pittsburgh, the Rochester Memorial Art Gallery, and the Worcester Art Museum in Massachusetts]

Special Exhibitions arranged by AS at the Anderson Galleries–
489 Park Avenue, New York

1921:
2/7–2/14(?) *Stieglitz*: 146 photographs (128 never exhibited before, 78 done since July 1918). 21 *Early Prints, 1887–1910*; 23 *Portraits from 291, 1907–1917*; 9 *From the Back Window—291*; 3 exhibitions at 291 (Brancusi, 2nd Picasso, last show 1917); 18 Portraits 1904–1920; 4 "Water" prints, Lake George; 6 miscellaneous 1913–1920, and a *Demonstration of Portraiture* (each set constituting 1 portrait): 2 Nelson Laurvik 1920, 3 Waldo Frank 1920, 2 Margaret Naumburg, 1920, 3 Jacob F. Dewald 1920, 2 George Herbert Engelhard 1920, 2 Georgia Engelhard 1920, 3 Dorothy True, 1920, 26 *A Woman* 1918–1920 (O'Keeffe)—8 hands, 3 feet, 3 hands and breasts, 3 torsos, 2 "Interpretations")

1922
late Feb. *Artists' Derby*: 40 painters, including all 291 artists

5/10–5/17 *Marsden Hartley*: 117 pictures (arranged with 75 pictures of James N. Rosenberg). The 5/17 auction netted Hartley $4,913.

1923
1/29–2/12 *Georgia O'Keeffe*: 100 pictures—oils, watercolors, pastels

4/2–4/16 *Stieglitz*: 116 photographs (1 exhibited before)–*Women*: 64 prints, including 13 Georgia O'Keeffe 1919–1922; 2 Claudia O'Keeffe 1922; 6 Rebecca Salsbury Strand; *Men*: 14 prints, including 3 Marin 1922, 1 Davidson 1922, *Clouds*: *Music—A Sequence of Ten Cloud Photographs* 1922; *Miscellaneous* including Hay Wagon 1922, 3 barns 1922, 3 trees 1921–2; *Judith* 1922; *A Portrait*; *Small Prints*, including 7 of O'Keeffe 1918

1924
2/28–3/14(?) *Stieglitz*: 61 photographs of clouds in one room simultaneously with *O'Keeffe*: 51 paintings in another

1925
3/9–3/28 *Seven Americans—Charles Demuth*: 6 poster portraits (first showing with AS); *Dove*: 24 paintings and drawings; *Hartley*: 25 landscapes and still-lifes (1921–4) shown with portrait bust of Hartley by *Arnold Rönnebeck*; *Marin*: 27 watercolors from Deer Isle and Stonington, Maine; *O'Keeffe*: 31 paintings, including large flowers, autumn leaves, trees, landscapes, Lake George; *Stieglitz*: 28 *Equivalents*, photographs of clouds and sky [these and all subsequent *Equivalents* 4 × 5 prints]; *Strand*: 18 photographs of New York, leaves, and "Machines"

The Intimate Gallery—Room 303 at Anderson Galleries

1925–1926
12/7–1/11 *Marin*: Watercolors: retrospective (two acquired by Brooklyn Museum)
1/11–2/7 *Dove*: Paintings on glass and metal; first "Assemblages" (Duncan Phillips acquires first Dove)
2/11–3/11 *O'Keeffe*: 50 recent paintings—flowers; first Manhattan picture, *New York with Moon* [show extended to 4/3]

4/5–5/2 *Demuth*: Watercolors and oils

1926–1927
11/9–1/9 *Marin*: 30 or more new watercolors—Cliffside, New Jersey, Ramapos, Berkshires, (includes $6,000 watercolor, *Back of Bear Mountain*)
1/11–2/27 *O'Keeffe*: 36 oils (first large earnings)
3/9–4/14 *Gaston Lachaise*: Sculptures in brass and bronze (?) (debut with AS)

1927–1928
11/9–12/11 *Marin*: 45 or more watercolors—Manhattan, White Mountains, Maine, boats
12/12–1/7 *Dove*: Paintings and assemblages—*Huntington Harbor* and *George Gershwin's Rhapsody in Blue Part I* (assemblages) sold
1/11–2/27 *O'Keeffe*: Recent paintings—series of 7 *Shell and Old Shingle*; flowers (six 1923 calla lily paintings sold for $25,000)
2/28–3/27 *Oscar Bluemner*: 28 recent paintings and drawings
3/27–4/17 *Peggy Bacon*: Pastels and drawings (debut)
May *O'Keeffe*: Calla lilies on "private" exhibition before being shipped
(several days) to Paris
4/19–5/11 *Picabia*: Large abstracts

1928–1929
11/14–12/29 *Marin*: 46 watercolors, 1927—Deer Isle, Maine, and White Mountain country
1/1–1/31 *Hartley*: 100 works, 1924–7—oils, watercolors, silver points, pencil drawings; still-lifes and landscapes from the south of France
2/4–3/17 *O'Keeffe*: 35 canvases, including several from years previous to 1928
3/19–4/7 *Strand*: Photographs—close-ups of webs, rocks, roots, etc.; Colorado and New Mexico landscapes; *Garden Iris* studies
4/9–4/28 *Dove*: 22 paintings (1928)
4/29–5/18 *Demuth*: 2 large paintings

An American Place—Room 1710, 509 Madison Avenue

1929–1930
12/15–1/25+ *Marin*: 50 watercolors—seascapes and mountains; Lake George
2/3?–3/15? *O'Keeffe*: New paintings—2/3 from New Mexico
3/22–4/22 *Dove*: 27 new paintings
4/25+–5/? *Group retrospective*: Demuth, Dove, Hartley, Marin, and O'Keeffe

1930–1931
11/1–12/? *Marin*: 1929 watercolors—32 from New Mexico, including Pueblo dances; 6 from New York, including Broadway at night
12/15–1/17 *Hartley*: Still-lifes from France, 1921–7; 1930 New Hampshire landscapes
1/18–2/27 *O'Keeffe*: 1930 oils—New Mexico and Lake George landscapes; last New York paintings; Jack-in-the-Pulpit series (6)
3/9–4/4 *Dove*: New paintings
4/?–5/? *Demuth*: Recent works
5/?–? *Group show*: Demuth, Dove, Hartley, Marin, and O'Keeffe

1931–1932
10/11–11/27 *Marin*: New paintings—first oils (14 from Maine) shown by AS; also 30 watercolors and 4 etchings from New Mexico
12/23–2/? *O'Keeffe*: 33 paintings from New Mexico—bones and flowers
2/?–3/? *Stieglitz*: 127 photographs—40-year retrospective plus New York from high windows at gallery and Hotel Shelton, portraits of O'Keeffe since 1922, and portraits of Dorothy Norman
3/14–4/9 *Dove*: "New Paintings (1931–1932)"—34 watercolors and 19 oils; and *Helen Torr ("Reds" Dove)*: 19 watercolors
4/10+–5/? *Paul Strand*: Photographs from New Mexico; and *Rebecca Salsbury Strand*: Paintings on glass
5/?–6/15+ *Group show*: Demuth, Dove, Hartley, Marin, and O'Keeffe

1932–1933
10/?–11/3? *Stanton MacDonald-Wright*: Recent oils
11/7–12/17 *Marin*: Recent watercolors and oils
1/5–3/15+ *O'Keeffe*: 13 new paintings—most from the Gaspé Peninsula; a few from earlier years
3/20–4/15 *Dove and Torr*: New paintings, oils, and watercolors
5/?–? *Group show*: selected early works of Dove, Marin, and O'Keeffe

1933–1934
10/14–11/27 *Marin*: Retrospective (1908–32)—watercolors
12/20–2/1 *Marin*: Works from 1932 and 1933—18 watercolors, 3 oils
2/5?–3/15? *O'Keeffe*: Retrospective—44 paintings, 1915–27
4/17–6/1 *Dove*: Selections from 15 oils and 60 watercolors done in 1933

1934–1935
11/3–12/1 *Marin*: Recent paintings from the coast of Maine (Cape Split) and New York—20 watercolors, 7 oils
12/?–1/? *Stieglitz*: Photographs—new prints of 50-year-old negatives; new images of O'Keeffe, the city from high windows, Lake George
1/?–3/15+ *O'Keeffe*: 9 new paintings and others
3/20?–4/15+ *George Grosz*: Watercolors, 1933–4 (debut in U.S.)
4/21–5/22 *Dove*: Oils, watercolors, watercolor sketches, 1934–5

1935–1936
10/27–1/1 *Marin*: Watercolors (including 12 from Cape Split, Maine); 7 oils of circus, women, NYC; drawings

1/?–2/?	*O'Keeffe*: 17 new oils
2/?–3/?	*Robert C. Walker*: Debut
3/22–4/14	*Hartley*: 29 paintings—Bavaria, 1933 and 1934; Dogtown (Gloucester, Mass.), 1934; Bermuda, 1935
4/20–5/20	*Dove*: New paintings

1936–1937

10/14–11/20?	*Ansel Adams*: 45 photographs (debut in N.Y.—large room)
	William Einstein: Seascapes, Maine, 1936; small portraits in oil (debut in U.S.—small room)
11/27–12/31	*Group show*: Demuth (posthumous), Dove, Hartley, Marin, O'Keeffe, Rebecca Strand
1/5–2/3	*Marin*: More than 15 watercolors (Cape Split boats and sea), 3 oils (circus)
2/?–3/?	*O'Keeffe*: 20 new paintings, including *Summer Days*; one earlier painting
3/23–4/16	*Dove*: New oils and watercolors
4/20–5/17	*Hartley*: 21 paintings, 1936 (Dogtown, Nova Scotia, sea shells)

1937–1938

10/27–12/24	"Beginnings & Landmarks—291—1905–1917": 72 works by 39 artists
12/26–2/12	*O'Keeffe*: New paintings—skulls and flowers
2/14?–3/27	*Marin*: Watercolors and oils—women and seascapes
3/29–5/10	*Dove*: 52 recent paintings, 1938 (20 oil-temperas/wax emulsions and 32 watercolors)

1938–1939

11/7–12/27	*Marin*: watercolors and 5 oils—Maine seascapes, trees in bloom, still-lifes
12/29–1/19	*Eliot Porter*: 30 photographs (first show anywhere); *Demuth* (posthumous): *I Saw the Figure 5 in Gold* (1928)
1/22–3/7+	*O'Keeffe*: New Mexico paintings—red hills, etc.
4/10–5/17	*Dove*: New oils and temperas

1939–1940

10/15–11/30?	*Marin*: "Beyond All 'Isms'—30 selected Marins (1908–1938)"
12/3–1/17	*Marin*: 20? watercolors and 5? oils from Cape Split—sea and trees (hand-carved and painted frames)
2/5–3/20+	*O'Keeffe*: New paintings, most from Hawaii, 1938
3/30–5/14	*Dove*: New oils and watercolors

1940–1941

10/15–12/11	*Group show*: Dove, Marin, and O'Keeffe
12/11–1/21	*Marin*: 1940 works—boats & sea (12 watercolors, 9 oils, and drawings)
1/30–3/25	*O'Keeffe*: New Mexico paintings
3/27–5/17	*Dove*: New paintings

1941–1942

10/10–11/30?	*Group show*: Dove, Marin, O'Keeffe—paintings, drawings, etchings; Picasso: 1 collage, 1 etching, 1 charcoal; Stieglitz: photographs
12/9–1/27	*Marin*: New works—8 oils—boats, ferry passengers; 15 watercolors —sea with boats, seashore with women
2/12–3/10	*O'Keeffe*: New paintings
3/12?–4/12	*Marin*: "Pertaining to New York, Circus & Pink Ladies"—works from 1936–41
4/14–5/27	*Dove*: Recent paintings, 1941–2

1942–1943
11/17–1/11 *Marin*: 12 or more watercolors and 6 or more oils—landscapes, sea-
 scapes, boats, portrait of son in uniform
2/11–3/17 *Dove*: Paintings, 1942–3
3/20–5/? *O'Keeffe*: Landscapes, feathers

1943–1944
11/27–1/8? *Marin*: 12 watercolors—Cape Split autumn; 3 oils—schooner and
 ducks [Reich dates show 11/5–1/9]
1/9–3/18+ *O'Keeffe*: New Mexico oils, including floating pelvises
3/21–5/21 *Dove*: 1944 paintings and wax emulsions, some large

1944–1945
11/27–1/10 *Marin*: 12 oils and 12 watercolors—Manhattan, hurricane sea,
 "nymphs," clowns, birds, trees (oil portrait of wife withdrawn)
1/10+–3/15+ *O'Keeffe*: New paintings—pelvises against sky
5/3–6/15 *Dove*: 16 paintings, 1922–44

1945–1946
11/30–1/17 *Marin*: 9 oils and 15 watercolors—Maine (trees, village, boats,
 mountains) and lower Manhattan
2/?–3/? *O'Keeffe*: 14 new paintings
4/?–5/? *Marin*: Recent paintings
5/4–6/4 *Dove*: Recent paintings, 1946

[At some unrecorded time during the 1930s, the experimental film *Portrait of a Young
Man*, by Henwar Rodakiewicz, was shown at The Place. After Stieglitz's death in
July 1946, and Dove's in November of the same year, an attempt was made by
O'Keeffe and Marin to keep the gallery going. The effort lasted until December 1950,
when—after a show of O'Keeffe's recent works—An American Place closed.]

APPENDIX III

MAJOR STIEGLITZ COLLECTIONS

Manuscripts

New Haven, Connecticut — Collection of American Literature, Beinecke Rare Book and Manuscript Library, Yale University

New York, New York — Archives, Metropolitan Museum of Art

Manuscript Division, New York Public Library

Tucson, Arizona — Center for Creative Photography, University of Arizona

Washington, D. C. — Archives of American Art, Smithsonian Institution

Photographs

Albuquerque, New Mexico — University Art Museum, University of New Mexico

Boston, Massachusetts — Museum of Fine Arts

Chicago, Illinois — Art Institute of Chicago

Cleveland, Ohio — Cleveland Museum of Art

London, England — Royal Photographic Society of Great Britain

Nashville, Tennessee — Carl Van Vechten Gallery of Fine Arts, Fisk University

New Haven, Connecticut — Beinecke Rare Book and Manuscript Library, Yale University

New York, New York — Metropolitan Museum of Art

Museum of Modern Art

Philadelphia, Pennsylvania — The Alfred Stieglitz Center, Philadelphia Museum of Art

Princeton, New Jersey — Art Museum, Princeton University

Rochester, New York — International Museum of Photography, George Eastman House

San Francisco, California — San Francisco Museum of Fine Art

Tucson, Arizona — Center for Creative Photography, University of Arizona

Washington, D. C. — Library of Congress, Prints and Photographs Division

The National Gallery of Art (contains the master set of images from the personal collection of Stieglitz)

APPENDIX IV

MISCELLANEOUS

A
CATALOGUE STATEMENT BY STIEGLITZ

First Exhibition of Stieglitz Photographs at Anderson Galleries, February 7 (to 21?), 1921.

The Exhibition is photographic throughout. My teachers have been life—work—continuous experiment. Incidentally a great deal of hard thinking. Any one can build on this experience with means available to all.

Many of my prints exist in one example only. Negatives of the early work have nearly all been lost or destroyed. There are but few of my early prints in existence. Every print I make, even from one negative, is a new experience, a new problem. For, unless I am able to vary—add—I am not interested. There is no mechanicalization, but always photography.

My ideal is to achieve the ability to produce numberless prints from each negative, prints all significantly alive, yet indistinguishably alike, and to be able to circulate them at a price not higher than that of a popular magazine, or even a daily paper. To gain that ability there has been no choice but to follow the road I have chosen.

I was born in Hoboken. I am an American. Photography is my passion. The search for Truth my obsession.

PLEASE NOTE: In the above STATEMENT the following, fast becoming "obsolete," terms do not appear: ART, SCIENCE, BEAUTY, RELIGION, every ISM, ABSTRACTION, FORM, PLASTICITY, OBJECTIVITY, SUBJECTIVITY, OLD MASTERS, MODERN ART, PSYCHOANALYSIS, AESTHETICS, PICTORIAL PHOTOGRAPHY, DEMOCRACY, CEZANNE, '291,' PROHIBITION. The term TRUTH did creep in but may be kicked out by any one.

B
STIEGLITZ PHOTO EQUIPMENT

[Sources include: AS correspondence; *Camera Work*; Doris Bry, *Alfred Stieglitz: Photographer*; Dorothy Norman, *Alfred Stieglitz: An American Seer*; and the Stieglitz Collection at George Eastman House, Rochester, NY.]

Student and Berlin Years

1883–4 A "large view camera" with no shutter
A tripod
Glass plates, 18 × 24 cm
Wet plate, collodion method
Paper: "the smoothest possible platinum" imported from England (to 1916)

After 1884 Dry plates

1887 AS was first amateur to use orthochromatic plate, developed by his professor, Hermann Wilhelm Vogel.

1889 His prizewinning photos were on "Pizzitype" paper (printing-out platinum), not yet in wide use.

New York and Lake George

1890–2 Camera #1: An 8 × 10 inch of unknown manufacture

1892 Camera #2: A Folmer & Schwing, New York, 4 × 5 inch Graflex Lens: Goerz (Berlin & New York) Anastigmat Series III, f6.8 (1⅝–35 inch equivalent focus)
[This equipment used to take *Icy Night*, reported by AS to have been taken "in January 1898, at 1 a.m., full opening, 3 minute exposure."]

1890–1917 Most "important" prints were platinums made from 8 × 10 inch negatives; gum and carbon print enlargements were also made from 8 × 10 inch slides. Most 1890s negatives printed as photogravures, however, were made from 4 × 5 inch glass slides.

1900–3
(perhaps
longer) AS used Seed (Co.) Non-halation Ortho-Portrait-plate "for virtually all my serious work, including so-called snapshots" (*Camera Work* Number V advertisement).

New York, Lake George, and Europe

pre–1907 Camera #3: *possibly* the same 8 × 10 inch Eastman (Eastman Kodak, Rochester, New York) 2-D View camera with a Packard shutter used definitely after 1917
Lens a: Goerz Double Anastigmat 14 inch [as described by George Eastman House] or
Goerz Anastigmat 13½ inch, direct size 21 × 26 cm [as described by Bry]
Lens b: 19.2 inch Cooke (Taylor, Taylor & Hobson, London) [This camera and these lenses are in the collection at George Eastman House]
Camera #4: 5 × 7 inch Folmer & Schwing Auto-Graflex (as identified by AS in *CW* Number XVI, October 1906 advertisement, with following:)
Camera #5: 3¼ × 4¼ inch Folmer & Schwing Auto-Graflex
Camera #6: "A Pocket Kodak"

Note: Between October 1905 and January 1906, Folmer & Schwing moved to Rochester, New York. In October 1907 the company was acquired by Eastman Kodak. In the year 1909–10, Eastman Kodak was divested of Folmer & Schwing in an antitrust action. The company became independent once more as Folmer/Graflex, and eventually the Graflex Company.

Camera #7: 4 × 5 inch Auto-Graflex
Lens: 180 mm Goerz Double Anastigmat
Camera #8: 4 × 5 inch Reflex (Reflex Camera Co., Newark, New Jersey)
[Cameras #7 and #8, with 180 mm Goerz lens, are also in the collection at George Eastman House.]
Further equipment identified by AS: 3 yellow filters (K-1, K-2, K-3), 3 lens hoods, 2 tripods, and a white cotton umbrella as an occasional reflector for portraits.

1907–14 AS color photography done with Lumière Autochrome plates.

1913–17 *Portraits and views from windows*
Usually platinum prints from 8 × 10 inch negatives
In 1913, AS used Shiro-Koto paper imported from Glasgow in sheets

11 × 15½ inches. When "the smoothest possible platinum paper" was not available, he used "Satista."

1918–22 *Portraits*
Usually Palladio and chloride prints, from 4 × 5 inch and 8 × 10 inch negatives. "Old" Palladio was used up in 1922; "new" Palladio reportedly "not so bad."

New prints made from 1880s and 1890s negatives

Periodically, until about 1932, AS reprinted old negatives he found in 1917. Printed originally as enlargements on platinum paper, the new prints were contact chlorides.

Lake George printing after 1920

Humid atmosphere and heat during the summer made use of Palladio difficult; AS waited usually for colder, dry weather of fall. In 1922, he referred to using Arturo for proofs, Palladio for prints only on rare nonhumid days.

1922 Intense complaints about changing Kodak papers began; also about "shiny little films" to which, however, he eventually became used.

1927 Experimented with "platinotype" paper at Lake George

1936 Receiving a gift from Zeiss of a Protar lens, AS responded that he had admired Zeiss since 1889 but had never used one; too late now.

C
THE PHOTO-SECESSION

Statement of Policies, and Membership, July 1903

So many are the enquiries as to the nature and aims of the Photo-Secession and requirements of eligibility to membership therein, that we deem it expedient to give a brief résumé of the character of this body of photographers.

The object of the Photo-Secession is: to advance photography as applied to pictorial expression; to draw together those Americans practicing and otherwise interested in the art, and to hold from time to time, at varying places, exhibitions not necessarily limited to the productions of the Photo-Secession or to American work.

It consists of a *Council* (of whom all are Fellows); *Fellows* chosen by the Council for meritorious photographic work or labors in behalf of pictorial photography, and *Associates* eligible by reason of interest in, and sympathy with, the aims of the Secession.

In order to give Fellowship the value of an honor, the photographic work of a possible candidate must be individual and distinctive, and it goes without saying that the applicant must be in thorough sympathy with our aims and principles.

To Associateship are attached no requirements except sincere sympathy with the aims and motives of the Secession. Yet, it must not be supposed that these qualifications will be assumed as a matter of course, as it has been found necessary to deny the application of many whose lukewarm interest in the cause with which we are so thoroughly identified gave no promise of aiding the Secession. It may be of general interest to know that quite a few, perhaps entitled by their photographic work to Fellowship, have applied in vain. Their rejection being based solely upon their avowed or notoriously active opposition or equally harmful apathy. Many whose sincerity could not be questioned were refused Fellowship because the work submitted was not equal to the required standard. Those desiring further information must address the Director of the Photo-Secession, Mr. Alfred Stieglitz, 1111 Madison Avenue, New York.

Fellows (Founders and Council): John G. Bullock, William B. Dyer, Frank Eugene, Dallet Fuguet, Gertrude Käsebier, Joseph T. Keiley, Robert S. Redfield, Eva Watson-Schütze, Eduard J. Steichen, Alfred Stieglitz, Edmund Stirling, John Francis Strauss, Clarence H. White; [and others not founders or council] Alvin Langdon Coburn, Mary Devens, William B. Post, S. L. Willard. *Associates*: Prescott Adamson, William P. Agnew, A. C. Bates, Edward LaVelle Bourke, Annie W. Brigman, Norman W. Carkhuff, William E. Carlin, J. Mitchell Elliot, Dr. Milton Franklin, Herbert G. French, George A. Heisey, Sam S. Holtzman, Marshall P. Kernochan, Sarah H. Ladd, Chester Abbott Lawrence, Fred K. Lawrence, Oscar Maurer, William J. Mullins, Olive M. Potts, Harry B. Reid, Harry C. Rubincam, T. O'Conor Sloane, Walter P. Stokes, Mrs. George A. Stanbery, Katharine Stanbery, George B. Vaux, Mary Vaux, Lily E. White, Myra Wiggins, Arthur W. Wilde. [Published as a supplement to *Camera Work*, No. III, July 1903]

D

THE LINKED RING:
London society of avant-garde photographers (founded 1892 by George Davison with H. P. Robinson, Lionel Clark, H. H. Hay Cameron, and Alfred Maskell), to which AS was the first American elected, in 1894. Among members of the Photo-Secession, Frank Eugene, Gertrude Käsebier, Joseph T. Keiley, and Clarence H. White were elected in 1900; Mary Devens and William B. Dyer were elected in 1902; Alvin Langdon Coburn in 1903; Sarah C. Sears in 1904; and Annie W. Brigman in 1909. Steichen declined an invitation in 1901; his friend and early sponsor, F. Holland Day, was elected in 1895, a year after Stieglitz. [Source: Weston Naef, *The Collection of Alfred Stieglitz*; see Bibliography.]

THE NEW SOCIETY OF AMERICAN ARTISTS IN PARIS:
Founded February 25, 1908. Advisory board members and founders: Eduard Steichen, with D. Putnam Brinley, Alfred Maurer, Donald Shaw MacLaughlan, and Max Weber. Charter members included: Patrick Henry Bruce, Arthur Beecher Carles, Jo Davidson, Richard Duffy, Lawrence Fellows, Maximilian Fischer, J. Kunz, John Marin, E. Sparks, and Albert Worcester.

THE INTERNATIONAL UNION OF ART PHOTOGRAPHERS:
1909 Membership List: James Craig Annan, Annie W. Brigman, Alvin Langdon Coburn, George Davison, F. Holland Day, Robert Demachy, Adolph de Meyer, William B. Dyer, Frank Eugene, Herbert G. French, Joseph Turner Keiley, Heinrich Kuehn, George Henry Seeley, Spitzler [given name and/or initials unknown], Eduard J. Steichen, Alfred Stieglitz, Clarence H. White.

E

The Royal Photographic Society, London, in presenting its Progress Medal to AS, wrote that it was given him for "services rendered in founding and fostering Pictorial Photography in America, and particularly for your initiation and publication of *Camera Work*, the most artistic record of Photography ever attempted." (Source: Waldo Frank et al., eds., *America and Alfred Stieglitz*, pp. 107–8.)

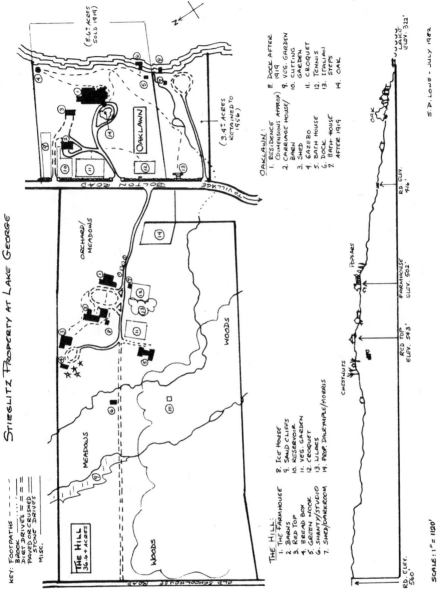

STIEGLITZ PROPERTY AT LAKE GEORGE

KEY: FOOTPATHS ------
BROOK
DIRT DRIVES === ==
PAVED OR CRUSHED ————
STONE DRIVES
MISC.

THE HILL
36.6 ± ACRES

N

(8.6± ACRES
SOLD 1919)

(3.4± ACRES
RETAINED TO
1956)

OAKLAWN

BOLTON ROAD

TO VILLAGE

OLD SCHOOL-HOUSE ROAD

WOODS

MEADOWS

ORCHARD/
MEADOWS

WOODS

THE HILL:
1. THE FARMHOUSE
2. BARNS
3. RED TOP
4. BREAD BOX
5. GREEN NOOK
6. SHANTY/STUDIO
7. SHED/DARKROOM
8. ICE HOUSE
9. SAND CLIFFS
10. RESERVOIR
11. VEG. GARDEN
12. CROQUET
13. LILACS
14. PROP. DALRYMPLE/MORRIS

OAKLAWN:
1. RESIDENCE
(DIMENSIONS APPROX)
2. CARRIAGE HOUSE/
BARN
3. SHED
4. GAZEBO
5. BATH HOUSE
6. DOCK
7. BATH HOUSE
AFTER 1919
8. DOCK AFTER
1919
9. VEG. GARDEN
10. CUTTING
GARDEN
11. CROQUET
12. TENNIS
13. ITALIAN
STEPS
14. OAK

S. D. LOWE - JULY 1982

RD. ELEV.
560

RED TOP
ELEV. 543'

CHESTNUTS

POPLARS

RD. ELEV.
416'

FARMHOUSE
ELEV. 502'

OAK

LAKE
ELEV. 322'

SCALE: 1" = 1120'

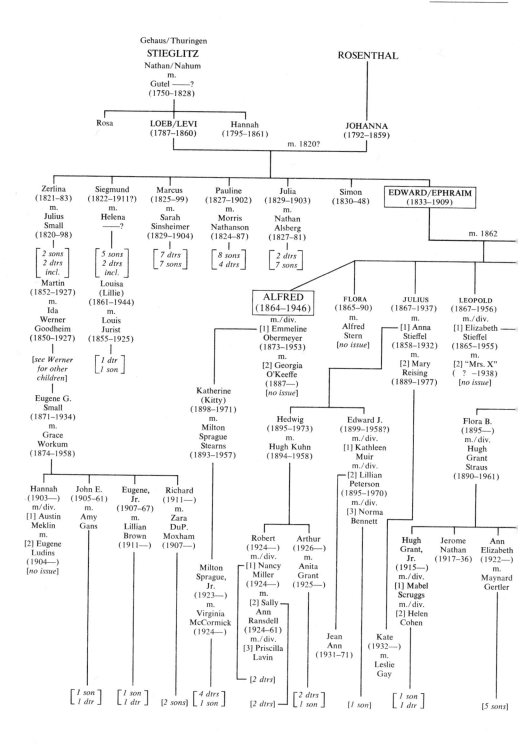

FAMILY TREE

INDEX

Abstractionists, 164
Adams, Ansel (1901– —), xvii, 342, 345–6, 363
Adamson, Robert, xvii, 151
Albright Gallery show, 147–52, 154, 164
Alsberg, Julia Stieglitz, 18; *see also* Stieglitz, Julia
Amateur Photographer, The, 84, 92, 99, 256
America and Alfred Stieglitz, A Collective Portrait, 331–2
American Amateur Photographer, 99, 106–7
American Caravan, 209
American Earthquake, The, 270
American Hebrew, The, 236
American Photography, 374
American Place, An, xviii, 158, 160, 193, 279, 302–4, 307–8, 310–13, 316–19, 322, 324–325, 327–33, 338, 340–2, 345–9, 351, 353–354, 357–60, 362–8, 370–1, 373–7
Anderson Galleries, 130, 217, 234, 240, 243–244, 247, 257, 262, 265, 269, 276–7, 288, 291, 293, 299
Anderson, Sherwood (1876–1941), 209, 244, 260–1, 269
Annan, J. Craig, 106
Apollinaire, Guillaume, 195
Arden, Elizabeth, 339
Arden Gallery, 227
Arensberg, Louise, 197, 209
Arensberg, Walter, 197, 209, 227
Armory Show, 127, 150, 163–4, 166–8, 177, 181, 190, 201
Art Students League, 136, 164, 202
Artists Derby, The, 247
"Ashcan School, The," 163–4
Association of American Painters and Sculptors, 163–4, 168
Astor, John Jakob, 24

Bach, Johann Sebastian, 130, 294
Back of Bear Mountain, 282
Bacon, Peggy, 282
Baekeland, Leo Hendrik, 81
Baltimore Museum, 367
Balzac, Honoré de, 164
Barnes, Djuna, 277
Barr, Alfred, 308, 360, 363

Baruch, Bernard, 239
Bauer, Karl L., 63, 66–8
Bayley, R. Child, 255–7
Beckett, Marion H., 196–7
Beecher, Henry Ward, 43
Beethoven, Ludwig van, 82–3, 253, 289, 294, 338
Bell, Clive, 253
Bell, Curtis, 125, 164
Benton, Thomas Hart, 332, 371
Bergson, Henri, xvii, 121, 125, 210, 212
Bernstorff, Count Johann-Heinrich von, 191–192, 204
Bismarck, Otto von, 73, 76
Black Abstraction, 285
Blake, William, 212
Bliss, Lillie P., 300
Bloch, Ernest, 244, 257, 260
Bluemner, Oscar Jr., 200, 282
Böcklin, Arnold, 129
Bonner, Margaret Foord, 140; *see also* Foord, Margaret
Boston Museum of Fine Arts, 112, 260
Bourgeois Gallery, 227
Boursault, George, 159, 215, 263
Boursault, Marie Rapp, *see* Rapp, Marie
Boursault, Yvonne, 263
Boys of '76, The, 47
Brahms, Johannes, 83, 284, 289, 338
Brancusi, Constantin, xvii, 127, 173, 181
Brandes, Georg Morris, 211
Braque, Georges, xvii, 127, 181, 190, 196–7
Brett, Lady Dorothy, 292, 298
Brill, A. A., 204
Brinley, D. Putnam, 148
Brisbane, Arthur, 242
Brooklyn *Eagle,* 283
Brooklyn Museum, 244, 278
Brooks, Van Wyck, 209
Bruckner, Anton, 83
Buffet, Gabrielle, 168
Burke, Kenneth, 244, 261
Burty, Frank, 181
Buttersworth, James Edward, 6–7

Caffin, Charles Henry, xvii, 112, 122, 125, 148

Calla Lily series, 287
Camera Club, 108–10, 112–14, 118, 120, 136–7, 190
Camera Notes, 108–10, 112–15, 120, 122
Camera Work, xvii, 106, 109, 112, 115–28, 131–4, 136–8, 142, 146–9, 151–2, 154, 156, 158, 160–3, 166–9, 180–2, 184–5, 187, 189–91, 195, 198, 200–1, 204–8, 211, 237, 294
Cameron, Julia Margaret, xvii, 167
Cannan, Gilbert, 253
Cardozo, Benjamin, 192
Carmen, 73
Carnegie Art Galleries, 121
Carpenter, Edward, 253
Caruso, Enrico, 140, 218, 245
Cézanne, Paul, xvii, 127, 142, 150, 152–4, 168, 189
Chamberlain, Neville, 351, 354
Chaplin, Charles, 244, 330
Charlemagne, 77
Chauve Souris, 253
Chiang Kai-shek, 351
Chicago Institute of Fine Arts, 114, 366–7
Coburn, Alvin L., xvii, 121, 151
Collin, Flora, *see* Werner, Flora
Constable, John, 127
Content, Marjorie, 325, 329
Cooke, Mabel, 84
Coomaraswamy, Ananda K., 260
Cooper, James Fenimore, 6
Corcoran Gallery, 121
Coronet, 374
Corot, Jean Baptiste, 127
Correggio, Allegri da, 77
Coughlin, Father, 351
Cowley, Malcolm, 261
Crane, Hart, 212, 261
Craven, Thomas, 332
Creative Art, 291, 318
Creative Evolution, 210
Cromwell, Georgia Engelhard, 374, 378; *see also* Engelhard, Georgia
Cromwell, O. Eaton ("Tony"), 362
Crowninshield, Frank, 186, 227
Cubism (ists), 152, 154–5, 162, 164, 184, 190
Cummings, E. E., 212, 261

Dada, 195, American, 197
Dahlberg, Edward, 360
Daniel Gallery, 207, 227
Dante Alighieri, 237
Darwin, Charles, 76, 82
Dasburg, Andrew, 168
Daudet, Alphonse, 74, 82
Davidson, Donald Douglas, xx, 5, 96, 131–2, 208–9, 213, 215–16, 220–2, 227, 229, 232–6, 238, 246, 253, 264–5, 267, 272, 276–7, 285, 289–90, 294–5, 298, 303, 314–15, 327, 333–4, 336, 340–1, 343, 346, 349–51, 355, 360–1, 369–70, 378
Davidson, Elizabeth Stieglitz, xx, 79, 88, 96, 131, 149, 222, 227, 229, 232–5, 246–8, 257, 262, 264–5, 267, 272–3, 276, 289–90, 294–6, 298, 313–15, 334, 336, 338, 342, 349–50, 354, 361–2, 370, 375, 377–8; *see also* Stieglitz, Elizabeth
Davidson, Peggy, xix, xx, xxiii, 4, 19, 88, 179–80, 218, 224, 229, 232, 234, 253, 267, 272–5, 285, 289–90, 294–5, 302, 310, 315–316, 328, 334, 336, 341–2, 350, 354, 366, 370
Davies, Arthur Bowen, 163–4, 166, 168, 227
Davis, Stuart, 321
Day, F. Holland, 112, 115, 185
Debs, Eugene, 178
de Casseres, Benjamin, xvii, 122, 125
de Forest, Robert, 288
de Meyer, Adolph (1868–1927), xvii, 145–7, 154, 159, 166, 186
Demuth, Charles (1883–1935), xvii, 244, 252, 259–62, 269, 281, 293, 308, 338, 346
Dewey, John, 315
De Zayas, Marius (1880–1961), xvii, 127, 148–9, 152–3, 162–3, 169, 181–4, 187–8, 195–200, 203–6, 212, 227
Dial, The, 240, 242–3, 259
Diary of a Travelling Philosopher, 211
Diaz, Porfirio, 148
Dietz, Fredrika, *see* Werner, Fredrika
Dodge, Mabel, 168; *see also* Luhan, Mabel Dodge
Dole Company, 355–7
Dos Passos, John, 209
Dostoevsky, Feodor, 77, 164
Dove, Arthur Garfield (1880–1946), xvii, xix, 127, 148–9, 154, 163, 187–8, 190, 199–200, 207, 210, 213, 216, 231, 237, 244, 251, 255, 258–9, 261–2, 266, 269, 271, 277–81, 291, 293–4, 296–7, 300, 303, 308–9, 318, 323, 325, 327, 330, 333, 339–43, 346–7, 349–51, 353–7, 359–60, 362, 364, 366–9, 372–4, 376
Dove, Helen ("Reds") Torr (1886–1967), 199, 261, 303, 318, 325, 339, 341, 350, 353, 367, 369
Dove, Paul, 347
Dove, William C., 199, 341
Dow, Arthur Wesley, 202–3, 237
Downtown Gallery, 313, 359
Dreier, Katherine, 300
Dreiser, Theodore, 209
Dreyfus, Alfred, 118
Droth, Andrew, 332, 370, 377
Dualities, 324
DuBois-Reymond, Emil, 73, 82
Duchamp, Marcel, 167, 197–8, 260, 300
Duncan, Charles, 203, 236
Duncan, Isadora, 131
Duncan, Raymond, 131
Duse, Eleonora, 94, 129, 186, 295

Eastman, George, 99, 107, 115, 226, 276, 298, 328, 330
Eastman, Max, 178

Eddington, Arthur Stanley, 211
Eddy, Arthur Jerome, 237
"Eight, The," 163
Einstein, Albert, 210–12
Einstein, William (1907–1972), xix, 157, 211, 340–7, 349–50, 353–4, 361, 363
Ekkehard, 79
El Greco, 142
Elizabeth of Rumania ("Carmen Sylva"), 273
Ellis, Havelock, 79, 211
Emergence of an American Art, The, 366
Emerson, Ralph Waldo, 77, 212
Encke, Erdmann, 68, 72, 74–5, 84, 90
Encke, Fedor, 46, 57, 63–4, 68, 72, 90, 103, 186
Engelhard, Agnes Stieglitz, 137, 170, 184, 227–30, 233–4, 237–9, 245–7, 263, 266–7, 273–5, 336–7, 343, 350, 357, 362–5, 370; *see also* Stieglitz, Agnes
Engelhard, George Herbert, 97–8, 137, 144, 170, 192, 216, 219, 227–30, 233–4, 245–7, 257, 267–8, 275, 336, 338, 344, 365, 376
Engelhard, Georgia ("The Kid"), 154, 170, 180, 206, 228–31, 234, 238, 254, 284–6, 289, 320–1, 336, 362; *see also* Cromwell, Georgia Engelhard
Equivalents, The, 130, 260, 362, 367
Ernst, Agnes, *see* Meyer, Agnes Ernst
Erxleben, Mr., 46
Eugene, Frank (1865–1936), xvii, 122, 136, 145–7
Evans, Frederick H., 106, 151
Ezekiel, Moses, 46, 57, 88, 90, 129, 237

Family of Man, The, 193
Faust (Goethe), 47–8, 210, 212
Faust (Gounod), 64, 103
Federal Arts Project, 330–1
Fields, Lew, 94
Fisk, James ("Jim"), 43
Flint, Ralph W. (1885–?), 211, 320–1, 341, 350
Foord, Barbara ("Foordie"), 89; *see also* Small, Barbara Foord
Foord, John, 43, 48, 89, 93
Foord, Kitty, 89
Foord, Margaret ("Maggie"), 89–90; *see also* Bonner, Margaret Foord
Ford, Henry, 239, 330
Forum Exhibition of Modern American Painting, 201
Fountain, 197
Fourment, Helena, 78
Francis Ferdinand, Archduke, 182
Franco, Francisco, 346, 351, 354
Frank, Margaret ("Margy"), 234
Frank, Waldo, 209, 236, 240, 244, 252, 331, 360
Freed, Clarence J., 236–7
Freud, Sigmund, xxi, 79, 204, 211–12, 257
Fuguet, Dallet, 112, 115, 120, 160, 163

GBS, 211
Geiger, Peter, 371, 373, 375
Glackens, William J., 164
Gleizes, Albert, 198
Glimpses of the Moon, 253
Goebbels, Joseph, 374
Goethe, Johann Wolfgang von, 47–8, 79, 82, 212
Goetz, Fritz, 166
Gogol, Nikolai, 82
Goodwin, Philip L., 360
Gounod, Charles François, 64
Goya, Francisco, 162, 164
Grant, Ulysses S., 31
Greene, Nathanael, 47, 105
Gris, Juan, 181
Grosz, George, xvii, 333
Guernica, 349
Guteman, Ernest, 346

Hahlo, Hermann, 19, 23
Haldane, J. B. S., 210
Hamson, Knut, 212
Hapgood, Hutchins, xvii, 125, 157, 168
Harris, Frank, 211–12, 240
Hartley, Marsden (1877–1943), xvii, 138, 143, 148, 150, 154, 162–3, 168, 173, 177, 183, 187–8, 199–200, 203, 205–6, 213, 226, 244–6, 251, 261–2, 269, 271, 278, 281, 291–3, 300, 308, 325, 331, 333, 339, 342, 346–8, 367–8
Hartmann, Sadakichi, xvii, 112, 121–2, 125, 153
Hâsemann, Hermann, 67, 75–6, 104
Haviland, Paul (1880–1950), 136–8, 148–9, 152, 157, 160, 162–3, 169, 181–4, 187–8, 195–6, 198, 206
Hegel, Georg Wilhelm Friedrich, 77
Helmholtz, Hermann von, 73
Henri, Robert, 164
Herrmann, Frank ("Sime"), 172, 220
Hesse-Wartegg, Ernst von, 48, 63
Hill, David Octavius, xvii, 124, 151
Hine, Lewis, 200
Hitler, Adolf, 65, 325, 333–5, 351–4, 357, 360, 374
Höeber, Arthur, 122
Hofmann, August von, 73, 81
Holland House Round Table, *see* Stieglitz Round Table
Hoover, Herbert Clark, 287, 325
How the Other Half Lives, 99
Huneker, James, 122
Huxley, Thomas Henry, 82

Ibsen, Henrik, 73
Icy Night, 109
Il Trovatore, 38
Impressionism, 127, 154
Intimate Gallery, The, xviii, 130, 278, 281–3, 287, 291–3, 295, 300, 304, 310–11; *see also* Anderson Galleries
Isidor, Moritz, 18, 19

Isle of the Dead, 129
It Has Been Said, 322
It Must Be Said, 322
Ivins, William, 287–8

Jacobi, Abraham, 11, 58
Jeritza, Maria, 253
Jones, Mary Mason, 42
Josephson, Matthew, 211, 261
Joyce, James, 212
Jung, Carl, 211

Kalonyme, Louis, 3, 4, 211, 291, 295–6, 298, 310, 316, 327, 341, 346, 366
Kandinsky, Wassily, xvii, 162–3, 168
Kant, Emmanuel, 77
Käsebier, Gertrude, xvii, 123, 132, 151
Kaufman, George S., 213
Keiley, Joseph Turner (1869–1914), 112–13, 115, 120–4, 145, 160, 163, 177, 179
Kennerley, Mitchell (1878–1950), 217, 234, 240, 247, 262, 269, 293
Keppley, Joseph, 48
Kerfoot, John Barrett, 112, 120, 125, 160, 163
Keyserling, Hermann A., 211
Knoedler's, 184
Krafft-Ebing, Richard von, 211
Kreymborg, Alfred, 190, 209, 212, 272
Kuehn, Heinrich, xvii, 145, 147, 152
Kuhn, Hedwig Stieglitz, 170, 235
Kuhn, Hugh, 235
Kurtz, Charles, 147

Lachaise, Gaston, xvii, 244, 281, 338
Lafferty, René, 203
Lauer, Clara, 111, 115, 134, 137, 143, 145, 161, 172, 219
Lawrence, D. H., 211–12, 264–5, 292
Lawrence, Frieda, 265, 292
Lawrence, Stephen B., 149, 158–60, 195
Leatherstocking Tales, 6
Léger, Fernand, 198
Lenbach, Franz von, 129
Leonidas of Sparta, 47
Lermontov, Mikhail, 82
Liebermann, Karl, 81
Liebeslieder waltzes, 284
Life, 353
Lincoln, Abraham, 21–2, 31–2
Lind, Hermann, 48
Lindbergh, Charles, 287
"Linked Ring Brotherhood," 106–7, 121, 141
Lippmann, Walter, 240, 244
Liszt, Franz, 64
Little Galleries of the Photo-Secession, 125, 130, 137, 304; *see also* 291
London, Jack, 212
Loy, Mina, 212
Luhan, Antonio ("Tony"), 294
Luhan, Mabel Dodge, 283, 292, 294; *see also* Dodge, Mabel

Lumière brothers, 81, 134, 136, 145, 187, 189
Luther, Martin, 77

McAlpin, David Hunter, 345–6, 357
Macbeth Galleries, 163
McBride, Henry, 211, 242, 279, 282, 347, 374, 376
MacDonald-Wright, Stanton, 206
Madame Bovary, 236
Madeleine Férat, 74
Maeterlinck, Maurice, xvii, 125, 210
Manet, Edouard, 150, 164
Marconi, Guglielmo, 136
Marin, John Curry (1870–1953), xvii, xix, 127, 138, 143, 148–9, 152, 159, 162–3, 166–7, 169, 188, 190, 199, 206, 213, 216, 226, 231, 244, 247, 252, 255, 258–62, 265, 268–9, 278–9, 281–2, 287, 291, 293, 296, 298, 300, 303, 307–8, 316, 325, 327–8, 338–9, 341–2, 346–7, 349–51, 353, 359–360, 362–7, 369, 371–4, 376
Marin, John Curry, Jr., 199, 341, 369
Marin, Marie Hughes, 199, 316, 341, 369–70, 373
Marriage of Figaro, The, 27
Marx, Karl, 76, 210
Masses, The, 178, 237
Matisse, Henri, xvii, 126–7, 137, 142, 148, 150, 153–4, 161–3, 166, 168–9, 326
Maurer, Alfred, 138, 143, 163, 206, 321
Meade, George Gordon, 21
Mein Kampf, 335
Mellquist, Jerome (?–1963), 211, 346, 366, 377
Mencken, H. L., 209
Metropolitan Museum of Art, 152–3, 287–8, 326, 329, 367
Meyer, Agnes Ernst (1887–1970), 148, 152, 154, 162–3, 181–4, 187, 195–200, 203–4, 206
Meyer, Eugene, Jr., 152, 157, 162, 183, 199, 206
Meyer, Willy, 137
Meyerbeer, Giacomo, 37
Michelangelo, 64
Mill, John Stuart, 211
Miller, Henry, 360, 366
Modern Gallery, 199–200, 205, 207
Modernism, 184
Monet, Claude, 163
Montross Gallery, 207, 227, 261–2
Moore, Marianne, 212, 261
Morgan, John Pierpont, 186
Mörling, Alie, 208–9, 213, 222
Mozart, Wolfgang Amadeus, 27, 73, 83, 253
MSS, 244, 251, 254, 330
Mumford, Lewis, 211, 331
Munson, Gorham, 261
Museum of Modern Art (MOMA), 193–4, 300, 307–8, 318, 339, 342, 345–7, 357, 359–60, 363, 367, 369, 374, 376
Music—A Sequence of Ten Cloud Photographs, 198, 260

Mussolini, Benito, 354, 374
My Life and Loves, 211

Nadelman, Elie, xvii, 127, 200
Nana, 79
Napoleon, 47
Nast, Condé, 186, 192–3
Nast, Mrs. Condé, 186
Nathanson, Pauline Stieglitz, 18; *see also* Stieglitz, Pauline
Nation, The, 240
National Arts Club show, 114–15
Nature of the Physical World, The, 211
New Republic, The, 240, 269
New Society of American Artists, 142–3
New York *American*, 166–7
New York *Herald*, 21, 242
New York with Moon, 280
New York *Morning Sun*, 148
New York *Sun*, 99, 242, 279
New York Times, The, 43, 48, 137, 283
New Yorker, The, 366
Newhall, Beaumont, 345, 363, 374, 377
Newhall, Nancy, 374–5, 377
Nicholas, Grand Duke, 143
Nietzsche, Friedrich Wilhelm, 237
Nikhilananda, Swami, 349–50, 354, 361
Norman, Dorothy, xxii, 194, 300–1, 310–22, 324–7, 329–32, 337, 340–2, 346, 348–51, 353–4, 357, 359, 365, 371, 375–6
Nude Descending a Staircase, 167

Obermeyer, Dorothy, 105, 169; *see also* Schubart, Dorothy Obermeyer
Obermeyer, Emmeline ("Emmy"), 63, 90, 100–2; *see also* Stieglitz, Emmeline
Obermeyer, Joseph (1862?–1943), 62–3, 65, 77, 90–3, 100, 102, 106, 144–6, 165, 249
Of, George F., 217, 240
O'Keeffe, Anita, *see* Young, Anita O'Keeffe
O'Keeffe, Claudia, 204, 213
O'Keeffe, Georgia, xvii, xix, xx, xxii, 7, 49, 52–3, 90, 97, 105, 127, 131, 136, 149, 164, 179, 188, 190, 193, 200–9, 213–19, 222–49, 251–5, 257–302, 307–29, 332–4, 336–7, 339–42, 346, 348–50, 353–7, 359–60, 362–374, 376–8
O'Keeffe, Ida Ten Eyck, 267, 283, 290
On the Spiritual in Art, 162
Oscar Wilde, 211
Our America, 236

Pack, Arthur Newton, 332
Parrott, William, 4
Peabody, George Foster, 87
Pearson, Hesketh, 211
Pearson's, 240
Peary, Robert E., 109
Pennsylvania Academy of Fine Arts, 111, 243
Persons and Places, 211
Peschel, Oskar, 82

Philadelphia Museum of Fine Arts, 372
Phillips, Duncan, 279–80, 282, 296, 300, 331, 339, 356, 360, 364
Phillips Memorial Gallery, 279, 347, 356
Photographic Journal of a Baby, The, 115
Photographic Society of Philadelphia, 111
Photography, 136
Photo-Pictorialists of America, 128, 151
Photo-Secession (ists), 115, 119, 121, 123–8, 132–4, 136–8, 141–2, 145, 147, 149–52, 190, 210
Picabia, Francis (1878–1953), xvii, 127, 168–9, 184, 190, 196–200, 205, 212, 282
Picasso, Pablo, xvii, 127, 142, 150, 152–3, 161–3, 166, 168, 181, 187, 190, 196–7, 359, 365
Picturesque Bits of New York, 109
Place, The, *see* American Place
Police Gazette, 98
Pollitzer, Anita, 199–204, 263, 280
Porter, Eliot (1901–), xvii, 346
Porter, Fairfield, 346
Post-Impressionists (ism), 130, 155, 161
Price, William J., 87
Prosser, Margaret, 289, 298, 314, 326, 328–9, 340, 343, 346, 361
Psychological Types, 211
Psychopathia Sexualis, 211
Puck, 48
Pushkin, Alexander, 82
Putaux, Les, 198

Raab, Fredrick, 122
Rabelais, François, 79, 164
Radio City Music Hall, 318, 320–2, 376
Raphael, 64, 362
Rapp, Marie, 120, 158–61, 179, 198, 206–8, 213–16, 263, 376
Rembrandt van Rijn, 162, 362
Remington, Frederic, 362
Renoir, Pierre Auguste, 142, 150, 153, 163
Rhoades, Katharine N., 196–7, 263
Riis, Jacob August, 99
Ringel, Fredrick J., 321, 346
Rivera, Diego, 318, 329
Rockefeller, Mrs. John D., Jr., 300, 331
Rodakiewicz, Henwar, 330
Rodin, Auguste, xvii, 126–7, 136, 142, 149–150, 153–4, 163, 169, 187
Rönnebeck, Arnold, 269
Rood, Roland, 121, 125
"Room, The," *see* Intimate Gallery
Roosevelt, Franklin Delano, 321, 325, 362, 374
Rosenfeld, Paul ("Red") (1890–1946), 209, 211, 236, 243–4, 253, 255–6, 259, 261, 263, 265, 267, 272, 274, 283–4, 286, 292, 298, 309–10, 314, 321, 331, 375
Rosenthal, Johanna, *see* Stieglitz, Johanna Rosenthal
Ross, Cary (1902–1951), 320, 325, 340, 346, 354, 356

Rousseau, Henri "Le Douanier," xvii, 127, 150
Royal Photographic Society, 106
Rubens, Peter Paul, 64, 78, 129, 362
Ruell Gallery, 227
Rugg, Harold, 331
Russell, Bertrand, 210–11
Russell, R. H., 109

Sage, Cornelia, 147
Salon Club, 125, 164
Salsbury, Nate, 255
Sandburg, Carl, 244
Santayana, George, 211
Sappho, 74
Schauffler family, 298
Schönberg, Arnold, 244
Schopenhauer, Arthur, 77
Schubart, Dorothy Obermeyer, 192, 273, 284, 289; *see also* Obermeyer, Dorothy
Schubart, Louis Howard, 62–3, 77, 90–3, 102, 106, 110, 115, 123–4, 139, 143–5, 218–19, 245, 286
Schubart, Selma Stieglitz, 63, 106, 109–10, 113, 131, 139–40, 144–6, 169, 184, 191–192, 218–19, 228, 237, 245, 255, 263, 265, 267, 273–5, 284–6, 333, 336–7, 343, 350, 352, 357, 362, 370; *see also* Stieglitz, Selma
Schubart, William Howard, 110, 145–6
Schubart, William Howard, Jr., 192, 373
Schulte, David, 288
Secession, 261
Seligmann, Herbert J. (1891– –), xix, 211, 244, 246, 263, 280
Seligmann, Lillias, 263
Sembal, 253
Serf, The, 154
"Seven Americans," 269, 288
Seven Arts, 209
Severini, Gino, xvii, 127, 206
Shakespeare, William, 48, 212
Shaw, George Bernard, xvii-xviii, 125, 211–12
Sheeler, Charles R., Jr., 227, 244
Since Cézanne, 253
Sinclair, Upton, 212
Small, Barbara Foord, 314; *see also* Foord, Barbara
Small, Eugene W., 87, 102, 209
Small, Flora ("Flick"), 143, 146, 183, 209
Small, Herbert, 143, 209, 313–15
Small, Ida Werner, 143; *see also* Werner, Ida
Small, Julius, 31, 33
Small (Schmal) ("Lina"), Zerlina, 18, 31, 33
Smith, Pamela Colman, 187
Soby, James Thrall, 377
Société Anonyme, 300
Society of Amateur Photographers, 99, 107
Society of Independent Artists, 197
Soirées de Paris, Les, 195
Staats-Zeitung, 20–1
Stalin, Joseph, 354

Stearns, Katherine Stieglitz, 248–50, 262–4, 310, 323, 326, 353; *see also* Stieglitz, Katherine
Stearns, Milton Sprague, 248–50, 263
Stearns, Milton Sprague, Jr., 248–50
Steerage, The, 127, 154, 198
Steffens, Lincoln, 168
Steichen, Clara Smith, 173, 183–4
Steichen, Edward (Eduard) J. (1879–1973), xvii, 114, 116, 119, 121, 123–6, 129–30, 132, 134, 136, 142–3, 145–6, 148, 150–3, 157, 162–3, 169–70, 173, 179–95, 210, 229, 251, 326, 364, 377
Steichen, Mary, 185, 233
Stein, Gertrude, xviii, 125, 142, 153, 161, 168
Stein, Leo, 142, 154, 168, 227, 244, 375
Stein, Michael, 142
Stern, Alfred, 86, 91–2
Stern, Flora Stieglitz, 89, 91–2, 94, 140, 165, 353; *see also* Stieglitz, Flora
Stettheimer, Ettie, 333
Stettheimer, Florine, 333
Stevens, Wallace, 261
Stieffel, Anna, *see* Stieglitz, Anna Stieffel
Stieffel, Elizabeth, *see* Stieglitz, Elizabeth Stieffel
Stieffel, Jacobine Sterck, 92, 183
Stieglitz, Agnes, xx, 7, 13–14, 17, 34, 37, 55, 60, 63–4, 68, 76–7, 83, 88–9, 92, 94, 110; *see also* Engelhard, Agnes
Stieglitz, Anna ("Anny"), 63, 92
Stieglitz, Barons von, 17
Stieglitz, Edward (Ephraim), xxi, 3, 4, 6–24, 26–37, 39–43, 45–52, 54–5, 57, 59–61, 63–8, 72, 75–7, 82–4, 86–90, 92–5, 97–8, 105–6, 109–11, 116, 119, 129, 133–6, 138–42, 153, 191, 232, 237, 239, 265, 299, 352
Stieglitz, Edward Julius, 219–20, 228, 285, 354
Stieglitz, Elizabeth, 52, 110, 165, 169, 171–2, 183, 208–9, 213–16, 220–2, 230; *see also* Davidson, Elizabeth Stieglitz
Stieglitz, Elizabeth ("Lizzie") Stieffel, xx, 55, 63, 79, 88, 90, 106, 110, 131, 137, 140, 165–6, 222, 224, 227, 232–3, 239, 245–6, 264–5, 272–5, 283–5, 289, 296, 312, 315–16, 319–20, 328, 334–6, 338, 342–3, 350, 361, 370, 376
Stieglitz, Emmeline ("Emmy"), 90, 102–6, 109–11, 113, 115, 119–23, 129, 134, 137, 140, 142–3, 145–6, 153, 161, 164–5, 169–170, 172–3, 177–8, 198, 205, 207, 209, 215–19, 222, 247–9, 265–6, 343; *see also* Obermeyer, Emmeline
Stieglitz, Flora, 7, 8, 13–14, 32–4, 36–7, 55, 60, 63–4, 68, 76–7, 83, 86; *see also* Stern, Flora Stieglitz
Stieglitz, Flora B., 110, 149, 165, 170, 172; *see also* Straus, Flora B.
Stieglitz, Hedwig, *see* Kuhn, Hedwig
Stieglitz, Hedwig Werner, xxi, 6–17, 20, 24–39, 42, 45, 49–51, 55, 57–65, 68, 72, 76,

83, 86–92, 94–5, 100, 109–11, 113, 116, 119, 129, 134–5, 137–40, 144–5, 169–72, 181, 184, 191, 208, 217–18, 227–9, 232, 234–5, 237, 245–7, 253, 255–7, 263, 265, 352
Stieglitz, Helena, 20, 33
Stieglitz, Johanna Rosenthal, 17–18
Stieglitz, Julia, 13, 17; see also Alsberg, Julia Stieglitz
Stieglitz, Julius Oscar, xx, 7, 13–15, 17, 34, 37, 39–40, 53–5, 60, 64, 68, 76–7, 83–4, 86, 89, 91–3, 131, 138, 170, 172, 192, 220, 226, 235, 263, 265–6, 285, 328, 347, 350
Stieglitz, Katherine ("Kitty"), 105, 111, 113, 115, 120, 122–3, 134, 137–9, 142–3, 146, 149, 153, 160–1, 164, 169–70, 172–3, 198, 208–9, 215–16, 218–20, 222, 225, 228, 230, 246, 248, 285; see also Stearns, Katherine Stieglitz
Stieglitz, Leopold ("Lee"), xx, 3, 7, 13–15, 17, 19, 34, 37, 39–40, 52–5, 58, 60, 63, 65–8, 72, 76–7, 83–4, 86, 89–90, 92–3, 97, 101, 106, 109–10, 113, 120, 129, 131, 137–8, 144–5, 165–6, 169–72, 184–5, 194, 213–14, 216, 220–2, 225–8, 232–3, 235, 237, 239, 243, 245–6, 248–9, 262–6, 271–275, 283, 285–6, 288–90, 292, 299, 315, 319–20, 322–3, 334–6, 338, 340, 342–4, 347, 350, 352, 354, 359, 361–2, 365, 370, 375–6, 378
Stieglitz, Loeb (Levi), 17–20
Stieglitz, Louisa ("Lillie"), 17
Stieglitz, Marcus, 17–20, 22
Stieglitz, Pauline, 17; see also Nathanson, Pauline
Stieglitz Round Table, 126, 148, 177, 183, 210–11, 231, 239, 247
Stieglitz, Sarah Sinsheimer, 20
Stieglitz, Selma, xx, 7, 13–14, 17, 34, 37, 55, 60, 63–5, 68, 76–7, 83, 89, 92, 94, 101; see also Schubart, Selma Stieglitz
Stieglitz, Siegfried, 17
Stieglitz, Siegmund, 13, 17–21, 23, 28, 31, 33
Stieglitz, Zerlina, 17; see also Small, Zerlina
Story of Mankind, The, 253
Story Teller's Story, A, 261
Stotesbury family, 362
Strand, Paul (1890–1976), xvii, xix, 124, 180, 192, 200–1, 205–6, 208, 213, 215, 226–7, 229, 231, 244, 251, 253–5, 261–3, 269, 278, 281, 283, 288, 292–4, 298–302, 308, 318, 326, 329–31, 349, 363
Strand, Rebecca "Beck" Salsbury, xix, 251, 253–5, 262–3, 265, 272, 283, 292–3, 298, 300–2, 318, 329–30, 346, 369
Straus, Ann, 350, 354, 360, 362, 365
Straus, Flora B., 315–16, 361; see also Stieglitz, Flora B.
Strauss, Johann, 64, 83
Strauss, John Francis, 115, 120, 138
Stuck, Franz von, 129, 153
Studies in Classic American Literature, 264

Summer Days, 348–9
Sykes, Gerald, 314

Tannhäuser, 78, 253
Taylor, Francis, 360
Ten Commandments, 154
Terminal, The, 100
Thomas, Norman, 211
Thompson, J. Walter, 193
Titian, Vecelli, 77
Tolstoy, Leo, 76–7, 164
Toomer, Jean, 212, 261, 328–9
Torr, "Reds," see Dove, Helen
Toscanini, Arturo, 355
Toulouse-Lautrec, Henri de, xvii, 126–7, 147–8, 150
Towards Democracy, 253
Träutlein family, 63, 172
True, Dorothy, 241
Truman, Harry S, 374
Turgenev, Ivan, 82
Twain, Mark, 74
Tweed, William Marcy ("Boss"), 43
Twice A Year, 327, 348–9, 354, 357, 366, 371
291, 127, 195–8, 200, 205, 237
291 (gallery), xvii, xviii, 126, 130, 132–4, 136–8, 143, 147–64, 166–70, 177–8, 181, 184–5, 187–90, 195–211, 213, 216, 225–6, 230, 241, 243–4, 246–7, 257–8, 262, 269, 276, 278–9, 291, 304, 351, 353, 373; see also Little Galleries

Van Dine, S. S., see Wright, Willard Huntington
Vandyke, Anthony, 64
Van Gogh, Vincent, 152–3, 168, 362
Vanity Fair, 186, 253
van Loon, Hendrik Willem, 253
Van Vechten, Carl, 168
Varèse, Edgard, 190, 244
Varnum, Ella, 232, 245
Varnum, Fred, 232, 236, 239, 245
Veblen, Thorstein, 211
Velasquez, Diego, 162
Verdi, Giuseppe, 64
Vermeer, Jan, 362
Villon, Jacques (Gaston Duchamp), 198
Virchow, Rudolf, 73
Vogel, Hermann W., 75, 80–1, 83, 356
Vogt, Karl, 82
Vogue, 364
Voltaire, 211

Wagner, Richard, 64, 78
Walkowitz, Abraham (1878–1965), xvii, 150, 154, 162, 166, 168, 177–8, 182, 204, 206, 213, 261, 325–6
Washington, George, 47
Washington Square Gallery, 197
Wave, The, 329
Weber, Joseph M., 94

INDEX

Weber, Max (1881–1961), 143, 148–52, 156, 162–3, 187
Wells, H. G., 125, 211
Werner, Abraham, 27, 29, 31, 58, 61, 140
Werner, Adolph, 26–7, 37, 45, 48, 51, 59, 63, 66, 67, 73, 101
Werner, Edward J., 27
Werner, Ernest, 27–30, 36–7, 72
Werner, Flora Collin, 27
Werner, Fredrika Dietz, 27, 30, 58
Werner, Hedwig, *see* Stieglitz, Hedwig Werner
Werner, Ida, 8, 27, 29–30; *see also* Small, Ida Werner
Werner, Jane, 27, 29, 30
Werner, Julius, 27, 37
Werner, Rosa, 7, 8, 11–13, 29–32, 34, 36, 39, 42, 49, 51, 59–61, 63–4, 68, 72, 76, 83, 94, 110, 246
Werner, Sarah, 27, 29, 30
Werner, Siegmund, 27
Wharton, Edith, 253
Whistler, James A. McN., 142
White, Clarence, xvii, 121, 123, 132, 148, 151
Whitman, Walt, 212

Whitney, Gertrude Vanderbilt, 331
Whitney Museum of American Art, 308
Wilde, Oscar, xviii, 125
Wilhelm, Kaiser, 65, 226
Williams, William Carlos (1883–1963), 156, 209, 212, 244, 261
Wilson, Edmund, 269–71
Wilson, Margaret, 354
Wilson, Woodrow, 191–2, 204, 207, 354
Winesburg, Ohio, 236
Winter—Fifth Avenue, 100
Wolff, Adolf, 178, 182, 191
Woodhull, Victoria, 43
Worcester Museum, 360
Wright, Willard Huntington, 212

Young, Anita O'Keeffe, 323
Younger American Painters in Paris, 148, 163

Zigrosser, Carl, 326
Zola, Emile, 74, 77, 79, 82
Zoler, Emil, 177–8, 182, 191, 204, 207, 261, 286, 293–4, 309–10, 325, 340, 342, 346, 361, 370, 375–6